Principles of Egyptian Art

Heinrich Schäfer

Principles of Egyptian Art

Edited, with an epilogue,
by Emma Brunner-Traut

Translated and edited,
with an introduction,
by John Baines

CLARENDON PRESS • OXFORD
1974

Oxford University Press, Ely House, London W. 1

GLASGOW NEW YORK TORONTO MELBOURNE WELLINGTON
CAPE TOWN IBADAN NAIROBI DAR ES SALAAM LUSAKA ADDIS ABABA
DELHI BOMBAY CALCUTTA MADRAS KARACHI LAHORE DACCA
KUALA LUMPUR SINGAPORE HONG KONG TOKYO

ISBN 0 19 817198 6

First published Leipzig, 1919
Fourth edition, Otto Harrassowitz, Wiesbaden, 1963
First English edition, Oxford, 1974

English translation and additional material © Oxford University Press 1974

*Printed in Great Britain
at the University Press, Oxford
by Vivian Ridler
Printer to the University*

CONTENTS

CONTENTS vii

A

The oldest sources show that the earliest pictures represented what a man *is*, not how he *appears* to us, his outline, not a view of him.

Winckelmann (after Plato?).

B

To look back to the first beginnings of painting from the pinnacles of achievement it has reached in modern times, to gain an awareness of the admirable qualities of the founders of that art, and to pay homage to the artists, who were ignorant of some methods of representation with which even novices are familiar today; all this demands firmness of purpose, calm detachment [*Entäusserung*], and an appreciation of the great value of the style which has with reason been termed '*essential*' [*wesentlich*], since it is concerned *more with the essential character of objects than with their appearance.*

Goethe, 'Polygnots Gemälde . . .' (after A?)

C

People always talk of originality, but what does the word mean? From the moment of our birth the world begins to act upon us, and it continues to do so until we die. And this is so everywhere [= in all cases]! So what can we call our own but energy, strength, will?

Goethe—Eckermann 1825

[Sources: J. J. Winckelmann, *Geschichte der Kunst des Alterthums* 1. Dresden: Waltherische Hof-Buchhandlung 1764, p. 4. (Facsimile edition, *Kunsttheoretische Schriften* 5, Studien zur Deutschen Kunstgeschichte 343. Baden-Baden—Strasbourg: Heitz 1966. Later editions have a very different text, e.g. *Johann Winckelmanns Sämtliche Werke* 3. Donauöschingen: Verlag Deutscher Classiker 1825, p. 64.)

J.W. Goethe, 'Polygnots Gemälde in der Lesche zu Delphi', *Weimarische Kunstausstellung vom Jahre 1803 und Preisaufgabe für das Jahr 1804,* Jenaische Allgemeine Literatur-Zeitung. Extra-Beilage zum 1. Januar 1804, section 'Noch einiges Allgemeine'.

Schäfer's italics in A and B; for discussion see Appendix 4, note (J.R.B.).]

FOREWORD

This book is more than a classic of Egyptology. Its results must be of interest to art historians, psychologists and philosophers who concern themselves with systems of signs and their role in communication. It constitutes indeed the only attempt ever made of analyzing an artistic style as a mapping procedure. Heinrich Schäfer has successfully reconstructed the key we have to consult if we want to interpret an Egyptian image in terms of what it is intended to represent. Put in another way, he teaches us the rules of transformation we must apply if we want to translate an Egyptian representation into the corresponding verbal description of a real or imaginary situation.

Most readers, of course, will be aware of the highly conventionalized character of Egyptian representations and they may therefore be tempted to take Schäfer's rather laborious analysis as read. It is a temptation that should be resisted, because it is in the fine detail that his method really comes into its own. Indeed the reader may be well advised first to sample the illustrations of these fascinating *minutiae* in Chapter 4 to gauge the importance of this book.

Not that Schäfer's general argument is anything but challenging. He was convinced that the role of the Greeks in the history of art could never be overrated. It was they and they only, he postulated, who launched the visual arts on that quest for the imitation of appearances that ultimately led from the pictographic to the photographic modes of representation. Wherever we encounter such illusionist features as foreshortening, perspective, light and shade, aerial perspective or the attempt to render textures we must assume the influence of the Hellenic tradition. It is one of the many merits of this English version of Schäfer's book that its learned editor-translator has undertaken to test this radical thesis in the light of present knowledge. It may be said to emerge dented but not demolished. The counter examples from Mexico (Addenda, p. 364) certainly acquire fresh interest in the light of Schäfer's thesis, but they do not dispose of his assessment of the re-orientation that art underwent in ancient Greece when the changing aspects of objects were first submitted to systematic investigation on the part of the artists.

The failure of earlier styles to take full account of these phenomena, Schäfer rightly insists, should not be taken as an indication that the world had to wait for the Greeks to become aware of the diminution of apparent size with increasing distance. His reference to a passage in the Etana epic which describes this diminution should have disposed of this fallacy for good and all. What is less clear in Schäfer's discussion is the explanation he proposed for this refusal to take note of the shifting appearance of things in space, a negative characteristic that the most sophisticated Egyptian representations share with the drawings of children. Like other students of this intriguing problem Schäfer took recourse to the alleged structure of mental images, though there is more than one indication in his text that he was far from satisfied with this explanation.

Possibly the great Egyptologist was here debarred from further progress by the intellectual tradition which he inherited and to which he adhered to the end. Like so many eminent German art historians he thought in terms of polarities or fundamental

oppositions. For him there was an unbridgeable gulf between the Egyptian and the Greek method, a gulf that was symptomatic of contrasting national characters. Maybe Schäfer's results could become more fruitful if they were differently interpreted. Could the Egyptian system not have owed its success and its stability over so long a period to the fact that it was more self-consistent than the Greek? It could be argued that we owe the variety and drama of the history of Western art to the self-contradictory elements in the aims of *mimesis*. This happens to be the point I tried to make in my book *The Story of Art* where I said that 'the "Egyptian" in us can be suppressed, but he can never be quite defeated'. (Twelfth edition, p. 446).

Once this gravitational pull of the pre-Greek mode of representation is fully acknowledged we may also be entitled to ask, what could have led the Greeks to counteract this universal tendency? I have suggested in *Art and Illusion* that this motivation may be sought in the attitude of Greek culture to mythological narrative; the image was put into the service of story telling, of a fictional evocation not only of what happened but how it might actually have appeared to an eye-witness. It seems that this function is indeed largely alien to Egyptian art, but why this should be so is a different matter.

We cannot tell how far Schäfer would have accepted any such reading of the situation in terms of the differing functions of images. But if I understand the Epilogue to this book by Emma Brunner-Traut correctly, it may at any rate not be inconsistent with her view of Egyptian notions of space and time.

The Warburg Institute E. H. Gombrich
University of London.

TRANSLATOR'S INTRODUCTION

Schäfer's *Von ägyptischer Kunst* is one of the most significant books in Egyptology, and one of the few that are of practical and theoretical relevance to work in other fields. It does not merely reapply knowledge and insights acquired in other contexts: its fundamental idea, that Egyptian artists, as well as many others, construct their representations according to mental images which, in their view, summarize the essential physical character of the objects depicted as opposed to their appearance, which is incomplete and foreshortened, is to a considerable extent Schäfer's own. In the book Schäfer works out in great detail the implications of this artistic method for actual works of art. In the process most major genres of Egyptian art are discussed, the only important exception being three-dimensional art of the Late Period— to which little attention has been devoted until recently. Apart from the first two chapters the whole book is unified by its basic thesis, which appears to be as valid— and in some areas as little appreciated—now as when it first appeared.

Yet the book is at the same time one of the least read in Egyptology. This seems to be chiefly due to the difficulty of its language, which diminished its impact even in Germany. In addition, the first three editions were printed in gothic type, and even the fourth and most recent (1963), which is translated here, is not as up to date as it might be in the material used for illustrations and in its editorial presentation. A further discouragement to foreign readers has probably been the fact that it is primarily directed at a German audience; for example, it seldom cites non-German literature,[1] and it draws heavily on Goethe's scientific and philosophical writings, and other sources which are culturally important in Germany but relatively unknown in the rest of the world. It is hoped that this English translation will make the book more accessible, and interest people for whom its remarkable qualities might have been obscured by some of the peculiarities I have mentioned. Though the book can never be light reading it should be of interest to anybody who is concerned with wider issues in the study of any type of representational art.

Heinrich Schäfer was born in Berlin in 1868, and lived there until the end of the Second World War. He was fascinated by ancient Egypt from an early age, and despite parental opposition he studied Egyptology at Berlin University, taking his doctorate in 1892 with a thesis on an Egyptian medical papyrus (Schäfer 1892). He was the oldest of the first generation of Erman's pupils, and Erman, Sethe, and he were the chief members of the 'Berlin school', which was until the 1930s the most prestigious group of Egyptologists in the world.

Schäfer began work in the Berlin Egyptian Museum while still a student and remained there all his working life, becoming a titular director in 1907 and the director of the Egyptian section in 1914. He never taught in the University, although he gave a number of public lectures and much of his writing has a didactic flavour. He retired from the Museum in 1935. He was thus its director during the time when the collection was being built up, and a large proportion of his academic work was concerned with the publication of objects in the collection. Despite the concentration

[1] A characteristic example is the neglect in discussing child art of the classic works in the field, Luquet 1913, 1927.

of his life's work in a single area, he was evidently a man of wide general culture.
The breadth and depth of his knowledge of fields outside his own are astonishing.
He was also very much aware of and involved in the intellectual life of his time. This
involvement, together with his patriotism[2] verging on chauvinism, sometimes makes
his work read as if it were the product of a National Socialist approach,[3] and he
would probably have approved of some of the terminology of National Socialism as
expressive of what was essentially German. But, although he was a friend of promi-
nent Party intellectuals like E. G. Kolbenheyer and Wilhelm Stapel—both of whose
works he quotes, and to whom he dedicated the third edition of his *Propyläen-Kunst-
geschichte* (Schäfer–Andrae 1942)—he was never apparently a Party member himself,
nor did he repudiate his Jewish or masonic friends during the period. So details like
the implicitly anti-Darwinian phrasing of his term for heredity (p. 39) and the fre-
quent occurrence of references to race and people (*Volk*) as concrete entities should
be taken rather as instances of a particular attitude current during his lifetime. His
linguistic purism is another product of his patriotism, but purism had been current
for a very long time, and does not necessarily relate to National Socialism.

Apart from his museum work Schäfer visited Egypt on a number of occasions
between 1899 and 1937, working in particular at Abu Gurab on the Niuserre' sun
temple, and at Philae. In 1946 he moved from Berlin to Hessisch Lichtenau, where
he died in 1957. The bibliography of his writings includes over 200 items, ranging
over the entire field of Egyptology—a vast achievement, especially in view of his
work as a museum curator. His books include fundamental text editions and cata-
logues, but the most significant are without doubt his various works on the Amarna
period, and above all his studies of Egyptian art. Of these the present book is by
far the most important.

Von ägyptischer Kunst was first published (in two volumes) in 1919, but was the
fruit of more than twenty years' work on the subject.[4] Schäfer describes in his
own preface how the work grew until 1930. It had then reached a form substantially
similar to its present one. However, although the form remained largely the same,
the book was then reworked in such detail that there is seldom a paragraph identical
in the third and fourth editions. The main body of the changes incorporated between
1930 and 1957 evidently dates to the 1930s and the war period; during all this time
Schäfer was publishing articles on subjects related to that of the book (cf. Abbrevi-
ations and Bibliography), but he almost ceased writing at the end of the war, only
one further piece appearing in 1957 (Schäfer 1957 posth.). The vast majority of the
references and the other material used also date to the same time or earlier, nor was
Schäfer able to take account of later work on Egyptian art, even Anthes's 'Werk-
verfahren ägyptischer Bildhauer' (1941). Therefore, for practical purposes, the reader
is presented with a book written in the years preceding the Second World War.
Virtually no revision of the material used as evidence is possible, as the argument is

[2] Visible for example in the dating of the first edition of this book (Schäfer 1919 p. VII) 'im
fünften Kriegsjahr' (in the fifth year of the war).

[3] An example is his discussion of Kolbenheyer's 'biological' approach to an explanation of the
origin of perspective (p. 270), which does not seem to carry the argument of the book any
further; but even here he is sober and critical. He does also quote Hitler's *Mein Kampf* in
one of his works (Schäfer 1936.8), but not an ideological passage.

[4] Further details of the history of the book are to be found in the Author's and Editor's
Prefaces.

based so closely on it; however, this is not necessary, as the argument itself has not become dated. It is, on the other hand, possible and useful to offer better and more accurate illustrations in place of many of the author's, and to add references to new and English-language literature.

It might be asked how much Schäfer's findings are still accepted or would still be accepted if they were examined; as the original version of the work goes back over fifty years it might be thought to be completely superseded. The value of much of the evidence used by Schäfer is as great as ever, but it is in the area of theory that deficiencies might be expected. To discuss Schäfer's theoretical standpoint in the light of contemporary work in related fields would involve consideration of wider issues in art history and theoretical psychology, and would go beyond the scope of this introduction. A short discussion of the status of Schäfer's approach among present-day egyptologists will suffice for my purposes here.[5] Reviews of the 1963 edition were mainly brief,[6] while those of the 1930 edition are too far back in time to provide information relevant to contemporary issues. The most important critical stance taken by a subsequent Egyptologist is Wolf's (1957.687–8), implicitly re-iterated in his obituary of Schäfer (*ZÄS* 82 [1958] p. III).[7]

Wolf takes Schäfer to task for being concerned with the mental processes of the artist producing a work, rather than with the resultant work itself, whose structure of meanings he says can be understood on its own terms. Wolf characterizes Schäfer's approach as 'psychologism' and links it with a general tendency in German studies of art in the first years of this century. He allies himself with the 'Strukturforscher', a school of art historians who used primarily formal criteria to classify and study works of art, and tended not to concentrate so much on content. Some of them worked on Egyptian art, and their ideas were in turn criticized by Schäfer (Krahmer [1931], von Kaschnitz-Weinberg [n.d. (1933)], Matz [1922 (1924), 1923–4 (1925)], cf.

[5] One problematic issue which falls outside the strictly egyptological field may be mentioned here: this is Schäfer's explanation of the juxtaposition of unforeshortened planes in a picture as the result of their being diverted by the resistance and attraction of the picture surface (e.g. p. 94 below). In doing this he is rightly opposing the viewpoint, influenced by Crocean aesthetics, which gives absolute priority to the image in the artist's mind (cf. Schäfer 1936.40 n. 63, citing Krahmer; Wollheim 1970.50–9, 175–6), but his view of the relationship of image and picture is none the less over-simplified, as he neglects the possibilities of multiple interaction between the two, apparently seeing the process of production as fundamentally as 'technical' one (here pp. 94, 103; cf. also Schäfer ibid.). Schäfer's interest in children's drawings probably influenced his approach, as children create much more *ex nihilo* than do adult artists; but even with children the problem is almost certainly more complex. It seems as if he is taking his hypothetical process of production as a starting point for argument, and giving it a unity which it would inevitably lack. In general, of course, his book is only peripherally concerned with problems of artistic training, tradition, and influence, so that it would be wrong to criticize it for not covering an area which it was not the author's intention to cover. See also below n. 11.

[6] They are as follows: Groenewegen–Frankfort 1972, Hornung 1964, Slow 1964, Vandier 1965, de Wit 1964. A posthumous note by Senk on the book also appeared (1967). Reference to an important review of the original edition, Davies 1921, was not explicitly included in later German editions.

[7] Wolf also discusses the sources of Schäfer's ideas, but his remarks do not tally with what Schäfer says in his own preface (which Wolf had not seen). Many of Schäfer's ideas seem to have been developed by him independently of other scholars.

pp. 321 etc. of the present book).[8] Wolf's criticism seems to me to be open to question in so far as he implicitly places Egyptian art in the same classification as the art from a study of which the concepts of *Strukturforschung* were evolved, and also in so far as he implies that Schäfer evaluated or should have evaluated Egyptian art aesthetically, or analyzed it from a purely formal point of view. In art such as Classical art which originally served *Strukturforschung* the evidence for the various meanings we may discover in any work is relatively well known, both in the area of material culture and in that of aesthetic and other ideas. In Egypt the ideas prevailing at the time of production of a work of art are barely known, if at all, and the material culture and activities represented—in great detail—are sometimes unattested from other sources. Therefore it is necessary to establish basic facts about the material and cultural implications of works of art before proceeding to analyze them formally; i.e. formal analysis is often a later stage in the process of study, and where it is placed earlier this is frequently because little else can be said about the work in question.[9] Also, the evidence Schäfer uses in his discussion of the artist's mental processes is chiefly derived from the very works which he is seeking to elucidate, and he applies his arguments to these works only. In other words, Schäfer does not have a theoretical axe to grind; although his discussions have theoretical implications, no all-encompassing theory is built on them.[10] His method frequently allows him to identify what is in fact being represented; he explains at the same time why the object comes to be shown in this particular way. These two types of identification are among his most valuable contributions. It seems to me that Schäfer's explanatory hypothesis— what the conception in the artist's mind might be—is much more revealing than any more 'intrinsic' one is likely to be—and it should be emphasized that what is offered is *only* an explanatory hypothesis.[11] In addition, Schäfer himself explicitly states that he is not primarily concerned with aesthetic evaluation—or even simple description; thus it is clear that the aims of his work are quite different from Wolf's. If he

[8] Cf. also Epilogue n. 5, to which the reservation should be made that there are problems involved in interpreting Egyptian art according to our idea, for which we have very little unambiguous evidence, the Egyptians' 'image of the world'—the approach may come perilously near to the 'two mentalities' or 'if I were a horse' impasses, because much of what can be said about such a notion is primarily the product of introspection. (For criticism see Evans-Pritchard 1965, Ch. 2, 4.)

[9] It should not be denied that formal analysis is also relevant in a study of the rendering of nature.

[10] His chief theoretical construct, the notion of 'depiction on the basis of frontal images' (*Geradvorstellung*), is not disputed by Wolf, and is of a rather different character from the tenets of *Strukturforschung*.

[11] Schäfer's method in using children's drawings might be open to similar criticisms of lacking an over-all supporting theory. However it was not his intention to provide such a theory; his observations are of coincidences in type and in the rendering of nature between children's drawings and Egyptian art, and although he has a hypothesis as to the general *principle* underlying most of the aberrations—from our point of view—in the rendering of nature, this is not the same as a theory, and his subsidiary hypotheses as to why a particular rendering was chosen in a particular case are more or less *ad hoc*; while this does not mean that they are incorrect, they are not sufficiently rigorous or consistent to form the basis of a detailed explanation of the cognitive processes involved—nor, again, were they ever meant to be. Some of his individual observations and hypotheses are none the less of great value to psychologists. The more rigorous psychological approach is exemplified by Luquet 1927. See also above n. 5.

claimed that his approach in this book was part of an aesthetic evaluation he would clearly be open to Wolf's criticism—though Wolf's own approach is also open to objection.

Where Schäfer may be criticized is in his failure to relate a general awareness of the cultural background of Egyptian works to the evaluation of Egyptian art in a coherent manner. And what Frankfort (1932.37–8) says on this score seems to me to be fully justified: Schäfer's general discussion in Chapter 2 seems to lack focus and does not give a clear enough impression of what he believes to be the essential character of Egyptian art.[12] Chapter 2.3 also wavers uneasily between the aims of an exposition with general validity and one specific to Egyptian art. It is here too that, as in Chapter 8, he is rather easily led off into the realm of almost mystical concepts. The fundamental defect of this section is the lack of any coherent framework within which an aesthetic evaluation, if this is what is desired, or a definition of the 'essential character', can be made. The *Strukturforscher* did indeed provide such a framework, and at a descriptive level many of their ideas are very useful; but they do not help one to understand why a particular work of art is different from another, nor do their approaches to aesthetic problems lead any further thah any other approaches, and they seem to be rather inappropriate to the study of any art whose primary purpose is the representation of reality, born as they were in the age of cubism and the first abstract painting. More recently art historians have been able to throw no more light on the problem of aesthetic judgement—apart from an increasing insistence on evaluation within the contexts in which works were created—though considerable advances have been made in analyzing the individual character and meaning of works of art, using approaches from the history of ideas (iconology), the social background, and simply the study of technique. Among these other approaches, it has still been possible to maintain the view of the history of art as a faltering but constant progress —until recently—towards an accurate representation of reality, this progress not being taken as one towards aesthetically 'better' works of art (Gombrich 1968; cf. also p. 343 of the present book). In the light of these contemporary preoccupations Schäfer's remarks in Chapter 2, diffuse though they are, discuss precisely the aspects which might provide the illumination desired; but we shall never be able to know more than a limited amount about the social, intellectual, and technical context in which Egyptian works were produced, so that the lesser effectiveness of such an approach, in comparison with what is possible for Western art, can be readily understood. What Schäfer's treatment does lack is a clear articulation such as he gives to the study of the rendering of nature in Chapter 4; and in some respects it claims to achieve more than it actually does.

Among more or less technical points certain aspects of Schäfer's use of language deserve more detailed comment, as they are extremely striking in the German text, even forming part of the texture of the thought, yet are inevitably more or less lost in translation. As I said above (p.xii, Schäfer's German patriotism extended to ideals of linguistic purity, and apparently to an over-all preference for academic and literary works in his own language. German linguistic purism, which is in no way exclusive to Schäfer, consists in a dislike for words of foreign (i.e. romance or even Greek) origin

[12] Schäfer (1934.19–25) replied in detail to Frankfort's criticisms of his views on Amarna art, and to some more general points. His stand against the pure formalist approach would of course be shared by many contemporary art historians.

and loan-words (*Fremdwörter* and *Lehnwörter*), and in printing in a preference for gothic type (*Fraktur* and *Schwabacher*) as against roman (*Antiqua*). A number of common German words fall into the despised category, as of course does much specialist terminology. Apart from the odd direct manifestation of his opinion,[13] wherever possible Schäfer suppresses words belonging to this category which would otherwise occur in his text, though he is less rigid with specialist terms than with everyday words, among which for example *Problem* (problem) *Idee* (idea) never occur. He is also not averse to extensive rewriting of passages he quotes where they offend him in these respects—sometimes without acknowledgement.[14] When Schäfer wished to devise new terms he did this on the basis of German roots and word-formations, and the book abounds in such words, the most crucial of which is *Geradvorstellung* (see below). The ideological implications of some of his beliefs—not necessarily related to linguistic purism—can occasionally be seen in the text (see above), while his cultural background is very evident in the allusions to the relationship of genius with the 'divine' and his discussion of L. von Ranke at the end of the book—and in the countless references to Goethe. The idiosyncratic style, a compound of long, involved sentences interspersed with occasional brief, almost epigrammatic ones—apart from the peculiarities of vocabulary—is another element evidently derived from this same background, partly literary, partly academic. There are places where it is almost wilfully obscure, for example where Schäfer's own word is used in place of the normal one for warp in weaving, (Ch. 4. n. 120), and even Germans are occasionally baffled as to the meaning.

In translating I have not tried in any way to disguise Schäfer's idiosyncrasies or to 'improve' on him at all. The sentence patterns of the original have been retained, and the technical terminology has been rendered with phrases specific to the book, not terms of roughly similar meaning that are current in English-language writing on art. Occasionally a term does of course translate straight into English, but this is not true of the neologisms, which have been translated as literally as was practicable; I have mostly given the German at the first occurrence. The resulting English probably reads much more like normal English academic prose than Schäfer's German, with its eccentric word distribution, reads like normal German. Any loss of individuality seems to me to be more or less unavoidable—some might consider it to be a gain—and although these traits are most prominent they only rarely affect the actual substance of the book.

Two terms in particular require more detailed discussion. The more important is *geradvorstellig*,[15] a portmanteau word I render with 'based on frontal images' or variants. Various other versions are possible, and other writers have used 'conceptual' (Gombrich 1968.101), 'ideoplastic' (Frankfort 1932), 'aspective' (Epilogue here), 'paratactic' (Krahmer 1931), 'non-functional' (Groenewegen-Frankfort 1951.7), and '*ideogen*' (Kolbenheyer 1935.129, 136) for comparable notions (see also Schäfer 1930.390-1 n. 333a). I have not selected any of these, as the precise form which Schäfer finally adopted was new, so that it might be misleading to render it with a familiar phrase, and because all the other words carry with them the overtones which

[13] e.g. Schäfer 1943.74. For his patriotism see ibid., p. 95.

[14] I have noted cases of this where I have discovered them, and have once or twice translated from the originals; a footnote states what I have done in such cases.

[15] For Schäfer's discussion, and use of further related words, see pp. 91–2.

their own inventors have given to them. Schäfer would not have approved of the use of 'frontal', but the alternatives, 'direct' or 'straight', seem yet more obscure, and also pose problems of phraseology.[16] The term means that the (mental) image on which a representation is based is one that excludes all accidental factors in the perception of the original object, and is therefore unforeshortened and not distorted in any other way; the processing by the mind implies that a selection of elements in the object according to their significance normally occurs (e.g. below, pp. 96–7). In literal terms frontal will therefore mean that in strict geometry the object is at right angles to the visual cone, as della Seta says (1906.29, quoted below p. 338). Schäfer objected to the word frontal because of its misleadingly similar use in the context of archaic Greek sculpture (a form ultimately derived from Egyptian or Near Eastern models);[17] it has not been practical to accommodate this scruple in English. In order to distinguish the two usages of frontal I have put the word in italics where *frontal*, which has the meaning Schäfer rejects, is in the German text (below, Ch. 7). The word *vorstellig*, which I render 'image-based', is also a neologism, and means approximately 'based on a mental image' (or in sociological terms a 'representation'). The remaining important neologism is the doublet *Gerüstschicht/Ausdrucksschicht* which I render 'framework'/'level of expression'. The *-schicht* in both words means either a 'layer' or a 'level', but level seems more appropriate because of the analogy with other usages of phrases for levels of meaning etc. Although I could find no phrase to include 'level' in 'framework' it should be understood to be implicit in the word. As with any other theoretical dissociation of structures such an analysis does not affect the fact that both 'levels' are perceived by the viewer at once (below, Ch. 8).

All these topics are also treated by Dr. Emma Brunner-Traut in the Epilogue, which proposes one vital change in terminology, suggesting a modification of both *geradvorstellig* and Schäfer's characterization of Egyptian and other art as 'pre-Greek' to a comprehensive term 'aspective'. However, for the reasons given above I have not adopted this. The Epilogue's aim is also preliminarily to integrate the notion of aspective into a total view of Egyptian—and other—culture. Dr. Brunner-Traut is preparing a book in which this idea will be treated in depth. Of course, although such an extension may be read into Schäfer's text, it is nowhere explicit in it: what Dr. Brunner-Traut is doing is to draw the consequences of Schäfer's unrivalled penetration of artists' methods for other areas; her conclusions are independent of Schäfer's, and do not affect them. I have had the benefit of Dr. Brunner-Traut's advice over the translation of this section, and the text has been modified slightly for this edition, with the deletion of one passage.

The German edition of the book is editorially unsuitable for an English-speaking public because of the condensed and complicated form of its citations, and because some of the works referred to are inaccessible and others have since appeared in translations or in new editions. The book also departs to a surprising extent from norms of citation in modifying or paraphrasing passages quoted, yet retaining

[16] In addition, the formulation already used by Slow ('the depiction of each part of an object as it is when viewed directly', 1964.192) has the disadvantage of including the word 'view', which was rejected by Schäfer (p. 91), and whose presence I would consider more harmful than that of 'frontal'.

[17] Cf. for example Boardman 1967.98, and for the technical aspect Iversen 1957.

quotation marks, and in failing to acknowledge other quotations. A fair number of references are simply wrong, especially in the list of sources for illustrations—I only hope that not too many errors have crept into this edition. To remedy this situation all books referred to have wherever possible been checked against their originals, and the references and abbreviations have been collected in a conventional bibliography, standard abbreviations being used. The footnotes have been brought together in one series, as against the original two, one of which was at the foot of the page and the other at the back of the book; details of translations and/or new editions have been added in the bibliography wherever they have been found. But although a fair amount of recent literature has been added to the footnotes there is no consistent reference to new studies of Egyptian art, as the only recent book of fundamental importance, apart from Wolf's and Smith's general surveys (1957 and 1958), is Bothmer's *Egyptian sculpture of the Late Period 700 B.C. to A.D. 100* (1960), which falls outside Schäfer's sphere of reference. When Schäfer refers for his examples to art books that are not readily accessible I have in most cases added new references to a few standard works. The corpus of illustrations is almost identical to that of the German edition. A few photographs have been added and one or two new originals for line drawings chosen where the old ones could not be found. Many new line drawings and photographs have been substituted for the ones in the German edition: such replacements are marked in the lists with an asterisk*.[18] None of these changes would necessarily have been made by Schäfer himself (cf. Editor's Preface, p. xxii) but I do not think they alter the substance of the book in any way, and the reproductions on the whole give a better idea of the physical appearance of Egyptian works of art than did the ones Schäfer used. Much that was inaccurate or obsolete has thus been removed from the illustrations, the most modern source almost always being used. In the text some inconsistencies and duplications are due to the uncompleted nature of the fourth edition; one or two of these have been removed, while others have been retained at Dr. Brunner-Traut's suggestion.

A new chronological scheme (printed after Chapter 8) has been substituted for Schäfer's, which is now out of date; the scheme is taken from Hornung (1967), and the dates throughout the book have been adapted to it. Additional changes are the use of 'predynastic' for 'prehistoric' in conformity with modern usage, and modifications in the description of historical periods (cf. Chronological Table). The forms of Egyptian names have been adapted for use in this edition, and vocalizations based on cuneiform, where they exist, have also been used (e.g. Nafteta for Nefertiti), with the normal form retained in brackets. Appendices 1—4 are new translations from the originals of the texts which Schäfer quoted; Appendix 1 is Speiser's translation from Pritchard (ed. 1955), and I owe the remainder to Anne Burton (Appendix 2) and John Tait (Appendices 3—4). The notes to Appendix 4 are the same as in the German edition. A concordance to plate numbers in the German edition and a list of Berlin Museum numbers with present locations complete the editorial changes.

It is hoped that all these modifications, which constituted the major part of the work on this edition, will make the book more useful to people working on Egyptian art, and to art historians in general.

[18] A number of critical remarks on the figures are made in the appropriate entries in the section Sources for Text Figures, and this should be consulted when evaluating the figures.

Finally, my thanks are due to a number of people who have helped me in the work: first of all to Dr. Emma Brunner-Traut, who has helped me especially over editorial points, and with the version of her own Epilogue; to John Tait for reading the whole work in manuscript and suggesting improvements on almost every page, and for advising me on all the Greek material; to Carol McClure for typing the book from an almost illegible manuscript; to Osman Durrani and Nigel Palmer for help with numerous problems of German; to Dr. Steffen Wenig for assistance over Berlin Museum numbers and photographs of objects in East Berlin; to Jaromír Málek and Helen Murray of the Griffith Institute in Oxford for inestimable aid over objects in museums and sources for illustrations; to Pat Clarke for devoting much time to producing new drawings and improving my own; to the officials of all the institutions which have co-operated in supplying photographs; to Prof. R. Anthes, Dr. J.C.A. Baines, J.-L. de Cenival, Dr. J. D. Cooney, Dr. I. E. S. Edwards, J. V. Kinneir Wilson, Prof. E. Lüddeckens, Simon Parkes, Donald Richards, Tao-Tao Sanders, Mary Tregear, Prof. E. Wind, and many others for advice and help on points of detail; and to Prof. J. R. Harris and the Clarendon Press for agreeing that the project was worthwhile in the first place.

Durham 1971

EDITOR'S PREFACE

This book was Heinrich Schäfer's own favourite among his works. Frau Schäfer wrote to me that his only preoccupation during his move from Steglitz (Berlin) to Hessisch Lichtenau was for the safety of the manuscript of the fourth edition. He handed over the responsibility for all the other projects in his charge, even for the *Atlas zur altägyptischen Kulturgeschichte*, on which he so much enjoyed working, in favour of this posthumous work, which occupied him in his new home for every free moment up till his death in 1957. Disregarding his friends' advice to publish the book himself he left it unfinished because 'there are still points that need clarifying'. And in accordance with the author's wishes I received the manuscript in 1959.

For the editor the unresolved problems—of a different sort—revealed their nightmarish extent in the course of the work. It would scarcely be more laborious to reconstruct the original sheets of paper from a basket of confetti than to turn this posthumous material into a book. The text was entirely without notes—either at the foot of the pages or at the end of the book[1] —and included no references to the illustrations. The author's intentions in these matters were merely noted on a collection of envelopes and paper bags, and the different directions in which they pointed or their different versions, which were produced in the two and a half decades they spanned, could only be discovered through an analysis of the writing materials. As editor I had hoped to be able to delegate the technical and organizational work, which necessitated the use of several concordances, but this illusion was shattered by the sight of the tangled material, and I only continued the work because I believed the book should be read and readers needed the book. And I think I may confidently say that it has been possible to deduce Schäfer's intentions with certainty from the material he left. In cases where no indications could be found I went back to the third edition; for the text itself this was only necessary at the end of Chapter 7. But the third edition was the only guide for the references to the illustrations, and new examples had to be found on the basis of mentions in the text itself; the author's wishes for changes in the scale or the method of drawing of the pictures were noted in two different copies of the third edition.

The author's idiosyncrasies in orthography and punctuation have not all been respected, as the extreme and pedantic departures from the norm were inconsistent and irritating. For technical reasons the illustrations have been numbered straight through, and not, as the author wished, according to the page on which they occur; and for similar reasons the lines of the text have not been numbered. Schäfer's method of quoting other works has been retained[2] although it differs from current practice, but page references have frequently been added. The book is printed with Schäfer's permission in roman type, out of consideration for foreign readers.

New photographs were procured for the plates, which are ordered chronologically according to the author's wishes, and most of the illustrations were redrawn by Frau Johanna Dittmar, a draughtsman with a sure touch and feeling for style. I remember

[1] [This refers to Schäfer's system of annotation, which has been abandoned in this edition. cf. Translator's Introduction, p. xviii (J.R.B.).]
[2] [Abandoned in the English edition. cf. Translator's Introduction, p. xviii (J.R.B.).]

my work with her with especial pleasure and gratitude. The remaining illustrations have not been taken from the most recent publications, as the author himself had not done this in earlier editions[3] —parts where the drawings diverged from the original were either of no relevance for his concerns or even helped, through their unintentional shortcomings, to prove his point. And it must be said in his favour that the addition of material that has since been published might enrich his presentation, but it would not affect his detailed results or basic theses.

Schäfer seized the opportunity to demonstrate and refine his rules wherever it presented itself in his work on Wreszinski's *Atlas* 3, but he intentionally did not refer to these studies in this book. It is not an editor's job to do what the author did not do.

In his later years Schäfer twice took issue with critics of the views expressed in his works (Schäfer 1942, 1944). The fourth edition, however, contains much less polemical material, and I thought it would harmonize much better with the style of the book if I only referred occasionally to these works. Anybody who studies the subject seriously will still have to read both essays in their entirety.

These decisions were almost automatic and were easily taken; but it was with regret that I decided to leave out of consideration material published after the beginning of the war and most especially abroad, as Schäfer himself had done (e.g. Donadoni 1942—Schäfer annotated this article: 'I much regret being unable to speak with this colleague. A discussion with such a man would be very valuable'— van Os [1943]; Smith [1946]; Groenewegen—Frankfort [1951]—and many other articles by different authors). He saw no point in discussing the works of Senk, though he would no doubt have welcomed the opportunity to come to grips with Wolf's *Die Kunst Ägyptens* (1957), which appeared after his death, and with the same author's preparatory detailed studies (Wolf 1951). But in this matter Schäfer, with whom I discussed this gap in his work, held to the view that can be summarized in Goethe's maxim: 'As one gets older one must make a conscious decision to stop at a certain stage.'

I hope, then, that I have released the book for publication, thoroughly reworked, enlarged, and deepened, in as good a state as it was possible to reach on the basis of the Master's manuscript, and after a sincere attempt to fulfil his intentions faithfully. There can be no doubt that he himself would have achieved more; but, although nothing we undertake in earnest reaches a conclusion, it may and indeed must be brought to a close if it is to have its effect, even if it could have been enlarged by the addition of further examples. And 'it is not the amount of experience that makes age wise, but its condensation, that is, an inward working-over and deeply considered formulation' (Eduard Spranger).

I would like to thank Cand. Phil. H. Blersch and Referendar E. Kissling for their help in correcting the proofs, and more particularly the publishers for their unhesitating support for the work and for the pleasure of working with them. In conclusion I must thank the *Deutsche Forschungsgemeinschaft* whose financial support of the project and the printing made the publication possible. The low price at which it appears is the result of Frau Schäfer's self-sacrifice. The sacrifice was made for her

[3] [For the choice of illustrations in this edition see Translator's Introduction (J.R.B.).]

husband and for ourselves, who have been waiting so long for the appearance of this indispensable book.

Tübingen, December 1961

Thanks both to John Baines's skills as a translator and indefatigable energy, and to the publishers' willingness to accept the project, Schäfer's work on the basic principles of Egyptian art is at last to be made easily available to non-German scholars. Schäfer's wilfully idiosyncratic style required translating because of its difficulty, and Baines's work is the more to be applauded since the book is one of the fundamental works of Egyptology. It gives me great pleasure to be able to express my gratitude to him. He also deserves considerable praise for the thoroughness and carefulness of his work, and for his conscientious approach to it.

Another cause of satisfaction is that in this translation the mistakes which went unnoticed or which crept in at the proof stage of the fourth edition have been, if not removed, at least painted over. Lastly, I have reason to hope that it will be possible for my own Epilogue on Aspective, whose German is probably even more difficult than Schäfer's, to be evaluated by a larger circle of readers, and that it may provoke further discussion of the subject, which I should then be able to take into account in the comprehensive work which I am planning.

I am grateful for the response I have had hitherto, and pleased that the term has been introduced into the discussion of other branches of art. I wish for the value of Baines's work to be appreciated, and for scholarship to benefit from it; and at the same time I am confident in the expectation that the book will provide new stimuli to the study of ancient Egyptian art and culture.

Emma Brunner-Traut 1971

AUTHOR'S PREFACE*

The stimulus for this book came—though I did not realize it at the time—from the sixth chapter of Adolf Erman's *Ägypten und ägyptisches Leben im Altertum* (n.d. [1885]).[1] Younger egyptologists will scarcely be able to imagine the effect the book had on us when it appeared in 1885; each page had something new to offer, the periods were clearly distinguished culturally as well as historically on the basis of the chronological ordering in Lepsius's *Denkmäler* (LD), and the presentation was fresh and lively. My teacher told me on one of our many walks that Gustav Freitag's *Bilder aus der deutschen Vergangenheit*[2] had inspired him to produce his own images of ancient Egyptian life.

FIG. 1–2. Wreaths made of petals and complete flowers. NK[3]

At the beginning of the 1890s I tried for the first time to understand exactly how the utterly alien rendering of nature in Egyptian two-dimensional art differed from our own:[4] I began boldly, by transposing in the gymnasium the wrestler groups from Beni Hasan into our artistic style, which was then still entirely perspective.

From that time I have related everything I have encountered in life and in my scientific work to these problems. In this way I have learnt to see, and the book is the product of constant thought about the subject if not of constant work at it.[5]

The first turning-point came in 1905 when I began to question Erman's inter-

* See motto C, p. ix.
[1] [For references cited see the list, pp. 380–407. Notes in square brackets are added by Dr. Brunner-Traut, notes in square brackets and initialled (J.R.B.) are by myself (J.R.B.).]
[2] [(1859 ff.). Subtitled *Kulturhistorische Studien* [studies in cultural history], a series of prose vignettes of German life (J.R.B.)]
[3] [For the abbreviations in the captions see Chronological Table (J.R.B.).]
[4] I did not find the egyptological publications on the subject then in existence satisfying. Most of them were very superficial, lacking both breadth and depth, although there were many excellent observations on individual points.
[5] Below is a list of my previous publication on the subject of this book. I give it here not because I believe somebody might wish to follow the gradual clarification of my views, but because material I have not included here as I thout it inessential or wrong may none the less seem of value to future students: Schäfer 1911, Schäfer 1913, Schäfer 1915a, Schäfer 1919, Schäfer 1921, Schäfer 1922, Schäfer 1923a, Schäfer 1923b, Schäfer 1923c, Schäfer 1923d, Schäfer–Andrae 1925, Schäfer 1926a, Schäfer 1927a, reprinted in Schäfer 1928, Schäfer 1929a, Schäfer 1929b, Schäfer 1929c, Schäfer–Andrae 1930, Schäfer 1931a (a reworking of Schäfer 1923b and Schäfer 1923d), Schäfer 1931b, a whole series of articles in *Amtl. Ber.*, Schäfer 1931d, Schäfer 1932a, Schäfer 1932b, Schäfer 1933, [Schäfer 1934], Schäfer 1935a, Schäfer 1935b, Schäfer 1936, *Atlas* 3 (with Hermann Grapow), Grapow–Schäfer 1937, Schäfer 1938, Schäfer–Andrae 1942 (cited as Propyl.), Schäfer 1942, Schäfer 1943, Schäfer 1944, Schäfer 1957.

pretation of the image of the human figure. But for a few more years my views were still determined by other people's ideas. I was finally liberated from these influences one day when the Babylonian story of Etana's flight to heaven came alive for me.[6] But the decisive change in the direction of my ideas came still later when I had the happy idea of characterizing Egyptian representational methods positively and not negatively (see p. 91). From that moment my path became clearer before me with each step I took.

In addition, living with my own children rekindled my enthusiasm for the study of children's and primitive peoples' drawings.

When I sent an article written some time previously, 'Scheinbild oder Wirklichkeitsbild?, eine Grundfrage für die Geschichte der ägyptischen Zeichenkunst', to the *Zeitschrift für ägyptische Sprache* in 1911, on the 150th anniversary of Richard Lepsius's birth,[7] Adolf Rost, the then owner of the publishing house J.C. Hinrichs, wrote to me that he had read the piece with much interest and hoped a book, which he suggested he should publish, might come out of it.

When the book appeared, at the end of 1918,[8] most of its subject-matter was so alien to my egyptological colleagues[9] that I had seldom been able to discuss it seriously with them. If I had sought advice in other quarters I might have saved myself the occasional lengthy detour. But I have never regretted detours in my work any more than I have on a walk.

The first edition went rapidly out of print. This fact, together with the large number of reviews, revealed to me that there was a market eager for a book of this sort. As early as 1922 I was able to bring out a second, revised and enlarged edition.

Thanks to enthusiasts for my work on ancient Egypt—I should mention especially my faithful friend Bruno Güterbock—and to the publishers, I was then able to produce a third edition in 1930, incorporating the results of the previous eight years' work. Since then I have constantly examined the content in the light of old and new facts, and reconsidered the form of the book as I re-read it, re-arranging it substantially at many points: the first courses of an enlarged building were laid over the old foundations.

The main addition was the chapter on the principles of three-dimensional representation, which I came to understand only after the publication of the second edition. In this way I was able to drop the subtitle *besonders der Zeichenkunst*, which restricted the book's scope to two-dimensional work. But while studying three-dimensional work I could not rid myself of the feeling that some vital element was not yet clear in our relationship with Egyptian art. Finally, without my intending it and in a way that seemed obvious only on reflection, the same solution as had served for two-dimensional art suggested itself and proved to bear examination. This I believed to be another indication that I had grasped the thread leading to my goal.

When the publishers, who were always so painstaking and helpful, asked me in 1944, when they were hardest pressed, what the prospects were for printing a fourth

[6] [Text printed here as Appendix 1 (J.R.B.).]

[7] [(Schäfer 1911). It was in fact the centenary of Lepsius's birth (J.R.B.).]

[8] [Schäfer 1919, so dated on title-page (J.R.B.).]

[9] Of course I explained my ideas to many people and showed them my first written drafts. In this way I often found that other people held the same opinions before I ever printed them, though sometimes in a form I would not myself have chosen.

edition, I was unfortunately unable to deliver a finished manuscript. With that my hopes were temporarily shattered. But I continued to improve the work so that when the edition was required it could appear in the new form. Even if this will never be possible I have still had, in Adalbert Stifter's words, 'the satisfaction of producing what I believed to be a more mature formulation of things that seemed immature to me'.

In the decades since the book first appeared many academic colleagues and laymen, some now dead, some still alive, have brought to my attention in conversation, or in print, or by letter, points that have occurred to them. Everybody who helped in this manner to clear stones from the way may rest assured that I have been grateful for any information and have given it careful consideration.

I reckon myself lucky that the fortunes of war should have brought to the same place as myself a man like Adolf Rusch. I have had him at my side from then up till this moment, when I believe I have brought my more than sixty-year-old work to its first organic conclusion.

The primary aim of the text figures is not to show the beauty of Egyptian works of art. They are chiefly intended as examples of renderings of nature which seem strange to us. In most cases this goal can be achieved in line drawings which demonstrate in an unpretentious way the point I am discussing. I have not been sparing with illustrations, indeed I was often tempted to include even more in order for the reader to see that the book is not a mere verbal exercise, but the result of intense visual study.

I assume no specialized knowledge on the part of the reader, nor is my language comprehensible only to an inner circle. I write neither for the unduly cerebral, nor for the over-emotional, nor exclusively for scholars, but for everyone who understands German; and I did not feel I had been helped at all by a sentence I once read about Egyptian architecture with its abundant pictorial decoration, 'we can almost hear the scream which was frozen into the hieratic gestures of this mass of stone.' Anyone looking for that sort of writing may as well lay this book aside at once.

A reviewer of the first edition sensed the balance I wish to maintain: to state what can be worked out in the mind and at the same time imperceptibly to suggest to the reader the things that can only be felt. It is still necessary to count on the reader's following me in making serious efforts to master the subject with which we are both concerned, for its difficulties are not removed even by the use of the most lucid language.

My primary intention is to explain the elements in Egyptian art which can be seen and touched, in order to provide the necessary basis for future research.

After a period in which study in depth, even of religion, was becoming rare, one can now observe an opposite tendency, which is also to be found in art study. The excessive swing in this direction reminds me of Gottfried Hermann's warning: *est quaedam et nesciendi ars et scientia.*

Although this book sticks very firmly to Egyptian material I believe it to be useful for the study of representational art in general. *I unite Egyptian and many other arts under the heading 'pre-Greek'. I should state at this point that I use this term only in a limitedly temporal sense.*[10] *It refers to any art which has not been affected by the*

[10] If the formulation were not so open to misunderstanding I would say that I used the word 'pre-Greek' to describe a stage of development. I avoid the word 'primitive' as far as possible. As a concept it is ill defined, and it contains in itself a value judgement. The

the adoption in Greece around 500 B.C. of a method of representation that takes
note of perspective, oblique views, and foreshortening in place of one that is based
on frontal 'views'. As will be shown, representations that are 'pre-Greek' by nature
occur not only in earlier Greece, but also all over the world today, even among our-
selves.

The term will not satisfy everybody immediately, but attempts to replace it with
another will do so even less. 'Pre-perspective', for example, should only apply to
ancient Greece: otherwise the mistaken impression would be produced that any
people could have found its own way to true perspective.

The concept 'pre-Greek' need not be restricted to art.

Anybody who studies the Egyptian rendering of nature should keep his eyes
open, in space over the whole world and in time through all of history; this desire
was constantly nourished in my many years' work in the Berlin museums, which
were always intended as one entity.

The placing of Egyptian art among the other 'pre-Greek' arts leads one to expect
that much of what occurs in Egypt may be found outside also, and that it may be
illuminated by this material, while the clarity and profusion of the Egyptian material
may often lead one to insights in other areas. In fact, I believe nobody can study any
art really seriously if he has not reflected on these problems. At the very least the
distinction between the 'pre-Greek' and 'Greek' renderings of nature should be out-
lined wherever art is taught.

Much further study will be possible on this basis before somebody else again
draws the material together to make a synthesis. But nobody can be more aware than
I am that a book like this one is never finished.

Hessisch-Lichtenau, near Kassel, 1956 Heinrich Schäfer

word 'archaic' also has a variety of senses and is therefore unusable in this context. It is
to be hoped that a master of the language will one day produce a German word for the
purpose. [*Naturvölker* and related expressions are rendered 'primitive peoples', etc., in
the translation (J.R.B.).]

1. WHAT VALUE DOES EGYPTIAN ART HAVE FOR US?

I will not rest until there is nothing left
that is for me only word or tradition,
until everything is living idea.

Goethe, Rome 27 June 1787[1]

An art is of course created and enriched by individual men in their own particular
ways, but at the same time it has a wider aspect, it is a product of the mental activity
of an entire people, and so has an existence in its own right, to some extent indepen-
dent of the passing of single men, and separate from the works of other peoples.[2]

In every people the artistic impulse finds expression in a number of fields, which
together compose a unity precisely because they are being exploited by *one* people.
But only a few especially gifted peoples work uniformly, and with the same degree
of success, in all these fields.[3] Usually, creative power and vitality only find suitable
ground in some of them, or reach high points at different times in different media
(see p. 66). In addition, any man who attempts to portray the art of a bygone

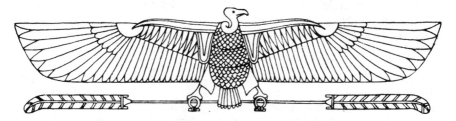

FIG. 3. Vulture on the ceiling of the royal processional way in a temple. NK

people is dependent on what has been preserved by chance. Moreover, his own dis-
position and circumstances will only very rarely allow him to comprehend all areas
in equal measure.

For this reason this book does not study in equal depth the whole range of mean-
ing of the word art, but restricts itself to the consideration of what we normally call
representational art. Essentially, only two-dimensional and three-dimensional rep-
resentation will be discussed, and these chiefly in so far as they depict human or animal
bodies. Architecture will be considered only when this is unavoidable; purely decor-
ative art, verbal art, music and dance will only be alluded to.

[1] [*Italienische Reise,* letter of 27 June 1787. Schäfer's text is inaccurate (J.R.B.).]
[2] How far the expressive capacities of a people in language and representational art
may diverge over a long period can be seen in the case of the Jews. Excavations reveal
that this people, which produced the literature of the Old Testament, possessed a
really miserable artistic culture—indeed their material culture is poor as a whole.
[3] Stapel 1928.18. [Wilhelm Stapel (1882–1954) German nationalist author and National
Socialist (J.R.B.).]

A thorough acquaintance with Egyptian art is more than a fascinating and desirable extra, it is indispensable to anybody who wants not just to enjoy looking at, but really to understand the beginnings of Greek art, itself the progenitor of contemporary European art.

Strictly speaking, before the growth of great representational art in Greece only two parts of the Mediterranean world can be thought of as independently creative: Babylonia and Egypt. Both influenced art in Greece in various ways (Von Bissing 1912, 1925).

At all periods there was only one route from Babylonia to Greece—by way of Syria, Asia Minor, and the islands.

But in the case of Egypt there were two routes, the straight one across the sea, and the longer one round the coasts of Syria and Asia Minor. In the earlier period of the flourishing of Cretan—Mycenaean culture in the second millennium, the 'islands of the sea', as the Egyptians called these countries, probably traded directly with the Delta. But for a long time north Palestine and Syria also passed on to Greece Egyptian influence and Egyptian forms, often mixed with local and Babylonian ones and considerably altered. This longer route may even have become more important than the direct one for the effect Egyptian art had on early European art: it is almost as if Egypt's independent, self-assured art had to be dissolved and analyzed in order for the Greeks to be able to make use of it. The significance of the intermediaries can be easily seen in the case of ornament. Syria added an element of unrestrained fantasy to Egyptian style, which, although it transformed motifs into geometric forms, always kept close to natural models; only after this addition did it become productive for other peoples. Around 700 B.C. the direct link started to become more important.

There may be other echoes of these changing routes in Greek myths. There are obscure allusions to the direct route in the descriptions of the arrival of various legendary heroes, such as Kekrops and Danaos, the brother of Aiguptos. On the other hand, it is as if Egypt had been expunged from another group of myths. All the technical processes, like glass-making, which the Greeks derived from Egypt, are attributed to the active transmitters, the Phoenicians, or to native Greek inventors such as Daidalos.

Just as the method of transmission changed with time, so did the Greek estimation of Egypt. Although they criticized the Egyptians, the Greeks esteemed highly the intellectual world of this peculiar foreign people: Herodotus, Plato, and Plutarch knew what they could hope to find there. Philip of Opus, a pupil of Plato,[4] admitted that such hopes were not unjustified, even if, he added proudly, it was the Greeks who 'brought what they took over to a finer culmination'.

One should not overestimate the influence of Babylonia or, especially, Egypt on Greece; but it is obvious that the mere existence of those two great artistic and cultural areas must have acted as a stimulus. Many a chapter of the history of Greek and hence of all European art would appear different today if those teachers had not worked beforehand to smooth the way for the first steps of the pupil of genius, who was to outshine them in influence on the world, and to open up entirely new paths.

[4] [It has not been possible to verify this passage. For Philip of Opus see *RE* 19.2351—66 (J.R.B.).]

But these links with Greek art do not by any means constitute all that knowledge of Babylonian and Egyptian art can offer us.

In order to solve the riddle posed by the blossoming of art in mankind, it is important to be able to carry out research among the peoples who created a great art independently. Since the Greeks arrived as new-comers among cultures that were then still far superior, one cannot expect their art to produce an answer to these questions; false impressions are often produced by its situation in time and space. Before reaching any judgement it is essential to establish what has developed spontaneously and where the preliminary work of another people has been exploited. The situation is quite different with Babylonia and Egypt.

Babylonian art can be traced as far back into prehistory as the art of the Nile valley, if not further, yet we are a long way from knowing the complete course of its development.

Egypt, on the other hand, is probably the only country in the world where we can observe the development of art more or less from its origins and in great detail: this development was furthermore given unity by the integrating physical shape of the river valley (see p. 32). The production of this people extends over more than four thousand years from its beginning to its high point, and on to its extinction a few centuries after the birth of Christ. There are of course still gaps, even if many that were once keenly felt have been bridged by new finds.

It is obvious how great a protection the length of this artistic life and the wealth of documentation provides against misinterpretation. It is scarcely the fault of the monuments[5] that there is as yet no entirely satisfactory history of Egyptian art,[5] since nowhere else are we offered such rich material for study, relatively free from sources of error, and chronologically well ordered. From the moment when Egyptian art reached maturity superimposed foreign influences, which might have diverted or in other ways disturbed the continuous process of development, are entirely absent; what was most essential to Egyptian art was not to be found in the art of any neighbours. Of course, Egypt was never entirely cut off: at certain periods it was astonishingly open to the outside world (p. 32). But in its progress its representational art took over apparently foreign material so authoritatively that it presents itself to us as a whole cast in an exceptionally unified mould. It would be an attractive and revealing exercise for historians of Egyptian art to study how it reacted on the one hand to Cretan—Mycenaean influence from the beginning of the second millennium to about 1300 B.C., that is, at a time of strength, and on the other to Greek influence from the fourth century B.C., in the weakness of old age. Many problems in the scientific study of representational art, especially in the rendering of nature, are most clearly stated and most surely answered from Egyptian art, thanks to the Egyptians' unremittingly consistent approach and to their insatiable delight in creation. There can scarcely be another great art about which it would be possible to write a book which sets out with the aims of this one.

The scientific study of art and the historical study of Greek art would in themselves provide sufficient reason to research into the art of the Egyptians. But there is a further incentive for us. Anyone whose interest in Egyptian art has been awakened will discover in it an irresistible fascination: he will find not only that his academic curiosity is satisfied, but also that he is dealing with a rich and mature art that still

[5] [Among the books published since, two should be singled out: Wolf 1957, Smith 1958.]

has a vital message for him.

And yet there will almost always be a residue that is not understood. It is relatively unimportant that many people cannot completely understand the content of works of art. *Not* because the content is a subsidiary matter: in the end all Egyptian works were created to express it (see p. 154–5). But any guide-book can help with such questions, and we need similar aids for works in many other spheres.

What is much more significant is that the strange form in which this content is presented does not allow someone unused to looking at pre-Greek art to arrive easily at a full appreciation. However, the exponents of some types of modern art have not found the rigidity of the statuary and the apparent distortion in two-dimensional works to be obstacles; rather they have considered that it is precisely in these matters that they have again come close to Egyptian art. Our studies will show that they have been mistaken in this (see p. 340). Those who sense that we are removed by thousands of years from these works, in which the method of rendering nature is fundamentally different, are nearer the truth. In fact, not only must we find our way in a world of alien forms of expression; we must also accustom ourselves to a quite different mode of apprehension of the world of the senses, before Egyptian representations reveal to us what the ancient craftsmen put into them. In this process three-dimensional works, that is statues, tend to be more accessible than two-dimensional reliefs and paintings. In statuary the observer may be disconcerted by a peculier squareness in posture and form, but he can adapt to it with relative ease. For the posture, at all events, *could* be adopted by a living body. But in most figures in two-dimensional representations one finds postures and movements which to the untutored eye look positively dislocated.

To reach a correct appreciation of the rendering of nature in these works it is not enough to leaf through a few picture-books or to walk once or twice through a large collection; a considerable amount of work is necessary, entered into with the firmness of purpose and calm detachment which Goethe requires (see p. ix, motto B) for the appreciation of early Greek art.

Egyptian art long suffered from being regarded as at most the trainer of the 'future saviour', without being valued on its own merits—perhaps because it was seen as standing so close to Greek art. This situation has improved, partly as a result of ideas we owe to Herder.[6] He introduced a way of thinking in which the history of representational and other art became the 'great fugue, in which the voices of individual peoples come to the fore one by one'.

Early indifference was followed by a reaction. Since the beginning of this century the general opinion of things Egyptian has risen to such an extent that it has often resulted in an underestimation of the art of other areas: I have indeed heard it said in as many words that the whole of Greek art from the fifth century on was just an aberration when measured against Egyptian. It is true that the vigorous rejection and acceptance of the two types of art expressed an awareness of the fundamental nature of the issue. Indeed, the opposition between the Egyptian rendering of nature and that initiated in Greek art and brought to a scientific conclusion in the modern era (see p. 274) is an opposition between two fundamentally different modes of artistic creation. I would like to offer an insight into this opposition by providing a better understanding of the basic principles of Egyptian art than has hitherto been

[6] [On Herder and Egypt see Morenz 1968.154–8 (J.R.B.).]

possible. In doing this I wish to make clear what were *the forms of the images in which the Egyptian, i.e. the 'pre-Greek', mind assimilated the physical world in order to show it with objective accuracy*. In this way it will automatically become easier to understand how the basic elements of the other half of the pair, the 'Greek method', came into being. The general implications of these principles in global terms will also be considered. The better understanding achieved will finally allow us to examine the question (see pp. 340–42) of whether an artist of today can use again ancient Egyptian forms in the spirit in which they were originally created.

I hope, by discussion in the following pages of the basic problems of Egyptian two- and three-dimensional representation, to enable the reader to cast off his pre-conceptions and to make the necessary adjustment, a much harder task than most people imagine.

There are two types of approach to different forms of art. They normally occur in conjunction, but should be kept apart at least for theoretical purposes.[7] For many it is almost an article of faith that all genuine art can immediately be recognized for what it is, and that its value can be appreciated at once by a person who is genuinely receptive to art; this should be possible at any time, and most especially now that we are at a peak of sensitivity. But the most superficial glance at history will reveal how opinions of contemporary and earlier masterpieces have varied—to such an extent that it is difficult to avoid asking Pilate's question, 'what is truth?' It is as if every man thought himself unique in being truly sensitive and correct in his judgement.

Unless, when one approaches an alien art, one makes a scholarly attempt to grasp its essence, one will grant recognition only to what one feels has a positive effect on one's own personality and acts as a new and enriching element in one's life. That is the natural way for a man to approach a strange work of art. In doing this he may calmly take appearance for reality, and fill the form, which would otherwise be dead for him, with new life; this is how many ideas become fruitful only when they are misunderstood. Any man, and that includes any artist, is entitled to do this, but not to make the arrogant assumption that he has found the key to a strange art in what he is thus able to perceive and appreciate of it. Classical Antiquity has assumed many forms in the minds of later generations, and will doubtless assume many more. How much, within the field of Egyptian art alone, the estimate of New Kingdom art in general, and Amarna art in particular, has fluctuated! So perhaps one is justified in being sceptical if today artists and enthusiastic laymen believe quite seriously that Egyptian works evoke in them the same feelings as they did in the Egyptians. Delighted at finding in Egyptian works of art elements that accord with what moves our own artists, people will leap over the vast abyss which separates us from those times and those men, and from the intellectual world of their works.

The scholar, who struggles to understand the essence of Egyptian art without hoping to find in it some immediate gain in his responsiveness to life, cannot be satisfied with the kind of observation just described. Many people have probably been drawn to this art because at some time it appealed to their emotions. But the scholar must test whether the forms are really created with the intentions suggested

[7] I discussed the importance of the distinction between pleasurable and academic methods of viewing collections for their arrangement and use in Schäfer 1920.

to him by his emotions. He tries by his studies to remove what may be false impressions, and wants to be able, as far as possible, to hear what the works have to say from the point of view of the intellectual and emotional world in which they were created. In order to achieve this he will have to stand at a distance and abandon his instinctive sympathy for the works.

Representational art stands in the centre of the life of a people as one impulse among many that proceed from a single matrix. No scholar can afford to neglect this unity in the mental outlook of a people. In the case of Egyptian art we are not as fortunate as with Far Eastern art, where it is still possible to be guided by descendants who live in the same culture, or with Greek art, where there are many writings preserved from Antiquity. One cannot expect to find comparable statements by ancient Egyptians about their art. Yet we are not in such a hopeless situation as with the stone statues of Easter Island, where a few works stand isolated, and the meaning of the inscriptions is probably lost for ever.[8] We are also much more fortunate than with Cretan art, where there is of course a profusion of surviving art works, but the religious, political, and intellectual environment into which the works were born is still almost entirely hidden from us by silence on the part of the written sources.[9] The situation is different with Egypt. Here it is possible to become thoroughly absorbed in an overwhelming, ever-increasing mass of texts, from the most spiritual to the most worldly. Of course a knowledge of the language sufficient to let one penetrate to some extent into the writings is necessary for this. With Egyptian in particular, translations are quite inadequate, because the problem is not so much one of the literal meanings of texts as of absorbing as much as possible of the spirit of the language and of the script. A man who also knows the nature of the land can hope to throw a footbridge over that chasm, and to look at the ancient works in something approaching the total context from which they emerged. He[10] might even achieve something which could be called thinking and feeling in Egyptian, which provides a protection against much false interpretation.

Many people tend to be shocked when it is suggested that they apply their intellects to works of art. Yet for anyone who is seriously engaged in the study of art it is essential. At least the basic principles underlying the rendering of nature in Egyptian art are quite simply comprehensible only through thought; they must necessarily remain closed to unaided sensibility. This is an area where Goethe's maxim that 'a work of art should just be enjoyed, not dissected by analysis' is invalid. And it is not satisfactory to ignore intellectual questions—they demand to be answered, precisely for the sake of the purity of one's aesthetic enjoyment. But there is no cause for concern; if the method of study allows both intellect and sensibility their rightful place, so that one is in no danger of coming to believe that what the intellect alone can grasp was created by the intellect, and if the whole idea can be made to live again, feeling will not be stifled. On the contrary, if the boundary is clearly drawn,

[8] [But see now Barthel 1958.]
[9] [But see now Ventris – Chadwick 1956 and Chadwick 1958.]
[10] One will always be tempted to make the original surroundings of the works of art concrete for viewers. But this could probably only be done harmlessly by using temporary pictorial reconstructions. Attempts to do it physically, for example in a museum, must be extremely cautious and leave a lot of room for fantasy if they are not quickly to become intolerable. Apart from this—and it is often forgotten—the inner eye has to do most of the work even when visiting what is still standing in Egypt, and not just because of the state of preservation of the pieces.

thought and feeling can develop in close communication, each in its own field; then and only then is the way clear for a full appreciation of the whole.

But all this work would be wasted for a man who had nothing more than the acumen of a bright *homunculus*. Such a person can lead us into the strange land, but only a man with something of a Faust in him can become in a deeper sense at home there. It is possible for anyone to experience any art once in one of its master-pieces with 'bated breath' or 'beating heart', when a door between the work and the inner understanding, which may have been shut for a long time, finally opens. Thus many may be able to name works in other fields, whose significance dawned on them in a refreshing insight which then led to an appreciation of hitherto unattainable treasures. Verbal explication is of small assistance here; it must always be a deepen-ing acquaintance with the works themselves which brings true understanding, and the acquaintance must be wherever possible with good originals, as even the best repro-duction is only a makeshift. Nothing more than preparation can be achieved through words. As E.G. Kolbenheyer[11] said, they must 'perform their service and then at the the appropriate moment fall silent'.

It is essential to bear in mind the distinction between an artistic and an academic method of looking at ancient art, and to understand that, as in life, they do not re-main at opposite poles, but are inextricably intertwined. For a man like H. von Helm-holtz 'an artistic mode of reaction is undeniably part of the scientist's makeup'.[12]

We must always be aware that our understanding can never be complete. This is less because what is preserved, despite its profusion, remains, and always will remain, one-sided and full of gaps, or because we cannot waken a perfect human being from antiquity and incorporate him in our lives, as Faust did with Helena: it is far, far more because it is completely impossible for us to transport ourselves into the mind of a strange people. Such an awareness of the limitations of insight or perceptiveness should never stop us from pressing forward as far as we can. Research itself acquires from this barrier a particular, stimulating attraction. If no scholar can entirely free himself from himself and from the context in which he lives, this means that each individual will approach Egyptian art in his own way, which is racially, culturally, personally and temporally determined, and will by his agreement or disagreement conquer new areas or show known ones in a different light; all this will help scholars who test these contributions rigorously to draw an ever richer, more living, and more accurate picture of the whole. Here, as with all communication with other human beings and their activities, the best help is founded on a sympathy and devotion, which will of course recognize another approach as being different, but provided it is valid, will appreciate it and for this very reason not need to fear disappointment. We must keep ourselves as far from the excessive enthusiasm which foists our own personalities onto the creations of ancient artists, as from a prim coldness—which is in the final analysis just as lacking in objectivity.[13]

One may be confident that, as agreement and disagreement alternate, true values will repeatedly assert themselves. 'They can remain hidden from view for a long time, but in the end their invincible patience triumphs. They can wait. Even if at a particu-

[11] [Foremost poet of the National Socialist movement (1878–1962) (J.R.B.).]

[12] [Hermann L. F. von Helmholtz (1821–94): great physiologist and physicist, inventor of the ophthalmoscope (J.R.B.).]

[13] Like that of Worringer (1927). See my discussion (Schäfer 1929b).

lar time the dominant movement banishes a perfect work of art into the outermost darkness or treats it with little discernment, provided it is physically preserved the work itself survives artistic movements and shines forth again, as soon as its time comes.'[14] Thus, despite temporary eclipses, there accumulates a permanent and ever-growing treasury of pieces ascertained to be great, giving us the confidence that behind changing opinions there is something firm, that there is some consistency.

In all attempts to penetrate into foreign realms of art, and therefore also with Egyptian art, one should bear in mind the warning Winckelmann gave to 'young beginners and travellers' as the best advice to take with them on the way to understanding Greek art:

Do not look for deficiencies and imperfections in works of art before you have recognized and learned how to discover what is beautiful. This reminder is based on daily experience–the beautiful has remained undiscovered by all too many, because they wanted to criticize before they had begun to learn; they behave like schoolboys, who are all sharp enough to discover the weaknesses of their teacher. ... But just as a negative sentence can be found more easily than a positive one, in the same way it is much easier to notice and to discover the imperfect than the perfect.

The aim of this book is to throw light on the position of Egyptian art in the art of the world, to show its living strength, and to prepare the way for an understanding of its achievements, as far as possible independently of the shifting 'values' (Schäfer 1929a) it may have for posterity. At the end the reader may himself decide whether the art thus contemplated seems lovable or worthwhile to him, and whether it is of a kind he finds personally enriching. No one who approaches Egyptian art today is likely to find, and he could hardly expect to find, an art which can satisfy him as it satisfied the ancient Egyptians. But even for us Egyptian art can provide at least many enjoyable hours of leisure, and surely nobody can occupy himself with the art of this gifted people, who more than any other created in joy for their own artistic instruction and hence for that of humanity, without bringing some personal profit away from the exercise.

[14] Cohen 1925.4 [Very extensively modified by Schäfer (J.R.B.)].

2. ON THE FORMATION AND ESSENTIAL CHARACTER OF EGYPTIAN ART

2.1 On the formative period of 'Egyptian' art

Until about 1890 we had no knowledge of the history of Egyptian art before the third dynasty, that is around 2630 B.C. The monuments then thought to be oldest displayed an art that was already mature and well established, but they came immediately after a period of obscurity which it seemed impossible to illuminate other than by conjecture. People did not dare to hope for the good fortune of earlier monuments being recovered. So the very few really early pieces that were already in collections went unrecognized, and the small amount of historical information preserved was considered as fiction dressed up as history. In the last half-century many objects from the first two dynasties (2900–2628) have been recovered, and also much older pieces from predynastic times, which cannot yet be dated in terms of years. We had previously regarded as characteristically Egyptian works produced from the middle of the third millennium on; these discoveries first showed how Egyptian art developed up to that point.

If we survey the whole progression as we now know it we see that chance had not after all misled us. Of course we can now see a long development before what was until then the beginning; but 'Egyptian' art in the proper sense only exists from a certain point in the known historical period onwards, and this point is close to 2700 B.C. Earlier art, the nearer it approaches that date, reveals more and more of the seeds out of which later 'Egyptian' art grew, but it lacks something which I cannot describe in words, but which can be sensed all the more surely in the works themselves. It should be possible to demonstrate its presence there. Take one of the oldest pieces of relief work, for example the palette with the king in the form of a bull (pl. 2), which must have been made shortly before the first dynasty (2900): its relief work is in itself an outstanding achievement. But if in one's mind's eye one removed all the distinctively Egyptian emblems, objects, and the like, one might wonder who would have the courage to claim with confidence that the work was Egyptian. However, the history of the pieces in modern times makes it unnecessary to attempt this. Although the objects appeared in Egypt, people have preferred to ascribe them to foreign peoples, Near Easterners, or Libyans, rather than to see them as directly connected with Egyptian art. At the beginning of this century they seemed to be so different from the rest of what was known from Egypt, that even some scholars who had devoted their lives to ancient Egypt and Babylonia fell into this error. The bull palette, for example, was first exhibited in the Near Eastern and not the Egyptian collection in the Louvre.[1] In 1896 I was able by a youthfully impetuous letter to persuade Steindorff to change his article 'Eine neue Art ägyptischer Kunst', in which he was still, shortly before printing, undecided between 'early or late, and if so under foreign influence', to state definitely that the pieces were old. At that time, when the idea

[1] The placing of the illustration of another of these decorated slate palettes in Maspero's *Histoire ancienne des peuples de l'Orient classique* (1897.767) is also significant.

that royal monuments of the Early Dynastic Period could be preserved was still remote from people's minds, the crux of my argument was that we could only make sense of the slate palettes if we took them to be tablets recording the victories of Egyptian rulers.[2]

FIG. 4a–c. OK ornamental friezes.

Now if one thinks of an Egyptian representational work from any period later than the beginning of the third dynasty (i.e. after 2628), and assumes, in order to make the test harder, that it does not depict Egyptians, but perhaps only foreigners, and has no element that is distinctively Egyptian, one may still be confident that anybody who had only a modicum of experience would recognize its Egyptian origin, even if it were to come to light in Babylonia. Naturally some conditions would have to be fulfilled, chiefly that it be of at least average quality for its period.

These experiences and considerations make us aware that, despite the many changes, there is something common to Egyptian works of art from the third dynasty until late in the Graeco-Roman Period, and that this element distinguishes them clearly from the works of other peoples, and, what is more important here, from Egyptian works of the previous period. The meaning of this is no less than that 'Egyptian'-ness was not an indissociable part of Egyptian works from the beginning, but that the new art which was peculiar to the people was only formed in the full light of history, between the beginning of the first (2900) and the third dynasty (2628). But between these two dates there are still several centuries, a short space of time in the long life of Egyptian art, but still too large an uncharted area, which research must narrow down more and more as the number of monuments is increased by new finds and as these are studied thoroughly.

The slate palette of Na'rmer (pl. 8–9) was spared the vicissitudes of the bull palette. Various factors contributed to this: it was found at a moment when we were already more used to the idea that Egyptian works of the early period might be preserved. It was found in circumstances which precluded any doubt about its authenticity, and its representations contain many more elements we are used to from Egyptian art than those of all the other palettes. But above all, the forms of expression on the Na'rmer palette represent, compared to the bull palette, a big step forward on the way to the new, authentically 'Egyptian' art.

Another big step forward occurs almost immediately, under Kenkenes Djer, the second king of the first dynasty, in the form that is given to the sacred falcon. Up till then it had always been shown leaning forward (fig. 5a), in a posture based on

[2] [Modern students of Egyptian historiography would dispute this (J.R.B.).]

keen observation of the normal stance of the bird, but now it was stood upright in the pose of a ruler (fig. 5a [and c]). This does not mean that nature has been abandoned, for the new form is taken from nature too. Think of the passage in Wolfram von Eschenbach's *Parzival* where Gahmuret is transfixed by the beauty of Queen Herzeloide radiating from above the tower as he rides up to her castle, and 'braces himself' from his previous posture in the saddle 'like a falcon set to fall on its prey.'[3]

FIG. 5. Artistic realizations of the sacred hawk. a. ED b. First dynasty c. Late

We can observe a similar development in the form of the Egyptian royal snake, the uraeus as we call it, using the originally Egyptian name (meaning 'the climbing one') which was taken over into Greek in late Antiquity.

In repose this hooded cobra lies stretched out on the ground with a slightly raised front part. The whole body is the same thickness from the throat to just above the tail.

Already in the Early Dynastic Period the narrowness of the breast is abandoned and the familiar form the animal takes on when it is provoked and preparing to attack is substituted. It then presents a flat shield (cf. pp. 144–5)—not puffed out—which is formed by spreading the ribs. Artists believed they could recognize several types of marking on this shield.[4]

The falcon and uraeus have in common the fact that the artists who transformed the repertory of forms in this transitional period did not clothe the existing iconography in a new style, but simply abandoned it. In its place they put another which had greater expressive potentialities.

The form of lions in sculpture, which appears to have been thoroughly remodelled under the same king as the sacred falcon (cf. Schäfer–Schubart 1926) leads us to make observations that are just as important, though of a different type. The granite lion from the end of the predynastic period (pl. 83) shows the complete animal with its head slightly raised and pugnaciously open jaws. The tail is probably meant to be arched above the animal's back, but the physical demands of the stone result in its being shown in relief from its root, lying on the back. There is still no base; instead the underside is worked as well. It is a clumsy but important work. Its later counterpart is a newly created form, to be seen in an Old Kingdom alabaster head (pl. 79): instead of the wild animal we have a royal one with an aristocratic gaze and its

[3] [*Parzival* 64. 7–8. Schäfer has modernized; the Middle High German is translated here (J.R.B.).]

[4] It almost always has a depression running downwards from the throat, which is cross-hatched, while the remaining space is mostly divided on either side into a semicircle and an oblong. Part of the inside of the arc of the semicircles sometimes has a wavy edge, and on the straight sides there is a shape which splits into two points. The forms of these additional elements should be collected and checked against the natural form; then their chronological distribution should be studied.

muzzle held shut in an expressive line. A comparison of these two lions shows a greater moderation of expression in the new art, but also a purer and deeper grasp of natural forms. The granite lion could still almost be a dog; the alabaster head is not indeed a particular lion, but completely Lion: the economy with which the essential is stated here in the simplest possible form is hard to parallel even among Egypt's much-admired representations of animals.

If one imagined the head completed in the form of a recumbent animal, the tail would not be on its back, as with the granite lion; at this time the almost perfect solution had already been found, to curl it round the hindquarters. The animal would also have to be placed on a base, as sculptors of this period no longer included the underside of the subject.

The lions show that the base was not only designed to ensure the stability of the figure—the four legs lying at the same level would have done that. It is probable that the addition of the base expresses the desire to give prominence to what was now consciously intended as a work of art. One must make the same assumption with standing figures of men and animals, although here, especially with human figures, the wish to provide a surface for the statue to stand on must have played an important part.

When we come to investigate the human figure in Chapter 6 we shall see the stages through which it too developed from the representations on the slate palettes to the 'Egyptian' rendering of a human being. The decisive change came in the second dynasty and the process was completed in the third. In order to appreciate the chasm that divides the Na'rmer palette from the third dynasty it is extremely instructive to compare a royal figure on its verso (pl. 7) with reliefs of Djoser or Ḥesire' (pl. 1). In its way the small picture on the palette with its muscular shoulders and protruding veins on the forearm is very skilful. And yet it seems so dull and stiff when set beside the others. In the portrait of Ḥesire' there is an entirely new, finer conception of man, indeed for the first time there is a feeling for what is essential in the build of the human body, and despite the severe stylization there is a mastery of individual forms which shows no lack of freedom.

What we have inferred from this relief can be confirmed in sculpture. For we have from the second dynasty the portrait statues of King Kha'sekhem [W fig. 34—5], works which show an astonishing mastery of stone-working, and which are also unmistakably 'Egyptian',[5] even if they are clearly some way removed from the classical forms. A sureness of style corresponding to that in the reliefs of Djoser and Ḥesire' has been completely achieved in the seated statue of Djoser, which strikes us with its quality of austere reserve, a portrait of a ruler which demands our attention not only because of the effect of its damaged face [L-H pl. 16—17].

Let us now study for a moment processes which occur rather on the fringes of major art.

Looking through books illustrating monuments of the Early Dynastic Period nobody' will fail to notice that the script changes significantly in the second dynasty. From then on its forms, relationships, and ordering of signs have a decisive new purity of style: by now they have all undergone a transformation similar to those of the falcon, lion, and uraeus. Inscriptions are now so different from those of their predecessors

[5] The earliest seated figure of a private individual, Berlin 21839, is probably also of second dynasty date, cf. Steindorff 1920.

that when the originals of fig.6 and related material were found scholars (Müller 1898) wondered whether they did not perhaps belong to a period many centuries later than fig. 7. History can set up no 'experiments'; but sometimes, as we have seen here and with the slate relief, a first mistake on the part of scholars constitutes something like an experiment. The change in the nature of the hieroglyphs, which, because of their pictorial nature, are closer to major art than any other script, would

FIG. 6. Cylinder seal impression: first dynasty writing (Dewn). ED

FIG. 7. Cylinder seal impression: second dynasty writing (Kha'sekhemui). ED

in itself have justified the hypothesis that it must have corresponded to a change in other art forms: everywhere artists were pressing forward to achieve purity and clarity in their art, and forms were becoming tauter.

We can see what was at work in this new method if we place a good selection of stone vessels of the second dynasty and Old Kingdom beside some predynastic ones. We feel the beautiful, but imprecise and fluid, forms become more self-conscious and firmer.

So we can be certain that in the second and third dynasties Egyptian art acquired characteristics which stayed with it for several millennia without ever becoming rigid. It is 'well proportioned and thought out, and expresses itself with great consistency', one might say that it was 'classical'. The self-conscious character[6] of this new art suggests that this period was probably also one of decisive steps forward in other intellectual areas.

[6] [In other words the artist is aware of the properties of the forms as forms and of the works of art as objects in their own right, as well as trying to render nature (J.R.B.).]

2.2 On the essential character of Egyptian art

> To catch you they go out with nets and stakes,
> but treading with paces of the mind you step through their midst.
> Schiller, *Votivtafeln*.[7]

It is extremely difficult to capture in words the essence of the art of an individual or still more of a people—this is something that it is only really possible to feel; in our case we must say what the new thing was which came into being at that time, and from then on, despite many changes, unites Egyptian works of all periods. Perhaps the subjects discussed in what follows and various remarks throughout this study will help the reader to find that something.

In works from the period before the beginning of the first dynasty (2900), of which our example can again be the bull palette (pl. 2), elements which could have developed in various ways are found side by side. There are undeniable reminders of similar phenomena in Near Eastern art. Whether these are the result of real connections, and if so which country influenced the other, cannot at present be decided; opinions on the subject are in a state of flux. But that is not relevant for us here, because whatever conclusion is reached it is a matter of indifference for the genesis of truly 'Egyptian' style. Egypt owes it to no foreign people. But an examination of later Near Eastern works shows what fruit the 'Near-Eastern' stylistic seeds in works like the bull palette could have produced. They are rejected gradually during the first dynasty, and definitively by the creators of the new art; instead the seeds cultivated are those whose fruits we can see in later Egyptian art. I need hardly emphasize that what follows does not concern differences in quality, but simply differences. We have a representation of a battle from predynastic Egypt (pl. 4): the king, who is shown as a lion, dominates the battlefield; he has thrown an enemy to his feet and is tearing open his stomach; vultures or other birds of prey are flying to the scène of battle and attacking the eyes and limbs of the dead bodies, just as they do in Old Babylonian and Assyrian representations. There is nothing comparable in later Egyptian pictures of war. The barbaric Nubians of Meroe are the first to reintroduce similar scenes (Schäfer–Möller–Schubart 1910.128).

In their titles and in other contexts where they referred to themselves Egyptian kings not only stressed that they saw to the well-being of loyal subjects, but also that they had kept their neighbours in order and made them respect or rather fear them by force of arms. Although the texts and pictures in which they tell of this are no doubt very exaggerated, they seem in general to have acquitted themselves honourably, in both internal and external affairs, of the tasks demanded by their circumstances. But at one period there existed something similar to the spirit of our age of chivalry—the knights are charioteers: in the New Kingdom, when Egypt was the leading power of the world for centuries, teachers portrayed the career of a military officer in dark tones, probably because their pupils were running away from class to the battlefield (cf. Schäfer 1929d). We can conjecture from pictures what it was that attracted them. There we see the light chariots of the king and his fellow heroes flying across the battlefield; the towering figure of the son of the

[7] [*Votivtafeln* no. 21, *Die Forscher*, first published in Tabulae votivae in *Der Almanach* 1797. Schäfer's quotation is inaccurate (J.R.B.).]

gods drives the fleeing enemies before him like game (pl. 54)[8] or kills them with a great swing of his arm (pl. 56); it is a representation of the poetry of battle or of hunting. On the other hand, when in reliefs of the great period of the Assyrian empire the king goes into battle or out hunting, we seem to hear the roar of the huge chariots and the hammering of the horses' hooves: we sense the hard work of Assurbanipal's fighting troops and think of Isaiah's powerful evocation of the Assyrian army (5:26–30). The difference between Egyptian and Assyrian methods of showing horses springing into attack (pl. 55–7) is particularly striking.

The Egyptians represent lions as royal animals. Assyrians represent them as powerful beasts of prey; it is essential to this distinction that no purely 'Egyptian' statue of a lion shows it with its jaws open (pl. 79, 81), a pose that still occurs in the Early Dynastic Period (pl. 83) and is almost the rule in the Near East.[9] In the entrance hall of Djoser's step pyramid there is a throne base like fig. 120, which is decorated with several heads of lions.[10] The heads do not have open jaws, but are baring their teeth, so that they would be exceptions to the rule if we wanted to see them as belonging to the new style. But as they also lack the clear-cut high quality of work-manship characteristic of Djoser's funerary complex, we should no doubt take them to be an Early Dynastic piece (from the first or second dynasty) which was removed from a revered older building and reused for some ritual purpose: already in Djoser's time the piece was antique.

In earlier Egyptian art there are set forms for only two animal gaits: the walk and the gallop. In both all four feet are always touching the ground: for the walk they are more or less equally far apart (pl. 29 top L); for the gallop the front pair of legs is shown reaching out obliquely in front and more or less parallel with one another, and the rear pair is in a comparable position behind the body [cf. for example fig. 192 (J.R.B.)].[11] The form of galloping jump with the front hooves thrown up only occurs from the eighteenth dynasty on, and its introduction is related to that of the horse. The fact that the latter was brought in between the Middle and the New Kingdom, probably from the cultural complex of the Mitanni, indicates that the new form of the jump was taken over from the Near East,[12] and with it the major changes in forms of expression just mentioned, which affect the whole figure down to the hind hooves. Assyrian horses have their back hooves firmly planted on the ground (pl. 93) while Egyptian ones are pushing themselves away from the ground with the front tips of theirs (pl. 56–7). The running gait of hunted animals which appears in the eighteenth dynasty is not pure Egyptian: they flee with their hindquarters raised, and their backs often form a continuous curve. In this we sense something of Cretan-Mycenaean culture, in whose art this form of gallop could almost be regarded as typical.[13] (In hunting scenes animals that have been hit also rear up; but this

[8] Egyptian pictures of battles and of hunting are identical not only in the way in which they represent flight without resistance, but also in their composition; cf. Schäfer–Andrae 1942.107.

[9] Cf. pp. 11–12, Schäfer–Schubart 1926, and Löwy 1911. Note also the alteration in the position of the tail discussed on p. 12.

[10] [Firth–Quibell–Lauer (1935 pl. 56).]

[11] Propyl. 249.2 [partially reproduced in W fig. 169 (J.R.B.).]

[12] For Near Eastern parallels cf. Moortgat 1930.

[13] Evans (1921.713–14). In Early Babylonian art it seems to be shown in the same way as in Egypt.

posture is not related to that of the gallop). In the case of human beings Egyptian art indicates even a very swift running pace merely by showing a longer stride with raised back heels and front toes placed on the ground, despite the fact that postures with raised legs occur in the representation of other motions, which might lead one to expect something similar for a run. So Egyptian running men do not suggest violent action, but rather a controlled, elastic swiftness (pl. 30), as they hold their trunks vertical, or at most slightly bent forward; only in the New Kingdom after the Amarna period (fig. 172) are they frequently bent forward more sharply. I only know of one representation (fig. 172) of men running with their feet raised above the ground, from a tomb at Amarna; this might be called a jumping run. Depictions of running men with both feet off the ground never occur, nor does anything comparable to the curious 'knee-run' which indicates speed in early Greek art.[14]

Egyptians were probably the first to be aware of the nobility inherent in the human form and to express it in art. One can sense the pleasure that the Egyptians must have taken in the balance of the shoulders and the delicate way in which they contrast with the aspiring shape of the rest of the body. In Old Kingdom drawings we can use the guide lines and dots (fig. 323) to deduce the proportions which govern the body's equilibrium. Julius Lange showed with great sensitivity that we should not imagine the fact that human figures in Egyptian art 'have stiff and erect backs, with their heads held high, and set squarely on their bodies' to be a sign of incompetence [1899]. Rather 'the awareness grew that this attitude expresses vitality and confidence in real life, and that it is therefore appropriate to the triumphant spirit which art should proclaim.' The transition from the fat predynastic female figurines, with their heavy breasts, thighs, and buttocks,[15] to the slender classical Egyptian pictures of women, which 'remind one of the profiles of precious vases'[16] indicates how much effect aesthetic impulses had in the genesis of 'Egyptian' art; among these pictures, apart from a few exceptions determined by their contexts,[17] only youthful, firm, and well-formed bodies are to be seen (pl. 1, 26). One might also note how reticently the body of a pregnant queen is drawn.[18] The same is true of the depiction of buttocks, where the delicacy of Egyptian drawing led people to describe pictures in terms of foreshortening. The changing forms of representation of these parts of the body in two and three dimensions would be worth studying.

Again, it is impossible that the long line of Egyptian kings included only men whose bodies were perfectly healthy for all their lives; and yet, apart from Amenhotpe IV, who had his and his family's unhealthy bodies shown in all their

[14] Not even in pl.8, bottom. The people shown are of course, like those in pl. 4 bottom, killed or collapsing, despite what Matz says (1923–4 [1925] 15). Borchardt (1931 pl. 1, top R) is a forgery, cf. Capart 1932.

[15] Propyl. 177 [Similar figure W fig. 10, also M fig. 144, 150 (J.R.B.).]

[16] Fechheimer (1923.53) [Schäfer has modified the phrasing of the original (J.R.B.).]

[17] Fig. 90, for example, is one of them, showing the sky goddess who gives birth to the sun anew each day. So also are the god of the Nile and the personified parts of the country (pl. 37), whose pendulous female breasts symbolize fecundity. (Thus water pours from the breast of the god in Rosellini 1844 pl. 27.2 [Graeco-Roman Period].) A comparison between the hieroglyph for 'old woman' (Steindorff 1913 pl. 47.2 [=Épron–Daumas 1939 pl. 39 (J.R.B.)]) and pictures of youthful women shows how consciously the representations of the breasts were varied; these variations would repay closer study.

[18] Erman–Ranke 1923 pl. 15.1 [=Naville n.d. pl. 49 (J.R.B.).].

unattractive detail,[19] there is hardly any king who shows a deviation from the body form thought to be ideal at the time. Some kings are thin and slender, others broad and thickset, some severe and others more abundantly developed, but their bodies are almost always well formed; traces of portraiture can only be found in the faces, and, except for Amarna and a group of Middle Kingdom royal statues,[20] these are toned down a great deal. Instances of the 'naturalistic' portrayal of the bodies of non-royal personages (pl. 32) prove that the idealizing representation of kings is based on the desire to lift the 'good gods', sons and likenesses of the gods, above what is human, imperfect, and subject to chance. But under Amenhotpe IV we can find, next to a picture of his father Amenhotpe III in the exalted style, a pitilessly precise depiction, in the Amarna style, of the decrepit human appearance of the old and sickly father.[21] This is not all: we can compare representations of Amenhotpe IV himself from his early idealizing period with others from the time after the change in style.

With faces we can see clearly how each period developed and then cultivated its own ideal of beauty. Thus faces in relief from the time of Amenhotpe III are often recognizable by the small and fine snub nose and slightly swollen lips of the ruler.[22] This bears only a superficial resemblance to the case of the artists of the slate palettes, who almost always had only one face at their disposal: excellent portraits were made over and over again from the Old Kingdom on. Their quality and number show that the Egyptians possessed the ability to observe and reproduce personal human traits, an ability which reached its high point in the royal portraits of the twelfth dynasty.[23] They were unequalled in neighbouring countries before the fourth century B.C., when Hellenistic artists discovered new aims in portraiture. The essential character of these heads of rulers and their relationship with literature and political events are discussed on pp. 27–9. In Egypt the tendency towards portraiture manifests itself very early, chiefly in sculpture. As has often been suggested, this tendency doubtless originated in the cult of the dead, in which prayers and offerings of food or other gifts were made to figurines or statues representing the dead person (fig. 232, pl. 27).[24] Even the Egyptian word for sculptor refers to the cult of the dead, for its basic meaning is 'he who keeps alive'[25] and it therefore derives from the group of ideas which is frequently expressed in tombs in the case of a son who 'makes his father's name live [by establishing the tomb and its equipment]'. Inscriptions on temple statues which men set up for themselves occasionally indicate a similar purpose, for example, when

[19] Propyl. 375 [cf. L-H pl. 183 (J.R.B.)].
[20] Propyl. 281–6, pl. 7 [L-H pl. 108, 114–16, 117–19, 120–1, Sm pl. 64A, 65, 68A, W fig. 259, and generally fig. 249–76 (J.R.B.)].
[21] *Atlas* 1.203 [cf. L-H pl. 154-5] and Griffith 1926a pl. 1 [Sm pl. 128 (J.R.B.)].
[22] Propyl. 336 [W fig. 201], 372 [372.2 = W fig. 479 (J.R.B.)].
[23] Propyl. 281 [L-H pl. 108 (J.R.B.)].
[24] Compare for instance the following three examples: (1) Anonymous 1925.13: the dead man is shown in three dimensions at the foot of the false door, just as if half his body were emerging from the ground to receive offerings; (2) in the tomb of Metjen (Berlin 1105, LD2.5) a spell which ensures that the dead man is provided with food and the words 'for the statue' are written round the slit in the *serdab*; (3) in the tomb of Ti (fig. 232) priests stand censing behind the inscribed words 'for Ti' next to the appropriate opening.
[25] Sethe showed that the word should be translated thus. It was earlier interpreted as meaning 'bringer to life' or 'the creator of life'.

the owner says he 'placed this statue in the temple in order never to be far from him [the god]',[26] or another rejoices that he can 'sit in the shadow of the temple and hear the priest's morning hymn from his mouth and always see Amun'. The body was less of a help to recognition than the head, so people were more frequently content with typical forms for it than for the face.[27]

One can of course only suggest what may have provided the stimulus to produce a portrait, and not why this stimulus, which was not lacking among other peoples, did not produce the same results with them. In the superb portraits of the Old Kingdom, or the best of the Middle Kingdom and of the Amarna period, there is an insight into the essence of the character of the man portrayed which is unknown in the art of those other peoples. But there is one thing an Egyptian artist did not do: he never used in his pictures specific facial characteristics of people he knew to impart particular mental attributes to the figures of people unknown to him. Artists place a figure that is close to being a portrait among the typical ones on the walls of tombs, not to show the person's character, but to identify people they wish to recall in a friendly or satirical way (pp. 46–7). As a consequence no Egyptian god expresses the spiritual essence which he has in myths in his bodily or facial form in the way Zeus, Poseidon, and Pluto, Athene and Aphrodite are distinguished physically by the Greeks. Egyptian gods, like Greek gods before the fifth century, are only identified by external emblems, and conform for the rest to the general ideal of beauty, or to the artist's own. However capable the Egyptians were of producing true portraits, the tendency to the typical and idealizing is dominant. Both occur together at all periods, and often in different pictures of the same person.

A very different point must be mentioned here. Wiedemann (1921) was the first to observe that obscene pieces are almost entirely lacking from finds of the earlier periods, while in the racially mixed Late Period they are almost intolerably common. Earlier Egyptians were not immune from such practices, and we can quite often see behind the veil that is drawn over unhealthy excesses of human behaviour, but they were rarely brought into the open in representational art. Most of the obscene representations that are found have a religious basis.

The self-control indicated by this restraint points to one of the most important facets of Egyptian culture [cf. Brunner 1957a Ch.3]; Egyptians being excitable by nature, the didactic texts (texts instructive in everyday wisdom)[28] are full of exhortations to self-control. Similarly, much that occurs in mature Egyptian art, but not in the earliest, must be regarded as restraint. I am thinking for example of the change

[26] Berlin 17272 and Ranke 1907–8.43 n. 3.

[27] Even figures that are not at all like portraits can serve as such. This end was achieved through the name which the artist had in mind when he made the work, or which was uttered over or written on it. In two dimensions the obvious method was to write the name next to the figure; for this reason portraiture is not striven after as much there as in sculpture. In Old Kingdom tombs the body may be dispensed with entirely and just a portrait head be placed in the tomb, cf. *Giza* 1.57. Cases where a king merely changed the name on a statue in order to claim other people's portraits for himself show how much more faith the Egyptians had in the name written on a piece than in facial likeness. A very interesting example is a statue of Amenemḥat III (dyn. 12, Berlin 1121) usurped by Merneptaḥ (dyn. 19), who only altered the creases in the extremely individual face (cf. pp. 27–8) leaving the actual form of it unchanged. In Merneptaḥ's time there were only youthful portraits of kings.

[28] They are translated in Erman 1923 [and von Bissing 1955].

in the position of a lion's tail and the closing of its jaws; also of the subdued smile that plays on the lips of Egyptian statues as an expression of kindness, in comparison with smiles in other art. The particular quality of Egyptian self-control stands out in the larger context of 'pre-Greek' art against the marvellous but somewhat unrestrained nature of Cretan–Mycenaean art. The latter had considerable attractions for New Kingdom artists who took much over from it, but always removed from it what they must have felt to be formally crude,[29] just as Mycenaeans in their turn may have felt that Egyptian motifs needed to be made looser. In two- and three-dimensional work Egyptian artists always concentrated on the solid construction of figures (static qualities) and not on making them appear to be carried away by their inner strength (dynamic qualities), which is the area in which the depictions of early Mediterranean art excel; nor is their aim a harmonious development of organic forms (p. 343) as in the case of Greek artists (cf. Schäfer 1928 fig. 60–2).

This static quality and a tendency to use geometric forms, among which more or less rectangular ones (cf. pp. 321–2) are the most important, and a love of clarity and simplicity in individual figures and in the composition of a picture, first manifested themselves decisively in the second and third dynasties and then became second nature for Egyptian artists (fig. 8). It is these qualities above all which set 'Egyptian' art

FIG. 8. Chest ornaments worn by the high priest of Memphis. OK

apart from Egyptian pre- and protodynastic art, and from the art of neighbouring peoples. There were of course periods when this geometric framework became less rigid. In the reign of Amenhotpe III some artists revel with the abandon of calligraphers in the beauty of their lines (cf. Schäfer 1928.53–5, fig. 64–8). Again in the Amarna period there is a tendency—I use the modern terms with reservations—to

[29] Egyptians must have felt this with Mycenaean just as with Cretan art, even though modern research shows ever more clearly that there are many more rigid elements in Mycenaean than in Cretan art. (My attention was drawn to this difference by the lectures of G. Karo.) It will be asked how contact between Cretan–Mycenaean and Egyptian artists arose. I cannot think of any work of any size that has been found in Egypt which could be thought to be the product of collaboration between Egyptian and Cretan–Mycenaean artists. I can only suspect small pieces, which could have been imported, to be Cretan work. Unless new finds alter the picture—and it should be remembered that there are almost no monuments from the Delta—we must assume either that Egyptian artists visited the countries or that imported paintings on papyrus, wood, and similar materials had an influence. But the fact remains that the Egyptians never simply copied foreign works. Frankfort (ed. 1929) discusses the connections between Egypt and Crete and Mycenae. [Cf. also Kantor 1947, 1952 and Smith 1965 (J.R.B.).]

produce almost 'expressionist' figures,[30] or to a Cretan—Mycenaean 'impressionism'.[31] But the mathematical foundation is never lost. Some ancient American statues are very close to Egyptian ones in their sharp geometry; but they lack the other half of Egyptian art, the positive acceptance of nature.

The Egyptians' attitude to flowers,[32] which is influenced very little by religion, is very characteristic of their own essential qualities and those of their art. A plant which occurs in two forms and is called—the names are very uncertain—bindweed (fig. 9b) or lily (fig. 9a), and the papyrus-plant (fig. 10) may be said to be the 'heraldic plants' of Upper (bindweed/lily) and Lower (papyrus) Egypt. In these roles

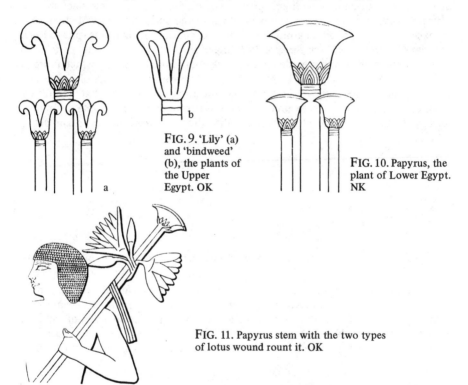

FIG. 9. 'Lily' (a) and 'bindweed' (b), the plants of the Upper Egypt. OK

FIG. 10. Papyrus, the plant of Lower Egypt. NK

FIG. 11. Papyrus stem with the two types of lotus wound round it. OK

[30] Within Egyptian art I use the term 'expressionist' for a tendency to exaggerate natural forms under a strong expressive impulse until they border on caricature. There is however no element of mockery in this, so that it is not true caricature. Much Amarna art can be called 'expressionist' in this sense, while many Egyptian pictures of foreign captives lie within the realm of caricature. I place the words 'expressionism' and 'impressionism' in inverted commas as a reminder that modern words like these always contain nuances (pp. 321—2) which should not be thought to apply in the ancient context. Thus, for example, Cretan—Mycenaean 'impressionism' is not based entirely on visual impressions as it is 'frontal' (cf. pp. 338, 343—4).

[31] Propyl. 379 [379.2 = W fig. 508 (J.R.B.)].

[32] Borchardt determined the originals of the most important plant forms in Egyptian art and analyzed them into groups, both in his book *Die ägyptische Pflanzensäule* (1897a) and in an article (1902—3). He provisionally called the plant emblem of Upper Egypt a 'lily'. Daressy (1917a.228) proposed to identify it as *convolvulus arvensis*.

they are found countless times on the monuments; but the papyrus-plant seems also to be connected with the goddess Hathor (cf. Sethe 1929). On the other hand the lotus, which is otherwise the most frequently used flower, has no significant religious or symbolic associations. We do indeed hear that the young sun god appeared like or on a lotus above the surface of the primeval ocean; a god called Nefertem carries a lotus on his head and is even called 'the lotus before the sun-god's nose'. But this adds up to little and is certainly not central to religious speculation [cf. now Morenz–Schubert 1954]. Fig. 11 shows both types of Egyptian lotus, the blue *Nymphaea caerulea*, a triangle when viewed from the side, and the white *Nymphaea lotus*, a semi-circle, both wound round a pair of papyrus stems. In modern times all these three have been confused, together with the *Nelymbo speziosa*, which comes from India and only arrived in Egypt late in the first millennium B.C.

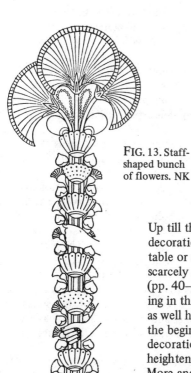

FIG. 13. Staff-shaped bunch of flowers. NK

FIG. 12. Jars with lotus stem wound round them. NK

Up till the fifth dynasty flowers occur relatively rarely as decoration in daily life. But from then on scarcely an eating table or still life of food (p. 35) is without a lotus, and scarcely anyone at table does not hold a lotus to his nose (pp. 40–41). There is no need to look for some deeper meaning in this use of the lotus. The epithet of Nefertem could just as well have been suggested by the visual image in art. At the beginning of the New Kingdom the use of flowers as decoration increases considerably with the generally heightened sensuous appreciation of the beauty of life. More and more plants and flowers are used simply out of joy in their beauty, and in many new forms: long-stemmed lotus flowers that are curved round jars without being fastened in any visible way (fig. 12);[33] as borders in the form of garlands (fig. 1–2) with the individual

[33] Forerunners are occasionally found somewhat earlier.

flowers and leaves hanging vertically from the band that holds them,[34] and not, as with us, turned in the same direction as it; as staff-shaped bunches (fig. 13), that is, as bundles that are often the height of a man and have papyrus stems as their 'spines'; and other types. The border-like pattern also occurs among the favourite broad collars (pl. 42) which had previously been made only from small geometric shapes like plaques, balls, pear-shaped pieces, and tubes (pl. 21). Very sumptuous examples can be seen on mummiform coffins.[35] Love of flowers becomes ever more characteristic of the Egyptians. Finally, towards the end of the New Kingdom there is scarcely anything to which flowers do not give their decorative qualities, directly or through the adoption of their forms.[36] In the Amarna period one can see in the way in which bushes, leaves, and tendrils are drawn[37] that older Egyptian elements have evidently been enhanced by contemplation of Cretan works, which catch rapid movement in such a lively way.

Flowers as pure ornament are very rare up till the Middle Kingdom: they are found almost exclusively on the bands women wear on their foreheads, as rosettes of a type that later often decorates flat surfaces. In the New Kingdom plants have many and various ornamental uses.

Stone columns in the form of plants are already found in Djoser's step pyramid, and their development down to the latest periods shows a rich element of fantasy, which was inspired by the artistically neutral supporting poles of huts and by papyrus stems or bundles of reeds used in tents; in these models artistic life is derived from the plants themselves.

When the stems that have become artistic forms acquire papyrus umbels or the blossoms of other plants the tendency to give life to artistic forms, described on p. 55, is manifesting itself.

The structure of plant columns is of course partly determined—like that of all sculpture (pp. 47–8)—by the material used, but they end up, as Borchardt was the first to point out, by becoming free and not load-supporting elements, so that palm columns towering under the weight of stone beams[38] have the same form as the horizontal carrying-poles of a palanquin,[39] which jut out into the air. The basic function of an Egyptian plant column is to carry, but its decorative form is largely the product of a fantasy[40] which ranges virtually as far as the limitations of the material will allow. It is Greek art which demands that architectural elements should not only be statically and mechanically adequate to carry a strain, but that stress and counterstress should also be expressed by their lines and surfaces—this is what is called an organic method of composition—and the Greeks themselves only developed this idea gradually.

Light wooden columns supporting testers or a throne canopy are often given most daringly fantastic forms.

[34] Garlands where the leaves run parallel to the framework of the wreath probably only occur from the Ptolemaic Period on.

[35] Propyl. 400.3 [cf. L-H pl. XXXIX (J.R.B.)].

[36] In certain ways the much older plant columns of course belong here. Cf. p. 55 and Schäfer 1929a.16–30.

[37] Propyl. 379 [379.2 = W fig. 508 (J.R.B.)].

[38] Propyl. 216.2 [W fig. 81 (J.R.B.)].

[39] Propyl. 268.1 [Wilson 1951 fig. 6a, Baker 1966 fig. 38 (Wilson's photograph is of a reproduction in Boston) (J.R.B.)].

[40] [Modern research is continually identifying more symbolic content in decorative forms.]

If one is aware of the unity in a people's intellectual life it is tempting to refer to other art forms in the attempt to approach an understanding of the essence of their representational art. And our ultimate goal would be reached if, by studying representational art, architecture, literature, music, and dance, we could develop a complete picture of Egyptian artistic life in which each part would complement the others. But we are a very long way from such a point—we have not reached it even with many peoples about whom we know much more and with whom we are more familiar. Moreover, I can only draw attention here to the most important of the aspects which we think we can now understand.[41]

Egyptian representational art is intimately connected with *architecture* by their close spatial and physical association. Ludwig Curtius (1923.33–5) emphasized the extreme importance for all architectural history of the fact that Old Kingdom stone temples were the first buildings to express large-scale architectural ideas in a clearly thought-out plan and design, and to create large complexes of spaces that no longer served a basic need or an immediate functional end, but gave expression to an artistic intention.

It has long been known that it was the Egyptians who taught the Mediterranean peoples to construct buildings with carefully squared blocks. But the last few decades have brought the surprising discovery that they themselves first created this method in the historical period. The first step was made deep in the predynastic period when people began to cut Nile mud into rectangular bricks,[42] one of those discoveries in which the technical and the aesthetic are inextricably mixed. There are indications that this change brought about the transition from round to angular buildings: the rectangular bricks are in themselves an incentive to the rectangular composition of architectural elements and spaces. Burnt bricks appear not to be known before the New Kingdom, and.they are then only used for various special forms.

In the second dynasty, when years were still named and not numbered, it was thought worthwhile to call a year the 'year in which the building "the goddess endures" was constructed in *stone*'. The step pyramid at Saqqara, Djoser's enormous funerary monument with its beautifully integrated surrounding buildings, was built shortly after. It is the oldest preserved work of architecture which is entirely made of stone. From that moment building in stone became the passion of Egyptian kings,

[41] Egyptian gardens as we know them—mainly from New Kingdom representations but also from actual remains—have a rectangular layout with the plants arranged in straight lines (cf. *Atlas* 1.60). In Xenophon's *Oikonomikos* [4.20–3] the Spartan Lysander tells how the younger Cyrus (about 400 B.C.) 'personally showed him the park at Sardis. When Lysander admired it for the beauty of its trees, and because they had been evenly planted and the rows of trees were straight, and everything was splendidly four-square, and because many sweet scents accompanied them as they strolled, as he marvelled at it he said: "I admire all this for its beauty, Cyrus, but I am much more amazed at the man who measured out and arranged each detail for you." When Cyrus heard this he was delighted and said, "you know, it was I who measured out and arranged all this, Lysander, and some of it", he said, "I planted in person." ' This attractive scene from the Persian court can reasonably be used to bring the image of a New Kingdom Egyptian garden to life.

[42] On the subject of the following few lines cf. Schäfer 1929a. The fact that limestone is layered may have encouraged the transfer of brick forms to it. The temporal relationship of the introduction of rectangular bricks in Egypt and Mesopotamia has yet to be studied. On bricks in Babylonia see Andrae 1930.81. There existed there for a time a brick type called 'plano-convex', flat on one side and curved on the other to imitate rough stone (A. Hertz).

and indeed of the Egyptian people. Of course there is a vast and impressive mass of statues, reliefs, paintings, and other such works; but the works of architecture far outweigh them, and when Egyptian art and style are mentioned the dominating image in our minds is that of the Great Pyramid of Giza. And this is as it should be. Anybody who says that pyramids developed from heaps of stone and so do not belong to art proper does not take into account the amount of artistic effort devoted to this development. The Great Pyramid of Giza inspired 'Umāra al-Yamanī's line, which is quoted by al-Maqrīzī: it is a building 'feared by time, yet everything else in our present world fears time'.[43] We should not think this is just a clever turn of phrase, it really touches something deep. There can be scarcely any other people whose monumental inscriptions speak so often of millions of years, of eternities. This long-ing for immortality first found an appropriate means of expression in the giant square blocks of the fourth dynasty. Against the thundering of the royal monuments we can hear faintly in works of literature the whispered question whether all this effort by the great ones is not in vain—an undertone that is never entirely silenced after the terrifying collapse of the Old Kingdom. So Egyptians also knew that time is an eroding, destructive force: but when they talk about eternity they are only thinking of effective preservation for an endless period in the future. Similarly they do not consider mummification to be an 'evisceration', a drawing off of fluids, that is as something negative, but as a conservation of the body. The overtone of terror which has attached itself in some unknown way to our word eternity must be kept away from the Egyptian words *nḥḥ* and *ḏt*. And above all one should not see in the unforeshortened Egyptian rendering of nature a desire to remove from life the creatures represented, in order to place them in the context of eternity (pp. 46–7).

We must not overlook the fact that, as we now know, construction with stone blocks was developed as a means of artistic expression in the same period in which the new element which gave the representational art its own individual stamp came to be certainly and consciously part of the whole. Immediately small figures were developed into large statues, sculpture became closely associated with architecture. While the Greeks on the whole preferred to set up their figures in the open air (Löwy 1913 [1915]), this sight evidently offended the Egyptian sensibility. Statues almost always had a part of a building as their background, except when they stood in rows and thus formed a sort of enclosure themselves, as lines of rams,[44] sphinxes, or human figures form a border for someone walking between them. Just as sculpture asked for the support of buildings, so did Egyptian architecture demand statues. Statues were a desirable and frequently used helping element in architecture. And from the Old Kingdom on we find statues coalescing with walls or columns (pl. 31, Propyl. 324), but both in meaning and in form they remain more or less independent. Even in the rare cases where figures support structural elements, the working-out of the form is not affected by their doing this (p. 22).

The element we call a *plaque* or *slab*[45] at the back of a statue group is in the same relation to an Egyptian statue as the wall of a building. On the other hand the *back pillar* (pl. 86–7) will have another explanation. It was probably the result of real or imagined

[43] [*Khiṭaṭ* of al-Maqrīzī (Bulaq edition) 1.121 (J.R.B.).]

[44] Propyl. 318 [W fig. 357, M pl. 128 (J.R.B.)].

[45] Propyl. 235 [L-H pl. 53, 56–7, Sm pl. 31B (J.R.B.)].

technical necessity; but it must be noted that according to Fechheimer (1921.17) it was only introduced in the Old Kingdom, when Egyptian art was already sure of itself. The technical aid soon became an aesthetic weapon which reinforces most appropriately the tectonic expression inherent in the figure itself;[46] the back pillar is unknown in Mesopotamia.

Let us look again at the entrance halls of Djoser's step pyramid complex (fig. 14); the long hall appears to be divided by the side-walls, which end in engaged columns, into two rows of recesses opening on to a corridor down the middle. But we can see from the room placed at right angles just before the great court that a division of this sort is not the real function of these tongues of masonry. Here there are no recesses; instead, the central 'nave' is blocked off. The architect paid this price in order to achieve a free passage from the long hall to the great court. The impression one has is that a hall with three naves, which might before have been built of mud brick with wooden supporting poles or bundles of stems, was transposed into stone. The idea of a stone column is already present, but the architect is not yet confident enough to leave it to stand free; it was left to the inner eye of the visitor to perceive the idea of an open three-nave structure in the heavily shut-off physical structure of the room placed at right angles.[47]

Two-dimensional representation first appeared on the flat surfaces of rocks, pots, utensils, and the like. But immediately architecture produced suitable surfaces they also were appropriate. Initially the surfaces of buildings were sparingly decorated with pictures, but later there was scarcely a wall which was not covered with relevant reliefs and paintings.

FIG. 14. Plan of the entrance hall of the Step Pyramid complex. OK

The more strictly the surfaces are divided in this process into squared areas and strips, the less our instinct rebels against such a covering of the walls. In this respect later artists, even those of the Graeco-Roman Period, seem to us to have been more sensitive than Ramesses II's sculptors, who dared to cover a vast pylon wall with one of their enormous, loosely organized battle scenes. In this they may have been following the practice of Amarna artists who already loved to fill whole walls of tombs with a single picture with the king at its heart (Frankfort ed. 1929.12). However excellent the Ramessid works may be in · themselves, they are not inferior merely to later styles as exterior decorations to buildings: a third method, which can for example be found in the temple of Angkor Wat in Cambodia, would also seem preferable. In content these reliefs are not unlike the Ramessid ones, but they fill the available wall-space right to the furthest corner with closely packed low-relief figures, and so produce a wall-covering similar to a carpet. But an Egyptian would not have been pleased by such a crowded pictorial surface. He too liked to cover the surface within a picture, but in more satisfyingly

[46] As 'bridges' do, cf. p. 48.
[47] [For an opposed view cf. Wolf 1957.114 with the references cited there.]

balanced proportions of figures and background (cf. p. 166)—proportions which
varied considerably according to their content and to the taste of different periods.

In the Old Kingdom (cf. pp. 44—5) all the pictures on a wall begin to be brought
together above and on the sides by a band of colour. It is a narrow strip of longi-
tudinally arranged rectangles divided by black and white vertical lines (fig. 4a, c).[48]
This framework can acquire an imposing thick band of decoration on top, which
occurs in two forms (fig. 4a, c): the first (a) is pointed and is found free-standing on
top of walls, gates, and on the roofs of chapels or tower-like buildings (pl. 63). The
other (c) is blunt, tied just below the top, and fanned out a little above the tie.[49]
It is first seen as the crowning element of walls in pyramid temples. The two are
evidently related, but it is not yet clear how they and their differences are to be
explained. The blunt type occurs occasionally in private tombs of the Middle
Kingdom,[50] while the use of the pointed type is only extended in this way in the
New Kingdom. We normally call the pointed type by the sound value of a hiero-
glyphic sign that resembles it, *kheker* (*ḫkr*) 'ornament', while attempts have been
made, no doubt mistakenly, to explain the blunt one as a fringe of a carpet knotted
so that the carpet can be hung by it. Apart from these two there is a whole range of
other types of frieze whose composition changes a great deal through the centuries.
Before the use of the *ḫkr* penetrates to private tombs we find in the same place a
continuous narrow row of upright or inverted triangles[51] which are painted alternately
black and white, or placed apart and made to resemble the lashings of torus mouldings
(pl. 31).

Decoration of the base of an area counterbalances a frieze at the top (fig. 144).[52]
In the predynastic period this decoration is just a wide band of black with a narrow
red line to mark its bottom: in the Old Kingdom (fig. 4a) an additional line of yellow,
sometimes[51] grained to imitate wood, makes the ensemble more colourful. In the
New Kingdom base friezes are developed, consisting of personified geographical
areas, plants, and similar images that are the earthly counterparts to the sea of stars
on the ceiling (p. 236).

The flatness of Egyptian relief work makes it suitable to be applied to architecture
without loosening its structure. The flatness was not the result of the association with
architecture, but may have been preserved and encouraged to continue by the ever-
closer connection between reliefs and the wall-surfaces of buildings.

As the new almost geometrical sense of form in two- and three-dimensional
representation was first given clear expression simultaneously with the invention
and development of building in squared blocks, an inner connection between the
two would seem to suggest itself. But it would be wrong to hold that the new
representational style owed its geometric character to the influence of architecture.
We only have to recall that the square-cut brick was invented many centuries earlier,
and that something of the new spirit began to be active in relief work shortly after
the beginning of the first dynasty, that is, before the technique of building in squared

[48] Propyl. 418.2 [L-H pl. XLV, also for example on Tut'ankhamun's box, cf. Chapter 4 n. 161 (J.R.B.)].
[49] Propyl. 362 [Mekhitarian 1954, pl. on p. 18, Davies (1917 pl. 6) (J.R.B.)].
[50] Propyl. 300 [= LD 2. 130 (J.R.B.)].
[51] Propyl. 220 [= LD 2.19—20 (J.R.B.)].
[52] Propyl. 184 [= fig. 144 here, Case—Payne 1962 (J.R.B.)].

blocks was evolved. The one thing does not depend on the other; they are separate streams with the same source, which become united in the second and third dynasties. The close spatial association of representational art with architecture encouraged the reworking of all forms occurring together when one of them was changed. So it is natural that statues placed in architectural contexts are stricter in form than the smaller figures, which are frequently more loosely styled. We shall see in Chapters 4, 6 and 7 that another force is at work in Egyptian as in all 'pre-Greek' art beneath the superficial precision of the forms of expression; this treats statues as series of planes approximately at right angles to each other, and lays out expanses of relief or painting without foreshortenings or oblique views. From at least as early as the beginning of the Old Kingdom Egyptian architects gave substance to their sense of the sublime in buildings of sacred character that greatly exceed normal proportions. Colossal size is used for the same purpose in representational art too, and it had a continual attraction from the time of the making of the Great Sphinx at Giza. Size can be aesthetically expressive by itself; but undoubtedly the power of representational art to express worth and inward greatness is enhanced by the association of sculpture with works of architecture.

It would be dangerous at this point of time to go deeper, beyond what I have suggested, into the inner connections between representational art and architecture, as the latter has scarcely been studied so far, except in its technical and superficial aspects. Experts know how much more needs to be done in this field before it will be possible to progress to an understanding of the spirit of it, and in this search the basic ideas set down in this book will have to be borne in mind.

We know almost nothing about music and dance,[53] despite the number of musical instruments and pictures of performances that are preserved. We must be grateful that a scholar of musical history has been able to deduce from this evidence that the music of the earlier periods was mostly tranquil. The dances that are associated with it are also clearly sober in character (fig. 164).[54] Dancers, singers, and players never display the tension which seizes performers of animated and exciting music. But it should be noted that the old close lines of dancers with their controlled movements are already broken at the end of the Old Kingdom, and dance steps are exaggerated into powerful thrusts of the leg;[55] however, even in this case the effect is one of youthful vigour and agitation rather than the sensuality of dances of the later periods.[56] When we again have monuments at the beginning of the New Kingdom, after the gap caused by the Hyksos, the picture is rapidly transformed: the tranquillity, mildness, and simplicity of the earlier music disappear; new instruments are introduced, the new music appears to sound shrill and loud, and the tempo seems to be increased; players and dancers move more passionately and sensually in loose groups. Asiatic music with its heightened stimuli has possessed the Egyptians' souls. But of course a people with the artistic achievement of the Egyptians could not have foreign music in their country for several centuries without adapting it to their own temperament and needs. So it would be wrong to assume that from the New Kingdom on their music was purely Asiatic. In the archaizing Late

[53] What follows is based mainly on Sachs (1921); cf. also Brunner-Traut 1938.
[54] On jumping and acrobatic dances cf. Brunner-Traut 1938.22 ff.
[55] Propyl. 264.2 [cf. L-H pl. IX (J.R.B.)].
[56] Propyl. 397.2 [W fig. 587 L (J.R.B.)].

Period our sources for music and dance too show a conflict between groups who indulged in whatever was new and others who felt themselves to be the guardians of Egyptian traditions. If the sketch I have given portrays correctly the development of music it can be compared with what can be deduced from the development of representational art itself. In particular, an intensification in the expression of emotion in the New Kingdom is common to both.

Egyptian *literature* has as yet hardly been studied at all.[57] We shall not be able to analyze its nature in any depth without a thorough comprehension of the superficial structure and fundamental character of the language. But we are for the moment further from that than with the languages of other great cultures, for reasons that can easily be understood. Only the most obvious literary forms have been identified, and it is doubtful if we shall ever penetrate the finer nuances of the literature, as the Egyptian script, like many of its successors, does not write vowels, so that we shall never know about important factors like sound and accent. For the present we can only follow the development of one or two genres of literature, though it is reasonable to hope that further research will eventually bring about a more satisfactory state of affairs. We have a number of sublime and beautiful poems preserved in religious texts written on the walls of the chambers and corridors of the Old Kingdom pyramids; a great deal of this material goes back to the Early Dynastic Period, a certain amount probably to the predynastic period. A comparison can plausibly be made, with regard to their general character, between the straightforward biographical texts and a few instructions in practical wisdom of the Old Kingdom and the sober quality, lacking in anguish, which we recognize in the art of the time. The tremendous collapse at the end of this period, and the reconstruction under the great rulers of the Middle Kingdom, enriched Egyptian literature with a series of works which meditate deeply upon the contradictions in human life [cf. Otto 1951], and were long looked to as models of language and presentation. There can be do doubt that a series of portrait heads of kings that are serious, even melancholy, and yet show an intensely active spirit, faces that are 'at once full of pride and sorrow, pain and strength' (Wolters 1924) were the products of the same experience (cf. pp. 16–17). They too occasionally exerted an influence throughout the ages. Literary works of the New Kingdom, when Egypt was a great power, show the joy of city dwellers in the profusion of life with images and similes that are full of fine and sensitive detailed observation of the natural world, and thus reflect works of representational art— Amarna too was an Egyptian offshoot; and anyone who reads the royal texts of the Ramessid period, for example the poem on the victory over the Hittites at Qadeš which Ramesses II won by his own courage [Gardiner 1960], will be aware of the same monumental sweep that can be seen in reliefs of the period (pl. 55–6, 58).

Much in the daily life of primitive peoples has a magico-religious setting. Their forms of social organization and their culturally unifying institutions link future generations with present and thence with past ones. With the arrival of civilization these links retreat ever more markedly into the sphere of religion[58] in a narrow

[57] We owe the first history of Egyptian literature worthy, despite various reservations, of the name, to Pieper (1927) (apart from Schneider 1907.138–277). On Pieper's methods cf. Hermann 1929. Translations in Erman (1923) and Roeder (1927). [More recently *Handbuch der Orientalistik*, ed. B. Spuler, I Ägyptologie 2 Literatur (Leiden: Brill 1952, [2]1970), Lefebvre (1949), Pritchard (ed. 1955), Brunner-Traut (1963), Donadoni (1967)].

[58] On the priesthood see p. 60.

sense, into dealings with gods and the dead, in Egypt also into the kingship. Therefore things that are used specifically for these purposes tend to retain signs of great antiquity. Thus some chapels (cf. Jéquier 1908) preserve memories of the reed hut form of the earliest temples ![symbols], and modes of action and of speech and pictures in these contexts are more archaic in form than secular ones.

The reliefs from the sun temple of Niuserre' in the Berlin Museum are good examples of how much form depends on content in these cases. There are two types of reliefs. The first, which made up by far the larger part of the wall decoration, shows festivals with many participants in long rows (fig. 248, Propyl. 255). They seem to be centuries apart from the pictures from a room called by the excavators the *Weltkammer* or Chamber of the Seasons; in them there are huge personified figures of the three Egyptian seasons, each representing the earthly life of its months, and the forms blossom in a way which must have suited the most advanced taste of the fifth dynasty.[59] Despite their differences both groups of reliefs come from the same building, are contemporary, and perhaps even the work of the same artists. The pictures showing daily life are independent products of their own time, while nobody would have dared to reinterpret the solemn ones in a contemporary style, though they too naturally express something of the spirit of the fifth dynasty.

With Amenhotpe IV's reforms[60] it is evident that an art of the same temper accompanied religion in its sea-change, from the gentle first waves through the uncontrolled storm breakers and the hard-won equilibrium to the dying ripples: this is important for the understanding of both the art and the religion, and should be studied. At scarcely any later period did art and religion change together thus from year to year. At this time the contrast between religion and secular representation apparently ceased to exist for almost twenty years, for anthropomorphic gods were no longer depicted. It became apparent again after the collapse of the undertaking, which allowed the gods to return, though at first it was not so glaring as before.[61]

Great though the power of religion to preserve forms was in Egypt, it did not exercise a rigid restraint. Temple architecture is an example. Whether in divine temples or royal funerary temples, the architects, like other artists, everywhere had a large measure of freedom, given certain fixed elements in the ground-plans. Another case is that of offering tables: decades ago I had the opportunity to look through a collection of the forms of these objects, and there also I found a surprising degree of freedom.[62]

We should not imagine private houses to have been decorated with statues of any size, unless they were used for religious purposes here too.[63] It is unlikely that

[59] [Von Bissing (1956) (see also Smith 1965.141–6, fig. 178; the reliefs are mostly in East Berlin, J.R.B.).]

[60] My own opinions on this period are to be found in Schäfer (1931a). Frankfort's study (ed. 1929) seems to me to be too one-sided and to emphasize realism too much, underestimating spiritual or emotional expression, especially at the beginning of the movement. Cf. above n. 30, Schäfer 1928.53–5.

[61] Cf. p. 339 and Schäfer–Andrae 1942.121, bottom (tomb of Petosiris [= Lefebvre 1923–4 (J.R.B.)]).

[62] [Schäfer was probably thinking of the unpublished catalogue of A. Würz, which is now in the Egyptological Institute in Tübingen.]

[63] [Cf. Cooney 1953.8–9, pl. 23, with references. The Gallatin collection is now in the Metropolitan Museum of Art, New York (J.R.B.).]

statues were erected in Egypt out of pleasure in works of art for their own sake, except for small semi-humorous pieces. A few remains of paintings in private houses of the Middle Kingdom are preserved from Illahun, and rather more New Kingdom ones from Amarna.[64]

As almost everything we have that is ancient Egyptian comes from tombs and temples, and settlements and their contents are, apart from a few exceptions, destroyed, we cannot know with any certainty whether there was any good representational art which was secular in purpose, not only in content, which in other words existed in its own right and was not, like secular pictures in tombs and temples, 'made under the darkening shadow of religion'.[65] Because of the peculiar nature of Egyptian kingship it is not possible to count everything relating to it as secular. But the 'idea of religion' should probably be counted among those themes mentioned on pp. 345–6 which cannot produce their own forms of expression. It can only be made concrete by means of actions and gestures or symbols.

It is easy to demonstrate how carelessly the relationship between religion and art is discussed. It is well known that statues of tomb owners and those from temples mostly show a few simple poses. It has been suggested (Fechheimer 1923.14) that these were determined by the religious purpose of the statues, which would have made it desirable that the subject should appear on his own, divorced from the outside world. But nobody who has realized that from the Old Kingdom to about 1000 B.C., when scenes of daily life disappear, the Egyptians did all they could to preserve the dead man's connection with life and to overcome spiritually the material barriers which were erected for his protection, will credit the idea that statues of the dead should appear to have no connection with the living world. The statue stood in an open niche in the offering chamber (Fechheimer 1923.2) so that the person represented was in lasting contact with visitors and the activities of life that were shown on the walls and thus kept always at his disposal and present to help him. The poses of these statues are appropriate in their moderation to a distinguished man who is in a position to command—a role even the humblest of the dead of course assumes. So religion did not give rise to the simple poses of these statues, it took them over from life. But their incorporation into the consecrated areas of tomb and temple naturally contributed to the intensification of these calm poses so that they came to express grandeur and solemnity—that is the element of truth in the position I have been attacking. So the situation here is similar to that with architecture and painting and relief. But there are of course movements shown in statues which are entirely derived from religion. The example I shall take is the Berlin statue of Amenemḥat III (Fechheimer 1923.52–3), one of the most magnificent images of a king praying, full of proud humility; there are also a number of other figures of people performing cult actions.[66] In these cases I would like to speak of 'religious purposes': the statues are directly determined by the nature of the religious action.

Anywhere where 'enlightenment' has not made cultural spheres independent, religion and art, which are in essence so close to each other (p. 38), are linked at

[64] Glanville (in Frankfort ed. 1929) studies the painting of houses. [Cf. more recently von Bissing 1941; also Brunner-Traut 1956, s.v. *Hausmalerei* and the material from Deir el-Medina cited there.]

[65] Dehio 1926.7. [Dehio's phrase reads '. . . dieselbe [representation of the 'world'] müsste in einem kirchlichen Rahmen eigenschwärzt werden' (J.R.B.).]

[66] e.g. Propyl. 358.1 [W fig. 547, M fig. 537 (J.R.B.)].

a deep level. Art is one of religion's most important means of communication, and on its side religion is able to add deep elements of its own to art. This is the case in Egypt. There can be no doubt about it; indeed Herodotus' saying that the Egyptians of his time were 'excessively religious, more so than any other people . . .'[67] is largely justified for earlier periods. But nothing is gained by saying, in an attempt to explain why the art of different peoples varies so much, that religion is what ultimately determines art. Whenever religion can be analyzed as a separable entity, no two peoples are found to have the same myths, cults, and doctrines; these forms of expression must therefore be determined by something outside religion itself. To discover the reason for the divergences in the orientations of different peoples it would be necessary first to find this something. Research of this kind soon reaches the limits of what can strictly be known, so one must be content to note the differences between peoples without trying to explain them. 'They cannot be ordered intellectually into concepts, but they can be observed and taken in; it is possible to cultivate in oneself a sympathetic awareness of their existence' (von Ranke 1916). At this point I need mention only that not all works of a strongly religious subject and tenor (cf. p. 42) are works of art simply because they are religious.

Egyptians knew nothing of the fact that other peoples had lived in their country before them. Egypt was the centre of the world and the place where the first habitable land appeared out of the primeval waters; and they assumed that their forefathers had lived there since the time of creation. They lived in close contact with the productive divine land and the life-giving Nile, which they equally gratefully revered. Animals and plants, many of them of a divine nature, surrounded them. The heavenly bodies and most especially their leader, the sun, shone above them. The desert with its hunting-grounds, but also its frightening secrets, enclosed them. They felt on all sides the influence of gods of particular localities; a divine being lived in that jutting rock, this animal, or that tree; the tiny chapel of the snake goddess of the harvest stood in the middle of the ploughed field. It is fair to say that Egyptian thought, writing, and much else will remain a closed book to someone who fails to appreciate what it means to be tied to the land, and more precisely to the land as God created it, not as man has made it to be. Egyptians loved their homeland above all things; the idea of dying away from it—'in misery', as our ancestors said—was desperate. Many a visitor to the Nile valley has observed how precisely the plain, massive forms of the landscape harmonize with those of Egyptian art. But I prefer to leave undecided the question of whether the two facts should be associated, as is often done, with the inference that the art was designed to fit the landscape.

This problem, which is related to the question of racial influence on art, and on the other hand to that of environment on race and people, needs to be carefully studied in the context of many countries and peoples before any judgement can be attempted. In Egypt itself, despite the apparently favourable conditions, for there are of course vast numbers of well-preserved bodies, scarcely any progress at all has been made in separating the different racial elements in the population. Probably the most important thing would be to decide whether the appreciable cultural progress towards the end of the predynastic period could be attributed to the arrival of a more active racial group.

Who would accept without proof the assertion that the form of the Homeric poems

[67] [Herodotus 2.37.1 (J.R.B.).]

was fixed for ever precisely at the time of the geometric style? Or, in Egypt, that the rich and fine literature mentioned above was produced at the time of a disastrous decay in representational art between the Old and Middle Kingdoms? In addition, not every stage in the history of the art of a people like the Egyptians has only one living thread running through it, as there are always exceptionally advanced and very conservative artists living side by side.

If we compare Egyptian figures with Mesopotamian ones, whose massive muscles often strike us, but not infrequently repel us too, we can sense the straightforwardly majestic qualities of the former, and a fine humanity which is often, as it were, poured over the geometrically pure form. As these qualities are constant in the better works of art of different periods it is clear that something was created at the turning-point between the Early Dynastic Period and the Old Kingdom, which was appropriate to the nature of the Egyptians as it had developed up till the second dynasty and remained in essence from then on. Our feelings when we become absorbed in good Egyptian works of art, and perhaps especially when we have just left more melancholy Asian ones, are the same as those we have when we study other aspects of the Egyptians of the periods when they were still full of fresh life: everywhere there is an easy charm that delights in nature, and also harmonizes with a genuine feeling for what is valuable or sublime. Of course, Egyptians were human beings with human inconsistencies (cf. p. 306)—carelessness and laziness exist side by side with steady tenacity.

In Egypt, the 'gift of the Nile', the central role of irrigation encouraged voluntary or forced cooperation in work and a systematic division of labour, as it does anywhere where there are dykes and canals.

The *form of the country*, a narrow valley divided in the middle by a river without tributaries and hemmed in on either side by the desert (pp. 3, 66), must have influenced its inhabitants and hence its art in many ways, in their nature and especially in their history. The river linked all the parts of the country, and yet every nome, apart from those in the Delta, only touched its neighbours directly at two points. And the country as a whole is only open to the north and the south. But there was always a lively traffic back and forth through these openings, in the north to the Near East, Libya, and Crete, and in the south to the Sudan. The pages of Egyptian history, from prehistory to the present, are full of comings and goings (of peaceful or warlike nature) at these points. For this reason one should be cautious when calling Egypt an 'oasis'.

A great work of art is never simply the product of an institution, and just as genius and a desire to work tend to go hand in hand, so will inspiration always play a part alongside reflection in the achievement of perfection.

All of Egyptian mental life is tempered by an intelligent, or rather sane, sense of of reality.[68] For example, in order to write the fractions $\frac{1}{2}, \frac{1}{4}, \frac{1}{8}, \frac{1}{16}, \frac{1}{32}, \frac{1}{64}$ of a corn-

[68] Plato's statement, *Republic* 436 a, in which he develops the important idea that it is possible to speak of the individual character of a people as well as of a man, shows how this attitude became prominent in the Late Period. Thus he classified the Egyptian and Phoenician national characters together under the heading of lust for money, that of the Thracians and Scythians under passionate temperament, and that of the Greeks under thirst for knowledge. Steindorff (1923) attempted to define the nature of the Egyptian people as the 'economic' among Eduard Spranger's five 'forms of life' [*Lebensformen*].

measure they came early to use, by an allusion to the ancient legend of the wounded eye of the god, the picture of the sacred eye cut into six pieces with each part standing for one fraction—and the fractions, in correspondence with the legend, do not make up the whole.[69] This breaking-up of the picture of the eye throws light on the peculiar intellectualizing trait which also often appears in Egyptian religious thought, but has nothing to do with our 'logic'. As a result the paths the Egyptians trod frequently appear so tortuous that we can scarcely follow them in order to penetrate to the unity of ideas which they sensed behind it all.

There is a similar intellectualizing vein in Egyptian art, though here things are presented in a more comprehensible way. One very characteristic instance was only recently noticed because of its remote position: we know that the arch of the human foot is closed on the outside, so there is no view through under it. Yet in Egyptian two-dimensional representations it is often treated as if this existed. In the Middle Kingdom there is a case (fig. 15) where the paw of a man's dog, which is walking

FIG. 15. Master with dogs. MK

FIG. 16. Feet of a seated man. OK

beside him, can be seen through the arch of his foot. And corresponding phenomena are often found in the Old Kingdom with the feet of seated people (fig. 16)[70] and standing women (as in fig. 167). In these two cases the front foot is placed only slightly forward, so that its heel comes next to the arch of the other, and it is then seen through the arch of the back foot.

Egyptian artists certainly created many magnificent works among their animal-headed gods and human-headed sphinxes (pl. 90), and we frequently almost forget that they fused heterogeneous elements; but these parts are not really[71] as closely amalgamated as with many Babylonian figures, where there is equally no organic unity; yet there are beings which look as if they could exist (pl. 92). The parts of the Egyptian figures are mostly linked together by more or less disguising elements like head-dresses, masses of hair, and so forth. For an Egyptian it does not matter if, when 'divine water' has to be shown in a row of personifications in a religious picture (Blackman 1918 pl. 5 no. 19), a tilted jar with water flowing out of it is

[69] My observation that a series of strange indications of measure, which were pointed out to me by Borchardt, combine to form the sacred eye, was the starting-point for Möller's article 'Die Zeichen fur die Bruchmasse des Hohlmasses' (1910), which puts forward this idea together with others common to the three of us. In the *Instruction of Amenemope* the corn-measurer is warned: (18.15) 'beware of violating the *wd3t*-measure . . . (18.23) as for the bushel-measure (it is) the eye of Re' [the sun god]' (Lange 1925.92) [There is a word-play: *wd3t* is the name of the sacred eye and of the measure (J.R.B.). Cf. Griffith 1926b.215–16.]

[70] The earliest example is probably Propyl. 248.1 [cf. L-H pl. 18.1, 19. An earlier case now Sm pl. 13 (J.R.B.).]

[71] Not even in the sphinxes of Amenemhat III, despite their powerful qualities as works of art (Propyl. 286 [L-H pl. 117 (J.R.B.)]).

made into the head of a human figure without the use of an additional linking element. When we look at the many pictures of demons in representations of the underworld (pl. 64) we are seldom likely to feel the terror which their names often suggest and their forms should inspire. They *were* terrifying for Egyptians, but not because of the expressive quality of the forms themselves, as with the Assyrian demon (Propyl. 583.3—4) with its bared teeth, or with many a Mexican idol; rather they juxtapose parts of animals that were known to be fierce. They are instructions which produced horror in the spectator by way of what he knew of those animals. The images themselves belong to the sphere of rationally observed natural forms. There is little room for the creation of fantastic forms in the construction of these fabulous creatures; this is true of all Egyptian art, however bold the fantasy may be within the limits set in it.

None the less we can still, as we have been accustomed, consider the sphinx (pl. 90) to be the hallmark of Egypt, but only in a certain sense—certainly not as an embodiment of the great enigma of all existence, and just as little as an image of the union of wisdom and strength. The sphinx, whose artistic form was probably devised at the beginning of the Old Kingdom, rather represents simply the king, uniting a portrait head of him with the body of the royal animal (cf. pl. 4, 83). And this procedure provides an archetypal example of the way in which Egyptians invented their composite fabulous creatures. The method of joining the parts referred to above is superficially a fault, but it does not stop the Egyptian sphinx from being one of the greatest creations of any people, one which was given an entirely different expressive function when it was taken up again in modern times. For a work to reflect natural organic body structure is just as little a *sine qua non* of quality and effectiveness as true perspective and related phenomena are (see Ch. 8). Perfect Egyptian works are organic if they are looked at as works of art, but not if they are considered to be renderings of living beings.

The Egyptian tendency is indeed often to preserve older elements beside more recent ones. In art Egyptians were not violent innovators, driven to alter forms of expression rapidly; the sudden change-over to the Amarna style is an exception. More than that of many other peoples, Egyptian art resembles the treasure chamber of an old and distinguished family, which preserves the jewellery of its ancestors in active use together with what the present generation with its indefatigable energy adds to the collection. What we are used to considering defects are found often enough in Egyptian art. But not in masterpieces, where they give way to a firm, closed objectivity and to a majesty and greatness which cast a spell over us and yet forbid intimacy. But we must beware of fancifully attributing signs of an inner struggle to Egyptian art forms. They stand before us with an unerring, calm sureness of purpose, proclaiming the two great groups of ideas which encompassed all the more noble parts of Egyptian life, religion, and the state as embodied in the king. Egyptian kings brought these two dominating ideas together in the truly monumental consecration formula which is found on all Egyptian temples from the Old Kingdom on: 'King B made it as *his* monument for his father, *god* A.'[72]

Many people will be puzzled when they study other areas of the Egyptians' life while under the influence of their logical method in creating works of art With religion, for example, it is difficult at first to find anything even remotely like logic;

[72] [The Egyptian texts do not contain these emphases (J.R.B.).]

instead there is what looks like a hopeless muddle.[73] But deeper study will reveal there too the ever-renewed attempts to order the enormous material and to deepen its meaning, which occupied the minds of Egyptian priests right down to the Graeco-Roman Period; Akhanyati (Akhenaten)'s attempted reform was only the most intolerant of them. In literature one can discern a similar striving towards more rigid structures.

The developed form of the Egyptian *script* adds to the words written with sound-signs sense-signs which indicate their sense by means of an image which is not pronounced. In the early period this might be a lion or a bedstead. Later, it was observed that related ideas could be brought together under images common to a category, e.g. the writing of words for anything made of wood would include a branch of wood, and that of any four-footed animal the part of the skin that includes the tail, originating therefore from animals that have hides. In this way the Egyptians came to divide their vocabulary into groups approximately according to their meaning. The most individual of these groups is certainly the one gathered under the image of a roll of papyrus. The first place of course belongs to the roll itself and everything connected with it by way of writing and reading. In addition there is the vast mass of words we normally term abstract, without considering that we are using to describe Egyptian thought a specialized modern term that is entirely alien to Egypt. One should take notice of a phenomenon of this sort in its context, but not value it too highly as an intellectual achievement. This can be avoided by using an apt formulation Adolf Rusch suggested to me when we were discussing this problem: the papyrus roll, when used as a sense sign, applies to everything that cannot be depicted, only written.

Finally, one should never forget that the men who created the new 'classical' art belonged to the same generations as the men who built up the Old Kingdom state, and whose descendants established a new order again and again after periods of collapse—and Egyptian institutions continued to exist long after the people and the country had become subject to foreigners. Of course the Egyptians never won their way through to the same level of clarity in any of the other areas I have mentioned as they did in art. But one should not be put off by this discrepancy and try to belittle the achievements of Egyptian art by saying they are simply a matter of soulless technique and of slight artistic value.[74] Egyptians are certainly easily excitable, rather than deeply passionate—there is no people for whom the word 'demonic' [*dämonisch*] would be less appropriate—and equally certainly there is a large element of technique in Egyptian art. Yet this clever and alert people, who were far from stagnant in their most vital period, did in their own way think seriously about deep and important matters and expressed these thoughts either in myths or directly. Their inborn technical skill and delight in perfect craftsmanship were helping hands which enabled them to express significant thoughts and feelings economically in consistently constructed art forms.[75] The result is, in quite another context, similar to the products of the German genius, as described by Wilhelm Raabe;[76] that 'philistine elements'

[73] [For a clarification of the apparent jungle of Egyptian religious beliefs see now Morenz (1960), Hornung (1971).]

[74] This is the basic argument of Worringer (1927); cf. my review (Schäfer 1929b) and Schäfer 1929a.

[75] Outside the sphere of art the Babylonians perhaps show an even greater tendency to order and work systematically through the implications of an idea than the Egyptians do.

[76] *In Abu Telfan oder die Heimkehr vom Mondgebirge* (1868).

brought it down to earth in good time, thus preventing it being stifled by the old giant Thought while still hovering in the air. By using all their technical gifts, and skills, as believers, in the service of the kingship and religion, the Egyptians were able in moments of grace to produce the pure and noble works which we now admire. We should remember what I said at the beginning of this book, that only very few peoples have been equally creative in all or even many fields, when we see how the Egyptians were able to 'continue unimpeded' in art and express what was best in them so clearly. Their greatest achievement was their art. So nobody should imagine that he has grasped the essence of the Egyptians merely by studying what they wrote, while remaining indifferent to their art; the situation is the opposite to that of ancient Israel. How to unify the aspirations I have described constituted a problem for the Egyptians which exists in one form or another for any people.

All in all, it is probably not an overstatement to maintain that, except for the Greeks, no people in all of Antiquity put their talent to greater use, or were so in-spired by a creative drive, in representational art. At high points in history the work-ings of this process resulted in art informing all of life to such an extent that every-thing down to homely tools was not only decorated but also took on an artistic form— I am thinking most of all of the eighteenth dynasty, from which we have the greatest variety of remains. It is only necessary to take in one's hand one of the marvellous copies of the *Book of the Dead* (pl. 63), or even to look through a modern publi-cation, where the various sections of the roll have to be separated, to realize that these strips of papyrus are examples of a simply perfect art of book production, which may be equalled by others, but cannot be surpassed. We would have an idea of the nobility of form that was achieved in the country even if all we had was a few pieces of furniture.[77]

I have not been able to supply as many illustrations to this chapter as to the others, despite its being the one that most needs to be supplemented by looking at works of art. So my words, which were intended as an aid to appreciation, will only be illuminating for the man who feels himself drawn by the illustrations which I have included to look at other works of art.

2.3 On the concept of art and on creativity

At this point it is essential for the reader to consider the meaning and context of the term 'art' as I intend to use it.

We do not use the word when describing an undisciplined play of lines and surfaces which is the result simply of liveliness; our starting-point is rather the moment when a man first feels the desire and the capability to devise forms which represent images with an emotional content, in a way which the senses can comprehend.[78]

This *definition of the concept* allows, through the reference to a desire to produce forms, for the fact that we should not accept all representations as art. We must take care to separate true art from what might be called the 'antechambers of art'. But it is not possible to decide in the abstract whether the crucial step is taken in one par-ticular work; only the 'evidence', here as it were an inspired perception that a given form is creative or artistic, can tell us this.

[77] Propyl. 404 ff. [Cf. Sm pl. 123, 148–9, TP pp. 120–4, M fig. 442, Baker 1966 (J.R.B.)].
[78] [This definition is close to that of the German concept of *Kunstwollen* (J.R.B.).]

Our formulation of the concept allows us to contrast art with structures in nature. The latter can indeed have an aesthetic effect because they appeal to man's basic aesthetic feelings, like pleasure in certain proportions and rhythms, or in symmetrical or other dispositions of lines and surfaces. But not only works of art have an aesthetic effect.

The relationship with technology is somewhat different. Older technologies tended to give their products an 'artistic' clothing by the use of purely ornamental art forms or ones which imitate nature. Contemporary technology rejects this. Its structures can also appeal to the same feelings in man, i.e. they can have an aesthetic effect. But as long as they or parts of them are constructed or composed without any intention of influencing these feelings they are not art. But whenever, as is frequently the case, the purpose of the object allows it to take any one of several forms, and the designer chooses one which satisfies aesthetic sensibilities without affecting performance, then and only then does the object come into the sphere of art. This is not a value judgement, only a clarification of a concept. Experts on ships have confirmed to me that the number, distribution, or angle of slope of the funnels chosen for a steamship sometimes does not increase performance, but is only meant to enhance the impression of speed.

Genuine works of art are the result of an inner impulse, even if this is often called forth by a commission. Art itself is based 'on a sort of religious sense, a deep and unshakeable seriousness; it is for this reason that it so readily associates with religion. Religion needs no artistic sense, but is based on its own seriousness' (Goethe)). But the degree to which man feels that religion and art are close to one another (pp. 30–31) can be seen from periods when religion is declining: many people then try to find consolation in art. Adalbert Stifter illustrated the relationship between the two in a beautiful and enlightening image: 'art is religion's earthly sister, who also sanctifies us, i.e. as religion does; and, if we are so made that we can hearken to it, it exalts us and makes us happy.' So it is not the same as religion, but related.

Every true work of art, great or small, is a 'symbol' in so far as it shows us Art (pp. 345–6). Behind it there is something akin to what Goethe said: 'life can only ever be grasped bit by bit; art contains an intimation of the whole'.

There is a nasty after-taste in what we today call mannerism, where an artist exploits an often very ingeniously used individual mode of expression in order to obtain superficial effects.[79]

Works of art which represent living beings or things[80] do not have the same meaning for us as they did for the Egyptians, or for many other peoples. For them figures could have not only aesthetic qualities but also those of *living beings*. We too warn each other, if only as a joke, not to paint the devil on a wall. Only if we take such attitudes to representations seriously shall we understand quite why figures were so often worshipped in Egypt, and also destroyed or made unrecognizable. Now people only try to affect their power to preserve or destroy memories. For an Egyptian this property of pictures produced a further extra-aesthetic effect: he could only comprehend the miracle of a man's being able to create with his own hands images which reminded him and others of absent people, animals, and things, as a secret power in

[79] ['Mannerism' as used here has nothing to do with the descriptive term for sixteenth-century art (J.R.B.).]

[80] Everything that is said here about pictures applies also to names.

every image, and the images he assumed to be spirits. So we can understand that pictures could be credited with the power to be helpful, useful, or harmful like what they represented, without any inscription, spell, or even thought which gave them a specifically magical function. It could be said that this belief in the independent life of images was one of the reasons why ancient Egypt left behind it such an unbelievably rich legacy of sculpture and two-dimensional representations.

Even though artists will often enough have abandoned themselves entirely to creation while they worked, there is no Egyptian work of any importance that would not have had a definite function to fulfil, apart from and before any consideration of its value as art: to put it another way, it was not there only to be enjoyed.

Thus the basic purpose of religious images in tombs is to make the dead man partake of the benefits of the people and performances shown; and the pictures of daily life, which show the activities on the dead man's estates and other aspects of his environment, were the result of a pious effort to keep these people and these things not only before his eyes, but at his service.

The content of these representations was placed in three-dimensional form among grave goods from a very early period, with the number of the items often specified, although the totals clearly represent wish-fulfilment dreams (Borchardt called the pieces 'servant figures'); they could be single figures or proper groups,[81] or, especially from the end of the Old Kingdom to the Middle Kingdom, arranged in compositions often containing many figures,[82] like rowing or sailing boats with their crews,[83] fishing boats, musical ensembles, troops of soliders, kitchens, herds of cattle, work in the fields, brickyards, weaving shops, carpenters' shops, granaries, normal dwelling houses, and many other subjects—all of which we have become accustomed to calling 'models'. They are not models in the normal sense of the word,[84] trial pieces for works of art whose definitive version will later be produced. It would be better to coin a word like *Nachmodelle* [approx. 'small-scale copies'] so that the architectural pieces among them could be compared to the small reproductions of medieval cathedrals that donor statues sometimes carry. Comparable reproductions of temples have been found in Egypt, and were probably dedicatory offerings; for example, among the reliefs in the temple of Medinet Habu, a sculpture of that fortress-like holy place is represented with other offerings.

Model ships are one of many examples of the extent to which Egyptians considered pictures and models to be alive. On the Nile, where a north wind blows for most of the year, it was normal to sail upstream (southwards) and row downstream (northwards). Models of rowing boats were placed in the burial chamber accordingly, and, if the disposition of the walls in the offering chambers permitted it, the pictures of ships then were arranged so that the direction in which they were travelling was the same as the real one. Proximity to life goes still further. Human beings among these figures have their names written on their clothes. Thus they represent particular members of the tomb-owner's household. Similarly, in the Old Kingdom especially, people shown on the walls of offering chambers whose status is very lowly or

[81] Propyl. 241, 290, 291.2 [241 = W fig. 131–4, 290.1 = W fig. 154, cf. L-H pl. VII, p. 63, 291.2 = von Bissing 1911–14, pl. 29 and in general Winlock 1955 (J.R.B.)].
[82] Propyl. 292 [cf. Sm pl. 62 (J.R.B.)].
[83] Propyl. 293 [Ranke 1936.89, Reisner 1913 pl. 21–2 (J.R.B.)].
[84] [*Modelle* in German has a much narrower meaning than model in English, and the normal English tèrm for the pieces to which Schäfer is referring is 'models' (J.R.B.).]

not indicated at all just bear their names. So the owner enjoyed the service of an intimate circle in the afterworld as well, and on the other hand the servants had the rewards of his protection and provision for them: both together show the patriarchal atmosphere of Old Kingdom estates—except when taxes were being collected.

The number of pictures that are intended rather more to fix an event in the memory, and which are therefore true 'memorials' or monuments, increases gradually in proportion to the number of those whose content is magical, and which were therefore chiefly meant to serve for the future.

Unconsciously, *formal inclinations* arise in an artist and are developed to a greater or lesser degree by his creative activity, taking on a definite shape as he transforms his various materials from inert masses to living entities. These inclinations can be observed but not explained. They are part of the artist's ethnic, tribal, and family heredity, and are very much influenced by every natural or man-made object that he perceives from the time his senses start to function, and also by what he picks up from his intellectual environment. But this is subordinate to the core of creativity in a thinking and feeling personality. What is true of individuals is also true of peoples and groups of peoples, which can in certain circumstances be considered distinct beings. Just as the formal inclinations of the artist determine in part how he makes his works, so do those of the viewer influence his pleasure in or dissatisfaction with them. I should make it entirely clear that when I talk about formal inclinations in this book, the forms I refer to are always artistic ones; I need scarcely add that these are not just 'beautiful' forms in the ordinary sense.

A passage from Ludwig Richter's autobiography[85] will, because of its simplicity and modesty, always be the most appropriate example with which to illustrate the effect of these formal inclinations. Four artists once agreed to paint the same object from the same point, and everyone strove for the utmost fidelity of reproduction. So Richter was not a little astonished when he got up at the end of his work and, looking at the pictures in front of him, found considerable variations in them. The general mood, the colours, and the basic outlines were a little different in every case, subtle changes could be sensed. Each pair of eyes had presumably seen the same, but what they saw had been transformed inside each of them according to his temperament. This was clearest in the case of a melancholy man. The lively outlines of bushes and masses of rock were calmer and less uneven in his rendering, and the cheerful colour of the golden brown rocks became paler and sadder: in the shadows, which seemed so bright and colourful in nature, a dark, reddish brown was very prominent. In other words, the man's personality was decisively revealed in his work, as indeed was that of each of the others.

External influences on formal inclinations are by no means always consistent, and for this reason changes which one would think could not be accommodated in a single life span can in fact occur, gradually or suddenly. Goethe's works or the revolution under Amenhotpe IV are examples. But just as Goethe felt the unity of his *Faust* so strongly that he wrote in one of his last letters that later generations would not be able to distinguish the earlier parts from the later ones, so one can be conscious of the inner connections between works of the Old Kingdom and of the Amarna period; it is another question whether one can say what they are. The visible form may change considerably, but the form in the mind remains the same.

[85] [Richter 1909.176–7 (J.R.B.).]

The meaning of these remarks for Egyptian art can perhaps be seen best in the treatment of plants: the beautiful form of the papyrus plant in art (fig. 10) is of course a reproduction of the natural form. But it is equally plain that, here and everywhere else, the Egyptian's artistic act was not in the choice and noting of his subject, but the way in which he absorbed it into his mind and then re-formed it with such fidelity. In this context Dürer's saying comes to mind: 'truly, the rule of art is concealed in nature; he who can pull it out has it.'[86] The upside-down bell shape of the papyrus in pictures is so well concealed in the actual umbel of the plant that it was not discovered in the first dynasty (pl. 8), and is first found in third dynasty works. Nor did it remain unchanged. In the New Kingdom open swinging forms with long hanging lips appear beside the old, more restrained umbel, and they

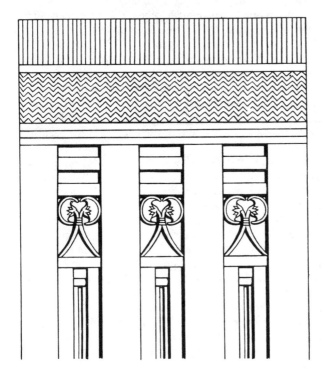

FIG. 17. Papyrus bundles above the niches of an ornamental false door. OK

are anticipated by papyrus bundles in the niches of Old Kingdom decorated false doors; here the need to fit the plants into small box-like areas (fig. 17) probably acted as a stimulus. In the New Kingdom the open form was used by craftsmen to beautiful effect in the handles of mirrors (cf. p. 55, Propyl. 414).

The motif of a person sniffing a blue lotus (p. 21) was the subject of especially interesting transformations. In the Old Kingdom the pliable stem is grasped just under the flower (fig. 18a), in the Middle Kingdom it is held at the bottom and stands upright (fig. 18b), while in the New Kingdom it is held in the same place but

[86] [See Chapter 7 n. 55 (J.R.B.).]

a b c

FIG. 18a, b, c Methods of holding the stem while sniffing a lotus flower, OK (a), MK (b), NK (c).

curves in an *S*-shape towards its holder's nose (fig. 18c).[87] We have no reason for assuming that the latter two forms represent a conscious departure from nature.[88] But however trivial they may seem, the three together are inestimably valuable since they give us our clearest summary of the formal inclinations of the first three great periods of Egyptian art. In the Old Kingdom the natural way of holding a water plant is shown. In the Middle Kingdom the impetus to produce straight lines violates the yielding nature of the stem, while in the New Kingdom the predilection of the time for beautiful curving lines preserves the softness as an essential element, though both these latter show dispositions that would be impossible in nature. In this context one may quote Goethe's penetrating remark: 'Everyone sees the material'—not necessarily the working material—'before him, only a man who is involved with it discovers the content, while the form is a mystery to most people' (cf. p. 337). Thus the three drawings of fig. 18 have as their 'material' (or subject-matter) the simple visual image of sniffing a water plant, the 'content' being what this meant to an Egyptian and the 'form' the fashioning by the artist. Nor should one forget that 'what everyone sees before him' had for artistic purposes first to be properly seen or found, and then to show itself able to live as a form. This image was not 'discovered'—as Fechheimer puts it—before the fifth dynasty. The Late Period was not able to add another 'basic form' to the three shown above.

[87] [The figure is highly schematic. The original sources are (a) *Atlas* 1.376 (reversed), (b) Schäfer 1913.17 no. 4, also reproduced in Brunner 1965 pl. 6 (Berlin 1197), (c) *Atlas* 1.116 (PM 1^2.29 (3)) (three cases; drawing of one, Säve-Söderbergh 1957 pl. 22). The juxtaposition of the three forms is misleading, as the arm pose is probably the determining feature in the motif, and that of (c) is different from those of (a) and (b); forms (a) and (c), with their corresponding arm poses, do in fact occur together in New Kingdom works (e.g. Durham N. 1964). The Middle Kingdom work chosen is more in the style of the First Intermediate Period, and a number of details (especially the hieroglyphs) show that the artist did not follow normal conventions; one is tempted to think that the rod-like form of the lotus-shaft may be due to a reminiscence of a staff, sceptre, or fan (for the latter see *Atlas* 1.116, top; see also the form (c) of Schäfer 1931b.9 fig. 1 [= Ranke 1936 pl. 261, Berlin 15003; this is not identical with *Atlas* 1.116, as Schäfer implies], omitted in this book). In the Middle Kingdom Schäfer's form (a) is the most frequent, but all three are found (for (b) in the New Kingdom see Berlin 9610 = *Ägyptisches Museum Berlin* [1967] 58 no. 640) (J.R.B.).]

[88] [Cf. Schäfer 1942.169 with fig. 5, Schäfer 1944.113 with fig. 4.]

In studying any fairly long series of examples of a motif one is constantly finding concrete examples of what Goethe meant by his statement: material, content and form are not always indissolubly and mysteriously linked. None of the three should be lacking in a perfect work of art. We are right when we speak of an empty form when it has no content. But on the other hand material and content do not in themselves make up a work of art. Think for example of religious pictures: there are enormous numbers of these which satisfy all Goethe's three requirements, and are among the greatest works of art. But equally there are innumerable others, which may be full of religious import for a believer, but show no trace of artistic form, so have nothing to do with art.

Artistic predilections for particular forms are only some of the factors that involuntarily shape everything any man produces or says in any activity he may practise. These predilections are largely determined by his inherited character. Religious works that we must judge to be without any artistic form are not only vehicles for purely religious, non-artistic values, but also for the personalities of their makers. Graphology can illustrate the meaning of this. It reveals characteristics peculiar to the handwriting of a particular person which make it possible to distinguish the personality of the writer from others with a fair degree of certainty, and, to some extent, to interpret it. Normally the question of aesthetics or art does not enter into it, although it can play a part. References in discussions of painting to an artist's 'handwriting' have the same implications as my term 'formal inclinations' or 'predilection for particular forms'.

In those types of ornamental art and architecture which are not based on natural forms the formal inclinations of the artist are almost unhampered in their expression. But whenever the intention is to render the world of natural phenomena, as is the case with by far the largest part of Egyptian art, the essence of any art is the resolution of the conflict between the repertory of forms in the artist which are seeking expression (as Goethe would say, the interior nature) and appearances (exterior nature), that is between reproducing sense data and making a new creation of them.[89] 'Nature and art seem to flee from one another, / yet before one can take thought they have found each other.'[90] But this does not always happen 'before one can take thought'. Even if the struggle is scarcely felt when artists, as in Egypt,[91] are far more concerned with a calm ordering process, in other cases it can arouse powerful feelings and become bitterly serious.

If one classifies the art of various epochs and peoples according to this criterion, the two ways of feeling and forming appear separate and opposed. A more sober temperament is generally expressed by calm forms, and the opposite by restlessly jagged or involuted ones. Yet the reverse situation can exist, and outwardly calm forms may be the result of firm self-discipline. Only an insight into other dimensions of the temperament of a man or a period can help in deciding the matter.

[89] Evers (1929) used the term *Bedrängung* [approx. 'coercion'] to describe this flux which crystallizes in a work of art and in the artist's vision. I cannot see anything especially constructive in the term, although it expresses the active nature of the process in an attractive way.

[90] [Goethe, 'Natur und Kunst', 1800 (J.R.B.).]

[91] The expression of a certain degree of inner tension is in fact apparent only in the best MK works (Propyl. 283 and others) and at the beginning of the Amarna period.

The necessity to resolve the conflict between interior and exterior is as vital a factor in contemporary art as it is in the most ancient. The problem must be taken up again and again, and no artist or period can produce a definitive solution that would be as convincing for any other. Someone who adopts older or different forms or styles, or even the man who tries to copy an alien work of art as faithfully as possible, can never produce anything exactly like the ancient piece; he will always reveal modern traits, even in a repetition. One might remark by the way that the collector's conviction that he will in the end expose even the most skilled of forgers is based on this fact. But here there is the danger that even the greatest connoisseur will be led astray when judging the work of a forger who is his contemporary by con-temporary touches that can never be entirely suppressed. In these cases true individuality of style is only expressed by what became part of the work against the forger's will, and the piece's main features are determined by his desire to produce something quite different. Only because this desire is also in the last analysis part of the forger's nature can that nature find expression. Finally, Jacob Burckhardt remarked in the introduction to his *Griechische Kulturgeschichte* that a forger can also, much against his will, learn his most important lessons for future forgeries from his own fakes that have been exposed.

The essential character of art is that the conflict in any work can never be resolved entirely in favour of nature: if it were so resolved—if such a degree of approximation were possible—the idea of art would be rendered meaningless. But the divergence possible in the other direction is more or less unlimited: the natural form can disappear almost entirely and the work still remain good art. It is well known that in many drawings by children or primitive people, and indeed in many areas of great art, the formal inclinations in the draughtsman are so wayward that he forces nature into sharply geometric or ornamental structures, and many artists might well be asked why they bind themselves to objects in nature at all and do not create freely. One movement in modern art has taken this step and intentionally excluded the objective world. But the level of artistic attainment does not in any way depend on the work's degree of removal from reality. Similarly the difference in the artistic value of two works need not consist in a clearly visible diversity but may be based on minute details.

Early Egyptian art shows in its compositions only what is necessary to make clear what is meant. This is still true of the tomb of the chief master of the hunt Metjen[92] from the transitional period between the third and fourth dynasties, where only a few figures of animals among the pictures allude to the owner's profession. He is not seen hunting, the ground is not characterized as desert land, and we get no impression of its extent from the short vertical lines. But among the animals we see an eagle, a hare, and a jumping rat; and three of the antelopes arranged in five pairs one above the other[93] are being bitten in the leg by dogs. That is all we see. The 'inner eye' of the artist, one of the great artists of his time, must have achieved the desired effect by the use of a few 'signs' which were, as the space-saving arrangement on the plates shows us at once, distributed over several walls, and which were all the evidence presented to the imagination of the viewer. And for viewers of that time these few indications were really enough to evoke the image of a hunt in the desert, with all its

[92] Berlin 1105. In Lepsius (LD 2.3–7) the relationship between them is not easily understood, as the pictures are unfortunately arranged in the manner of architectural drawings.
[93] Propyl. 249.2 [in part W fig. 169 (J.R.B.)].

excitement and activity. They were in a position to understand all the aspects of the artist's intention. Art of this type is like literature whose effect is achieved not only through the ideas made explicit by the words, but also through the ripples of association caused by their passing. A modern observer unacquainted with the background will not be able to comprehend at all what the ancient artist meant by his depiction of those animals; at best they will call into his mind a scanty image of a hunt, and not necessarily a desert hunt. And so an essential part of the work of art will have no meaning for him. Then it must be feared that a viewer who does not use his mind to look at the work will only observe what is immediately visible: the material details of the figures, draughtsmanship, and construction. It may be possible to approach a later, more communicative art in this way, but not a laconic earlier one, in which every figure and every line carries its load of meaning. Anyone who believes he can do this is like the person who thinks he can do justice to a poem in a foreign language on the basis of the bare sense of the words, and perhaps also of their sound and rhythm, although all the mysteriously associated emotional echoes, which are essential constituents of the poem, are missing for him, because he does not live with the poet's own language. So in its austerity this picture illustrates something which is the prerequisite for all artistic experience: that every work is dead until a man with similar intentions comes to it, looks at it, and brings it to life again inside himself. And this is an example of our surprising ability to give life to the ideas and feelings which the forms in this picture must have evoked for the artist. The more deeply we are able to comprehend ancient Egypt, the more aware we shall be of the point at which we must stop in order to prevent our sympathy from becoming the sort of importunity that destroys true understanding, just as it does between man and man. In this case, for example, one will have to beware of relying on a sensitive 'feeling for nature' when referring to the landscape. Such a sentiment is visible in the New Kingdom (cf. p. 45), but was remote from the mentality of the Old Kingdom. Then, an unsentimental factual recording of nature was dominant, and the attitude to it was almost entirely unemotional.

Brief statements in single, evocative words seem to be characteristic of all the oldest literature, as indeed they are now again of contemporary literature, in reaction against the broader method of elaboration that was dominant in the intervening periods. The same is true in art. After the initial period of concise clarity, pleasure at the depiction of life in its many aspects took a sure hold in Egypt. The image of each individual object contains more and more details of single parts, though the basic aim is never absolute completeness. When artists are producing works with a secular content they become to a large extent absolved from considering the aim of a piece, and the works themselves are released from the tyranny of their 'sign'-like nature. Reserve is weakened and no more than what is immediately necessary is given: involvement with subsidiary elements increases.[94] For example, food, which was once only suggested, becomes a rich still life (pl. 19 compared with pl. 35, 43), and the beginnings of a true representation of landscape develop from sparse features necessary to the action.

One most remarkable picture, in which the landscape itself shows an action, is of an area laid waste by Ramesses II's armies.[95] There are no human beings, animals, or living plants, only ruins of buildings, felled trees, and bushes hacked to pieces. The

[94] Propyl. 249.1 compared with 261.1 L [W fig. 168 and fig. 190 (J.R.B.)].
[95] Wreszinski drew attention to this, *Atlas* 2.65, cf. Schäfer–Andrae 1942.108. The 'green room' discussed in this paragraph is excellently treated by Davies in Frankfort (ed. 1929).

painted decoration of a room at Amarna, where the wide high window gave on to a courtyard for birds, is unusual in a different way. All round the walls an uninterrupted papyrus thicket, enlivened by swamp flowers, birds, and fish, is painted on a base consisting of the blue river and the black soil of the bank; square nest-holes, framed in black, are distributed above the papyrus. There are none of the 'bands of colour' (p. 26) which normally emphasize so aptly the enclosing function of walls. Here in the 'green room' at Amarna the papyrus thicket and not the walls delimits the area, and serves not as a background to painted men, but as an environment in which they can enjoy themselves. The trifling sentimental feeling for nature of the urbanized New Kingdom, especially the Amarna period, is expressed in this wall decoration and in the whole building, which brings together palace, administrative offices, stalls for cattle, and dovecote.

The satiated Late Period finally returned to the old concision, but that time was still many centuries off. In the Late Period what happened naturally in the Old Kingdom was produced self-consciously. In between, although sculpture was almost entirely dominated by more rigid types of human and animal forms, the two-dimensional artists drank at the refreshing stream of life's manifold forms, and displayed in their work all their abundant inventiveness and executive abilities. They did this without even considering whether all the detail in their works, often in remote and almost completely dark positions, would ever be deciphered by human eyes. For the majority of the works we marvel at in our collections come from rooms in tombs or temples which were not lit at all, or at most by the light coming through a door or slit window. Of course the sun's rays are of a completely different luminosity in Egypt from what we are used to, and we must reckon with the figures having, even by lamplight, a quite different effect in the splendour of their colours from the one they have in their present condition; but still a great deal of what the artist gave of himself in selfless and conscientious love of his work must have remained hidden to the eye. What, apart from this love, could have driven a sculptor to make the signs which wrote the noble words destined for the top of a pyramid as beautiful as possible?—they were placed so high no man could have seen them.[96] Winckelmann, and Goethe (perhaps influenced by him), long ago commented on this when they saw the point of an obelisk that was still lying on the ground in Rome.

Imitation of nature is not the essence of artistic creation, although it is so closely involved in it that Goethe called nature 'the eternal spring from which even the most perfect man should never cease to draw'; it is at once a stimulus to and a check on fantasy. But in large areas of any art, to which nobody would want to deny the designation, the imitation of nature is of very limited relevance, if of any at all. The Greeks, who were the great founders of the study of art, especially Aristotle, laid excessive emphasis on the imitation of nature in art, and their authority kept us on a false track for a long time.

There will always be many people who will base their judgement of an artist on the

[96] Schäfer 1904 and Schäfer 1929.47 n. 13. Cf. also Goethe's second stay in Rome, as related in his September report and in his letter of 3 September [1787] on obelisk tips [*Italienische Reise* pt. 3. Various English translations as *Italian Journey* (J.R.B.)]. Incidentally, the inscription on the north side should probably be translated: 'the soul of King Amenemhat is higher than the height of Orion and he unites himself with the god of the underworld' and not 'he unites himself with the underworld', if indeed there is any reference at all to the underworld. The Egyptian word underwent a considerable shift in meaning (Sethe).

degree of his success in reconciling the closely related yet opposing forces of creativity and of the rendering of nature in a truce in which neither is the victor; some will do this out of a predilection for harmony, many more to satisfy their own inclinations. For contemporaries of ours who think this way the Egyptians may well seem to have found a satisfying solution in some areas. Leaving aside architecture and decorative art these people will consider that the Egyptians created in their best statues of men and animals something which everybody recognizes as having eternally lasting qualities. Forms of such purity do not seem to most people to have been achieved in other areas of sculpture and two-dimensional art, partly because we have grown up on ground prepared by Greek art. Here these same people will think that the Egyptians did not find a way to overcome the conflict.

This judgement misses the truth. It mistakes the degree of approximation to nature in Egyptian art, because it is not based on a knowledge of the premises of the Egyptian rendering of nature. Not only do the advocates of this point of view refer to the sometimes very abstract forms of expression in Egyptian reliefs and painting; they also mention immediately the 'distortions' in them; but I have already indicated and will prove in the later parts of this book that the 'distorting' Egyptian method of drawing attempted an objective fidelity to life just as much as the perspective one familiar to us does. It shows a thorough misunderstanding to object that its methods wrenched things in the outside world away from their natural context and freed them from all their mundane elements in order to purify them for a higher world or prepare them for eternity. This places the facts in an entirely false light. The rich life of the pictures speaks as clearly against this interpretation as do the innumerable texts written next to them. Egyptian artists[97] 'interpreted the language' of their art 'as if it were nature'. For them it was natural, objective, clear; it gave them the possibility 'of giving their history the form not of a dream, but of reality'. It is seriously misleading to consider, as has been done in recent art-historical study, that any ancient art, whether Egyptian, Greek geometric, or the art of the later Stone Age, should have wanted, in all its productions, even those depicting human beings in their normal activities, to banish life by overemphasizing form.[98]

The Egyptians' works of art remind us continually that their invention was more closely linked with the content of their representations than that of many other peoples. They were capable of expressing themselves in free lines, surfaces, and shapes, but only to a limited extent. Thus, for example, one can as a rule almost always suspect foreign influence in Egyptian ornament—whose development has not yet been satisfactorily studied—when a decorative form cannot be traced back to an origin in nature or human beings.[99] An Egyptian would certainly not have hesitated to declare himself in favour of a definition of art as the reproduction of nature. In many Egyptian works of art the observation of nature is striking, almost infallible; many people have first been made aware of the artistic merit in them by this quality. When this gift is combined with the equally innate Egyptian insight into the failings of one's fellow men, words and pictures often exhibit a tendency to good-humoured or biting mockery, and the pictures a certain degree of pleasure in the depiction of bodily

[97] H. von Einem [contemporary German art historian and literary critic (J.R.B.)].
[98] p. 24. This was first stated by Worringer in *Abstraktion und Einfühlung* (1907) and *Formprobleme der Gotik* (1920).
[99] Borchardt's assumption that all Egyptian wall decorations originated as reproductions of wall drapes decorated with figures goes too far in its use of a well-established technical interpretation. On the problem see Schäfer 1926a.

deformities.[100] A general bond with nature and a sense of natural geometric form were happily combined in the Egyptians, and we can see how all Egyptian works of art approach nature closely, yet we feel their self-sufficiency quite distinctly. This tension between two realities is part of the attraction Egyptian art has for us.

The sharpness of observation which Egyptian art has at its disposal can be seen in representations of the flight of birds. In this case careful works distinguish the layers of feathers, which I am deliberately describing in technical language. The following are distinguished (fig. 3): above, the underwing-coverts of the third series. They terminate in the tertiaries, which are mostly joined with them to make one band. In the middle, mostly reduced into a single band, the underwing-coverts of the first and second series. These are separated proximally from the tuft of scapulars, and, distally, from a fanned group of underwing-coverts of the first series. At the bottom is the band with the two types of pinions, which are not distinguished from the fanned underwing-coverts in simplified drawings. Among these feathers eight to ten of the outside ones, the primaries, are sometimes coloured differently from the inside ones, the secondaries. The top and the underneath of a wing are sometimes distinguished. These distinctions, which correspond astonishingly closely to those of a natural wing, are first found fully developed in the falcon protecting king Re'kha'ef (Khephren),[101] in other words they go right back to the beginnings of 'Egyptian' art. They are not found on the slate palettes; there at most one series each of underwing-coverts and pinions is rendered (pl. 4).

If we look again at the slate palette with the bull (pl. 2), and especially at the taut lines of the veins on the animal's head and legs, which are also found on first dynasty furniture with legs in the form of wild bulls' legs,[102] and on the underarm[103] of pl. 7, we can see that Early Dynastic art was on the point of becoming mannered. The new art marks (pp. 10–11) a new position with regard to nature and a deepening of the relationship with it. At any rate, as soon as the new impulse reaches equilibrium in the third dynasty, the new geometric works have a calmer effect than the old ones. But it is clear that this harsh monumental quality (pl. 16) is not a stiffening or a sign of age, as Spiegelberg thought (1903.5), only a last clarification and testing of the basic orientation, as it were a signal that the art has achieved a powerfully self-aware virility, a gathering of strength before blossoming forth in the prime of life; to see this one only needs to look at the riches produced in the fifth dynasty.

It will be useful to refer to architecture at this point (cf. Schäfer 1929, Junker 1928). The simple and noble form of the smooth four-sided pyramid on a square base was evolved during the transition from the third to the fourth dynasty. We know that the pointed form was arrived at by conscious effort, through the intermediate stage of the step pyramid on a rectangular base.[104] When we finally came to know the long-neglected buildings surrounding the third dynasty step pyramid it was surprising to find constructions most of which looked as if they were wooden, reed, or wattle buildings transposed into stone. At the time I none the less considered their almost delicate forms to be the forerunners of the massive geometry of fourth dynasty

[100] p. 18. [On the wife of the ruler of Punt cf. Brunner-Traut 1957a.]
[101] Propyl. pl. 2 [L-H pl. 30–1, IV, Sm pl. 40 (J.R.B.)].
[102] Propyl. 202 [cf. Baker 1966 figs. 1–8 (J.R.B.)].
[103] The front legs of late sphinxes still have heavy veins, cf. Evers 1929.2 § 587 'Band'.
[104] Propyl. 206–8 [L-H pl. 8, 13, 25–6, Sm pl. 24A, 25A, 32, M figs. 824–46 (J.R.B.)].

remains, thus taking the expansive monumentality of the latter to be a conscious turn-
ing away from the earlier more refined style. But Ricke [1944] has shown that a link of
this sort cannot exist: the Djoser buildings are in fact, to a much greater extent than
I thought, stone reproductions of the lighter living and working quarters of the ruler
of the time; the remains of funerary buildings which we have from the fourth dynasty,
with their breathtakingly massive geometry, do not go back to mud and brickwork.
Some elements are stone adaptations referring back to the mud, wood, and reeds,
like the panelling of all outside walls, the torus moulding at corners, and also plant
columns; but these are absorbed into the large-scale stone conceptions and integrated
as thoroughly as the corresponding elements in Greek temples. The cavetto cornice,
a beautiful crowning element, is one of the achievements of Egyptian art which in-
fluenced other cultures. Fourth dynasty buildings seem to us to have aimed primarily
at working out as clearly as possible the essential principles of all future Egyptian
building in stone. On this now irrevocable basis the fifth dynasty substituted light,
open dignity for the earlier restrained grandeur.

Other factors influence the shaping of a work of art, and I shall mention the most
important of them here.

First of all the *material* for which the work is conceived and in which it is executed.
The effect it has can be most clearly seen in sculpture.

The closed bodily form of Egyptian statues is generally held to be a characteristic
trait: the projection of parts is avoided as far as possible, limbs are placed against the
main part of the body, or are connected with it and each other by areas we call
fillings or bridges, so that there are no gaps in the whole. Even a fist hanging down
loosely clenched on a standing statue[105] is filled with a round object that is painted
white and set off against the colour of the skin by a red line,[106] as explained on
p. 71. In New Kingdom royal statuary this is often replaced by a box-like object
with the king's name on it.[107]

A classic example of the closed form of a whole statue is a statue in limestone
dating from about 2650 (fig. 19): the man stands in a walking pose holding sceptres
that indicate his rank, one almost the height of a man and one like a chisel, his legs
linked by a bridge, and his arms and staffs close against his body. The long sceptre
is only very rarely held this way in reliefs or paintings (fig. 20).[108] In these men
mostly stand it on the ground in front of them with their raised arm, and always
hold the short one horizontal (fig. 166, 167). A contradiction of this sort between
three- and two-dimensional representation is not peculiar to this early period:
thousands of years later we still find statues of goddesses with their sceptres held
vertically against their bodies,[109] although it is known from two-dimensional pictures
and bronzes that they were thought of as carrying them forward away from the body,

[105] Propyl. 231–5 [L-H pl. 21, 40–1, 53, 56–7, Sm pl. 29B, 31B, 44B, M fig. 222; Propyl.
231.2 cf. M fig. 221 for a near parallel (J.R.B.)].

[106] This is basically the same thing as the supporting cushion in the open hand of a statuette
from Amarna (Berlin 21263, Fechheimer 1921.79). As a description of the simple filling
the term *'Schattenstab'* [vestigial staff] (Spiegelberg 1906.176) misses the point.

[107] Propyl. 357 [L-H pl. 232 (detail not very visible), W fig. 545 (from other side) (J.R.B.)].

[108] [Early parallel in the tomb of Hesire', Quibell 1913 pl. 30, late OK example Abu-Bakr
1953 fig. 10; cf. *Giza* 12.76–7, fig. 5–6 (J.R.B.).]

[109] Propyl. [340.2] [cf. Worringer 1928 pl. 14, Fechheimer 1923 pl. 77–8; this phenomenon is
also found with male deities (J.R.B.)].

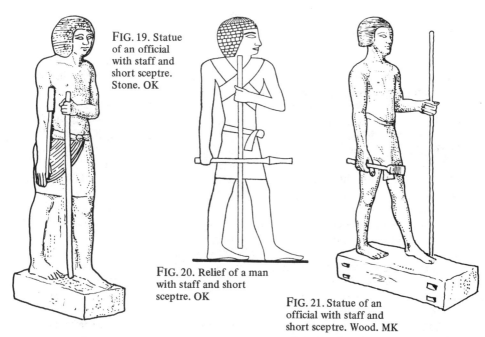

FIG. 19. Statue of an official with staff and short sceptre. Stone. OK

FIG. 20. Relief of a man with staff and short sceptre. OK

FIG. 21. Statue of an official with staff and short sceptre. Wood. MK

with the arm slightly raised. With sitting figures wearing a cloak which only leaves the fists free, the sceptres are curved to follow the two angles between the body and the thighs, and between the upper and the lower leg. But in these cases the pose of the figure is not a real one, the form being based on that of the standing cult image, the whole of which is adapted to a sitting posture. Another solution occurs with standing divinities whose four wings are extended sideways to make flat vertical surfaces. In order to find support the hand with the sceptre is not bent in to the body, but, as if it were in a relief or painting, outwards to the wall of wings,[110] just as in fig. 210 the arm appears flattened against the painted surface.

The merging of hands and staffs with the body and the non-separation of the legs from each other, as in fig. 19, are almost only found in stone statues. As soon as the sculptor begins to work in wood (fig. 21) or cast metal the arms, staffs, and legs of his statues are almost always as free as in his two-dimensional work. It is often forgotten that gold, silver, copper, bronze, ivory, wood, and clay statuary was much commoner in Egypt from the earliest periods on than what is preserved would seem to imply. And in these media artists exploited to the full the greater possibilities of rendering different movements. Faience (coloured frit) and, often, clay stand somewhere between the two extremes.

It can be deduced from stone works themselves that sculptors did not simply reject freer forms, for we find cleared areas in place of bridges[111] from the fifth dynasty, in high-quality as well as low-quality works, and where the fillings are present they are very frequently painted black or white, that is as if they were holes or did not exist.

[110] I have seen a piece like this at an art dealer's [this is the normal form, or the figures may have four arms (J.R.B.)].

[111] Propyl. 238.2, 239.2 [W fig. 118, L-H pl. 60, M fig. 211 (J.R.B.)].

The purpose of this is to make the bridges disappear, that is to produce something which at least looks like what was actually made in wood and metal. The painting often goes a stage further, and the base and back pillar are painted black so that the figure appears to stand completely free.[112] Many modern art critics find it hard to forgive Egyptian artists for the cleared areas or the *trompe l'oeil* painting of bridges.[113] They interpret it with regret as a concession to the natural form of objects. The fact that all statues, except for ones in metal and perhaps in costly coloured stones (cf. p. 74), where the painting was partial, were painted in colours corresponding to those of their models,[114] and the fact that eyes were given the shine of real eyes[115] by the use of polished stones are also part of this striving to achieve a natural effect. After the Old Kingdom cleared areas in stone statues become much rarer.

But the attitude which I have described as obtaining with other materials and with the colouring of bridges seems to me to prove that Egyptians felt themselves to be influenced by the material when producing statues, in other words that the solid forms are not the product of an innate sense of artistic form, but conditioned by the properties of the material. A particularly clear piece of evidence for this can be adduced. It is a fine limestone figurine of a queen from Amarna,[116] which had hanging arms and open hands which face backwards (cf. p. 298). Not only are the arms and the sides of the hands with the thumbs secured, as is usual, by being united with the body; the artist has also strengthened the fingers with cushion-like fillings in the palms of the hands.

Apart from the many beautiful varieties of stone whose hardness made them difficult to work, Egypt had the fine white Tura limestone, which is as characteristic of Egyptian work as marble is of Greek; it is easy to work, and other types of limestone and most sandstones are only a poor substitute for it. Anybody who has seen how easily lesser, yellow limestones shatter, and how even large blocks of the snow-white type split into slabs with just a few blows of the mason's hammer, will say to himself that account must have been taken of these properties in the formation of Egyptian style. It would be dangerous to expect to produce the same forms in it as could be produced in other stones; equally, closed forms were particularly appropriate to granite and the other hard stones.

In art-historical studies it is only rarely possible to observe the degree of influence exercised by the material chosen as easily as can be done in Egypt. But it is not enough just to notice it. Experience probably makes every sculptor aware, once his attention is drawn to it, that work in difficult materials tends because of its slowness to be

[112] This brings to mind the way in which, in Japanese puppet plays, each of the beautifully carved and dressed wooden figures is handled on the stage by four players who are dressed from head to foot in black and wear long black gloves and black masks. One is meant to forget entirely that the players are there and to see only the figures. Which is exactly what happens.

[113] As a result of unconscious selective bias cleared areas are completely lacking e.g. in Fechheimer 1923.

[114] The problem of the painting of hard stones should be examined comprehensively and systematically. There is much material in von Bissing 1898 and von Bissing 1911–14. [A recent study in this field is Reuterswärd 1958. A hard stone statue with the paint still intact has since been discovered: Michalowski 1969 pl. 91 (J.R.B.).] The same will be true of Egyptian as of Greek bronzes, that the colour desired in antiquity was gold, not black or still less green oxide. [Cf. Watzinger 1931.835–6].

[115] Late predynastic figurines already frequently have inlaid eyes.

[116] Berlin 21263 [= Schäfer 1931a pl. 21].

carefully thought out and to produce economical and highly self-conscious forms. If a sculptor has found difficulties and obstacles at a first attempt, but has not allowed himself to be put off, and returns to the same material because of its beauty or because he hopes it will be long-lasting, in developing his forms he will unconsciously be conditioned by its properties. So we can observe a phenomenon which can be defined, with the help of a saying of Schiller, as follows: Egyptian sculptors made the demands of the material a part of their approach, so that the closed form of the works became one of the basic rules of their sculpture in stone. As we have seen (pp. 24–5), the back pillars in stone statues were subject to a similar process.

The cult-image of the fertility god Min of Koptos,[117] well known from many figures of the historical period, had its right arm raised and bent at right angles, and an object like a flail lay on or against the hand, which did not grasp it. These details suffice to show that the original in the temple sanctuary must have been composed of pieces of wood. But the limestone statues of the god up to two metres high, which were used in the temple decoration at other points,[118] do not raise their arms but have them hanging by the side of their bodies with the flails held horizontally through a hole bored in their fists. Although these enormous stone images are predynastic in date, while the drawing that refers back to a wooden figure (Berlin 15454) is of the Early Dynastic Period, the chronologically later relief contains the more archaic elements. These elements could not be derived from the stone statues, while the iconography of the latter can easily be explained on the lines of the relationship between figs. 19 and 166–7, except that in the stone statues the flail was made separately and inserted in the fist, so that it must have been made of wood.

When we find in the New Kingdom[119] processes similar to those that occur with the Min statues or fig. 19, these no longer have precisely the same meaning. Now the staffs appear to be intentionally held against the breast, and the material helps rather than dictates. The tyranny of stone has been broken. I have already discussed a beautiful instance of this, the difference between the positions of the tails in Early Dynastic and New Kingdom statues of lions, on pp. 11–12. The block statue[120] developed in the Middle Kingdom transforms the figure of a man squatting on the ground with his knees drawn up towards him into a solid cube, which is the purest expression in Egyptian sculpture of the dominance of forms suggested by the material (cf. p. 325). The block statue, mostly of a man covered by a cloak, has a position in sculpture corresponding to that occupied in architecture from the fourth dynasty onwards by the true pyramid. It evolved around 2000 B.C., at a time when other forms of statue also showed men covered in cloaks or other long garments, as against the Old Kingdom, which shows a definite tendency to avoid representing in male statues clothing that conceals the form of the body. The many Early Dynastic figurines of people wearing cloaks are certainly based on different intellectual premises from those of the Middle Kingdom.[121] Some twelfth dynasty statues show the human figure more or less embedded in a hitherto unexplained angular block, a form which later disappears.[122] In the course of development, periods when the

[117] See Propyl. 454 top [Junker–Winter 1965.348 (J.R.B.)].
[118] Propyl. 179 [W fig. 27, cf. Baumgartel 1948 for further illustrations (J.R.B.)].
[119] Propyl. 340.2 [Worringer 1928 pl. 14, cf. Fechheimer 1923 pl. 77–8 (J.R.B.)].
[120] Propyl. 334 [W fig. 384–5, M fig. 324, cf. 322 (J.R.B.)].
[121] [But cf. Baumgartel 1968 (J.R.B.).]
[122] [Cf. now Eggebrecht 1966 (J.R.B.).]

modelling is softer and the forms of the limbs may be clearly delineated alternate with ones when it is almost geometric in its rigidity, but without ever quite eschewing bodily form. In the New Kingdom the front surface is often broken by a cavity in the form of a chapel or by additional elements placed in front; or the front and two sides are covered with well-laid-out texts. The block statue was especially popular at the turn of the first millennium, when some very fine pieces were made. A similar form is also known from pre-Columbian America.[123]

It can easily be seen that between the two main groups of statuary there are considerable differences and that these are due to differences in material, on the one hand stone, on the other material of other kinds. There are in addition more minor differences between works in hard stones and in the softer limestone.

But if we compare all of Egyptian statuary with post-fifth-century Greek it is obvious that there is a contrast between the two that has nothing at all to do with the materials used. In Chapter 7 we shall learn to understand this contrast, which lies in the axial fixity or directional straightness of Egyptian works [p. 310–20]. In Egypt the differences in detailed execution between works in different materials are not great. If the same object is represented a very acute eye is needed to isolate the differences that result from use of limestone, wood, or metal.

It is clear from these remarks that the material is among the factors that determine a work's final form, but that its importance in this process should not be overestimated. This can also be seen from the fact that beautiful and important art forms often achieve permanence in a material for which they were not originally designed. Despite their strong feeling for genuine materials, Egyptians were surprisingly often willing to use cheap substitutes.

In our treatment of the relationship between materials and works of art we must not be content with the connections that I have discussed up till now, which have to do with the physical form of the works, but must also consider ones which affect only the surface, the skin so to speak, of a work. It sometimes happened that there was only poor-quality stone in the place where a work was to be sited. For example, Amarna alabaster is often blistered and inclined to split. So some of the royal statues hewn in the cliff face next to the boundary stelae had the area of the face from forehead to chin removed, and a horizontal slot was made. In this way a face made of another stone and with an appropriate 'tongue' could be attached, thus making possible finer detail in the execution of the face and perhaps the use of the right colour. We have stone and wooden statue heads of the same period whose necks end in a peg[124] which could be inserted into the collar part of a torso in another type of stone or wood. Similar procedures are found in reliefs and paintings: if the background was a coarse-grained sandstone, for example, spaces were hollowed out for the figures, and these were then filled with pieces of coloured stone or faience. In the sphere of craftsmanship it is worth mentioning that at the beginning of the first millennium B.C. the beams of coffins, which were made of local gnarled

[123] It is no coincidence that a similar form is found in Michelangelo's work, even though the starting-point is quite different: the piece in question is the figure in Leningrad of a crouching boy who is doing something to the toes of his right foot with his hands [in the State Hermitage Museum, Leningrad, cf. e.g. Weinberger 1967 pl. 144 (J.R.B.)]. Here even the head is bent forward, while in Egyptian block statues it stands out vertically from the cube. Cf. Schäfer–Andrae 1942.61, [M fig. 646 (J.R.B.)].
[124] Propyl. 348–9 [Sm pl. 117, W fig. 318–9, M fig. 457, cf. L-H pl. 188 (J.R.B.)].

sycamore wood, were covered with planks of good-quality imported wood (Propyl. 401.3). And already in the New Kingdom boxes were overlaid with thin strips of ebony, on which the inscriptions were cut and the signs then filled with light-coloured paste.

The last few examples included one or two where the quality of the material was no longer the only important point, but colour played a part or was the determining factor. To these I would like to add a Middle Kingdom figurine,[125] where the white loin-cloth and the libation jar, which we should imagine to be made of silver, are made of white wood, while the naked parts of the body are in pale brown wood, so that it was hardly necessary to paint the figure as well. With polished hard stone painting seems to have been restricted to certain areas, although the speckled appearance of granite, for example, destroys to a large extent the plastic form of the eye. Anybody who wants to discover this form may sense the need to feel for it with his hand. Obviously these considerations were disregarded because of the artist's pleasure in the beauty of the stone.

The ebony strips mentioned above belong to a genre that was very important in Egyptian art and craftsmanship, and according to the inscriptions much more important even than the rich mass of preserved materials would suggest—the genre of coloured inlay. One might almost say that there was no suitable material which was not linked with another in this way. Metals were employed together: reddish-yellow bronze, red copper, yellow gold, electrum, white silver, with black niello work between them. Varieties of semi-precious stones and faience were set in wood, and long texts were often composed of individual signs which were made of the rarest materials (Propyl. 463), sometimes covering whole coffins. But semi-precious stones were mostly set in gold. The quality of the craftsmanship in these pieces is astonishing, and the tastefully splendid colours laid out in this way never fail to inspire admiration. Royal treasure, as we know it from the few intact burials preserved, and temple treasure must in times of prosperity have been overpoweringly opulent.

It is worth remarking that it is only in the last centuries B.C. that the pouring of molten glass into facets in the gold replaces the fitting of pre-shaped pieces of inlay. The custom of decorating the signs in inscriptions on royal coffins or on the walls of royal buildings will have led to their being painted blue or green in imitation where the texts were either everyday ones or too long (p. 78).

Just as the material has its influence, so do the *tools*. A stroke of the brush is something different from one with a reed pen. When, about the time of Christ, the Egyptians adopted the reed pen in place of the traditional rush, their script acquired a different character. But it is perhaps true to say that they would not have taken this foreign tool over if they were not already tending to use smaller sign forms. Often it is impossible to say whether the means used had a decisive influence on the form, or the tendency to the form caused the adoption or invention of the means. A type of chair-leg developed in the eighteenth dynasty (fig. 177) is instructive in this respect. In one picture of such a leg[126] the top part is a straight cylinder and the bottom part a flared one, scored with several rings. At first glance one would assume that the form of the bottom half was the result of experiment with the lathe-cutter, yet here we have a case of the invention of a form coming centuries before that of the tool. For

[125] Propyl. 289.3 [W fig. 294 (J.R.B.)].
[126] Propyl. 404.4 [Baker 1966 fig. 196 (J.R.B.)].

a close inspection of older pieces shows that they were not turned but carved. Lathe work first occurs in Egypt in the first millennium B.C.,[127] so that the interpretation, which would seem so obvious, of the form arising from the technical process, is impossible; however, a bundle held together with rope can scarcely have been the direct inspiration.

I shall also pursue the common yet fascinating problem of the relationship between techniques and artistic form, in one aspect of architecture. The Egyptians, like the Babylonians, learnt early how to build vaults out of sloping courses of mud brick without a supporting framework, either in the form of hemispherical domes,[128] or, more often, of barrel-vaults.[129] Of these two forms the dome was never used in large-scale Egyptian architecture. The true barrel-vault, in its form of an arch with voussoirs,[130] was for a long time used in brick building alone. In the course of millennia only one element of arch construction was transposed into stone: the hollowing of an underside in a ceiling. In some cases we find apparently vaulted ceilings of this type which give a magnificent sensation of space, for example in one of the Middle Kingdom nobles' tombs at Asyūt, and in the tomb of Sety I from the New Kingdom. But both these rooms have been cut from the living rock. Free-standing stone vaulted ceilings are only found in buildings of modest proportions, and then they are constructed as so-called 'false vaults'. In other words, as must originally have happened in brick building also (Propyl. 171.1), the upper courses of walls that faced each other must have been built gradually closer together without a supporting framework, until the two touched and supported each other.[131] The stepped underside of the construction was then cut to make a smooth apparent vault. The obvious step of transposing the technique of the vault with voussoirs, which had been learnt in brick or in rough approximately fitting stone, into precisely dressed stone, was not taken in Egypt until the first millennium B.C. [132] It can be seen here that the technique of vaulting performed useful service in brick but could not affect the development of monumental architecture as the 'artistic will' of the people, which derived from other sources, was not readily enough inclined towards it. The 'artistic will' seized instead on the technique of construction with ceiling beams spanning the space, a mode of expression much better suited to it. The Egyptians' technical sense, normally so lively, was held in check by this form, and they did not feel the need to take these solutions over from brick building and to construct wedge-cut vaults in stone until near the end of their history; this development came too late to be fruitful for Egyptian art, but was probably valuable for other peoples.

We shall often in the course of this book have our attention drawn to the great influence of the *content* of a work on the method of representation; we have seen already that not all the innovations in secular works were followed in religious ones;

[127] The earliest representation of a lathe is in the tomb of Petosiris (Lefebvre 1923–4.3 pl. 10).
[128] Junker 1926 pl. 1 [= *Giza* 7 pl. la; cf. also Larsen 1950].
[129] Propyl. 205.2 [cf. generally Clarke–Engelbach 1930.181–91 (J.R.B.)].
[130] Propyl. 278.2 [cf. Clarke–Engelbach 1930 figs. on p.188. For false arches cf. ibid pp. 184–5 (J.R.B.)].
[131] More detailed study is still necessary in order to establish when the true barrel vault first occurs in brick, and when the various possibilities of layering and joining were first exploited. [Cf. nn. 129–31.]
[132] The oldest example known to me of a wedge-cut vault dates from the twenty-sixth dynasty, and comes from Medinet Habu (Choisy 1904.68 [= Hölscher 1954 pl. 16]). The essential point is that the spandrel fillings disappear and the vaulting stones themselves are wedge-shaped.

we also find that servant figures are livelier and show a wider range of movement than those of their masters or other dignitaries. There are many comparable instances.

Again, the purpose of the work has a closely related influence on its form. Thus at Luxor[133] papyrus columns which represent a single three-sided element of the plant become almost entirely independent of the triangular section of the sedge, and the papyrus bundle column does not even separate the stems;[134] the form of the architectural element tends towards a rotundity appropriate to its function, and in the case of plant columns the plastic expression of the plant forms themselves is often limited to the capitals.

The effect on the form of a work of the use to which it will be put is clearest in works intended for manual use, which we normally consider products of craftsmanship. Mirror handles in the favourite shape of a papyrus stem also show the same easily grasped form (Propyl. 414.1). But one should be cautious also with craftsmanship. We should never forget that absolute functionalism, to which form and decoration must be accommodated, is a purely modern ideal. Even if, as is to a large extent the case in Egypt, the demands of the function are often fulfilled involuntarily, they are just as often disregarded out of sheer pleasure in ornament. One should not try to analyze structures created by the Egyptians through the distorting lens of a theory that takes account of the mental unity in the relationships between their parts. If an ivory ointment spoon (Propyl. 407.1) consists of a figure of a boy holding an oval mussel shell the same size as himself upright on his head, and a round handle ending towards the boy in a papyrus umbel, and in the other direction in the head of an ibex, the purist may turn away in horror, but an unprejudiced person will be charmed by its decorative qualities. Or another example: there are mirrors whose handles are made in the shape of a papyrus stem with its umbel (e.g. Propyl. 414.1). But mostly the head of Ḥathor, the goddess of beauty and love 𓊹 is inserted between the umbel and the stem. And if only the umbel of the papyrus remains and the stem is replaced by a figure of a girl holding the umbel on her head, and perhaps attractively raising her arms towards the long drooping rays of the umbel, the thing is rationally nonsensical, yet it is an enchanting example of Egyptian craftsmanship, and has a definite expressive unity. Innumerable further instances could be added.

Such a profusion or exuberance of form is often a manifestation of an innate human tendency to give life to the dead world of things by seeing and making use of similarities in form between natural or manufactured objects and animals or plants: the significance of this impulse for the origins of all representational art should undoubtedly be considered. Leonardo da Vinci, when discussing Botticelli, advises artists in all seriousness to seek inspiration in the play of forms in nature.[135] Similarly Ice Age cave dwellers were inspired to represent animal bodies by irregularities in the rock walls, which could be finished off merely by adding a head and limbs. In Egyptian New Kingdom pictures of tribute human heads have sometimes been placed between the bases, and hands at the tips of the horns of the oxen represented (fig. 22); this decoration arose because the artificially deformed horns brought to mind the upstretched arms of men begging for mercy [cf. now Leclant 1956]. A literary image

[133] Propyl. 321 [L-H pl. 162 (furthest colonnade), W fig. 360 (J.R.B.)].
[134] Propyl. 323 [L-H pl. LIII, 231, Sm pl. 157 (J.R.B.)].
[135] The Leonardo passage is in the *Trattato di Pittura* (Ludwig 1882.1.124 no. 66 para. 2 [= McMahon 1956.1.50 no. 76, 2.35v, cf. also Ludwig 140 no. 181 = McMahon 1.51 no. 77, 2.39v, Pedretti 1964.32, Carta 13 (J.R.B.)] —reference supplied by Hedwig Fechheimer). The pebble resembling a human being, Berlin 19079, is in Scharff (1926.62 pl. 39 [434]) [cf. now Keimer 1940]. In general cf. von Luschan (1913–14).

FIG. 22. Decorated cattle horns. NK

in the Amarna sun hymn, which says of birds flying upwards that they lift their wings in adoration towards the sun,[136] shows us that we have interpreted the horn decoration in a genuinely Egyptian way.

Of particular importance in a discussion of sculpture is an unworked stick-shaped pebble with thigh-like protruberances on its sides which was found beside a robbed Egyptian predynastic tomb, probably originally a grave-good in the tomb; it must have reminded the buriers of a human figure with arms hanging by its side, and have been put into the tomb as a servant figure (p. 38)[137]. The idea of a flower was naturally associated with cups and bowls. From the beginning of the New Kingdom the Egyptians liked to interpret wine cups as lotus flowers. It is probably not chance that the blue type (fig. 11) was the first of the two to be used in this way for pointed chalices, while the hemispherical one was only adopted later. In pictures of people smelling lotuses (cf. p. 41) we only ever see the blue type, which may have had a stronger scent. These images will have reminded people of the aroma of the wine which the chalices contained. It is comprehensible, even if the association is wrong, that the actual chalices are often closer in form to papyrus umbels. Some pottery vessels are made in the shape of men and animals (e.g. Propyl. 197), just as we still speak of the neck and the belly of a pot.

Just as objects in nature are transformed for these purposes, human products can serve to stimulate fantasy. Indeed they became very important for Egyptian art, rather as we involuntarily recognize natural forms in purely ornamental wallpaper patterns. For example, a predynastic potter painted a complete view of a rowing boat in plan on an oval bowl, responding to the similarity in shape between the body of the bowl and that of a boat (fig. 258R) just as humps in stone suggested animals' stomachs to ice-age painters. The practice (cf. p. 138) of interpreting straight-legged chairs and beds as four-footed animals (fig. 66, 119), and the curved legs of stools (fig. 73) as the necks and heads of ducks nibbling at a piece of wood lying on the ground, may also be mentioned here (Schöne[138] first drew my attention to this). But, even when there is no such basis for the idea, heads of ducks and other animals are continually used to decorate the forms of straight or hook-shaped terminations.[139]

We saw on pp. 22 and 55 how supports made of single plant stems or bundles of them led to the creating of stone plant columns.

[136] In e.g. Schäfer 1931a.63–70 [Erman 1923, English ed. 288–91 (J.R.B.)] (Grapow 1924.127).
[137] [Natural objects that have been touched up slightly are treated by Keimer (1940); the piece Schäfer cites is illustrated there pl. 3.4.]
[138] [Director of the Berlin Museums from before Schäfer's arrival to 1905 (J.R.B.).]
[139] A razor from Carthage that goes back to an Egyptian model (Delattre 1899.307) shows how making an end in the form of a duck's head brings further consequences (wings and tail) with it. [On this question in general cf. Hermann 1932.]

There is a very remarkable example of how such an additional interpretation can occur in language before it is reproduced in art. Egyptians called the horizontal sections of a balance its arms,[140] i.e. with a human figure in mind. Accordingly in an Old Kingdom tomb a balance is shown in the form of a woman—the word is feminine in Egyptian as in German—with outstretched arms.[141] Many mythological representations have a basis in the language; even the sun disk of Amenhotpe IV with its many hands bestowing life at the end of its rays goes back to an earlier address to the 'unique, many-armed' sun god, though the idea was not expressed in art before the Amarna period.

All the subjects touched on here—formal inclinations,[142] the influence of material, content, or purpose on the form of a man's artistic productions—may be included in the all-embracing term *style*. It can be used in every one of the contexts just mentioned, but also in a wider and more abstract sense, in order to designate as the meaning of a work of art the way in which all these forces come together in it. Used thus, the word may describe the style of one work, or, more comprehensively, the individuality of all the work of an artist, or a period, or a people. Stylistic purity can contribute to the aesthetic effect of a work (and one's judgement of it), but is not the decisive factor in an estimate of its quality. Although there are varying levels of artistic attainment within any style, there can scarcely be differences in quality between different styles as such. But the word is normally used to describe something of value, if not of the highest order, and always refers to the expression in human creations of an attitude independent of nature. This is also true when one speaks of stone, bronze, or wood styles, as this is only a shorthand way of referring to work in these media. Style is not entirely limited to the realm of art; mathematicians' or engineers' solutions are said to have style. But it is a misuse to apply the word to structures in nature. This would only be permissible with reservations: just as one can only talk about a man's 'style of life' when discussing those areas of it in which he has freedom of choice, to speak of the style of a tree or a mountain range is to imply that it is self-determined, even if all that is really meant is that it would be at home in a man-made work of a given style.

Egyptian style manifests itself chiefly in the simplification of forms. That of other peoples is often very definitely orientated towards the transformation of lines and surfaces for ornamental effect, or towards the heightening of expression in other ways. When this occurs we can see even more clearly than with simplified forms that human formal inclinations are exerting their influence.

In representational art there can be various reasons for departing from the model. Such a departure may show that the forms which an artist has remembered are inadequate for reproduction, however great his technical skill may be. They can be the result of straightforward technical incompetence. But they may be due to unconscious artistic transformation or conscious stylization. Of course it is often very difficult or even impossible to decide in individual cases. It is only possible to speak with certainty of conscious transformation—if it is thought worthwhile to distinguish this—if it can be proved that the same artist was in other cases able to reproduce faithfully. At all

[140] [As is also the case in English (J.R.B.).]
[141] [Now published in Sm pl. 51A.]
[142] [Schäfer's discussion of the usage of the word 'style' is only partly relevant to its use in English (J.R.B.).]

events it is only worthwhile to distinguish between the first two possibilities if the judgement is based on an awareness of the whole context of the time when the work was made, and not merely on an acquaintance with the particular work in question from the point of view of our own time.

As far as I know the best material for testing whether Egyptian artists were often aware that they were nowhere near a simple recording of nature comes from the workshop of the sculptor Thutmose in Amarna. A room containing many plaster and stucco casts of heads, faces, hands, and feet was discovered there. Some of the faces lead one to suspect that they are worked-over masks of living or dead people,[143] for they have characteristics never found in free Egyptian works in the same form. So artists of this period probably understood how to make models which kept still, by using casts of real people.[144] Now if, although they were technically perfectly capable of reproducing them exactly in their finished works, they did not do this but rather simplified their forms, this is surely a proof that, when executing their works, they disregarded minor details of their models. And if these casts were not taken from nature but from sculptor's trial pieces this would only increase their value as evidence. Seeing how an Old Kingdom artist chose to represent a lion, as in pl. 79, in a grandiosely simplified way, while another of the same period attempted to reproduce all the details of the natural model (pl. 81), it is hard to believe that they never became aware that one worked in a different way from the other. It is almost more striking that two sculptors who lived in the Amarna period both stood, as their works show, at the peak of inward and outward poise and technical accomplishment, and one showed the bald head of an official as in pl. 84, while the other showed that of a princess as in pl. 85; the former is smooth, almost like a taut bubble, while the other catches all the bumps and hollows of the head with a wonderfully sensitive eye. Who could imagine that the artists of the lion head of pl. 79 or the official's head of pl. 84 were incompetent? Exactly similar observations can of course be made from a comparison of two-dimensional representations with one another.

All this seems to confirm us in our view that at least a fair number of artists were consciously independent of nature; but it is clear that we should not simply extend a single positive answer, which we had from a certain period, to all the people of those periods, let alone any further. And we can also be certain that every Egyptian artist, even one who stylized, would reject any suggestion that he was not reproducing nature. He might have said that he brought out what was true, or something of the sort.

These questions are distantly related to the problem of how people of one period viewed the art of another. The inscriptions tell us nothing about the point, yet a solution must be attempted. On the west bank of the river at Thebes heavily decorated colossal Ramessid buildings are only a few minutes walk from constructions of the great rulers of the early eighteenth dynasty. There is so great a difference, for example, between the pure and noble forms of Deir el Bahari, with the delicate shadows of the reliefs, and the wall-surfaces of Medinet Habu, which are furrowed by the deep shadows of the sunk reliefs, that the Ramessid rulers cannot possibly have failed to notice the contrast. But we can be certain they did not feel inferior;

[143] Propyl. 353.1 [L-H pl. 190 (bottom), cf. Sm pl. 136 (J.R.B.)].

[144] I asked whether the technique of making plaster casts may not already have been discovered in the Middle Kingdom (Schäfer (1915b.87). It is highly unlikely that maquettes as we know them existed (see. p. 331).

they were no doubt proud: Egyptian art had not yet reached the point of borrowing the manner of an earlier period, as later happened. 'We recognize and marvel at the greatness of what you created, but what we want is quite different, and we believe we can achieve it.' Amenḥotpe IV's artists may well have spoken in similar, if stronger terms when the old and the new generations of artists stood opposed (cf. p. 153).

All the greater works of Egyptian art were of course the result of commissions, not of independent work (p. 37). Thus the choice of the artist itself gave the man commissioning the work some influence on its type and quality. But some pictures in the entrances to tombs from the end of the Old Kingdom show that the part the man commissioning the work played was sometimes considerable—and we must remember that, it they could, Egyptians normally had their tombs constructed while they were still alive. In these pictures we see the tomb-owner sitting with a painter's tools in front of some sort of easel and indicating to the artist in an abbreviated form, i.e. by means of figures of the seasons,[145] the rich life he wants to see in the wall-reliefs.

I shall show in the following paragraphs what we should imagine to have been the effect of art on high-ranking people; but let me first quote Goethe's ever-valid saying: 'Nobody but the artist can advance art. Patrons advance the artist, and that is right and proper; but art itself is not always advanced by this.'

Attempts have been made[146] on the basis of older correct observation to show that a fixed court style and a free popular style existed side by side in Egyptian art. We should not allow ourselves to be led to believe that the terms 'court style' and 'popular style' might appropriately refer to the rank of the artist. [145] They cannot even be accurately applied to the content of representations.[147] They do contain an element of truth, as can be shown by looking at fig. 284, where the lady is drawn in sharply delineated geometric lines, while the servant-girl is shown by means of a supple outline, and from an unusual point of view. Obviously the artist felt that the representation of the lady was more noble. Later in this book (pp. 302–06), we shall study the search of Egyptian draughtsmen for a method of showing a side view of the human shoulder: it might be expected that these attempts would only be carried out on figures of normal people. And indeed the geometric broad-shouldered form was always adhered to for the calmly standing nobles and even for the humblest dead, worthy of respect because they were dead; the use of the tentative side views for these types was only a passing fashion. But certain considerations should not be overlooked: as we shall see, the choice of a side view for the shoulder is largely determined by the position and movement of the arm, and as nobles do not normally move to the same extent as working sailors, peasants, craftsmen, or servants, for the most part their pose is naturally the broad-shouldered one. But if they are represented in action the same attempts to show a side view are seen in their figures while, on the other hand, normal people who are not shown in motion are in exactly the same pos-

[145] [Cf. now Junker 1959.83–92, Barta 1971.]

[146] Spiegelberg 1903.62, Bénédite 1896.481–2 distinguishes between 'art libre et populaire' and 'art canonique et hiératique'.

[147] The fact that Worringer (1907, 1948 ed. p. 24 [= English ed. p. 12 (J.R.B.)]) considered that the Sheikh el-balad (Propyl. 237 [L-H pl. 58–9, Sm pl. 45A]) and the Louvre scribe (Propyl. 239 [L-H pl. 60–1, M fig. 211]) were examples of popular art shows us what sort of misunderstandings they lead to. From the point of view of purpose and of style these two statues belong to the same group as the rigidly composed statue of Re'nefer (Propyl. 235 [L-H pl. 53, 56–7, Sm pl. 31B (J.R.B.)]). Worringer must have been misled by the modern designations of the two statues.

ture as nobles. Anybody who has got to know the East will find that when he tries to picture to himself moderately well-educated inhabitants of the countries, they only appear to him in a few poses that distinguish them from the attitudes of normal life. This is probably also true of all periods and of all people whose lives are governed by custom. The fact that we find Amenhotpe IV represented on his monuments in postures which scarcely any Egyptian king before him dared to adopt[148] is not only the result of a change in artistic form or presentation, but also no doubt reflected the reformer's new habit of informality when showing himself in public.

In older histories the priesthood is normally presented as exercising an inhibiting, dictatorial influence on art. Its influence is still often seriously overestimated, even when such an influence seems at first sight to be as clear as daylight, as in the final stages of Amenhotpe IV's art. But in the last analysis all that is certain in this case is that a politico-religious development happened at the same time as an artistic one. Of course, the clear-cut return to old artistic forms at the end of the period started simultaneously with the same phenomena in religion, and this was because the king had linked art indissolubly with his religious innovations. It should not however be forgotten that Amarna art, with its expressive methods that often verge on caricature (p. 153) must in itself have seemed like a slap in the face to the greater part of the Egyptian people, and probably to many artists. This hypersensitive and delicate art, which threatened to destroy the human greatness of the Egyptian style, must, despite its charms, have called forth a violent counter-reaction, which sent art back more or less to the condition from which it emerged during the reforms. It is hardly surprising that priests, as well as civilians who adhered to the old beliefs, went along with the return to the old forms. But the return would probably have taken place, if not quite so abruptly, without them.

The residual influence of Amarna art, which can be felt for about two hundred years, is an indication worth pondering of how independent art was. Only after that time does the situation appear to change significantly, and the influence of the priesthood to increase here as in the political sphere. But there can scarcely be any question of the priesthood having an inhibiting influence on any art except temple art before the end of the New Kingdom. And priests as such certainly had nothing to do with the formation of Egyptian art in the second and third dynasties. The extent of the priesthood's power as promoters in religious art and architecture can probably best be imagined by a comparison with the position of the Church in the Middle Ages.

It is generally assumed that schools and workshops attached to temples were the places where artists were trained. But there is no evidence for this. We do of course hear of temple workshops, but there is no reason for assuming that artistic creation was closely linked with them. At Amarna the artists' workshops that have been found so far have no external connection with temples—though this does not of course exclude the possibility of temples having their own workshops to cope with their considerable requirements. Further excavations may tell us whether the sculptors lived together in one quarter or separately in various areas.

[148] Though a representation of one of the Mentuhotpe's of the eleventh dynasty (Naville 1910 pl. 11, 18) may be mentioned. However, unlike the Amarna ones, these pictures were not meant to be placed in full view, but were only accessible to a few people, as were the well-known later ones of Ramesses III in the High Gate in Medinet Habu [now published in *MH* 8 (1970) (J.R.B.)].

The other great power in ancient Egypt, the *kingship*, was at least as important as the priesthood in the development of of art. When we wish to imagine the Egyptian king, modern, or even highly medieval, images conjured up by the word are inadequate. The king is not appointed through God's grace, nor is he the descendant of a divine forbear; he holds the throne as the divine bodily son of god.

Always and everywhere (except possibly for artists themselves, who can be carried along by a heroic inner defiance), a certain fullness of life and the carefree enjoyment of it made possible thereby, and a relatively heavy concentration of wealth and power, are prerequisites for the prospering especially of representational art. But in other countries the fulfilment of this condition does not depend so much on the political structure of the whole country; they have experienced flowerings of their art at times of great political unrest—one only needs to think of Italian history. In Egypt, however, a decline in prosperity always occurs when the reins slip from the king's hand and the country is divided into independent parts. And if there emerges a line of rulers who reunite the resources of the country after a period when they have been wastefully dispersed in this way, artistic achievements soon improve in quality again (cf. p. 67). This is not contradicted by the fact that periods at which weakness is beginning, or even periods of dissolution and decay, often produce the first indication of new ideas, which then grow in strength with the recovery that follows.

Thus one can of course consider the formation of truly Egyptian art described above, pp. 9–13, as a product of the event we associate with the name Menes, or the date approximately 2900: the definitive forging of one people and one state out of the previously independent states of Upper and Lower Egypt. Egyptian kings understood early the power of art to propagate their fame and act as a symbol of their stable power—as becomes evident with such shattering force in the Old Kingdom, with its massive concentration of artistic activity around the residence of the court. One can say with confidence that what was produced away from it in the provinces was feeble in comparison with the quality and abundance of works of art in and around the capital.[149] In the New Kingdom when the court had several places of residence, the predominance of a single locality is not so overwhelming in art either.

Apart from the more or less impersonal effect of the kingship it seems sometimes to be possible to discover the individual attitudes of important rulers to the works of art produced during their reigns. The concentration of power in the king makes it unsurprising that his preferences should be visible in his choice and appointment of artists. It is however hard to decide how seriously we should take the statements architects and other artists make in their inscriptions, that they were brought up by the king or received instructions from him. It has been said (Spiegelberg 1903 p. v) and not without reason, that we can use the names of kings like Thutmose, Amenhotpe, and Ramesses as promoters and supporters of certain artistic movements, in more or less the same way as we speak of a Louis XIV style. This is clearest in the case of Amenhotpe IV. It seems as if, shortly after he ascended the throne and before he moved to Amarna, he must have taken a young or unrecognized artist, with whose works he felt a spiritual kinship, into the court, and placed him in a high position. In this way he was able to allow a type of art that had hitherto been over-

[149] Kees (1921) began to make careful studies of late Old Kingdom provincial tomb reliefs and their relationship with those of the capital.

shadowed to develop, and we can observe a rapid transformation, almost like a complete break, whose effect is more striking than if Greek art had jumped from the pediments of the Parthenon to Lysippus in five years. The development, character, and disintegration of Amarna art have come to be understood more and more clearly through the finds of recent decades, and in the future it will gain an almost unique importance in art history as an example of the intervention of a non-artist in artistic development.

To us a very curious manifestation of the kings' personal relationship with art in many periods is the way in which the bodily features of the reigning king, the 'good god', are incorporated as a sort of ideal in portraits of his subjects and of the gods. The most striking example of a renunciation of self-portraiture in favour of an approximation to the image of the king is probably the tomb of Ra'mose, which dates from the reigns of Amenhotpe III and IV. During work on the tomb the stylistic change just mentioned occurred, transforming the method of depicting the human form. On one wall (fig. 23) Ra'mose is shown as a vigorous Egyptian with a powerful body, brachycephalic with a square lower jaw and firm rounded chin, a short thick neck and sturdily proportioned limbs. On the other half (fig. 24) he is equally paunchy, but has a long thin skull, a drooping pointed chin, and long thin neck and arms; all the outlines are mobile in an almost ornamental way. If the two were not ascribed to the same man one would reject the idea that they represented the same Ra'mose and were produced within a few years of one another. The pictures of the kings in the two parts of the wall are just as different from each other, and show us how to explain the contradiction between the pictures of the vizier. This effect of a king's features on those of his subjects is well known to occur in Hellenistic art, perhaps influenced by the Oriental mind. A corresponding relationship between king and god can be seen in the head of a statue of Amun, whose features are unmistakably those of Amenemhat III.[150]

We do not know who the *artists* were who formed Egyptian art in the second and third dynasties, and we would probably not know it even if we had more material from this initial period of the new art, or if we possessed later traditional sources which mentioned it. For scarcely anything is preserved of the old books painters and sculptors must have had, just as other artists and learned men did, and we cannot form any clear picture of what they might have been like. Occasionally it is as if one caught an echo of them, as in a well-known Middle Kingdom inscription, whose obscure sentences read like chapter headings from such a book.[151] No doubt much that was worthless is lost with these ancient art books, but there must have been as much that would be well worth knowing. But even if we had them we would probably find very few artists' names in them. We would perhaps read how the 'ancient writings with the sayings of such-and-such a god were found again'. We know that works of art were mentioned frequently early on in the state annals, but there too without

[150] [*Encyclopédie photographique de l'art, Le Musée du Caire* (n.p.: Editions 'Tel' [1949]) pl. 50. There is a statue of Khonsu with Tut'ankhamun's features in Propyl. 356, L-H pl. 201.]

[151] The Louvre tomb stela C 14, details of which, despite the efforts of many scholars, are still incomprehensible to us [cf. Barta 1970 (J.R.B.)]. It has been suggested that the title of a relevant book may be preserved in a book list in the temple of Edfu (von Bergmann 1879.48, pl. 65 = Brugsch 1871.44) [*E* 3.351.8–9 (J.R.B.)].

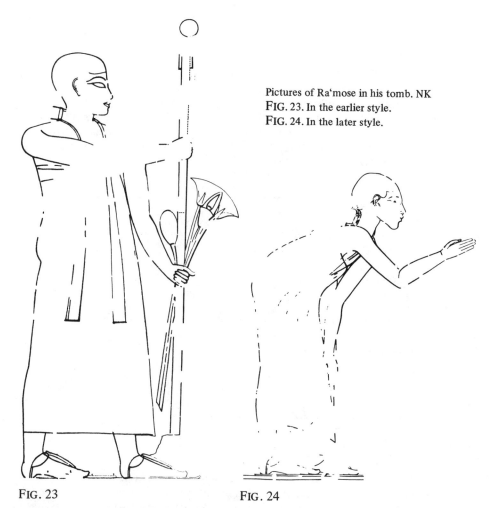

Pictures of Ra'mose in his tomb. NK
FIG. 23. In the earlier style.
FIG. 24. In the later style.

FIG. 23 FIG. 24

the names of the artists.[152] It is none the less worth mentioning in this context that
reliable historical information about Imḥotep,[153] the architect of Djoser's step
pyramid, was still available in the Late Period. It might even be that we have in him
one of the men, if not actually *the* man, who first made architecture in stone into a
medium for artistic expression. Later Egyptians esteemed him as a person of import-
ance in other areas and revered him as a god.

It was not normal to associate works of art with the names of their creators. In
all the history of Egyptian art there are scarcely two dozen works that can be linked

[152] On mentions of works of art in Egyptian annals cf. Sethe 1917, Borchardt 1917.36, note.
[153] Sethe 1902.21 and *passim*. The man's name has now been found in the step pyramid
enclosure (Gunn 1926.190–6 [= Firth–Quibell–Lauer 1935 pl. 58]). [Imḥotep's name is
also written on the surrounding wall of the pyramid enclosure of Sekhemkhet, Djoser's
successor (Goneim 1957 pl. 13).]

with the names of their makers, and by no means all of these are really worthy to be called works of art.[154] The Egyptian 'X made it' does not contain a claim to recognition comparable to that of the ἐποίει of Greek vase paintings; mostly it will only mean something like 'X had it made' or 'was the donor'. It was not because artists thought little of themselves or their art that their names are not given—we know from many inscriptions how proudly they spoke of themselves or their works, and, despite the arrogance of 'scribes', how high they stood in the esteem of society, higher than ancient Greek and Roman masters generally did.[155] The existence of several grades of artists' titles reflects more than a superficial ranking. Even in Amarna a depiction of a sculptor's workshop shows the head of a statue and a chair-leg being worked on simultaneously (fig. 25).

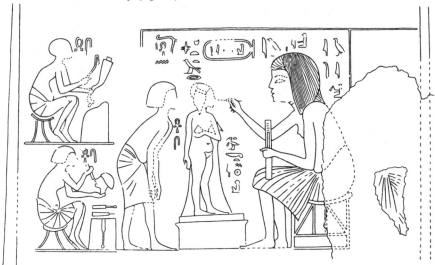

FIG. 25. Sculptor's workshop in Amarna. NK

The Egyptian language does not distinguish artists and craftsmen, as a work of art was for them only a product of craftsmanship, even if a more noble one. 'The Greeks were the first to see in representational art a separate area of human creativity. They gradually selected it from among the host of crafts as a distinct genre, related to literature, and esteemed it as a product of the intellect and not of technique' (Bernhard Schweitzer). Whenever an Egyptian word is translated 'art' it should not be understood on the lines of this Greek attitude, although this latter is definitively present in all art-historical studies.

[154] List Williams Ware (1927). Von Bissing gives a further instance (1929.137). [Junker (1959) contains much material of relevance to the attribution of tombs to particular artists. A case of three tombs 'signed' by the artist's presence among the representations has recently been found by Klaus Baer in Upper Egypt (Hierakonpolis, tomb of Horemkha'uef; el-Kab, tomb 8—owner unknown; el-Kab, tomb of Sebeknakht); this will be published in one of the next numbers of the *Journal of the American Research Centre in Egypt* (personal communication) (J.R.B.).]

[155] [Junker (1959) confirms this statement with regard to the Old Kingdom.]

There were doubtless forceful personalities among Egyptian artists but there were no individualists. We must be careful not to look for the highly charged, almost mystical modern notion of an 'artist' in Egyptian artists and their attitude to their work.

Gradually research will enable us to isolate the 'work' of different artists; but even then we shall have to be content with calling them 'master of ...', as is often the case with the art of other peoples. And there too success has often only come after a long struggle.

Every artist has his own 'handwriting' (p. 42). So the possibility of identifying works by the same master should certainly not be disputed, although there are various peculiarities of Egyptian art which prevent us from raising our expectations too high. But pl. 36, where the complementary halves of a beautiful large inscribed block can definitely be ascribed to two different hands on the basis of certain features of the hieroglyphs, proves that there is no need to abandon all hope [cf. Appendix 5]. In the same way as the proof that two people were at work here is in distinct differences between equivalent elements of the composition, it is reasonable to suppose that one man produced a series of different works if certain elements have the same abnormal form in all of them. On account of its pictorial nature this is as possible with the Egyptian script as it is with actual pictures. Morelli[156] deliberately and not unsucessfully based his attributions on details of minor artistic importance.

The question of where the artists who formed Egyptian art worked is important. But it is clear that we cannot as yet give a definite answer, because so few monuments of the decisive period have so far been recovered, although it may be reasonable to guess that the art that is typical of the Egyptians began in Memphis. It was certainly not in southern Upper Egypt, which was often the starting-point of significant political actions, but was far removed for centuries to come from the basic sources of Egyptian art and culture. A modern traveller who passes through the whole country—not by a fast train—can see quite clearly that it must have been due solely to the power of its rulers that Thebes was able to gain the ascendant and dominate the great northern centres of the nation's activity for half a millennium. Among the main northern towns Memphis, not far from the still problematic Delta, seems to have been much more important as the artistic leader of all Egypt than would appear from the monuments which chance to have been preserved. This leading position is probably reflected in the fact that Ptah, the god of Memphis, for whom the Greeks significantly used the name of their artistic smith god Hephaistos, early became the artist among the gods and the protector of the artists and craftsmen of the whole country, and that his chief priest had the title 'chief overseer of artists'—artists, as was indicated above, in the broad sense that includes craftsmen. It should not be imagined that Memphis's leading position permanently suppressed the individuality of the other main towns of the country. There will have been 'local schools' in the great religious centres, at princes' seats, and at the shifting residences of the king's court, and attempts have been made to identify them.[157] But the evidence that has

[156] [Giovanni Morelli, late nineteenth-century Italian senator and art historian (J.R.B.).]

[157] This was one of Maspero's favourite ideas. On a Tanis school see Daressy 1917b, and, contradicting him, Evers 1929.2. 117 § 727. [Further Kees (1944).] It is becoming clearer all the time that Amarna art originated in Thebes and not in Hermopolis, as Maspero thought. At any rate, the earliest examples found hitherto are from Thebes. Important discussion in Junker 1928, and Demel 1929.

been adduced for them is not convincing, so that it looks as if, at least with the means at our disposal today, it is not possible to prove their existence. The form of the country, with the river as its aorta linking all the important towns (pp. 3, 31–2), together with the high degree of concentration of administrative power in one man, probably never allowed large divergences to develop in high art.

The reader of a history of Egyptian art who has seen its formation, growth, and decay may not pay special attention to the dates given for the periods and be only vaguely aware that he has covered a span of about four thousand years. This is all to the good. For, although he will naturally notice many unusual details in the development, he will not have the impression that there is anything extraordinary about it. Here too we find confirmation that art tends to follow a similar course with all peoples: there is a long beginning period, when one would hesitate to speak of art, and when the products of different peoples still resemble each other strongly. Next comes a period when the works are often extremely attractive, but in the context of the whole development appear only to belong to the preliminary stage before the classical period of maturity. At the end of this archaic period a few generations of important artists, who are lucky enough to have been born at the right time, arrive as if at one jump at a level of attainment that may sometimes later be paralleled, but never excelled. Their works instantly establish the position of their people in the history of art as a whole. Compared with this enormous and, as with all decisive changes in the human spirit, rapidly accomplished step forward, more or less completed in fifty years—one only has to think of Greek culture in the fifth century, the Italian Renaissance, or German literature in the eighteenth century—compared with this step forward everything that comes after seems only to be a leisurely-paced, more thorough penetration of a territory already taken by storm.[158] Each subsequent period probably has new goals in mind and finds its own way to them, and variations which can be as manifold as the dialects of an extensive and highly differentiated linguistic area grow up within an artistic sphere. But the works of the best artists maintain their position beside the best later works, and indeed often continue to act directly as a stimulus when all possible approaches have finally been examined. The creative power of this particular people in this particular era draws to its end, and a nostalgia for the youthful period grows up; salvation is found in a return to the original sources, an imitation of the works of the earliest generations, and people believe that they can create new works in the old forms. In this way life can continue for a long time without coming to a complete halt, but also without reaching great peaks of achievement. The living belief in the artist's own creative power falters; if progressive spirits remain they may perhaps abandon long-obsolescent forms in favour of a compelling outside influence in an attempt at self-preservation; and they may thus continue their activity in a foreign guise. In Egypt this process finishes with Coptic (Egyptian Christian) art, whose formation marks the close of the long struggle between Egyptian and Greek forms.

The Egyptians made their decisive artistic steps at the time of the second and third dynasties, around 2700. So at that time artists must have been at work in Egypt who, as heirs to what their predecessors had done, first created what we call Egyptian art, which found rich expression in the fourth to sixth dynasties. Detailed research must not be allowed to remove the initial impression that something new was created

[158] [On comparable results in the field of biology cf. Schindewolf 1960.]

at that time. Of course such work may easily show many threads leading from the old to the new—after all, the creators of the new style were not simply working from nothing.

More than ever we feel that death is only the other side of life. 'Life is nature's finest invention, and death is the imaginative stroke by which it ensures life's abundance.' Thus we now see life as lasting, even if it is constantly emerging in new forms, and we can see more clearly that it is almost always possible to sense the coming of something new beside the phenomenon of ageing. But this is only true if one looks at life as an all-embracing cyclic pattern. In any area there are obviously periods when representational art, in a spurt of creativity, reveals more of a people's deep characteristics, which alternate with other periods of weakness or of standstill, comparable with the birth, maturity, and decay of any organism. And this is not only because the energies of the people are turned to other artistic genres or are taken up by entirely different tasks. For this reason, and despite objections, I shall continue to speak of the life of an art in images derived from human and plant life [cf. Schäfer 1944].

Normally histories of Egypt are divided into 'Kingdoms' or periods to make them easier to grasp. After the Old Kingdom (up till 2134) there follow: Middle Kingdom (c. 2040–1650); New Kingdom and Third Intermediate Period (1551–c. 700); Late Period (c. 700–300); Graeco-Roman Period (300 B.C.–A.D. 400). Each of these parts was in itself rich with artistic creation. They are separated from each other by periods of decline, if not of collapse. These were the result of attack from outside or of internal disturbances, and can be compared with events in the history of other nations, though here of course they are of an oriental or, more precisely, Egyptian character. Art was harmed but not destroyed by them: only once (p. 153) do we find any sign of artistic questions being seriously argued over.

It has already been shown above that, in general, the phases of Egyptian art correspond closely with those of the state. Both exhibited at all times an astonishing tenacity in rescuing themselves from decay.

It is probably a trait common to all of mankind, although it is especially characteristic of Egyptian art, that every period of advance looks to a greater or lesser extent to the previous one. In this way the continuity of artistic life is maintained despite periods of confusion, and the interruptions do not take on the character of breaks in tradition. It can be said that soon after the new start the earlier period ceases to be necessary as a support. As long as the art itself was still alive each new upsurge extended artists' expressive powers, just as areas are open to an ageing man that are closed to a young one, despite all his driving energy. Above all we have come in the last few decades to see clearly that it is only in the second half of the New Kingdom, more precisely in the period from Amarna to Ramesses III, that the circle of artistic achievement was fully rounded off.

But the driving force begins to be extinguished around the year 1000. There is probably nothing that justifies the comparison between the life of a people and that of an individual as much as the return to the methods used in youth. In itself it is not necessarily an indication of exhaustion; on the contrary, it is often a quickening impulse felt by creative powers that still have a strength of their own. The striving to immerse oneself in the past can lead to a fresh burst of creative energy. The Egyptians returned to their earlier forms, no doubt also confident that they would achieve both

intellectual and emotional purity and freshness by this re-adoption of old forms. But only a few artists found in this return a powerful source of new creative energy.

At this time periods of foreign rule succeed one another, yet until the influx of the Greeks we can find extraordinarily little trace of what the people must have experienced. They succeeded in throwing off the yoke twice, the first time for about 150 years, from 664–525 B.C. under kings called Psammetichus, the princes of Saïs, and again in the fourth century for about fifty years under the two Nectanebos. These periods of political independence were also the parts of the Late Period when most monuments were produced; in addition, the proportion of works of art among them that fail entirely is small, and there are a number of at least technically excellent pieces. The general level of achievement is high and many attractive and finely conceived, even a few really great works were produced, although we do not experience new revelations of the Egyptian mind as strongly as with earlier material. But, even if they became narrow and arrogant, the Egyptians maintained their culture for about a thousand years after the end of the New Kingdom, diligently searching through their past for its treasures, and regarded with a mixture of admiration and astonishment by foreigners, even by the Greeks.

The achievement of the early artists of the second and third dynasties continued to be influential for millennia, and what is more, if we exclude strictly religious art, it was not maintained by values outside the realm of art, but only by its own inherent worth.

3. PAINTING AND RELIEF

There are two-dimensional works by children and primitive peoples which depict human beings and animals without representing surfaces, but rather by indicating the extent of torso and limbs with simple strokes. Palaeolithic caves contain pictures of this sort (fig. 26)[1] , which are often quite strikingly expressive, and modern teachers

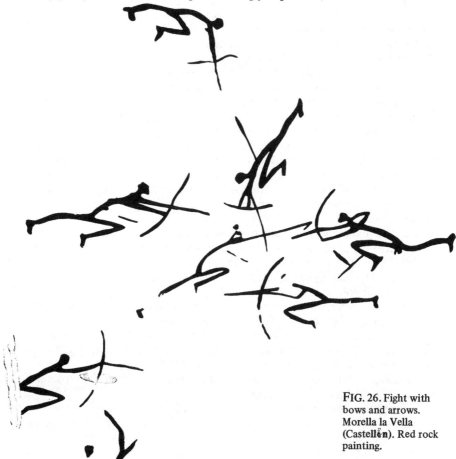

FIG. 26. Fight with bows and arrows. Morella la Vella (Castellón). Red rock painting.

of drawing recommend the procedure to their pupils, probably to exercise their talent for isolating postures and movement. There are enchanting examples of it in

[1] The picture of a fight with bows from Morella la Vella is one of the most impressive examples. [Cf. Kühn 1952.74 pl. 45 = English ed. 74 pl. 34, = fig. 26 here.]

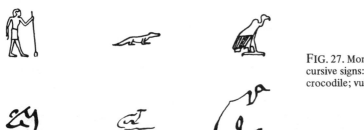

FIG. 27. Monumental and
cursive signs: man with staff;
crocodile; vulture.

Egyptian cursive writing (fig. 27), but in representational art there are no match-
stick figures, only ones exhibiting planes.

We must distinguish two Egyptian methods of showing forms in *non-raised two-
dimensional representations*. One has only coloured areas, which are not enclosed
within lines, while the other delineates the figures without filling them in with
colours. The lines can be on the surface (painted) or incised.

We are so used to purely linear drawing that we feel it to be the obvious method.
But in fact the method of rendering of a physical structure by means of lines only
would not have been especially obvious. Neither our own children nor primitive
people can help us solve the problem of the relative positions of the two methods in
the development of representation. Children have all learnt from adults that lines can
represent physical objects, and contemporary primitive peoples already have a long
cultural history behind them. In this case a search for the historical sequence—so often
decisive in other contexts—is of no help. The oldest pictures in the world, the cave
paintings, already show both planes *and* lines.

It is quite unnecessary to assume that one arose from the other, lines as abbrevi-
ations of the complete surface, or surfaces as a way of filling out figures composed
of lines. Line pictures will originate from a resemblance involuntarily seen between
lines, whether in nature or produced by human play, and some physical structure.
The texture or colour of the area enclosed by the lines may originally have helped
to unite the whole. Pictures using surfaces only may also arise from the discovery
of a meaning in originally meaningless patches of colour. The idea of a physical body
which detaches itself like an opaque surface from a void then suggested itself at once.
Perhaps the sight of shadows was also a stimulus, although it certainly did not lead
to their being traced with a brush.[2]

To attempt to derive the two methods of representation from the senses of touch
and sight (p. 90) greatly over-simplifies the problem.

In Egypt the oldest painted figures we have, red or white-figured pictures on pre-
dynastic pots (fig. 141),[3] and the Hierakonpolis wall painting (fig. 144),[4] show the
use of *surface and lines* next to each other, but pictures using surfaces without
emphasized outlines predominate. There is a group of pots where the outlines of

[2] Pliny, *Natural History* 35.15, recorded the Greek idea that painting (and according to
 35.43 also relief) arose from the tracing of shadows, and modern writers (e.g. Woermann
 1915.1.224) have repeated it when discussing Egyptian art.
[3] Propyl. 198 [W fig. 4–5 (J.R.B.).].
[4] Propyl. 184 [= fig. 144 here; cf. Case–Payne 1962 and W fig. 37–9 (J.R.B.)].

the figures have a curious filling of criss-cross lines.[5] Crude scratched images on other types of pot and on slate palettes [fig. 306] are line pictures.

In later periods line pictures continue to exist alongside pure surface pictures. But mostly they are allied to surface pictures. So pictures are almost always filled-in outlines (pl. 60) or area pictures surrounded by lines, because areas of colour could be given a sure and clear-cut form in this way. For this reason not only paintings but also coloured reliefs are almost always surrounded with red or black lines. Cretan painting has no line round the edges of figures; only Mycenaean painting shows it, perhaps borrowed from Egypt. Pictures of golden jewellery are painted yellow with red for the outline and decoration within the surface area. The blond hair of a few noble ladies is shown in the same way in Old Kingdom tombs. Those people are obviously the first forerunners of the blond blue-eyed group of Libyans who came from the north after the older black-haired brown-eyed element. Broad red lines show the disposition of the hair and seem to give it a slightly red glow, although the red is only the drawing material and not part of the colour of the hair.[6] When human limbs cross part of the body so that their outlines would be invisible against it they are often expressed in white lines instead of black,[7] as also happens in Greek black-figure vase paintings.

In New Kingdom pictures it can occasionally be seen how a drawing of a man's naked body has been finalized first of all and only then has the clothing been placed upon it. So these preliminary lines are only aids to the composition and not what I call on p. 120 'false overlaps'. Wherever we can follow the path of the Egyptian artist's brush we are astonished even in mediocre works by the surety and suppleness of his line (cf. p. 304).

As regards the *colour* of the surfaces of the body, I think the earliest Egyptian paintings are still at a stage where artists are only gradually beginning to give things the colour of their models. But it is possible that we are deducing too much from as yet insufficient material. In the historical period artists strive to give each object its own colour, in which process the Egyptian eye often perceived and evaluated differently from our own.[8] As is well known, the skin colour of men is mostly a reddish brown, and of women a yellow, both of which appear in many gradations of tone. In the New Kingdom for example, the yellow colour of the women approaches a light tone of the male colour by way of a pale red. Egyptian hair is black and naturally long. When gods', kings', and dead people's hair is depicted as blue in paintings one wonders whether this may have a symbolic basis.[9]

In groups where the individual elements that are in fact the same colour obscure one another so that the eye could easily confuse them, as with wrestlers, teams of horses, and especially rows of people, artists do not scruple to paint the figures alternately light and dark (p. 181).

Of course, the colours of pictures are always meant to represent the colours of the objects as seen from close to, and not as they appear modified by aerial perspective, or by the reflection of nearby colours and other such phenomena. We correct factors

[5] Propyl. 198 top [W fig. 4−5 (J.R.B.)] ; see also fig. 290 here.
[6] [This has since been identified as a cap over the hair.]
[7] e.g. Davies 1920 pl. 11a (MK).
[8] [Cf. Brunner-Traut 1956.4−and Schenkel 1962, *Reallexikon für Antike und Christentum* 7.362−73.]
[9] [As Kees suggests (1943. 464 ff.).]

of this type so automatically and unconsciously that there are still people who are unwilling or even refuse to admit of their existence. They may agree, as they have seen pictures from childhood on that show it, that distant hills appear blue, but scarcely that only a few metres of air have a similar effect. Egyptians worked almost solely with even areas of unbroken colour, though they knew how to modulate gradually from one to another in places where the colours do not separate sharply from each other, as with spots on animals' skins. In such cases the transition is sometimes effected by means of hatching or stippling [cf. Brunner-Traut 1956.4]. Between the upper edge of a picture or the sky and the lower edge or the ground the figures are mostly set against a white background. White is the colour against which forms are most clearly distinguished. When other colours are used in its place it must be assumed this is for reasons of taste, not because of differing models in nature. This applies especially to a very attractive blue-grey that was popular at some periods, and is excellently suited to act as a mediator for vivid colours without associating them one with another. The browny-yellow background of many New Kingdom pictures has a similar effect; it reminds one strangely of the predynastic wall painting in Hierakonpolis. I think it is mistaken to take these two colours to be a bluish air colour and the yellow of the desert. It is shown on p. 244 that not all kinds of background should be thought of as a coloured representation of space.

It has frequently been remarked that Egyptian art does not of course pay any attention to cast *shadows*, but nor does it to the shadows within a body. This is true for the most part. But in the nineteenth dynasty[10] one side of an arm, the hollow of the neck, the skin, the cheek, or the side of the nose is sometimes given a deeper skin tone than the rest. These variations in tone, which are not distributed as if they were the result of a single light source, are not intended to indicate rounding of the features or the actual shadow, but rather the warmer tone that colours have in the shade [cf. Smith 1946.263, 1958.145].

The only places where shadows are to be found in Egyptian painting are the natural folds of clothing in New Kingdom pictures (pl. 44). At first their colour is a fine grey, while later yellowy-green appears.[11] Earlier art does not show such folds either in painting or in relief, only the artificial close pleats used decoratively in many garments (pl. 51). In the Middle Kingdom it was fashionable to render the sharp-edged creases, which are produced by clothes lying in a large pile, as lines,[12] as if to show that the owner could always dip into a full chest of garments (fig. 28). When pleated clothes fall close to the red-brown body the surface is coloured a soft pale red by spreading

FIG. 28. Garment with creases caused by keeping it folded. [MK]

[10] Cf. Davies 1927.18, 43 n. 4. Davies thought that the idea might have been suggested to artists by the painting out of reliefs.

[11] Cf. Davies 1927.8, 45. Pieper refers me to Bulle (1912.627) for the fact that shadows first occur in Greek painting in the folds of clothing. In Egyptian pictures folds in clothing can easily be confused with the streaks of oil that has dripped out of the hair.

[12] These are also found in statues, e.g. Borchardt 1911-36. 2.32, 2.40, nos. 427, 475. As is well known, creases are also rendered in Greek art, e.g. on the Pergamon altar.

FIG. 29. Peasant with thick body hair. [NK]

white thinly over it; it is left thus for the recesses in the pleats, which lie against the skin, while their peaks have additional layers of white (pl. 59). So light and shade are not represented here, only degrees of translucency.

As is well known the Egyptians are not alone in their reluctance to paint shadows. Medieval and, still more, Far Eastern painting avoids them entirely, or softens them as much as possible. As they are changing all the time shadows are felt to be accidental and off-putting; and heavy ones would deface an otherwise harmonious picture.[13]

The black hatchings on certain parts of the bodies of comically represented peasants in New Kingdom paintings (fig. 29) do not indicate shadows but hair, however anatomically unsound their distribution may be. It must remain doubtful whether in painting of the same period, a black line in the cleft of the mouth and in the nostril is meant to indicate the deep shadow or just the cavity (Davies 1927.18).

When shadows were incorporated into painting by the Greeks in the last generation of the fifth century and were added to linear perspective, the new mode of expression had such a strong impact that σκιαγραφία 'shadow painting', became a term for perspective as a whole (cf. p. 272).

In order to avoid misconceptions it may not be superfluous to say that Egyptians of course never exploited the effects inherent in colours, so that many surfaces painted in a particular colour seem to us to press forward into the foreground, while others recede from it. 'Colour perspective' of this sort could only be consciously used in the context of normal perspective.

If pictures consisting of painted surfaces have their origin in the feeling that physical objects are opaque, *raised two-dimensional* representations, i.e. true reliefs, of course make immediate reference to this fact, simply because they come forward out of the surface.

Nowadays we are used to considering reliefs as a genre of their own between painting and sculpture, and there is good reason for this. But we can still see today from the fact that even the highest relief is accommodated between the original surface of a block and its own base level, just as in a painting the frontmost part and the painted surface are the same, that the origin of relief is very close to that of drawing and painting. In fact both have in common that they belong to two-dimensional as opposed to three-dimensional representation. In all pre-Greek art, and this applies entirely to Egyptian art, the same rules for the rendering of nature govern both.

[13] There is a definite report of such attitudes in Hoskins (1835.52).

Since the Egyptians always painted two- or three-dimensional works, with the exception perhaps of a number of works in granite and other hard stones, they did have painting without relief, but never, apart from these exceptions, relief without painting. The enormous number of reliefs we can now see in Egypt or in collections were or were meant all to be painted. In this interpenetration of genres reliefs had the added attraction of unbroken colouring, and paintings gained something they otherwise lacked through the modelling of the relief; if not three-dimensionality, at least a reflection of the movement of the surface of a physical object.[14] Natural shadows were seen here just as in sculpture, where they are one of the artist's more important means of expression, perhaps without his realizing it.

In this book, for the sake of convenience, I frequently group Egyptian painting and relief work together under the heading of two-dimensional art or drawing. But it should not be forgotten that the observation which has been made, that Egyptian reliefs are only a way of making painting durable, is a superficial one. There are two considerations which contribute to the formation of this view: a predominant concern with the element that is common to both forms, i.e. painting, which for reasons just mentioned is most universally used; and the habit of publications, which are orientated chiefly towards the content of the works, of reproducing reliefs in line drawings in which the modelling of the surface is at most indicated by a few inadequate hatchings. Of course, one's eye for true relief is not exactly sharpened by continual use of this sort of picture. Line drawings, despite their usefulness, can be just as harmful as the ones of Greek sculpture that were normal until Meisenbach's invention of a method of printing photographs in books (half-tone printing). Just as modern drawings of this sort do, eighteenth dynasty paintings already occasionally show one or two muscles by the use of lines within the main outlines. But the only cases I know of this phenomenon are in crippled dwarf divinities who are also often shown in sculpture with heavy muscular protuberances.[15]

If reliefs were only paintings made durable it would be impossible to understand why the interior surfaces of the figures should not be entirely flat. But as good Egyptian reliefs intentionally create a play of light and shade by means of restrained but clear movement of the surface (pl. 14), in other words they produce what is avoided in painting, it is obvious that despite its near-flatness relief does not have the same effect as painting. None the less the greater durability of relief will of course have been a quality that contributed to its being preferred to painting.

A relief from Deir el Baḥari in Berlin shows several figures from the crew of a ship. Among the beautiful figures of the men one only is painted. It has been deduced from this that he was meant to be in the background; but the Egyptians would not have thought of using the distinction between relief and painting in this way; we can be certain all that happened was that part of the composition was felt to look empty and the figure was added as an afterthought.

As I said above, Egyptian relief never has very much depth. Reliefs that tend at first glance to be called high relief are not true relief at all; they are figures which look at the viewer from inside niches (pl. 31), and whose frontmost points do not come forward beyond the block surface (e.g. Berlin 7781). These sunk *half-statues*

[14] Borchardt *et al.* (1913.4-5). Kreitmaier (1914.49) makes similar observations about Beuron reliefs.

[15] One example Naville 1886.1 pl. 39.

never look sideways, as they would if they were Egyptian reliefs (p. 217). By use of this process the material for the figure was found and time and effort were saved by leaving the remaining pictorial surface untouched. It is confusing to call rather thicker Egyptian reliefs, which are equivalent to other ones in all respects, high reliefs: the term should be reserved for the genre in Greek and later art for which we are accustomed to using it. I doubt very much if even the most massive Egyptian relief is raised more than a few centimetres from its background. It is not common for the thickness of the relief to vary from figure to figure in the same composition.[16] None the less, in the predynastic slate relief of pl. 5 the figures round the edges are somewhat thicker than those in the middle, and in the Old and Middle Kingdoms the chief person in a relief is sometimes emphasized by the depth of the relief as well as by size.

There are local and temporal variations in the course of the Old Kingdom. Thus the third dynasty reliefs in the step pyramid enclosure are only slightly raised, while the Meidum ones from the transitional period between the third and fourth dynasties are almost a finger's breadth deep (pl. 16), and late fifth dynasty work at Saqqara is often almost paper thin (pl. 23). In later centuries there are further fluctuations. In the Roman Period although the reliefs are not especially deep most of them have a more 'swollen' appearance. But in general fine relief triumphs again and again, especially in the best works of the earlier periods. So we may say that it is the most complete expression of Egyptian formal inclinations in two-dimensional represent-ation. As other 'pre-Greek' reliefs tend to be more or less flat and only moderately raised, it might be suspected that this flatness was the result of the representational method which, as we shall see, lays figures and their parts out over a flat surface. But this conclusion would be hasty. For there are also pre-Greek works like the Babylonian ones I have mentioned which are heavily rounded yet still obey the same basic rules as the shallower ones. This juxtaposition can probably only be understood as the consequence of the different plastic sensibilities of different periods, peoples, and individuals. Evidence of various kinds can be adduced to show that the Egyptians' plastic sense was not strong. An example I think convincing is how they saw the sign of life ☥ in the protuberant shape of a libation vase ⧗ and (fig. 30) thus, full of pleasure at giving graphic expression to the relationship between the ideas of water and life, they created new types of libation vase which were called *'ankh* like the sign of life itself. It is worth remembering that the half-statues discussed above ex-isted side by side with reliefs without ever influencing their style, for they could have influenced it if circumstances had been different: in other words it is not just chance that this did not happen.

In immense numbers of Egyptian reliefs the surface of the figures is even, and the edges are vertical with only a slight rounding (fig. 31 a 3).[17] In other works, however, the surface rises gently from the background (fig. 31 a 4). Both types are already found in archaic slate palettes: the distinction is the same as has been noticed in the Near East between Babylonian (fig. 31 a 4) and Assyrian (fig. 31 a 3) reliefs (Koldewey 1903.20).

[16] Wreszinski (1927.47). On pl. 4 too the figures at the edges are somewhat higher than those in the middle.

[17] The same treatment is also found in much 'pre-Greek' art, e.g. pre-Columbian American.

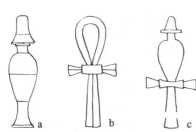

FIG. 30 a. Libation vase. b. Sign of life
c. 'Life vase'. NK

Pieces whose decoration was left unfinished in Antiquity allow us to follow the
process by which true reliefs were produced: first of all the future outlines of the
figure, of which a preparatory drawing was made in red, sometimes even preceded by
a rough sketch in yellow,[18] and neatly worked over in black, were lightly scored in
with a chisel (pl. 78). Then, avoiding for the moment the inner edge of this furrow,
the whole surface of the stone apart from the figures was removed (fig. 31 a 1—2);
then the edges of the figures were rounded (fig. 31 a 3—4) and their surfaces modelled.
The highest points were more or less on a level with the block surface that had dis-
appeared. Figures in reliefs sometimes have different stepped levels within them
(fig. 31 d 1) showing which parts are in front and which behind. But the two parts
are very often at the same height and one is set off from the other by a sunk line
that is rounded on one side only (fig. 31 d 2).

Relief was preferred to painting for all monumental purposes. The appearance
to the contrary in the rock tombs of many areas is due to the stone's being flaky
and unsuitable for reliefs, while the wall coating necessary in these places was a spur
to painting and encouraged the production of masterpieces.

Apart from smooth painted surfaces and raised relief the Egyptians evolved a third
type, *sunk relief* (pl. 24) [also called incised relief] ,[19] where the body of the relief
does not stand out but—in this respect similarly to the sunk half-statues—is as it were
pushed back behind the block surface that is visible between the figures. This forward
movement of the surface forces one to the conclusion that both here and in all other
two-dimensional pictures the surface should not be understood as representing space.

In the production of sunk relief the whole of the surface of the block apart from
the figures is left untouched. The outlines of the figures are cut vertically, or in care-
less work obliquely with sides in the form of a funnel, into the block. Then the
modelling continues, carefully avoiding the vertical or sloping sides (fig. 31 b 1, c 1),
and a raised relief is gradually completed between them (fig. 31 b 2). Its highest points
are often behind the surface of the block, but more normally roughly on a level with
it. So, when in the New Kingdom the general tendency to exploit the effects of
shadow grew, the modelling within sunk relief was able to become more pronounced.

It is obvious that this type of relief—previously known as *relief en creux*—has a
completely different intellectual background from true relief, and it is so unusual
that one is inclined to search for a precise origin for it. In one of the Meidum tombs
from the turn of the third to fourth dynasties the owner boasts that he 'made his . . .
with painting that could not be washed away'.[20] And the inscriptions and pictures of

[18] On initial sketches in unobtrusive yellow cf. Daressy 1901.29, no. 25144 and Davies
1903-8.3.28. First dynasty preliminary drawing for a relief Petrie 1900a.26, pl. 30.
[An addition to this note, which was stuck into the copy, is lost. But cf. Brunner-Traut
1956.3 n. 3.][Cf. also Ransom Williams 1932.5—6, Smith 1946.246 (J.R.B.).]
[19] [Nims 1965.13 (J.R.B.).]
[20] Published in Petrie 1892 pl. 24; in the text p. 39 the word left untranslated is rendered
'his gods', which Spiegelberg (1930a.119) explained on the basis of what is said here on

FIG. 31 a. Carving of a raised relief;
b. Carving of a sunk relief with vertical incisions;
c. Carving of a sunk relief with sloping incisions;
d. Raised relief with two layers and one layer.

his tombs are in fact made by cutting away a vertical-sided area in the stone for each colour and filling it with a coloured paste up to the level of the block face. Great trouble was taken to provide something for the paste to grip against by subdividing the larger areas into small squares with small divisions in between, half the depth of the whole, that were to be covered up, and by use of tiny sticks set at an angle into the ground of the colour recesses. It was all in vain, today most of the paste has fallen out again, and the work is in much the same state as it was before it was filled. When I first saw these depressions with their sharp contours I could not help thinking of sunk reliefs. If—and it is questionable—an artist was inspired to create a new art form by the sight of depressions of this sort, this would be one of the frequent cases in the history of art, where what was intended as an intermediate stage in the production of a work became a finished art form in itself.[21] The rustication on walls and columns in Roman and Renaissance architecture is another example of this, just as the empty eye-holes of Greek metal statues that had lost their inlays led later sculptors to use such cavities for their own effect—a process which would be a still closer parallel to the Egyptian one.

It seems that at first the Egyptians only used sunk relief for hieroglyphs: until the fourth dynasty[22] the signs were, true to their pictorial nature, raised in the same way as pictures, and true raised relief was still considered preferable in later periods. Only when experiments with the script had accustomed people to see artistic value in sunk relief were the larger areas of human and other figures sunk and the base

pp. 56–7; this seems highly dubious to me. The statue of Ḥemiunu in Hildesheim also has signs filled with coloured paste (cf. *Giza* 1.155 pl. 23). There are also later reliefs of a similar type, only the coloured paste is replaced by hard materials. (Examples Berlin 7954, 7955, etc. in faience; Berlin 17540, 17800, etc. in stone.) Inlay work in ancient Babylonia Propyl. 476.2, 482-5 [476.2 cf. H-S pl. 74-5, 482-5 cf. Fr pl. 36-8, H-S pl. 72, 78, X-XI (J.R.B.)].

[21] There is another case in Egyptian art where a comparable process did not occur: Egyptian sculptors created the bust form, that is, a head with the top half of the chest or part of it, for the teaching pieces they kept in their workshops (Propyl. 350 [L-H pl. XXX, W pl. III, M pl. 103], 351 [W fig. 424, TP p. 113], 448.1 [W fig. 669], 448.2 [W fig. 670 (J.R.B.)]); but this form scarcely left the workshop in Egypt, only occasionally producing independent works of art. The Egyptians probably felt it to be incomplete.

[22] The oldest examples known to me are the inscriptions and small figures on the sides of the thrones of royal statues (Re'kha'et [Khephren] fragment in Hildesheim; Menkaure' [A.S. 1922.27]), and those on stone sarcophagi of the fourth dynasty, where the figure of a jackal is quite clearly a hieroglyph emphasized by its size. Green or blue painting of the depressions will have been suggested by faience inlays, and these latter by ones in semi-precious stones. [Cf. Smith 1946 pl. 46a (time of Re'kha'ef [Khephren]).]

level of the recess brought to life by the use of relief.[23] When they did not have living colours like true reliefs the bases were painted with an even colour like green or blue so that one should be reminded of malachite or lapis lazuli. In works of hard smooth dark-coloured stone like basalt artists understood how to achieve superb effects without the use of paint, by exploring the contrast between the dark shiny surface and the paler finely grained sunk areas (pl. 66), just as in predynastic rock drawings the surface of the stone, which has mostly been weathered smooth and dark, is struck away without cutting at all deep in order to produce the distinction between pale and dark. If it did not seem certain that sunk relief was first used for writing and not for larger figures of animals or human beings it could be thought to be a deeper version of the roughening of rock faces. It can in any case be called an invention, thus making clear that it remained unique to Egypt. Only in ancient China was there anything remotely similar, but it was not the same at all. There the contrast between the pale grey of the pounded background and the smooth black of the figures, or vice versa, is more one of colour, as in rock drawings, than of high and low and light and shade, as in sunk relief.

Where the outlines of figures basically shown in sunk relief (pl. 37) intersect and overlap, everything which is at base level is made into true relief by the removal of the surrounding area of stone. The battle relief reproduced in pl. 55 is worthy of note; when the action moves in front of the fortification, i.e. to the left of the dividing line (emphasized at a on the plate) the whole changes from sunk to true relief. This seemingly complex process all occurs naturally without over-subtlety, especially where the colours are still preserved to guide the eye.

Sunk relief suggested itself when rapid work was desired, and for this reason it was used almost to excess in the hasty creations of Amarna art and in the giant structures of the later New Kingdom, especially from the time of Ramesses II on. But it was not only for reasons of expediency that it was widely used. It was favoured in particular where dazzling sunlight or semi-darkness might drown the normally softer outlines of true relief, while the harsher outlines of sunk work remained visible. If the rendering of nature alone is considered, there will be a tendency to condemn the ambiguous and strangely exciting play of light and shade which surrounds the figure; the effect is most confusing when only small islands of the block surface are preserved amid the sunken figures. But great mastery in the use of this technique was acquired in the New Kingdom, and it could almost be said that it was only then that its artistic possibilities were realized. Its peculiarities were particularly suited to the spirit of the age, which began in its second half to be more receptive than earlier periods to the striking effects of shadow in other sculptural contexts too; one of the peculiarities of the New Kingdom style is the heavy shadow of the wall of the depression nearer to the light source, as against the brightness of the other one, which is affected at base level by the shadow of the relief modelling. Whenever it is possible to distinguish in two- and three-dimensional art between works whose effect is almost solely based on the forms themselves, and others which take more account of the effects of shadow, it is found that works of the second type abound most in Amarna art and its descendants. Some magnificent New Kingdom works (pl. 45, 48, 52) owe a large part of their

[23] Nelson (1931.42) says quite correctly that a line drawing could never do justice to the effect produced by the relief in pl. 57 'for the life of the piece rests largely on the boldness of the carving, on the plastic elements'.

attraction to the careful, delicate exploitation of the possibilities which, as artists knew, were present in the many shadows that occur in sunk relief that contains an admixture of true relief.

Among Egyptian two-dimensional artistic techniques it would be most plausible to assume that sunk relief attempted to make painting permanent, as its depressions preserve the painted figures in quite a different way from simple painting or true relief, both of which leave their images open to any attack.

Sunk relief expresses most clearly what basically governs all the Egyptian techniques of two-dimensional representation I have discussed, whether it be painting or relief: the dominating position of the outline which surrounds every figure and exceeds the treatment of the inner areas in importance.[24] There is scarcely any other art where everything else is so much subject to the all-important outline. The same can be said of sculpture.

[24] Klinger's exposition (n.d. [1919] 30-1, 1907.37-9) of the power of pure outline to express rhythm and movement, and therefore action, may need some correction on points of fact, but is otherwise admirable.

4. BASIC PRINCIPLES OF THE RENDERING OF NATURE IN TWO DIMENSIONS

Heinrich Wölfflin

Seeing has a history of its own and the discovery of
historically differentiated visual levels must be
considered the most basic task of the art historian.
Kunstgeschichtliche Grundbegriffe (1915)

I would regret it very much if art historians and
psychologists of art had always to be different people.
The result would be the removal of the backbone from
art-historical studies. *Gedanken zur Kunstgeschichte* ([3]1941)

4.1 Introduction

Normally the difference between ancient Egyptian art and our own strikes us more
and in a more clearly definable way in two-dimensional works. This is because the
two employ different methods of depicting on a flat surface things that are in reality
distributed in depth.

Our eyes receive a picture of the world that is essentially different from the idea
we have of the physical reality of things. Quite apart from the effect of the air between
us and them, which we call aerial perspective, the displacement of every line produces
many optical illusions, which a child only gradually learns to compensate for on the
basis of all kinds of experiences, and with the help of the non-ocular means at his
disposal—until the moment when these illusions become his guides. These appearances
which present themselves to the eye and the method modern art uses to reproduce
them are what we call linear perspective. This is the only type of perspective that will
be taken into consideration here. It would be merely superfluous and confusing to
expound in full the laws by which we produce the impression of depth through the
use of perspective on a flat surface. I will confine myself to drawing attention to the
points that are important for a comparison with the Egyptian rendering of nature;
the formulation of the propositions themselves has been tailored to this purpose. The
following statements are valid, not only for the relationships of several bodies to one
another, but also for parts of one and the same body:

1. Almost all objects are opaque. Therefore nearer ones obscure further ones, in so far as both
are in a straight line from the eye.
2. With things in or on a horizontal plane, the more distant they are the higher they appear, and
the more the eye must be raised in relation to them.
3. Objects that are further away appear shorter, narrower, and less deep than nearer objects of
the same dimensions.
4. Lines and planes appear with a few exceptions to be in some way displaced towards one another.

Our seeing is thus based on the structure of the human eye, since the seen form of
things, the impression they produce on the retina itself, changes in shape as the position
of the body changes in relation to them, according to fixed mathematical laws which
are independent of the will of any individual. So one cannot strictly speak of optical
illusions—as Goethe remarks: 'our judgement, not our senses, deceives us.' No healthy
man has ever seen the world in any other way. So if there are variations in the visual

form by means of which the outside world is rendered in art, these can only be the result of processes occurring in the brain behind the organs of sight. Only in this sense can we speak of a history of seeing.

It seems entirely obvious to most of us that we must render the perspective aspects of our visual impressions if we want to represent the outside world. We shall probably adjust to the fact that primitive peoples, adults among ourselves who have not been taught to draw, and all our own children up to a certain age do not do this, by feeling superior. We can hardly comprehend that a highly developed art could have got by without allowing more than occasionally for all those countless foreshortenings and displacements of lines. But these adjustments, as has been increasingly confirmed, remain unexploited not only by Egyptians and the other cultured races of the ancient Near East, but also by every 'pre-Greek' people or individual—that is, as I stated in the Preface, by everybody who has not been directly or indirectly touched by what the Greeks created under the name of perspective from the beginning of the fifth century B.C. Thus earlier Greek art also comes in the same category; I shall discuss the latter at length below (Chapter 5.2).

Since they began to be aware of the problem scholars have persistently sought the reason why 'pre-Greek' man does not follow the dictates of his eyes when drawing. It is of the greatest importance to find the answer to this question, because it is absolutely fundamental to an analysis of the rendering of nature.

As Hermann Stehr[1] put it, 'we look at the world with the help of objects', and the artist in particular derives his most important motifs from the visible world.

We have to decide between two possibilities. One is to assume that men who do not use foreshortenings in their drawings never became aware that, for example, objects appear smaller when further away than when close at hand. This, if it could be proved, would be the simplest possible answer to the question. But if this reasoning is taken a stage further it becomes clear that this solution could not be final. How could it be possible that visual impressions, which the eye after all constantly receives, should not penetrate into a man's brain sufficiently to be reproduced in drawing?

The other possibility is that men have always been conscious of the phenomena of perspective at all periods, but for some reason they have not at all periods made use of this awareness in their drawing.

It is easy to show that this second answer to the problem is the only one possible. For example, every primitive marksman uses his knowledge that an object in the distance seems smaller than one near by. No arrow or spear would reach its target if he did not take this into account. Without any hesitation at all he raises the trajectory of his arrow or spear in order to achieve the distance of the target, even if he is never aware that he is doing it, or why he does it. It may be said that the sense that prompts him to do it is in his hand, although it is quite obvious that, together with other indications of distance, the apparent size of the target is the chief factor determining his action. Yet if the same man were to take up a drawing implement instead of his weapon, his drawing would contain no foreshortenings to indicate distance. It is somewhat over-ingenious to say that he does not see the objects as small but as distant (von Uexküll 1928.26).

[1] [Hermann Stehr (1864–1940), German novelist (J.R.B.).]

I myself do not know of any saying of a primitive people which might indicate that the phenomenon so often unconsciously exploited was also realized on a conscious plane—though such sayings may in fact be recorded. But by a happy chance we possess an invaluable piece of written evidence from a period and context which nobody had yet thought of exploiting in representational art the fact that objects appear smaller the more distant they are. It is curious that it was so long before the relevance of this passage was noticed.

There have been preserved extensive fragments of a Babylonian poem in which Etana, the father of a future king of the world, attempts to bring a magic plant back from Heaven.[2] Two large sections tell how an eagle carries him up, first to the 'heaven of the god Anu', and then, as he does not find the plant there, higher, to the 'throne of the goddess Ištar'. In both parts of the flight the eagle tells Etana to look down three times, each time after a league's ascent.[3] *Each time the world appears smaller.* Thus, after the first league the land mass and the ocean surrounding it are like an island in a river; the next time like a garden with a ditch round it; then in succession like a hut in a courtyard and a roll on a plate—and finally they disappear completely. Then the hero becomes terrified, and while still far from his goal he falls back to earth with the eagle.

In order to give the correct weight to this piece of evidence, which compares the apparent sizes of land and sea with objects that are in reality infinitely smaller, one must bear in mind that we are not reading the observation of a single mind, which might never have been passed on, but a passage from a recorded work of literature which must have been read and heard by many people.

What is more, there is a special value in the poetic nature of the text and in the legendary character of the action. For it demonstrates very convincingly how accustomed the poet must have been to objects appearing smaller as they move away, if he used this observation, which must have come to him in real life from looking down from towers or mountains, to lend verisimilitude to an account of an occurrence outside human experience. And what the poet grasped consciously and gave to the reader and the listener will have been at least as familiar to many artists, who were after all constantly observing the visible world.[4] But representations of the flight to heaven on Babylonian cylinder-seals take no account of the facts referred to in the poem, and show no aerial views. The procedure is the reverse, and men and dogs raise their heads to look at the curious flying man, a motif also used in the Vatican statue of Ganymede after Leochares.

The oldest manuscript in which this particular part of the poem is preserved comes from the library of the Assyrian king Aššurbanipal (660–627 B.C.) in Nineveh. There is a fragment of the same composition from the period of King Hammurapi (about 1750 B.C.), but it does not treat of the flight to heaven, so we cannot say if it contained the dwindling of the world. But even if the passage was different in that version the tablet from the Aššurbanipal library is sufficient for our purposes. For in

[2] [For the text of Etana's flight to heaven cf. Appendix 1. Schäfer's rendering of the transformations in the earth's appearance differs from that given there, as he was using an earlier translation (J.R.B.).]

[3] [In fact a *bēru*, a double-hour's march, a Mesopotamian measure of distance (J.R.B.).]

[4] Lidzbarski (1892 and 1893) showed that the Etana passage influenced a description in the Greek Alexander novel (Pseudo-Callisthenes 2.41) [= Recension Γ, Engelmann 1963 (J.R.B.)].

the seventh century B.C. no similar observation had ever been exploited in representational art whether from Mesopotamia or the Nile valley, China or Greece. As the Nineveh tablet is a library copy it is obvious that the original will be still older.

From Hebrew literature the words of a prophet from around 540 B.C. are just early enough to be usable as evidence here. There it is said of Jehovah who sits high on his throne and gazes down: 'it is he that sitteth on the circle of the earth, and the inhabitants thereof are as grasshoppers' [Isaiah 40:22 (Revised Version)]. These minute creatures are not only an image of teeming numbers, but also and primarily of smallness.[5] Smallness must also be referred to in Numbers 13:33; here Joshua's messengers from Palestine report that they seemed to themselves to be like grasshoppers in comparison with the giants of the land. Lastly, in about 500 B.C., roughly contemporary with the Isaiah passage, Confucius is supposed to have said at the top of the 'Gate of Heaven' on Mount T'ai, the holy mountain of China, which had an ascent of 6000 steps: 'how small the world is when you look down at it from above'.[6] All these three quotations are worth attention in the context of our inquiry. The Etana story shows that there is no need to ascribe the reflection of the Chinese sage to a later tradition, or to declare that the Numbers passage is in fact quite late. It is possible that older genuine observations were given a literary form in the two Old Testament passages, as perhaps in Etana.

At all events these sayings provide the proof that a certain type of perspective reduction was noticed and observed with attention among several peoples at a period when nobody had yet used it in art. As so often happens (cf. pp. 196–7), literary language was far ahead of representational art, which is restricted by its materials. The occasional conscious observation of reductions at great distances appears to be helped if the path between the eye and the object looked at is free of things of known size, which could provide a progressive scale.

No. 1 of the list on pp. 86–8 shows a *horizontal* line of vision. Nos. 2 and 3 are cases of a *rising* line to the top of a tower. In no. 4 one is looking *along* a path. But the best examples, like the ones just dealt with, are of looking *down*, only one must assume that the Palestinian giants were the height of towers, not merely abnormally high for humans.

Our task has become no easier. Now that the question is why one should not when drawing take into account something one knows, the necessity of investigating it increases. What goes on behind the eye when it receives those countless foreshortened images?

Lepsius represented the situation as follows (1871.7): when a beginner at drawing confronts living nature for the first time and attempts to reproduce it in two dimensions, he is at first confused by the endless multiplicity of interwoven outlines. In order to simplify them and to master them for reproduction he turns his attention to individual objects and attempts to render everything in its most recognizable and characteristic position. This description, which we may take as exemplifying older views, does not analyze the mental processes quite correctly. First of all we can see in it, if not in as many words, the implication that perspective is 'too difficult'.

Most people one discusses the question with will say so quite explicitly. They

[5] The two ideas also occur together in Egyptian similes involving grasshoppers, cf. Grapow 1924.98.

[6] [This Confucian saying is not in the *Analects*, though it may be preserved in the works of some other Confucian philosopher (J.R.B.).]

forget, *that it is not a question of mathematically precise perspective, but only of a more than occasional use of approximate foreshortenings.* It is no solution to say that draughtsmen of the order of the Egyptians found such foreshortenings 'too difficult' or 'could not' have reproduced them. Anyone who contents himself with this as an answer has thought the problem through as little as the person who finds a way out by speaking of 'not wanting to' or 'simply not doing it' (Blunck 1924.354). What then causes this 'difficulty', which did not after all hinder any Coptic or medieval European painter? What holds back the 'ability to', paralyses the 'will to', or stops the 'simple action'?

Whether he comes to like it or not, even the most casual viewer of Egyptian art becomes aware that it is an art that aims at and achieves much, and moreover that its forms are of a purity that makes one most strongly sensitive to the lack of foreshortening. So he can easily gain the false impression that he is dealing in its 'unnatural' rendering of nature with the result of the Egyptians' peculiar self-imposed laws, of a 'science'.

The best protection against this mistake is the realization that foreshortenings do not occur in the work of our own children[7] and adults who have not been taught to draw, or among so-called primitive peoples,[8] or in any of the great 'pre-Greek' cultures. It is one of the most fruitful discoveries in the study of pre-Greek representation, that all these four groups, despite great diversities in modes of expression, are closely related in this aspect of the rendering of nature. This has put a stop to all ideas of coincidence or diffusion; the basis must be a general perceptual-cognitive tendency of the human mind.

We have only been able to look more deeply at these fundamental rules of pre-Greek rendering of nature since we began to give serious attention to the drawings of children, 'uneducated' people, and 'savages', all of which used to be treated with contempt.

As long as scholars compared Egyptian art only with works from the other great pre-Greek cultures they got no further than pointing out similarities in their methods of drawing, and were lost when they came, as we are doing now, to interpret them. But our children and fellow adults, and especially primitive people, whose vision is exceptionally acute, can at any time provide information in a well-organized inquiry and answer well-thought-out questions—which should not, however, encourage the informant to give a simple yes/no answer.

If examples from Egyptian art are always treated in the context of works from the other groups this will be a protection against any misinterpretation that may arise from the sophistication of the Egyptian method, and one will come in this way to realize that the whole phenomenon is entirely natural. This is the procedure I shall adopt; in other words I shall work from both categories in order to substantiate the hypothesis of the basically similar character of the representations and deepen our understanding of them.

If I were studying the drawings of primitive peoples, children, and uneducated adults by themselves I would have to try to separate the stages discernible in each of these groups before the occurrence of foreshortenings. But that is not part of my task. I must of course follow any development there may be in the Egyptian method, but for the other groups it is sufficient to isolate the remarkable correspondence in

[7] Material in Levinstein 1905 Bühler 1924, Wulff 1927. Cf. Schäfer 1930.390 n.331b [absent from this edition (J.R.B.)].
[8] Material in e.g. Koch-Grünberg n.d.

their characteristics and the identical underlying causes.

In order to interpret Egyptian pictures I shall often refer to the strange drawings which give us the clearest insight into the workings of a child's mind, because they best show the way to the source which is common to both. Of course I do not intend in any way to equate the artistic merits of the two. It should, on the contrary, be clear that 'art' is not for the moment at issue, only the main features of the rendering of physical objects. I am well aware that it will appear almost insulting to some people to see these childish productions placed beside works of art, and that for other readers Egyptian works may actually be cheapened at first. On the other hand I have confidence in the conquering power of Egyptian art.

Older interpretations derived from the supposed 'conventions' of Egyptian represent-ation are to be found in all the technical language normally used to discuss these matters. These terms speak of the Egyptian 'turning' things 'over' to draw them, 'lifting' them 'up', 'shifting' them together, or 'drawing in section', and so on. 'Projection' is also a favourite term—yet the procedure it alludes to plays no part in an Egyptian two-dimen-sional picture, unless the word is emptied of its content and just used for 'sketch, repre-sent'. It should be allowed the meaning it normally has in drawing, that is, that the various parts of the model be thought of as fixed in their relation to the drawing sur-face by lines that are parallel or grouped in the eye. It is a different matter if Egyptian sculptors transfer to the surface of a squared block of stone the main points and lines of the figure which they intend to produce out of it, and can already 'see' behind the surface. In this context 'projection' would be an acceptable term. But for this very reason these outlines would look different from corresponding normal freehand Egyptian drawings.

It is tempting to use these convenient simplifying terms; but they are dangerous because however much care is taken they may blur the truth. The most they could do would be to enable one to produce drawings that looked the same as the ancient ones.

The Latin-derived *Komponieren* [compose] and *Komposition* [composition] are harmless today, as their now generally used sense of 'artistic ordering of the parts of a picture' is suitable for the art of any period. But the terms were not always so accom-modating to sensitive minds. Goethe was so unpleasantly conscious of the basic mean-ing 'put together' that he rejected the words as 'mean' (in conversation with Ecker-mann').[9] We cannot think about 'pre-Greek' Egyptian art (pp. 109—10) in the same way as he did about the art of his time.

The essence of the greater part of the rendering of nature in Egyptian art, which is related to that in the productions of primitive peoples and children, could be stated theoretically in a few sentences. But these would be shadows without substance. They take on life, and we acquire an active insight into the construction of the drawings, only when we pursue both with verbal reasoning and in our observation of pictures the extensive implications of these sentences. True to its nature, the whole field has almost no development as we understand the term, it remained essentially the same throughout history. So I have been able to take my documentation from all periods.

[9] [J. P. Eckermann (1792—1854) Goethe's helper and companion 1822—32; his conversations with Goethe were published in three volumes (1836—48) (J.R.B.).]

It is common knowledge how important a part memory plays in artistic activity, so important that Hermann von Helmholtz[10] could define the notion 'artist' from a certain point of view as 'a man whose observation of sense data is outstandingly fine and precise, and whose memory for visual images is outstandingly faithful'. This is just as true of the artists of today as it is of Egyptian and primitive artists.

Let us now study what children and adults say about perspective.

1. A three-year-old boy on a sea voyage from London to Holland travelled along the Dutch coast at a distance from it and thought he had seen tiny girls working on a quay with dainty little wheelbarrows. Up to the age of more than five Holland was for him the country with the nice little people. The visual image was received and proved enduring but the puzzling aspects of it were not noticed for a long time. The child had had no chance to correct the illusion; but in later life he understood it retrospectively on the basis of deductions from other experiences.[11]

2. Karl Philipp Moritz[12] recounted how a certain tower in Hanover always had a special fascination for him. He looked at it enchanted and envied the city musicians who stood up on the ambulatory in the morning and evening to play. He looked at the railing for hours; from below it looked so small it would not have come up to his knees, yet the musicians' heads were only just visible above it. The puzzle is grasped and the child transposes the shapes of the men, perceived in reduced form, to life size, as he knows the musicians to be adults. It is different with the railing, which he has not seen from close to. This still seems small to him, though he is perplexed by the contradiction.

3. Hermann von Helmholtz (1903c) remembered clearly even in old age the 'moment when it dawned on him' that distant things look smaller. He passed by a large tower on whose top gallery there were some people, and asked his mother to fetch the nice little dolls down. (Then—and that was the 'decisive moment'—he must have realized the truth, either by his mother explaining, or by approaching the people, or by his own inference from other experiences.) Later he often looked up at the tower when there were people at the top, but now experience had taught him they would not become dolls again. This example continues the one of the little Dutch people (1.): the illusion is recognized, and from then on the correction, which Karl Philipp Moritz had learnt before the experience described, occurs automatically; as with the marksmen of p. 81 the apparent reduction becomes a tool to judge distances by. It is noteworthy that the great physicist's account leaves out the most important part, which I have filled in in brackets, namely the moment when, and the way in which, the fact of reduction dawned on the boy.

4. A schoolgirl came to notice by herself that the path from school, which stretched out in a straight line in front of her, became very narrow at the level of a particular house, and she was astonished when she arrived there to find the path as wide as at the beginning. A three-year-old boy (Kurt Lange) was shown a picture of a railway line disappearing into the distance, in other words getting narrower. He rejected it and insisted that the rails be parallel, as otherwise the coaches would be derailed. In both cases reduction in width was observed, but distance was not deduced from it.

[10] Cf. Dilthey (1924.172) for corresponding remarks about literature.

[11] Told me by the boy's parents, Mr. and Mrs. Karl Curtius.

[12] *Anton Reiser* (1785–90), end of first part.

5. From Classical Greece we have Plato's remarks[13] protesting against movements in Greek art of the time, whose adherents depicted appearance and not reality. Exploiting all available methods of deception they worked on the weaker parts of the mind, which did not try to refine their judgement by measuring, counting, and weighing, but accepted the illusory impressions of the senses. Plato cites explicitly as an example of 'errors of the eye' the fact that one and the same object appears large or small depending on how far away it is, a phenomenon artists of the time took into account in the case of very high works by painting the upper parts larger in relation to the lower than they would be in reality, in order to compensate for the misleading foreshortening. Further phenomena in this category were the refractions of lines which occur when objects are under water, and the impossibility of distinguishing concave from convex. This last refers to the fact that, depending on the lighting, an observer can take the same shape to be a bowl or a hump. Plato's condemnation[14] can be summarized as follows: bad in itself (because it is deceptive) and used for a bad purpose (because it does not aim at the only true eternal forms of things, the ideas, but at earthly objects which are imperfect in themselves) art which does not produce a true image of its model, but only shows it as it *appears* to the eye, (*Republic* 598a), can only produce bad results.

One is tempted not to allow this polemic its full value as evidence, because a philosopher is talking, and the point under consideration was an important element in his teaching. This objection may be valid for the metaphysical part of what he says, but we are not concerned here with the philosopher or man of ideas, but only with one among many other witnesses against perspective.

Plato's argument is at the core of the general resistance to the innovation. For the aversion to perspective as a deceiving, distorting reproduction of reality speaks clearly in all the evidence which we can collect today.

6. I have often been told by teachers who have taught children the elements of drawing that when their pupils wanted to draw a round vessel they drew the mouth passably, and then hurriedly rubbed it out, saying, 'no, it *isn't* like that.'

7. A nine-year-old girl drew a chair with a circular seat. But it came out in such a way that her mother asked her if it was perhaps a bunch of keys on a ring. Her own drawing with an oval seat was rejected by the child; the chair *was* round.

8. Mrs. E. Brunner-Traut described to me how sixteen-year-old secondary-school children still produced drawings of bowls and lakes like figs. 262-3, considering them to be the only correct ones; only after much argument were they persuaded grudgingly to transpose them into perspective.

9. My friend the painter A. Bollacher[15] told me of a Black Forest peasant who felt very similarly. The painter drew the peasant's house while the latter looked on. Scarcely had the artist indicated the side of the gable and made the line of the top of the roof fall away obliquely in correspondence with the low centre of vision, when the peasant stopped the work and exclaimed in astonishment, pointing to the line: 'Why're you making the edge of my roof slope so? My roof *doesn't* slope'.[16]

[13] *Republic* 602–3, *Sophist* 235–6; cf. Appendix 4 below, pp. 349–51.

[14] *Republic* 603b [The version Schäfer gives is a paraphrased conflation of the various *Republic* passages he cites (J.R.B.).]

[15] [A painter who was employed on German excavations in Egypt around the turn of the century (J.R.B.).]

[16] [The peasant's words are in dialect (J.R.B.).]

10. I shall cite one more example at the end of this long list, as it happens to come from contemporary Egypt. Upon request, my informant drew an upper-class Egyptian employed at the vice-regal court, showing his face from an oblique angle. The man looked at the picture, at first seemed satisfied and wanted to have it, but then thought a little and said he did not want it, as it was not correct. When asked what he objected to about it he replied that his moustache was the same length on either side, but in the picture it was longer on one side than on the other. He could not be convinced that the drawing was correct, but kept repeating that his moustache was the same length on either side and must be drawn thus. In the end he in fact refused the miniature, and years later, when the man who had drawn him met him by chance and did not recognize him, he jogged his memory by saying: 'Have you forgotten? You once painted me with a moustache half big and half small!' No doubt the man was so sensitive to the slight foreshortening in the drawing because his male ornament, whose proportions he checked several times a day, was at stake.

11. As this last example shows, perspective sometimes leads to a decisive rejection of finished pictures. But normally children and adults who have not been taught to draw react to strange drawings, whose execution they have not witnessed, just as they do to nature itself: the foreshortenings in the picture are quite unconsciously corrected in the mind. The end of the story of the Black Forest peasant is very instructive in this respect: after much effort on the painter's part he was able to see the falling line of the top of the roof in nature, but still insisted that none the less his house was straight. Finally the only advice the painter could give was not to watch the painting of the picture any more. After it had been finished the painting was brought into the house; the peasant looked at it and was beside himself with astonishment: 'extraordinary thing about that painter—the thing's very clever; that's my house all right, it's just like that.'

All the examples I have quoted—and as I have said, their number could be increased indefinitely—are different from each other, and yet in principle the same. On the one hand we have the philosopher (5) who protests against the facts as he knows them, and the child who adopts one such fact probably by accident, and then removes it immediately from his pictures (6); on the other are the peasant (9, 11) and the Egyptian official (10) who had never been consciously aware of perspective distortions. These people, differing in age, social circumstances, national and racial character, unanimously rejected the appearances to which their attention was drawn, for the same fundamental reason: extensive experience had taught them to correct the appearance of perspective, or to remove it because it was an illusion which distorted things. So what they said is similar to what we are used to hearing from people accustomed to perspective when they approach pre-Greek works of art. The brain of a pre-Greek man performs the correction so often with such quiet confidence that the contradiction will only occasionally strike him and force him to make a decision. But where there is a clash and a judgement must be made we meet the same refusal everywhere: 'the thing *is not* as it is shown in the perspective drawing.'

Emanuel Löwy (1900.4) objected to arguments referring to an avoidance of what might 'deceive' the eye, however this might be explained. He was no doubt chiefly led to this denial by older descriptions which gave too reasonable a character to the procedures of perspective. But however useful it may have been to isolate the unconscious element in our sifting of remembered images, the impetus of Löwy's reaction carried him too far. For he could not avoid observing that memory excludes

certain types of view, in fact foreshortened ones, but did not ask himself why this should be. So in the end he never solved the problem, indeed never posed the final question. The evidence we have reviewed proves that we are quite justified in considering the basic motive for avoiding foreshortening to be an attempt to get round the contradiction between perspective sense data and 'objective' reality; or rather that the experience of this contradiction is the reason why perception and even conscious observation of the oblique views and foreshortenings of perspective have no effect on pre-Greek draughtsmen.

So, from this point of view, to contrast a painting style with foreshortenings and one without them is to show the change from one method of depicting the physical world to another which is fundamentally opposed to it; the 'Greek, perspective' method familiar to us today has been used to approximate ever more closely to the uncorrected images perceived by the eye, with all their apparently unsystematic foreshortenings, and in fact, as Goethe said, 'perspective laws [have] made it possible for all, or rather many, confused masses of objects to be transformed into ordered compositions, by a sensible and correct relation of the world to man's eye and view-point.'

The user of the 'pre-Greek' method, on the other hand, aims to show things objectively as they are, or as they live in his imagination—within the limits of the knowledge he has from his various senses, and from his intellect and sensibility, and as far as his emotional involvement of the moment allows.[17] But he too creates order and clarity for himself in his picture, only in his case by eliminating foreshortening, shadows, and other disturbing elements.

If one bears in mind that the correct ratio between the depth of an object and its other dimensions can almost never be observed even in the best perspective drawing done without calculations or preliminary sketches, one will have to admit that perspective requires to some extent that exact statements about the properties of physical objects be abandoned. Imagine a discussion between a Greek and an Egyptian after the fifth century B.C. ; the Egyptian could object with apparent justification to the 'deceptiveness' of Greek painting, and set his own up against it as 'painting of reality'. If he could illustrate the discussion he would be able to show how, if they are understood, Egyptian drawings show the relationships of the bodily measures of length, breadth, and height in an immediately comprehensible way, while this is not true of drawing with foreshortening, even for someone who understands it. The Greek artist could then give a smiling reply along the lines of Goethe's dictum which emphasizes the importance of oblique views: 'there is much we would know better if we were prepared not to analyze it so much—after all, objects can only be comprehended easily from an angle of forty-five degrees.'

Any draughtsman's senses give him a host of perceptions of different objects, and of one and the same object. The 'pre-Greek' rejects from these the ones with a perspective character, because of his experience that the 'foreshortened' view deprives the original of its rights, cheats it of part of what belongs to it.

The foreshortened views that are expelled from consciousness are not simply lost. They disappear into the subconscious, and from there they help a man to adapt to

[17] In *ZÄS* 48 I published an article entitled 'Scheinbild oder Wirklichkeitsbild?'(Schäfer 1911) ['Picture of appearance or of reality?']. I could not have expected a man like Ludwig Curtius (1923.119) to object that not even a photograph was a 'picture of reality', for it was precisely a photographic (perspective) picture that I termed 'picture of appearance'.

his physical environment. Whole series of these views turn into authentic mental images, are observed, and, as we shall see on pp. 259–69, often play a part in drawing, forming the exceptions (pp. 260–65) to the rule of forms based on frontal images.[18]

We avoid the word 'law', which does not permit exceptions, and prefer 'rule', which does. It is necessary to say, if only half in earnest, that the exception proves the rule. But whether laws or rules are referred to, these are to be understood as descriptive, not prescriptive.

The great majority of the non-foreshortened views which dominate Egyptian drawings go back to data which the eye at some time provided. One could almost say that in any artistic creation of forms, whether perspective or based on frontal images, the hand seeks out these notions in the material, directly or by means of a tool. This becomes clear at once if one imagines the model to be a rectangular table-top. This would have a rectangular form in any pre-Greek drawing (like fig. 32), although, except in very rare cases, it is only seen with foreshortened sides and without right angles at the corners. But one must remember that a small child explores

FIG. 32. Child's drawing of a table with a tablecloth hanging down on all sides. By an eight-year-old girl.

its environment by feeling its surroundings with its hands,[19] and by grasping them, both literally and metaphorically. Even much later the self-contradictory impressions received by the sense of sight must very often take a subordinate position to impressions formed by touch in the widest sense—like muscular activity when focusing the eyes, investigation by the hands, and pacing out—and let themselves be corrected by them. Only by keeping before us the silent collaborative work of this sense, which is immune to 'false' foreshortening, can we comprehend the fact to which we become accustomed with such difficulty, that any foreshortened impressions that may come to the surface while drawing are immediately suppressed. The ones that may slip through are so weak, 'floating' as they do without a mental framework, that they could not become powerful enough to compel a transformation of the whole method of rendering nature. Even with the Greeks this only happened when the intellectual climate was ripe for the great revolution. We shall return to that later (pp. 270–71). But however important the sense of touch may be, one must start from the fact that, for every man who is not blind, the rendering is based on images that are derived from the perceptions of what Goethe calls the sense organ 'which is well suited to earth and world', the eye. So every interpretation, even of the pre-Greek rendering of two- or

[18] [*Geradvorstellige Regel*, cf. Translator's Introduction p. xvii (J.R.B.).]

[19] To test this it would be necessary to study the drawings (and sculpture) of entirely untrained congenitally blind adults (not people who have become blind).

three-dimensional forms, must start from that and not from touch, which only helps and checks.

Corrective experience does not have to be acquired from the piece immediately under consideration. If it is not, a deduction from what is or is thought to be comparable may be decisive, and often the experience connects with its final utilization through a whole chain of correct or false, conscious or unconscious deductions. At the end there may be a very different object from the one at the beginning.

Now we can understand where the 'difficulty' in foreshortened drawing lies for somebody who is confronted with it for the first time:[20] in an opposing predisposition to a different sort of ordering, which exists in every man. It is this predisposition which determines the powerlessness of oblique views and foreshortenings to influence a pre-Greek draughtsman, so that they only very rarely produce a remembered image that is adequate to serve as a basis for reproduction. This principle is so fundamental that even when an artist works from nature and in the presence of the model the rendering of a pre-Greek does not correspond to a visual impression of the seemingly foreshortened object, that is to a defined view of it, but to a mental image which alone is relevant to the rendering, and is not foreshortened as a whole or in its parts. The work of art embodies this image. So it is not faithful to a perceived visual impression but, as I shall term it, *image-based [vorstellig]*. Now in all artistic creation the image is sometimes more, sometimes less active than the attempt to reproduce the sense-impression entirely perfectly. So we should not only characterize pre-Greek art with the generic expression 'idea- or image-based',[21] but must also delimit it more precisely with a term that describes its basic procedure. At the same time our new concept must not be negative: for by speaking of 'missing oblique views' one reproaches an art for lacking something and measures it against another art which is different in kind, and this would not be appropriate to our endeavour to comprehend 'pre-Greek' representation on internal evidence. So as early as the first edition of this book I turned the negative into a positive by saying: figures are always drawn as if their planes were looked at frontally.[22] From this formulation I coined the word *geradaufsichtig* [approximately: using frontal[23] observation] and finally, as I have reservations about speaking of *Ansichten* [views], by way of the clumsy compound word *geradansichtig-vorstellig* [approximately: based on a frontally viewed image] I was emboldened to try *geradvorstellig* [based on frontal images]. As Lessing did in a similar case I am here counting on the reader's gradually accustoming himself to attaching the concept to the word, although he may not do so at first, so that he may perhaps come to use it himself in the end.

We can if need be define the technique of Greek art, which is based on oblique views and foreshortenings, as *schrägvorstellig, schrägsichtig, sehbildähnlich*, or *sehbild-*

[20] Helmholtz (1903b) already expressed this clearly: 'it is well known that one of the greatest difficulties in perspective drawing is to eliminate the influence which one's idea of the true size of seen objects automatically exercises.'

[21] [For a discussion of the translation of Schäfer's neologisms see Translator's Introduction (J.R.B.).]

[22] I first characterized the situation in this way in the first edition of this book (1919); in my *Grundlagen der ägyptischen Rundbildnerei* (1923a) I coined the term *geradaufsichtig* (changed in the 3rd ed. of this book to *geradansichtig*) ['using frontal observation' and 'frontally viewed']; only later did I discover that Bühler (1924.266 n. 2) had used a corresponding word *orthoskop*. In this edition I have avoided using compounds of *ansichtig* ['pertaining to views'; it has not been possible to dispense entirely with 'view' (*Sicht* or *Ansicht*) in English (J.R.B.).] [Cf. also Epilogue.]

[23] [For 'frontal' see Chapter 7 n. 2 and Translator's Introduction (J.R.B.).]

getreu[24] [based on oblique images, obliquely viewed, resembling visual impressions, faithful (reproduction) of visual impressions] , and lastly as perspective (pp. 271–2). The gradations of these words are easily comprehensible. One should however avoid thinking of 'realism' or 'naturalism' in the case of *sehbildähnlich* and *sehbildgetreu*, because the words I am proposing only refer to the degree of relationship with perspective phenomena.

The term 'frontal', which describes basic procedure, would be just as inadequate in itself as the generic term 'image-based'. For there is a whole series of elements in pre-Greek art, to be discussed later, which are not covered by it, because other aspects of image-based creation than the frontality of the images assume importance. Examples are: emphasizing figures through colossal size (p. 231), the fact that parts of figures are missing, or the presence of too many parts on other occasions (p. 119), false transparency (p. 121), 'sections' (p. 124), even the lack of reduction in more distant figures as against nearer ones of the same size (pp. 83, 230, 231). All of this occurs long after the fundamental adoption of foreshortening in art containing perspective elements (p. 274), until perspective that reproduces visual impressions comes in at the Renaissance. So whenever, in discussing Egyptian art, I use the term '(mental) image' by itself I ask the reader to understand it to mean 'frontal image', for the phenomena just referred to are represented with frontal images in a pre-Greek art. This descriptive term summarizes all that is essential in their rendering of nature: this is not true of designations derived from the term 'oblique view'. They only serve to distinguish such works easily and clearly from works based on frontal images, by reference to an important characteristic.

If we arrive at a grasp of depiction based on frontal images this has results that lead us from two-dimensional art to an understanding of the rendering of nature in three dimensions (Ch. 7).

Even if we speak of the use of frontal images as a 'rule' we must guard ourselves from believing that a pre-Greek artist was ever aware of this property of his creations on a theoretical plane, or of a norm opposing the 'exceptions'. The tendency is instinctive. Details at most, and in Egypt the aesthetic elaboration of forms, are to some extent the result of conscious work of this sort.

An image is an individual mental structure on which very few people meditate seriously. Only too frequently in life one is misled by sentences like 'I can see it as if it were here now.' In reality, even when a man is able to remember a past event to general satisfaction and describe it, even draw a picture of it, he will not necessarily have a visual conception of it, will not see it. 'I can see it as if it were here now' is seldom to be taken literally.

The meaning of this can be clarified by a reference to the people E.R. Jänsch termed *eidetic* after the Greek εἶδος, 'image, form' (Jaensch 1925, 1930, Metz 1929). The eidetic have mental images which are clearly visible as bodily sensations distinct from the normal range of ocular sensations, and which occur on a flat surface or in

[24] Words like *erscheinungsgemäss* and *erscheinungstreu* ['corresponding to appearances' and 'true to appearances'] seem to me to be suitable models for further compounds, as experience shows in the case of Bühler (1924.307f) and Wulff (1927 p. XIII). Previously I used the term *wahrnehmig* [approx. 'perceptual'] in opposition to *vorstellig* ['image-based', i.e. the product of a mental image of an object, not of an immediate perception of it] , but I have dropped it in the light of von Recklinghausen's objections (1928.15).

space, or with the eyes closed. Not only are earlier perceptions 'seen' again in the same form after a short or a long time; these eidetic image clusters can also be the products of a creative fantasy and can even depict continuous action. The best-known example of an eidetic experience is probably Goethe's at Sesenheim.[25]

Visual constructs of this sort exhibit all the foreshortenings of the immediate visual image. Egyptians were not eidetic, nor should one characterize Cretan art thus because one is blinded to the frontal images by a certain naturalism in the pictures.

Eidetic children are not different from others as regards foreshortening; initially the perspective elements in eidetic perceptions have as little effect as normal perspective impressions do on other children of the same age: at first they are almost always transposed into frontal images. And when they do become aware their drawings are still only 'perspective-like' in the sense explained on p. 269. Eidetic people only take up true perspective in the same circumstances as anyone else.

Eidetic representational draughtsmen can never be better than other artists merely because of their peculiar quality. Any contest would have to be decided on the basis not of accuracy of reproduction, but of creative power.

4.2 Isolated objects

We shall study first simple, then complex isolated objects, and finally closed or open groups (fig. 33); in doing this we shall be able to test to what extent one can speak of tendencies to use oblique views, though not yet of perspective. It is not possible to draw a sharp line between the various sections of this exposition: so on

FIG. 33. Child with a lion in bed. Child's drawing.

occasion I may count two or more isolated objects that stand in relation to each other as complex objects. In other respects also I cannot confine my study too rigidly.

4.2.1 Purely two-dimensional models

As we want to start from what is simplest let us first find a model that is purely two-dimensional. This is only possible if we take the surface of an object from nature, for example a pool of water (fig. 262) or a pond (fig. 34), more or less as in a surveyor's plan.

FIG. 34. Pond viewed from above. NK

[25] [Goethe had a love affair with Friederike Brion, the daughter of the pastor of Sesenheim, while he was studying in Strassburg in 1771. Schäfer may be referring to the vividness of the episode recounting the affair in *Dichtung und Wahrheit*, Books 10–11, or to one or two specific passages. In one Goethe becomes distracted by an impression that he is present among the characters of Goldsmith's *The vicar of Wakefield* (Book 10), and in in the other he has a vision, later to become a reality, of meeting Friederike on horseback (Book 11) (J.R.B.).]

If the chosen surface shows us a full view, that is, can be directly seen by the eyes, it is at once clear what happens: the hand that does the drawing moves over the surface to be drawn on with strokes which are mathematically identical or similar to the features of the model, with the exception that the object's size is fixed, while the scale at which it is reproduced is a matter of choice.

But if the model is standing or lying in such a way that it can only be seen obliquely and therefore foreshortened, two cases must be distinguished: suppose the draughtsmen had never met it before or had never seen it except from this particular foreshortened angle, and they were not able to change its position in relation to themselves, or theirs to it, nor were they led to deduce the existence of the illusion by comparisons with structures which they thought to be similar: in this case their drawings could only have a perspective appearance.

But when the draughtsmen know what type of object they are dealing with they may, as can often be observed with children, attempt to place themselves in a position from which the model appears to correspond to their non-foreshortened image of it.[26] But even if this does not happen, a picture which is exactly like the one drawn on the basis of a full view will result: one which lacks any trace whatsoever of perspective.[27] In this case it is of course irrelevant whether the draughtsman really knows the subject or only thinks he does. It is this that makes it so difficult, indeed almost impossible, to test behaviour in front of unknown models in conditions that do not admit of error. For the draughtsman will almost always adapt himself to what he has deduced from something that is, or is thought to be, comparable.

Conze,[28] alerted to the problem by Schöne,[29] has taught us what the opposite attitude to the model is: it has sometimes been observed among primitive peoples that they even turned their backs to an object when drawing it. This can probably only be explained on the assumption that they really[30] do not want their image to be disturbed while they are working by the infinitely various and complex appearances before their eyes.

We can now formulate the procedure of a pre-Greek painter when he draws a flat model thus: the hand which does the drawing feels its way over the picture surface in accordance with the painter's frontal image of the object. If the drawing surface is parallel to that of the model the drawing implement follows the direction of all the lines in it. But if the drawing surface is at an angle to that of the original the hand allows its course to be modified in the case of receding or advancing lines, either because of resistance by the drawing surface or because it has to maintain contact with it, and instead of following the direction of the lines of the original it performs corresponding non-foreshortened movements.

[26] I observed this with my children, and others have confirmed it. This movement can easily be confused with the one which someone who is drawing makes when he wishes to grasp more precisely details that are to be incorporated in the complete form, which he already has in his mind (cf. n. 31 below). Also, if it is possible, the object is frequently turned so that it is in a full view.

[27] Cf. p. 107.

[28] [A.C.L. Conze, classical archaeologist who worked in the Berlin Museum at the same time as Schäfer (J.R.B.).]

[29] [Cf. Chapter 2, n. 139 (J.R.B.).]

[30] Cf. pp. 83, 89.

If someone draws a purely perspective picture the use of the drawing surface does not lead to physical contradictions of this sort, since he represents his surroundings according to the perspective impact they make on his retina (we do not need to take the concave shape of the latter into account here).

4.2.2. Objects with a simple, clearly three-dimensional form

I have had peculiar experiences with genuine three-dimensional objects. I placed a normal conical glass in front of one of my children, a boy of six, in such a way that he could scarcely see into the top, or so that it appeared to him at most as a very narrow oval: in other words the glass was seen in a side view (fig. 35b). To my astonishment his picture was a simple circle (fig. 35a). The small draughtsman looked at his model and seriously tried to represent it faithfully, but at that moment he was so dominated by his idea that 'the glass is round' that everything else gave way to it and from the drawing it would seem as if he had looked vertically down into the glass. This surprising picture is by no means unique. I shall add to it a drawing of a cup by a thirteen-year-old girl (fig. 36a) and beside her drawing one of the oblique

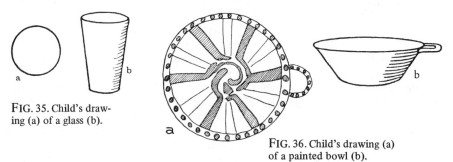

FIG. 35. Child's draw-
ing (a) of a glass (b).

FIG. 36. Child's drawing (a)
of a painted bowl (b).

view which was actually before her eyes (fig. 36b). Again we see that the picture is not derived from a visual impression but from a frontal image.[31]

A picture like fig. 35a of a tall vessel will probably be drawn only by a child, scarcely by an uneducated adult. At the period when we begin to know Egyptian art artists had already felt for a long time that a circle O reproduced a characteristic of all wide-mouthed vessels, but not what distinguishes individual types, which are usually seen from the side because of their height. So the draughtsman—as my son could have done with fig. 35—almost always shows, as in fig. 43d, a pure side view, and does not use the non-distinctive view from above. The latter is only shown if the pattern inside a shallow bowl or its contents need to be shown, provided that in the case of the contents it is not important whether or not they are piled up. Such a picture (fig. 37)[32] looks exactly like the child's drawing in fig. 36a. Sixteen-year-old school-children still made combinations of figs. 43d and 36a, looking more or less like fig. 49, for Mrs. E. Brunner-Traut (p. 87).

[31] The girl added the drawing of the inside afterwards, thus making the picture more like a
frontal view. Cf. n. 26 above.

[32] On the positioning of lotus flowers cf. p. 167.

FIG. 37. Basketwork dish full of fruit with lotus flowers on top. NK

FIG. 38. Flat loaves. MK

This is how it comes about that as a rule only one of the surfaces that can be seen appears even in pictures of three-dimensional subjects. This surface may be a curved one (fig. 38), a broken one, or one with raised parts (fig. 39), provided that, at the moment of conception, the rises and falls lose so much significance for the mental image that everything might just as well be on a level. So even a ball is represented by a simple circle, which is for the draughtsman an adequate expression of 'roundness'; and balls, disks, and drums will be as indistinguishable when represented as O as say a cylinder and a rectangular blank will be when shown as follows: ⊏⊐ . It is only possible to deduce what is meant from the context, not from the picture by itself. For example, it may be obvious from the context that a circle is intended to represent the sun, but while for an Egyptian the image would have referred clearly to the sun's disk form in nature this is not so at once for us. Thus, on the basis of the pronounced curvature of the sun in a sunk relief,[33] an academic colleague of mine came to believe that the Egyptians may have thought of the sun as spherical, but only at the time of Amenḥotpe IV. This could not be rejected *a priori*, because many primitive peoples imagine the sun and the moon to be spherical. But there are incidences in three-dimensional works which can be cited in evidence against this; on the heads of divine statues[34] and in independent amulets and similar objects both sun and moon are shown as flat or more often lens-shaped disks.

Where one surface of an object is significantly larger than the other it will mostly become the basis of the image in a draughtsman's mind, as it is almost always the most characteristic. So an egg always appears in its longest aspect ◌ , and not, as it might, as a circle. But it is not an invariable rule that the largest surface must be shown, and it is quite conceivable that the smaller one should be chosen. Sandals are normally represented as in fig. 39, with the full width of their soles, but it is not uncommon, even when they are not being worn, to find a drawing like fig. 40, where

FIG. 39. Sandal viewed from above. MK

FIG. 40. Sandal viewed from the side. MK

the thin sole is seen from the side, because the form of the straps needed to be shown. If the chests of figs. 41 and 42 are compared it will be seen why each of the two views has been chosen. Two different types of chest are being shown: the one in fig. 41 has

[33] Propyl. 375 [parallels L-H pl. 183-4 (J.R.B.)].
[34] Propyl. 340 [Worringer 1928 pl. 14, cf. Fechheimer 1923 pl. 77-8 (J.R.B.)].

a lid that rises in a straight line from the back and then falls again in front in a short curve, an elegant shape whose individuality can be presented to us by depicting the long side. The other, fig. 42, has an arched lid whose half-barrel shape can be seen

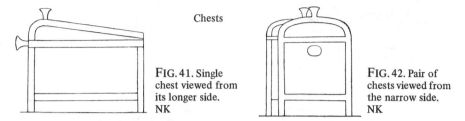

Chests

FIG. 41. Single
chest viewed from
its longer side.
NK

FIG. 42. Pair of
chests viewed from
the narrow side.
NK

from its narrow side. If we wish to define more closely which surface the artist chooses we must content ourselves with saying that it is almost always one in which the subject presents itself in its most characteristic form. As with models that can be viewed from only one side the chief view is drawn according to a frontal image.

If the outline of the surface is to be given life by the addition of details that seem necessary the result is a strange contradiction in our eyes. Thus in pictures of New Kingdom *kraters* the plant stem decoration of the body of the vase, which is a fixed element in itself, is not crowded together near the sides, as it would be in a perspective drawing, and its lines in fact frequently do not fit the outline of the vase, but are placed vertically and parallel with one another on the surface as if they were an independent framework.[35] The same process can be seen in a somewhat different form in the bowl in fig. 43e. As usually happens, the bowl is shown in a pure side view, and so the artist could have finished the pattern that surrounded the front with a straight line at the top, like the wreath of leaves in fig. 43d.[36] But the draughtsman of fig. 43e knew that the pattern surrounded the foot in a circle, so he drew as much of the circle as there was room for within the profile of the vase.

Throughout the drawing process the artist may glance many times from the work to the model and back, thus checking the accuracy of his work against actual views by use of his eyes and mind, and letting the results of this process influence his drawing without altering its fixed frontal character.

If, for one reason or another, more than one surface of a subject seems important, the draughtsman can do one of two things. He can separate the two with lines, or join one to the other without a dividing mark. Both forms are found in the drawings in fig. 44, which are children's solutions to the dilemmas referred to above, where they attempted to distinguish a cylinder cut at right angles to its axis (fig. 44a) from a board. In drawing the cylinder they linked the two straight lines by means of circles (b) or semicircles (c), thus showing that the object had length and breadth, with parallel long sides and round end faces. Even the long outline may be arched in a drawing; a child who drew it thus (fig. 43d) said that this was because the object as a whole was round.

The very common transition in pictures from the image of one surface to that of another, in which the two are not separated by dividing lines, is naturally most

[35] A warning is necessary against the picture in Borchardt 1893.4 top R, since the photograph *Atlas* 1.275 shows a fanning, not a parallel pattern on the body of the pot.
[36] [Cf. Sources for Text Figures (J.R.B.).]

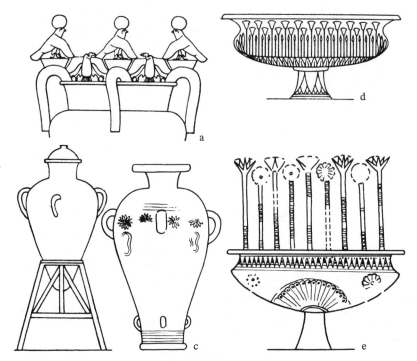

FIG. 43. Egyptian drawings of containers.
 a. Neck and shoulders of a jar with three or four handles and applied figurines.
 b. c. Jars with three or four handles.
 d. Dish with fanned, beaten, and chased decoration on the outside.
 e. Ornamental dish with three-dimensional applied flowers and beaten and chased
 outside decoration (fanned pattern at the top of the base).
 All NK

frequent when the surfaces of the original are at an
angle to each other but not divided by sharp edges. In the
pictorial form of the hooded cobra [glyph] the side view of the
head is followed by a front view of the breast, just as with
human beings the side view of the head (pl. 14) shifts to a
front view of the shoulders, and again to a side view of the
breast.[37] In the same way the side view of a bird is changed
to a broad full one of the tail, and in the pictures of animals
described on p. 119 the front view of the area round the eyes
changes to a side one of the jaw. The last only occurs in poorer-

FIG. 44. Cylinder (a)
in children's draw-
ings (b–d)

quality Egyptian works, while in China until about the time of Christ it occurs even
in the best art (fig. 45). Fig. 46 is a perfect example of how images can be associated.
It is taken from a relief showing Thutmose III's offerings to Amun, in other words a
work of art which is at least competent, and contains something that looks rather

[37] For a more detailed treatment of the human figure cf. Chapter 6.

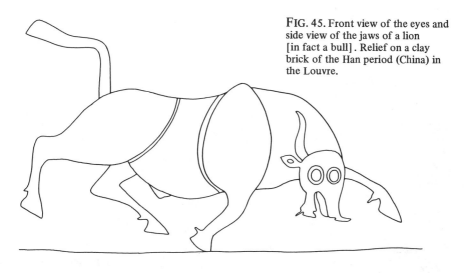

FIG. 45. Front view of the eyes and side view of the jaws of a lion [in fact a bull]. Relief on a clay brick of the Han period (China) in the Louvre.

FIG. 46. Arm-rings in a NK relief with modern rendering.

like flat hearth rings laid one inside the other. In fact the picture is of broad rings for the upper arm of the type that were used as rewards for good service in the New Kingdom, piled on one another. Here two notions became associated: 'I have two arm rings each of a given thickness, which are touching each other all the way round.' Sometimes the change from one image to another is even found when the surfaces of the original are separated by sharp edges, as can be seen from the following examples. After the Old Kingdom ships were built with steering gear consisting of a huge oar in a slit in the stern. In order to show this clearly draughtsmen bring together a side view of the stern with a view of the slits from above, without taking account of the sharp edge dividing the two (fig. 47). In fig. 48 the same thing has happened, and the flat surface of the stand through which the jackal's tail hangs[38] moves from a side view (right and middle) to a view from above (left).

Normally, however, surfaces which are at sharp angles to each other are reproduced with lines to separate them, even when the neighbouring surface is circular (fig. 49). This gives rise to pictures of beds (fig. 66) or chairs (fig. 122) where the sitting or lying surface is placed unforeshortened on top of the legs. There are also drawings of bags (fig. 50) in which both the sides are shown together with the broad main surface, just as three sides of four-sided house roofs are visible even in mature Greek art.[39]

[38] As in the drawing which Matz (1923–4 [1925] 38–9) discusses, referring to Steindorff 1913 pl. 77–81 [=Épron–Daumas 1939 pl. 47–9 (J.R.B.)] and other material. The lack of reduction in the bottom end of the sail is the result of the idea that it is flat. The sail also seems to be shown slightly filled with air.

[39] Greek figures of this type: Benndorf 1899.16 (= Schäfer 1928 fig. 47), Orsi 1892.362.

FIG. 47. Slit stern of a boat enclosing a rudder. NK

FIG. 48. Standard with image of a jackal god. OK

FIG. 49. Child's drawing: upturned flower-pot.

FIG. 50. Pack bag. OK

FIG. 51. Child's drawing (a) of a box (b).

We already saw a corresponding case in fig. 44b with a child's drawing of a cylinder. With rectangular objects the main surface can be surrounded by four subsidiary ones: in fig. 32 a table with the cloth hanging down and in fig. 51a a box with all four sides, so that the drawing suggests a flat frame rather than the box shown in fig. 51b, which was what the child in fact had before his eyes; one is reminded of the apparent hearth rings of fig. 46. It is normally (cf. p. 85) said of the examples just mentioned and related cases that the draughtsman thought of the surfaces as 'folded out'. But cases of transition from one view to another without a dividing line demonstrate that such an expression is a completely false description of what went on in the draughtsman's mind.

A search through Egyptian two-dimensional art for cases where several surfaces of a single object are set side by side shows that this does not happen as often as in children's drawings. Mature Egyptian art looks for and mostly finds a single view of the model which renders its content adequately and satisfies the artist's sense of form.

The exposition given above of the method of drawing an object with one surface also applies to that of drawing a many-surfaced object, that the drawing hand feels its way along the lines of an image of the unforeshortened lines of the original. It

can be seen from the following example how important it is that a correspondence with reality which satisfies the sense of touch be arrived at: children who want to draw a glass as in fig. 35b frequently pick it up, up-end it on the paper, and run their pencils round it. A twelve-year-old boy, since he had been made aware of perspective, drew the top correctly as an ellipse, but none the less rendered the bottom, not as a circle as in fig. 35b, but as a straight line, like fig. 49. When he was asked why he had not made it round too he lifted up the glass and ran his hand under its base saying: 'but it *is* straight: if it was round it wouldn't be able to stand up.' A colleague of mine who knew nothing about drawing admitted he could see nothing wrong with the picture and even though he was forty years old would draw the glass in exactly the same way. He had no need to be ashamed, as hundreds of thousands of educated people would do the same. It shows how deeply the tendency to use frontal images is rooted in us all: it can be overridden only by teaching.[40]

Egyptian drawings do not give us an impression of the depth of any individual object, since there are no lines or surfaces that direct our gaze into depth; they are all spread out on the picture surface. So, in theory, they could equally well be renderings of any direction in reality, either parallel to the picture surface, or moving away in the direction in which we view. The lines and surfaces of an Egyptian picture do not tell us anything about directions,[41] unless we know the physical form of what is represented.

The Egyptians' indifference to the rendering of physical depth can be seen all the time. I shall mention two examples: in the favourite scene of a fight in boats (fig. 52 = *Atlas* 3.39 R) a man has fallen overboard, but is still holding on to the papyrus boat by the crook of his knees. In the representation of this his legs straddle the boat sideways, as if it had no breadth. Even clearer are cases where a box or a chair is being carried, and one hand of the carrier is on the side nearest to us, with the other on the invisible one (fig. 126). In the picture the hand which is in fact hidden can also be seen on the near side, as if it were not holding something which has thickness in the plane of the viewer, but a board; compare also the way in which the hand is placed round the head in pl. 50. The artists needed to show fingers in these cases in order to evoke the idea of carrying or grasping. They help us to understand the pictures too, and only worry us if we are paying particular attention to the impression of the action on our senses. Phenomena of this sort are what Goethe[42] and Lessing (*Laokoon*, 1766), obviously under the influence of Diderot's letters about deaf mutes, and on the basis of what was known about Egypt at the time, termed 'hieroglyphs' —we today would rather speak of 'signs' or 'symbols'—'necessary to all art'.

[40] The following passage came at this point in the 2nd ed. (Schäfer 1922): 'Fig. 329 [p. 355] shows an instructive combination of a pure side view with other images. At a brief glance one might think that it was intended to be a drawing of a simple bowl, in which the fruit was heaped up and held in place by bands. But it will soon be noticed that two of the compartments are filled with figs and two with grapes. So the apparent bands are in fact divisions which form a cross in the bowl (fig. 329.2). There is no means of deciding whether the Egyptian picture represents a bowl of this type that can only be filled level (fig. 329.3), or one with raised divisions between the compartments (fig. 329.4). (In addition to bowls simple platters with intersecting divisions or just one dividing wall seem to have existed.)' I have discarded this section from the text, as the explanation, which was in any case already given by Petrie (1895.69), may be doubted now that filled clay bowls with a handle spanning them have been found in a Theban tomb (*Relazione* 2.163, 167).

[41] [*Richtungsstumm* ('directionally dumb'), cf. Epilogue pp. 420–21) (J.R.B.).]

[42] 'Plato als Mitgenosse einer christlichen Offenbarung' (1796).

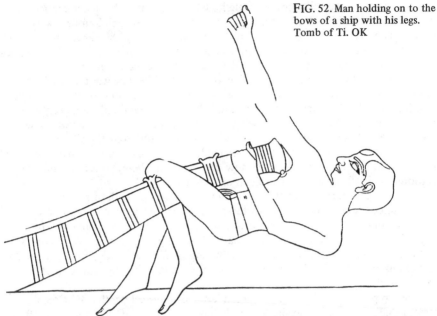

FIG. 52. Man holding on to the bows of a ship with his legs. Tomb of Ti. OK

If a drawing does not give us a feeling of the physical reality of an object we cannot of course deduce from this that the ancient draughtsman had no knowledge of the spatial arrangement of the parts of the picture. When he is feeling his way over the picture surface in accordance with his images of the lines and planes of his model, he does not necessarily notice that he should really move to and fro to either side of the surface. But even if he does think of it the appearance of his drawing is in no way changed. What then happens is that his hand, as it reproduces his frontal image of a plane extending in depth, encounters the resistance of the drawing surface and is diverted by it. Thus the lines showing depth are there, but like those showing breadth they are spread over the drawing surface. Two painted horsemen are among the most striking proofs of this: one seen from behind, in a thirteenth-century German manuscript (fig. 53a), where the back leg which is raised into the picture, is not foreshortened but diverted sideways on the paper; the other is a rider seen from in front, on a sixth-century Greek black-figure vase (fig. 53b), where the legs of the man, which are raised forwards, are spread sideways on the surface, unforeshortened and without any concern for how the thighs join the body. In diversions of this sort one can recognize the influence of the materials used on the artistic form without being reproached for thinking materialistically [cf. also Schäfer 1942.170–1, fig. 6]. After all, the frontal image is of necessity present in the mind before the artist's hand takes up its work. Other influences of the material on a work were identified on pp. 50–51 above. Unless there was an error in some particular case no Egyptian would have agreed that there was any doubt that the top surface in fig. 122 lies horizontally, and not for example vertically.

An experience I had with one of my sons (not the one who drew fig. 35) when he was five gives some insight into the image a draughtsman has, showing again the power of the drawing surface, even if in this case it was really only an obstacle. The boy

a

b

FIG. 53a. Horseman in a thirteenth-century
German manuscript
b. Horseman on a sixth-century
Greek vase

FIG. 54. Child's drawing: house with hip roof.

placed himself midway along the longest side of a house with a partial hip roof. In
the drawing (fig. 54) the sides of the main plane of the roof are a vertical continu-
ation (b) of the sides of the house (c). It did not of course occur to the boy to follow
his visual impression and lean them in towards one another. But he was probably
troubled by the restrictions imposed by his drawing surface. Without being questioned
he explained in defence of his drawing: 'I can't draw the sides of the roof in any other
way, otherwise I'd have to pull them towards me like this [away from the paper, he
illustrated what he meant] through the air.' I have been told other similar stories.
Other children thought of pushing lines through the paper, in other words of trying
to conquer the resistance of the drawing surface, in order to render objects. Thus it
can be seen how important a part the sense of touch can play and how accurately
the forms of objects can be perceived, although the lines of the drawing still give us
no sense of their direction. It must be taken as certain that Egyptian pictures without
depth gave Egyptian viewers sufficient indication as to which lines they should men-
tally adjust into the directions the artist wished, provided that they knew or could
deduce the nature of the objects.

It should not be forgotten that I have only been considering touch as a means of
understanding the disposition of a line, not as the exercise of a special feeling for
physical form, which is related to the plastic sense discussed on p. 75, and which,
like the plastic sense, the Egyptians only possessed to a limited extent.

4.2.3. Isolated objects with several component parts

If a simple object is to be incorporated as part, or part of a part, into a picture it
is still treated in the same way.

Here again the simplest solution is, when possible, for a dominant view of the whole object, which includes all its essential characteristics, to be incorporated in the artist's image of it. In this case also there is of course the condition that the spectator's gaze should appear to be perpendicular to the main surface of the object. In many cases this will be in a side view, not a front view. This is especially true of most quadrupeds (pl. 29), and pictures of them are so immediately understandable to modern eyes because the side view generally shows what is essential to characterize an animal. Similarly chairs and benches are most frequently shown from the side, as can be seen from pp. 138–9.

It is curious that even someone used to drawings faithful to visual images can understand very easily the method of showing furniture illustrated in fig. 41, a method which also occurs in children's drawings, and which I call a 'pure lateral image'. The human eye never perceives a chair in this way. Rather, Egyptian art and a finished blueprint arrive at the same end from different premises. When a modern technical draughtsman wants to give a theoretical justification of his methods he says that he postulates a view from an infinite distance. But if one were to be led to use the term *Fernbild* [distant image] to describe Egyptian drawing this could only be done with the reservations necessary when any modern technical term is used to describe Egyptian procedures, as the notion was quite foreign to Egyptian artists. Their pictures evolved their form simply because everything that was foreshortened around the frontal image of the main surface was invisible to the draughtsman's inner eye. If an artist reflected on the problem he might well have explained it by saying that in his drawing of a table the legs were invisible, as they were hidden behind the others. At any rate, my son, who drew fig. 54 when he was six years old, answered my question as to where the two other legs of a table drawn as in fig. 32 were by saying: 'behind'.

It is probably for the same reason that children who have drawn a human head viewed from the side correctly with only one eye, turn the paper over and draw the other one in the corresponding position on the back, before turning it over again to continue drawing.[43] It can be seen that, in this case as in others, the image-based draughtsman knows perfectly well how the physical model is made; and that is the only matter at issue here, not for example the act of turning the paper over. This explanation of 'behind' applies to the high columns in fig. 108 (each of which stands for a whole receding line), as well as to other similar phenomena. Pictures of chairs and beds where all four legs are visible occur very rarely indeed in Egypt, more frequently in drawings by children of a certain age; they are a realization of the idea 'the object has two legs next to each other at either end' (fig. 55). In precisely the same way two supports are shown in front of a throne canopy of King Na'rmer (fig. 56), not because the artist had in his mind a view from an angle where the stakes were close

FIG. 55. Meat table with four legs. NK

[43] Levinstein (1905.15) and several other observers.

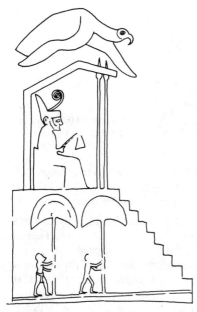

FIG. 56. The king is on the high throne; next to
it are standard bearers; a vulture goddess is
hovering protectively above. ED

together, but because he had the idea 'this roof has two supports in front.'[44] Similarly
with three-legged stools there is an idea that one of the legs is opposite the other two
(fig. 57c), unless it is desired to emphasize the equal separation of the three (fig. 57a–b).

 a b c

FIG. 57. The principal Egyptian
methods of rendering three-legged
stools.

The similarity in the positioning of the legs led Egyptians, as was mentioned above
(p. 56), to give four-legged chairs and beds a form approximating to that of animals.
So one might expect to find 'pure lateral images' in two-dimensional represent-
ations of animals too. The case of China, where bronze vessels of the early Han period,
around 200 B.C., were covered in pictures of bull hunts where the figures of the
animals, which are full of astonishingly powerful motion, all have only two legs
(fig. 58), shows that it is possible even for an art of great quality to attempt something
of the sort on a large scale. This happens only rarely in Egypt, with short-legged
quadrupeds like the crocodile �æ⟩ or ones lying with their front paws stretched out

in front ⟨æ⟩ (fig. 59), or with animals sitting upright (⟨ᵯ⟩). With long-legged stand-

ing animals a form is always chosen which allows us to recognize that all four legs
are in a walking posture.

[44] This should not be confused with pictures like Erman–Ranke 1923.68, where throne
canopies on different types of columns are fitted inside one another.

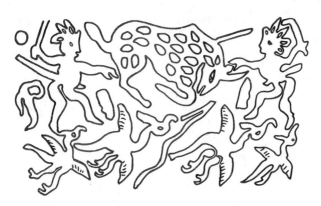

FIG. 58. Chinese bronze vessel of the Han period.

Two-legged creatures also repay attention. Here we find pure lateral images with kneeling (fig. 97a) or squatting (fig. 136) men, seated birds ⚹ (fig. 253), tadpoles ⚹ , etc. But in general both the legs of two-legged creatures are visible too.

Occasionally, none the less, standing long-legged quadrupeds with only two legs visible (fig. 48),[45] and human beings with only one (like pl. 60) are found. These are not living beings however, but cult images which retained their original free forms, which were definitely intended by their creators as normal sculptural forms, throughout the historical period. Drawings of them therefore belong in the same class as the even stranger forms of some sacred animals like seated falcons (fig. 60), crocodiles (pl. 36 mid.) and seated jackals (Sethe 1930.8 ff.); in all of these the front legs are subsumed in a plain unworked block.

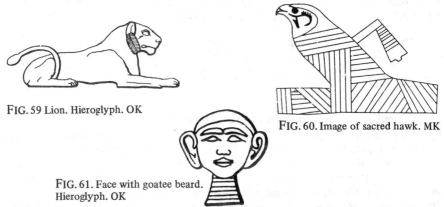

FIG. 59 Lion. Hieroglyph. OK

FIG. 60. Image of sacred hawk. MK

FIG. 61. Face with goatee beard. Hieroglyph. OK

Later Egyptian art sometimes reinterpreted constructions of this sort, showing the creatures wrapped in bandages like mummies; in other words, they were no longer felt to be natural. At any rate the forms always chosen for drawing living men and long-legged animals exhibit all their legs.[46] Two-dimensional figures of seated human beings are a reminder of this: one leg is almost always placed slightly forward of the other to give life to the picture (fig. 168 and *passim*). The fact that this is not found

[45] Jackals with four legs 🐕 occur (Petrie 1901.15, 109) as well as ones with two, as in fig. 48. (Reference supplied by Siegfried Schott.)

[46] The dogs on the edge of pl. 5 do not belong in this context, as the second pair of legs is on the other side of the palette, which is decorated on both sides.

in seated statues of human beings should not lead us to deduce that the mental attitude of the person represented is different, since the inner connection between the seated person and the one approaching with gifts and wishes is the same, whether we imagine ourselves to be living visitors in front of the statue or people merely depicted in front of the relief or painting. It goes without saying that the drawing of the two calves of the leg is not any sort of oblique view.

Up till now I have assumed that the several parts composing an object all lie in the same plane, or at least in parallel planes, more or less like the eyes of a face seen from the front in relation to the plane of its largest outline (fig. 61). If this is not the case and the basic orientations of a composite figure are in different intersecting planes, as for example with oxen ⛎ (pl. 28) the horns are in relation to the skull, each of the parts is again incorporated into the image, mostly with smooth transitions from one view to another, and treated individually in the same way as we have seen happens with independent objects, so that the picture has the same appearance as if the chief surfaces of all the parts, even the ones moving away from the viewer, were in an identical plane to the picture surface.[47] Apart from the ox horns the human face seen from in front (fig. 61), to which the ears are added unforeshortened rather like the handles of pots (fig. 65), may serve again as an example. An additional element that is strange to us is that temples are also spread out over the picture surface (pl. 80), so that all Egyptian faces shown head on look too broad at the level of the eyes.[48] The nose has both its passages in this case, so it is also seen from in front, and its ridge is mostly defined by two vertical lines. Two Middle Kingdom pictures of hoes make a very neat comparison. The first (fig. 62) shows the lashed-on blade in a side view like the handle, while the other (fig. 63) gives it in a full front view. Depictions

FIG. 62. Hoe with blade lashed on, in side view. MK

FIG. 63. Hoe with blade lashed on, in front view. MK

like the second, which are extremely common in Egypt, could be called *wechselseitig* [side-changing] after Krahmer, as the draughtsman as it were changes his viewpoint for almost every one of the numerous elements. He may actually do this occasionally, but in the vast majority of cases the shift in viewpoint will take place unconsciously and entirely in the mind, by selection of a particular one from the large number of images which he retains.

[47] In Egyptian art the 'half-moon' view of cattle horns dominates from the Old Kingdom on. On the slate palettes they are drawn in this way, or both bend forward next to one another (Capart 1905.236 top [L-H pl. 3 bottom R (J.R.B.)]) I only know of one case, the pendant Berlin 13797 (Scharff 1929.83 no. 113) where the horns are shown in a pure lateral image' as is normal in the Near East, and its provenance from Egypt is not documented. In the eighteenth dynasty horns bent forwards next to one another occur again, but almost always in pictures of bulls or objects with bulls' heads that come from the Mycenaean cultural area (cf. Müller 1904.49/161). This method of drawing is only rarely taken over for other pictures (Champollion 1845 pl. 17). This leaves undecided whether the reason for this change is a change in artistic form or a new breed of cattle. [Cf. more recently Kantor 1947.]

[48] Pietschmann in his translation of Perrot–Chipiez 1882–1903 (1884.865).

To sum up, we may represent the mental processes of the pre-Greek draughtsman thus: a man has in him a more or less fluid image of an object in the outside world, which has been produced unconsciously and without reference to a particular work he will later create, and in which everything is contained, everything the object in question has stimulated in terms of individual sense images, and also of feeling and thought. An artist's 'inspiration' (conception), when his work dawns on him and he 'receives' it, is not a mosaic of parts but maintains the original relation between the various constituent elements. But during the actual making of the work the frontal images, which up to that point have remained separate, undeveloped, and passive, are evoked, clarified, and ordered together according to the artist's particular image of the structure of the objects, and then turned into the creative 'shape' of the work of art, in which they again become a whole which is more than the sum of its parts.[49]

As the closeness and the nature of the links in the chain of images can be very different in the same man at different times, even if the model that is to be reproduced is constantly and physically present, visible in the one way only, before the artist, we can never predict what part of the object will be reproduced in what view. A pre-Greek draughtsman produces[50] a picture of an object with several parts by following and recording the individual frontal images he has at his disposal; it might almost be said he writes them down. It is a pity that in the German language we no longer have, instead of the borrowed *schreiben*, the old German word which meant both 'to write' and 'to draw' and which corresponded to the English 'write'.

It will help our understanding to add here something of what philosophers have to say of images (Windelband 1919.2.17), and of the formation of concepts: out of the vast mass of signs in reality only a small number enter our perceiving consciousness, and it is clear that all the image structures which are used by our recognizing faculties have in themselves a partly unconscious, partly conscious selective function.[51] The simplest way of making this clear is perhaps to consider what actually constitutes an image of any object. We have seen it in many changing positions, but our total image of it is restricted to a relatively minute proportion of all our individual observations. So the image we have of it is a selection. Now if we ask ourselves what the criteria were, according to which this as yet purposeless selection was made, we shall generally find exactly the same interests determining it as guide us when we contemplate the object with a conscious purpose. What interested us in it, was most noticeable to us, and stayed in our memories, was what could be important for its relationship with ourselves and other human beings; anything which did not tend to define such a connection was indifferent to us, and even if it was fleetingly grasped it was forgotten again afterwards.

[49] Stumpf (1918.57): 'The task of imagining the front and back and the entire surface of a human being strictly simultaneously could only be accomplished with the aid of non-visual knowledge.' And earlier: 'Is it possible to imagine one's entire surroundings at once in visual terms as a unified spatial image? In such a case I think we are aware that when we turn round on our own vertical axis we have a coherent and recurring set of appearances. Precisely in the field of notions of space not only visual images but also pure concepts and abstract knowledge are combined, in many cases very closely, with the sense data received from outside.'

[50] On the 'structure' of remembered images in literature cf. Dilthey 1924.172 bottom.

[51] Schneider (1907.77) discusses the formation of visual concepts. [Modern scholars often stress the visual quality of Egyptian thought (J.R.B.).]

Thus our involuntary formation of images is itself characterized by a selection of the 'essential', and the images we produce by conscious reflection are still more so. The academic term for such an image or idea is 'concept' [*Begriff*], and every concept is a new and selective product of the consciousness. If we evolve for ourselves a concept of any object at all, a tree, a chair, or a dog, not only a genre, but one of an individual object, we do it by emphasizing the separate distinguishing marks either of a single impression or of several impressions stored in the memory. But this only ever happens, and can only happen, to a small proportion of the manifold impressions which we receive and can never entirely grasp, and we then associate the distinguishing marks we have selected, thus producing a unity which is then our concept. This concept is the result of an analytic selection and synthetic reuniting of our perceptions. So the content of which we have an image is never a simple copy of reality, an illustration of the object, it is a product of selective and associative thinking.

Returning from philosophy to art we may feel that the comparison has been useful, but we must bear in mind that it applies primarily to the subject-matter of a work, and scarcely at all to its strictly artistic aspects.

We can see the serial evocation of images in all its simplicity in the drawings of small children and primitive people, and also in those of many modern adults. My five-year-old daughter wanted to draw a dog that was lying next to her chair with its head turned away from her. The picture (fig. 64) looked strange indeed. She

 FIG. 64. Child's drawing: dog.

explained, moving from front (right) to back: nose (the dot), jaw with teeth (the zigzag line) in the quadrilateral with the form of the head, ears, collar. The drawing is not a picture in our sense of the word, but an enumeration of the parts which impressed themselves on the child's attention, more or less correctly ordered spatially but only indicated by 'signs' that are scarcely reproductions. The parts are not even united by an outline. The whole could be understood as a physical expression of the sentence: 'the dog consists of nose, jaw, and so on.' After the neck the girl's enthusiasm gave out.

But it is noteworthy how the picture is linked despite all this to its model, as the eyes that are missing could not be seen by the child: on the other hand the dog's teeth, which were not visible while she was drawing, but were understandably a firmly rooted part of her image, are shown very prominently. The wavy line above is also worth noting: it shows that this kind of drawing method is still possible at an age when picture books, which normally show things in perspective, would already have been able to exert an influence; the zig-zag was in fact meant to represent, like the captions beside the pictures, the name, in other words 'writing'[52] This sketch (whose creator, like the artist of fig. 35a, later developed a very good sense of form) is of considerable value for an understanding even of the works of fine

[52] The American Indian drawing in Koch-Grünberg (n.d. pl. 57) has an exactly similar 'name'. The man drew in the field-worker's sketch-book, in which genuinely explanatory captions had already been written.

pre-Greek artists. Of course, their much greater sureness of grasp in the rendering of nature is no longer satisfied with unrelated indications of this sort. Not only are their works inwardly more complete and outwardly more finished, they also have an artistic unity of construction and form. The parts of living creatures are placed beside one another in a more natural order so that, where the tendency to flowing lines and supple movement of the limbs dominates, one is tempted to speak of organic composition.

But with its juxtaposition of parts their procedure always remains basically the same. If we follow the idea expressed above by the comparative use of the word 'write' to describe pre-Greek drawing it is fair to talk of the spectator's task as one of 'reading'. And in fact *we can approach the content of depictions based on frontal images best by reading off the content of their parts as enumerative statements,*[53] just as we did with the head of the dog. For a time Wulff used the word *Sehbegriff* [visual concept] to describe drawings of this sort.

When I took the glass of fig. 35b, mentioned above, away from the boy and replaced it with a cup (fig. 65), the idea that the vessel was round still gripped him so strongly that the picture was again a simple circle, the only difference being that the handle was added in a full frontal view.

FIG. 65. Child's drawing (a) of a cup (b).

Corresponding procedures can be found everywhere both in children's pictures and in any art based on frontal images. In these cases it is of no avail to look for a single natural view of the subject which might have been in the mind of the artist. We must try to read his image or idea off the picture and be content with that: 'the cup is round and has a handle on one side.'

In this way it is also possible to understand correctly Egyptian drawings of chairs where the flat surface is shown in a full view from above on top of the side view (fig. 122); 'the framework with the stretched leather seat is placed on the legs'. Even when people are sitting on chairs,[54] and therefore in reality covering the surface, the method is the same, according to the idea: 'the person is sitting on (over) the surface.' This method of representation is only found in the Early Dynastic Period and the early Old Kingdom; it was abandoned later on. But in New Kingdom religious art there are still beds with figures squatting on them shown in the same way (fig. 66).[55]

[53] Davies (1903–8.6.36) recognized this correctly in a single case, for drawings of horses. Bühler (1924.296) refers to the fact that the formation of declarative and evaluative language precedes the beginning of drawing.

[54] Propyl. 248.2 [Smith 1946 pl. 33a, Baker 1966 fig. 50 (J.R.B.)]. In these pictures the surface is shown as being narrow, as the picture has to conform to the length of the seated person's calves. Even in an empty chair, as in fig. 122, the height of the surface, which will probably be square, is reduced, perhaps because people were accustomed to pictures of chairs with narrow seats through seeing ones that were occupied. Cf. p. 168.

[55] Probably as a result of an early reinterpretation the single bed of fig. 66 has become two standing one on top of the other (Naville n.d. pl. 51), or (ibid. pl. 53) a bed with a box

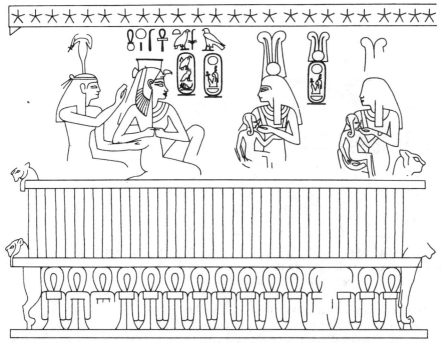

FIG. 66. Scene after the birth of the king and his *ka*. On a bed, with the sky above. NK

In terms of content this is the same as if a sledge with a load on it is drawn like the hieroglyph ⳥ . [56] As is known from preserved examples of the object the sign represents a simple flat sled, not one with a high superstructure; the apparent vertical sticks are in fact horizontal beams. In cases where the artists needed to show the back of a chair its whole width is depicted above the side view of the underneath framework (fig. 67, especially the chair on the right).

FIG. 67. Egyptian drawing of chairs with backs. OK

standing on it. Compare also what the early picture fig. 120a has later become (Borchardt 1926.34). [Cf. for details Brunner 1964.38–42, where the form is taken to be a later misunderstanding of an archaic picture (J.R.B.).]

[56] Davies 1920 pl. 19. Cf. n. 54 for narrowing.

FIG. 68. Donkey with twin
pack-bags. 1st Intermediate

A painter had to show a donkey with pack-bags hanging down on both sides and tied
to each other over its back. In the picture (fig. 68)[57] the pack-bag next to the viewer
is hanging in its correct place; the other appears to be standing upright on the donkey's
back like a basket. The whole picture can easily be confused with ones showing
donkeys carrying burdens on their backs as well as others slung over their sides.[58]
One might compare this with the part of the table-cloth uppermost in fig. 32, which
also in reality hangs down behind the table. The artist who drew the double bag was
concerned only to show that a second equivalent bag corresponded to the first one.
Anyone who looked at the picture would know where the second bag hung. Fig. 32
places the overhanging parts of the table-cloth all round the table surface.

So the parts of a composite object are often, in comparison with the drawing
methods with which we are familiar, very strangely arranged on the picture surface,
and this applies not only to the main axes and surfaces, but also to the relationships
of 'behind, in front of, above, and next to'. As a result we are of course often at a
loss when we want to translate an Egyptian picture into physical reality, because so
many pictures can be interpreted in more than one way.

Let us discuss one or two especially instructive examples.

Anyone looking at the chair in pl. 51 would deduce from it that the leg struts of
the model linked a front leg and a back leg. But in preserved chairs there are normally
only struts between the front legs and between the back legs (fig. 69); and that is what
will be meant in the picture. It can be seen that the Egyptian artist is satisfied if he
conveys the idea 'the legs are held together by struts' and he leaves it to the viewer
to decide whether they are in front and behind, on the right and on the left, or on
all four sides. In the New Kingdom there were stools whose surface was invitingly
curved in one (fig. 70L) or in two (fig. 70R) directions. In Egyptian drawings (fig. 71)
both have the same appearance. If the rods which linked the bottoms of the legs of

[57] [See Sources for Text Figures. Another parallel is Winlock 1942 pl. 17, also from the First
Intermediate Period. Note that in this case the artist refrains from complete symmetry. This
method of showing a donkey's load is probably a peculiarity of the period (J.R.B.).]

[58] Erman–Ranke 1923.518. The picture in Wiedemann (1920.365) does not belong in this
context, as the sack is being unloaded (*Beni Hasan* 1 pl. 29 = LD 2.127 [Smith 1965
fig. 170 (J.R.B.)]). The man who is grasping the upper half in the complete picture must
not be overlooked.

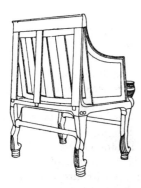

FIG. 69. Modern drawing of a NK chair

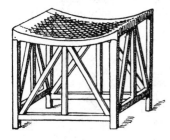
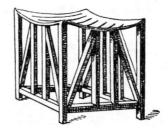

FIG. 70. Modern drawing of a NK stool with the seat curved in one plane (L) and in two planes (R).

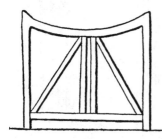

FIG. 71. Egyptian drawing of chairs like fig. 70. NK

collapsible chairs or faldstools had the simple form of smooth tubes, often all that was drawn, just as it would be in a modern working drawing, was the disk-like end of the rod (fig.72). But if these bottom rods had ducks' heads which it was felt worthwhile to render, the picture looked like fig.73, a form that could of course also have served for the smooth rods. If a modern carpenter was asked to make a collapsible chair on the model of fig.73 he would probably want to place the heads in the same plane as

Egyptian drawings of collapsible stools (NK)

FIG. 72. with plain base rods.

FIG. 73. with base rods in the form of ducks' heads.

the crossed legs, if preserved chairs with ducks' heads had not shown him that, as with the other stool, the heads linked the two crossed pairs of legs. But pictures of collapsible chairs provide pitfalls for our understanding in other ways too. For example, we could not deduce from fig. 72 alone whether the tail of the panther skin really hung down over one of the crosses or between the two of them. Both could only be rendered as in our illustration. Preserved chairs with fixed skins decide in this case in favour of what it suggests.[59] Nor is it possible to deduce from a picture of a collapsible chair with a man sitting on it[60] whether the crossed legs are really as they appear to be in the picture, beside the user, or in front and behind.

Pictures of cupboard-like shrines with open doors are often found. One would assume on the basis of a drawing like pl. 27 [or fig. 75] that the opening of the chapel was above one of the runners of the sledge base. But it is of course between the two of them, facing the man who is censing, and it is only because this artist was attracted by the image of the symmetrically opened doors and wanted to show

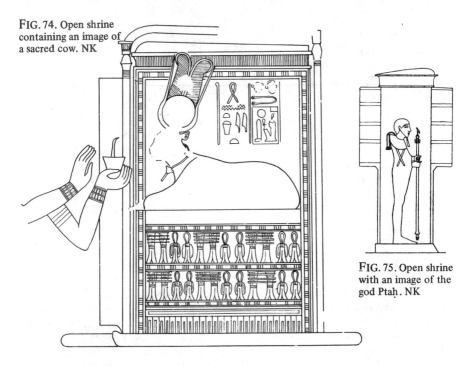

FIG. 74. Open shrine containing an image of a sacred cow. NK

FIG. 75. Open shrine with an image of the god Ptaḥ. NK

the statue inside the shrine that his drawing took on this particular form; others give a side view and seem to think of only one door (fig. 74). Again, we cannot deduce from this drawing alone whether the door in fact had one or two leaves. If the artist wishes to emphasize that the door has two leaves despite his side view, the back corner post becomes in his hands the second front post, and he attaches the second leaf to it, so that it is now in the same position as the one seen from in front in pl. 27. If one

[59] [i.e. that the duck's head hangs over one of the crosses (J.R.B.).]
[60] Propyl. 381.2 [L-H pl. XXXIII bottom L compartment (J.R.B.)].

were to understand the drawing of a tomb chapel in pl. 65L, or its early Christian counterpart in pl. 105, as being a reproduction of the visual impressions, it would be necessary to assume that the steps did not lead to the main doors but to invisible ones on the sides. In fact of course they lead to the ones in front. Drawings of the resurrection of Lazarus of the same date, which reproduce visual impressions, show clearly the relationship of the door and the staircase.[61]

There is a type of sarcophagus (fig. 76) whose form is derived from that of a building.[62] Their lids are in the form of barrel vaults which rest on the longitudinal walls and are contained between walls on the short sides that rise above them. Therefore the curve of the arch cannot in fact be seen in its entirety from any point of view. But if an Egyptian artist wishes to render a roof of this sort and he sets any store by the arching,[63] his picture can only look like fig. 77. This picture is chiefly based on the long side view, but the entire curve of the arch is shown in this context, as if it went from one containing wall to the other. Now another form of sarcophagus

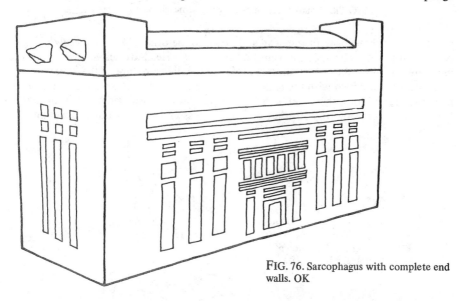

FIG. 76. Sarcophagus with complete end walls. OK

developed from this older one with solid end walls (fig. 76); it only occurs in wood (fig. 78) and has no complete containing walls, only posts at the corners. An Egyptian drawing of this too could only look like fig. 77.

From the New Kingdom on Egyptian kings are frequently shown wearing a hat-like crown which is composed of two different parts, a round one in front and a flatter one behind. They meet at a long sharp ridge that goes obliquely upwards from

[61] e.g. Wulff 1913–14.1.185 and *passim.*
[62] The oldest structure with this form (Capart 1905 pl. 1 [?]) has details (vertically divided end walls and arch and cross-hatched vaulting) which may suggest a different building material from brick; cf. the cross-hatching in fig. 114 (do these huts have domes or barrel vaults?) and p. 54.
[63] Cf. pp. 96–7, the remarks on fig. 42.

FIG. 77. Egyptian
drawing of figs.76 and
78. Hieroglyph. OK

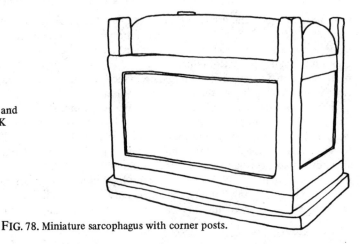

FIG. 78. Miniature sarcophagus with corner posts.

one temple over the back of the head and down to the other. This 'blue crown' can
be of great beauty, although this is not often the case. Head-dresses are always shown
in a pure side view. But if it is meant to refer to the divine nature of the king who
wears it, it is combined with the animal horns and ostrich feathers which we know
from pictures of gods; these can be seen from statues to project sideways from the
head. But in a drawing (fig. 79) they appear to blossom forth in front and behind.

FIG. 79. King wearing the 'blue crown'
with horns and feathers. NK

However, the physical composition of this becomes clear the moment we express its
content in words: 'the crown has an ostrich feather upright and a crooked ram's
horn horizontal on its right and left, which follow the direction of the shoulders.'
Sometimes in addition to these horizontal horns others are curved downwards; while
fig. 80a only shows that they hang down beside the head, fig. 80b also indicates that
they frame the face.

Now let us imagine that the artist wishes to draw a man carrying a long bundle of
papyrus in such a way that it lies *diagonally across* his back, held from above by the
arms reaching backwards. If the idea that the bundle was at a *diagonal angle* to the
carrier's body was uppermost in the artist's mind he would probably draw it behind
the body and at an angle to it. But then a viewer might think that the man was
carrying it sideways on his hips. Thus it happened that an artist, in whom the idea

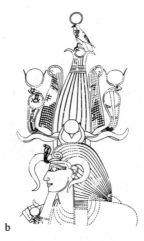

FIG. 80a. Horned crown. NK
b. Horned crown. NK

a b

that it was *on the carrier's back* dominated that of its diagonal angle, chose the dis-
position we see in pl. 39, although the axis of the bundle, contrary to the facts, is
now parallel with the body. But the positioning of the arms shows what is meant.

With all these examples we must assume that artists in periods where various forms
existed side by side in reality would certainly have found a way of distinguishing
between possibilities in two-dimensional representations, if they had wanted to. In
a large number of cases we can observe varying methods, in others we must abstain
from judgement.

Closely connected with the image-based method of constructing pictures is the
fact that in Egyptian art parts of a figure so often fail to *overlap* or *obscure*[64] each
other, where this would be expected if it was assumed that the figures were real
views. Thus, to name only one or two examples, arrows, spears, and sticks pass behind
and not in front of the face or the body of their user, and the struts of a small frame-
work chapel by the river avoid the body of the sacred crocodile inside it (fig. 81),

FIG. 81. Shrine with an image of a sacred crocodile. OK

as if they were taking care not to spoil its image. This is not a hard and fast rule,
as there are other cases where the same things follow the visual impression and cut
through the body.[65] And, it is worth noting, already on the late predynastic slate

[64] Sponsheimer (1928) studied overlapping.
[65] Figures cut through by the posts supporting a bed canopy, LD 2.14a; not cut through,
Davies 1902.2 pl. 23.

palettes, overlappings of the legs of human beings and animals define which limbs are nearer and which further away (pl. 4). At the beginning of the Early Dynastic Period even the tail attached to the king's loin cloth, which mostly hangs down from the belt away from the body, disappears behind one leg and reappears lower down (pl. 8–9). The decision as to what should be cut through and what should cut is entirely dependent on what is the dominant element in the artist's image.[66] This explains why parts of the landscape like trees and bushes almost always disappear behind human figures. When there are no overlaps people speak far too often of an 'aversion' to them. But their original absence and gradual adoption are in fact the result of an over-dominance of the idea or image and subsequent increasing approximation to what the senses perceive. Mostly overlaps will not have been present in the artist's image. A picture like pl. 22, which shows a papyrus thicket, can have several meanings. The figures are standing in front of a wall of stems, and the hippopotamus hunt shown here may indeed have taken place on open water at the edge of the thicket. But even if we were to transfer the action to a clearing surrounded on all sides an Egyptian picture of the scene would look exactly the same. It should not be said that the Egyptian removed huge masses of papyrus in front of the figures from his image, because he would not notice them as concealing the action. He wants to say 'the figures are surrounded by papyrus', and for him and his contemporaries that would be expressed in a picture that frames the action with plants. The viewer was able to decide between the two possibilities because he knew about hippopotamus hunting, unless the close connection between the hunt and papyrus thicket was enough in itself. With such pictures most, and, it is probably fair to say, better artists were well able to appreciate the attractiveness of the calm pattern of papyrus stems, composed of dense straight lines, as a background for the main action and for the other men and animals who give life to the thicket. But other artists did not feel the same way. Perhaps because the thick lines seemed too restless and distracting to them, or for the sake of convenience, they inserted a uniform green surface in the thicket, so that it sometimes looks as if a green curtain has been stretched out in front of the lower part of the papyrus thicket (fig. 82). Since, as shown on p. 101, no Egyptian picture gives any idea of the depth of the model by the disposition of the lines in an object, all obscuring and overlapping only attempts to indicate to the

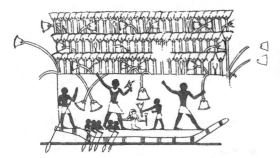

FIG. 82. Hunting birds in a papyrus thicket. MK

[66] According to Sponsheimer (1928).

eye that two objects are, from the point of view of the spectator, in front of or behind each other; that is something quite different from the creation of spatial depth and the like.

The description of the way in which a pre-Greek draughtsman turns his attention to the individual images which are associated to make a 'vision',[67] and the explanation of the formation of these images or ideas, both show that we should not expect always to find as great a number of the distinguishing marks and parts which would have been at the draughtsman's disposal as we might wish. It can be seen with children and with adults who have not been taught to draw, that the memory or the interest of the author often fails, and it even happens that parts which are necessary to the living organism are left out. Thus pictures of human beings sometimes lack a mouth, eyes, even arms and legs (fig. 85). Egyptian drawings often enough do not satisfy our desire for conceptual comprehensiveness—one only has to be reminded of the absence of toes on one foot (pl. 21, cf. p. 295). But in general a fair proportion of what is necessary to identify the commonest creatures and objects is recognized and incorporated into the picture.

The counterpart of the absence of parts is the *rendering of too many parts*, going beyond the rendering of a visual image; this is much more frequent in Egyptian art. It often happens that the knowledge, or rather the mass of individual images which crowd to the surface of the artist's mind, play him what is to our eyes a nasty trick. But it is part of the basic character of depiction based on frontal images not only that the parts of the model that appear foreshortened in the visual image are rendered unforeshortened, but also that things which are invisible in a given visual image are shown; parts which could never come together in a visual image may be seen simultaneously. Thus children draw human faces in profile but with two eyes, just because they are following through the idea: 'a human being has a round head and a jutting out nose, which I am now drawing, and two eyes I add thus.' In his *Maler Klecksel* (1884)[68] Wilhelm Busch already showed the way to an understanding of pictures of this sort by saying: 'two eyes are always depicted because he [the child] *knows* that they have them.' The meaning is doubtless the same when in Egypt we find a side view of a a cow with two eyes scratched on a pot, (Petrie 1903 pl. 12 no. 277), or even, in a relief, if a provincial one, a cow with two nostrils although the head is in a side view

FIG. 83. Side view of a cow with two nostrils. 1st Intermediate

FIG. 84. American Indian drawing: animal with its eyes next to the head.

[67] [*Schau*, i.e. the image of a natural form conceived as a whole (J.R.B.).]
[68] i.e. before the appearance of Corrado Ricci's famous book *L'arte dei bambini* (1887), to which this discovery is mostly ascribed; cf. Bühler 1924.266. He adds however: 'but this was not in fact entirely original, as Fröbel already realized it.'

(fig. 83).[69] And we have examples from primitive peoples of drawings of objects, whose parts are placed without context outside the outline, for example animals whose eyes are on their own next to the head (fig. 84). If we follow our procedure of reading the succession of images in the man's mind off the picture, and putting it into words: 'the animal has a head—there it is—and on either side of the head an eye—there they both are', the strange picture becomes comprehensible to us. In mature Egyptian works such things are long past. The pictures of cows mentioned above should be termed art as little as we consider the pictures on poor-quality shop signs to belong to our perspective art. But then, are the open chapel of fig. 75 and much of what has been discussed in this chapter so very different from a side view of a face that shows two eyes? Fig. 45 may remind us that an art like that of the early Han period in China produces in its reliefs of fighting bulls and lions something similar to the heads of those Egyptian cows.

The following examples show that the form of an image can even suggest something that goes beyond a simple mental image: Balcz pointed out that when craftsmen are shown at work the object on which they are working is always represented complete, even if it is still unfinished and in the hands of the workman. In both two- and three-dimensional representations of the earlier periods women's clothes are shown fitting close to the body (p. 121). But New Kingdom dress, which can be seen from painting and relief to hang loose, is still represented in statues of women as if it were close-fitting [W fig. 555]. However, when an Amarna artist wanted to show the making of a statuette of the queen in a relief he clothed the figure in an ample flowing garment (Davies 1903—8.3 pl. 18). In other words it was the queen herself, and not the statue the artist produced, who was drawn.

The excess of content in an image as against the visual impression sometimes results in the opposite of the absence of overlapping: 'false overlaps'[70] occur; this can only mean that the artist made different decisions as to what was important, and therefore not to be concealed, and unimportant, what was permissible and what was not, from the ones we make, and the result is particularly offensive to our eyes. Thus in pl. 33 our method of drawing would require that the heel of the kneeling leg disappear behind the calf of the stretched-out one.[71] But many artists cannot resolve to do this. In their pictures the foot is placed falsely overlapping in a way that would not be possible in a visual image, in front of the stretched leg. But in artistic terms, especially if the foot is shown vertical and resting on its ball (pl. 59), these pictures are extremely effective.

If we were to view several of the representations mentioned above from the point of view of our own methods, we should have to say that they break the first basic law of perspective, that physical objects are opaque.

There are many other cases in Egyptian art where one seems to be looking through an object. A drawing by an adult South American Indian (fig. 85) will help us to study them; it is so strange in appearance that we could never guess its meaning without

[69] Petrie 1900b pl. 8. [In this context it is worth drawing attention to the occasional occurrence of perfectly normal pictures of horses with the heads shown full-face, which means in the case of a horse, in a forty-five degree view from above, cf. Cooney 1965.52—3. The stimulus to this form may be the desire to show the details of the harness (J.R.B.).]

[70] The phrase is to be found in Sponsheimer (1928).

[71] The group of fighters in *Atlas* 1.118 should also be examined closely for overlappings, which are hard to make out from the photograph.

FIG. 85. American Indian drawing: woman athwart a tree trunk.

assistance from the artist (Koch-Grünberg n.d. 23): a woman dressed in a long
hanging shift is sitting in a riding position on the trunk of a tree, which is shown,
correctly indicating the area of contact of branch and body, by means of two lines
between the anus and the genitalia. The picture is more coherent than the child's
drawing of a dog in fig. 64, but still extremely remotely connected with the natural
model presented to the eye, yet in the last analysis it achieves its purpose with a fair
degree of success. And this purpose is to give as precise information as possible about
the object, but of course only to the extent that knowledge makes this feasible and
the artist is interested. In this process the artist's inner eye saw parts that were
concealed from the physical one. Similarly, drawings of human beings or animals
by primitive people very often show the heart, spinal column, or ribs, or the navel
and sexual organs even of clothed figures. These 'transparencies' have been called
jokingly 'X-ray pictures'. I call them *'false transparencies'*.

This procedure is not in itself foreign to the works of Egyptian artists, even to
their human figures. It is true that in pictures like pl. 32 the ribs are not invisible
but forced out by thinness, and in most cases where people have thought they saw
false transparencies what we have are rather close-fitting or thin and diaphanous
clothes. The situation is quite clear where a man is wearing two loin cloths, a short
tight one and a long looser one (pl. 42). Then the part where the modesty garment
is under the long tunic is painted white to show that it is opaque, while the outlines
of the legs can be seen where they are only covered by the long tunic. So this is a
rendering of genuine transparency. In representations of the earlier woman's dress,
which consisted of a large piece of cloth wrapped round the body and held in position
by shoulder straps (pl. 26), there was a firm rule that the outline of the dress should
differ scarcely at all from that of the body, although the actual garment could never
of course have fitted so tightly. Here again there is no question of transparency. With
the loose female dress of the later New Kingdom, where it is often only the white
colouring that allows one to understand that the body, whose form is visible, is to
be thought of as covered in front too (pl. 47,R), there may be some doubt. We
should imagine that the light material often held close to the body and showed its
form in many places, either through movements or gusts of wind. It was left to the
individual artist which bodily forms he should select. In fig. 86 we have a certain case
of false transparency. Elsewhere Syrian garments are never diaphanous. But this
artist wished to show the sex of the prisoner on the left. Fig. 87 is another instance:
a priest is wearing a jackal mask as required for some ritual purposes, and his head is
visible inside, because the artist wished to show how the priest was placed in the

FIG. 86. Captive Syrian princes. NK

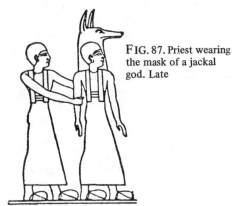

FIG. 87. Priest wearing
the mask of a jackal
god. Late

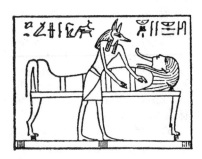

FIG. 88. The god Anubis tending to a
mummy. NK

mask and needed to be led. But that is a rare exception, since it never occurred to anyone to show the human head inside the very common figures of a priest dressed as a jackal-headed funerary deity who attends to the mummy (fig. 88) (see p. 202); instead the priest playing the role of the god is always represented as if he really had an animal head. Several terracotta masks of this type with holes for the eyes in the neck are preserved. The very attractive relief from Amarna, fig. 89, is a parallel case to fig. 87; here a man lies sleeping on a short bed under a blanket which covers him up to the neck.[72] The only cases I know of in Egyptian art where the interior of the body is rendered, as happens in the pictures of children and primitive people, occur in religious art. For example, in fig. 90 the young sun god is visible inside the body of the sky goddess, while in other contexts the Egyptians always limit themselves to indicating pregnancy by its outward characteristics 𓀘 . In the cryptographic writing known from the Middle Kingdom on, which intentionally provides riddles for the

[72] For a more precise study of the position of the body see p. 251. Davies (1921.224) considered that the top line might represent the edge of the mattress. But then the line would have to surround the head too. All the more so if, as Matz (1923–4[1925].25) rather strangely suggests, the picture showed an anti-insect net: would the man have abandoned his head to be bitten?

FIG. 89. Man sleeping
under a blanket on a bed.
NK

FIG. 90. The young
sun god in the womb
of the sky goddess.
NK

FIG. 91. Beaten vessel with hump in the base. NK

FIG. 92 a. Closed woóden box containing
 an ointment vase and a miniature
 cosmetic jar. OK
 b. Portable box containing a
 small stone eating table. OK

FIG. 93. Different Egyptian representations of washing equipment. a and c MK;
 b and d OK

reader, the word *jmj* 'who is in' is written as an egg ◯ with the sign for chick 🐣
inside it.[73]

The same of course occurs much more frequently with inanimate objects. Metal
bowls are found in a pure side view, yet the small hump in the middle of the inside
is shown (fig. 91). Objects in closed containers are visible (fig. 92),[74] and with
washing equipment (fig. 93d) the water pot can be seen through the basin in which

[73] Sethe in Northampton *et. al.* 1908 Appendix 10. In a Greek vase painting the twins are
 represented inside Leda's egg. See also the early Christian picture of Jonah in Schäfer 1928
 fig. 50. A modern example pl. 103.
[74] Many more fine examples in Quibell 1913.

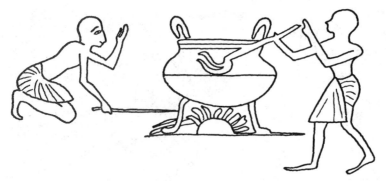

FIG. 94. Cooks busy by the pot. NK

it is standing. In fig. 94 the contents of the cooking vessel and the huge ladle with which the cook is stirring them can be seen. It should also be considered how, in pictures of grape-treading (fig. 95), the feet of the vintagers can be seen reaching down to the floor of the vat through the grapes. The chapel in fig. 74 is of course also a case of this. These examples are only a few among many.

If we look at fig. 85 more closely we notice that the bell-shaped garment is not finished at the bottom. So in this respect the drawing should be brought into association with a method that is not uncommon in Egypt, and which we normally call *section*, using an appropriate term borrowed from modern working draughtsmanship. In fact there can be no question of these being sections; such a detached approach as that of the working draughtsman should certainly not be attributed to the South American Indians. All that is meant here is: 'the dress, which is open at the bottom, hangs down on either side.'

In Egyptian art the most instructive cases of ostensible sections, many of which could naturally be interpreted just as well as 'false transparencies', seem to me to be representations of holes in the ground and similar phenomena. One of the hieroglyphs for a pond or a hollow filled with water is an open semicircle filled with water lines 〰, and similar forms also occur in New Kingdom landscapes (fig. 96)[75] next to pictures of pots whose images are based on views from above (fig. 34). A strange fact characteristic of the tenacity with which the Egyptians maintained a flat base line (p. 163) is that pits are never sunk into it but always placed on top of it. This can be seen in the New Kingdom picture just mentioned and in an Old

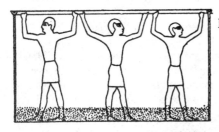

FIG. 95. Men treading grapes. MK

FIG. 96. Fortress by a lake. NK

[75] Spiegelberg (1930b.57) wished to interpret fig. 96 as meaning that the pond was inside the fortress. But his own reference to *Atlas* 2.41 and the observation of Albright's which he adduces show that the assumption is not necessary.

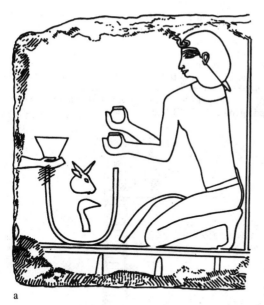

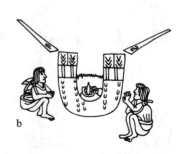

a

FIG. 97a. King offering over the found-
ation pit of a temple. OK
b. Offering pit in an early
Mexican manuscript.

Kingdom one where the king is offering over a pit in a temple foundation ceremony
(fig. 97a). This offering pit has a precise counterpart in Codex Magliabecchi, an Old
Mexican pictographic manuscript in Florence, fig. 97b. All we should see in these
'sections' is the idea: 'the cavity is surrounded for all its depth by something of
which a simple line gives a suggestion, or which a coloured strip shows to be the
earth.' In this light we can interpret correctly the similarly represented full baskets
in fig. 98R, or the wash-basin in fig. 93a, for which Neuss[76] was able to show there
are extraordinary parallels in Catalan manuscripts. But he saw wrongly in this the
influence of Egyptian art transmitted through Coptic art; these are in fact indepen-
dent products going back to 'pre-Greek' origins. The pictures of tomb shafts cut in
the earth (fig. 99–100), which remind one so misleadingly of architectural sections,

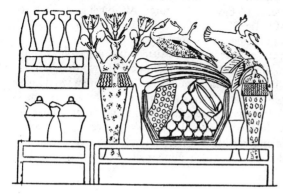

FIG. 98. Tables with jars, washing
equipment, basket and food. MK

[76] [1922, e.g. p. 56 (J.R.B.).]

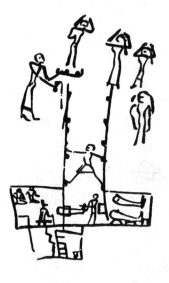

FIG. 99. Burial in a shaft tomb: at the mouth of the
shaft priests censing and libating, the widow and three
mourning women. A man is climbing up or down the
shaft. At the bottom are two lateral chambers and one
deeper one. In the right-hand chamber two mummies.
In the left one and in the shaft (probably in fact only
in the chamber) two priests, one in a jackal mask,
with a mummy. [Two further figures seated in the left-
hand chamber (J.R.B.).] NK

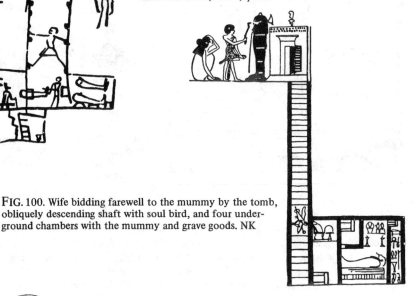

FIG. 100. Wife bidding farewell to the mummy by the tomb,
obliquely descending shaft with soul bird, and four under-
ground chambers with the mummy and grave goods. NK

FIG. 101. Hedgehogs in their burrow. OK

are now safe from false interpretation. For details, of course, it is necessary to re-
mind oneself here of the polyvalence of Egyptian pictures. Although a simple vertical
climbing shaft is certainly meant in fig. 99, fig. 100 could be a representation of a
staircase shaft. The artist would have imagined it looking at or down on to the step
because of the space into which the picture had to be fitted—it is placed between the
lines of a book; if he had had no such constraint he could have shown the shaft de-
scending at an angle with steps in it. We do not know what an Egyptian would have
done if the base line had not been indicated by a straight line, but by a wavy one as
in pl. 29. Hollows in the ground, in which lizards, hedgehogs, and other animals live,
can, if they are open to one side, be incorporated in such wavy lines.[77] Of course
the artists do not draw anything underneath the straight lines; they make room for
their indications of hollows and holes into which animals slip sideways by drawing

[77] A peculiar means of expressing the appearance and disappearance of animals that live in
burrows in painting in Davies 1930 (folio) pl. 48A top R.

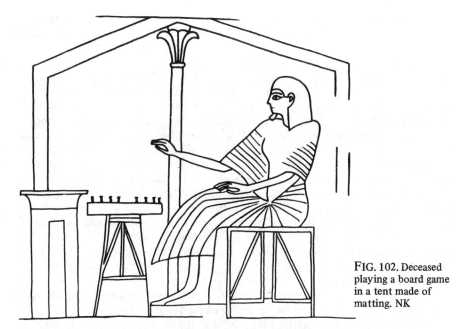

FIG. 102. Deceased playing a board game in a tent made of matting. NK

humps above the lines, a fact I shall return to on p. 239 (fig. 101). Taking the suggestion from pictures of this sort, the occasionally semi-pictorial hieroglyphic script playfully writes the words 'come out' and 'enter' with a crawling snake and its hole, which is suggested by a simple line ⌒.

Pictures of buildings where the artist is less interested in the ground-plan than in the vertical arrangement of the rooms and their contents are of a type close to that of the 'section'. Here the walls are contracted into narrow bands, which may be enough to indicate the material. This is the meaning of the rendering of roofs and walls, especially with tents made of matting as in fig. 102, where the walls are filled with the framework of stakes and bindings (e.g. Schäfer 1928 fig.10), which shows the surface of the mats, not a 'section' through especially thick mats, or even layers of them (fig. 156).

It should again be emphasized that it is impossible to speak of pictures that were intended as real sections through walls, such as were used to show the interior of rooms in Renaissance pictures, either in tent pictures like fig. 102 or in any other Egyptian picture of a house. Arbours open in front invite such an interpretation; the drawing consists only of a hatched band for the back wall and for the roof—which has no apparent support, for the side walls are not drawn—so that the picture looks like the structures in pl. 63. But fig. 103, which shows a walled-in altar on a terrace,

FIG. 103. Platform with walled-in altar. Beside it the ground plan to be deduced from the picture. NK

would certainly also be considered by modern architects to be a section drawing, except for the gate, which is seen from in front. Yet the pillar-like structure *b*, which indicates the girdle wall, is no more a section than is the drawing of the sides of the basket in fig. 98; and the screen wall topped with uraei *c*, which is intended to stop inquisitive eyes from looking through the door *a* (cf. fig. 107–9), is not the image of a section but perhaps of a side view.[78] The uraei at the top of the screen should be imagined to be either on the long front edge or, better, on all four sides. Nor should one be led to think that the method of showing many-storeyed buildings, sometimes with several staircases (fig. 221),[79] is sectional; pictures of staircases can easily lead one to think this. But, just as one can often see staircases climbing up the outsides of houses in modern Egypt, ancient Egyptians were used to imagining staircases, even interior ones, in side views which show the steps. It may be that genuine sections later arose, in a completely different technique of rendering nature, from an adaptation of apparent sections of this sort. This is not a purely verbal question. It would be just as absurd, perhaps even more absurd, to read our ideas of sections into Egyptian drawings as to apply the nominally identical concepts of modern science to corresponding pre-Socratic opinions about physical nature. The new science has taken over from the old the name of something to some extent similar, but the result is intellectually entirely different.

Let us conclude our treatment of 'sections' with a very noteworthy representation. Among the pictures of the sky on the ceiling of the tomb of Ramesses VI is a sun-boat seen from above (fig. 104). In the middle of the deck is a chapel with its god. In front of and behind it are large pairs of human feet whose heels are filled with ellipses, although it is not clear what the slab behind each pair of feet is—I suggest, without conviction, that it may represent the back pillar (there can be no doubt that these strange drawings are meant to stand for statues). One might be inclined to see the ellipses as sections taken a little above the ankle-joint, but this would certainly be wrong. As far as the rendering of nature is concerned the very common pictures of feet cut into temple roofs in the Late Period (fig. 105) belong to the same class;

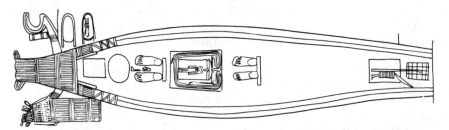

FIG. 104. Sun-boat viewed from above. On either side of the shrine standing statues are indicated by footprints. NK

[78] Compare with fig. 103 the picture of an estate with garden and buildings Davies 1903–8.2.38, pl. 36; also the drawing of a temple *Atlas* 2.171. The German picture in Schäfer 1928 fig. 14 shows how little even late medieval painters thought of sections and really imagined them as such: in it there is a hand on the apparent surface of a section in a wooden wall.

[79] Davies (1930) discusses the house in fig. 221 together with many other representations of many-storeyed houses.

FIG. 105. Different types of worshippers' footprints. Late.

these are meant to record that a devotee once stood praying there. As can be seen from the figure, these drawings are of several different types. In general it may be said that they are not, as happens in other countries, the soles of the feet, but represent with their sandal straps and toe nails what a man sees when he looks down at his feet, of course rounded at the back to give the invisible outline of the heel. Now since drawings of the footprints of worshippers can scarcely be meant to be sections, the ellipses must simply indicate the calves. On this analogy the indications of statues in fig. 104 can be removed from their misleading proximity to modern working drawings and placed in the correct context of the image-based ancient Egyptian mode of thinking and depicting (cf. e.g. p. 260).

Drawings of buildings can show us the way to *other peculiarities* of pictures based on frontal images, apart from what has already been mentioned. I shall briefly discuss the most important of these.

The sign 'house' in the Egyptian script is a black rectangle with a door opening ⊏⊐ . If we remember what was said about ostensible sections we know that the original meaning was simply: 'I have a room surrounded on all sides by something which I show to be made of Nile mud by using black colour.' A roofed room is not distinguished from an open courtyard. Soon it will also have been thought of as a ground-plan. Ground-plan drawings must have been early familiar to a race of architects like the Egyptians, who, as we know, used in the historical period to draw out any carefully constructed building beforehand on the levelled ground.[80] A number of pictures of buildings (fig.106) are certainly in the form of the ground-plans we know, and fig. 112 could, at least as regards its method of indicating the position of the columns, be incorporated into a representation of this sort.

FIG. 106. Ground plan of a house. NK (detail of a representation of a house).

If all buildings had been drawn this way the drawings would present no difficulties for the understanding; nor certainly does the predominant method of indicating doors, not as simple gaps in the walls on the plan (fig. 106), but by placing them on top of, or leaning them against, the lines of the walls (fig. 112), disturb us. But often it is desired not only to show the arrangement of the rooms and the imposing doors, but also to include rather more of the elevation, for example the roof and the columns. There could not of course be a consistent frontal image of all this, and so we often find here a 'visible representation of concepts' of such complexity that, in more

[80] As far as I know Borchardt (1896.72, 123) was the first to make this important observation; later he frequently reaped the fruits of it in his excavations.

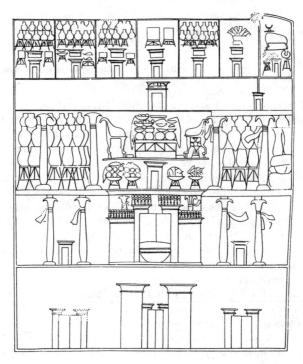

FIG. 107. From in front.

FIG. 107–9. Representations of the palace at Amarna. NK.

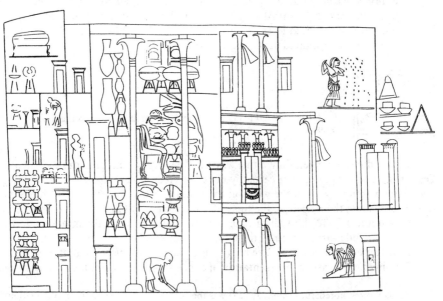

FIG. 108. From the side

difficult instances, we must for the moment give up the attempt to reach a precise understanding of the pictures.

Fig. 107 is one of the clearest pictures of houses, but only because the artist was fortunate in being able to show the house—it is the Amarna palace—from the front, in such a way that all the main doors fit on to the central axis. This is only possible if a building is not brought to life by human beings going in and out. For if that were the case glaring contradictions would arise: as in Egyptian art people only walk in the direction of the picture surface the people would all appear to be going past the doors. Mostly artists solve this problem by laying the house on one side (fig. 108). In this way people can go in and out through the doors, but the picture is much harder for us to understand.

Fig. 109 shows the ground-plan that can be deduced from fig. 107—8, without attempting to correct it by reference to actual remains at Amarna. The reader can use it to help familiarize himself with the two ancient pictures, and he will notice how many small problems of detail remain to be solved.

Some help can be given here: there are two instructive pictures from the politically unstable late Old Kingdom which show fortresses being stormed. In the first (fig.110a) we see shown in plan an elliptical surrounding wall strengthened by projecting towers. The artist has leant a storming ladder against it—he is able to do this because all he wants to do is to show: 'a ladder is leant against the fortress.' And for him his picture is more than a ground-plan; it is the *entire* fortress, even its character as a high building. And if the height of the walls is not visible here, in the second picture (fig. 110b) we see a substantial part of it, although it curves over at the top. At first one would be inclined to take this curve for an arched roof, but it is soon clear that the line of the vertically rising wall turns into that of the rounded ground-plan at this point. In

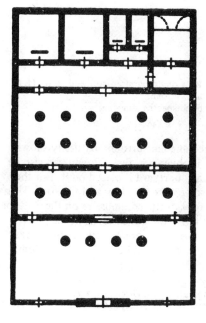

FIG. 109. Ground plan deduced from figs. 107—8. [On the basis of remains of palaces outside Amarna a stairway should be imagined behind the great audience window in the back wall of the courtyard.]

a

b

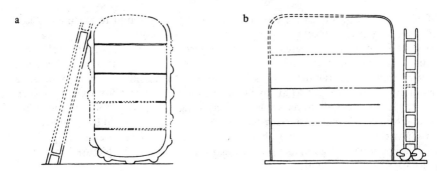

FIG. 110a. Ladder leaning against a fortress at Deshasha. OK
b. Fortress with ladder. Saqqara. OK

this respect fig. 111a is related to the pictures of the fortress. Here one can see a storehouse consisting of several long rooms next to each other, all filled with jars. The rooms apparently terminate with something like an apse. But nobody who has ever glanced at the enormous storehouses of the Ramesseum in Thebes with their rows of long barrel vaults will doubt Davies's interpretation of the picture as one of rectangular rooms with round vaulted roofs (fig. 111b). Therefore the lines of the long walls refer both to the ground-plan and to the walls which carry the arches.

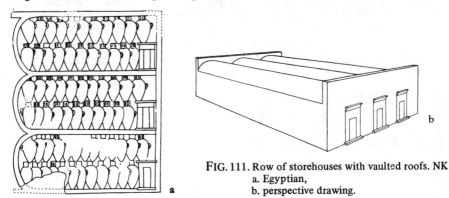

b

a

FIG. 111. Row of storehouses with vaulted roofs. NK
a. Egyptian,
b. perspective drawing.

In the palace pictures fig. 107—8 the large rectangular surround naturally shows the ground-plan of the house before all else, as is obvious in fig. 107, and can also be seen in fig. 108 from the fact that the gate to the courtyard is placed on it. But the top and bottom sides of the picture are at the same time the floor and the roof. Thus it is that in fig. 108 the sweeping man and the foot of the columns are on the bottom line, and the column capitals carry the top one.[81] So the tall columns in the great hall reach from the floor to the ceiling, but the lines of floor and ceiling also represent the side walls of the hall. It should also be noted how in fig. 107—8 the outline

[81] The same in an Old Kingdom picture of a caged-in poultry yard (Klebs 1914.22). The same model, strangely misunderstood in various details by the artist, in Capart 1907.2 pl. 58.

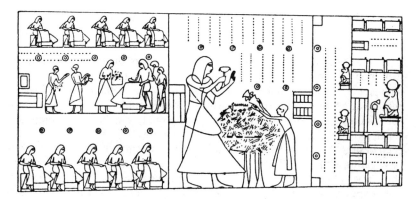

FIG. 112. Royal chancellery. NK
(The dotted lines indicate the
position of lines of inscription.)
Below, the ground plan of the
building to be deduced from
the picture.

of the house is raised to indicate a ventilation scoop over the bedroom, and thus
represents the roof here, while it is the side wall immediately beside this point. So
here too the meanings of the lines in the same picture merge together.

I should like to consider fig. 112, which shows work in an office, more closely.
The work is taking place in a building with an almost entirely regular ground-plan,
in which the columns, as was remarked on p. 129, are only indicated by the ring-
shaped positions. But, as is normal, the doors are presented in elevation, and, accord-
ing as space permits, are drawn either vertically or horizontally. The lower side wall
of the ground-plan, on which the drawing is based, is also, as in fig. 108, the line on
which some of the figures stand. It can be seen from one element in this picture
how much knowledge and participation drawings of this sort demand from the
viewer. On the right are three small rooms: in the two outside ones are boxes full
of documents, and in the middle is a figure of Thoth, the god of writing, in the form
of a baboon. It cannot be deduced from the picture itself where the door of this
middle room is. As the doors of the rooms next to it prove, it would have been
possible to make this clear. But in this case the artist was more concerned to show
that this door was more imposing than those of the small document rooms; and
there would then not have been enough space to place it vertically on the front wall;
so instead he showed its full height and leant it against the wall, leaving it to the
viewer to realize that the door of course belongs in the middle of the front wall of
the room, as the statues of baboons and the small flight of steps suggest. The plan
contributed by Borchardt makes all this still clearer.

A house can also be envisaged from outside as a block. A conversation with a
peasant, recounted to me by a woman who was a painter, is indicative of the probable
result of bearing such an image in mind. She drew a peasant's house and when she

had finished it asked the owner for his opinion. He was not at all satisfied and replied: 'the house can't be finished—I can't see the other side and its windows.' He was referring to the side that was invisible in this view. We already saw on p. 99 that a drawing of a house with three of its sides could not be said to be impossible, even though, as far as I know, no ancient Egyptian picture of a house in this form has been found so far. The painter added a concluding comment to her story: the peasant's idea of a picture of a house seems to have been that one should be able to observe the outside and the inside simultaneously, since he would have liked all his animals and belongings to be in her picture too. The palace in fig. 107–8 comes near to fulfilling such desires. There is a well-known old satirical poem: 'Oh Mr. Painter, do you want to cheat us with a fake?—me, the rich farmer Troll and my wife Marie?' etc., in which the farmer wants to see himself painted in his entire environment of fields with their boundaries, village, church, house, and family at work and at rest, indoors and out of doors, all in one picture. In this, as with Wilhelm Busch, who was mentioned on p. 119, the painter-poet gave us a deep insight into the nature of the pre-Greek rendering of nature before a scholar understood it.

In fig. 113, the work of a modern adult Nubian which he produced with a verbal description of his farm-house, we find again all the basic characteristics of ancient Egyptian pictures of houses.

The reader is unlikely to have noticed that in the picture of the tent in fig. 102 the door is placed against the wall and not in the middle of the base line. This is not done only to gain space for the contents of the tent, for we find the same also in pictures where buildings are only shown in an exterior view, as for example already in first dynasty pictures of huts (fig. 114), Old Kingdom granaries (Murray 1905 pl. 38,40), and archaizing chapels for gods which were made of matting (Petrie 1917 pl. 6 no. 152). In pictures of buildings of this sort, as in the hieroglyph shown on p. 129, the door can also be placed in the middle. One contributory factor is probably that the mental image of these buildings is not evolved entirely abstractly, but with reference to people who may want to go in and out, whether they are shown next to the buildings on the picture surface or not: the doors, mostly no doubt unconsciously, are moved towards them. The reason for this displacement of the door becomes very clear immediately an activity is shown (fig. 115),[82] even if only suggested by a ladder leant against the building or something of the sort, as with the huts of the Punt dwellers which are built round stakes.[83] And it is entirely obvious if the top door of a storage bin of the type seen in fig. 115 is placed in the middle, although corn is being poured in.

Sometimes artists take pleasure in giving the impression that half a creature's body is disappearing through a door, as in fig. 116a, or that it is coming out through it. If we look at fig. 116a we may be inclined to assume that it is drawn according to our method directly from a visual impression. But this is not entirely true; there is much more of the mental image in it than one might think. We shall not have such doubts with the superbly living group in fig. 117, where a man is looking out of the door of

[82] The original is almost entirely destroyed. But enough remains to show that the holes for pouring grain are rectangular, as would be expected (*Atlas* 1.279, and a tracing of the original for which I am grateful to Walter Wreszinski).

[83] Propyl. 364.1 [W fig. 452 (J.R.B.)]. Shorter 1930 pl. 15 facing p. 54.

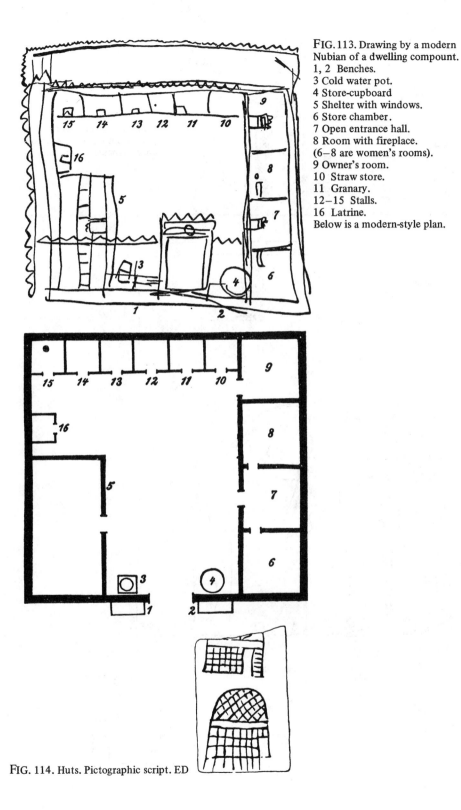

FIG. 113. Drawing by a modern
Nubian of a dwelling compount.
1, 2 Benches.
3 Cold water pot.
4 Store-cupboard
5 Shelter with windows.
6 Store chamber.
7 Open entrance hall.
8 Room with fireplace.
(6–8 are women's rooms).
9 Owner's room.
10 Straw store.
11 Granary.
12–15 Stalls.
16 Latrine.
Below is a modern-style plan.

FIG. 114. Huts. Pictographic script. ED

FIG. 115. Courtyard with granaries and piles of corn. NK [The holes for pouring corn in are rectangular in the original.]

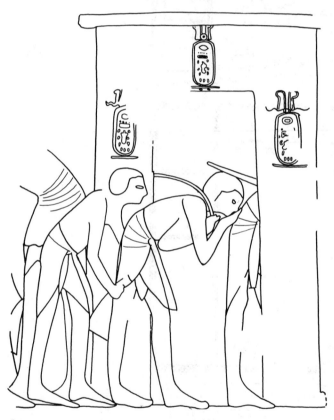

a

b

FIG. 116. a–b. Walking through a door and the gateway of a courtyard. NK

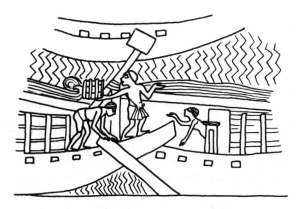

FIG. 117. Boatmen landing. NK

a ship's cabin with half his body projecting: his body only begins, like the open door flaps of fig. 74–5, at the outside edge of the doorpost.[84] In addition the door is not at the side of the cabin but in its front wall, and so leads to the passage running from one side of the ship to the other between the cabin and the forward cargo. Another New Kingdom picture should be compared (*Atlas* 1.119): this shows a festival procession which has gone towards the left through a temple gate between the two normal massifs of a pylon (fig. 231), and only the last man has not yet stepped entirely clear. The marvellous artist did not show the front part of this figure, which alone was visible, inside by the right door post, as is done in fig. 116a, but by the outside edge of the left massif. A picture from Amarna should be a particular warning to us (fig. 116b): an ox is being driven through the wall of a courtyard which is indicated as in fig. 116a just by a vertical band. The presentation was determined by the artist's idea that the ox was in the act of walking through the gate and so one part of it was this side of it, and the other on the other side. And his picture shows just this.

4.2.4 Miscellaneous remarks on isolated objects

The review I have given should, I think, in spite of its brevity, help the reader to understand the most important characteristics of Egyptian and also of all pre-Greek methods of representing isolated objects, if the interpretations of the examples are applied to other cases; I shall follow up certain points in this section and the next one.

It is obvious from what has been said that there can be no fixed rules. If we take an object that is to be drawn according to the strict laws of perspective, for example a chair, we can predict precisely how the drawing will look if made from a given point of view. And anybody who later draws it from the same point will always produce a picture that is in principle identical. This would be impossible with Egyptian methods. Even if every artist placed himself in precisely the same position in relation to the model as his predecessor had done, and attempted to draw it as faithfully as possible, the most various pictures could result, according to his degree

[84] Cf. *Atlas* 1.119,172. Even open door flaps sometimes begin at the outside of the door frame (Naville 1886 1 Chap. 92A, pl. 104). Similar features in Babylonia Propyl. 485.1 [H-S pl. 78 (J.R.B.)].

of interest in single parts and attributes of the chair, whether visible or invisible; and certain of these would for whatever reasons become fixed or lasting forms. Borchardt attempted to improve the older view of the essential character of the Egyptian rendering of nature (Borchardt 1893.1) by adding that the partial views which were not in accordance with one another none the less produced a unified approach, in so far as all of the points which could be seen from a single agreed point were reproduced. Anyone who has followed my argument as far as this will know that this addition is an incorrect description of the simple facts.

Children and people who have not been taught to draw, if they have not yet been led astray by a knowledge of the other method of drawing, as K. F. von Klöden was in his story related on p. 247, are not aware of insuperable difficulties, even though they sometimes reflect on how they might put their images down on paper and may even give up the attempt in discouragement. Mostly, with the sure-footedness of sleep-walkers, they find a form for everything they want. What they need is there, as if they only had to put their hands out and grasp it. This is often true of Egyptians too, if not with quite the same lack of self-consciousness. Let us take an example: a man hangs a goat on a tree, in order to disembowel it. The only image the Egyptian artist has of the tree is the old one with a smooth conical form. But at once the branch needed to hang the animal on grows out of the tree (fig. 118), and just this one branch.

FIG. 118. Disembowelling a goat hung on a tree. NK

It will be useful to consider for a moment some of the possibilities of representing a few subjects found in Egyptian pictures, for example *chairs* and *beds*; our series will not be an exhaustive account of all conceivable forms and perhaps not even include all the forms that occur on the monuments that are preserved.

Legs: It seems that there was a period in Egypt when, as is still the case with African tribes, chairs were the exclusive prerogative of the ruler. Now, as four-legged chairs and beds (p. 56) called to mind a quadruped, it was an obvious corollary to think when decorating the king's throne of the two species of animal in whose image he was so readily imagined: the wild bull (pl. 2) and the lion (pl. 4). As the symbolic meaning became less prominent the leg-forms were taken over for the chairs of Old Kingdom nobles, and the use of chairs gradually spread to large areas of society, so that there was a diffusion of formal notions such as is often found in art and cultural

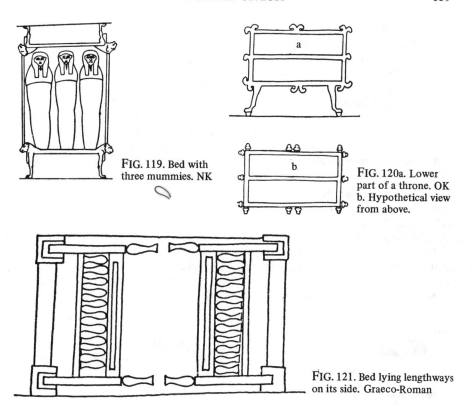

FIG. 119. Bed with three mummies. NK

FIG. 120a. Lower part of a throne. OK b. Hypothetical view from above.

FIG. 121. Bed lying lengthways on its side. Graeco-Roman

history. In tomb paintings it is possible to see how bulls' legs predominate at first and are gradually superseded by lions' legs in the fifth dynasty. As we shall see on p. 181 this happens more or less simultaneously with the first occurrences of the so-called *Staffelung* [layering] of chair legs—though there is no intrinsic connection.

There are in existence Egyptian drawings of chairs and beds in which (fig. 55) all four legs stand free next to each other at either end of the piece. The normal form is a pure lateral image with only two legs ⊨ of which the front one, next to the seated man's calf, is, for unknown reasons, omitted in earlier pictures,[85] so that the chair appears to have only one leg. There are drawings of beds (fig. 119) where the artist imagined the bed from above, from the head and from the foot. In addition, each lion head apparently lengthens the short side and is seen from the side, while our drawing method would require that the animal look in the direction of the longer sides. And the lions on other beds which the artist imagined from the two longer sides, in pictures on the same wall as fig. 119, also do this, so that their pairs of feet are perpendicular to those of fig. 119. I only know of beds with the legs drawn in this way in religious art, on the ceilings of the royal tombs; they were eliminated in secular art. The counterpart of the drawing of the lions' heads is fig. 120a. This bed-like throne-base is shown in the same view as the bed in fig. 66. But this time

[85] Propyl. 248.1 [cf. L-H pl. 18.1, 19 (J.R.B.)].

each of the four pieces of wood of the framework terminates in a lion's head; there is also one head in the middle of each of the short sides and two in the middle of the long sides. The Egyptian picture shows all the heads in side views; a view of the object from above according to modern methods would give fig. 120b.[86] In an early Mexican relief there is a representation of the plinth of a statue, out of the middle of which a skull projects on each side:[87] in two-dimensional form all the three visible ones are shown in a side view, like the lions' heads in fig. 120a. In the course of their work carpenters have laid an almost finished bed (fig. 121) on one side and are working on the other side from the head and the foot. In the drawing it looks as if the legs that are of course in reality fixed were turned inwards against the underside of the frame—just as can be done with many modern portable beds.[88]

Seat: The back and rarely also the front ends of the side members of the seating frames of chairs often terminate in papyrus umbels (fig.124–6); the reason for this is not clear. If a bench with several seats is being depicted the artist unhesitatingly stretches what would otherwise be the side of the seat until it is the required length. In fig. 168a this line cuts through the legs of the person sitting behind, a sure sign that the painter was not thinking simply of the long front edge. When, as in fig. 168b, the edge of the seat is cut by the person's legs, this means that here the side edge has been transformed in the imagination of the painter into the front edge. So the lines

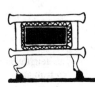

FIG. 122. Chair with the seat viewed from above. OK

FIG. 123. Type of bed with lying surface. OK

here are ambiguous, like the ones discussed on pp. 131–2. The surface of the seat can also be shown (fig. 122 and 66). There existed in the early Old Kingdom a type of two-legged bed, in fact only an angled backrest rather like a wedge-shaped cushion. It is normally shown in a purely lateral image, but once (fig. 123) the surface is also seen above this. We may never understand why its short sides are not placed at right angles to the long ones, but perpendicular to the line of the floor.[89]

Chair backs: A normal chair back can, as almost always happens, be shown from the side (e.g. fig. 221 L); but sometimes it is seen from in front (fig. 67). In fig. 124 it disappears in the process behind the body of the man sitting in the chair. If a back from fig. 67 were added on top of the seat of fig. 122 one would have a picture of a chair like one I know of from the hand of a three-year-old girl:[90] her picture looks

[86] A bed-like stone throne-base of this sort has in fact been found in the excavations in Djoser's step pyramid enclosure at Saqqara (Gunn 1926.100 [= Firth–Quibell–Lauer 1935 pl.56]).

[87] Seler 1915.126.

[88] An excellent counterpart to this is the clay model in the Berlin Near Eastern collection Inv. VA 4263 (Opitz 1930.108), a bed framework seen from above, in which the foot-board, which is to be imagined as standing vertically (cf. Propyl. 404.1 [cf. M fig. 815 (J.R.B.)]), is simply drawn in relief on the surface of the bed. It is of no importance what period or country the piece comes from, or even whether it is genuine or a forgery.

[89] [This is because there are effectively *two* pictures of the bed, and the angle thus created indicates the line of slope (J.R.B.).]

[90] Described to me by Mrs. D. Wolle-John.

like a ladder whose beams are joined at the top and at two points below by horizontal lines, while the bottom parts terminate separately. Thus the legs, seat, and back are placed one above the other in frontal views

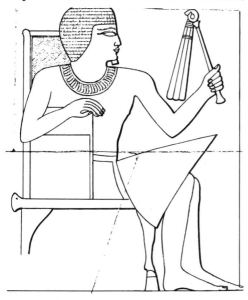

FIG. 124. Chair with arms. OK

Arms: Arms are mostly shown in their broad aspect (fig. 124), but sometimes also in the narrow front view (fig. 126) [cf. *Atlas* 3 pp. 182–3] . Fig. 125 shows how a picture is composed if a married couple with the wife's arm round the husband in the normal way are to be represented on a bench with two seats and flat sides: the side is stretched like the seat. I shall analyze the picture on p. 177.

As said above, this series could be extended; but from this selection it can already be seen that the question, 'is this or that representation of an object possible in Egypt?', simply cannot be answered. I have often been asked it, but have only ever been able to answer: 'any representation that can be derived from the basic characteristics of "pre-Greek" art is in theory possible. The only question is, which type the high art of that time took up and cultivated.'[91] A collection which was intended to establish what forms were chosen at what times for individual creatures and objects would have to reckon on being extended and corrected by every new monument that was found. But one day it should be made for a series of well-chosen subjects; it would prove very useful for our comprehension of the direction in which Egyptian art developed. I must limit myself to revealing and documenting with examples the small number of basic forms by analogy with which anyone can interpret new cases. Much that I have not remarked on can also be found among the illustrations in this book.

The material reviewed hitherto tells us one other thing, the truth von Bissing first stated, that there is *no single Egyptian two-dimensional representation of an object composed of several elements, where we can understand completely what is*

[91] [On the effects of aesthetic factors see pp. 338–44.]

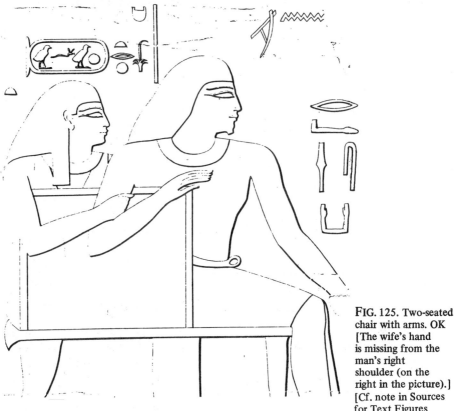

FIG. 125. Two-seated chair with arms. OK [The wife's hand is missing from the man's right shoulder (on the right in the picture).] [Cf. note in Sources for Text Figures (J.R.B.).]

represented without knowing the model or at least another object of the same type beforehand.[92] Only the unimaginable conditions make it nonsensical to say that, after the disappearance of the human race, its closest relatives in the animal kingdom, and all representations of them in three dimensions, nobody would be able to create a statue of a human being as he actually was purely on the basis of an Egyptian relief, where the sides shown vary (pl. 1, p. 107).

I hope nobody expects my descriptions and examples to give him a skeleton key to every lock. The meaning of many drawings is firmly closed to us, as that of fig. 85 would be, if the Indian who drew it had not explained how to understand it.

Often our knowledge of Egyptian antiquities is too limited to provide the assistance needed. In fig. 127a there appears to be a physical figure of a vulture on the breast of the mummy, and we would have to deduce that this was so if we did not know that the figures with protectively outstretched wings are always two-dimensional in this context (Propyl. 400.3). And any new coffin found which had a figure in high

[92] Von Bissing 1908.11–12 [Von Bissing does not state this in this passage (J.R.B.)].

FIG. 126. Carrying a chair with arms. OK. The seat is in a side view, the legs laterally layered, the back and arms in a front view. Both the hands of both the men carrying it are visible.

FIG. 127a. Mummy wrapping with painted decoration on the breast. NK

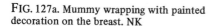

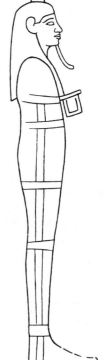

FIG. 127b. Mummy wrapping with tablet on the breast hanging free. NK

FIG. 128. Pot filled with water or painted with water lines. NK

relief could invalidate this assertion. Similarly, in fig. 127b a flat tablet is hanging loose in front of the mummy. But, as is the case with the vulture, this should, on the evidence of numerous preserved mummy wrappings, be thought of merely as painted on.

Many pictures are in fact entirely inaccessible to our understanding. There are detailed Egyptian representations of pieces of equipment whose appearance nobody has yet, despite much endeavour, been able to describe.[93] In fig. 128 what is meant is certainly a vessel painted with lines of water, yet the drawing as it stands could also be of a vessel full of water. But this seems quite impossible if, as in fig. 98, there is a band or ring drawn in the form of water round the body of the jar, which may sometimes stand out from the outlines of the jars themselves, and can even be interrupted in the middle.[94] We still do not know the meaning of these 'collars' of water.

Pictures like the figures on the rims of the open basins in figs. 129 and 43e are explained by one scholar as incised work on the inside surface and by another as three-dimensional decoration placed on the edge or inside the basin. Even though it can be proved that only the second of these two can be right, it is significant that a disagreement could have arisen at all.[95]

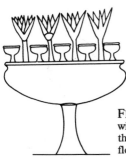

FIG. 130. Hooded cobra, from in front and from the side. Amulet.

FIG. 129. Metal dish with small vessels and three-dimensional flowers on the lip. NK

The front parts of men's kilts with their frequently huge projections (pl. 21—4) cannot yet be explained with certainty. Stiffeners of some sort have been considered, but now they are mostly and probably correctly interpreted as a mere indication of the looseness of the garment.[96]

In the same way many people who only know the uraeus from two-dimensional art will have a false idea of its real form. They will believe that it

[93] Several pieces of equipment which nobody has yet been able to transpose into our method of drawing are to be found in Quibell 1913.

[94] Sometimes there are even flowers in the area near the lip above the bands of water (*Meir* 4 pl.21). Lacau discusses the bands with water lines (1903a) without solving the problem.

[95] Borchardt 1893; Schäfer 1903; Jolles 1908; Borchardt 1923.17 n.4; Schäfer—Andrae 1942.79-80. If the whole range of types is considered, instead of the few examples selected by Borchardt in his article, there can be no doubt about the solution to the problem. Since the publication of the studies just cited the quantity of the material has increased, as has its value as evidence. The picture reproduced by Jolles (1908) as fig. 23 on a wrong suggestion of my own is not a 'section of a bowl' but a picture of a Ḥathor cow in a boat.

[96] These projections also occur on statues. [Cf. now Staehelin 1966, part 1A (J.R.B.).]

inflates its breast to make a thick bag when it raises itself up in anger. But in nature and in statues (fig. 130) it exhibits a flat shield which is not produced by its puffing itself up.[97]

Would anyone who does not know scorpions from nature or, for example, from Egyptian bronzes, understand correctly the drawing of the creature 𝕤𝕔𝕠 , in which the tail appears to rest on one side? The real animal holds it curved round over its back with the sting and poison gland on the underside. But if we know this fact we can read an Egyptian's conception correctly off his drawing: 'the creature's tail hangs over its body.' If the legs are shown in a side view (fig. 131) the correct relationship is clear to us without our needing to know anything more.

Many pictures were just as far from being completely self-explanatory for the Egyptians as they are for us. This is the explanation of the fact that misunderstood two-dimensional representations sometimes led to new three-dimensional forms which were different from what was meant by the original picture. Let us look at a few examples: the type of sarcophagus with four posts at the corner discussed on p. 115 (fig. 78) must have been inspired by two-dimensional representations of the older sarcophagi (fig. 76) with complete end faces (fig. 77), although the techniques of wood-working may have been an additional stimulus.

On p. 167 I shall discuss the image of a mat with a loaf on it (fig. 156). The outlines of this image became so fixed that they were even carried over for the slabs of wooden offering tables, and here the projection which in fact represents the loaf sticks out of the long side of the slab like a handle (Propyl. 269.4).

In Egyptian drawing the form ⌒ can have very varying meanings. It can be the 'sectional' image of a circular depression with a raised lip round it, as in the picture of the charcoal bed in fig. 132. It can also show two rounded breast-shaped hill-tops, or even a valley stretching away from the viewer between two mountain ridges; the carver of fig. 133 gave the foot of the sacred symbol of the town Abydos, the hiero-glyph for 'mountain' (*ḏw*), this channel-like form.

FIG. 131. Scorpion. Hieroglyph. OK

[97] p. 11. The puffing of the hooded cobra seems to be represented first in the second dynasty, that is, in the period when 'Egyptian' art originated. Earlier the snake, which is erect on its coils, is not puffed out (and not merely shown from the side), as the highly finished picture in Petrie 1901 pl. 7.12 proves. Sethe (in Spiegelberg–Sethe 1918.91) proved that the older ⌐ precedes the form of uraeus with the breast puffed out. This image, which was formerly thought to show a jumping snake, should probably be interpreted as follows: the snake is lying in a broad coil on the ground with just its head raised.

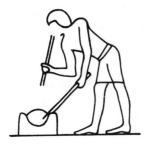

FIG. 132. Metal worker blowing on a charcoal fire. NK

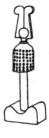

FIG. 133. The sacred symbol of Abydos. Statue

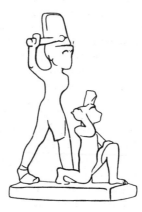

FIG. 134 Ivory group of the king and an enemy, in Berlin. NK

The best illustration of this is the Egyptian method of drawing the body of a snake wriggling flat along the ground 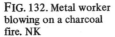, which inspired statues where the coils are pushed close together and raised like those of a caterpillar (fig. 130).[98]

In the preceding paragraphs we have frequently had recourse to three-dimensional representations in order to elucidate the physical structure of objects shown in two dimensions. Such parallel pieces should be collected systematically. Let us here discuss one more example of great art that demands a rather extended treatment.

We have probably all succumbed at some time to the temptation to deduce from the frequent and important symbolic image of the *destruction of the enemy*, discussed on p. 155, a posture in which one shoulder is pulled right back by the swing of the weapon and has, of course, taken the upper half of the body with it. But it must be pointed out that the drawing of the torso contains as little indication of twisting as the warrior figure in pl. 3, as is shown on p. 280. A small ivory group of the symbolic image in Berlin (fig. 134) is the most significant piece of evidence for an interpretation; here the shoulders are at right angles to the direction of walking, not turned, and the raised arm does not go behind the line they form, but remains in the same plane as them from the socket to the fist. Apart from this figure there is a whole series of other ones in similar postures; and

[98] In the same way the two-dimensional image of a snake ⌐, whose physical disposition was established in n. 97, seems to have given rise to statues in which head, body, and tail are in the same vertical plane, e.g. where a snake rests on a carrying pole (cf. fig. 48) ⌐.

wherever an arm holding a weapon is raised up the corresponding three-dimensional figure is bound to its axis without any twisting. Despite certain superficial similarities, the opposite case to this is that of the man fishing in pl. 38. He holds his long spear laden with its catch horizontally in both hands at breast height. For this reason, and because the point of the weapon is of course pointed straight ahead, if the relief were transposed without further reference into three dimensions the statue would have to be turned to the right (cf. pp. 319–20)!

The knowledge which is necessary to an understanding of what is represented, as was said on pp. 141–2, and which Egyptians had from their own environment, is often transmitted to us by chance. This is true of isolated figures and of the composition of pictures with several elements. A group shown in the second register from the top of fig. 151 is repeated in enlarged form in fig. 135a. The boys' feet are upright on their heels, and the heel of one is resting on the toes of the other, a chain that is continued by the extended hands, which are placed on top of them, with the boys arching their bodies to do this. A third boy is running from the right towards the seated pair. As the short inscription above the group does not help us, we would never have found the solution if E. S. Eaton had not fortunately found a game in Transjordan[99] which reminded her of this relief. In her photograph two men can be seen sitting opposite one another in the attitude of the two boys, and a third is jumping this living hurdle. He corresponds of course to the running boy in the Egyptian relief. Fig. 135b copies the distribution of the figures in the photograph and attempts to adapt the Egyptian figures to it. It cannot be doubted that the ancient and modern games correspond with one another, although one cannot see why the ancient artist could not at least have made the seated boys face one another.[100]

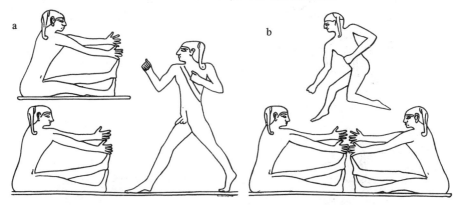

FIG. 135 a. Boy's game in the tomb of Ptaḥḥotpe (OK) and b. the picture adapted to the modern game.

Much of what has been said in the preceding pages may look like an open invitation to uncontrolled interpretation of depictions based on frontal images. And in fact it will be impossible in many cases to decide objectively whether a suggested interpretation lies within the range of what is allowed or not. Here again the patient study of all preserved material is the only method of acquiring a sure feeling for what is permissible, and the only protection against wild flights of fancy. Someone else, who

[99] [Eaton 1937 (J.R.B.).]
[100] [Cf. *Atlas* 3.16 with the addendum in the text.]

thinks out the consequences of the freedom of individual painters in the rendering of their subject-matter, may be afraid of ending up in a magical world; his mind may reel before the experience of a world where nothing seems impossible.

But in the first place the reader should not forget that my verbal and pictorial enumeration is indeed based on the totality of the material, but *attempts principally to interpret what might seem incomprehensible to us today, and so requires more expenditure of words than the rest*. In one respect this chapter is like an old picture in the veterinerary school in Hannover, in which all externally visible horse diseases are incorporated in a picture of a single animal. On the other hand, many Egyptian pictures will only be noticed if one's attention is drawn to them. Let us take as an example the figure of a sleepy overseer in fig. 136 (=pl. 41):[101] he is crouching on a log with his elbows propped on his knees and his head slumped between his shoulders. Not many people would even notice the fact that the positioning of the forearms in the very expressive drawing would be quite meaningless if it were interpreted as corresponding to a visual image. It is often astonishing how great a power of convincing Egyptian pictures have. It is so great that, in proportion to that vast mass of images which quickly become familiar to us, the number of ones which mislead us is extremely small.

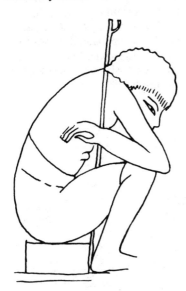

FIG. 136. Sleepy watchman. NK

There are various other considerations which make us take into account forces that restrict freedom in comparison, for example, with children's art, and these should allay doubts about the feasibility of our undertaking.

Just as man's capacity for inventing new visual ideas is much smaller than is normally thought, the multiplicity of frontal representations of an object that actually occur is only so great if they are assembled from the evidence of all periods.

[101] [The man's stick appears to run in front of his torso, but may have been meant to be masked by the paint of the torso (J.R.B.).]

Even if the works are not meant for other eyes but have only to satisfy the artist's impulse to express his inner state in material form, all creation based on frontal images has in common the *fixed character of the forms once they have been invented*. In the works of each individual artist then, animals, plants, and inanimate objects mostly appear in one basic form which is used again and again (cf. pp. 40–41).

But this is not limited to individuals who produce works for their own satisfaction only. It has been observed in a whole South American Indian tribe how only one way of representing certain living creatures is found (Koch-Grünberg n.d. 6). If there are one day collections of material which are made on a unified pattern for a whole series of peoples, it may be possible to note that one people prefers this form, and another that. Thus for example things that are in themselves possible did not occur in Babylonia and Assyria while they were normal in Egypt, and vice versa. On the other hand, as we have seen, an Egyptian cow head like fig. 83 should not be counted high art, while the fact that an ancient Chinese work (fig. 45) uses the same mode of representation does not lessen its artistic value. All these variations occur, although each of these peoples' productions are based on frontal images. *In Egyptian art every period has its preferred forms*, from which only rare exceptions depart any distance—although these, perhaps because they are exceptions, give us flashes of insight into the pre-Greek process of elaborating forms. Sometimes it is possible to see how such abnormal forms become diffused like fashions over a smaller or larger area (cf. p. 267).

The chain along which forms are passed includes the members of a single generation, but also stretches out through successions of generations. One generation takes up the representational types of another and hands them on because 'that's how it's done'.[102] *The great force of tradition is at work.*

One of the main tasks of art history is to follow the struggle between the tenacity of traditional forms and the upsurge of new ones. If the strength of tradition can be felt in drawings by primitive people how much more this will be so in pictures like fig. 144 from Hierakonpolis, or those of the slate palettes and finally of Egyptian art proper. It is almost impossible to overestimate the importance of the fact that in that archaic wall painting, which apparently contains only images of reality, there

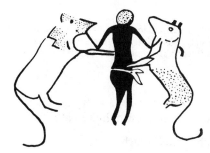

FIG. 137. Detail from fig. 144, enlarged

[102] De Buck made an interesting attempt to understand what is fundamentally typical in Egyptian art in his inaugural lecture *Het typische en het individueele bij de Egyptenaren* (1929), but without doubt he went much too far.

is a group (fig. 137)[103]consisting of a man fighting with two lions, which are jumping up to attack him from each side. This is not a reproduction of a real activity but the first trace of a free artistic invention, which is no doubt older and probably originated in Babylonia, where it was especially productive.[104]

Tradition is also reinforced by the instinct to communicate. An art in which anyone can render whatever he thinks is real or essential in an object, while to a large extent neglecting visual impressions, must, if it is to be comprehensible, build up a sort of *language of forms*, and for this purpose select certain modes of representation from the range of possible ones and cultivate them; capriciousness is kept in check by the interrelated character of the whole. If they are approved for any reason the normal forms will become widely diffused and then easily produce the illusion that the choice of them is based on tacit or perhaps even explicit agreement. In the predynastic period crocodiles were drawn either in a sort of view from above with all four legs stretched out sideways,[105] or in a pure lateral image. In 'Egyptian' art it is the lateral image of a crocodile ⟅⟆ that alone remains, while the view from above is reserved for lizards (fig. 150); with bees and flies the two views are similarly distinct.

I have in the preceding paragraph, as frequently elsewhere, chosen signs from the Egyptian script of 'hieroglyphs' rather than free reproductions. This is a reminder of how important it must have been for Egyptian art that the people not only evolved a pictorial script very early, but also retained it throughout its history.

The original form of the script is pictographic. It represents what it wants to say in pictures that do not in any way prescribe words or word forms to the reader.[106] The idea alone, and not the word, is established, so that, for example, a sign like could be read with the words 'beat, whip, hew' or another of similar sense, or even in another language. It is of course impossible to make a sharp distinction between simple narrative depiction and pictographic writing. No purely pictographic writing is preserved from Egypt. Single items similar to pictographic writing are of course found at the beginning of the historical period, but always interspersed with phonograms.

FIG. 138. King Na'rmer striking the Libyans. Mixed pictographic and hieroglyphic scripts. ED (On a cylinder seal. The captives on the left are continuous with those on the right.)

Let us consider an example from the reign of Na'rmer (fig. 138). In the middle hovers the name of the king, which is composed of a fish resembling a catfish (*n'r*) and a type of tool (*mr*) . The fish is emphasized through its size, as it is also

[103] Also Propyl. 185.2 [Sm frontispiece, W fig. 58 (J.R.B.)].
[104] The motif occurs again in Egypt at the beginning of the first dynasty (Propyl. 185.2 [see last note]). In Quibell 1900.16 no. 2 there are fabulous animals in place of real ones.
[105] Propyl. 198 top L [W fig. 4 (J.R.B.)].
[106] I showed in Schäfer 1915c.95 how the peculiarities of a pictographic script are still present in the vowel-less 'Phoenician' alphabet.

the protagonist of the action: its human arms are beating fettered Libyans with a rod. The name of the enemies (*ṯḥnw* = Libyans) is written phonetically under the fish's tail. One hawk is spreading its wings (cf. fig. 56) from above and behind the king('s name), while a second in front of it holds out the sign of life ♀ without moving its wings. The sense of the whole is therefore: 'King Na'rmer, protected and given life by gods, has defeated the Libyans and taken them prisoner.'

However, if there is no truly pictographic writing in Egypt, the hieroglyphs are a *pictorial* script. The individual signs are pictures of things, but these pictures link the reader with the words and sounds which the writer intended.

Painting and writing, whose origins are the same, soon go their separate ways. Art enriches its forms and increases the connections between the figures in pictures. Writing must, on its way from the pictographic to the pictorial, separate the individual component parts and give them fixed forms, and reduce the pictorial element ever more in its further development towards cursive forms. There are various stages in this process. Thus, for sacred or otherwise esteemed books, a very dignified and refined form (pl. 63) was created, which is half-way between hieroglyphs and handwriting (fig. 27). At certain periods the ancient Mexicans manipulated their pictograms into regular, even rectangles. In China and Mesopotamia the pictograms underwent a process of attrition which in most cases means that only a specialist can still see that the script was originally pictorial, or, as in China, purely pictographic. This process went a very long way, if not quite so far, in Egypt. But while the Babylonians and Chinese took over signs that had almost entirely lost their pictorial character for monumental writing, the Egyptians, alone among the peoples of the Mediterranean, preserved it in their writing for millennia and fashioned every sign with the same pleasure in its connection with nature as they felt with corresponding forms in real pictures. The Hittites and Cretans followed a similar course, though only to a limited extent, no doubt under Egyptian influence. However it may be evaluated, it is characteristic of the Egyptians that they should not have taken over the handwriting, which had lost its pictorial aspect, for monumental inscriptions.

Time brought many changes in the pictorial monumental script. In the process the stylistic changes to which any image is subject are mixed in character, including simple misunderstandings and other modifications, which leave the way open to the tendency to 'impart meaning'. An example is two strips of material knotted together ⋀⋀ , which becomes a group of meaningful objects ⋀⋀: two royal flails and a cartouche.

The sort of secret life that can exist between the lines of a decorative inscription is hinted at in Appendix 5, in the discussion of the inscription on pl. 36, and we have many inscriptions from the Middle and New Kingdoms, and especially from the Late Period, which even make play with the pictures which constitute the signs,[107] and place them in an active relationship with each other. And indeed, just as pictures in general are supposed to be intrinsically effective, so are the signs of the script; thus it is that, in many inscriptions on coffins and tomb walls, the heads of animals that were considered dangerous are separated from the bodies in order to render them harmless (fig. 139). The same ideas are at work when, in the religious inscriptions in late Old Kingdom burial chambers, standard epithets are constantly used for

[107] I discussed an Old Kingdom example in 'Die Sonne auf den Obelisken' (Schäfer 1929e).

FIG. 139. The hieroglyph for *f*, a snail (?), made harmless. MK [The sign is thought to show a horned viper, *cerastes cornutus*, but cf. Ransom Williams 1932.71 n. 208 (J.R.B.).]

certain gods, while their names are omitted in order to avoid introducing them into the realm of death (Firth–Gunn 1926.1.171–7). But the fact that images of gods and kings do not occur in the lively decoration of offering chambers should not be explained in the same way, as, although name and image are magically identical in strength, the names of gods are mostly uttered without a second thought. The simple explanation of their absence is that in the earlier Old Kingdom the tomb-builder's thoughts centred on preserving the dead person physically and guaranteeing him the necessary means of life and its enjoyment. Later on pictures of kings and deities are gradually introduced.

Despite the life I have described, which informs the Egyptian monumental script, there are of course vast numbers of objects in it that acquired a fixed form and maintained it, and it is understandable that normal two-dimensional art was strengthened by them in its evolution of constant images.

Thus we see in the natural consistency of forms of depiction once invented, in the strength of tradition and the need for comprehensibility, and in the existence of a pictorial script, factors which in reality limit the apparently infinite variety of representational forms. In stating this we have not even considered one of the most basic reasons, which is in the very nature of 'pre-Greek' artistic method, the use of frontal images. If a community or an artist has once laid down what parts of an object or body should appear in a picture of it in a given posture, the lasting form may be almost wholly established by this alone. For the basic requirement of frontal images allows very few 'views' of the vast majority of parts of objects. There is one final element: in Egyptian art many figures contain little or no information about the direction in which they face,[108] so that the 'visibly formed concept', as it were the 'idea' of a given object, can occur again and again at any point in a picture in a fixed form that adapts to its context only in respect of size. The chest in fig. 41 can appear anywhere, even where in the real situation in front of the artist only its narrow side with the knobs for securing the lid could be seen.

If one compares with this how, in accurate perspective drawing, the view of an object or part of it must change the moment the artist's position in relation to his model, or the place of the object on the picture surface, alters even slightly, it becomes clear that the relative numbers of possible representations the two offer are just the opposite of what might at first appear to be the case (pp. 318–9). As against the inexhaustible number of forms that are faithful to visual images there is a relatively meagre stock based on frontal images. This disproportion soon evens out and again favours the other side the moment the condition of the frontality of the images disappears and purely image-based creation remains entirely untrammelled, as in modern expressionism.

If one looks through the two-dimensional representations of the period of the slate palettes it may seem that the individual figures in the pieces do not have as many features that we find off-putting as later ones do, in other words that two-dimensional modes of representation based on frontal images only later took on such importance. But this is of course an illusion, produced by the restriction to a few motifs of the

[108] [*Richtungsstumm*, cf. above, p. 101, and Epilogue, pp. 420–21 (J.R.B.).]

early objects that happen to be preserved. As the types of object represented increase in number with time, so do the renderings we find startling. Indeed, just the same is true if we compare the relatively few and homogeneous remains of early Babylonian art or European cave paintings with the rich stock of subjects preserved from Egypt. But the situation is different if the Assyrian pictures of the first millennium, with their greater wealth of subject-matter, are taken instead of the Babylonian; the former contain many glaring cases of image-based representation.

Up till now we have seen tradition only as a chain binding the artist. But it should also be evaluated as a stimulus to progress. We know that in the earliest period of Egyptian art many generations had already had the opportunity to compare their works and those of their predecessors with natural models, and in this way the talented among them learnt to pay more precise attention to the way in which these works rendered nature. While at the beginning the same simple forms often represent the most diverse objects—for example, except in small details all animals look the same—the attention which Egyptian artists of the historical period devoted to recording the animal world excites universal admiration. In the same way all other images were adapted more surely and faithfully to nature, and technical perfection was enhanced.

The productions of succeeding generations constantly increase and clarify the repertoire of forms. The established values are clearly to be seen, and creative minds are able to master their own talents and proclivities and to extend the heritage. Works of art are both fruit and seed, both beginning and end. Either one creates in the same manner as one's predecessor, or a radical change is made.

The Amarna reform movement is one such conscious departure: after a few years' moderation Amenhotpe IV consciously opposed two- and three-dimensional works with fanatically intense expressive forms to the art of his father, with its beauty of line. It was previously thought that these works were late products of the movement, until Davies pointed out that they still had the name Amenhotpe, and so must have been made before the king changed his name to Akhanyati (Akhenaten) and hacked out the name and image of the god Amun. Should it not be taken as an indication of the value which the reformer attached to art in the context of his reforms, that he began his genuinely revolutionary activities with it?

In this way inwardly balanced and artistically formulated riches continually grew under a constant reciprocating stimulus. But we do not know and never shall know why such a life came to be in the Egyptian people, why they progressed while others remained stationary.

In this search for and adoption of new forms for their models from the physical world painters sometimes include ones that are apparently outside the realms of frontal images, but which may, as the 'Greek leaven' is not yet present, in fact enrich the store of forms (pp. 265–9), and are to be taken as formally new without containing elements of perspective.

If pictures of objects are frequently repeated in the form of decoration the idea of the original can fade more and more and the reproduction of it become gradually more remote from it. This has been well studied for Gallic reproductions of Greek coins. The so-called frog-lamps from Roman Period tombs (fig. 140) are among the best Egyptian examples of it. Originally they have a picture of a frog as a symbol of resurrection (fig. 140a). But the frog is gradually altered in one of two ways: either it becomes a picture of two palm fronds (fig. 140b) or it is almost entirely dissolved

FIG. 140. Lamps. The image of the frog turns into branches and ornamental shapes. Graeco-Roman

FIG. 141. Painted pot. Predynastic

into completely decorative forms (fig. 140c), a process in which formal inclinations have ever freer play. This is the opposite procedure to the reinterpretation of dead forms as living beings which was treated on p. 55. The initial stages of the dissolution of natural forms into ornament can be seen in the paintings on predynastic pots (fig. 141). Developments of this sort are not often found in Egypt's nature-orientated art. On the other hand, they play a decisive part in the transition from the pictorial to the cursive script.

Compared to the Egyptians we are now at an advantage, now at a disadvantage, in appreciating their works. As we frequently have no inner relationship with the subject-matter we often avoid the danger of being blinded by it and overestimating the value of a piece as a work of art. It is quite certain that the *decisive* element in a work of art is, as Stefan George says, 'not the meaning, but the form, in other words nothing external, but what moves us deeply in its proportions and harmony and has at all periods distinguished the truly original men, the masters, from the imitators and artists of the second rank'(*Tage und Taten*, 1903). But we must bear in mind that many perfect works of art can only have their intended effect if we grasp their content with more than just our intellects. For Egyptians too must have stood in the same relation to their art that Goethe expressed thus: 'Man is not only a thinking being: he is at once also a feeling one. He is a whole, a union of manifold intimately related forces, and a work of art must speak to the whole man, it must accord with this rich unity, this unified variety.' To an Egyptian it would probably have been a terrible idea to banish content from art. He required his own art to possess it in a particularly high degree.[109]

In this context it is necessary to take up and pursue further what was said above about pictographic writing. For a part of Egyptian art, which makes up a considerable proportion of its content, has the same origin: *symbols and symbolic groups,*

[109] Not only the subject-matter but also the 'content' influences the form. Goethe distinguished them thus in his *Maximen und Reflexionen*: 'Everyone sees the *subject-matter* before him, only somebody who is involved with it discovers the *content*, while the *form* is a mystery to most people.' (Cf. pp. 40–41 and 337.)

which are so inseparable from the sacred elements in art that nobody can appreciate them without some knowledge. For this reason one would be grateful if someone collected the commonest symbolic groups and published them with a commentary.

These groups often acquired beautiful artistic forms that were capable of development. See for example pl. 59 (sun between heaven and earth); pl. 62 (sunrise and sunset, read from bottom to top); pl. 66 (the two sun-boats, to be imagined side by side). In discussing some of these in greater detail we shall come across several things which seem repugnant to us. But we should treat that with respect too, as being formed by Egyptian art.

1. The symbolic group of the *destruction of enemies*. The prototype of this is predynastic. One of the numerous groups in the Hierakonpolis wall painting (fig. 142) shows a warrior without any mark of rank, whose great size indicates his strength, swinging a mace head over three captives who are bowed down on one knee and tied to a single cord. They are turning their backs to the conqueror, but he has taken the first of them by the hair and wrenched his head round. The torso of the victor is bent forward to deliver the blow. On the other hand his legs are not spread apart.[110]

FIG. 142. Detail from fig. 144, enlarged.

2. One of the oldest symbolic groups stands for the *unification of the Two Lands,* the two originally independent halves of the state, so is intended for the king as ruler of all of Egypt.[111] For this reason it is put in places where the king's body, image, or name is over it, most frequently on thrones (pl. 17, 20). The image is originally composed of the hieroglyphs for 'unite' ⚕ , Upper Egypt 🌿 (bindweed or lily), and 'Lower Egypt' 🌿 (papyrus). In the reign of 'Anedjib, the sixth ruler of the first dynasty, the signs are still written next to each other under the king's name, without any connection. But even here the sign for 'unite' ⚕ is not in front, as if the three signs composed a sentence, but in the middle 🌿⚕🌿 , so that it can affect both 'heraldic plants' equally:

King 'Anedjib with name and image

| *Lower Egypt* | *unite* | *Upper Egypt* |

In the second dynasty under Kha'sekhem we find the interior shoot of both of the plants, roughly in the form of the sign 🌿 , attached to the top of the ⚕ , probably already knotted, as they certainly are later. But it is only in the fourth dynasty that we find a perfect work of art whose influence continues through all later periods,

[110] [Supplemented from Schäfer 1957, where the transformation of this motif from a representation to a symbolic image is treated in detail.]

[111] [Schäfer studied this subject in detail in 'Die "Vereinigung der beiden Länder" ' (1943).]

the product of a superb artist, full of grace and strength; here the stems, which are contained within a square, bend towards the middle of the ⚇ and are held there by a slip-knot.[112] The knot then became the centre point of the composition for all time —as it were the heart, which is the terminal point of the veins which come from above and below and the starting-point of the arteries. Early on figures whose names change with time appear on either side. They can bring gifts, but normally fasten the stems[113] in varying poses, propping one foot against the ⚇ from the Middle Kingdom on (Daressy 1917c pl. 1). In the Middle Kingdom too the closest neighbours of Egypt began to be included in the idea of the 'heraldic plants'. And when the kings of the New Kingdom had conquered more peoples to the north and south, Asiatic peoples, Libyans, and Negroes, it occurred to artists to extend the old symbolic group by adding representative figures from these peoples bound to the monogram as an indication of their subjection. In continuation of the main line of development sketched here the individual parts show all kinds of variants. Thus there is in the whole history of the motif an almost inexhaustible wealth which reflects the transformations of great art through history just as the motif of sniffing the lotus flower does (pp. 40—41).

3. In a subsidiary group on the Na'rmer Palette (pl. 8) a human head grows out of a rectangle with rounded ends, in other words a country. A bit is placed between its lips, an idea not adopted in classical Egyptian art, though well known in the Near East and in Nubian Meroe. The hawk god holds the reins in a claw that is transformed into a human arm, and leads the enemy country to the victor, who is executing a prisoner with a mace; the papyrus clump on the back of the country shows us that the enemy is Lower Egypt. The basic idea of this group, the *leading-in of prisoners*, recurs again and again down to the latest periods, either in the form of pl. 25, where bound representatives of the defeated countries are simply led to the king (not included in the plate), or in another which is found from about 1900 B.C. on (fig. 143): rows of elliptical plaques ▢, with hieroglyphs inside them and the upper part of a captive's body growing out of each of them. The prisoners' elbows are tied firmly together behind their backs 𓀀 and a god leads them by a rope tied round their hips, or later their necks, to the king or to a superior god. As we know from pl. 9 the plaques are fortified settlements, and the hieroglyphs give their names. The inhabitants can be seen to be Asiatic, Libyans, or racially similar southern Hamites, next to whom we often now find Negroes,[114] who were lacking in the early period.

4. If *purification, refreshment,* and *revival* are to be represented symbolically a jet of water rises from the spout of a jug and envelops the recipient of the action in a great arch (pl. 52, 61). In order to make the meaning still clearer the jet of water is often made up entirely of the hieroglyph for 'life' 𓋹 and other words of similar meaning like 'permanence' 𓊽 or 'prosperity' 𓌀.

[112] [Reproduced in Schäfer 1943.73 fig. 1.] Here art is playing very freely with the form of the plant, for no real papyrus could be knotted in the way shown here. On the other hand the pliable lotus stem is represented in forms better suited to a stiff shaft (cf. fig. 43c and Schäfer 1931b).

[113] Earliest example on a fragment of a statue of Re'kha'ef (Khephren) in Hildesheim [reproduced in Schäfer 1943.85 fig. 20].

[114] Anthes (1930a) studies the history of pictures of captives being presented in greater detail.

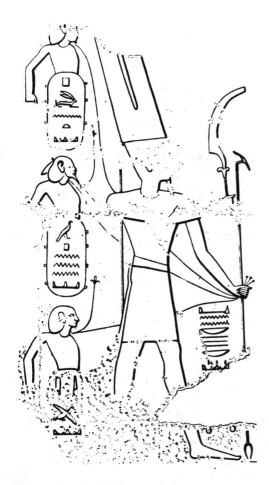

FIG. 143. Amun leading defeated towns (to the king). NK

5. With some of the symbolic groups we were able to establish the approximate time and method of their formation; for another much more modest one it is possible to establish the name of the *inventor*. Senenmut, Queen Ḥatšepsut's favourite, frequently places a strange sign on his monuments: a flying vulture which holds a lucky sign between its claws and whose body consists of the sacred eye 🦅 . Senenmut remarks in one place that he himself thought up the sign, which was not found in his forbears' inscriptions;[115] unfortunately he does not tell us what deep meaning he intended for it.

I have called the large category of images from which the examples discussed here are taken 'symbolic groups or images'.[116] It embraces in its scope all representations

[115] Sethe in conversation about the statue Berlin 2296 [cf. Drioton 1938 with pl. 32.1]. Later occurrences of the sign in e.g. Davies 1927.68 n. 3.

[116] [German has two words for symbol, *Symbol* and *Sinnbild*; Schäfer uses them differently (cf. also Schäfer 1943) (J.R.B.).]

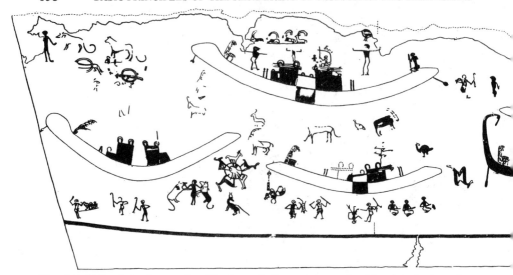

FIG. 144. Wall painting in a tomb at Hierakonpolis (b continues to the right of a). Predynastic

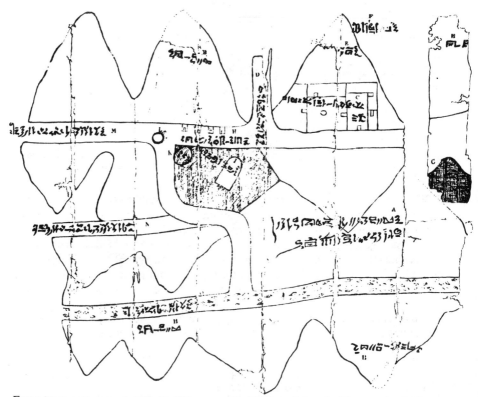

FIG. 145. Egyptian map [of the Wadi Hammamat]. [The parallel vertical lines are breaks in the papyrus.] NK

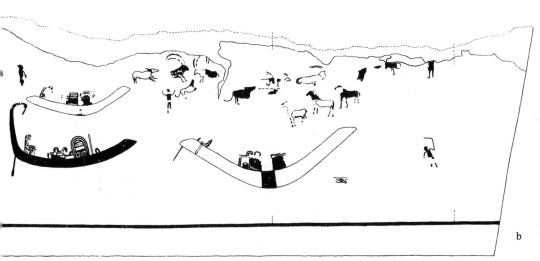

b

which mean more than they show. They can be ordered according to content, beginning with simple physical signs for concepts and ending with 'symbols', that is with images with more concealed reference, whose depth of intuitive association cannot be explained intellectually or exhausted verbally. The distinction between the two is of course fluid, and one may prefer to use 'symbolic image' as a wider term than 'symbol'; on the other hand 'symbol' should not be used for 'symbolic image', but rather be kept back as one of the words that should not be used unnecessarily.

4.3 Methods of rendering spatial distribution

4.3.1 Introduction

Up till this point I have chiefly considered isolated objects. Now I come to the question of how the spatial relationship of objects to one another is rendered on the picture surface. As we shall see, connections of this sort are given visible form in the picture only by *grouping figures or layering them, and not by altering their individual form.*

4.3.2 Loose assembly without indication of depth

In terms of development the history of two-dimensional representational art starts with isolated objects, and the human form may have been the actual beginning. Then animals which occupied man's mind because they were useful as prey or mysteriously harmful may have followed, and finally inanimate objects. If a large area acted as the picture surface and stimulated the artist's pleasure in assembling, the isolated objects were spread over the surface without any selection except that imposed by the amount of available space, or they were arranged according to the artist's sense of shape, in both cases without any recognizable connection one with another. In the Hierakonpolis wall painting (fig. 144), which is only given a certain degree of firmness by the two rows of heavy boat hulls distributed in a simple rhythm, figures of men and animals are on the whole distributed without 'composition' or connection one with another,

even if figures within single groups are related one to another. But it is clear that the whole picture does not render a visual unity, nor, for example, does it take the picture surface to be the ground (as against the cases discussed on p. 196); one need only observe how the men and animals walk to and fro between the boats.
One could not even say if there was any intention of rendering seen or imagined accumulations of living beings, that is, if the figures of the whole picture, when they are not related directly by their activities, are associated by any common factor at all apart from the need to repeat or fill up space. Even at points within the picture where the figures are more densely congregated than elsewhere but are still not touching one another, all that is probably intended is to indicate a collection of bodies, without specifying whether they are near or far from each other. This is also true of the two radiating groups, figs. 261 and 26, of which only the cave painting (fig. 26) really conveys—in a masterly fashion—the idea of the figures rushing towards each other.

4.3.3 'Maps'

Fig. 145[117] renders a visual unity as little as fig. 144 does. But unlike the latter it leaves one in no doubt that it distributes and associates the parts of the picture in correspondence with reality. It is in fact one of the maps, such similar examples of which are found among primitive peoples (e.g. Koch-Grünberg n.d. pl. 54). Here we can see mountains and valley paths, one of which is covered in boulders, while texts in the others tell us where they lead and that we are in the New Kingdom gold mines [cf. Goyon 1949]. In the central black area there is a watering-place with a stone memorial; in the path leading past it are workmen's huts and above on the right one can see a fairly large settlement. All of these could never have been seen from a single point. So the draughtsman can only have derived the images that determined the ordering of the picture from walking, an activity included on p. 90 in the idea of touching. Then the drawing came about by the draughtsman's following these images of movement with his pen. Finally the basic outlines which had been paced out were given details based on images which the eye originally supplied. Included in touch may have been the feeling that the hand with the pen must stretch itself out further for one part of the picture than for another, so that pushing it away and bringing it back may often have chimed with the distance or closeness of the original objects.

4.3.4 'Association of ideas'

Again we can penetrate more deeply into the ancient artists' thought processes by looking at a child's drawing. My five-year-old daughter had drawn a bent nail that was on the table in front of her (fig. 146 above). Only a few minutes later, as is so common with children and primitive people, the original meaning of the picture had disappeared: it became a carriage (fig. 146 below). A coachman is sitting on the

FIG. 146. Child's drawing: nail. Below, the same, transformed into a carriage.

[117] [Photograph Kayser 1969.156 fig. 143 (J.R.B.).]

wave—facing in the wrong direction—the horses were not included, the head of the nail was declared to be the carriage lantern, and—this is the important point for us—a small tree-like drawing was made next to the lantern, although it could equally well have been above or below; it represented of course, as the child explained, astonished at my ignorance, the burning match necessary for a lantern. A grand-daughter of mine,

just four years old, explained that in her three figures ⟨symbol⟩ ○ ☐ she was drawing

'a girl—that's her down to the last hair on her head—putting beads into a box'. So we see that the spatial relationship of lantern and match, or child, bead, and box, is not shown, only that they are part of the same idea.

This gives us the key to endless pictures in the art of all peoples and periods up till modern times. In exactly the same way the gaming sticks in fig. 155 are painted above the board[118] by *association of ideas*, the son in fig. 255 is placed next to his father like a double standing on air, the women shown at the top left[119] in fig. 147 (compared with pl. 42) belong in the boats, and in fig. 179 eggs are even added to flying birds.

FIG. 147. Sun boats. The women above belong in the boats by association of ideas. NK

[118] In *Atlas* 1.418 the knuckle-bone is on the floor.
[119] [Schäfer says they are on the left because he had only seen Champollion's sketch (J.R.B.).]

FIG. 148. Cobblers. NK

If a cobbler is shown at work (fig. 148), the idea of his equipment, even items he is not using at the moment, immediately suggests itself. It is entirely the result of this connection of ideas that it is shown all round him, so that it looks as if it were flying. It would be a waste of effort to wonder whether it lay on the ground around him, in the foreground, or in the background, or whether it was hanging on the wall,[120] or to try to establish at all from the picture how the pieces were arranged spatially in nature. The artist did not consider the matter.

Thus objects that are in reality a long way from one another can be brought close together in a picture. A picture on the surface of a scarab seal shows a king sitting with his bow raised to shoot and the prey, a bird, is close by his feet, not even facing in the direction in which the arrow is pointing (fig. 149a). Here of course the space available determined this placing, but there also exist free pictures where the target is close in front of the marksman (fig. 149b). In pictures of the death of St Sebastian the bowmen and their victim are still far too close to one another (an example in Schäfer 1928 fig. 55). As the limited space influenced the picture on the seal, in other cases considerations of space-filling can condition the composition, even leading to the addition of subsidiary figures.

[120] There are of course cases where the intention really is to show something hanging from the wall. We know from three-dimensional examples like Roth (1921) [= Winlock 1955 pl. 24–7 (J.R.B.)] that in weaving the warp is to be imagined as stretched round pegs in the wall, and this applies to pictures like Newberry n.d. pl.26. The rectangles in fig. 221 mid. L are the windows of the room, high up in the wall.

FIG. 149a. The king shooting a bird.
Scarab. NK
 b. Queen shooting at four
symbolic loaves. Late

4.3.5 Base lines and ground lines—registers

In true 'Egyptian' pictures more or less all the figures stand on straight lines. We mostly forget that this *base line* has nothing at all to do with the visual image. Rather it is one of the strongest signs of image-based depiction, and is in no way a natural inheritance from the early period. If one looks more closely, neither the statement of fact contained in the noun nor the judgement implied by the adjective is correct. In Hierakonpolis (fig. 144) still very few of the numerous figures (the three ibexes at the top and the three prisoners in the bottom left-hand corner) are on lines, and the one belonging to the prisoners comes up against the middle of the victor's body in a curious way. We can follow clearly the increase both in the use of the base line and in the number of figures on it, and hence in its length, through the slate palettes (pl. 8–9) into the Old Kingdom (fig. 151). So even something as familiar to us as the lines which dominate and order classical Egyptian reliefs and paintings is not a matter of course, but was worked out by the artists as they went along.

At the beginning the base line served to link figures at the same level and of the same height, like the groups of three at Hierakonpolis, which were mentioned above (Britsch 1926.33); in the case of single figures it emphasizes their vertical posture. One should bear in mind that the depressions in fig. 96–7 do not go down into it. But it takes on the meaning of the ground and often characterizes it, even if not as a whole, but only for the part the figure or figures are standing on. And in this way the insignificant line became an inestimable advantage for Egyptian art. For just as real figures stand and move on the ground, the figures in a picture were forced to come to terms with this line, which attracted them to itself, and thus gained firmness. The parts that carry them, like their feet, wheels and so on, no longer float free. Unintentionally pictures like that of the waggon in fig. 260, or drawings of feet like fig. 306, became less frequent,[121] and the number of 'pure lateral images' increases, although a rendering like the lizard in fig. 150, which is above the (wavy) ground line, still occurs between the Old and Middle Kingdoms. The attraction of the line is not equally strong in the art of all peoples.[122] On the other hand the power of this base line also constituted a fetter in Egypt, especially noticeable in the rendering of running.

FIG. 150. Lizard in the desert. 1st intermediate

[121] Matz (1923–4 [1925] 6) emphasizes this effect of the base line, but he exaggerates it. Cf. Ch. 6 n. 44.

[122] In some cases it cannot be seen: Koch-Grünberg n.d. 29, 33, 39, 43 (Brazilian Indians); von Sydow 1923.405 (ancient American).

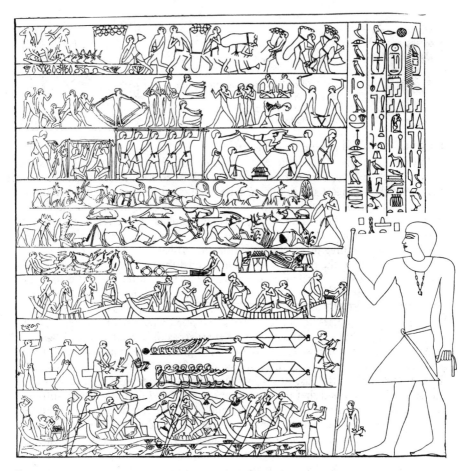

FIG. 151. Wall of the tomb of Ptaḥḥotpe at Saqqara. OK. [The small toes of the man on the right are not in fact shown.]

The gain for the articulation of complete pictures and the decoration of large areas was still more significant than that for single figures and rows. We can follow almost step by step how the figures become ordered ever more clearly into *registers* one above the next. But we only really feel that the Egyptians become aware of the value of the base line in the articulation of large areas in the flourishing mid-Old Kingdom. The registers of rows of pictures are placed one above the other with a sureness and purity constantly kept alive by the presence of good models. But this beauty can be properly appreciated only in front of the originals, as they suffer painfully in our perforce much-reduced illustrations (fig. 151). The towering form of the person for whom the whole composition is made, or at least to whom it all refers—the god, the king, or the blessed dead—often holds the registers together at the ends as if it were a huge parenthesis. Anyone who stands in front of such a wall must gain an inkling of the sensibility that constantly guided Egyptian artists,

however much the details may have varied, in the *well-balanced articulation of surfaces*, whether in a small decorative piece, the page of a book, or a huge wall. It is a pleasure to note how there are traces of ordering into registers even in areas which were intended to appear covered with disordered figures (cf. p. 182).

One senses a similar dependence on registers in the New Kingdom, when animals climbing a hill slope are placed on comparable but rising lines. Thus fig. 152 shows houses on the eastern edge of the city at Amarna which open on to the slope of the mountains in front of them. In the doors men are giving thanks to the early morning rays of the god, as is living nature in the form of the antelopes jumping up the mountain and the ostriches executing 'dances' of thanksgiving in three registers. If this is a rendering of nature, we see in pl. 62 a beautiful, carefully composed symbolic group standing for the course of the sun from its rising to its setting in the western mountains, protectively led and raised up by divinities and lucky signs. Here too the animal world takes part in the thanksgiving, in the form of the mythical baboons which greet the heavenly body with raised arms and cries in the morning and evening. Three rising wavy registers make up the mountainside. A small engraved golden container in Cretan-Mycenaean style has a representation of a griffon in a mountain landscape with similar registers.

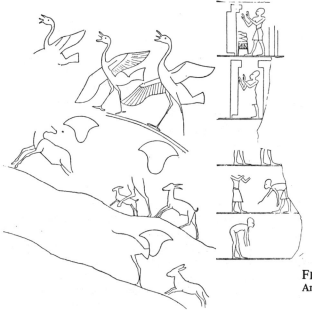

FIG. 152. Hilly desert behind Amarna. NK

The activities represented on the surface of one wall *are so arranged as a rule that the end of a register coincides with a break in the sense*. But there was nothing to stop the activity being spread out over several registers with each one continuing the last. Especially on unusually long tomb walls the continuous content, for example a mourning procession, climbs or descends through several registers in turn, probably

to save the viewer who walks along it from empty return journeys. If an action is divided into several stages these are frequently distributed over registers one on top of another, in which process the upper ones can follow the lower or vice versa. A tomb wall with a representation of bird-catching[123] is an excellent example: in the top register people are erecting the big trapping net. In the next it is ready to catch and the catchers are preparing to pull it shut, while the ducks are still swimming carefree on the water surface it covers. Further down the blow has been struck, the net has clapped shut over the scared birds, and the men are beginning cautiously to bring them down. In the lowest register the birds are being slaughtered and butchered. Thus the separate stages of a process, which would, as we shall see, also be placed side by side on one and the same line, are distributed over registers one above the other. Here the narrative begins at the top and continues towards the bottom. But there are also cases where someone 'reading' downwards would follow the action in reverse, so that one must begin from the bottom. For example, in Berlin 15071 the making of wine is shown, with the bringing of the grapes to the press and the treading by the harvesters at the bottom (cf. fig. 95), and above, next to the singers beating time, the wringing out of the remains in the pressing sack (cf. fig. 199–201), with the pouring of the wine into clay jars at the top. Compare with this another picture consisting of almost exactly the same groups but with the action moving downwards (LD Erg. pl. 21): the bringing of the grapes is at the top, the singers and men treading in the middle, and the wringing and filling of the jars at the bottom. There is also a representation of bird-catching where the net ready for the catch is in the lowest register (there is no scene of the opening of the net), while above, interrupting the sequence of thought, comes the poultry yard which will receive the catch, and, finally, the closing of the net is shown in the third register.[124] It can be seen that these things were entirely at the discretion of the artist who designed the picture, and who was sometimes very careless in the ordering and connection of his ideas.

Within the large registers subsidiary actions or figures which are distributed among the main figures by association of ideas, or in order to achieve an attractive covering of the surface (p. 25), are placed on shorter straight, or at times curved (fig. 150), intermediate lines (fig. 151 middle).

4.3.6 Objects depicted on or above one another without overlapping

1. It goes without saying that the positioning of figures standing above one another in a picture can correspond to the relative positions of the models. In such cases the situation is mostly quite simple. Consider for example fig. 56, with the hawk hovering protectively over the throne. But someone familiar with the subject-matter can sometimes discern another relationship, which is invisible in the picture, beside the certain above—below one. Thus while the fisherman's line in fig. 153 runs downwards, but also of its nature obliquely, in pl.16 the only relation established is the above—below one. In reality the men are standing on the land and drawing in the net, whose bulging wall is kept in place by floats and weights. So the angle of slope is certainly not as steep in nature as the picture makes it appear. In the New Kingdom a completely different image of the same activity is sometimes found. There the net with its

[123] Steindorff 1913 pl. 116 [= Wild 1953 pl. 120–2 (J.R.B.)]. I should like to note in passing that the interpretation I gave in Schäfer 1918–19.165 n. 1 is probably untenable.

[124] In Capart 1907.2 pl. 85. On a similar interruption in the sense of a picture cf. p. 197.

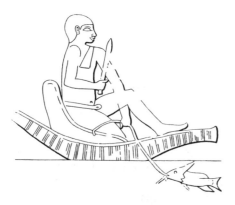

FIG. 153. Man fishing. OK

drawing ropes lies like a long sack in front of the fishermen facing it.

The placing of figures in free association one above the other to indicate that the higher ones are to be thought of as more distant is dealt with on pp. 189 ff.

In both these cases the impressions rendered are those received by the eye. A representation like fig. 92a, where parts are arranged contrary to nature, is only externally similar to them. There one sees the following, depicted freely above one another in a closed wooden box with a flat lid: below, a beaker-shaped unguent vessel, and above, its flat lid, with in between them a small unguent pot that is in fact the beaker. The beaker with its contents is paralleled by the large bowls closed by hemispherical basket-work lids, which are to be seen in tombs on the walls of offering chambers among the food for the dead man (fig. 154). If the contents did not concern the artist the lid would be placed directly on the bowl. But if the contents were to be shown the flowers or pieces of meat would be placed on the rim of the bowl, below the slightly raised lid. This was done from a memory of the actual lifting of the lid.

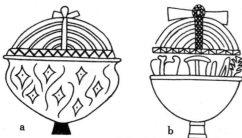

FIG. 154a–b Closed bowls, b with the contents visible. NK

2. Pictures where the figures stand immediately above one another exhibit the same peculiarities as single figures with several elements. In fig. 98 bottom left, washing equipment on a table can be seen. The grouping of the table in a pure side view, with the pottery shown as in fig. 93b, produced a combined image which also satisfies our demands. But many related representations require elucidation: in the pictures of the board game with the pieces (fig. 155), and of the mat with the bread (fig. 156) which stood for the sacrificial meal, the mat and the game board are shown from above and the pieces and the bread are placed on their long sides: 'the bread/pieces are on top of the mat/board.' Just as in the models for these pictures the bread was *within* the surface of the mat and the pieces *within* the squares of the board, in the same way the

FIG. 155. Board game with pieces
and knuckle bones. NK

FIG. 156. Mat with offering loaf.
Hieroglyph. OK

lotus stems in the model of fig. 37 lay across the middle of the plate full of fruit, and
not, for example, bent round the edge, but it is still true that 'the flowers are lying
on the plate'. A slight difference between the gaming board and the mat should be
noted. The Egyptian game really had the narrow rectangular form drawn, with only
three rows of squares, so that it was not like our corresponding boards. On the other
hand the Egyptian mat, although rectangular, was certainly not as narrow as it is
in the picture. Quite frequently we find surfaces on which another object stands
made narrower in the same way, for example the writing tablet under the scribe's
hand (pl. 23), the seat of an occupied chair,[125] or a sledge with its load on it (p. 111).
Artists drawing mats spread out on the ground under people or things[126] were
usually content, as in fig. 194, with a strip so narrow that they were only just able
to indicate the wickerwork. Next to longitudinally ribbed mats like these, speckled
wooden steps or platforms are to be seen, even in the same picture.[127] If the internal
patterns that distinguish these foundations were painted and have now faded away
all that remain are blank rectangles, and it is impossible to decide what was meant.
Even if somebody is sitting on one of them (fig. 157) with his behind on the end of
the platform or mat, and foot on the base line, no certainty is possible.

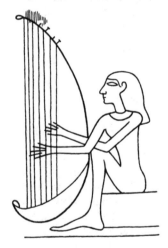

FIG. 158. Offering loaf.
Hieroglyph. OK

FIG. 157. Female harp player. MK

[125] p. 111, Propyl. 248.2 [Smith 1946 pl. 33a, Baker 1966 fig. 50 (J.R.B.)].
[126] Propyl. pl. XII [cf. L-H pl. 184, Sm pl. 128 (J.R.B.)], 365 [Sm pl. 104B (partial),
 W fig. 456–7 (J.R.B.)].
[127] Rosellini 1834 pl. 134.3.

An eating table like the one in pl. 19 with the upright forms of half-loaves (cf. fig. 158) placed on it is closely related in meaning to the offering mat. The standing form is not known from the mass of representations of eating tables on archaic cylinder seals, only a small table with loaves laid flat, or something of the sort.[128] Soon after, probably in the second dynasty, that is at the time when 'Egyptian' art came into existence, the pictorial form of pl. 19 must have been created.[129] The half-loaves, now apparently upright, stretching upward, often in strangely altered forms, have become a fixed element on the dead man's eating table, which is given in a pure lateral image; accordingly any further food there happens to be is placed on top of them (pl. 19). Nobody will doubt that the slices of bread should be thought of as lying on the almost certainly round surface of the table. So the rendering is the same as that of a broad necklace lying on a table (fig. 159). One would be attributing something foreign to the period if one introduced the sense impression received from a single oblique point of view (fig. 160), as has been attempted under the spell of the ideas about the Egyptian rendering of nature reproduced on pp. 137–8.[130]

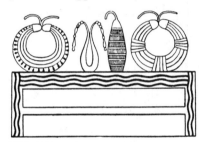

FIG. 159. Necklaces on a table. MK

FIG. 160. Modern drawing corresponding to a drawing like pl. 19.

3. The contents of an open bowl can be drawn in on its edge. When we looked at the washing equipment of fig. 98, above under (1), our attention was directed above all at its relationship with the table. But we must also consider that of the basin with the jug. If the artist's attention was held once by the way in which the jug disappeared into the basin (fig. 93b), and another time by what its form was and how the basin surrounded it (fig. 93d), it is conceivable that there should be a case where the observation of the form of *both* vessels predominated, and they were shown connected, but the exact spatial relationship was not indicated. This too does in fact occur and an image produced in this way is far from what the senses perceive; one might be inclined to say that the artist of fig. 93c thought the jug standing in the

[128] Many reproduced in Petrie 1917 pl. 1–2. Berlin 15337 (Scharff 1929 pl. 26 no. 147) is only an apparent exception; Berlin 16326 (ibid. no. 144) belongs in the second dynasty.
[129] The earliest examples are on tomb stelae like Gardiner 1917 pl. 55, Quibell 1923 pl. 26, and Berlin 23217.
[130] Borchardt 1893. In my *Die altägyptischen Prunkgefässe mit aufgesetzten Randverzierungen* (1903) I still accepted the interpretation, only with the slight reservation that the table top should of course be thought of as round and not rectangular. Klebs (1915b.132) gives a quite impossible interpretation. She had to introduce guide lines at the top of the loaves in her explanatory illustration.

bowl was raised onto its edge. But while this would be an accurate enough descrip-
tion of depictions of vessels with lids like fig. 154, with the washing bowls it would
be more correct to say that we can see how the artist's attention was given to the
basin and to the jug, one after the other. Many other objects are shown connected
in similar ways, and constitute a large family of variants, including for example semi-
or entirely visible balls of incense in a bowl (fig. 161).

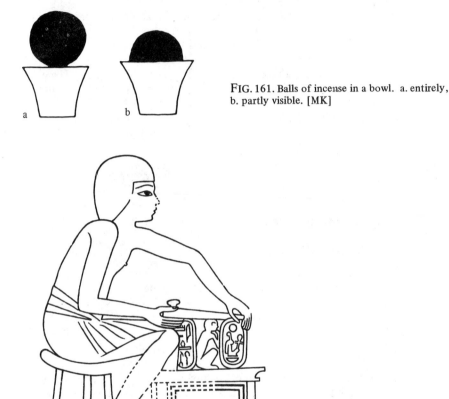

FIG. 161. Balls of incense in a bowl. a. entirely,
b. partly visible. [MK]

FIG. 162. Lifting the lid of a box. NK

Fig. 162, from a New Kingdom tomb, is an excellent and instructive example. We
see a man on the point of taking a piece of jewellery with the name of Amenhotpe
III out of a chest of the same form as fig. 41. He has already seen it in the box, but
certainly not yet touched it, as he is still using both his hands to lift the lid. Clearly
the movements necessary for this purpose were the factors governing the choice of
the image with the lifting of the lid, while when the artist drew the bottom half of
the box with the no doubt proportionately enlarged piece of jewellery, the notion
of lifting was as far from his mind as it was from those of the artists of the examples
discussed above. So, however attractive the picture may be, it cannot be used to

invalidate my warning against the idea that the jewel might be placed on the edge of the chest.

4. Certain groups of figures standing above one another took on a particular significance, and some of these became part of the stock of symbolic groups (pp. 155–9).

5. It is human instinct to affirm possession of something acquired by one's own efforts by placing oneself on top of it. Similarly it is normal in Egyptian art for the relationships of the Pharaoh to his subject, of victor to defeated, to be seen as one of on top and underneath. The subdued people lie, according to the favourite Egyptian phrase, 'under the soles of the feet' of the stronger man who stands or sits on them, and walks or even rides over them. They are rendered as firmly bound, mostly racially well-characterized men, but they are often also shown in symbolic groups. Thus, for example, lapwings with crippled wings generally refer to subject people (fig. 311), and nine bows to people an Egyptian king should control; or one finds a monogram indicating that he has united the 'two lands' (p. 155). Figures of this sort are reserved for places in the whole composition which correspond in a general way to the idea of 'subject'. They are, for example, found on the tops and sides of throne-bases, on the sides of the thrones themselves, and on foot-stools. Late Period mummiform coffins represent the dead man as the king Osiris; their bottom ends are painted with the undersides of sandals, which are decorated with figures of bound captives.

6. The groupings whose bottom element is the sign for gold ⌐⌐,which represents a necklace probably originally made of gold beads, demand individual treatment. Groups of this sort are found in art and in pictorial writing. Here we shall start from the latter, in particular from a royal title where a hawk is placed on top of the necklace ⌐⌐. In the place of this hieroglyphic monogram demotic texts and Greek translations have a phrase like 'who is on his enemy' or 'who is over his enemy'. Early scholars contented themselves with this rendering, but were unable to explain the monogram. Success in this came with Brugsch's ingenious idea that the hawk was the god Horus, son of Osiris. And where Horus occurs as conqueror the defeated character must be Seth, the murderer of his brother Osiris and local god of Ombos in Upper Egypt. Now the Egyptian name of the town (*nbwt*) contains the stem *nbw*, so that Seth can be designated by a word derived from it (*nbwtj*) as 'he of Ombos, the Ombite' and can be alluded to by the golden necklace sign *nbw* on its own. Thus in the monogram the victorious hawk god stands on the murderer of Osiris.

The evidence for this interpretation of course gives a true picture for the Late Period, from which it originates. But there are numerous earlier texts which give *nbw* its basic meaning of 'gold'. So we must deduce from this earlier tradition that the connection with Seth only came in later when it was desired to follow the general tendency and 'deepen' the meaning of the monogram of the golden hawk.[131]

It can also be explained on the basis of this old reading why, both in art and in pictorial writing, the gold sign was placed not only under the hawk but also under figures of goddesses like Isis, Nephthys, and Hathor, who admit of no reference to battle and victory. J. Evola,[132] without thinking of Egypt, gave an excellent

[131] [Cf. now Griffiths 1959 (J.R.B.).]

[132] [Author of *Il mistero del Graal e la tradizione Ghibellina dell'Impero*. Bari: Laterza 1937 (J.R.B.).]

description of the associations of the word gold: 'a symbol, rooted in tradition, for all that is indestructible and royal, and has to do with the sun'.

4.3.7 Figures juxtaposed without overlapping

By far the commonest distribution of figures in a picture is next to one another across the surface without overlaps: the forms stand free behind or facing one another, and move one behind the other or towards one another. From as far back as pre-dynastic times we have a whole series of tablets on which there are numerous animals, at first without and later with base lines, walking behind one another in such an order (Propyl. 185.1), and it is fair to say that this open arrangement without overlapping was always the most normal one for the Egyptians. It often seems, especially in side rooms of temples, that they could never tire of looking at long rows of figures, which sometimes fill whole chambers in tombs. Nor are they afraid of producing series of entirely identical figures. But these usually carry or lead different sorts of objects or animals, and as a result the positioning of the arms is also varied, without destroying the even tone of the whole. The reader is referred to Schmarsow's sensitive description of the effect of the many walking male legs in Egyptian art (quoted p. 295).

Juxtaposition of this sort without overlapping is by no means unambiguous. Often it only apparently indicates an ordering one behind the other. If the artists thought at all of a precise spatial relationship, a row of people standing next to one another is shown in exactly the same way as a row standing behind one another.

The common group on tomb walls, where a husband and wife stand together and receive gifts or watch their people at work, is a very good example. In the cases where the two do not have their arms round each other and are therefore in an *open grouping* (fig. 249) one could in fact just as well read off the depiction the statement 'the woman is standing behind him with her breast to his back.' The Egyptians knew what was meant and we too can say with certainty that the pair must be side by side and shoulder to shoulder. Many statues of married couples, which have the same physical and mental position in relation to the rest of the decoration, also show this. And in reverse we have Egyptian drawings of stone statue groups of this type, where the figures appear to stand one behind the other (fig. 163). But if we have no help

FIG. 163. Statue group. NK

from statues we *cannot deduce the spatial relationships of the original from any representation with non-overlapping figures*; again we have to depend on knowledge. If we take as an example the representation of dances (fig. 164) common in Old Kingdom tombs, it is not possible to decide whether the dancing girls executed their movements in a straight line next to one another (fig. 164a) or in a row behind one another (fig. 164b), and how the singers stood in relation to the dancers: in the same formation (fig. 164a, b), or as a second row (fig. 164d), or even at right angles to a row of dancers next to one another (fig. 164c). As there is no three-dimensional group preserved we can only guess that the dancers at least will have presented themselves in a row side by side. For an Old Kingdom Egyptian, who often saw such dances, there could of course be no doubt, and it would never even have occurred to

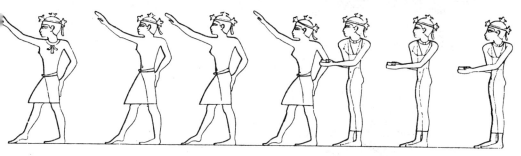

FIG. 164. Dance of the earlier type. The figure of the tomb-owner looking on from the left has been omitted here. Below: key to four possible arrangements of the figures.

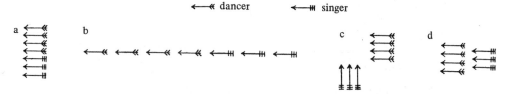

him that anyone should understand his picture except in the way he intended. On the other hand we may reasonably ask whether a New Kingdom Egyptian, who was used to quite different dance forms,[133] would have been able to understand these pictures correctly except from a knowledge of the earlier periods of his people's history, unless, as might well have been the case, the old style had been preserved in the lower social strata alongside the new fashion.

Let us consider again for a moment the group of man and wife, and imagine two such groups opposite one another, each presenting a different shoulder to the viewer; in each of the groups, as is normal, the man and wife will be shoulder to shoulder and the man on the right. If the whole were drawn in perspective in such a way that both groups appeared obliquely viewed from in front, the left one from the man's side and the right one from the wife's side (fig. 165), on a modern artist's picture surface the

[133] Propyl. 397.2 [W fig. 587 L (J.R.B.)] pl. XVI [L-H pl. XXII bottom R, W fig. 466 (J.R.B.)].

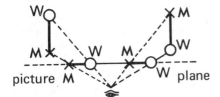

FIG. 165. Views of groups of man and wife.

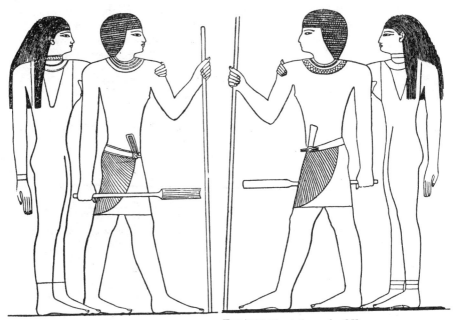

FIG. 166. Married couple. OK FIG. 167. Married couple. OK

wife's figure would be brought forward in the pair facing right, and the husband's in the pair facing left. But in an Egyptian drawing of a double couple of this sort the man stands in front in both cases (fig. 166—7). Thus the couple facing left alone (fig. 167), and not the couple facing right (fig. 249), correspond with the visual impression, and if we were to read the drawings as perspective drawings, we should have to assume that the man really only stood on the right in the first case, while the wife did in the second. It can be seen that the Egyptians did not think of the visual impression at all. The idea that the man as chief person should stand in front was uppermost in their minds. The same relationship is also expressed in relief and painting, where it is always the wife whose arm is round the husband: he is her support. In statues the man begins to have his arm round the wife in the New Kingdom, but this scarcely changes the sense: he is her protector.[134] A different formulation of this point will be found on pp. 233—4.

[134] Spiegelberg, who discussed these questions on the basis of an observation by his brother George, refers to the 'feminine character' of the New Kingdom (1929), to which I also allude on p. 294.

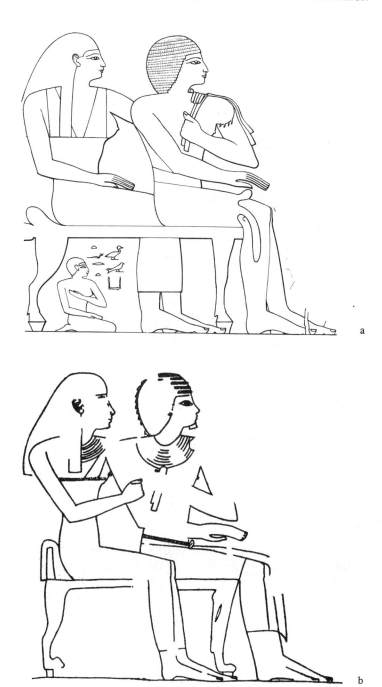

FIG. 168. Married couples on benches seating two. a OK b NK

If each of the groups is *closed* in that the wife's arm is round the husband, as in figs. 166–7, this becomes still clearer either when the wife's feet stand clear next to the husband's (Fechheimer 1923.120, 125) or when they overlap with them (fig.166). But if the wife's toes are covered by the man's heels,[135] it looks to us as if the wife is placing the wrong hand (the left instead of the right) on his wrong shoulder. It is almost always more important than anything else to the Egyptian that the man should stand in front, more important than the wife's position next to his left or right shoulder, or than the positioning of her hands. So far I know of only one case, from the Middle Kingdom, where the wife is in front in a two-dimensional group of this type, as one might expect from the left half of fig. 165. She then places her right hand on the right shoulder of the man, who is standing behind her in the picture.

If in the group in fig. 168a, we start from the fact that the wife's knees disappear behind the man's buttocks, we shall deduce that she is sitting by his left side. But the position of her arm is in complete contradiction with this, because it would not then be possible for her left hand to be on his left shoulder, as if she were sitting on his right. This grouping is consistent in the Old Kingdom and appears still to be the rule in the Middle Kingdom. In the First Intermediate Period the man's buttocks are occasionally obscured by the wife's knees, and this becomes normal at the beginning of the eighteenth dynasty (fig. 168b). In this way the group gains unity for us: the position of the wife's arm and the overlapping of knees and buttocks is consistent but now the woman always appears to be on the right in groups facing right, and on the left only in groups facing left.[136] However, the man's figure never takes its place behind the wife's on the picture surface. This clear indication of predominance was the deciding factor.

Attemps to understand groups of this sort from the point of view of visual impressions produce even greater confusion when both figures are sitting on a couch with arms (fig. 125). It is clear that the only visible arm stands for the back and the arm in a way that reminds one of the way houses were depicted (pp. 129–37); it was also discussed on p. 141 how, when taken as the arm, it should be extended to correspond with the size of the seat. Let us assume to start with that the man is in reality sitting on the woman's right: then his right arm, as in fig. 124–5, is crooked round the arm of the couch, with his hand on its corner. On the basis of the drawing of the thumb we should take this hand for a left one: but here it is a right hand (cf. p. 298). His left arm is stretched forwards. The wife in fig. 125 appears to be placing her left hand (forgotten by the ancient or the modern draughtsman)[137] on his left shoulder and her right hand on his right upper arm. But in reality that would be impossible: a woman sitting on the left can only place her right hand on his right shoulder, and her left hand on his left upper arm, and only the arm whose hand is touching the shoulder can be brought over behind the back of the couch. So in the picture an arm functioning like a left arm starts from a shoulder which we take to be the right one, and vice versa. If we were to assume that the wife was sitting on the man's right the result would be as follows: for the woman the distribution of activities of her arms would to our eyes be more or less in order. But how could an arm

[135] LD 2.13, 17a; photograph of another example Capart 1928 fig. 60.

[136] Cf. the fine drawing, which is also a counterpart to fig. 163, of a closed statue group of a seated man and wife facing left (von Bissing 1930.118 [drawing by Davies] [= Davies 1943.2 pl. 37 (J.R.B.)]).

[137] [In fact the ancient draughtsman, cf. note in Sources for Text Figures (J.R.B.).]

whose hand is gripping the man's upper arm come to be on the outside of the back or side of the couch? And in the man's case the left hand only, and never the right one, could rest on the side. It can be seen that, however convincing the picture may appear at first glance, either assumption produces impossibilities in the visual image, in one case for the wife and in the other for the man.

It may incidentally be noted how independent the figures in groups of this sort are. Basically they are mostly shown only as being beside one another. Whether there is a separation, as in fig. 168a, so that the arm grasping the husband often has to be lengthened out of proportion,[138] or whether, as in fig. 168b, the two bodies are brought closer together and the shoulders of one overlap those of the other, it is rare for there to be any physical connection apart from the embracing arm.

4.3.8 Overlapping of figures

Partial overlapping of figures is the only method 'pre-Greek' art possesses of showing with certainty that the models stand one behind another in the direction of the viewer's gaze. In perspective painting reductions and aerial and colour perspective can be used to give this impression, according to the circumstances.

At the period of the predynastic Hierakonpolis painting (fig. 144) independent objects do not yet overlap at all. Something of the sort is first found at the beginning of the historical period. But then we have in the bull palette (pl. 2) a relief which includes an astonishing wealth of overlapping. It shows a powerfully modelled group in which the king, in the form of a bull, holds down under him an enemy defeated on the battlefield. This representation is historically closely related with two others, of which one, showing the king as a lion (pl. 4), is probably earlier, while the Na'rmer palette (pl. 9 bottom) again shows him as a bull. All three animals place only their front legs on their victims, in the Na'rmer case only one of them, while the other is on the same base line as the remaining two legs. On the bull palette[139] one back hoof just touches one of the lying man's feet, and this is only an accident of the drawing, as can be seen from the other side, where the representation is repeated (pl. 2.1 = Propyl. 188.3). There is a considerable difference between the very abstract way in which the man lies under the lion's paws in pl. 4 and the inexorable heavy hoof which holds the man in pl. 2 under the bull. This distinction is not due to the different dates of the pictures but to the individual imaginative powers of the artists. The trampling of the defeated opponent by Na'rmer's bull is again much more lifeless.

Cases of overlapping are so many and so diverse that it is impossible to do justice to the subject here, and the individual cases are mostly so simple that it is unnecessary to adduce more examples in addition to the ones already considered. But a few mutually related types demand and repay more extensive treatment, as they developed into one of the most important Egyptian means of expression: so-called layer depictions, which are discussed in the next section.

4.3.8.1 Layer depictions. Introduction

These are connections where the overlapping figures cover each other in such a way that only a strip of the further ones is visible. In other words, the earlier form of 4.3.3 and 4.3.4 associated the figures in the mind, although images of them occurred separately to the artist (fig. 56, the fan-shaped shades), while the later form

[138] Propyl. 304 [Boeser 1909 pl. 10 (J.R.B.)].
[139] Propyl. 188.1 [= pl. 2 here. Propyl. shows recto and verso (J.R.B.).]

(pl. 6) incorporates the figures, which were hitherto only juxtaposed, into a unity. Delbrück (1899.5) introduced the term *Staffel* [layer depiction] for this phenomenon, and used it also for figures next to and over one another without overlaps. I adopt the word with gratitude, but I prefer to limit its use to the closed type, speaking of lateral layer depictions (subdivided into advancing and retreating layer depictions) and vertical layer depictions.[140]

The following remarkable note was published among Goethe's posthumous writings: 'nobody denies the ability of the sense of sight to estimate the distance of objects which are next to or on top of one another; but people are not willing to admit that it possesses an equal ability to evaluate successions of objects in the path of vision.'[141] It should be noted that layer depictions, which were unknown to Goethe, can indicate at least a certain amount of differentiation in the space between, and separation (fig. 163) of, objects by varying the distance between the overlapping lines.

4.3.8.2 Lateral layering

Lateral layering first occurs at the beginning of the first dynasty as a new form next to the open ordering of 4.3.3—4. I shall select a few examples from the available material: the fan-shaped shades carried behind the king, which we found entirely unconnected in fig. 56, are in pl. 6 a layered group of the extended type still

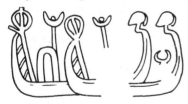

FIG. 169. Dogs hunting lions. [ED]

dominant in that period. Fig. 169 shows a row of groups layered among themselves in which a powerful dog catches a lion from behind. The groups are similarly connected with each other and form together a ring round a sort of cylinder seal. So two different animals are layered, and the position of the lions' tails is not uniform. In fig. 170 the care with which the raised parts of the ships are placed is noteworthy. In fig. 171 the presence of three ships, and the simple form of their prows, permits

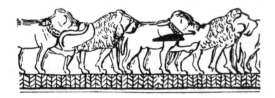

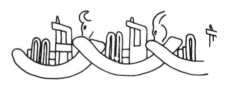

FIG. 170. Ships. Predynastic FIG. 171. Ships. Predynastic

[140] The only examples I know from Egypt of retreating layering of living beings are the figures facing left in Davies 1923 pl. 8, 10, and they are certainly mistakes on the part of the painter; for it is noteworthy that the faces, the part which really determines the direction, are in advancing layers. The reason for the retreating layer in *Atlas* 1.166 is the nature of the group. In the group of oxen *Atlas* 1.206 some animals are meant to appear to be being left behind.

[141] [Schäfer has edited Goethe's text (J.R.B.).]

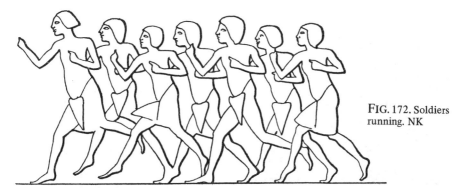

FIG. 172. Soldiers running. NK

an expression of the rhythm which is so pleasing in layered groups in Old Kingdom and later art. The master who drew the running sailors in pl. 30, for example—and many parallels could be cited for this picture—was not worried by the fact that sailors never run with such a beautifully measured, even step: he was quite unself-conscious in not restricting his impulse to produce a regularly rising and falling rhythm. Fig. 172 on the other hand shows us how an Amarna artist set himself the task of representing a restless jogging.

Close layering seems to come into existence at the beginning of the Old Kingdom, and to develop at first very slowly. We can follow the rise in the number of limbs in close layers, first with animals,[142] then with humans, and finally with objects. The first row of layered men of any length occurs in the Middle Kingdom (fig. 173), and similar arrangements of objects occur in the eighteenth dynasty. Not surprisingly the artists of the New Kingdom, with their love of beautiful line, had a special prefer-ence for the ornamental parallel lines of close layering.[143] Amarna artists ventured to use an extreme of closeness: before and after this period the Pharoah and his wife only sit in a completely open or very loose group.[144] But under Amenhotpe IV we find the two almost indissolubly close together (fig. 174), so that one very much misses the colour differentiation of layers that should, as stated on p. 181, be expected. We shall not be wrong if we take this extraordinarily closely integrated layer depiction as an expression of the well-known deep affection between the royal couple, which shows itself in other aspects of their communal life; compare for example the inter-locked fingers in fig. 310.

All the figures, the overlapping and the overlapped, stand on the same base line as if drawn to it by a magnet, and the further ones are of course not reduced by per-spective. There has been an attempt to see the occasional sinking of the outlines of the heads as an instance of foreshortening. But this is not admissible, as these par-ticular lines may sink quite spontaneously; anybody can test this statement himself by attempting to draw a similar group. If the sinking were really intentional one

[142] Four rows of draught animals in a close advancing layer depiction, from Ur, Propyl. 482–3 [Fr pl. 36–7, H-S pl. 72, X-XI (J.R.B.)]. A large number of wild horses (?) in an advancing layer depiction in a palaeolithic cave: Verworn (1909.42 fig. 22c [= fig. 178a here (J.R.B.)]).
[143] On the lesser rigidity of layer depictions at Amarna cf. Frankfort (ed. 1929.11).
[144] In Spiegelberg–Dyroff–Pörtner 1904 pl. 18 a loosely grouped couple facing right is sitting opposite a layered one facing left. (Observe the wife's forearm reaching over the husband's chest.)

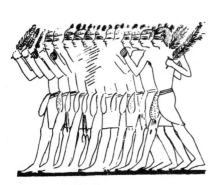

FIG. 173. Long layered row of running men. MK

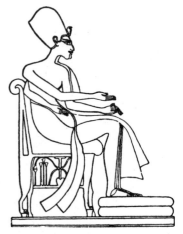

FIG. 174. Amenḥotpe IV and his wife on two chairs. NK

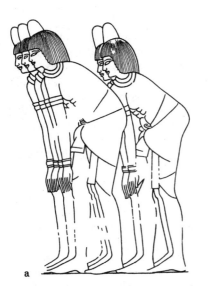

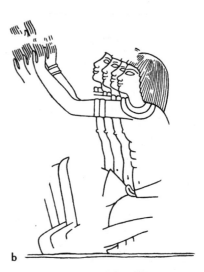

a b

FIG. 175. Advancing layer depictions of men looking down (a) and up (b). NK

would expect it to be exaggerated and much more obvious. From an examination of men bowing down it can be seen that in some cases the sinking is certainly intentional but equally certainly not perspective, and how it arose: the origin is the wish to make the lines of the faces (fig. 175a), i.e. eyes and chins, coincide to form longer straight lines, in more or less the same way as the almost horizontal arms of the reapers in pl. 41 are extended [cf. Schäfer 1938.31, fig. 8]. This explanation is as it were sealed by the fact that the line of the skull rises correspondingly if the figures are looking upwards (fig. 175b). The same treatment is extended to very open rows of bending figures (fig. 176).

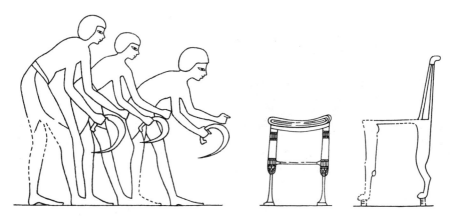

FIG. 176. Reapers. NK FIG. 177. Stool and chair. NK

Only very rarely are entirely different animals or objects arranged in layers: during the whole course of Egyptian art they stand free next to one another. Fig. 169 with its dogs and lions is of a special type, as the two animals are linked by the action. It is noteworthy that varying types of antelope are not infrequently placed together despite their different horns, indeed sixth dynasty artists love to unite three animals with different horns in one layered group. Apart from the closeness of the layering fig. 174 is unusual in another respect: in the New Kingdom married couples began to be given separate seats (fig. 177), the man a chair with lion legs and the woman a stool with apparently lathe-turned legs (p. 53). As the two types of seat are united in the layered group we have here one of the few examples of the combination of objects of different types, although the artist has succeeded in making the distinction apparent, if only to a very close observer.

An Egyptian relief is so low that the figures grouped in layers are not separated by strong shadows, so that layers of the same colour would easily be confused by the eye in painting without shadows, or in sunk relief (p. 78). For this reason artists tried to distinguish the layers by the use of alternating light and dark colours. This already happens with the normal overlappings of 4.3.6, as with pairs of wrestlers, where the figures are always in two different colours. This is the only reason why painted teams of ploughing oxen and chariot horses always consist of one light- and one dark-coloured animal—not because of some fashionable whim on the part of the owner. Narrow layers distinguished in this way sometimes contrast so harshly that groups with many parts look as if they were shot through with many pale bands of colour. Although the alternation of colour is only really meaningful if the whole surface is coloured, Egyptians were so used to distinguishing these figures by their colour that black and red layers sometimes alternate in simple line drawings,[145] especially in vignettes on papyri, whose scribes always had these two colours on their palettes (p. 71).

There have been two attempts at interpreting lateral layer depiction. One sees it as a method which places sketch outlines in a row, and which is not based in any way on the stimulus of a visual impression. In the other view it is held to be influenced by

[145] As in Devéria 1872 pl. 3: layered oxen.

oblique views of lines of figures next to one another. But neither attempt provides an entirely satisfactory explanation. The first is too abstract—it is difficult to believe that layer depiction could arise side by side with open ordering, without any stimulus from nature. As regards the second explanation, I still used it in the previous editions of this book, saying that layer depictions were derived from an oblique view of a dressed line of figures, and were only later taken over for groups which are certainly crowds and not lines. But this is not tenable, as dressed lines are far too rare in nature to serve as the starting-point for a method of representing something as common as crowds of objects.

It seems to me that it will further our understanding if we bring the oldest layered drawings in the world into the discussion; these are palaeolithic pictures of a pack of galloping wild horses headed by a leading animal (fig. 178a), and of a herd of reindeer (fig. 178b). It is clear at once what has happened in their artless forms: the disordered mass of crowded and overlapping bodies has been taken from nature, but an innate tendency in the artist to order ranks and parallel lines immediately took control of his sense impression [cf. Schäfer 1938.33, fig. 9]. Anybody can experience at first hand how deep-rooted this instinct is by trying to cover a surface with totally irregular lines. One can also observe time and again in Egyptian reliefs and paintings how there are vestiges of ordering into registers (p. 165), even in masses of figures intended by the artist to represent wild confusion. One is constantly made aware of how one's intentions are furthered or hindered by the human instinct for order. The same instinct forced the papyrus umbels in fig. 82 and 179 into closed mathematically horizontal rows, and it speaks to us with enormous artistic effect in the groups of sailors in pl. 30 (p. 179).

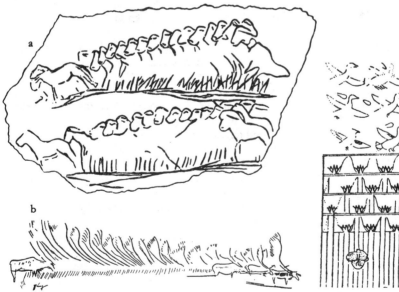

FIG. 178. Herd of wild horses (a) and of reindeer (b) on the move. Palaeolithic

FIG. 179. Papyrus thicket with birds, eggs and butterfly. OK

The disappearance from the discussion of the oblique view of a rank means that the notion of perspective no longer needs to be introduced into explanations of layering.

If, having removed this obstacle from our minds, we review the hundreds of lateral layer depictions, we find almost none that could be said to be ranks. Almost everywhere the context makes it much more plausible to think of a crowd. Lateral layer depictions simply represent a crowd. They may occasionally also include ranks, but even then oblique images as such did not play any part for the artist.

The solution given for crowds with many components is of course also valid for cases with only two layers, of which I shall mention what is probably the earliest case (*Atlas* 1.396): a team of oxen yoked at the horns (rather like pl. 46). Here too the initial stimulus was a perception of nature which was then modified by the instinctive preference for parallel lines. In most such cases the situation is fairly simple. But the layering of the legs in four-legged chairs needs further study (pp. 138–40).

It occurs in tomb reliefs almost solely when the legs are in the form of lions' legs. Following p. 138 one would expect it to occur with bulls' legs also. The reason why it is not found with them is that for some reason (p. 139) bulls' legs had already disappeared by the fifth dynasty, when the layering of chair legs was introduced. Two types are found in preserved pictures. They are distinguished chiefly by the conical or pyramid-shaped ends which stopped the actual animal feet from sinking into the earthen floors. One must assume that in the Old Kingdom there was a front and back pair of lion legs (fig. 126), each of which was left as one piece of wood right down to the ground. But in the Middle Kingdom (fig. 180) the legs are separated right down to the base line; thus the four legs of one and the same animal are under

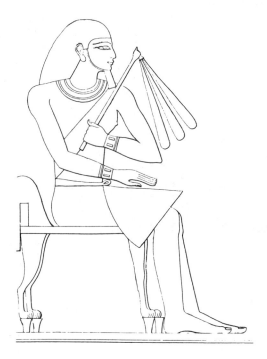

FIG. 180. Chair with layered legs. MK

the four corners of the chair. As far as the animal legs are concerned the artist's attitude was the same with regard to both types. But there is a difference: one can conceive of a perception in nature of the closed legs, from which the layer image could have been derived. This would have been impossible with single separate legs. So these separate legs are another case of intellectualizing representation like fig. 15–16, where the arch of a human foot is treated as if it could be seen through. It is worth noting that the layering of chair legs disappears again at the beginning of the New Kingdom,[146] just before the time when other close layer depictions are developed. This is a reminder of how much in art is dependent on the taste of the period—as is also to be seen in two-wheeled war and hunting chariots, where (pl. 55–7) the horses harnessed at the neck are layered just like the ploughing oxen yoked at the horns, while layering was never, for some unknown reason, adopted for the wheels—indeed layered wheels are completely unknown in Egyptian art.

The layer form was occasionally taken over for the pictorial script, especially for signs for animals; for example, the plural of the word for 'soul' is not rendered by

three jabirus[147] standing in an open group , but by a layered group like fig. 181.[148]

The closer the layering is, the more store is set by the perfect parallelism of the lines. But even then the group is sometimes made more lively by the introduction of small irregularities, which do not, however, spoil the parallelism. And while the elements in a close layer depiction composed of many parts follow one another immediately (fig. 182, top row only), in looser ones (fig. 182, bottom row only) there are often intermediate elements on either side of each figure, so that a second row can appear in the gaps in the loosely layered front one.

We sometimes catch the Egyptians being very careless even in layer depictions, and this is in keeping with their characteristic laziness, referred to on p. 32. Thus groups of animals are often unsatisfactorily worked out within themselves, so that

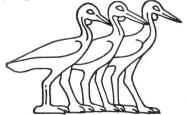

FIG. 181. Hieroglyph for 'souls'. OK

FIG. 182. Troops in close formation. NK

[146] There is a significant difference between the apparently identical Old and Middle Kingdom pictures. Only in the Middle Kingdom is it made clear that both pairs of legs are meant, by dividing the legs right down to the base line (fig. 180). In the Old Kingdom (fig. 126) the truncated pyramids on which the chairs are standing, or the reversed conical shapes of the legs themselves, only have one outline. So every chair leg probably represented a pair of animal legs which were not separated from one another. The artist's attitude to legs in animal form is the same for both types.

[147] Threefold repetition is found in Egyptian pictures, as well as in the script, as an indication of large number (pl. 16). In the script, as is well known, plurality (more than two) is also indicated by placing three strokes after the determinative.

[148] Sethe (1922.34 and 103) shows that the overlapping artistic form was originally taken over in writing when space was insufficient.

the number of legs does not correspond to the number of heads, as if the artist wanted to save the trouble of counting them. However this is not taken as far as it is by the palaeolithic artists, who abbreviate the legs of the wild horses and the bodies of the reindeer between the fully drawn end figures by simple hatching (fig. 178). There is one case of an Egyptian layer depiction of men, where the bodies are layered from the back while the heads, the part that really indicates the direction, are layered from the front [cf. n. 140 above]; if they too were layered backwards they would disappear. The layering is at times excessive: in the pictures of palanquins in Propyl. 266 and 389[149] the heads of the pairs of bearers are layered even when they would in reality be separated by the carrying poles and the seats. In the same pictures the crooked upper and forearms are given layering lines which are absent on the back legs in 266, but present in 389. And if an artist otherwise as good as the creator of the Rekhmire' tomb simultaneously layers horses forwards and backwards, one can only deduce that sketch outlines are sometimes lined up together without further thought.

As the use of overlapping, which had grown gradually for millennia, became restricted again in the Late Period, at the same time, of course, layer depictions dwindled, although they never disappeared entirely, but were adopted again by some of the schools in the Graeco-Roman temples. Representations of workers at the hearth or anvil show how this dwindling expresses itself in particular motifs. They apparently sit in two rows facing each other: but Balcz showed that they in fact formed a ring round their work. This ring is divided in two for representations in relief or painting, and its halves are arranged in equivalent layers. Now while the figures in an early sixth dynasty picture (fig. 183a) are closely layered on either side, a twenty-sixth dynasty artist (fig. 183b) drew them apart like the reapers in fig. 176, so far apart indeed that the back ones lost all connection with the anvil or fire, and the picture can only be understood by a specialist.

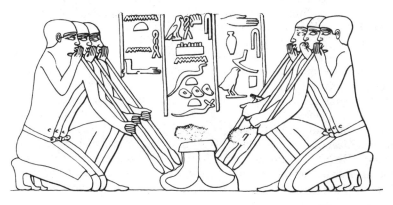

FIG. 183. Men blowing at a fire. (a) OK (b) Late

[149] [266 = *Atlas* 1.405, 389 = LD 3.121a-b, W fig. 565 (J.R.B.).]

4.3.8.3 Vertical layering: the obscured figures are at a greater distance

In vertical layering the further figures are above the nearer ones and protrude, dependent on their form, by a narrow upper strip like the quadrupeds in fig. 184, or, if they are men, by the head (fig.182), the bust (fig.182, top row), or the upper part of the body (fig.185). This form of layering poses such different problems from lateral layering that it must be treated in a separate sub-section, although much of what was said above is also true here.

It should be noted that no single example of this phenomenon is known from the Old Kingdom. It is not possible to assume in face of the enormous quantity of reliefs and paintings of the period that a spiteful fate arranged for the disappearance of vertical layer depictions.[150] And it is certainly no coincidence that palaeolithic cave paintings, among which are several lateral layer depictions (p. 182), do not appear to include vertical layering.

The figures are almost always placed on a base line, though this is only true of the bottom row; a series of base lines corresponding to the upper layers never occurs. And in certain pictures (fig. 185), to be discussed in the next section, the base line for the whole vertically layered group is absent; but there are many variations.

Vertical layering first occurs in the Middle Kingdom,[151] and even then only very rarely at first, and is used in the same period for living beings and for things. Thus in fig. 285R the poles of the palanquin are layered vertically in pairs, while Old Kingdom pictures always show a single unlayered one.[152] The first living beings depicted thus are swimming ducks (fig. 186 bottom). In the New Kingdom the new method is used with complete assurance from the middle of the eighteenth dynasty on. A teeming flock of geese, a herd of oxen, and a close-packed crowd of about a hundred men (similar to fig. 182), all in the British Museum and taken from Theban tombs of the time of Thutmose IV (Davies 1923 pl. 25), are probably the most brilliant achievements of this type. There is a Cretan parallel for the crowd of men in a group of spectators at a festival·performance.[153] However, the new form probably came originally from Egypt, where it can be observed growing from small beginnings.

In fig. 233, under the right-hand ramp leading to the throne canopy, there can be seen a vertically layered rank of bodyguards, which changes into a line of warriors standing one behind the other at right angles to it; the two together form a sort of courtyard round the throne canopy. It is tempting to place the work of my eight-year-old grand-daughter (fig. 187) beside this product of the central Amarna period. Here a fence made of planks at the top corresponds to the lower horizontal row of warriors and the 'fence' of the bodyguard, closed by the vertical layering, is equivalent to the vertical wooden fence, whose planks have been placed one above another without overlaps. Despite the similarities the layered overlaps in the Amarna composition, and the lack of them in the child's drawing, show the intellectual distance between them. And the vertical plank fence embodies much less observation of

[150] This invalidates Petrie's attempt (1892.31), in itself unsatisfactory, to interpret the sign as a row of columns viewed from above. It is in any case now known that the sign in fact represents a bundle of objects tied together (Firth 1927 pl. 2 to p. 109). [An archaic statuette of the object has recently been found (Saad 1947 pl. 14b); Helck (1954.383) interprets this as a stake, to which stepped circular layers of corn have been bound.] The ploughing oxen in *Atlas* 1.396 are not vertically layered, as might be thought.

[151] In Babylonia vertical layering is fully developed in the grouping of the mass of Eannatum's army (third millennium: Propyl. 490 [Fr pl. 34 (J.R.B.)]).

[152] Propyl. 266 [*Atlas* 1.405 (J.R.B.)].

[153] [Bossert 1937.126-7, Evans n.d. pl. 2, with comments by Cameron–Hood 1967 (J.R.B.).]

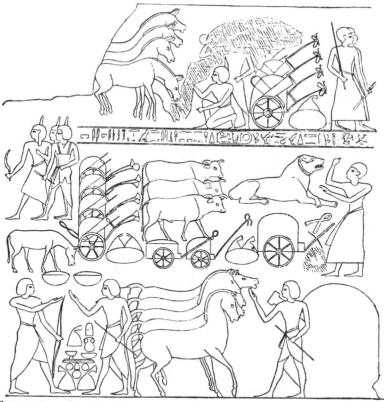

FIG. 184. Part of a war camp of Ramesses II. NK. [The legs of the further horses in the bottom group are in fact missing, although they are shown here two lines above and in *MH* 2.109.]

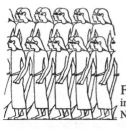

FIG. 185. Troops in loose formation. NK

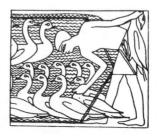

FIG. 186. Catch of birds being taken out of the net (detail). MK

nature and much more conceptualization than the true vertical layer of bodyguards.

Quite clearly vertical layering is based in the last analysis on the perception that, if a number of identical objects lying or standing on one level are seen from a higher point, as in fig. 188–9, the more distant ones appear higher than the nearer ones. The artist's whole store of visual images contained only this rising succession of over-lapping figures to indicate even slight degrees of distance in depth (pp. 189–98).

Egyptians saw only a massing of figures in vertical layer depictions, of the same type as we found to be the basic idea of lateral layering (p. 182). So we should have two forms with the same meaning. But I believe it is fair to say, without abandoning the other element of content I have mentioned, *that vertical layering is used for*

static groups[154] *while lateral layering is used for groups moving forwards.* It will probably be impossible to give a final answer to the problem, as walking and standing are still, as is shown on p. 294, expressed by the same rendering of the legs.

On p. 185 we were obliged to come to the conclusion that one type of association of vertical and lateral layering in the same figure was a mistake. The mixed use in fig. 186, on the other hand, is regular. The group in pl. 44 is composed in very loose vertical layers, close and extended lateral layers, and figures of various proportions facing in various directions. Together with the variations in positioning of arms and body this multiplicity of groupings gives the whole a delightfully lively quality.

FIG. 187. Child's drawing. House in a garden with the vertical slats of the fence placed one above the other without overlapping.

Fig. 188 is not entirely simple. Someone looking at this pile of flat circular pieces of bread might well think they were in rows seen from above, stretching away in depth, with their disks raised one on the edge of the other like piles of coins spread on a flat surface. But what is meant is of course a steep-sided cone with pieces of bread placed on top of each other. The artist constructs it according to a purely image-based schema, by starting with a row of completely visible pieces lying on the altar like the necklaces in fig. 159, and above it, superficially derived from a sense impression, using the model of vertical layers, the crescent of the rest of the bread. The whole is contained in the conical form of the pile. It is exaggeratedly narrow at the top, despite the fact that it still shows three loaves next to one another; these are held together at the top by a sort of cap made of wreaths of flowers that were originally painted in.

[154] As was still the case in ancient Rome (pl. 94).

FIG. 188. Altar with offering loaves. NK

FIG. 189. Three objects behind one another.
a and b shown in perspective, c in the Egyptian
style without overlapping.

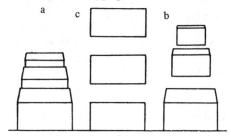

The Egyptian layer depiction of fig. 182 can be compared with a group from the
time of Emperor Constantine, and early Christian painting often contains layered
pictures of animals comparable with fig. 184. According to pp. 265–9, 275–6,
in Egyptian vertical layering one can speak at the most only of apparent perspective,
while cases from late Antiquity and early Christian art can be considered to *contain
perspective elements,* but neither should simply be called perspective.

4.3.8.4 Conclusion

In layer depictions the Egyptians invested and developed a clear and beautiful
form. This can be seen historically to be entirely their own creation. It was not un-
known among other peoples and at other times, but was probably never used so
much and with such loving care, so one concludes that it must have had a special
appeal for the Egyptian people.

4.3.9 Rising forms which indicate distance without recourse to overlapping

W. Von Kügelgen expressed the idea admirably in his memoirs of his youth:
'only the nearest thing is of importance to children: they live chiefly in the fore-
ground. There every detail absorbs them, while the distance can be arranged as God
wills' (1870, Ch. 5). Up to a certain stage one could speak in similar terms of the two-
dimensional art of all peoples. In the Hierakonpolis wall painting (fig. 144) all the
figures would still be foreground, although on p. 160 I preferred to express it by
saying that they only indicated an assemblage of figures in which individual ones
were not thought of as near or distant.

The further we move from the predynastic period into the historical period the
more we feel tempted to introduce a new interpretation for figures that are similarly

distributed without any sign of an optical connection. For we have become accustomed to using the maxim 'whatever is placed above should be imagined as further away' for all Egyptian reliefs and painting, without testing to what extent it is applicable. This habit is based on a personal experience common to all of us: if a man looks down onto objects lying one behind the other they appear, if the distance between each pair is sufficient, and the difference in height between them and the viewer's eyes is great enough, to be standing free one above the other.

It is clear that only in very rare cases shall we be able to say with certainty if the new visual perception finds expression in a freely ordered Egyptian picture or not. For example, the picture on the Naʿrmer slate palette (pl. 9) where the beheaded corpses are spread out like game[155] could in itself be interpreted as if, as in Hierakonpolis, no thought had been given to what was in front or behind; but the artist could equally well have imagined the figures as viewed obliquely from above. There is a third possibility, that the picture could be the product of the idea 'the bodies are lying next to one another in front of the victor on the ground, just as the calves in fig. 259 are walking in front of the king.' And who would for example commit himself as to whether fig. 197, in which the ducks' necks appear out of the water without overlapping, should be interpreted as an oblique view over the surface of the water with the birds in it, or rather as I try to interpret it on p. 199?

In such circumstances it must be of significance to establish from what moment on it is legitimate to incorporate the realization that more distant objects shift upwards into the interpretation of loosely ordered pictures.

The description of how distant objects in the path of vision shift so far upwards that they lose all contact with nearer ones suggested itself so strongly for the phenomena which I discussed in connection with vertical layering on p. 187, that one might be tempted to assume that the new interpretation should only be applied to loose groupings of objects that come after the introduction of vertical layering. Now the latter, as we saw on p. 186, does not occur before the Middle Kingdom. For this reason I still assumed in the last edition of this book that rising groups of non-overlapping objects were first used to indicate distance at that time. The conclusion followed that only from this time on should we attribute the new interpretation of these images to artists. With all earlier pictures we would have to bear in mind that an interpretation of this sort would be a pure assumption.

But this consideration is irrelevant. If we observe how at a certain age our own children always of their own accord, and without outside influence or acquaintance with vertical layering in art, notice that distant objects shift until they cease to overlap, we cannot possibly make the acceptance of the same observation in an art like the Egyptian dependent on a pictorial form that occurs by comparison so late.

So although it is reasonable to regard the existence of this interpretation as certain, the time of its first occurrence is quite uncertain. But if it is thought possible to recognize the first occurrence of the new interpretation it must also be assumed that from that moment there were pictures by previous artists, for which this optical impression was not relevant, which were viewed as if it were. One must bear cons-

[155] Compare the passage in the myth of the winged sun disk (translation in Roeder 1915.122.4): 'So the Person of Reʿ went, Astarte with him, and he saw the enemies' (killed by the winged sun disk) 'who had fallen to the ground, and whose heads were smashed.' [E 6.112.3–4 = E 13 pl. 520. For sqr see Wb. 4.307.1. My translation. (J.R.B.).]

tantly in mind, on the other hand, that remains of earlier stages are found beside forms which may be considered to be more advanced.

In comparison with the earlier forms of fig. 262–3 the new interpretation may be seen in the presentations of gardens from the time of Amenhotpe IV (fig. 190), somewhat tentative and half-hearted precursors of which occur in the immediately preceding period.[156] The charming picture of the bank of the Nile at Amarna with the landscape behind (fig. 191) is also an image with a unified conception. In the picture of Amenhotpe IV receiving envoys in fig. 233 the vertically layered bodyguards under the front incline of the throne-base suggest such an interpretation, but the whole layout of this beautiful composition does not seem to favour the assumption.

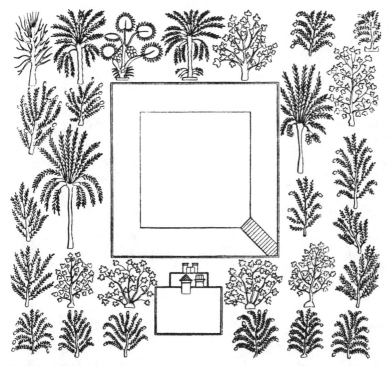

FIG. 190. Garden at Amarna. NK

Finally the Egyptians appear to have arrived at a method of composing pictures which look like vertical layer depictions spread out, and which I would term 'overlooked'.[157] At all events the new spirit is clearly recognizable in the great Ramessid pictures of land and sea battles, which, however off-putting one may find them, grip one again and again with their great sweep of action.[158] They really are high points

[156] *Atlas* 1.66, 92, 222, 300B.
[157] [Schäfer uses a term which applies to relief maps, and his usage here and on p. 196 cannot be rendered into English (J.R.B.).]
[158] Most of them are reproduced in *Atlas* 2.

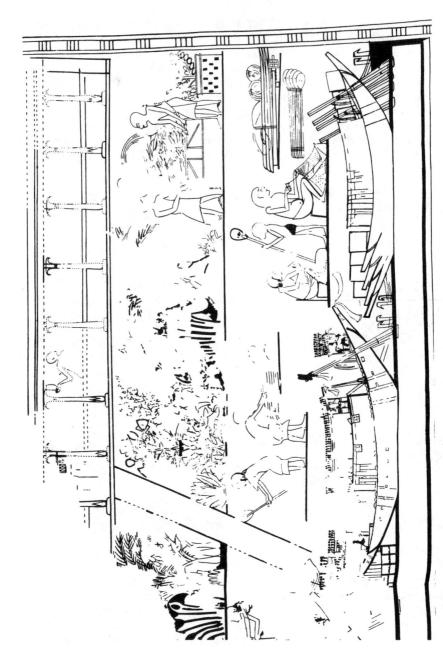

FIG. 191. The river bank at Amarna. NK

in the depiction of historical events, and New Kingdom Egyptians could look at them with as much pride as the Greeks had in the pictures of Polygnotus. On a more modest scale the forerunners of these works are the reliefs on Thutmose IV's chariot,[159] eighteenth dynasty hunting scenes,[160] and especially the hunting and battle scenes on a chest from the tomb of Tut'ankhamun[161] and the Sety I battle scenes in Karnak (pl. 55).

It is clear that it will always be a matter of personal opinion whether a given picture should be taken as a view over a wide area or not. Many more cautious people will deny it. But there are arguments that can be brought in favour of it.

Let us consider once more the division of pictures into registers discussed above (p. 164). It is often tempting to assume that the new interpretation is valid for the grouping of registers in Old Kingdom tombs. Thus there has been an attempt[162] to interpret the group of seven registers in fig. 151 as a bird's-eye view from the Nile across the valley into the desert. This is certainly wrong and falsifies the data slightly, for it divides off the four lowest registers from the remaining three, which are ignored in this context, and considered separately. It is true that the three bottom registers contain scenes that have to do with the river and the next one shows hunting in the desert, so that these four would to some extent correspond to a view from the Nile into the desert. But even then it would be remarkable that, if this were the intention, the vital agricultural land between the two should be omitted. Nor is it correct to take into consideration only those parts of a picture which fit one's thesis. In this case there come higher on the tomb wall, therefore apparently further into the desert, the making of wine, children's games, and right at the top the papyrus harvest which again takes place by the water. This distribution, which would be disconnected even as an association of ideas, makes the interpretation as a composite picture quite impossible. We should be extremely cautious with all similar Old Kingdom pictures arranged in registers, including for example the one with the vintage scene discussed on p. 166. It is misleading and proves nothing that in many hunting scenes the horizontal registers are defined and grouped by nets running from top to bottom (fig.192). How else could a representation based on frontal images be constructed to show that the animals are enclosed by a net over which the hunter shoots his arrows? *The distribution into registers has nothing to do with pictorial depth, and is solely a product of the artistic desire to produce a well-ordered and distributed picture.* It may fairly be said that there is not a single Old Kingdom composition in registers that contains any element which suggests that the artists really interpreted the grouping into registers as a view over a wider area. The opponents of this view[163] cannot produce any evidence to support it beyond personal opinion, and such an attitude does not further knowledge. It is also easy to detract from the genuine beauty of a picture by a useless

[159] Erman–Ranke 1923.489 [W fig. 463–4, Carter–Newberry 1904 pl. 11(J.R.B.)].

[160] *Atlas* 1.26, 185. Transitional works *Atlas* 1.53, 353; compare *Atlas* 1.215. [The model for this picture is identical to that of fig. 192 (MK) (J.R.B.).]

[161] Steindorff 1928.242–3 [Nina Davies–Gardiner 1962, L-H pl. XXXIV, Sm pl. 142–3 (J.R.B.)].

[162] By Maspero. His repeating it up till the end of his life, although Steindorff had already refuted it in Maspero–Steindorff 1889.321, did not make it any sounder. [Steindorff's note refers to p. 181 of Maspero's book.] The desert area with animals is often placed at the upper edge of the desert, but ships, and therefore the river, also occur in this position, e.g. in LD 2.9. The influence of famous works is a quite sufficient explanation of why the form with the desert at the top became the normal one.

[163] e.g. Matz (1922 [1924] 45).

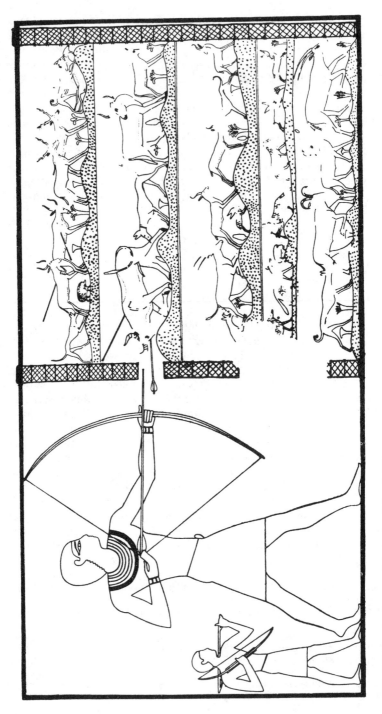

FIG. 192. Hunting in an enclosed area of desert. MK

effort to see a resemblance between it and our perceptions of nature: from this point of view an Old Kingdom tomb wall of this type would look imperfect. But if we look at it as it is, something is revealed to us which is quite simply perfect of its type.

The fact that Old Kingdom Egyptians adopted and extended the use of base lines to articulate their pictures into registers is probably an indication that they did not interpret these registers arranged above one another as a view from a raised position. On the other hand there can be no doubt that the attaching of the parts of a picture to the continuous base line can in its turn only have fixed the connections between the figures across the picture in the artist's imagination and directed his gaze away from associating them in depth.[164]

It becomes clear how close is the connection between the lack of pictorial depth and the ordering into registers, if one considers that at the end of Classical Antiquity, at a time when the tendency to render pictorial depth was again disappearing from Greek and Roman art, there were produced reliefs whose composition into registers is identical to that of ancient Egyptian tomb walls. For example, on Annius Octavianus' stone sarcophagus in S. Giovanni in Laterano in Rome,[165] the dead man stands, with his figure occupying the full height of the picture, watching his people, who are arranged to left and right in two sharply divided registers, at work.

This geometrical distribution of pictures became too faithful an expression of the essential Egyptian character for it ever to be displaced. On the contrary, it held sway for as long as Egyptian art lived, not giving way to the new form until the New Kingdom, and then only slowly. It is still possible to observe how the eighteenth dynasty hunting picture in fig. 193 is divided in the classically Egyptian way into registers and in each register the ground is shown as that of the hilly desert. One can sense how the rigid base lines must have worked against a mental unification of the picture.

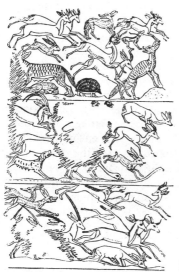

FIG. 193. Game animals in the desert. NK

[164] This opinion is also expressed in Erman–Ranke 1923.476 n.6.
[165] Reinach 1912.282 (reference supplied by F. Saxl).

It is only in the eighteenth dynasty that any considerable number of attempts to make the ordering into registers less strict are found. Jumping animals sometimes break through the base line, or it is quite reticently indicated.[166] In many hunting and battle scenes it disappears more or less entirely, so that it might seem on the surface as if the artist had returned to the old child-like method, in other words as if there were no difference between these New Kingdom works—let us take the Ramesses III picture of a sea battle[167] as an example, because of its similarity of content—and the Hierakonpolis wall painting (fig. 144) in their treatment of space. Yet the difference is enormous. *The very fact that the base lines that had been evolved over the centuries disappear again here seems to suggest that we are justified in interpreting the great New Kingdom historical reliefs as pictures whose surface represents the ground.*[168]

There is no justification for saying that a picture divided into registers is earlier than one which is not, as both types continue to exist side by side, and after the end of the New Kingdom pictures in registers are again almost entirely dominant.

Just as register pictures were always the commonest type in Egypt, vestiges of ordering in registers, even base lines, never disappeared completely from 'overlooked' scenes; they are still occasionally found at one or two points. They are also found in works from the period of dissolution of Greek and Roman art, and they show how hard artists find it to grasp the idea of the picture area being the surface of the ground. The artist of the Antoninus column (pl. 96) placed his figures on curious stone projections which have exactly the same meaning as Egyptian base lines.

In Egyptian 'overlooked' scenes there is always a base line at the bottom of the whole composition, on which the bottom figures stand. There is never an empty part of the picture surface below them: unlike the Hierakonpolis picture (fig. 144), the scenes begin with the feet of the front figures. Here again the magnetic power of the base line, which I discussed above, is at work. In this respect we have in a general way the same thing as with single vertically layered groups. It hardly needs to be said that the depiction of every individual figure in scenes viewed from above is based on frontal images and that more distant ones are not reduced.

In contrast with the constant presence of the base line, the horizontal line we call the horizon, which limits a level undistorted field of vision in the distance, is quite unknown in Egyptian representational art. The relative height of this line between sky and earth varies, since it is determined by the height of the viewing eye.

But in the literature we have a unique passage, dating from about 1050 B.C., which is of relevance to this phenomenon;[169] an Egyptian envoy tells how he came to Byblos to obtain cedar wood for the construction of the sacred boat for the temple of Amun. He was finally admitted into the presence of the prince and reports: 'I found him sitting in his upper room, having set his back to the window, while behind his head broke the waves of the great Syrian sea.' Commentators have thought in this

[166] *Atlas* 1.7.1, 1.26, 1.353. Elements from below also encroach on the register above, cf. Capart 1921 pl. 7 (time of Tut'ankhamun). This may be compared, for example, with fig. 271; how seriously the division into registers is taken in the latter, and how cavalierly the artist of Capart 1921 pl. 6–7 treats it!

[167] Erman–Ranke 1923.648 [*MH* 1 pl. 37 (J.R.B.)].

[168] As against the normal state of affairs, where it does not represent the ground (cf. p. 159).

[169] The context of the passage translated in the text is given in Erman 1923.229. On the passage cf. my remarks in Schäfer 1929c. [More recent translation in Galling 1950 (by E. Edel) — in English by Gardiner (1961.308 ff.). The English translation here is from Nims (1968.162 italics removed) (J.R.B.).]

context of waves breaking on the sea shore. But it is simpler and more vivid to imagine that the reference is to the upper edge of the apparently rising water surface, although it is well known that waves appear to terminate in a smooth horizontal line. For an Egyptian the *whole* sea is agitated by waves, and their disappearance in the distance is one of the perspective phenomena to which he was not receptive. So here we have something similar to Etana's flight to heaven (p. 82): an observation is described in literature but is not found in representational art. In addition, not only was the effect noted by an uncommonly perceptive man; he was also assisted in his observation, as K. Menninger[170] pointed out to me, by the exceptionally favourable circumstance of the open window, which only presented a small section.

It is in the nature of things that if in a picture with a high viewpoint only slight importance is placed on the faithful reproduction of sense data, it will look almost exactly the same as if the ground rose towards the back and the action took place on a mountain slope. But actions of this sort only entered the sphere of reference of major Egyptian art when the New Kingdom kings had to strom Syrian fortresses, and the faces of the towers were often seen swarming with attackers and fugitives. When the battle pitch and the fortress mound are contiguous (pl. 55), as is mostly the case, the figures in the two halves of battle pictures of this sort then intermingle for two different reasons: on the one hand (pl. 55 mid.) because the artist assumed the horizon was high so that the ground appears to rise, and on the other (pl. 55, L) because the mound does in fact rise.

The external similarity of the two halves occasionally leads to confusion. In the Sety I picture just mentioned, which shows the capture of a mountain fortress, the king forces the enemies in the open field (R) over the heap and pursues them back onto the rock face of the stronghold (L). The plain and the hill are strewn with people. In the middle of this we see one soldier[171] simply stepping over from the battlefield on to the middle of the rock face. Thus we are reminded once more that it is the depicted and not the real relationship between the objects which shapes the formal elaboration of the image which is transferred onto the picture surface (cf. pp. 228–30).

Yet a third image could play a part in a picture like this battle scene. The confused mass of slaughtered enemies quite certainly represents the level, corpse-covered surface of the battlefield. But this would not in fact prevent the incorporation of the idea of a heap into the image of the bodies lying on one another, as it is shown on the picture surface; the New Kingdom kings often speak in their inscriptions of heaps of their enemies' corpses lying on the battlefield. In other cases too it will often be hard to decide if a group of objects in an Egyptian representation should

FIG. 194. Gold rings on a mat. NK

[170] [Author of *Zahlwort und Ziffer* (Breslau 1933) (J.R.B.).]
[171] Pl. 55 L, the man under the arrow on the edge of the photograph.

be thought of as lying close together on the ground or piled on top of each other. Thus in fig. 194 a single layer of rings lying flat on the middle of the mat could be meant if the form of the group, narrowing towards the top (cf. fig. 188), and the whole context of the picture, in which an impression of opulence is created by heaps of semi-precious stones and other valuables, did not show clearly that what is meant is in fact a *pile* of gold rings.

Wherever the rendering of nature in Egyptian two-dimensional art is discussed we must, as has been said several times in this book, bear in mind the range of different physical phenomena to which any one representation could relate, and consider the freedom that image-based methods of depiction give to the artist to follow his personal inclinations, as against the restricted character of rigid perspective representations.

4.3.10 The rise in the optical field with distance and the reflection of this phenomenon in language

The observation, exploited in representational art, that more distant objects shift higher up the optical field than nearer ones, also finds expression in many languages. The most striking examples are from Middle High German, in which I know of three phrases for 'move backwards'; *hôher stân, hôher trêten,* or *hôher wîchen* [respectively 'to stand, step, or yield higher'] , all of which take account of the visual image (upwards) and the motion; and, in addition, *hinter sich trêten* [literally: 'step behind oneself'] , which has the same meaning but only refers to the movement, without mentioning the apparent upward shift. These particular usages have disappeared from the modern language, but similar phrases still occur, for example when we say 'walk up and down' meaning 'to and fro', and no movement upwards and downwards in space takes place.

The Romans spoke as we do of the 'high seas'. The Greeks used the prefixes 'up' and 'down' both for genuinely rising and falling mountains and for the apparent rise and fall of the sea, using for example 'climb' equally for a march from the coast into the country, or for a journey out into the sea. In these cases the images sometimes overlap, for when Homer says λαὸν ἀνήγαγεν ἐνθάδε 'he led the people out (to sea) to this place' the ἀνήγαγεν is basically seen from the port of departure and the ἐνθάδε from that of arrival. Similar word-formations occur in Egyptian too, if it is correct to suppose that the words for 'above' and 'distant' are derived from the same stem (ḥrj) and that the same is true for the pair of words 'approach' and 'descend' (stem h3j).

4.4 Miscellaneous studies in the rendering of nature

4.4.1 The power to attract inherent in lines other than the base line

Fig. 262 is taken from an eighteenth dynasty picture, and shows a pond from which two people are fetching water. With the man in the middle one might well think that the surface of the water was acting, from a raised viewpoint, as a background for the torso of the man standing in it. But there is no basis in the picture for such an assumption. How else could a pre-Greek artist render the idea 'a man is standing in a pond with the water coming up to his waist', except in this way?

Now if we suppose there is a boat in place of the man such a picture really could exist. But if we look at fig. 263, which is contemporary with fig. 262, we see that

the small boat there, although it is being dragged from both banks and is therefore in the middle of the water, is not separated by water from the bank at the bottom: for the artist's purposes the lower line of the pond has transformed itself into the base line, and in this capacity it has attracted the boat to itself. Now we can also interpret correctly a picture like fig. 195 (end of the Old Kingdom), with its antelopes in the desert; its content is the same as that of fig. 196, except that in the latter the antelopes and hedgehogs are placed, like the gaming pieces and offering bread of fig. 155–6, on the upper edge of the surfaces on which they stood, while in fig. 195, where the elements characterizing the area as desert are preserved, the base line of the register has drawn the animals down to itself through the ground.[172]

FIG. 195. Animals in the desert. OK

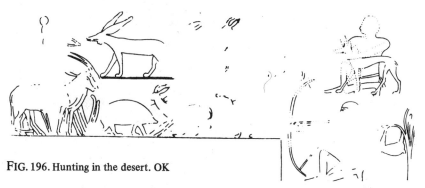

FIG. 196. Hunting in the desert. OK

A relief in Berlin (pl. 34) in which a woman is shown boating on a lotus pool, and where two methods of representation are mixed, could give rise to misconceptions similar to those produced by the desert picture. As is normal, the unbroken strip of water stretches under the boat. But as the artist also wanted to evoke the idea 'the boat and the woman are surrounded by lotus flowers which rise above the surface of the water' like the heads of the ducks in fig. 197 and the man's torso in fig. 262, he added the water above, with its spread of flower heads. He did not feel that the two contradicted each other. The waves in the water were only painted and have disappeared.

Not only genuine base lines, or the side lines of houses which have become them, as in fig. 108 and 112, develop the power to attract which I have described; any suitable line can exhibit it in certain circumstances. Thus in fig. 184 the line of

[172] This interpretation does not of course apply to a picture like Davies 1902.2 pl. 5, although it is similar in appearance to fig. 195. But it is not possible to decide on external evidence whether the people in the Deir el-Gebrawi picture are standing by the water, in which case it would belong with the lower figure in fig. 262, or whether they are standing in it, and the picture should be compared with fig. 95 (cf. n. 219 below).

FIG. 197. Ducks swimming (detail).
[The mesh of the net has been
omitted.] OK

FIG. 198. Serving a dead man. One figure is
standing on the knee and kilt of the others.
1st Intermediate

inscription inserted in the picture has drawn the upper figures to itself; and small
subsidiary figures sometimes came to stand on the lines of the clothing of a seated
chief character (fig. 198). There are frequent depictions in Old Kingdom tombs of
the wringing of the remains of the trodden grapes from the treading barrel in a piece
of cloth (fig. 199). Two men on each side—I know of no satisfactory explanation of
what the one who is lying down is doing[173] —take hold of the long poles around
which the cloth containing the grapes is tied. In the Egyptian schema, which must
originally have looked more or less like fig. 199, the two workmen on each side stand
above one another. An attempt has been made on this basis to deduce that the artist
analyzed the action into foreground and background by adopting a high horizon,
and distributed his figures accordingly (Klebs 1915a. 24). In reality he did not think
of pictorial depth at all, but placed the men one above the other, purely as a result
of his idea that a man was twisting at either end of both levers. Now, in early attempts

[173] {He is keeping the poles apart.]

199

200

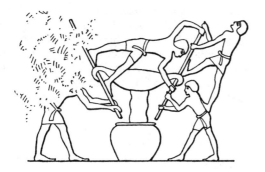

201

FIG. 199–201. Three representations of grapes being pressed in a sack. OK

to show the heaving and stretching of the labourers (Petrie 1892 pl. 25 bottom), in representations of the sack press the feet of the man above came perilously near to the backs of the lower ones (fig. 200), and later artists[174] rendering the schema of their predecessors gave in to the temptation to place the figures on top of one another (fig. 201); it should not be thought that the upper pair actually stood on their companions' backs. The same thing happens in the art of other cultures: when the figures in Anatolian or early Greek reliefs are not ordered into registers but distributed freely over the area, the upper ones sometimes stand on the nearest convenient line, for example the edge of the wing of a figure standing below (Poulsen 1912.79–80, fig. 76, 78). In medieval drawings things that should stand in the middle of a table-top are drawn to its bottom edge, and this is especially true of vessels with flat bottoms (cf. p. 101), just as in the child's drawings in fig. 32. In a picture taken from a popular illustrated version of an Arabic chivalrous romance, printed in Cairo, a jug and goblet are drawn in the same way (fig. 202).

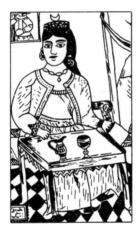

FIG. 202. From a modern Egyptian illustrated story.

4.4.2 Apparent passing next to, and action beside, an object

It follows from the directions of movement of the figures in Egyptian reliefs and painting that, if the models are not placed in the same plane perpendicular to the observer, they almost always seem to walk, grasp, or speak past one another. I already gave an example of passing beside of this sort in fig. 88, with the picture of the god of the dead beside the mummy, and in fig. 169 with the hunting dogs. If the god's hands do not overlap with the mummy by grasping it from the side but touch it from above (fig. 203), the appearance of passing by is no longer present. Fig. 88 has a rendering of work on an object from the side which corresponds to that of fig. 219, though the artist of the latter managed to solve the problem by assuming that the workman's body was turned.

It might be thought that part of what we want could be achieved by imagining or drawing the base lines of figures that do not overlap at angles to each other. But anyone who is at all familiar with the Egyptian sensibility, who attempts to realize

[174] As Klebs recognized (1915a.26). Junker made a similar suggestion when commenting on a relief reproduced in Junker 1929. 132 [= *Giza* 11.64 fig. 36 pl. 7a].

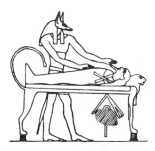

FIG. 203. The god Anubis tending a mummy. Late

this idea in a drawing of his own, will soon give it up again. Imagine a scene where long rows of people are moving from all sides towards a central point: if we had to draw this in a 'pre-Greek' manner we might arrange it so that the figures move towards the middle like the rays of the sun, and indeed an Assyrian might have shown it thus (cf. fig. 204); but this would be quite contrary to the Egyptian temperament. With an Egyptian the picture would certainly be externally similar to fig. 233, despite the difference in meaning; there only the upper registers, indeed, because of the height of the throne, only the highest of these, are directed towards the throne from both sides, while the envoys in the lowest register (see the extreme ends) are walking past the king (on this picture see p. 222). A picture like the Amarna desert picture (fig. 152) with its rising registers does not belong here, as mountains actually did rise up behind Akhanyati's (Akhenaten's) city.

In order to compare the Egyptian and Assyrian sense of form one should set the Assyrian picture of a colossal statue being dragged (fig. 204) next to an Egyptian one (fig. 205). Despite the fact that the two pictures are separated by a thousand or so years I think it is very valuable to bring them together. Rarely is one so sharply reminded that it is almost impossible to make a comparative evaluation of such key works of art produced by different peoples, instead of simply accepting the differences.

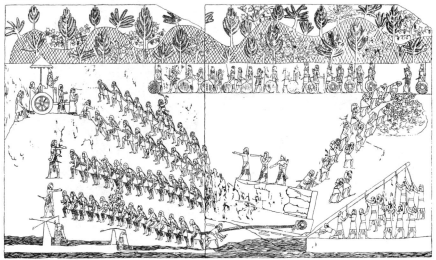

FIG. 204. Dragging a figure of a bull for a monumental gateway. Assyrian relief.

FIG. 205. Dragging a colossal statue. MK

Occasional New Kingdom experiments in drawing large lines with figures obliquely across the picture surface, for example to make the lines of charioteers in a battle charge the field in all directions, are exceptional, and however effective an individual composition may be it does not alter the rule at all. In them, too, how soon the rising and falling rows revert to the horizontal (*Atlas* 2.22–3)!

4.4.3 Turns. Looking and moving out of and into the picture

A peculiarity one must get used to in Egyptian reliefs and paintings is that the figures appear with few exceptions to be turned to face others in the same plane, at right angles to the viewing direction. So a modern viewer is often disconcerted by the absence of heads or limbs turned towards us. Egyptian artists did have solutions to this, and I shall discuss a few of them here.

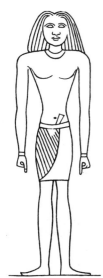

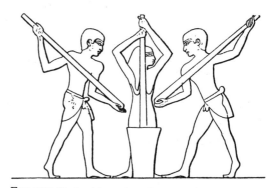

FIG. 207. Work with pestle and mortar. OK

FIG. 206. Figure in a front view on an OK false door.

There is a late Old Kingdom sunk relief in a false door (fig. 206, cf. p. 217), which is evidently meant to serve as a substitute for semi-sculpture. It is by no means a great work of art, and the full views of feet spread sideways have a particularly unfortunate effect. A picture of a woman pounding in a mortar (fig. 207) is more or less contemporary. Here the face is still in a side view, but in its context the form with the two breasts, the arms raised high to pound, and even the splayed feet, results in a front view that is not disconcerting for us, though an Egyptian would certainly not have thought of the woman as turning her head. Two figures in fig. 151, in the second row from the top, where boys are performing a balancing exercise, are similar: lifting the feet of their crossed legs, they are raised on their knees in a front view as regards all again except for their heads, which are turned sideways. From the Middle Kingdom there is a picture of a man playing a board game (fig. 208) who is sitting on a log with his legs wide apart and his shoulders turned to the viewer,[175] though his head

[175] From the New Kingdom on there are very interesting intermediate forms between front and side views of figures in this seating posture, e.g. Steindorff 1928.260 and Berlin 19782.

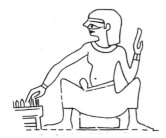

FIG. 208. Board game player. MK

FIG. 209. Rope maker. OK

and breast face towards the opponent, who is to be restored on the left. But we find it so easy to accept this picture only because we read into it something that was not meant. That is, not only head and breast but the whole man is turned towards his fellow player. [A similar view is used to render the movement of a rope-maker in an Old Kingdom representation (fig. 209).] On the other hand we have the seated god in fig. 210, also from the Middle Kingdom, a picture which we find almost entirely unacceptable; the god is meant to face the viewer fully. There is a break between the torso and the legs similar to that found in the drawing of a jug (fig. 211) between the lid and the spout, although we can discern that the reasons for the treatment differ in the two cases. It may conceivably be something to do with the nature of this

FIG. 210. Seated god. MK

FIG. 211. Vessel with spout. MK

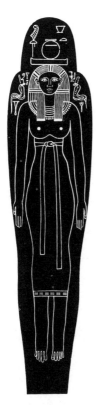

FIG. 212. Sky goddess in the lid of a coffin. NK

particular god that he looks out of the picture, while no such explanation can be found in the case of the jug, so that the form will simply be the result of a liking for the unusual front view [cf. Schäfer 1938.28, fig. 5]. For the god's right arm cf. pp. 48–9, 297. With the New Kingdom there is an increase in the number of represent- ations that might be termed front views of human beings. I shall only refer to two here, but intend to discuss others later. The ingenious practice of covering the inside of a mummiform coffin with figures of protective divinities grows in the New King- dom. Thus the anthropomorphic images of the sky and the realm of the dead (fig. 212) are painted on the ceiling and the floor. The head-piece too is made secure by the presence of the human-headed soul-bird, shown full face (fig. 213) in such a way that its wings surround the head. The idea is similar to that of the hawk in the famous seated statue of Re'kha'ef (Khephren),[176] except that the bird over the supine mummy approaches the crown of the head, and that on the statue the back of the head (p. 224).

From the eighteenth dynasty the figure of a man bending low out of the picture, for example over the side of a boat or the battlements of a fortress, is more frequent. In these cases the head, unlike the shoulders, is mostly in a side view, as it is in the basic normal form (fig. 214, pl. 58 R), but sometimes (fig. 215) the back and the back of the head are shown. When the head and torso face in different directions it need not always be assumed that the subject is turning in the real situations from

[176] Propyl. pl. II [L-H pl. 30–1, IV, Sm pl. 128 (J.R.B.)].

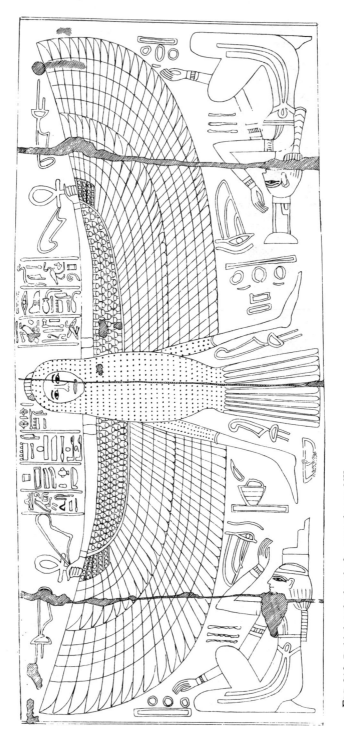

FIG. 213. *Ba* bird at the head of a sarcophagus. NK

FIG. 214. Leaning over
the edge of a boat to
draw water. NK
[Better parallel Smith
1946.325 fig. 202 (OK)
(J.R.B.).]

FIG. 215. Falling overboard. NK

FIG. 216. Sleepy door-
keeper. NK

which the representations are derived. But in a number of pictures this may be
intended.

With the guard in fig. 216, who is sleeping while standing on one leg and leaning
against the post of his gate, using his hands as a support and a cushion, it may be
doubted whether the head is really meant to be turned away from the torso. It seems
more likely that it is rather the whole man who is turning, as with the wounded man
in pl. 53 who is sinking back, exhausted by the attempt to climb up. At all events
a *pre*-New Kingdom version of the guard in fig. 216 would always have the face
turned away from the gate with the back of the head cupped in the hand, as the
sleeping man in fig. 89 appears to be lying on the back of his head and not, as in
reality, on his ear. Again in these cases it depends on the viewer's knowledge and
sensibility how he interprets what is before his eyes. Without any hesitation we will
take many of the figures making music and dancing, like those in fig. 217b, as ex-
amples of bodies that are turned, and we are certainly right in doing so, as fig. 217a
shows. But fig. 218 warns us against taking, for example, the drawing of the dancer's
breasts in fig. 217b as a proof, as the depiction is the same in fig. 218, where a turn
is impossible.

It is important that there is from the early period, next to the sign for head 𓁶
which is seen from the side, a much commoner one which shows the 'face', full-face
(fig. 61). There are even indications that this may originally also have represented
the head. The distinction between head and face would then have been made first in
the historical period, rather as we found the images of crocodile and lizard, bee and
fly were separated (p. 150).

So, although any scribe or artist was quite familiar with the form of the face
viewed from in front, we have scarcely fifty two-dimensional human heads in front

views,[177] apart from the Ḥathor head and the god Bes, 𓁺 , both of which may be

suspected to be influenced by Near Eastern forms. The full face does not occur in
Old Kingdom pictures of living people, and only becomes commoner in the New
Kingdom, chiefly in battle scenes, but also elsewhere as a personal caprice of the artist.

[177] They seem to be entirely absent from Assyrian reliefs of human beings, only occurring in a
few pictures of divine statues, whose forms are probably traditional ones taken over from
Babylonia.

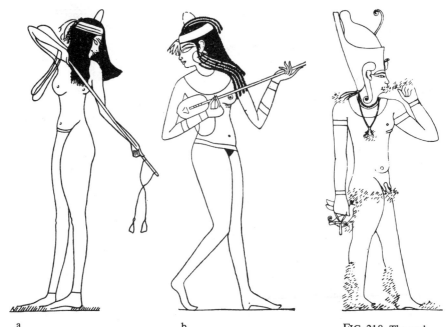

a b

FIG. 217a–b. Female musicians. NK

FIG. 218. The god
Harpokrates.
Graeco-Roman

In addition, every sculptor was used to showing human beings and animals in a front
view from top to bottom, and from the introduction of the block procedure to be
seen in fig. 325–6 he was forced to sketch them on the front of his block. If despite
all this front views were so restricted in two-dimensional art, one should not use the
facile explanation that they were too difficult. The problem can probably only be
understood in the context of what is a general and basic trait of the direction of
motion and action in Egyptian relief and painting: any figure present is there only
because it is related to others represented on the same surface, or more or less con-
sciously imagined. In addition the goddess Hathor always seems to have her head in
a side view when she is anthropomorphic, and in the earlier periods the full view only
occurs with the amuletic head by itself 🐮 .

Whatever applies to front views and to looking or acting out of the picture is of
course also true of back views with the action moving into the picture, except that
figures presenting the back of the head or still more the entire back are considerably
rarer even than front views. They too are certainly not found before the New Kingdom.

[The group of children forming a basket at play in the tomb of Ptaḥḥotpe (fig. 220a)
is a striking illustration of this. Of the two boys in a layer depiction in the middle, the
back one would have to be looking forward out of the picture and the front one back-
wards into it, while the heads in fact continue the advancing layers of the bodies. In the
corresponding group in the tomb of Mereruka (fig. 220b) the bodies are shown in re-
treating layers and the heads look in the opposite direction.] Fig. 215 with the wound-
ed man plunging overboard is of course a movement forwards out of the picture, despite

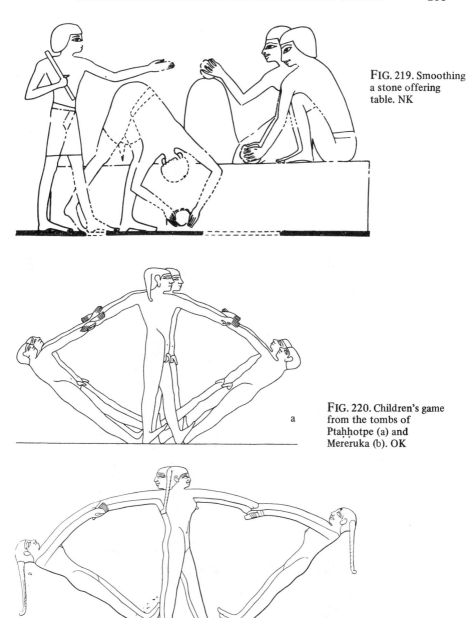

FIG. 219. Smoothing
a stone offering
table. NK

FIG. 220. Children's game
from the tombs of
Ptaḥḥotpe (a) and
Mereruka (b). OK

the back view. Fig. 219 shows a remarkable combination of different directions: a
mason is standing bent over and turning sideways at work on the front face of a
huge offering table (cf. fig. 156). The piece itself is viewed from above, but the man's
posture shows that the rectangle represents simultaneously the top and the side of
the block. The weavers in fig. 221, who are seen from the back, sitting in front of

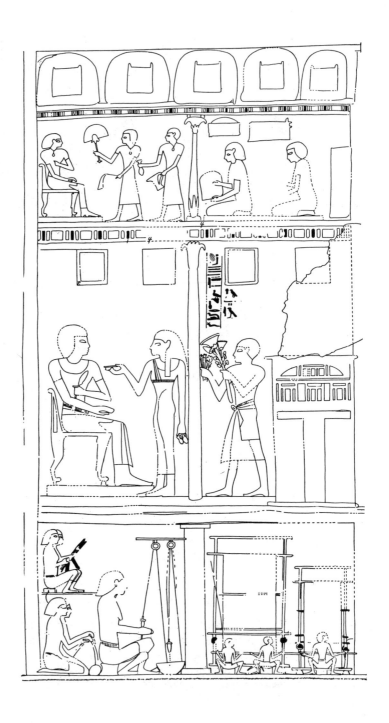

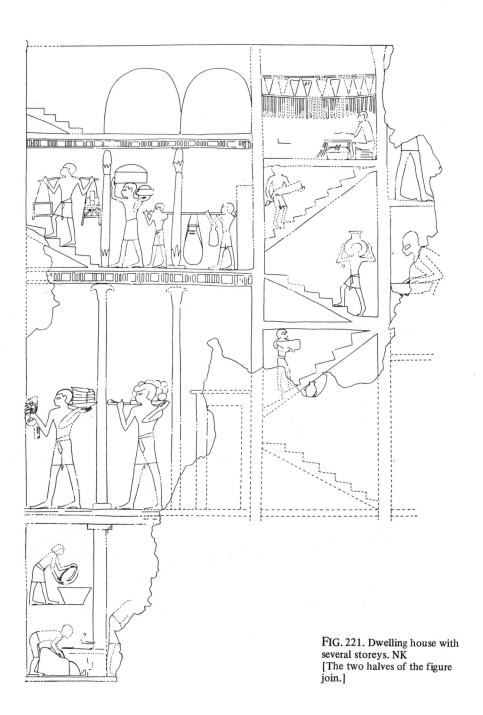

FIG. 221. Dwelling house with several storeys. NK
[The two halves of the figure join.]

the looms, are a case of an action entirely directed into the picture. Just as they are at the opposite extreme from a full front view of a man, the scene with goats looking out of the picture[178] (fig. 222) has a fine counterpart in fig. 223, which shows oxen yoked to a plough. One ox has lain down and the ploughman is trying to get it to stand up by calling it while his helper attempts to do the same by twisting its horns and beating it, meanwhile directing the standing animal. But the latter has turned its head in reluctance, and the head thus appears to be turned into the picture, perpendicular to the surface. In the eighteenth dynasty the heads of attacking dogs and beasts of prey are frequently given in a view from above, perhaps under Cretan-Mycenaean influence. In earlier Egypt animal heads seen thus are only found detached, on the pointed end of so-called magic staffs (fox) and as amulets (panther).[179] The full view of the head in the picture of an owl, which occurs in the extremely

frequent hieroglyph for *m* 🦉 , was an independent development.

FIG. 223. Ploughmen with team of oxen. NK

FIG. 222. Herd of goats. NK

The examples discussed up to now of the turning of one part of the body against the direction of the others have always been of quarter circles, that is of 90° turns, as with the side view of a face while the rest of the figure is seen full-front. But the head is more frequently turned through half a circle, so that the face is at 180° to the feet (fig. 224).[180] The intention is to express that 'the head is turned round', and this is successfully achieved. As the turn, which can affect the arms but stop short of the chest (fig. 225), mostly occurs in connection with a person standing in the same

[178] Compare the drawing (fig. 330) of the head of the sky goddess in the form of a cow, with a sun-disk between her horns, in which the young sun-god is sitting. This figure is also found between seated lions, as in the group Schäfer 1928.103. On this see Spiegelberg 1930c. Full front views of animals and animal heads in the palaeolithic period Verworn (1909.56−7). In the same tomb as the herd of goats there is a cat with a front view of its face (Davies 1927 pl. 26)−reference supplied by Rudolf Anthes. The artist of a religious papyrus in Cairo (reference supplied by Siegfried Schott) appears to have had a particular predilection for front views of faces [similar to fig. 210 (J.R.B.)] . [Now published, Piankoff 1957, papyrus 22; the same phenomenon occurs in papyri 3−4, 11, 18, 20; the method of representation probably has some specific meaning and can scarcely be attributed to the artist's own preferences.]

[179] Fox head Berlin 6709 and similar pieces; panther head Propyl. 308. The derivation of these panther heads from the much-worn panther skins is clear.

[180] An Old Kingdom example in the tomb chamber of Kaninisut (Demel 1929), a modern one in pl. 103.

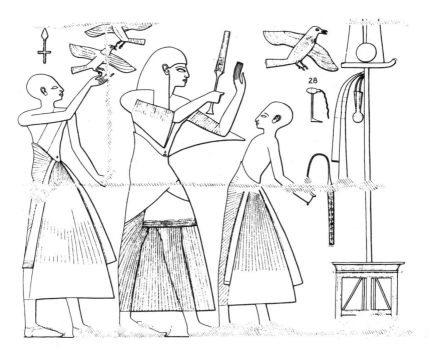

FIG. 224. Detail of coronation scene. NK

picture surface, one becomes accustomed to these pictures more easily than might be expected, especially when the full width of the shoulders is given. Exactly the same has happened here as for example in the representations of doors in fig. 103, 116b, 229, pl. 27, where the flaps are opened so far that they lie on one plane. Yet with no Egyptian building is this possible, whether the gate is thought of as seen from the inside or from the outside. The artist is simply rationalizing and showing an opposite position to the closed one. The same remarks apply to pictures of animals turning their heads 180° as do to ones of human beings. The reversed head is either above

the body (fig. 193) or within its area (fig. 226).[181] We are less put off by it

even than by reversed human heads, as animals' long necks allow them greater freedom of movement in nature too. Such, however, is certainly not the case with the

[181] In Mycenaean art turns are sometimes found which are as abrupt as breaks. Cf. n. 185 below.

FIG. 225. Goddess leading the king. NK

FIG. 226. Ox turning its head. OK

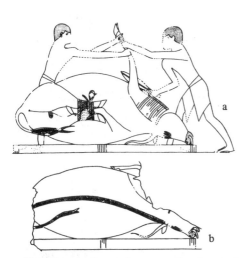

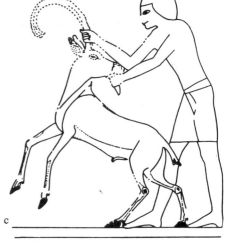

FIG. 227a–b. Oxen being prepared and ready for slaughter. NK
c. Catching an antelope. NK

unwieldy hippopotamus. Yet many artists hazard 180° turns with it too, when they show the monster raising itself up on its front legs and turning its bellowing jaws open towards a human enemy. Anybody who then sees for the first time statues representing the same motif in all its perfection, and is surprised to find a turn of only 90°, will realize how convincing these representations are. The most striking three-dimensional examples are the beautiful faience figurines of hippopotami[182] popular in the Middle Kingdom. They show us the appearance of the posture from which the image for two-dimensional representation must also have been derived.

Oxen were laid down for slaughter with their legs bound (fig.227a and b), resting on the sides of their bodies and on the arch of their horns. In the New Kingdom the

[182] Propyl. 294 [W fig. 296 (J.R.B.)].

turning of the neck is often indicated by a curved line (fig. 227c). A sculptor's teaching piece in Berlin[183] shows a lion trying to lick itself between its hind legs. In order to do this it bends its fore- and hindquarters sideways towards one another, more or less forming an ellipse [fig. 328 = pl. 109]. As its hindquarters are turned over backwards, while the forelegs are placed in an upright walking posture, the picture probably shows a more twisted body than has ever been discerned in any other Egyptian relief or painting. It might be thought that the Late Period artist quite deliberately undertook something of this extreme difficulty. He gives the hind-quarters in a rear view, the thorax with the saw-muscle from the right, and the fore-quarters with the head and forepaws from the left. Apart from a few details which he could perhaps have rendered more accurately he solved his problem superbly. No pre-Greek of whatever people could have gone about the task in any very different way. The covering of one front leg by the body is a genuine error. The placing of the base of the tail on the side of the haunch and not above the testicles is paralleled in an Old Kingdom relief,[184] where an ox bound for slaughter is excreting and the row of drops is not pouring from the anus visible on the surface, but from the outline of the haunch. It also calls to mind the door mentioned on p. 137, where the form of the man walking through it does not begin at the opening but at the outside edge of the post. In the lion relief the soft curves of an animal body appear as sharp breaks, $90°$ at the loins and $180°$ behind the front legs. A magnificent relief in wood, full of life, by a north Syrian precursor of Mycenaean art, shows the same angularity.[185] There a lioness is throwing herself sideways to jump at a pair of seated gazelles. As with our lion, there is a sharp break behind the supporting front legs.

It goes without saying that, before the occurrence of full front (fig. 222) or back (fig. 223) views with their $90°$ turns, only $180°$ ones are found in relief or painting. After all the discussion in this book one will not expect to find turns of the head of less than $90°$, in other words oblique views, either in human beings or in animals.

Devotional images that do not represent adoration but are meant to be the objects of it, that is, ones where a connection between the image and the worshipper stand-ing in front of it seems essential to us, are almost never directed towards the viewer. If the Egyptians use statues or semi-statues of the type discussed on pp. 74–5 (pl. 31) the appropriate feeling is of course present. We can sense this for example in the holy of holies of the small temple of Abu Simbel, which was dedicated to Ḥathor. There a group of semi-statues, now very decayed, looks at the viewer from the back wall: the goddess as a cow, with the king in her protection under her neck, just as someone entering a chapel near Deir el Baḥari faced a complete free-standing statue [Ranke 1948 pl. 38–9]. But if the cult image here were executed in two dimensions the divinity would certainly look and walk sideways, unconcerned by the praying worshipper appearing in person in front of him. We have instructive examples of this: in false doors, the focal point of Old Kingdom tombs, which takes the form of a door through which the dead man's spirit communicated with the living world, the dead man was commonly represented at the back of the door niche as if he were standing in the door (pl. 1). The door mentioned above, which is the only one known to me with the figure in sunk relief in a front view (fig. 206), and several others with semi-

[183] No. 23007; Propyl. 448.5 [fig. 328, pl. 109 here, cf. Wolff 1938].
[184] [*Atlas* 3.194, text figure 93.3.]
[185] Berlin 1882 [Schäfer 1931a pl. 61.1].

sculptures like pl. 18.2, prove that the description of the dead man as standing in the door renders accurately the image in the artist's mind. On this basis we are justified in attributing an inner direction towards the viewer, instead of the superficial sideways one, to these reliefs, which are in themselves neutral as to direction.[186] If we interpret a picture in the horizontal band at the top of a copy of the *Book of the Dead* (fig. 228) on the model of pl. 27 we shall hardly be able to guess what is meant. But there is fortunately another manuscript which replaces the anthropomorphic sun god by a disk which has no sideways direction in its form (fig. 229). The connection

FIG. 228

FIG. 229

FIG. 228–9. Gate of heaven with the rising sun. NK
 In fig. 228 the sun is shown as a man, in fig. 229 as the physical body.

with us is there at once: the daytime star enters an expectant world through the open gates of heaven. But this is also the meaning of fig. 228.[187] In Babylonia, where some gods look at the viewer from two-dimensional pictures, the opposite of the Egyptian type of representation of prayer results. There the god does not appear to concern himself with the praying man who is represented on the stone turned towards him, but looks at the viewer. The origin of this peculiarity may be understood if the viewer is not thought to be ourselves or nobody in particular, but the donor of the work, who is the same person as the man praying in the picture and in the inscription on the plaque. In this way the front view of the god's head would strengthen the meaning of the whole. The victory goddess in fig. 320 is hurrying, as her 'running knees' show, down from heaven to the man receiving the message, who is at the same time the viewer of the figure. She only appears to be flying past him and turning her head towards him. The mosaics on the side walls of S. Apollinare Nuovo in Ravenna contain similar effects. There long rows of martyrs, men and women, are moving towards Christ and the Virgin Mary at the ends of the walls, yet they are all looking at the faithful in the nave.

4.4.4 Splitting of groups

In pl. 20 we see the fifth dynasty king Niuserre' at the top, seated on his throne between two gods; underneath are two rows of bodyguards facing one another. The inscription between the latter indicates that they are only apparently following one another, and shows us how to interpret them correctly: '(making) a good path before

[186] [*Richtungsstumm*, cf. above, p. 101, and Epilogue, pp. 420–21, (J.R.B.).]

[187] In another picture (Schäfer 1928.100 fig. 24) the gate is represented from the inside with closed and bolted doors. It would be over-hasty to make deductions from this as to whether or not the artist imagined himself standing outside in space. If an 'image-based' artist wants to show that a door is shut it may be essential for him to render the bolts etc., and this may not indicate his 'position'. On this cf. Borchardt 1897b.117 and 1898.94 n. 1.

[the king (?)]'. So they are forming a path for the king. However, the artist indicated that this way leads to the front and not the side of the throne by giving the left row six men as against seven on the right, thus displacing the end of the path towards the front of the drawing of the throne. From this we can deduce how we are to imagine the action. Apparently it is carried out obliquely to the viewer (fig. 230a), with the king looking to the left and the goddess standing behind him facing in the same

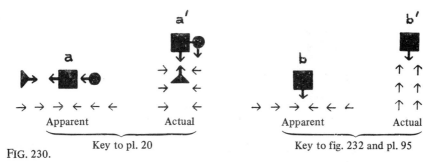

FIG. 230.

direction, while the god who brings the sign of life comes up to him from the left. But in reality we must imagine the action as follows (fig. 230b): the seated king is looking at us while the goddess stands on his left, shoulder to shoulder, with her right arm round him. The jackal-headed god approaches from the front, that is with his back to us; we look past him at the ruler, down the path between the bodyguards. A New Kingdom artist with sufficient space at his disposal and a less rigid attachment to ordering in registers would have been able to show the two sides of the path in a vertical layer depiction, like the bodyguards under the right ramp of the throne in fig. 233.

The ancient artist divided his double row and placed it on either side, thus creating a composition which has a partial parallel in a relief on the obelisk base of Theodosius the Great in Istanbul (pl. 95). The emperor on the balcony looks out of the picture at foreign envoys who are approaching him respectfully—he is really high above them on his throne, while Niuserre''s is only slightly raised behind the bodyguard. Also, the envoys apparently approach him in two rows from either side. But, however similar they may look in the pictures, there is a hidden material difference between the envoys and the bodyguard, which should be obvious to an informed eye. The envoys are of course facing the emperor in two rows, one on each side (fig. 230b); but Niuserre''s staff bearers must be imagined in two parallel dressed ranks facing each other. In other cases the artists may have thought of looser groupings of people, which were only adapted and made into orderly balanced rows for aesthetic reasons, as for example with the hordes of monkeys greeting the sun in the impressive symbolic image in pl. 62.

It makes no difference whether the element that unites the two rows is above or between them, whether there are long rows or just one person, or even whether in nature they are moving towards the central element of the picture or starting away from it. Thus for example the statues in fig. 231 in fact have their backs to the wall, and their direction is not related to that of the door opening. One wall of an offering chamber often has a slit (fig. 232) connecting it with the small chamber in which the

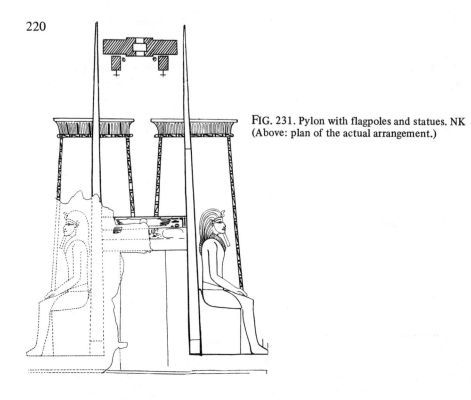

FIG. 231. Pylon with flagpoles and statues. NK
(Above: plan of the actual arrangement.)

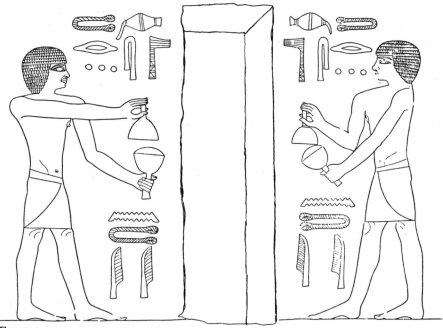

FIG. 232 Censing in front of the door
of a statue chamber. OK

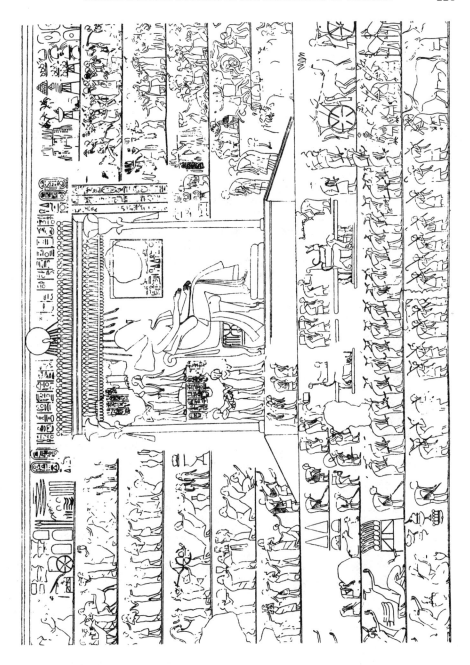

FIG. 233. Envoys being received at the court of Akhanyati (Akhenaten). The empty palanquins and the bodyguard are beneath the raised throne. NK

statue of the dead man once stood. He was embodied in a statue in this room, and through the opening he took part in everything that was done for him in the offering chamber. To left and right on the adjoining wall mortuary priests are censing, and they again apparently come from the side, but are without doubt to be imagined coming up to the opening from in front, like the man by the chapel in pl. 27. It can no longer escape our attention that the basic composition of the great scene of Amenhotpe IV receiving on his throne (fig. 233), which is meant to give an effect of glittering richness, is the same as that of the simple censing scenes. In the Amenhotpe scene even the ramp leading up to the throne is divided, as if there were two of them, one in front and one behind.

The Thasian altar of Apollo and the Nymphs in the Louvre[188] is a monument from Classical Antiquity which can be placed under the same heading as the works just discussed, in which people appear to be moving from two sides towards a point between them. From there a straight line, which does not of course represent a simple derivation, leads to modern times: in his great funerary monument in Paris F.A. Bartholomé[189] is a true heir to the tradition; Berliners can delight in the simple monument to the eye-surgeon A. von Gräfe by the Charité,[190] where the sick on the walls next to the standing figure apparently flock to their saviour from two sides. A form that arose from an entirely normal application of the principles of the rendering of nature on the basis of frontal images was created, perhaps at once, by important artists, and then taken over by others. This beautiful artistic form created long ago persists although the general rules of the rendering of nature have long changed, and the most the older method does is to influence the subconscious. Towards the end of antiquity its effect became stronger, and can still be felt in modern times.

In Egyptian religion the sun travels through the sky in two boats, the morning boat and the evening boat. The transfer of the sun from one to the other is a common motif in Egyptian art.

In the normal representation (pl. 66) the two boats are facing each other on a single line, and two goddesses are holding the disk above the bows. Dazzled by the beauty of the composition, scholars have always interpreted the action as I have just described it, without considering that such a transfer would be unnatural. A few years ago Grapow[191] demonstrated what is the correct interpretation on the basis of a picture from the ceiling of the tomb of Ramesses VI. There the two boats are shown lying side by side (fig. 234a), seen from above, with their equipment (still unexplained) and the two goddesses stretching out their arms to each other. The sun, which they would be carrying, is omitted, perhaps because it would conflict with the lines of the sides of the boats. Although it seems at first glance that we have the same boats in the same action, but two different ideas of the type of process involved, there can in fact be no doubt that both representations have the same meaning. The difference is that the normal side view only seeks to convey the fact that the disk is transferred, while the view from above in the new picture attempts to show how it is done. The arrangement we have deduced for the relief in pl. 66 is present in three

[188] e.g. Springer 1923.224. [In fact a niche with reliefs, cf. Picard 1935.416, with references (J.R.B.).]

[189] [Albert Bartholomé, born 1848; his 'Monument aux Morts', on which he worked throughout the 1890's, is at the entrance to the Père Lachaise cemetery in Paris (J.R.B.).]

[190] [This monument (by R. Siemering 1882) still stands; it is now in East Berlin (J.R.B.).]

[191] [Grapow–Schäfer (1937) (J.R.B.).]

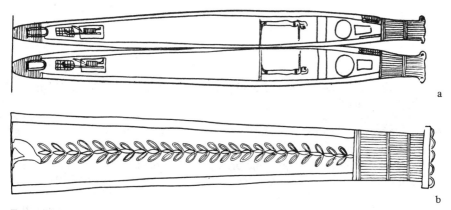

FIG. 234a. Two ships alongside each other viewed from above. NK
b. Sun boat viewed from below. NK
[The figures should be turned 90°.]

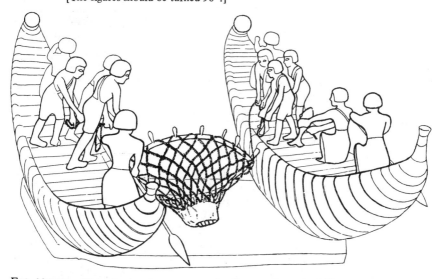

FIG. 235. Two fishing boats whose crews are hauling up a large net. MK

dimensions in one of the wooden groups mentioned on p. 38. It shows (fig. 235)[192]
two fishing boats parallel with and at a certain distance from one another, with the
big net full of fish being pulled out of the water between them. In an Egyptian two-
dimensional representation of these boats the group could of course be composed by
dividing them in the same way as pl. 66, but with the whole length of the net stretch-
ing under both craft. It is instructive also to consider the crew in such a transposition
of the boats into two dimensions: in the model, as is correct, the paddlers are facing
the bows while the men busy with the net face the side of the boat. In two dimen-
sions it would be necessary for both oarsmen and fishermen to appear to face along

[192] [Photograph W fig. 152 (J.R.B.).]

the boat. It will certainly be necessary to test many tomb pictures of boats bow to bow engaged in other activities, in order to see whether they too should not be imagined side by side, and to see how we should think the crews are really arranged in relation to one another.

A particularly daring instance is the way in which the group of workers at the hearth or anvil discussed on p. 185 is adapted to the surface by dividing the circle which they in fact form.

4.4.5 The image is in correspondence with the position of the viewer

One might expect that lateral layer depictions layered to the right would only occur in the left parts of pictures, and ones layered to the left only in right halves. This is not the case. But there are some pictures where the view of an object is adapted to the position in which it is placed, or to the direction in which the artist approached the model. The ceiling of the central aisle of a temple, down which the king processes into the presence of the god, is decorated with a long line of vultures. They have extended wings and their wings and legs are viewed from below (fig. 3).

In one of the gates on the island of Philae, instead of the normal winged sun disk a scarab with spread wings is depicted on the underside of the lintel ⟨◁▭▷⟩ , and the artist evidently took pleasure in drawing an accurate view of the stomach of the creature whirring above (fig. 236), with its legs and grooves in its belly, instead of showing it from above, as is normal with such beetles ⟨▭▭▭⟩ . A very fine Greek parallel from before 300 B.C. are the flying ducks seen from below on the underside of the cornice of the old temple at the Acropolis in Athens (Wiegand n.d. pl. 1–2).

In Egypt birds that are shown in the posture of the sign ⟨◁▭▷⟩ on vertical walls

are often seen from below when thought to be hovering above the Pharaoh represented under them (LD 3.120c, 243), and similarly a bird seen from below in the swarms above papyrus bushes is meant to be 'standing still' by beating its wings in the air in order to observe something. The head of a coffin, as we have seen (p. 207), often contains a picture of the soul bird spreading its wings round the deceased person, more or less like the hawk in the famous seated statue of Re'kha'ef (Khephren).[193] There of course we find that when the picture is on the outside of the coffin the bird is shown from above, except for the human head that completes the picture of the soul (fig. 237). But inside it is shown from below (fig. 213). In fig. 212 it can be seen from the view of the feet that the sky goddess in the coffin lid is seen from below, from the point of view of the dead man.

FIG. 236. Flying beetle, seen from below. Graeco-Roman [The wings are only indicated here.]

FIG. 237. Ba-bird, seen from below. Late

[193] Propyl. pl. 2 [L-H pl. IV, 30–1, Sm pl. 40 (J.R.B.)].

FIG. 238. Part of the framework of a throne canopy. NK

Among the complete sun boats on the ceiling of the tomb of Ramesses VI there is also a bow by itself, which (fig. 234b) the artist evidently imagined from below. In it there is a stem of pond weed, a plant which, as its Geek name ποταμογείτων indicates, fills the edges of stretches of water. In pictures of daily life on tomb walls they emerge under the bows of almost every Nile boat, often with a frog on them. The painter of the ceiling picture did not wish to give up showing the familiar growth with its baby frogs, even on the underside of the sacred sky boat.[194] There also exist a few groups whose elements are distributed in such a way as to make one suspect that the artist's eye lingered in front of the middle one. There were conical containers or bound heaps of gifts used for religious purposes, which were decorated on top with ostrich feathers. These feathers are mostly shown with their heads leaning outwards from the middle ⳩, and the middle one is sometimes (pl. 18) placed firmly up-right with only the ones on the sides leaning their heads. The distribution of the stool legs in fig. 57b and the handles in fig. 43c is similar. The four animal heads placed at right angles to each other on the capitals of throne canopy columns (fig. 238) are ordered according to the same principle in pictures. The same is true of the ancient victory group (cf. pl. 8, p. 155), which is sometimes presented in an over-elaborate form with the king seizing not one but a whole bunch of enemies by the forelock (fig. 239). Then the middle head may be looking at the viewer while the others look to right and left.[195] Here too of course everything that is superficially similar must

[194] [An interpretation also given by Grapow 1956; see in addition Thomas 1959 (J.R.B.).]

[195] The lack of rigidity in features like this can be seen for example in LD 3.186, where the middle head in the top layer of the group (the ultimate precursor of this type is fig. 142, from the Hierakonpolis wall painting) faces the viewer, while the corresponding one at the bottom is shown in a side view. A case where the group has been entirely dissolved into abstraction is reproduced by Daressy (1917a.228 with pl. 1); here the king is striking not men but the plant of Lower Egypt (fig. 10) round which the plant of Upper Egypt (fig. 9a) has wound itself. [Cf. now Schäfer 1943.85.]

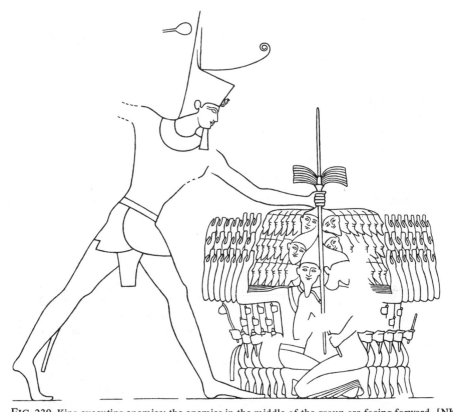

FIG. 239. King executing enemies; the enemies in the middle of the group are facing forward. [NK]

not be brought under the same heading. A rapid glance at a picture like fig. 240 would lead one to associate the rendering of the flat circles of bread with that of the lion heads in fig. 238. Yet the two have scarcely anything in common. In fig. 240, as in fig. 188, one should not think of horizontal columns of loaves stood on their sides, for in reality the loaves are lying flat in the basket, and are rendered in a purely image-based manner, in a view from above. This is the explanation of the fact that similar groups of loaves are also found with the layering reversed.

If therefore in fig. 240 sense perception plays a small part in the representation of the loaves, we may be sure that it was not the sole criterion which decided the ordering of the lions' heads in fig. 238 and similar pictures. The visual image would scarcely have had an effect there either if it had not been backed up by the instinctive preference for balanced symmetrical composition [*Gegengleiche*]. In using this word I refer to works which repeat the elements of one half in reverse on the other side of a central axis. This principle dominates the distribution of rooms in buildings. In two-dimensional art it is not possible to speak of dominance. But many pictures cannot be enjoyed to the full if the amount of open or hidden symmetry in them is not perceived. In classical Egyptian art it is not generally as evident on the surface as it is on some slate palettes from the beginning of the historical period (pl. 5), or as in ancient Babylonian art, where independent religious or other solemn groups tend to be amalgamated in rigid, almost heraldic forms.

FIG. 240. Man carrying offering cakes. NK

It may be considered a sensitive trait in the Egyptians that they like removing
the stiffness in large, essentially balanced compositions, by making details not equal
one another. There are also many representations of daily life in tombs whose halves
are too unequally filled to be considered balanced, but are none the less so well cal-
culated that one would be inclined to call them counterpoised.

4.4.6 Several stages of an action in one picture

We are still accustomed from Renaissance art to a whole series of stages following
on one another being rendered as a narrative in a single picture, in the attempt to
give the most accurate information—as opposed to the capturing of an action at a
vital moment. For example, in a miracle of bringing back to life we may see a boy
fall from a window, the body lying on the ground, and the resurrected child simul-

taneously rising up from the corpse's feet.[196] Egyptians do not go as far as this Italian painter. But in pictures showing men hunting birds with throwing sticks (Quibell 1907 pl. 20.2), or in a remarkable drawing in which the king and queen are showering arrows at one another (Daressy 1901.24, pl. 24 no. 25125), many more shots can be seen in the air than could have been aloft at one time. A related phenomenon is found in representations of offerings in incense or scent, when an uninterrupted line of little pellets of the material, or a sort of stream, connects the hand of the offerer with the spot for which it is intended, thus indicating at the same time abundance and the line of movement (fig. 241). Children draw people throwing snowballs in the same way, and bushmen do the same with arrows being shot. Pictures of dancing (fig. 242), where the movements in a dance figuration are represented serially on the same base line, as on the print of a modern film, are closer to the spirit of the Italian picture. Other examples, beside the dance groups, are a man cartwheeling over the back of a leader who is stood upon in the middle of the manoeuvre (fig. 243), and jumping girls rising into the air (fig. 244).

FIG. 241. Censing, with the direction in which the pellets are thrown indicated. NK

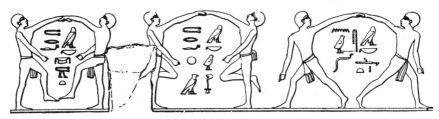

FIG. 242. Picture of a dance, showing three different steps. OK

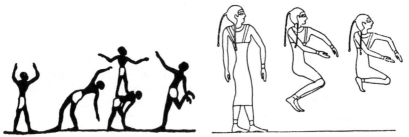

FIG. 243. Cartwheeling over a man standing in front. MK

FIG. 244. Jumping. MK

[196] Picture by Taddeo Gaddi in the Kaiser-Friedrich Museum in Berlin, no. 1074. [Now in Dahlem (West Berlin), Gemäldegalerie, no. 1074, Taddeo Gaddi, *Ein Wunder aus der Legende des hl. Franziskus.* Cf. *Stiftung Preussicher Kulturbesitz, Staatliche Museen—Gemäldegalerie, Verzeichnis der aufgestellten Gemälde des 13. bis 18. Jahrhunderts im Museum Dahlem* (Berlin 1966) 48 (J.R.B.).]

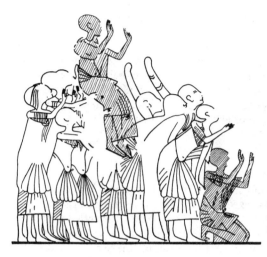

FIG. 245. A man thanks the king for a reward and is then lifted by his friends onto their shoulders. NK. (I have shaded the two figures of the rewarded man.)

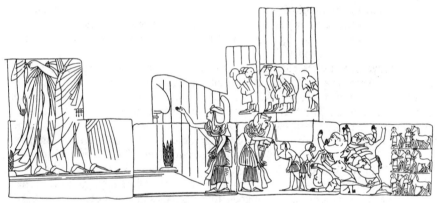

FIG. 246. A foreign delegation brings its pleas to Ḥaremḥab [and thence to the king] through an interpreter. NK

Perhaps somebody who knew more about wrestling than I do could deduce something similar from the hundreds of groups of wrestlers in Middle Kingdom tombs. In an Amarna picture (fig. 245) we see a high official receiving rewards first kneeling gratefully before the king and then raised on the shoulders of his joyful companions. On a wall from the Memphite tomb of Ḥaremḥab a foreign deputation brings its pleas through an Egyptian interpreter to Ḥaremḥab, who in his capacity of vizier, the office he held at the time, refers them to the king. The picture (fig. 246) contains the following, from right to left and from smallest to largest: the foreigners' servants with a gift of horses; the crying and gesturing crowd of envoys seeking assistance; the double figure of the interpreter, facing right to talk to the foreigners, and left to talk to Ḥaremḥab: Ḥaremḥab is also shown twice, once facing right and speaking to the interpreter, and once facing left towards the king. So both interpreter and vizier are acting in two directions in the same picture. The picture contains a further less obvious example of the linking of non-simultaneous actions. Let us take the interpreter

standing in front of Ḥaremḥab. Both have their hands raised in the speaking gesture 𓀁. Of course they are not really speaking to each other at once; speech and reply, which follow one another at a polite distance, have just been brought together in the picture. In Ramesses II's great pictures of the battle with the Hittites[197] the whole course of a military engagement is represented in an uninterrupted and closely linked picture, in which the king appears performing a variety of actions. While the individual stages of the action are here placed side by side and not separated, in another case they are divided by lines and placed next to or above one another, as we saw with the bird-catching on p. 166.

4.4.7 Different scales in one picture

Here too early European art has taught us not to think it strange that certain especially important things are emphasized by their size in Egyptian pictures.

Even the most untutored artist will maintain approximately the actual relative sizes of the parts of an object. But often enough even these ratios will be treated with great freedom, and the size of single parts, for example the head, is frequently exaggerated, especially by children, because of the importance it assumes in the artist's mind at the moment of conception. In a good Egyptian picture, however, the parts of one and the same object are only rendered in different scales in particular circumstances. Thus in closed groups (pp. 141, 176–7) arms, arm supports and the sides of chairs may be lengthened.

The relative size of different figures in one picture also normally corresponds with reality, but artists have no qualms at all about disregarding natural proportions if a larger or smaller object is required for artistic reasons, or if the artist is more interested in one particular figure than in the others. Men sitting in a bower or under a canopied throne (fig. 56, 102) would have had to stoop to get in, and would pierce the roof if they stood up—in fact their high feathered head-dresses often overlap with the roof. A butterfly is drawn almost as big as a duck (fig. 179), or even a hippopotamus.[198] In fig. 100 and 115 the mummy and the man carrying the sack are almost as big as the houses next to them. Already in the Old Kingdom we find the strange custom of representing oxen and other animals small, minute even, next to the men leading them (as in pl. 52 R); this is certainly only in order to stop the men from losing prominence in comparison with them. Of course the actual proportions of figures are not taken into account at all in pictures of heavenly bodies in which gods are standing (pl. 59)—nor do any of us wonder how big the man in the moon is, or how big the moon would have to be to contain him.

There also belong in this context all the cases that modern observers thought they had found of perspective reduction, where smaller figures were by chance placed—though of course only in this respect by chance—in the upper part of a picture. Any search for perspective phenomena only leads to unprovable assertions. But if the cases are examined carefully and closely, with the observer attempting to remain detached from our modern method of viewing pictures, other reasons for the smaller scale of the figures will almost always become apparent. If none can be found

[197] These can be found in *Atlas* 2.
[198] Butterfly next to birds, *Atlas* 1.376; next to a hippopotamus, Davies 1902.2 pl. 20, text p. 26 n. 1.

we should abstain from making a judgement. Fig. 247, where the men raising the levers of a wine press are much smaller than the ones pulling it down, is very revealing. The overlap of the figures and posts shows that the artist did not think at all of foreground and background, but chose the sizes with only the composition of the picture in mind, here because of the possibility of inserting two of the labourers in the empty spaces between the posts, the sack, the stream of must, and the barrel. The artists of the wine presses may have meant by the differences in the direction of the poles to indicate in the case of fig. 199 that they are moving in parallel planes, in fig. 200–1 and 247 that they are twisted in opposed directions.

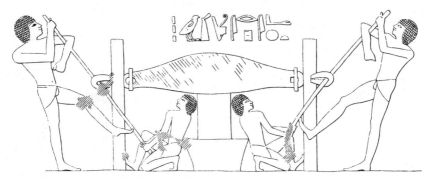

FIG. 247. Wine press. NK

Cases where somebody is standing opposite a row of other people in descending order of size, as in the delegation before Ḥaremḥab and Tutʻankhamun (fig. 246), have been interpreted as if the delegates were in some way seen from the point of view of the chief character.[199] But a layout of this sort would only be permissible in an art which recognizes perspective reduction in general, and in such cases it is salutary to remind oneself again (cf. p. 83) that even in Greece the reduction of distant figures only appeared long after all other possible foreshortenings had been exploited. The progressive reduction in the row of figures mentioned only expresses decreasing rank.

Often we ourselves unconsciously approach tall people with a feeling of esteem and we use words of size both for physical size and inward, spiritual greatness. These are perhaps the traces, *transposed on to an aesthetic plane, of a residual feeling which goes back to a time when bodily strength still gave its possessor greater power than it does now*, that is to a time when the feeling of admiring awe before a healthy and massive physique was much stronger. For this reason an obvious means, even for children and primitive people, of expressing power and strength is to exaggerate the size of one figure in relation to the others (Koch-Grünberg n.d. 36). But when an Egyptian emphasizes someone by exaggerating his size this is meant less to indicate physical strength than *power and authority*. Oversized figures had already undergone

[199] Curtius 1923.146–7 on Davies 1903–8.6 pl. 29. Unger (1917) thought he had observed the same phenomenon. Hölscher (1910.9–10) assumes that the effects of perspective were taken into account in the high gate at Medinet Habu; similarly Legrain (1929.25). Wulff is similarly mistaken in his belief that evidence can be found for Egyptian artists imagining themselves in the position of high-ranking people, so that they represented such people large and others small (1907).

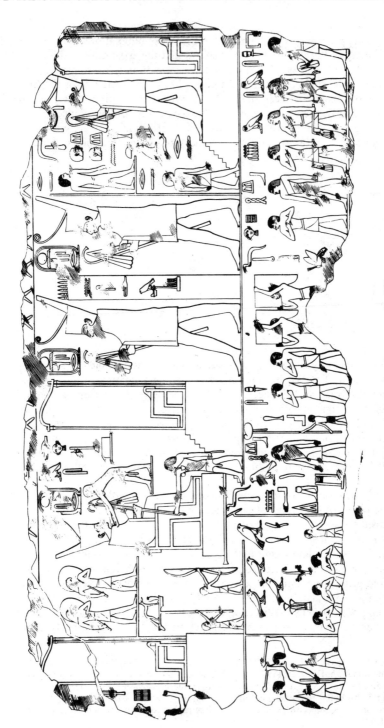

FIG. 248. Fragment of a relief showing the *sed*-festival, from the Abu Gurab sun temple. OK

this change in meaning at earlier stages; even in the simplest of conditions the plain bodily strength of the more powerful man does not dominate without the mental stature and rank which give him the effective means of using it. American Indians drew a member of a scientific expedition smaller not because he was smaller but 'because he was not so prominent in the work as the others' (Koch-Grünberg n.d. 36). And when eleven-year-olds from Berlin were asked to draw freely imagined pictures for Uhland's *Schwäbische Kunde*[200] the Swabian hero was represented larger than the other characters 'because he's the chief character'. Here it is clear that the artist's 'vision' (cf. pp. 90—91) is composed not only of the sense data offered by the relevant figures, but also of what they evoke in his thought and feeling. So this is one of the cases when the image-based rather than the frontal character of the representation should be emphasized, which can also be seen from the fact that exaggerated size is not restricted to pre-Greek areas, but lives on for a long time together with the use of oblique views and foreshortening, for example in medieval European and Far Eastern pictures. The Egyptians emphasize the king (fig. 248, pl. 6, 55—6, 58) in religious and secular scenes and deceased men in their tombs (pl. 21—2, 42, 61) by making them larger than the other people in the picture. Our earliest example is the victor in fig. 142, where the baseline of the defeated man is interestingly placed on a level with the middle of the larger man's body. The next case of excessive size is Na'rmer's slate palette (pl. 8—9), where the subjugated man is on the same base line as the victor, as is fitting. On the other hand gods are not normally larger than human beings (pl. 60), nor does the chief wife come below her husband, although the natural difference in size between the sexes is shown (fig. 249). Much of the detail depends on the artist's inclinations and on the type of task he has before him.

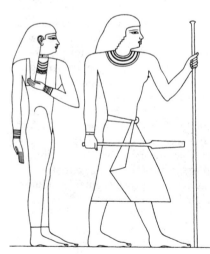

FIG. 249. Married couple. OK

Normally of course people act in accordance with the scale at which they are shown. Thus wife and child often (pl. 21, 42) grasp the calf of the colossal figure of the head of the family, scarcely reaching to his knees; in this way their trust in his

[200] [A poem about an emperor and a Swabian hero, in *Balladen und Romanzen* (1814) (J.R.B.).]

protection is charmingly expressed. And the little figures of the servants who wash and anoint their master's face and feet in the morning are placed above and below against his enormous form, like the Lilliputians beside Gulliver's recumbent body.[201] If a scribe has to hand over a statement of what is in a register of a picture on an unrolled papyrus, a favourite method is to place him at the front of the register which finishes by the owner's face.[202] There are also pictures (pl. 58) of the giant king standing on a plain and quite simply seizing a mountain fortress from above (cf. p. 155). A strange phenomenon, which can however also be observed frequently in Greek art, is that the difference between the height of the heads of a person standing and one sitting or even squatting on the ground next to him is completely or almost completely compensated for (pl. 52). Various factors must play their part in this. Perhaps the desire to emphasize the seated person; for in these cases seated or squatting people always possess a higher status, and through the fact that their figures are *equal in height* to those of people who are standing—though this rule [*Scheitelgleiche*] was never applied universally—they acquire a scale that gives them greater prominence. But we can see from fig. 250, where the tops of the figures of the men climbing the staircase are on the same level, that this explanation alone is not sufficient (*Atlas* 1.63).

In sophisticated art like the Egyptian there are two sides to the emphasizing of figures. On the one hand it is a factual statement of importance without aesthetic meaning, just as it is in drawings by children and primitive people, and in this respect[203] the procedure has been aptly compared to our use of spaced and heavy type to draw the reader's attention to particular words. But this comparison does not do justice to the other side which is only to be found in mature Egyptian art. While spaced and heavy type in a text are always an obstacle for the compositor, Egyptian artists of all periods were well able to appreciate the great advantage for construction and composition of exaggerating the size of certain figures.

However much it may offend us moderns to find three or even more scales often used in the same two- or three-dimensional composition, it is clear that in this way the Egyptian artist gained an enviable freedom in the composition of his pictures, much greater than that possessed by an artist bound to strict perspective. And good Egyptian artists used this freedom in a masterly way: could the idea of taking and destroying a fortress be more concisely and arrestingly rendered than in pl. 58? And is it not characteristic of the persuasive power of Egyptian art how quickly even somebody who is initially amused at the simplicity of this fortress picture is seized by the magic of the work of art composed in this way, and can enjoy it even more?

Since the elements that make up an Egyptian picture are quite different from those that make up a perspective one quite different rules govern its formation. Therefore it can reasonably demand to be measured by its own standards and not by ours, which are taken from the perspective method of composition.[204]

[201] *Atlas* 3.2; Davies 1900–1.1 pl. 30. Similar cases *Atlas* 1.365, 405.

[202] Propyl. 258 [W fig. 187, cf. perhaps L-H pl. 67 (J.R.B.)].

[203] Borchardt 1910.5–6. The life inherent in an image has been discussed by many writers.

[204] Discussion in Matz 1922 [1924] and Balcz 1930b. Frankfort discusses the composition of pictures at Amarna (ed. 1929). One should not be misled by the title of Cornelius's *Elementargesetze der bildenden Kunst* (1908) into looking in the book for real 'basic laws' which would be valid in equal measure for art based on frontal images and art based on visual images. The author is not even aware that his definitions exclude all pre-Greek art.

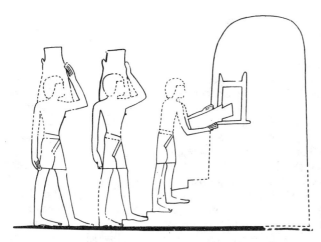

FIG. 250. Putting corn into a silo. NK

4.4.8 Earth and sky. The world and the universe[205]

This group of subjects is of such importance and scope that at least some points in it should be briefly considered.

Egyptians of the historical period, like other peoples, imagined the *earth* to be a huge dish (pl. 59), but in general it is written with the sign ⊂⊃ (a masculine word) which is used as the opposite of sky (a feminine word), also denoting 'land' as against water, and as a defined area of the earth's surface.[206]

The *sky* normally has the old traditional form ⊏⊐ , which seems to represent an upturned shallow chest whose sides terminate in points at the corners. The primitive belief, which is also found among Australian aborigines, is that this roof rested on four supports ⅄ , which are normally replaced in art by signs like ⅃ that bring good fortune. But later the points of the roof are placed on the mountains at the edge of the 'dish' of the earth. Thus the sky in the Egyptian pictures is only a narrow strip of spotless blue at the top (fig. 66, pl. 59). The night sky is distinguished by yellow five-pointed stars which stand on a black background only when they constitute the entire ceiling of certain rooms.

In the Amarna tombs besides the normal form of sky another type is also found with some frequency; it resembles an hour-glass, that is a straight strip with curved ends which run down into the mountains while remaining the same width, so that it comes near to our image of the vault of heaven.[207] As is well known, the sky is also shown, on the tops of Egyptian stelae, as an accurate arc of a circle.[208] Cases where

[205] On the following section cf. Schäfer 1928 and Sethe 1928; Sethe's comments on pictures like pl. 62 do not by any means exhaust the question. [Cf. also Schäfer 1935b (J.R.B.).]

[206] See Schäfer 1928.90. In *The Thousand and One Nights* the earth looks like a bowl of water to a man carried up into the sky by an '*ifrīt* (reference supplied by H. Ehelolf). Cf. also Schäfer 1928.98. What was the source of the image of the earth's original 'nest' form in Immermann's fine 'Mondscheinmärchen' (*Die Epigonen,* Book 6 Ch. 12 [1836])?

[207] The well-known fact that we consider the apparent vault of the sky to have the form of a watch-glass is irrelevant in this context. In the Egyptian rendering the horizontal part is in all probability determined by the arrangement of pictures into registers, and perhaps influenced by the earlier image of the sky,

[208] Propyl. 449.2, 455.1 [Brunner 1965 pl. 26 (J.R.B.)].

the sky is curved when there is no need for it to be show that the arc is not, as might be thought, determined by the semi-circular form of this type of stone. The arc would probably not have been used on stelae, and another solution would have been found, if the idea of a vault had not already been present next to the commoner one of the flat sky. The arc could equally well suggest a cupola or a barrel vault. But as the cupola was not used in Egyptian architecture a barrel vault will originally have been behind the rounded representation of the sky. That was in itself possible: in the Berlin Museum für Völkerkunde (Dahlem) there is an image of the world made by the Cora and Mexicano of America which is in the form of a pumpkin shell with a raised edge and flat base, containing on the inside figures made of clay and beads.[209] Above this is a barrel vault (Schäfer 1928.98) on supports, open at both ends, made of reed with large flocks of cotton wool representing the cloudy sky.

Between the strip of the sky and the earth is an *empty space*, in which, however, winds blow, gods and spirits have their being, and men, animals, and plants can find a living. Air is only thought of as air if it is in motion. On the use of newly growing plants at the foot of a wall as the opposite numbers of the roof which represents the sky see p. 26.

The more or less technical image of the sky with its four supports is never shown completely, although its separate parts can be deduced with certainty. Nor is it entirely lifeless, since the roof was raised from the ground on to its four supports at the beginning of time, and they must still be watched and held by guards. But a more lifelike image, a product of the people's creative fantasy, was preferred in representational art. According to this the sky goddess once lay coupled on top of the earth god. But then a being came between them—perhaps originally their son, as in New Zealand[210]—and raised up the goddess's body, with the result that only the extremities of her four limbs touch the ground. The same basic ideas can be seen in the human figures of this group as in the structure erected on poles, but the boats which travel over the sky goddess's body are manifestations of the desire, also common in other contexts, to enrich the content of an image with material of varying types. It is typically Egyptian that the additional elements in representational art, too, are not products of the same idea, but are taken without any hesitation from elsewhere. The linking factor is not the forms but a common idea: the boats also originate in an image of the sky, but of the sky as a stretch of water. One might be reminded of poetry, where others beside the Egyptians accumulate similes. The phenomenon is also found in poetry whose context is close to our own. In Walther van der Vogelweide's marvellously delicate *Leich* a new image for the Mother of God comes in almost every line: flowering Aaron's rod, glowing dawn, Ezekiel's gate, purest glass, burning bush that is not consumed, and many others besides.

The *sun* is generally shown as a simple disk ◯, which, for some unknown reason, frequently has a double border ◎, while the hieroglyph, strangely, often has a small circle in the middle ⊙. When the sky is a strip the sun hangs on its lower edge, but it is only shown as a simple heavenly body in astronomical and mythological pictures. The divine sun, on the other hand, often hovers, entirely unconnected with the sky, in protection over the king's head, in one of the various

[209] [This object was destroyed in the Second World War (J.R.B.).]

[210] The same applies to the Greek Uranos myth, where Kronos is the son, while in Egypt Shu is the father of the pair he divides.

different forms in which the Egyptians imagined it: as the disk with one or two
cobras , or with wings . The winged sun disk, which seems to
have originated from the wings of the sky god, is found countless times, especially
above almost every gate, protecting with its wings but itself guarded by the poisonous
snakes. It also gives the king life, duration, and good fortune in the form of three
signs which hang on the edge of the disk or on the snakes, and are presented
to the king.

Amenḥotpe IV used an old literary epithet applied to an earlier form of the sun
god ('he of the many arms') to create a new iconography for his god the Yati (Aten),
which we call the *Stahlenaton* [Yati with rays] : a sun disk with snake which is set a
little into the sky at the top and sends out numerous rays. The rays end in hands
(cf. p. 56) which hold out the signs mentioned above to the royal family as represen-
tatives of humanity[211] and rest against their crowns or bodies, or curve round them
just as the hands of the old anthropomorphic gods did. This new image of the sun,
which ceased to be used at the end of the reform period, is closer to and
than to in so far as it is turned to the viewer; indeed it speaks to him more
urgently than the others, as the snake, which is shown in a front view on the lower
edge of the disk, looks forward out of the picture.

In the New Kingdom the disk and helping divinities, 'good wishes signs' with arms,
rejoicing apes, and other additional elements were used in the creation of a whole
series of images of the rising and setting sun which have many variants often of great
beauty. Pl. 62 is an example.

As is understandable, the *moon* is only rarely shown as a heavenly body in two
dimensions, but it occurs more frequently on the heads of moon gods both in two
and three dimensions. It can be recognized by the sickle attached to the lower edge
of the disk. The surface of a bronze mirror has been smoothed on both sides, gilded
on one, and plated with silver on the other (Berlin 13187, Propyl. 414.3); so despite
the absence of a sickle shape it is probably meant to represent the sun and the moon.

The *ground* is always indicated by the simple black base line (p. 000), unless the
artist needed to show the type of ground: if it needs closer definition, for example
as desert or water, a corresponding painted surface is placed between the base line
and the figures.

The *desert* is painted a reddish yellow and stippled with dark red, green, and even
blue and white dots which indicate pebbles and sparse plant growth (Nina Davies—
Gardiner 1915.31). In spring straggling plants, which soon dry up again, often appear
after falls of rain, and Nile acacias grow in a number of depressions. All of this
(fig. 253) is placed on top of the strip of red and green ground, just as living beings
are. In one case the strip has a smooth top (fig. 196). But as the deserts which enclose
the flat valley of Egypt to east and west are mountainous or at least hilly, the strip
representing the desert floor is almost always unevenly waved at the top (pl. 29).[212]

[211] Propyl. 374.3 [cf. L-H pl. 183—5, Sm pl. 116A], 375, 382.1 [L-H pl. XXXV, M pl. 107
(J.R.B.)].

[212] Paintings of men, the lower parts of whose bodies are covered with the wavy lines of hills,
occur in the *cella* of the 'Shield and Jaguar Temple' at Chichen Itzá (North-East Yucatán;
about A.D. 1200, according to W. Lehmann [a contemporary of Schäfer's, who worked
in the ethnological section of the Berlin Museums (J.R.B.)]). [The temple Schäfer is refer-

The normal straight base line always runs underneath, even on the earliest monuments.[213] In these cases too it is mostly black in painting, but in the earlier periods it is painted green in the hieroglyphs for 'mountain country' ⌒⌒⌒ and 'mountain' ⌒ ; it has been suggested that this is an indication of the green fertile land (Petrie 1892.30). The opposition between the 'black' ground of the flat Nile valley and its red surroundings was so obvious to the Egyptians that foreign countries were always determined with the sign ⌒⌒⌒ in the script.

The idea that buildings, people, and things *stand vertically on the ground* is so firmly rooted in plain-dwellers that it often exerts an influence even when the ground is hilly. Starting again from children's drawings we find that in them houses and trees on mountains very often point in enormously varying directions *vis-à-vis* one another, but that every one is perpendicular to the short stretch of ground on which it stands. A remark by a sixty-five-year-old woman who came from the German plain and was in real mountains for the first time[214] gives us an insight into the mental processes of the artist. On her return the woman said: 'There were such high mountains! And houses stood on them just as they do on the hill here in the village. They stood straight [upright] , exactly like your house here! You couldn't believe it if you hadn't seen it. The things they manage to do these days!' I only know of one Egyptian picture which corresponds with this woman's original idea; this is a representation of Osiris' burial mound (fig. 251) and is therefore no doubt based on an old model. The trees growing on the mound fan out like the sun's rays. In all other Egyptian pictures trees and houses are perpendicular to an imaginary horizontal base line beneath the whole composition.

If an action takes place on *water*, and the water is nothing more than the bearer of the action without reference to the form of its surface, it is almost always represented in the form of a narrow rectangle (pl. 22, 42, fig. 253, etc.) with straight edges. I know

ring to is now called the Temple of the Jaguars, and he will have seen Seler's publication (1915b.324—56), in which it is called the *Tempel der Jaguare und der Schilde*. However, no figures of the type described occur there (this is confirmed by an examination of the Adela Breton copies Seler mentions [1915b.325], which are now in the Peabody Museum, Harvard). As this note does not occur in the third edition of *Von ägyptischer Kunst* (Schäfer 1930) it is likely that the name of the temple is wrong and that Schäfer has in mind paintings in the Temple of the Warriors, published in 1931 (Morris—Charlot—Morris 1931, e.g. pl. 139), which show men with striped bodies, in contrast with their opponents, who mainly have black bodies. The figures with striped bodies are also shown against a *background* of wavy lines, which however almost certainly represents water; other non-striped figures occur against the same background (ibid. pl. 146—9). The colours of the stripes on the bodies and of the non-striped figures show a wide variation. Whether the striped bodies in fact represent mountains is uncertain; they could also be paint applied to the body, or some more arbitrary device for recognition. The lines are not wavy, nor, except where the figures are clothed, do they cover only the lower part of the body. Morris (pp. 392—3) does not suggest an interpretation on Schäfer's lines; in the text to pl. 141 he suggests instead that the stripes were used to distinguish the defenders of a town from its raiders; however one group appears to show one striped figure attacking another, whose stripes are a slightly different colour (J.R.B.) I am grateful to Profs. M.D. Coe and G.R. Willey for advice on this point.]

[213] On the reliefs on the Koptos Min statues (Capart 1905.225 [cf. Baumgartel 1948 (J.R.B.)]). Pictures like Newberry n.d. pl. 7—8 and *Meir* 2 pl. 7—8, where the lower line of demarcation is lacking, cannot be used as counter-examples, as they are unfinished.

[214] Sponsheimer 1925.23. He also mentions similar phenomena in Assyrian art. There are even people walking up a ramp who are perpendicular to it.

FIG. 251. Osiris' grave mound. Late FIG. 252. Ship on a wavy band of water. OK

of very few cases of evenly waved stretches of water bearing boats (fig. 252), and these are in religious pictures of the Old Kingdom.[215] Water surfaces are covered with close parallel wavy lines (pl. 6)[216] which are stylized early to make sharp black zig-zags on a blue background (e.g. pl. 42), mostly running across and not along the surface. If the flat swampy edges and neighbouring streams of the Nile are to be shown, and not the broad open river, the water is brought to life with much care and skill by the addition of water animals, and if it is fresh water, also by plants (pl. 38). Rectangles of water are not sunk in the base line ⌇⌇⌇⌇ any more than trenches are (cf. fig. 96–7), but stand on top of it, so that when the water does not occupy the whole of a register an action that takes place on it appears higher (like the boats in fig. 151 top L) than actions on the nearby land. A New Kingdom artist proceeded in a curious fashion when he had to characterize the stretch of land next to the water not simply with a base line, but as level desert ground. He[217] sloped both the water and the land downwards at the join, thereby forming a sort of groove. If it is necessary to show the direction of the banks or the alternation of land and water this is done in the same way as on modern maps (pl. 6, fig. 145). If there are objects such as ships on top of a straight stretch of water it is only possible to deduce from the objects themselves whether they are in the water or on the banks. If the subject is the building of boats, the situation is clear. None the less a great but over-cautious Old Kingdom artist added a further line to mark the ground between water and boat (fig. 253). One is tempted to think of straight stretches of water as sections, and this idea may be supported by pictures of fish that are not covered with water (pl. 22). But the situation is the same as with the gaming board and its pieces in fig. 155, and the image of the water surface must count essentially as a frontal view from above. This is shown by the water lilies and indeed by the swimming ducks in pl. 42, although they are of course seen in a side view, and the lower half of the ducks' bodies should be covered in water. With some figures like the hippopotami in fig. 254 and pl. 22 or the crocodile in fig. 151 top L the lower edge of the water

[215] LD 2.10b as well as fig. 252. Griffith (1922 pl. 26.1) interprets a curious graffito as a representation of sandbanks or rocks.

[216] Water with small, soft waves occasionally occurs in later periods when it is being poured out of a jug, e.g. Steindorff 1913 pl. 64, 66–9. But zigzag lines are mostly found in such representations too. In pl. 40 the water being poured to prepare the path of the waggon (despite fig. 283 probably the first representation of one on an Egyptian monument) is shown as separate long strips, without zigzags (cf. also Ch. 5 n. 4).

[217] Erman–Ranke 1923.360. [360.1 = Davies 1933 pl. 22–4. Erman's illustration does not make it clear that the picture is continuous (J.R.B.).]

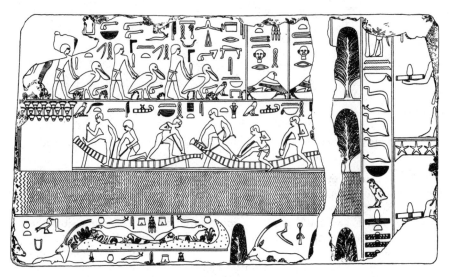

FIG. 253. Relief from the Chamber of the Seasons (*Weltkammer*) in the Abu Gurab sun temple. OK

has become the base line on which the animal stands.[218] But this too did not happen because the artist intended to produce a section. His associations were much looser. What he intended to express in pl. 13 was: 'hippopotami are wallowing in the shallow water which is teeming with fish; one of them is raising its head threateningly out of the water.'[219] The impression the artist desired to give will still be received in its entirety by an unprejudiced viewer.

When the water surface in a larger picture is covered with zigzag lines this type of filling arouses our inclination to unify the picture in our minds to a peculiar extent. So when narratives are presented on a large stretch of water (fig. 262–3, 197) we must again be wary of introducing alien elements into our view. The even, textile-like pattern of the water will have seemed to many Egyptian artists to be a good background for their compositions. On the other hand it is quite clear that some did not welcome the incised zigzag lines of water and the shadows which they cast, because they brought with them a certain lack of tranquillity and clarity. Rather as with the papyrus thicket discussed on p. 118 this, or a simple desire to avoid so much tedious work, may explain why the lines of water were often only painted, even in reliefs. Now that most reliefs have lost their colouring the surface has no distinguishing marks, even where water is intended (pl. 16, 34, 38). As Egyptian art has its pedantic side it will not seem surprising that even considerable artists draw exaggeratedly precise guide-lines for water depictions. Small irregularities do occur, as they do in all handmade works; but an ancient Egyptian would not even remotely have intended that they be accepted unconsciously, or still less welcomed, as they are by us, for the vitality they impart. One of the favourite pleasures of high-ranking

[218] This is of course always true of wading figures, cf. n. 172 above.

[219] [The hippopotamus is not in fact 'threatening', but is being pulled out of the water by lines attached to harpoons, just as the fish on the left is being pulled by the hook; but this does not alter Schäfer's interpretation in any way.] I know of no representations of swimming hippopotami with complete bodies.

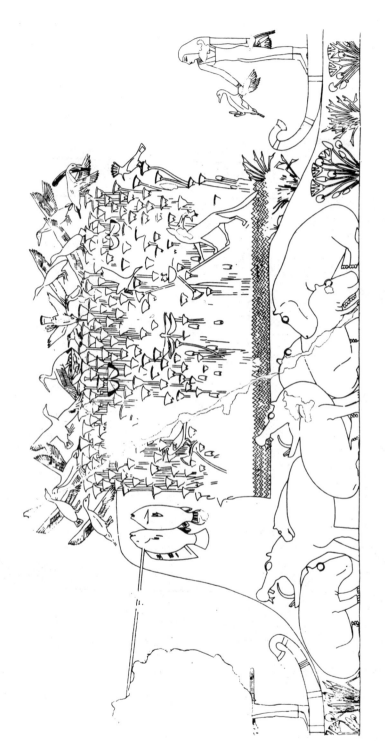

FIG. 254. Stretch of water with papyrus thicket. L and R are the boats of the tomb owner, who is spearing fish and hunting birds. MK

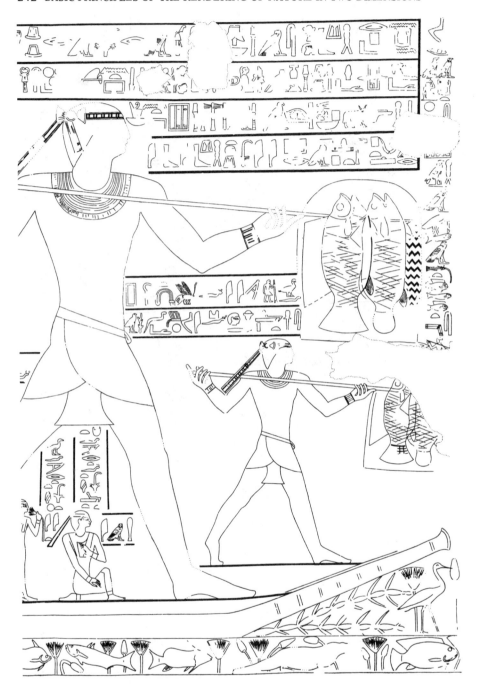

FIG. 255. Spearing fish (detail). OK

Egyptians was spearing fish from a papyrus boat. In pictures like pl. 42 or Propyl. 300 [= LD 2.130] the tomb-owner stands on the boat with his feet wide apart holding the long two-ended spear which is laden with his catch. The speared fish in these pictures are almost always surrounded with water which rises like a hill from one corner of the strip of water below. Sometimes the two pieces of water are separated by a line (pl. 38), and sometimes not; in the latter case both the vertical and horizontal areas of water are full of swimming fish. A real bay in the water cannot originally have been meant, otherwise it would have been more clearly shown that the feet of the clumps of papyrus, which often rise up behind the 'hill' of water (pl. 38), were on the edge of the bay. Only from the eighteenth dynasty on (pl. 42) do leaves at the base of the plants occasionally occur in this context; so only then was the earlier form reinterpreted as a representation of a bay in a stretch of water. One earlier artist moved in this direction, in the Middle Kingdom, and, taking the raised part of the water as a bay, he produced an entirely individual and brilliant solution to the problem: he placed (fig. 254) a large papyrus thicket at an angle to the outline of the bay, which rises gently from the right. The earlier form is still present beside this new one. The same self-willed Deir el-Gebrawi artist, who has frequently helped us in our studies, also shows us how to take this latter. In his rendering (fig. 255) the water below is the normal rectangle with its lively content of water plants and fish. But above there is a completely detached splash of water around the father's fish and those of his son, which are shown on a smaller scale. One cannot interpret this picture on the basis of sense data; it is completely image-based. The artist's rendering was determined by the idea: 'the fish are speared in water, so I shall surround them with water.'[220] The 'hill' of water in pl. 38 should be explained on the same lines, only there the upper piece of water is linked to the one on the ground, and so it is clear that the fish are being taken from the water on which the boat is travelling.

Something in addition to simple images of the action played a part in the making of these forms. The oldest picture of fish being speared (fig. 256) shows a man—it is the king—stabbing obliquely from the land into an irregular pond like fig. 34. This archaic picture was of course not the only one of its type, and a familiar form like this no doubt helped to establish the idea that the tip of the spear was surrounded by water. So it remained the same when the fisherman was no longer shown standing on the ground but travelling over the water, and when the habit had grown up of rendering not the actual downwards thrust, as in pl. 42, but the moment when the triumphant man (pl. 38) has the fish hanging from his almost horizontal spear. We owe the pictures of the 'hill' of water to the association of ideas spear-tip — water and to the enduring influence of an earlier iconography. While looking at the romanesque bronze font in Hildesheim I became aware that medieval representations of the baptism of Christ make the water rise up into the picture like a hill in a very similar way, so that it covers or frames the Saviour's form. I did not know at the time that much more striking counterparts (fig. 257) are to be found in the history of representations of Christ's baptism,[221] and that these can also be traced back to an earlier reinterpreted form. The 'hill of water' in the baptism is derived from pictures where the Jordan in its narrow rocky path flows straight towards the viewer,

[220] From the end of the Old Kingdom hunted hippopotami are also surrounded with a 'hill of water' (Davies 1902.2 pl. 20). Earlier hippopotamus hunts do not seem to have this feature. [Cf. now Säve-Söderbergh 1957 pl. 14.]

[221] Strzygowski 1885. See also Hauttmann 1929.664.

FIG. 256. Inscribed tablet. In the picture above: the king thrusting his spear into a pod after fish. ED

FIG. 257. Baptism of Christ. From a medieval mosaic.

in other words downwards in the picture, thus providing the background for Christ, who is standing in the lower reaches of the stream. After the real meaning of these pictures had been lost, later artists retained the idea that a man being baptized must be surrounded by water in the form of the 'hill of water', and perhaps gave it a myth-ical interpretation—which would be out of the question in the Egyptian cases. Thus we have a case where a rendering based on a visual impression was transformed into an image-based one, while the outward form was preserved more or less intact.

I know of no cases where scenes that take place at night are given a dark back-ground. If they existed they might look like the Gethsemane scene in the Rossano purple manuscript (in e.g. Burger 1913.49): below, a light mountain landscape with human figures, and above, a blue strip of sky with stars, while the space in between is black.

The colouring of the background in Late Period wooden tomb stelae, and on coffins and the like, often contains no suggestion of a rendering of reality.

There are large numbers of mythological or symbolic pictures of the *structure of the world*, of *plan-like representations* of regions of heaven and of the underworld, and pictures of the whole world.

The vast majority of these are connected with the deceased man's journeyings, which are normally accomplished, from the New Kingdom on, in the retinue of the sun god.

All the ceiling pictures in the halls of the royal tombs of the New Kingdom are rectangular, so it is fair to assume that the actual world was imagined in this form; this would fit in well with the shape of the land around the Nile, which stretches far to north and south and adjoins the Near East and Crete in the north, and the Sudan in the south.

But it is noteworthy that we have two circular pictures of the world.[222] One, now in Paris, inscribed on a massive ceiling block from the temple of Dendara, dates to the last decades B.C. , and shows the Egyptian and Greek constellations next to one

[222] [Fragments of a third representation Clère 1958.]

another. A circular earth corresponding to it should of course be assumed. The second picture, on the lid of a large stone sarcophagus of about 300 B.C. now in New York, includes the round earth in the universe. Here no Greek figures are to be seen, but it is extremely significant that the Egyptian nomes form a ring and not a straight line. At the moment it is not possible to say with certainty whether the circular form is taken from a Greek source or from an Egyptian one that has not yet been discovered. It is surprising that the unusual plan of the universe in this Egyptian representation found its way into St. Hildegard of Bingen's second vision [Liebeschütz 1930] and into Tibetan painting [Evans-Wentz 1927 pl. 1–3].

4.4.9 Leading in captives, and related motifs

There is a large picture from one of the Abusir pyramid temples (pl. 25) in which the gods are leading bound enemies of Egypt before the king. The registers into which it is divided in the normal fashion alternate, with a row of gods above and a row of prisoners below in each case. Each god holds two ropes in his hand, each of which binds one enemy in the row below. Any idea that the intention is to express spatial relationships between the gods and prisoners will soon be abandoned; certainly the gods are not in the sky and the prisoners on earth; both are moving on earth, below the sky.

hunter with dogs section rowing boat

FIG. 258. Paintings on the inside of prehistoric bowls.

Pictures where a man is leading animals on leashes or driving them before him are clearer. The earliest representation of this type (fig. 258) is predynastic in date. This painting (inside a pottery bowl) shows a man leading four dogs, which are not bound to each other, on leashes behind him. The way he is standing at quite the wrong angle to the animals, and the way the leashes run over the dogs' heads, make it plain that it was the arrangement of the dogs that inspired the picture, and that the painter was not in the least concerned with the relative distance of the objects from himself. If one tries to summarize the content of this picture in words one is soon convinced that nothing more is meant to be expressed than 'the man is leading four dogs which are walking side by side.' But if this is compared with fig. 259, from a New Kingdom religious picture, where the king is driving four calves in front of him on base lines which they are not in fact using, there is no reason for interpreting the equivalent group, which is only different in that it is in the 'Egyptian' style, in any other way. The dragging of the statue in fig. 205 has a similar construction, but the drawropes are aligned early in their length with the straight registers of the picture.[223] These pictures are closely related to prehistoric European ones, where for

[223] The men dragging the colossus are also layered laterally (cf. pp. 178–85). In Petrie (1892 pl. 27) the leashed dogs are straining to attack the game, which is arranged in three registers in front of them. The leashes run from the owner to the top and bottom registers, the middle one remaining free.

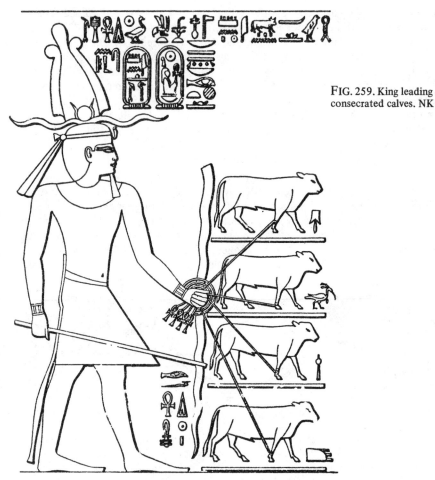

FIG. 259. King leading consecrated calves. NK

example ploughs and waggons drawn by teams of animals (fig. 260) simply corres-
pond to the mental sequence: 'the animals dragging the vehicle are one on each side
of the shaft and the drawrope: they are kept together by the yoke beam.'

FIG. 260. Drawing of a waggon on a
European pot of the Hallstatt period.

FIG. 261. Detail from fig. 144, enlarged.

4.4.10 Trees, etc., around open spaces[224]

The Hierakonpolis wall painting (fig. 144) shows five antelopes—the number was probably wishful thinking rather than fact—in a wheel trap. The picture (fig. 261) reproduces the image: 'the antelopes walked into the trap from all sides', and nobody would come to the conclusion, for example, that the artist imagined the scene from the point of view of himself in the centre. Nor need one make a similar assumption for pictures of ponds and gardens whose construction is similar (fig. 262–3), as they too may conceal the simple image: 'the plants' roots are at the edge.' But in the case of more spacious models like these the other possibility cannot be excluded when one thinks of K.F. von Klöden's amusing tale of how, at the age of nine, he stood in

FIG. 262. Drawing water. NK

the market square of the town where he lived with the intention of drawing all its four sides from the same point in the same picture; he was very downcast because he could not think of a way of coping with the row of houses behind him (1911, Ch. 7). If he had not at that age already been influenced by representations based on visual impressions, but had been an uncorrupted artist rendering frontal images, he would not have realized the difficulty: we can see what his solution would have been from the pictures of ponds bordered by trees. As it is we can sense from his description how the two mental approaches were struggling inside him. Parallels to

[224] [The process discussed in this section is known by psychologists as *rabattement*. Another case of a similar type is exemplified by fig. 254–5 above—cf. Badawy 1966.129 (J.R.B.).]

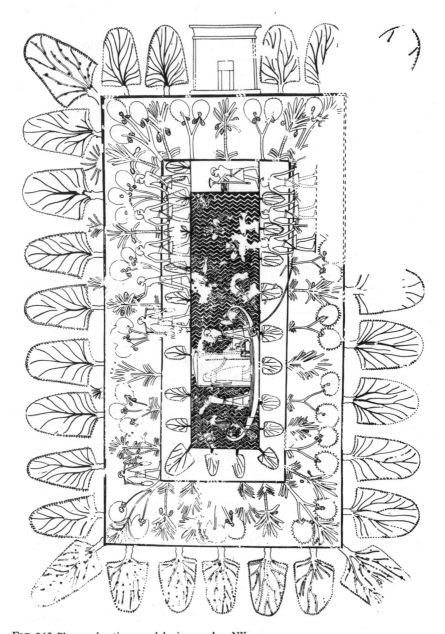

FIG. 263. Pleasure boating on a lake in a garden. NK

these radiating pictures are common in drawings by children and primitive people. Fig. 264 is the work of a ten-year-old boy: a garden which, as the direction of the trees and fencing posts shows, has been as it were encompassed from the outside in the artist's mind, in contrast to figs. 262–3. An Egyptian example of the same thing

FIG. 264. Child's drawing. Garden.

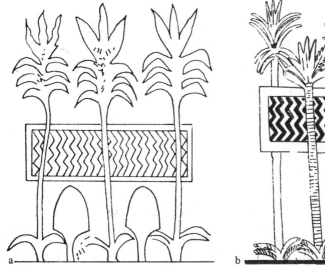
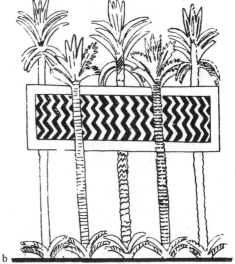

FIG. 265a and b. Lake between date palms. NK

is the representation of a festival in which Amenhotpe III walks round a large fortress-like building knocking with a mace-head at each of the many doors in order to gain admittance (Breasted 1908.93). But this Egyptian picture, which cannot be reproduced here, is not so clear and regular as a corresponding Assyrian one of a town under siege,[225] where again the image was only derived from walking round the outside.

There is a type of picture of a pond between trees (fig. 265a), which occurs in several eighteenth dynasty tombs, and it is often cited as the normal Egyptian picture

[225] Paterson n.d. pl. 49. The Cretan picture of a man plucking crocuses (Bossert 1937.120 fig. 224 [the fresco in question probably represents a monkey, cf. Evans n.d. pl. 1, Cameron–Hood 1967.27, Smith 1965.77–8, fig. 102–3 (J.R.B.)]) has the same scheme, only in this case what needs emphasizing is not so much a surrounding from the outside, but rather that the flowers are surrounding the man in readiness to be plucked. The Taq-i-Bustan representation of an enclosed hunting-ground exhibits a very interesting mixture of image-based elements and ones based on visual impressions, especially in the positioning of the people next to the side fences (Glück–Diez 1925.130 [Fukai–Horiuchi 1969 pl. 32–78 (J.R.B.)]).

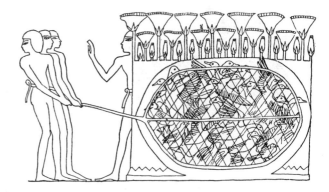

FIG. 267. Clap-net over open water in a papyrus thicket. NK

FIG. 266. Papyrus thicket with an area of open water. OK

of a stretch of water surrounded by trees. But this is not correct. The form seems in fact to occur in only one context and to be derived from a very old sacred book. In some cases there are alternating overlaps in the group (fig. 265b) which were only added at a later period in order to indicate unambiguously that the pond is between the trees. Drawings of ponds which were really produced afresh in the eighteenth dynasty, and do not rely on earlier models, look different (fig. 262—3).[226] None the less pictures which, even if they are not identical to the older ones, derive their inspiration from them, are still occasionally painted. The idea for fig. 266, from a late Old Kingdom picture, which is meant to show an area of water in the middle of a papyrus thicket, must be attributed to its own artist, who shows himself elsewhere to be distinctly perverse, though faithful to his perceptions. But it must be admitted that even his picture, however disconcerting we may find it, is still adequate to convey to us the intended image. A similar form still occurs in the eighteenth dynasty, only there the pond in the thicket is spanned by the great clap-net (*Atlas* 1.24). Another painting of the same period (fig. 267) is for us a much less effective expression of 'in the middle' as the papyrus clumps here are only above and beside the net, not below it.

[226] *Atlas* 1.170 shows the association of palms with the (probably T-shaped) pond obscuring their trunks. The old form of fig. 265a is found next to a new one, which approaches that of fig. 190, in *Atlas* 1.181 (R and L).

4.4.11 Sleeping postures and scribes' poses

After what has been learnt in this chapter it will not come as a surprise that, in addition to what was said about the sleeping man in fig. 89 on p. 122 and p. 209, he is in fact sleeping on his side with his stomach and knees facing us, and that his calves are not vertical but lying flat parallel to our angle of view. His head is resting on the destroyed head-rest 工, and we know from several three-dimensional examples that the sleeper lay with his ears on the head-rest, which thus compensated for the width of the shoulder. Egyptians, who knew no other posture, would never have been perplexed by the two-dimensional pictures, although sleeping people in them always appear to have their necks on the head-rest.

The problem of interpreting this picture of a sleeping man is related to the riddles posed by Egyptian representations of men kneeling or squatting with folded legs. A figure like the kneeling king in fig. 97a, the balls and toes of whose feet are on the ground while his buttocks are resting on his heels, presents no problem: similar figures also occur often in three dimensions.[227] But people who appear in two-dimensional pictures to be kneeling with their insteps pressed flat on the ground (fig. 268f), like the marvellously delicate figure of a girl on a boat plucking a lotus flower in pl. 42, already pose problems. However flexible Oriental joints may be, and although an Egyptian might well have chosen this girl's pose for a short time, it is very unlikely that he would have done for any long static period; his feet and legs would have had to bend outwards.[228] So my own experience leads me to suspect that figures in this pose frequently conceal something different from what appearances might suggest. And a few two- and three-dimensional works (fig. 268 g, h, Fechheimer 1921.54) show that the feet in fact took up a more comfortable position. Now how does the matter stand in cases where the leg posture is depicted as in fig. 268a, that is with one calf under the thigh of the same leg and the other standing vertically? Here too the answer seems at first to be very simple. But the position of the foot folded under the thigh is open to the same objections as in fig. 268f. A kneeling position with the instep flat on the ground can only be considered a temporary pose, not a lasting stable one. Yet almost all Old Kingdom pictures of scribes show them in this position, and their work must certainly have lasted a long time. There are indeed a few statues of people squatting on the ground where one calf is placed vertically and the other folded under a thigh,[229] but it is under the one diagonally opposite, not under the same leg. This fact increases the suspicion that the leg posture in reliefs and paintings should not be interpreted in the immediately obvious way. There is a further point. The three-dimensional form just described, which I shall term an asymmetrical cross-legged posture,[230] is not the normal one for scribes. Almost all Old Kingdom statues of scribes exhibit the conventional symmetrical cross-legged

[227] [Propyl. 224.2, L-H pl. 7; 335.2, W fig. 389–90.]

[228] [This seems only to be true of men: many women find the position acceptable for some time (the question of whether the feet splay outwards in such a pose is irrelevant). Schäfer does not appear to consider that some of the forms he discusses could represent the squatting position with the feet flat on the ground, such as is generally used now in Egypt for working at ground level, even for long periods of time (J.R.B.).]

[229] Propyl. 291.1 [W fig. 295 (J.R.B.)].

[230] [Halber Schneidersitz.]

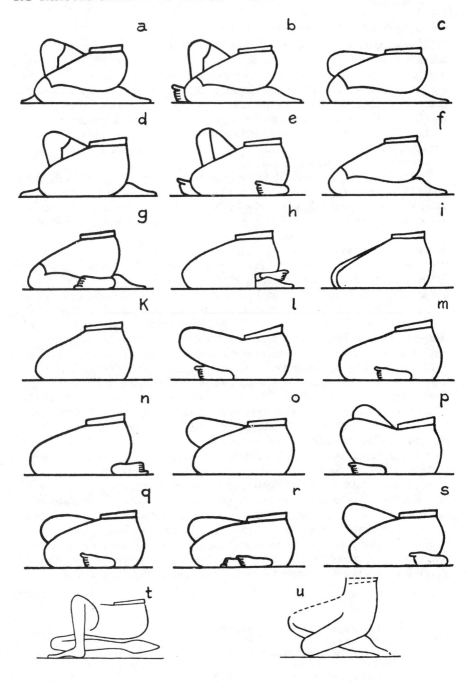

FIG. 268. Two-dimensional representations of squatting figures. OK-NK

posture.[231] There are two possible ways out of this difficulty: either the two-dimensional representations took from nature and developed different postures from the ones used in three dimensions, or the various forms of fig. 268 are meant to represent the symmetrical cross-legged pose as well as kneeling, and the asymmetrical cross-legged pose. Forms that come in during the New Kingdom, showing foot-soles, mostly their entire surfaces,[232] and often in the strangest places, show that there is no need to fight shy of this last explanation. The sole visible in front in fig. 268b and e probably proves that the apparently vertical calf should be imagined sloping outwards away from the viewer, and in fig. 268h the sole of the leg which is folded under is also beneath the buttocks. It must in reality be on the far side of the body, so that it would be invisible in a modern representation. When it is shown notwithstanding the reason is similar to the one for showing the carrying hands under the chair in fig. 126. It is beyond dispute that the forms 268i–s render the conventional cross-legged posture which in an Egyptian context we may call the scribe's posture—despite the at times almost incomprehensible positioning of the soles of the feet. I cannot discuss the individual forms in more detail in this book, but must content myself with referring the reader to the incomplete collection of forms in fig. 268, in order to give an idea of how hard it is to determine the position and direction of the limbs of the model which the artist had in mind[233] in Egyptian or any pre-Greek, image-based drawings. (It seems that the art of Angkor Wat in Cambodia, to which I shall return later, did not solve the problem of the scribe's pose entirely (pl. 97).)

4.4.12 Goats by a tree

Fig. 269–71 are a collection of three Old Kingdom representations of goats feeding off the upper branches of a tree. In some pictures there are other trees in course of being felled next to the ones with the goats feeding, and there is a Middle Kingdom case where goats are gathering round a tree which is being felled. It has been thought

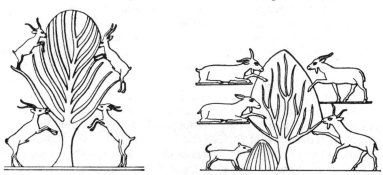

FIGS. 269 and 270. Two representations of goats eating off trees. OK

(Klebs 1915a) that this provided the starting-point for a solution to the difficulty, and the branches would be on the ground within reach of the goats: the trees should therefore be imagined as felled and lying away from the viewer, and the

[231] [*Voller Schneidersitz.*]
[232] Early American drawings contain certain instructive parallels, cf. for example Seler 1915a.
[233] On the cross-legged pose cf. *Giza* 3.105–11 [and *Giza* 11.88–9].

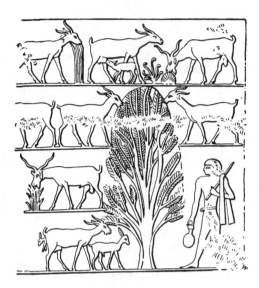

FIG. 271. Representation of
goats eating off trees. OK

animals, which do indeed have their own base lines in fig. 270–1, would be distri-
buted between foreground and background. But then might one not expect at least
some indication that the tree was falling or had fallen, for example by its being placed
obliquely and divided from its stump, or by the indication of a notch? In addition, the
register containing fig. 270 only shows shepherds threatening their goats with sticks
and no tree-fellers, who only occur in the bottom register of the wall.[234] And no
woodcutters are to be seen in the context of fig. 271 (= *Atlas* 1.108) at all, only
shepherds and their animals; yet the goats are still eating from the top of the trees.
In fact the pictures should be analyzed differently, and each in its own way. Fig.270
can be explained by analogy with a contemporary representation of fig-picking
(fig. 272). One man is sitting and one climbing among the branches of a tree, gathering
the fruit in baskets with handles. Below on the left a scribe is piling his harvest on a
mat or board. But above him a man is squatting away from the tree on his own base
line plucking figs from the upper part of the tree and placing them in two baskets in
front of him; beside this group is a complementary one. As these are healthy trees
there can be no question of an interpretation on the assumption that they are felled.
So it is clear that the artists of fig. 270 and 272 never had it remotely in mind to
render spatial depth by placing the figures higher. This position in the picture is due
to the wish to exploit the motif of plucking or eating as much as possible, and at the
same time to achieve a pleasing composition. In fig. 271 the situation is different. The
artist, one of the finest of his time, was taken by the idea of making the tree twice
the height of the shepherd standing next to it, so that it projects into the lower half
of the divided upper register. Now as the top interrupts a row of goats he could not
resist the suggestion offered by the animals' voraciousness of making the right-hand
animal, whose mouth is within the outline of the tree, eat the foliage. To complement
it he then turned round the first of the row of goats facing left, so that its mouth is

[234] [In fact the register below (J.R.B.).] Woodcutter and goat are also together in *Meir* 4 pl. 14.

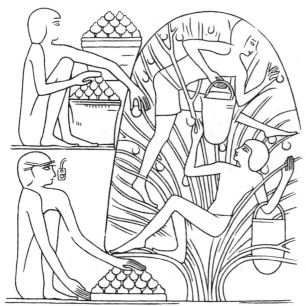

FIG. 272. Picking figs. OK

also among the leaves. The picture may never have been executed on a wall surface in its original form, but was more probably modified beforehand in the artist's imagination. In the original version the tree will simply have interrupted the register (cf. *Atlas* 1.112 [NK]) without the goats paying any attention to it. Here again, as so often in these studies, it gives me pleasure to be able to refer to a striking example from the early Christian period when the rendering of nature according to visual images was again losing its force: a relief on a sarcophagus in the Kaiser-Friedrich Museum in Berlin (Wulff 1913–14.1.103) is, element for element, even down to the base lines of the upper goats, almost a transposition of fig. 270 into another style. There can be no question of one being derived from the other. In the third edition of this book I still considered fig. 269 a transformed derivative of fig. 271 by way of an intermediate stage like fig. 270: after the loss of the base line the feet of the top left-hand goat would, in accordance with the principle outlined in my observations on fig. 201, again have sought a support. Then Schweinfurth's charming description, to which I have already referred,[235] of goats climbing trees in the Sudan might have helped me to a better interpretation of fig. 269. But it was a photograph of the Wadi Sus in southern Morocco (fig. 273) which finally did this; in it there are trees on which goats, which are standing both on the ground and in the branches, are feeding. The only difference is that a branch must be added beneath the top right-hand goat in the Egyptian picture.

4.4.13 The script

It is necessary to bear constantly in mind that countless survivals from earlier stages are present in Egyptian art of all periods next to the forms which must count as more advanced in terms of their adaptation to visual images.

Every art is held in the supporting and restricting chains of tradition, but a strength and weakness that is essentially Egyptian is present in a high degree in Egyptian art:

[235] [Schäfer 1930.379 n. 186b (J.R.B.).]

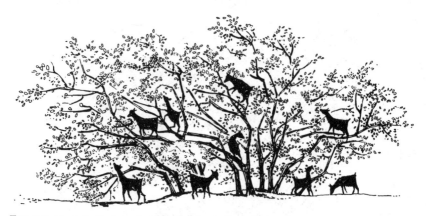

FIG. 273. Goats in the branches of a tree in southern Morocco.

nothing could be forgotten.[236] Whenever a forward step is made one may be sure that the new feature is almost never, or not for centuries, shown in its pure state, but the old one is still retained in the form or it is placed side by side with the new one.

The history of the Egyptian script is a typical example of this. As far as we know, and new surprises are scarcely possible in this area, the Egyptians were the first and probably the only people to evolve among themselves the idea that all human speech consists of a restricted series of sounds and to set up twenty-four phonetic signs. They are already used in the earliest inscriptions. Yet until the latest periods the Egyptians retained large elements of pictographic and logographic writing mixed in with the phonetic signs. And it is wrong to assume that hieroglyphs are as a result inherently more difficult to read than a pure alphabet. On the contrary, the additional signs are frequently helpful to the instructed reader.[237]

Representational art and script are superficially much more closely related to each other in Egypt than they are with us. There is scarcely a picture, secular or religious, which is not richly interlarded with accompanying texts, which tell us the nature and names of objects, and the thoughts and speeches of the persons depicted, or name the action, and all this occurs even when the picture would have been enough in itself. In origin, and very frequently later, this use of writing is one of the non-artistic means of exhibiting and elucidating what is represented in all its aspects—a sign of the Egyptians' passionate desire for objective clarity and meaning. But in mature Egyptian art the role of writing does not stop there. In the same way the bands of writing in Gothic pictures are really meant only as vehicles for names and other words, but soon develop into an essential element in the formal structure of the whole. Similarly it is possible to overhear—although we shall sometimes be disillusioned—what the Egyptian accompanying texts reveal beyond what the gestures show of the mental attitude of the people, and even of the spiritual basis of their art. But one only has to look at temple and tomb walls and even statues to realize how important the lines and groups of lines have become for the work's artistic status. The inscriptions on statues for the most part subordinate themselves superbly to the chief forms, sometimes even emphasizing them. Only on some Late Period works, whose purpose is magical, do hundreds

[236] Erman 1909.5 [English ed. p. 3, Erman 1934.11 (modified) (J.R.B.)].
[237] [On the Egyptian script see Schott 1950, 1959.]

of lines of text envelop all the bodily forms in a deadening cloak. Nor did the Egyptians come to cut figures in reliefs through with broad bands of inscriptions, as the Assyrians did.[238]

The Egyptian script also grows more firmly in together with pictures than other scripts, as the direction in which the signs face is adapted to them. The *cursive* script, which is free from extraneous considerations, shows that in the direction of writing that early became standard the writing starts on the right and the signs face in this direction. Originally, as in China and earlier Babylonia, writing was in vertical columns; horizontal lines become the norm only at the beginning of the Middle Kingdom. Frequently it may appear that there are genuine horizontal lines in the accompanying texts to pictures of daily life in early tombs. But a closer inspection shows that they are always very short columns, sometimes consisting only of one or two signs. The pictorial nature of the signs would not in itself have determined the start on the right-hand side any more than the choice of columns or horizontal lines: the rule could perfectly well have been established differently. It is not known why the right to left direction was chosen.[239] As the cursive script increasingly practised a marvellous alternation of thick and thin strokes within each sign (fig. 27) it became impossible to reverse the direction. The monumental Egyptian *hieroglyphic* script with its clear images always maintained complete freedom in this respect. In every context it adapts itself perfectly to the composition of a work, for example to an artist's need for symmetry, whether by the use of horizontal or vertical lines, or by beginning from the right or from the left; and it is integrated in pictures by making the signs face in the direction in which the person they belong to is speaking, looking or acting.[240] It is worth noting that texts to be read retrograde are found in certain contexts in which the direction of the lines and the order in which they are to be read contradict one another [cf. Brunner 1964].

Earlier in this chapter I described how order is introduced into representations from the Old Kingdom on by extending the use of registers with continuous base lines. The practice adopted ever more self-consciously from the third dynasty on, of dividing lines of inscription with straight lines and enclosing them between them, is also related to this love of lucid ordering in pictures.[241] From the second dynasty the positioning of the signs within the lines is deeply harmonious. The signs have acquired well-defined relative sizes, and artists try to arrange neighbouring ones to make more or less square groups, and, as with ornamental Arabic writing, the artists are not afraid of transposing signs.[242] In great art too there is a tendency to order two-dimensional groups in areas surrounded by rectangles, or which at least can be imagined thus. The beauty of the writing is of course not always the same on every monument or at all periods. But the same scale of values should not be applied to all

[238] Propyl. 537 [cf. Fr pl. 89, H-S pl. 194 (J.R.B.)], 542.

[239] Von Recklinghausen (1928.22–6) attempted to give an explanation which I do not find illuminating. He believed that the normal procedure in Egyptian art of making figures face right (cf. p. 300) originated in the representation of kings and heroes as warriors and hunters. But how could a figure that is in fact quite rare be decisive for the whole method of rendering nature?

[240] Rapid signs in the cursive script cannot be turned round so easily. Where it is desired for some reason to begin the text on the left the first line is on the left, the second to the right of it, etc., but all the signs look right as usual. This practice was sometimes adopted in the hieroglyphic script too.

[241] The earliest indications I have found of this tendency are in Quibell–Green 1902 pl.23.

[242] A detailed treatment in Lacau 1903b.

categories of inscriptions, and one should not expect the quality one is accustomed to in decorative inscriptions to be present in more literary ones. The signs in the latter are sometimes less monumentally beautiful and show the influence of cursive script. Both types of writing, cursive and monumental, have the same origin, but by developing forms appropriate to their different purposes they gradually grew quite far apart even in their arrangement of signs.

As with other scripts outside Egypt, the form of the individual signs, and also the way they are arranged within the lines, follows the pattern of development of the formal sense in major art. And in fact I used the script (fig. 6—7) to try to illustrate the genesis of genuinely 'Egyptian' art.

5. ON PERSPECTIVE

5.1 Perspective-like exceptions to the fundamental rule of depiction based on frontal images

5.1.1 Introduction

As we were brought up to the 'Greek' method of representation, and in view of the human tendency to find what one expects to find, we should be especially cautious in our approach to the forms in Egyptian art in which the rendering of nature appears close to our own. This is true particularly in cases where, in contradiction to the basic rule, the artists render oblique views and foreshortening.

One could wish there had been such caution in the choice of terms to describe these phenomena in studies of Egyptian art. Instead it has become habitual to use the normal terminology of perspective.[1] But the language used in art-historical studies of this kind must be as pure as possible. Terms that express similarity but deny identity should be used.

In advocating caution two studies, which try to provide a detailed demonstration that perspective is an important element in Egyptian art, should be mentioned.

Klebs,[2] who knew nothing at the time of image-based representation, was at pains to show that the Egyptians had a sure feeling for perspective and an empirical knowledge of its manifestations, but did not draw any conclusions from this or establish any laws. And in order to show this she was often forced to read new meanings into drawings which contain no indication that the artists were rendering anything other than a frontal image.

Senk attempted to find an approach quite different to Klebs's. He recognizes that depiction based on frontal images is a basic characteristic of Egyptian art but goes on to assert that perspective and the use of frontal images were equally important elements in habitual Egyptian representations: that their relationship was essential and reciprocal. In his forcible bringing together of the two opposed principles he even states that a form whose content is partly perspective is the ultimate fulfilment of the principle of depiction based on frontal images.

I shall illustrate the point at issue with a few examples. These can of course only be cases where visible elements justify one in thinking of foreshortenings and oblique views. And even where this applies it is necessary to test whether the perspective interpretation is the right one. With pictures published in line I shall also use every opportunity to test whether the perspective-like features are not mistakes on the part of the modern draughtsman.

[1] This is especially true of Klebs 1915a, and to a large extent of Matz 1922 [1924] and 1923–4 [1925]. There are of course good observations in all these studies. The wildest idea must be the one of interpreting predynastic pictures of ships (fig. 141) as perspective pictures of round fortifications (Loret 1902.92, Naville 1911.196, 1916–18, 1920–2); Petrie (1914b) argued in favour of their being ships, but unfortunately introduced a predynastic pot with forged painting into the discussion.

[2] [1915a (J.R.B.).]

5.1.2 Bird flight and related motifs

Let us paraphrase what the late predynastic artist of pl. 4 expresses. He imagines:
'I am drawing a bird (fig. 274a) spreading one wing out on one side (fig. 274b) and
the other on the other side (fig. 274c).' In this way the wings, both in full view, are
simply attached to the outline of the bird's side view. But in the fourth dynasty there
is introduced a modification of this basic form which is part of the great revolution
in Egyptian art. From then until the Late Period the points at which the two wings
are attached are treated differently. One wing grows out of the side of the body itself
without a dividing line, while the other emerges from the clearly marked outline
(fig. 275b). It is left to the artist which form should appear on the upper part of the
body and which on the lower; but this choice never expresses whether the bird is
imagined flying high and seen obliquely from below, as could be assumed in the case
of pl. 99,[3] or spreading its wings low down and seen from above (pl. 98). Even though
the Egyptian drawing sometimes seems to admit of such an interpretation, as in the
examples given, there are plenty of instances where the spatial positioning of the bird
is in contradiction to a mental image of this sort. In addition, according to Erman's
rule (pp. 293, 297), the fig. 275a type will be commoner in Egypt than that of
fig. 275b. We must not let ourselves be misled by our method of rendering nature
into discerning its approach—for which two Far Eastern cases may serve as instances
here (pl. 100—01)—erroneously in an Egyptian context.

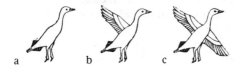

FIG. 274. Composition of a picture of a bird
with the wings simply attached.

FIG. 275. Bird with one wing beginning
within the outline of the body.

Norman Davies, probably the most knowledgeable of my colleagues and a man
who thought along the same lines as myself, rightly remarked about the second
edition of this book that I was probably too ready to admit the existence of oblique
views here.[4] And in fact there is no basis for admitting them; the solution will be
seen to be quite simple if one considers the intellectualizing tendencies in Egyptian
art described on p. 33. In this light such pictures stand next to mental processes
which play an important part in Egyptian art in other ways too, and the difference

[3] In Egyptian representations flying ducks and geese are almost always shown in the attitude
which they adopt when rising up from the reeds, with their bodies and necks raised at an
angle. I only know of one case (*Atlas* 1.298) where the sharply horizontal position, which
is so characteristic of the level flight of these birds, is shown.

[4] e.g. on fig. 275: Davies 1921.224. Fig. 60 of the 1st ed. of this book (after LD 3.118)
= fig. 104 of the 2nd (after the drawing for the LD plate) has been removed because of
Davies's objections (ibid). Nina Davies—Gardiner (1926 pl. 24) shows what N. de G. Davies
thought he could see. Pl. 40, which I still took to be a log-paved road at the time of the
2nd ed. (Schäfer 1922.206), was explained differently in the 3rd ed. as a result of Ranke's
warning in conversation and Davies's detailed exposition (1926). For the correct interpret-
ation, which they both gave, see Ch. 4 n. 216. See Ch. 4 n. 82 for the filling holes with
apparently distorted angles in fig. 115. See next note for the fringe on the shade in fig. 277a.

between the earlier and the later rendering is less one of seeing than one of thinking; the drawing no longer says that the wings are on the outside, but that they grow out of the surfaces of the body, at corresponding points on the visible and invisible sides.

The treatment of wings is in no way unique; many parallels can be found with other subjects. The two twisted horns projecting from the temples in the picture of the crown in fig. 79 are equivalent to the pair of wings. Almost all of the nearer one is visible, while half the further one is concealed. The foreshortening is only apparent; both horns, like the wings in fig. 275, are the same length from root to tip.

The lowest small shoot which projects from the surface of the tree in fig. 276 (= pl. 41) is comparable with fig. 275.

It is worth studying how three- or four-handled jars (which cannot be distinguished in Egyptian pictures) are depicted. Fig. 43b, where all three handles are shown, as is mostly the case, in a side view, more or less corresponds to the tree and its branches, while the middle handle in both rows in fig. 43c is shown in a front view, with no opening, a rendering that could have no equivalent in a picture of a branch.

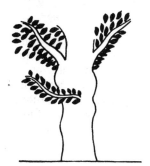

FIG. 276. Small shoot on a tree trunk. NK

FIG. 277a–b. Sunshade of the earlier period with a flat top and fringe.

a

b

5.1.3 Sunshades

Sunshades like that in fig. 277a are found most commonly in the Old Kingdom. The carrying-pole almost always touches the point at which the diagonal struts of the rectangular top cross.[5] The artist's idea is clear. The picture might lead one into

[5] A north European drawing of a waggon (Schuchhardt 1926.255 fig. 148, ⁵ 315 fig. 200), in which an obelisk-like cult image stands at the point where the diagonals meet, corresponds to fig. 277a. [On representations of sunshades see Fischer 1958.]

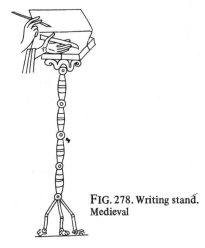

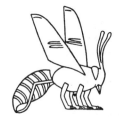

FIG. 279. Bee. Hieroglyph. OK

FIG. 278. Writing stand.
Medieval

FIG. 280. Arm-rings. NK

believing it contained an oblique view all the more easily, since the fringe that is in fact rectangular has distorted angles as in perspective. Only these do not stem from perspective, but because the sides had to be equal in length. In other drawings of the object (fig. 277b) the pole ends at the bottom edge of the top, which only indicates that the artists did not think hard enough. The same is apparently true of their medieval counterparts who really do show the tops of their writing-stands in a form containing perspective elements (fig. 278).

5.1.4 Bees

It is clear that the well-considered alternation of both the wings and the legs of the bee in fig. 279 cannot be based on an observation of the insect itself, but that it must embody an observation (admittedly indirect) of nature in general. The arrangement is probably taken over from representations of mammals, where artists very early became accustomed to attaching the limbs irregularly to the body, finishing alternately against its surface or on the outline (pl. 4). A careful look at the picture of the bee will also show that it has a small pointed bird's beak for stinging or biting. This mistake does not lessen the picture's value for us. On the contrary, the fact that the artist went astray in his use of models allows one to recognize the role which thought rather than observation plays in the Egyptian artist's approach. A picture of a swimming frog with human arms in an Old Kingdom tomb is an interesting pendant to this example (*Atlas* 1.401 R).

5.1.5 Arm-rings, etc.

Pieces of rope, rings, or painted bands surrounding round objects are almost always rendered by straight lines in two-dimensional art. But curved lines are also found instead of straight ones, extremely rarely in the earlier periods but more frequently in the New Kingdom. A drawing of this type, for example of an arm-ring (fig. 280), may sometimes look scarcely different from one by a modern artist,[6]

[6] OK: Borchardt 1907.39 fig. 19. NK: apart from fig. 280, Davies 1923 pl. 2, 14, 21, 23.

though the curve is mostly shallower. But the curve is only in the apparent direction of the lines of the ring, it does not indicate three-dimensionality in the body on which the ring is placed.[7] Other decorations worn on the body, like belts, are instances of the same phenomenon, as is the decoration running round pots and other vessels.

5.1.6 Fish-traps, mortars, etc.

Fig. 281 takes us a stage further. It is an Old Kingdom picture showing a round, bottle-shaped fish-trap, whose longitudinal threads were only painted and have now disappeared. The incised and still visible lines running in the other direction are slightly curved, with the concave side facing the broad opening through which the fish swim. The real wickerwork would not end with a cradle-like, bent band but with a straight one, but the picture ends with one drawn back like the belt. One cannot help suspecting that the slight apparent depression is meant to indicate not only the cavity which in fact runs right to the other end, but also the circular opening. The drawings of the mortar in fig. 282, and of the feeding tubs in *Atlas* 3.37, correspond exactly to this, since in these cases too the curvature could not be as slight as the picture shows it.

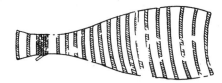

FIG. 281. Fish-trap. OK

FIG. 282. Mortar. OK

FIG. 283. Foot of a scaling ladder on wheels. [This drawing is inaccurate, cf. Addenda (J.R.B.).]

5.1.7 Scaling ladders on wheels

Even more clearly than the arm-ring and related images, fig. 283 goes back to an observation of nature. The detail, enlarged from fig. 110, shows the foot of a scaling ladder[8] in an oblique view, as is proved by the change in size between the nearest and furthest parts of the axle. But the picture is not indicative of understanding or even of precise observation, otherwise the line of one of the vertical shafts would continue through the disk of the wheel to the axle; this would most likely be the one on the right, as the wheels are probably to be imagined on the inside of the

[7] Cf. p. 72 [and Schäfer 1938.30 with fig. 7].
[8] The picture of a fortress under attack (Quibell–Hayter 1927 frontispiece) is itself a fine example of one line in a drawing serving a base line and outline (cf. pp. 114–15 and 131–2).

shafts. The wheels themselves are of course perfect circles as are all rings and disks. As often happens with pairs of elements, the artist was still under the influence of the first when he was drawing the second (cf. p. 297).

5.1.8 Back view of a servant girl

The central figure of fig. 284a, who is seen from the back, was generally considered to be one of the chief 'perspective' achievements of Egyptian art, until Balcz discovered that for a century all the artists who reproduced it had 'corrected' it according to the standard of their own time (fig. 284b). In the original the feet overlap wrongly from a modern point of view. In addition, the line in fig. 284b, which runs into the nape of the neck to give an expressive shoulder profile, is in the original the rounded neckline of the dress lying on the unforeshortened shoulders. The modern artists' drawings are misleading in other details. It goes without saying that the small toes are not shown and both hands are image-based frontal representations. Thus this justly famous figure has become an instructive example of the real positioning of such figures in Egyptian art and not a shining example of Egyptian 'perspective.[9]

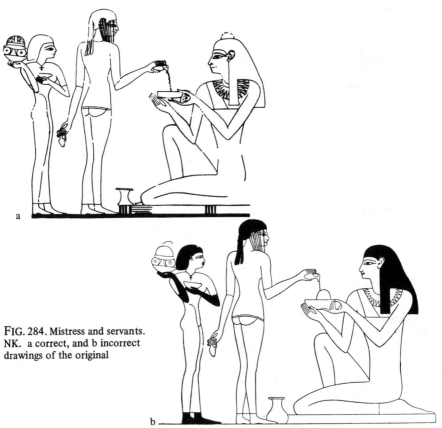

FIG. 284. Mistress and servants. NK. a correct, and b incorrect drawings of the original

[9] [On this picture see also Schäfer 1942.163 with fig. 3.] A similar picture is reproduced by Prisse (1879 *Atlas* 2 pl. 7a) in a drawing by another hand, which has shortcomings similar to those of fig. 284a. Davies found the remains of the picture in Tomb 95 at Thebes and published them (1928.63). [This note, 292c of the 3rd ed., was misplaced in the 4th ed. Its wording has been slightly modified (J.R.B.).]

5.1.9 Shield

In fig. 285 a Middle Kingdom monarch is being carried in a litter while a body-guard holds a huge curved shield to protect him against the sun and the wind. The picture is an unfortunately characteristic example of the publications we often still have to use. It has been drawn five times, but no two of the drawings are in full agreement, and, as with fig. 284, none of them shows the true state of affairs. All the drawings except the Lepsius one show the detail at issue here, a 'perspective-like' view into the curved shield (fig. 285a), and the remaining picture (fig. 285b) shows something rather curious in its place. But this one dissentient voice is sufficient to shatter one's confidence in the others. And, as I found in 1925, nothing more can be deduced from the original, as an irresponsible draughtsman has traced over a lot of badly preserved areas in the tomb, including the shield, with heavy pencilled lines. It should be noted that the drawings of the men carrying the litter also contradict one another, so that we should not make any deductions from the fact that a man who is walking sedately has his heel raised.[10] The large flat fighting shield which is painted at the top is of course always shown in a full view, while the small eighteenth dynasty curved one, rounded at the top, is shown as in fig. 295 or in full view.[11]

5.1.10 Conclusion

These examples could be multiplied. But there is little point here in searching for oblique views or foreshortening in an attempt to invalidate the rule of depiction based on frontal images. It would not lead to the desired goal, even if the number of cases was increased by a few hundred. And there is always the danger that these questions may become much too prominent. Goethe's warning that 'there is much that is certain in scientific inquiry, provided one does not allow oneself to be misled by exceptions, and provided one is careful to respect the problems involved' should not go unheeded.

I use the word 'exception', as always, when there are structures that do not fit a widespread basic rule. They may none the less be collected, but not as examples of perspective, organic composition, counterpoise, etc., only as instances of the artists' tendency, discussed on pp. 152–3, to look for new forms.

If anyone asks how exceptions come to occur in such a clearly image-based art as Egyptian art, it is enough just to remind him that items in our environment, or even details in those items, which we have previously passed over constantly, strike us and stay in our minds for a short or long time, without our always being able to say why, or why it should be these ones in particular. Frontal images are not based

[10] Cf. p. 294.

[11] [The weight of the evidence is against Schäfer here. The Rosellini version (almost identical in Champollion) is more detailed, and the form of the palanquin is more unconventional, without being fantastic, and so perhaps more authentic–Lepsius's is merely a standard Egyptian formula. The Rosellini axe is also nearer to a MK type. The illustration in Wilkinson–Birch (1878.1.421 fig. 199) is probably nearest the truth, and explains the curious form of the shield, which was Schäfer's starting-point, by adding a vertical strut (it may be that the jutting hand holding the shield in Lepsius is a reminiscence of the strut). The Wilkinson–Birch picture is probably from the Wilkinson MS. (2.26 A [15 lower]), with details from Rosellini. No independent source supports Lepsius, while Wilkinson–Birch and *Beni Hasan* 1 pl. 29 support Rosellini. There is no modern picture of the scene. (Bibliography PM 4.148 (20); cf. Addenda for newly-discovered evidence (J.R.B.).]

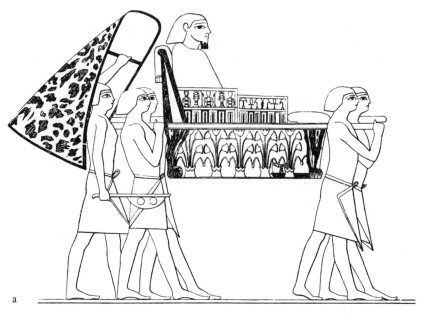

a

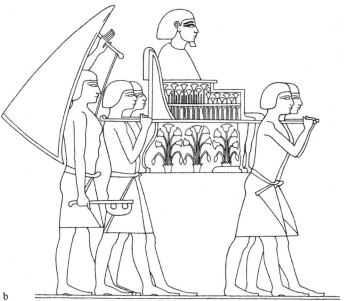

b

FIG. 285. Nomarch in palanquin and sunshade-bearer. MK. a after Rosellini, b after Lepsius

on a rigid law (p. 90) but on a more flexible rule, and Egyptian artists were not even aware that it was a rule (p. 92).

In ancient Egyptian art exceptions of this sort mostly occur only in small details which we often scarcely notice. And they certainly do not—as Jacob Grimm said of linguistic exceptions—'herald new rules which will establish themselves over a short or a long period of time'.

And it should constantly be borne in mind that exceptions in Egypt are completely dominated by regular cases, even if one agrees with Senk that the numerical proportion is not in itself decisive. What is decisive for Senk is the observation, for example, that the representation of a girl musician as in fig. 217 became a more or less fixed form. This, he says, is a decisive indication of the strength and necessity of perspective within Egyptian art. But would not the assumption of a local or temporary fashion (cf. p. 268) be sufficient to explain such phenomena? At all events, words like Senk's 'strength and necessity' are pitched far too high for the evident triviality of the Egyptian exceptions.

There are exceptions in all pre-Greek art: their number and superficial closeness to a visual image varies according to the strength of the artist's memory for forms.

Similar phenomena are of course found in drawings by children of a certain age. I shall discuss two examples here, as each shows a different mental attitude.

The thirteen-year-old boy who drew fig. 286 was evidently never troubled by the relationship between frontal and oblique views. Without thinking he put together the exact rectangle of the base of his portable candlestick with the foreshortened oblique view of the top of the stick itself and the apparent twisting of the strip handle, and combined these with an astonishingly accurate observation of the rivets anchoring the handle.

a

b FIG. 286. Child's drawing (a) of a portable candlestick (b).

The children drawing bowls referred to on p. 87, on the other hand, let themselves be surprised by a single oblique view which became included among their mental images. But the suppressed rule of frontal views soon recovered sufficient strength to make them take back the foreshortening they had already committed to paper.

The Egyptian examples are genuine observations, but the artists have not yet undergone the intellectual transformation that stems from Greece and leads to the view that the distorted lines in originals show perspective depth.

One extremely important insight, which, once grasped, is valid for all such 'exceptions', is gained from the behaviour of the boy who drew the candlestick, namely that *only the recognizably foreshortened parts of a drawing of a figure are understood as such by the artist, and these never give us cause to interpret the rest as obliquely viewed. We must learn a similar restraint in interpreting the rendering of parts of left-facing pictures of human beings* (p. 301).

Shortly after I had alluded to what might at least be termed the 'weakness' of such phenomena in Egyptian art in the previous edition of this book Krahmer treated the question in detail. He says[12] that perspective

[better: 'foreshortening and oblique views'] was very well observed in Egypt, as occasional figures which are drawn foreshortened prove [fig. 281 ff. here]. But the Egyptians did not become aware of it [foreshortening] as a means of artistic expression, they did not discover it [in the form of perspective]. The fact that these few attempts, which led to nothing and came to be forgotten, are found proves that this form of representation had no particular message for them, that it was scarcely more than a curiosity for them. *These figures drawn in [apparent] perspective are nothing more than experiments [attempt to render striking phenomena], and in them the lines are not elements that create space, the expression of an understanding of the subject as an organism (p. 337), they are merely understood as a rendering of the individual image [better: part of the image, p. 267] which is observed afresh in occasional cases.* The artist [strives to render what is characteristic in the object], and in this case conceives the characteristic element as being the line which differs from all his other [frontal] images; in this way he arrives at the representation of 'foreshortening'. But as these figures were unable to strike a chord in his spatial sensibilities because they lacked the basic characteristic of [frontal] images, the separate attention paid to individual parts, they could only seem to him to be indistinct and unclear, and of interest merely because of their strikingly different quality (as a sort of passing fashion); for all these reasons they were unable to influence his artistic approach.

Krahmer is of course thinking not only of the few drawings like fig. 283, but of all instances where there are traces of oblique views and foreshortening.

It cannot be a matter of indifference what term we use for figures which do contain oblique views but lack the intention, which is indispensable for the concept of perspective, to render physical and spatial depth. In his *Ägyptische Kunst* (1944) Hamann is tolerant of the word perspective to a worrying extent, and its unrestricted use has had dangerous consequences. Evers let himself be misled by the picture of the desert in fig. 287 and the simultaneous introduction of vertical layering (p. 186) into speaking of 'Middle Kingdom perspective',[13] and Wolf followed him in *Individuum und Gemeinschaft in der ägyptischen Kultur* (1935).

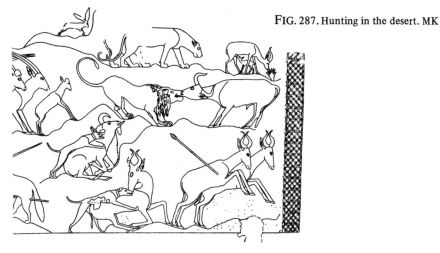

FIG. 287. Hunting in the desert. MK

[12] 1931.64; I have used square brackets to adapt Krahmer's formulations to my own. [Schäfer's italics.]

[13] [1929 (J.R.B.).]

In what follows I avoid the word perspective in the context of 'pre-Greek' art and use instead the more harmless 'foreshortened' where it is appropriate, or, where it is necessary to make the avoidance of 'perspective' felt, I use the terms suggested on p. 93, 'perspective-like' or 'apparently perspective', as indeed I have done occasionally in the intervening sections. The word *perspektivehaltig* [containing perspective elements] proposed by Senk is not suited to pre-Greek contexts, although it is correctly formed and may even be gratefully received in other areas. It should be used only for the initial stages of perspective, and again for its decline (p. 275). The decline did not lead to a total eclipse, but only a meagre and irregular stock remained until the Italian Renaissance, when the word perspective can be used again.

Krahmer's discussion refers only to Egyptian exceptions which are apparently perspective and organic, but it can be applied to much else. It can give us an idea of how the transition from 'pre-perspective' art based on frontal images to true perspective was accomplished in Greece. The next section describes this transition (pp. 270–71).

5.2 On the history of true perspective

Moving from matters of detail to a consideration of the whole, we have surveyed the framework which Egyptian artists created in order to render the physical world in two dimensions. It is essentially the same as the one primitive peoples and children have at their disposal, but it has been extended in important respects, so that in the end it includes all the means accessible to pre-Greek art for its confrontation with and representation of the outside world. However rich the possibilities for a single people may be, and however various the solutions arrived at by their exploitation, this should never obscure the fact that data supplied by the senses of sight and touch are mixed in a distinctive way with data derived from thought and feeling, and above all that oblique views and foreshortenings are only used by an oversight, as one might almost say; so visual impressions are avoided to a very large extent.

The opposing mode is *perspective, (Perspektive/-isch*; French *perspective/if; Italian prospettiva/-ttivo)*, which reproduces visual impressions faithfully, basing itself on the visual image built into the structure of the human eye, and which, far from avoiding foreshortening, seeks it out.

It is still believed that drawing with foreshortening is a stage of development that is reached everywhere by every gifted person or people. If it is not reached the person, it is said, cannot be gifted, or, as with the Egyptian people, must be held back by some constraint.

As already stated on p. xxviii, this attitude is wrong. The occurrence of perspective is a unique historical event. Out of all the peoples in the world the Greeks are the only ones who were bold enough to take the step by themselves and to renounce representing—we shall no longer misunderstand the words—objective reality, to make this 'intellectual sacrifice' and to represent the world of appearances which our eye presents to us, multifariously distorted. Just as no individual arrives at a more than occasional use of foreshortening without an outside stimulus, no people in the world arrived at it without Greek influence. All other peoples who drew or draw in this way took it over from them. The truth is obscured because one forgets how far and how deep the influence of Greek culture has extended since the Hellenistic period, and will continue to extend; and how our children, for example,

unavoidably become familiar with perspective representation through the models around them and through teaching. Even with modern primitive peoples the same process will occur more with each century, until in the end, among them too, only children and uneducated adults will still depict according to frontal images.[14]

It can be misleading to use the word 'development' to describe our children's transition to the use of perspective, at any rate if what is envisaged is something similar to what occurs with plants, each of which, as for example with oak-trees, develops from the seed stage on into a tree, according to a programme in its seed, if it is capable of life at all. The transition from frontal to oblique modes of represent-ation is no longer a self-generated growth of this sort, or development in this sense of of the word; it was of that kind only in the first transformation made by Greek artists; in the further diffusion each individual had and still has to acquire the knowl-edge by transference from outside—he must have external support in order to arrive at the new mode. That is not a development but a 'diffusion'.

E.G. Kolbenheyer[15] has attempted to get closer to these problems by a biological approach; art is the creative artist in life, an element operating biologically in a people's struggle to define its existence. It is of necessity in correspondence with the people's biological condition. Thus the transition to perspective will be based on intensified differentiation, and will be a manifestation of an ordering tendency in the brain—not in an individual's brain, but a development of the brain on a national scale. This would mean that a stage in development had been reached, where, if the people were to be metaphysically at ease, perspective would have to appear as the appropri-ate form of orientation. One can only comment that a biologist's decision that it must be assumed that a 'threshold' has been reached can only be arrived at on the basis of knowledge acquired by historical methods. All a biologist can observe is that per-spective occurs among 'pre-Greeks' where a people is subject to Greek influence when it is at a certain threshold. But to attempt to forecast the form the 'pre-Greek' render-ing of nature would take if a people arrived at this threshold without having absorbed perspective with Greek influence would be to go beyond the boundaries of biological or historical method.

It has always seemed to me to be a very remarkable fact that the change in artistic attitudes to the world of the senses occurred independently in Greece alone, to be precise from the fifth century on, and was held back to some extent by artists who kept to the old ways (Reichhold 1919.29). We saw above in the case of Plato (p. 87) how the new method was still being contested in the first half of the fourth century.

Those were years in which the Athenians were engaged in all areas in intense intellectual discussion and had to make decisions about matters of life and death. And anyone who did not feel the need to clarify problems in lively discussion and opposition was not a true Athenian. Most of this discussion has disappeared if spoken, or been kept from us by the 'fate of books', but Plato's dialogues preserve important evidence from the greatest turning-point in the history of art. I shall add to the passages quoted on p. 87, which certainly only refer to processes in Greek art, a passage where he is dealing specifically with Egyptian art.

I think it is necessary to assume that Plato had been in Egypt himself, and that he had seen and experienced personally the things he speaks of here (*Laws* 656–7 [=Appen-

[14] [Confirmed by Hermann's observation (1961.153).]
[15] [1935.129, 136. For Kolbenheyer see Ch. 1 n. 11 (J.R.B.).]

dix 3]). But his words pose curious problems for us. He praises the Egyptian because no painter or other artist among them had been allowed, whether he was working from his own imagination or reproducing nature, to innovate or to apply his inventiveness to anything not in keeping with traditional customs. And he says that at that time it was still forbidden, in representational art and in any other art governed by the Muses. If one looks more closely, he says, one will see that two- and three-dimensional art of ten thousand years before—he means it literally, not in the normal vague sense—is not more beautiful or uglier than the art of his own time; it shows just the same level of artistic accomplishment.

Anybody with any degree of knowledge of the history of Egyptian art will be disappointed by these statements. Plato believed he saw an art, whose age was legendary to the Greek way of thinking, which had been strictly regulated from the beginning, and which had remained unaltered through the application of strict laws. The tone is just the same one as other Late Period guardians of the cultural heritage believed they could adopt; it struck a deep chord in Plato's personality.

Even if we can no longer accept what he says, it is necessary to ask what aspect of Egyptian art came to serve as the source for a belief in its unchangeability.

And indeed my section on the two 'levels' in a work of art (p. 336) will uncover the source. I show there that a basic 'framework' underlies the 'level of expression', whose forms are endlessly changing. The 'framework' retained 'frontal images', that is, the lack of foreshortening, *as a fundamental characteristic throughout its history*. The lack of foreshortening will strike with particular force anyone like Plato, who comes from an environment where there is a struggle with its opposite, with perspective, but who has not become aware at once of the true nature of the opposition. In this way the framework strikes him, not the real expressive forms, so that he is led to assume that the main characteristic of Egyptian art is that its level of expression is unchanging.

Our interpretation is strengthened by the recollection that *modern Europe's first encounter with Egyptian art of course led to the same judgement.*

We have seen how Plato praised a foreign people with calm objectivity in a case where he believed himself to be in agreement with them, but he felt he had to express himself quite differently in his attack on what his contemporaries were doing in his own country. There he saw his struggle for truth endangered by thought currents and by events. This conviction intensified, to an astonishing extent, his attack on the deception of the senses in perspective art (p. 87).

This attack, directed against a rising 'new art' which was carried forward by confidence in its own victory, was unsuccessful at the time.

Oblique-foreshortening representation did not become true perspective in a moment. Considering how we regarded the Egyptian 'exceptions' as a rare and faltering glance beyond depiction based on frontal images, it seems reasonable to interpose a space of time in Greek art, after its long 'pre-Greek' period, when forms based on frontal images were indeed placed together with perspective-like ones, but without their perspective content being 'experienced'. This latter could not grow just out of an observation of oblique views and foreshortenings; its existence only became possible when the Greek view of the world, as it steadily increased its scope, perceived and took possession of a vast, coherent, brightly lit area of perspective in place of a dimly seen succession of individual foreshortened segments of space.

Thus the 'perspective-like' exception in the end really became 'the rule of the future', that is true perspective, among the *Greeks*, whereas it did not among the Egyptians or anywhere else. The extent of the area in between cannot immediately be grasped from the monuments: it will always be necessary to hold to the evidence that can be deduced from a knowledge of the spirit of the age, to that final certainty which cannot produce a water-tight theoretical proof, but which does not need one.

Foreshortening and oblique views start becoming more frequent in Greek art in the last decades of the sixth century B.C. But Agatharchos of Samos, around 460, and above all Apollodorus of Athens, about a generation later, have been considered by posterity to be the inventors of perspective. They must therefore have contributed a great deal to this break-through, which it is not my task to describe here.

The fact that perspective was called 'shadow painting' (p. 73) and Apollodorus the 'shadow painter' shows that when the word came in people had become conscious of the shadow as a new and effective means of expression side by side with foreshortening, so that shadows must have been particularly striking to viewers.

The adherents of the new art must have felt themselves by the end of the fifth century to be the victors, even if many battles and still more concentrated work on the new style lay ahead of them. In the centuries around the birth of Christ some phenomena were completely mastered, and it became known how to use them, no doubt in full awareness of 'perspective' effects.

Of course, we can no more offer a true explanation of why perspective came to be than we can of any other historical occurrence. We can only accept it with astonishment and integrate it as one element among all the other enormous transformations which the fifth century brought to humanity as heir to its blossoming predecessor—as part of the 'Greek miracle', to use Renan's fine phrase. This modification of the artistic method of seeing is part of the shift in what is called the *Weltanschauung* in German. In representational art the change does not signify, as Plato would have it, a descent into deceptive appearances, but a move from seeing nature in isolated parts [*einzelsehen*] to seeing it as a whole.

It should be noted that these events occur in art during the period when in philosophy too the best intellects among the Greeks were occupied with the problem of the reality or non-reality of phenomena—Empedocles' ideas about the physical process of seeing are still preserved. In this period too the scientific thought, to which we are accustomed and which the Greeks created, even if it was re-created and put to new purposes, began to emerge from mythological[16] thought, the two nodes gradually becoming more and more sharply opposed. The simultaneous occurrence of the two changes seems to me due not to chance but to an inner connection.

Greek artists did not of course go to be taught by the philosophers, making the latter the fathers of perspective. The tone of the period had been established beforehand by the philosophers, and two- and three-dimensional artists had achieved the inner freedom that enabled them to develop a firmly rooted tendency to observe oblique views and foreshortenings seriously, to render them as a general rule, and to deepen them by the application of perspective. Artists and scholars then produced by reflection further work, which contributed to a solution of the task set by physical objects and by space. But the decisive point was still that such ideas could arise in a people that was born to see and appointed to look; Indian philosophy may have

[16] [Schäfer means 'mythical'.]

produced ideas about appearance and reality at an equally early period, without their having the same results in art. And in any case all the art of India known hitherto—except for the earliest Punjab art[17]—is under Greek influence.

But the fact that science was so close was not without its influence on the shaping of the forms in Greek art. In the fourth century Pamphilos of Amphipolis went so far as to declare that painting could not be accomplished without arithmetic and geometry. Although efforts had been made at it he considered that 'the Greeks may have sought after perspective, but they have not yet achieved it'. There is no need to ask here whether the failure was due to mental inhibitions like those of Far Easterners (see below), or whether it only happened because the aids mentioned on p. 274 had not yet been invented.

We shall see from the example of the Far East what can be achieved in a perspective that is not taken to its mathematical conclusion.

I shall show in Chapter 7 that the transformation in two-dimensional art was closely related to a comparable one in three-dimensional art.

In *other periods* and among *other peoples* all occasional and chance observations of foreshortening inevitably bore no fruit. Sometimes one might think that only a slight shift would have been necessary for a break-through into representation according to visual images all along the line, but this move forwards is missing everywhere. This fact is decisive. The reason why the process did not occur anywhere else, must be that it was highly improbable that the necessary fusion of so many lines of force, which were parallel for the Greeks, should take place. It cannot be repeated in future, as there is no longer any people at a certain stage of culture that has not been touched by Greek influence.

Peoples who were less firmly turned in on themselves than the Egyptians were quicker than they were to adopt the perspective-like methods of representation spread abroad by Greek art. Among these peoples there are stretches on the long routes of Greek influence where perspective is adopted, but as it were 'falls asleep'. The new form of representation by no means always strikes ground on which it can flourish. Often it is only taken up because it is the language of something that comes to the fore by means that have nothing to do with art. Thus in the Near East it was under Alexander the Great that the overpowering impression of military and diplomatic power collected the Greek influence that had previously trickled in in small streams and turned it into an irresistible flood. In Egypt Greek art finally triumphed over Egyptian when Christianity in Greek dress began to dominate. Similarly, in China it was the connection with Buddhism, which was penetrating the country, that brought complete victory to the Greek rendering of nature, while only a small proportion of foreshortening had been adopted from the later Han period on (around the birth of Christ). The diffusion of approximate perspective and the resistance it met with must be taken into consideration too. If its processes are to be understood art must not be isolated and separated from the rest of the life of a people.

In cases where perspective has awoken after the periods of 'sleep' mentioned above, and has become powerfully effective, particular conditions in the intellectual life of the peoples involved have always been prerequisites.

In the *Far East* the seed carried by way of India and Turkestan fell on such fruitful ground that one is tempted to use again the Lynkean[18] comment previously applied

[17] [What is meant is the art of the Indus valley civilization (J.R.B.).]

[18] [So called after a character in Goethe's *Faust* who is noted for his detachment and objectivity (J.R.B.).]

to the Greeks. The Chinese and Japanese achieved a high degree of artistic perfection and effectiveness in perspective, although the idea of taking it to its mathematical conclusion remained foreign to them.

For an understanding of this fact it must be viewed against the background of the Far Eastern mind, which, as has frequently been remarked, has avoided reducing life to conceptual formulae, dissecting it, and systematically reconstructing it, out of the fear that this would remove much of the 'rounded quality' and 'fullness' from life. It should not be said that Far Easterners got stuck in the attempt.

In Renaissance Italy the unified viewing of nature begun by the Greeks was brought to its scientific conclusion in the creation of perspective centred on a vanishing point; in this process much of the knowledge and technique that had already been acquired in Antiquity was rediscovered. It would be idle to speculate whether perspective would have been invented then without the stimulus provided by the Greeks, for facts like the one that foreshortening was used in Antiquity had been transmitted both in writing and in the works themselves, and so were not entirely lost; these cannot be removed from history for experimental purposes.

Greek and Roman, medieval, and Far Eastern art show that the attraction of approaching visual images may have had its effect in the general inclination towards them, but not the drive to reach a logical conclusion. There must have been something in the Renaissance itself which drove artists beyond what had been achieved in the distant Far East. It seems clear that we may speak, as with the fifth century in Greece, of a transformation that is closely linked with the beginnings of a new natural science: Leon Battista Alberti was able to say around 1450, like Pamphilos whom I quoted above, that without a knowledge of geometry no one could become a good painter, however great his other gifts were. Such words may seem startling today, but they can be understood when one considers the pride men felt at that time in the fact that art was raised to the level of a science by its exemplification of mathematical laws (cf. p. 89). And their way of thinking has had tremendous consequences. It has been the basis of European painting in the last four centuries, and up till recently mistakes in perspective could still disturb, if not destroy, a viewer's enjoyment of a work.

Around A.D. 1500 *European painting, under Italian leadership*, presses forward to a complete solution and, with a genuine feeling of triumph, adheres closely to visual images as physical eyes received them or in the opinion of the time could receive them. In this period 'image-based' elements like the ones enumerated on p. 92 disappear from European art.

The solution offered in the Renaissance is of course not read immediately and solely off nature; it is thought out geometrically, initially with the help of the equipment which was probably based on Leonardo's ideas, and which Dürer immortalized in magnificent woodcuts. Only with the help of tools of this sort could men completely overcome his inhibitions.

And even a picture constructed with the use of these aids demands that the viewer give up a great deal. It is still only true if it is looked at with one eye only from the point from which it was conceived. In addition, it is well known that a perspective picture is never, even under these conditions, a mathematically true reproduction of the visual impression which the eye receives, since the retina is the inner face of a sphere, while our pictures are painted on the assumption that they were received on a flat plane. For this reason precisely centred perspective constructions are often

unacceptable, especially near their edges, so that every artist must avoid them or soften their effects. With all this in mind one is inclined to ask if a Greek would have taken the line of assuming that the picture was seen with one eye, as the aids just mentioned do.

In *more recent times* it is possible to observe connections between science and the rendering of nature. The thorough dissection and reworking by impressionist painters of certain of the phenomena of colour are connected with the more intensive optical study in this area which began a few decades earlier. And should not the dissolution of mathematical perspective, which was felt to be oppressive, in expressionism as it came to the fore at the turn of the twentieth century, be related to a wave of reaction from a 'scientific' view of the world which overtook many circles at the same time? Nor should we be deceived in this estimate by the simultaneous upsurge of applied, technically useful science.

I have already indicated that depiction according to visual images did not spring forth complete after the fundamental decision in Greece, but that it needed a long time to master appearances, even while it was still approximate and based purely on experience, and a still longer time, more than one and a half millennia, before it reached the stage of drawing in perspective any view that might be desired, without a mistake. Memory for forms, gradually given an excellent training within the hitherto current method of depiction based on frontal images, retreated and adapted itself to the impressions imparted by the eye step by step and with difficulty, so that one repeatedly sees elements of the natural method of depiction based on frontal images (cf. 90, 335) openly or covertly breaking into the realm of learned representation according to visual images.

A person acquires perspective quickly, slowly, or not at all, dependent on the degree of development in him of the faculties which make possible the formation of images capable of becoming pictures. But only a man who knows certain mathematical axioms and applies them in the construction of his pictures can draw precisely in perspective. If he is not strictly tutored or if he does not keep himself firmly in control it will always be possible to catch him going astray. Our own inner nature always lies between us and the rendering of visual impressions, and it is an inhibiting factor that can be overcome only with difficulty.

In the course of history there are periods when the impulses that are present, but repressed, in every man make themselves felt more strongly, while perspective 'sleeps', as I put it above. In contrast with *Hellenistic* art, the art of *late Antiquity* was indifferent to perspective. Artists concentrated on creating an illusion of pictorial depth and a material quality in objects, by means of the play of lines and shadows. Shadows disappeared, and lines were mostly kept on the surface instead of leading away in depth. Perspective remained equally decomposed for a long period and through many changes in style. At this time elements containing perspective were mixed with pre-perspective ones in a remarkable way, and the latter rose to the surface again wherever the true Greek spirit was in retreat. 'Pre-Greek' forms were produced in an area steeped in Greek culture not, in most cases, because local works of art from long-past epochs handed on their forms, but because pre-perspective characteristics came alive again in the artists. *Byzantine* painting[19] almost entirely lost the ancient feeling for the unity of a visual image, but there was no

[19] The following section makes use of Woermann 1915.3 (1916) 3–4.

question of abandoning completely foreshortenings that contained perspective habits: single human forms show traces, at least, of rounded modelling, and depth ordering occurs in groups, though in new ways.

Attempts in our time to weaken perspective considerably only go as far as a complete denial of foreshortening in the writings of one or two theorists who will not let themselves be taken in by a two-dimensional image. This latter attitude has nothing to do with the fundamental tendency to depict according to frontal images, which is the subject of our present study.

In this context Krahmer has already remarked that to say that two-dimensionality is part of the essential nature of the surface to be decorated, so that 'true' surface art must be two-dimensional, is to make a value judgement that is dependent on the judge's personal taste, which is dependent on the period in which he lives, and such a judgement can only be arrived at by contrast with the dissolution of the surface.

In comparison with precise perspective depiction which fixes the artist firmly once he has chosen his standpoint, image-based depiction does indeed leave the artist with a great deal of freedom. But we have seen (p. 152) that this freedom is significantly reduced by the frontal nature of pre-Greek images, and that the language of art was infinitely enriched when it moved away from depiction based on frontal images and gained life by the use of oblique views.

That is one of the great achievements of the Greeks. In the fifth century there occurred the greatest change in artistic vision in all the history of the world. How much less significant, despite its own enormous importance, is the mathematical perfecting of perspective in the Renaissance. Whether it is viewed as a blessing, or, as a few violent critics would have it, a curse, the Greek artists of that period showed a new path for two- and three-dimensional representation that was to be followed for thousands of years; they also opened the way from pure surface representation to the creation of a feeling of physical reality and to the pictorial articulation of space, and thence to aerial perspective and to the phenomena of light, a proud progress upon which ever more peoples have embarked, each at its own appropriate point, and upon which many more will start. Only in our own time have there been attempts to leave this line of development and to begin new ones (cf. Schäfer 1928).

If the Greek revolution had remained, as can perfectly well be imagined, that of one people, a purely Greek occurrence, our rendering of nature and that of the whole world would be based on the same principles as the Egyptian rendering, though its modes of expression would be different; unless another people had been placed under the influence of precisely the same constellations as the Greeks.

6. THE BASIC FORM IN WHICH THE STANDING HUMAN BODY IS RENDERED IN TWO DIMENSIONS

As it is quite correct to say that, for most observers of Egyptian monuments, Egyptian art is at first 'disconcerting because of its striking treatment of the human figure' (Erman n.d. [1885] 531–2), it is of central importance whether and to what extent we are able to accustom ourselves to the human form as it appears in two dimensions. Experience, it is true, shows that it is not too difficult—and I have observed this especially among artists, as well as among my more immediate academic colleagues (Erman n.d. [1885] 534)—to make the adjustment, at least aesthetically, to most two-dimensional pictures of human beings, and to grow to appreciate them. But it does not seem to me that it is enough to conquer reservations of taste: we must also attempt to gain a correct understanding of its epistemological [*erkenntunis-theoretisch*] bases. Of course, these must be the same as those which apply to the rest of the rendering of nature, and we shall not be able to grasp them correctly without a knowledge of the latter. So my task in this chapter is to apply the comprehension of depiction based on frontal images acquired in the previous chapters to the most important object represented in two dimensions.

As in so many contexts, the key to an understanding here is to be found in historical processes. So I must study the genesis and modifications of the forms of representation and we shall see that early pieces in particular provide valuable clues. The Egyptian two-dimensional human figure was not created in the earliest period, afterwards being carried along as a survival. On the contrary, its gradual genesis occurs before our eyes. Its constituent parts were firmly defined at the same time as 'Egyptian' art was defined, and its history does not stop there either.

At least one fact about the Egyptians should not be forgotten: already in the fifth dynasty (about 2500 B.C.) they had working drawings in which the parts of the human form were brought into a fixed relationship (fig. 323).

So in what follows I shall attempt to provide the reader with an understanding of the phenomenon by isolating the data in the order of their occurrence, and by examining the meaning of each of them. In the process I shall constantly attempt to see individual pieces in the context of the whole, but I shall also take care not to read into the art of any given period ideas which were as yet alien to it.

Before I begin, however, I must define my present task more precisely, for I shall only consider a part of the large field of the representation of the human form in two dimensions. I shall only study the figure with which I may expect the reader to be at least moderately familiar (pl. 1), for it is almost a talisman of Egyptian art, and from the Old Kingdom on the Egyptians use it almost without exception when they want to show a man standing at ease. This is the form I call the 'basic form'. By keeping it in mind I shall be able to order better the treatment of the individual parts of the body. After excluding everything which makes Egyptian pictures of human beings into works of art, my aim resolves itself essentially into an exposition of the images of the parts of the human body which an Egyptian used when he produced his pictures.

The evidence goes right back into the predynastic period with figures on pots (fig. 141), the Hierakonpolis wall painting (fig. 144), and rock drawings. Because of their nature one should not try to extract from such pictures defined views of the parts of the body. But it is still possible to make some deductions from them and to see that the seeds of the later forms are already present. It is clear that there must have been a development of some length even before these earliest figures, which laid down what was necessary for a picture of a human being: already the process of fixing the 'vision'[1] by giving the various parts the form of certain 'views' is fairly far advanced—as before I am using the word 'view' for convenience, with the reservations mentioned on p. 91.

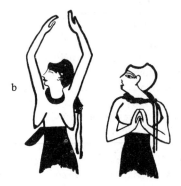

FIG. 288. a Figures of women on red-figured pots. Predynastic b Women mourning. NK

First of all let us study fig. 288a, a drawing of women which is far removed from the later form (pl. 26). Let us leave the position of the arms, which may indicate dancing or mourning, out of consideration. The drawing is so crude that it is not clear what view has been chosen for the head. The chest seems to be seen from in front, but one is immediately struck by the fact that the breasts are not indicated. They could have been rendered in a front view; even in fifth-century Greek works like the Ludovisi relief[2] they protrude on both sides of the frontally viewed torso, just as they do in occasional Egyptian New Kingdom drawings (fig. 288b)[3] and in the Mexican example in fig. 289. In the Egyptian case the broad hips and undivided thighs which jut out beyond the narrow waist appear to be seen from the front, probably in order to make room for the genitals, which would be indicated in a more carefully drawn example, and which are mostly shown very large in figurines. Feet are sometimes also indicated (Capart 1905.121), and they seem to be imagined in a side view. But they are quite frequently lacking in these pictures of women, and this peculiarity is also found in the figurines; it probably has a magical explanation.

The male figures (fig. 290) are much closer to the later Egyptian form. The head is evidently seen from the side, since the nose is indicated in the front outline, and, if at all, one eye only is shown within the outlines. The feet and the legs, whose

[1] [*Schau*, the image of a natural form conceived as a whole (J.R.B.).]

[2] Rodenwaldt 1927. [1]259, [2]277 [normally called the Ludovisi throne-base, reproduced e.g. in Richter 1950.509, 409 fig. 185 (J.R.B.)].

[3] [Photograph of a scene from the same coffin, Sm pl. 171B; the work dates to the Third Intermediate Period, not the New Kingdom. OK example Sm pl.51A (J.R.B.).]

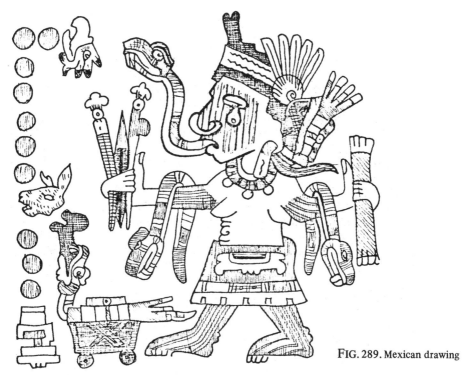

FIG. 289. Mexican drawing

thighs are divided, all face in one direction. In addition it is worth mentioning the shoulders, which are already broad here. There are many drawings by children and primitive people which show human faces seen from in front, no clearly defined broad shoulders, and no feet pointing sideways.

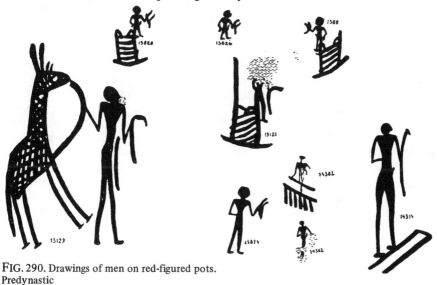

FIG. 290. Drawings of men on red-figured pots. Predynastic

I passed over the chest and torso of these male figures because it is not at all clear how they are to be understood. It would be possible to read a swelling in the front outline of the breast of the few Hierakonpolis figures that are published at a relatively large scale (Quibell—Green 1902 pl. 79), though unfortunately only in drawings, and this would make them more like the picture in pl. 12 and the later basic classical form. But I would prefer to take this rounding, whether on the printed plate or on the original, as the result of chance, and it should not be given undue weight, as the other pictures from the tomb—which are, however, published at a much smaller scale—and the ones on pots show nothing of the sort. It is far more plausible to assume that, if the painters had been required to draw the breast with care, the result would have been scarcely different from what we find in the representations I discuss next.

We are on sure ground only when we arrive at a group of important and clear reliefs which must date to the end of the predynastic period, around 3000. Fortunately the beautiful bowl fragment in the Berlin Museum, pl. 3, is not the only one preserved. The representation is one of the many examples of the motif of a warrior swinging a weapon over a captive. An obvious interpretation would be to take the formation of the chest as showing the victor's torso twisted towards us by the swing of the arm. But we are prevented from coming to this false conclusion by the fact that the chests of all the men in the reliefs on the contemporary ivory knife-handle from Gebel el-'araq[4] are rendered in this same way, although they are doing other things. Thus the form is not limited to a particular type of action, it must be considered the normal representation of the male chest in that period. The head is seen in a side view with the eye, seen frontally, inside it; legs and feet are again seen from the side. As on the slate palettes (pl. 4) one of the legs is characterized as the one further from us by the outline of the nearer one coming in front of it at the thigh. As can be seen in another fragment of the bowl, the toes are not represented even on the foot which we believe we are seeing from the outside.[5] The arching of the feet is not noted, although one might discern a very shallow arching on some of the slate palettes (pl. 4). As in the colossal statues discussed on p. 317 the knee-caps are indicated by triangles. The arms are in correspondence with the front view of the chest, but, on the other hand, the raised arm, which should of course be the right one, will be taken by many modern observers to be the left one. It is not clear how the hips and the belt from which the penis shèath hangs are to be understood. One would probably interpret it instinctively as a side view; at any rate, there is no sign that the body is imagined from the front. The navel is not shown.

This sort of composition corresponds to what is still found, among other places, in earlier Greek figures of human beings. The composition is of the same type as we found in Chapter 4 with all objects consisting of several elements, except where they present a single easily remembered view, which includes everything that seems essential to the artist. It is clear that the human form, with its two equally important viewing planes at right angles to each other, belongs with very complicated objects.

The full view of the chest is occasionally seen in later periods, for example in fig. 291, from the time of Ramesses III, which shows a jubilating man, and where the

[4] Propyl. 185.2–3 [Sm frontispiece, W fig. 58, M fig. 180 (J.R.B.)].
[5] The feet are missing in pl. 3. But they are preserved on the relief Berlin 15693, which comes from a very similar, if not identical, vessel.

full view of the chest may have been called forth by the outstretched arms. It should not be thought that the body is twisted sideways; rather what I said on p. 207 about the positioning of the shoulders applies here.

Egyptian art did not stop at the rendering of the human figure in pl. 3. The bull palette (pl. 2) marks the next step. This may belong to more or less the same period as the relief on the bowl, but it is at a later stage of development. One may already take pleasure in the rich variety of living forms presented in it—for example in the palm of the upper hand, or the way in which the bull's hoof presses into the man's calf muscle.

FIG. 291. Man rejoicing. NK

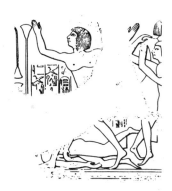

FIG. 292. Girl. Cretan painting

Again feet, legs, and head are clearly seen from the side. And the stomach, which presses out a little beyond the low-slung belt with the penis sheath, must be taken as a side view. But the whole area of the shoulders is imagined frontally, as can be seen from the shoulders themselves and from the strongly modelled collar-bones. It is not so easy to decide the matter with the chest, yet it is of importance for us to do precisely that. In comparison with the bowl fragment one notices that the two equivalent chest muscles have disappeared. There are muscles on the chest, but they can hardly be identified accurately. But at all events the pair are no longer present, and this chest should not be claimed to be a front view. And now we discover something quite new: within the surface of the chest, but close to its edge, a nipple in a disk-shaped surround is clearly indicated, and is therefore not thought of as projecting. It is easy to find comparative material for this positioning of the nipple, from Egypt and other countries, and from primitive peoples and children; a few examples must suffice. The closest case is probably a Cretan painting of a girl (fig. 292), where the nipple is just as close to the outline as in the bull palette.[6] The same is true of a doodle by a nine-year-old boy (fig. 293), who playfully added to his model a face in the form of a crescent moon—which is the reason for the laterally viewed eye—inserting the cockade and the buttons, in just the same way as the nipples we are discussing. It can be deduced from the child's drawing and from the Cretan painting

[6] Cf. *Phylakopi* 73 fig. 61, where a nipple with its areola is shown thus 🔘 . Fig. 218 is identical to these pictures and therefore to pl. 2 in this respect, so that it presumably represents a late reuse of an old form. It may be right to assume that the body of the dancer in fig. 217b is turned, cf. p. 210.

themselves that the artists must have been aware of the difference between front and side views, and we can observe their attempt to give the figures side views. But the image of the round form of the nipples, cockade, and buttons was too strongly implanted to allow them to disappear in the outlines of the body. So they are clearly visible close to the outline, in just the same position as the snake coils in the crowns in fig. 79–80 and 299, which are situated in reality above the middle of the forehead. I shall conclude this series of examples with the bird in fig. 294 (= pl. 108) whose slit-shaped anus (the *cloaca*)[7] is placed in as nonsensical a position in the picture as the dog's paw under the sole of its master's foot in fig. 15.

FIG. 293. Child's drawing.

FIG. 294. Bird, showing the anus. Late

After these considerations there can be no doubt that the chest in the bull palette is meant as a rendering of a lateral image. As would be expected, we shall find on p. 284 that the same holds for the navel.

We learn in addition from the bull palette that the shoulder area should not be simply included with the chest, but that both should be treated separately; this figure is in short a significant link between the representation of a human being in pl. 3 and the later Egyptian representation.

In the immediately succeeding period there are no figures on the preserved monuments which can be grasped so clearly. Except in a few cases where the deviation is intentional the two chest muscles have disappeared definitively, but the nipple in the middle of the surface is no longer to be seen either (pl. 6, 8–9). Sometimes we may think we can observe something I alluded to in discussing the Hierakonpolis men: how the sharpness of the transition between the narrow chest and wide shoulders is softened by making the surface of the chest somewhat broader (pl. 12), without apparently modifying the mode of viewing it.

But it soon becomes again possible to follow, as it were from milestone to milestone, this progress from the picture of Na'rmer, which is still somewhat loose and unstable, to the well-organized, taut form which was created in the second or third dynasty, and which was from then on the main form of 'Egyptian' human figures.

The pictures left by the seventh king of the first dynasty, Semempses-Semerkhet,[8]

[7] M. Hilzheimer informs me that birds have a single slit-shaped orifice for urine, faeces and sexual functions.

[8] [It has since been discovered that these reliefs were wrongly attributed: they belong in fact to Sekhemkhet, Djoser's successor, so that they are more or less contemporary with the Ḥesire' wooden reliefs. The elements which Schäfer isolates, which are archaic in comparison with Ḥesire', are due to the lesser quality of the Sekhemkhet works. Schäfer was quite correct in his stylistic evaluation of the 'genuine Egyptian' pose as standing on the brink of the classical form.] [(Gardiner – Peet – Černý 1952–5.2.53 J.R.B.)]

on the rock faces of the Sinai peninsula (pl. 13) already show a genuine Egyptian 'bearing', not yet achieved under Usaphais-Dewn (pl. 11). I am thinking in particular of the broad straight line of the shoulders, probably used self-consciously (p. 16) by this stage, in the Semempses-Semerkhet reliefs, and which is ineradicable in one's mental image of subsequent Egyptian art.

In the existing publications the Semempses-Semerkhet reliefs[9] appear to have the classical Egyptian form, though not down to the last detail. The appearance of this *basic form* can be seen in the wooden relief from the tomb of Hesire', who was buried in the third dynasty under Djoser (about 2650) (pl. 1, 14–15), among the most noble two-dimensional works of any people or period. Here and especially in good Old Kingdom reliefs we find fully developed what we saw in the process of formation in Na'rmer's slate palette. The outline and the surface are full of restrained yet clear life, despite the chaste refinement of the changes of level which often, at least in our northern light, only reveal themselves completely to the sense of touch. In detail the following observations may be made about the Hesire' relief: the chest area is still relatively narrow, though rather broader than in the bull palette. Only the forward of the large chest muscles curves inward at the bottom. Instead of an indentation or a nipple placed within the surface there is now an unmistakable lateral image of it projecting from the outline. The stomach bulges slightly in a natural way out from the tightly drawn belt. Above all the navel is now clearly to be seen; it is near the front outline and in a depression which terminates in a shallower area at the top. Other reliefs also show the bulging round the navel,[10] made narrower at the sides. Sometimes, especially in Amarna, we find a horizontal depression for the navel instead of a vertical one.

It is characteristic of the earlier approach to Egyptian art that this unusual placing of the navel was only remarked upon in 1885, by Erman. His description was the first to enumerate all the essential elements in the basic representation of the human form. It runs as follows:[11]

In their attempt to show every part of the body as far as possible from the side which reveals it most characteristically, Egyptian artists produced a body whose strange contortions completely contradict nature. In general, the body is seen in profile, as is shown by the head, arms, legs, and feet. But a face-on [*en-face*] eye is placed in the profile head, and the torso in particular emerges completely confused. To enumerate: the shoulders are seen from in front while the thighs are in profile, and *the chest and abdomen have to provide a transition between them.* [Schäfer's italics]. With the chest this is achieved by making its back contour a face-on view and its front one a profile; the abdomen [stomach] should be considered to be more or less a three-quarter profile, as is shown by the positioning of the navel.

The following passage, which describes the arms, hands, and feet, can be omitted for the moment.

I would have reservations about this enumeration only in respect of one point— but it is a vital one: the rear delimitation of the torso. I see no justification for assuming that it contains the outline of the chest seen from in front. There is more reason for seeing in it an outline of the back, somewhat influenced at the top by the fact that it has to conclude at the armpit, just as it is generally the case in Egyptian art that the course of many lines or surfaces is conditioned by the fact that they

[9] A comparison of the left-hand figure in Petrie 1906 fig. 47 with ibid. fig. 45 for the rendering of the chest, shows how hard it is to decide such issues even on the basis of such apparently undeceptive photographs. [Drawing Gardiner – Peet – Černý 1952–5.1 pl. 1, commentary 2.52–3 (J.R.B.).]

[10] Propyl. 333 [W fig. 392 (J.R.B.)] (Amenhotpe II), Berlin 15081 (Amenhotpe IV).

[11] After Erman n.d. [1885] 532 [quotation extensively modified by Schäfer: the original is translated here (J.R.B.)].

have to link given points in the picture.[12] I believe Erman could only have interpreted the back outline as he did under the spell of his explanation of the siting of the navel. Nonetheless, with the exception of the feature just mentioned, anyone would be able to draw without a model a tolerably Egyptian-looking figure, as discussed on p. 110, on the basis of Erman's description. That of course does not in any way prove that the interpretation is correct.

And in fact, without considering the objection already raised, the description can only be assented to in so far as it treats external characteristics. I believe that its essential elements are wrong.

Torso.[13] It is indeed obvious that the *shoulders* are imagined in a front view—this is shown by their breadth—and that the collar-bones belong to the same area as them. But the interpretation of the rest of the torso must be rejected. In the quotation above I placed the passage that seems most dubious to me in italics: it states that the torso, which is supposedly a mixture of side and front views, 'provides a transition' between the shoulders, seen from front, and the lateral view of the legs. I shall quote von Bissing's sharper formulation of Erman's view in order to exhibit with clarity the position I am attacking. He says:[14]

It [the navel] could no doubt have been rendered from in front like the rest of the torso, if the artist had not posed himself the problem of making a transition between the side view of the legs and the front view of the chest and shoulders, both of which are the only distinctive ones. Accustomed as he was to change his standpoint constantly when rendering inanimate objects and animals, he did the same without hesitation for human beings. But it is a solution of genius to soften the harsh transition from the side view to the front view by introducing a three-quarter view between them.

In consideration of everything else we have found in these ancient reliefs and paintings, it is impossible to imagine that an Egyptian artist would have been aware that he was linking things that did not fit one another, with the result that he might have invented an intermediate view to provide the transition. It should be noted, as von Bissing himself correctly observes, that interpretations of this sort refer to unconscious processes: 'it can be seen that [this entire mode of representation] is the creation of an artist, carefully considered down to the last detail. As we see it before us it cannot be the result primarily of development: it must have been discovered at some juncture.' There could scarcely be a more strongly expressed contrast to what I worked out in the last chapter.

In this case as in others it has been forgotten that the Erman — von Bissing explanation of the placing of the navel attributes to the artist thoughts that never should be ascribed to him, but which only apply to a period which has a whole history of representation behind it, and which is beginning to free itself again from the strict rules of perspective. Such a process is something quite different from the shift from one full view to another, with which we became acquainted on pp. 97—8.

I have already stated (above p. 281) what I put in the place of the rejected interpretation of the *stomach*, when discussing the rendering of the chest in the bull palette: unlike the projecting nipple the normal navel could not be completely incorporated in the outline, as it would disappear, and its loss would be felt. Therefore it is placed where it is clearly visible, next to the outline of the side view. What

[12] On three-dimensional works cf. pp. 318—9.

[13] Della Seta (1906.171—2 = 53—4) understood the representation of the torso correctly. [Cf. also *Giza* 11.23—4.]

[14] Von Bissing (1911—14, text to no. 34, last column) [modified by Schäfer (J.R.B.)].

transition could the placing of the navel in pl. 54 (Amarna period, p. 283) provide?— the shoulders and thighs are both in a side view in the piece.[15]

Although most other peoples take the navel as the mid-point, and so prefer to place it in the middle of the torso, it is still possible to produce a parallel to the Egyptian procedure: the Mexican picture in fig. 289 with the circular navel next to the wall of the stomach. And in this drawing the knot fastening the loin cloth, which should be below the navel, is in the middle of the belt. In Egyptian pictures this is mostly not the case, and the belt fastening is in fact placed under the navel, either with its full width visible (pl. 14) or, as sometimes happens with the ⊏⊐ –shaped fastening on the king's loin cloth in the New Kingdom, only half of it, as if there were a sharp break in it at the outline. In other contexts too the Egyptians habitually rendered half of a symmetrical object that is bisected by the edge of a body, as can be seen, for example, in the semicircle above the foot of the vessel in fig. 43e; this is also more or less what happens with normal New Kingdom fighting shields with semi-circular tops (fig. 295).

In their pictures of peasants Old Kingdom artists often delight in drawing attention to bodily malformations. In one case a heavily protuberant navel has been observed, and the artist has then of course incorporated it in the outline.[16]

It is worth noting that figures with round fat bellies sometimes show an abnormal treatment of the navel. The gods of the two lands on the throne-base of Senwosret I (pl. 37) have been given, to the evident satisfaction of the artist, luxuriant bellies with the navel placed in the middle, thus emphasizing their rounding; the placing is made without reference to the folds of the stomach, which I shall now discuss.

It has never been disputed that the *chest* outline in the basic classical Egyptian form represents a side view. In contrast with the bull palette the nipple is now incorporated in the outline, where the fact that it projects makes it sufficiently clear and visible.[17] Its areola often encloses it, in the form of a coloured half-disk, which is sometimes surrounded in its turn by a row of small dots (fig. 210). The back outline of the chest has been treated above (p. 283).

We should therefore take the chest as a lateral image. If it were a genuine view, a rendering of a visual impression, and not formed on the basis of mental images, the shoulders and arms would have to lie within the surface of the torso (cf. p. 304), half obscured by it and half obscuring it in a side view, as in fig. 313 L. And it is important to make it clear that there is no trace of the basic form of the chest's being conceived of as a broad, that is frontal, view. If this were so something in the modelling of the surface would show it. But it only ever stretches as far inwards as would be expected for a side view; the part of the surface between where the side view ends and the back line does not render any specific part of the human body. Finally, it should be noted that in two-dimensional works the folds of skin under the breasts (pl. 42, 45, 72) penetrate very little into the surface, just as in the Mexican drawing in fig. 289. In contrast, how sharply the furrows and bulges are drawn like ridges right across the torso on statues, for example at stomach level.[18]

[15] [Note the unique representation of the female genitals in Säve-Söderbergh 1957 pl. 15, below L.]
[16] *Atlas* 3.15, third line from bottom, L.
[17] Apart from fig. 43e, discussed in the text above, cf. the drawing of the eye in fig. 302.
For a nipple with a completely circular areola see fig. 315.
[18] Propyl. 333 [W fig. 392 (J.R.B.)].

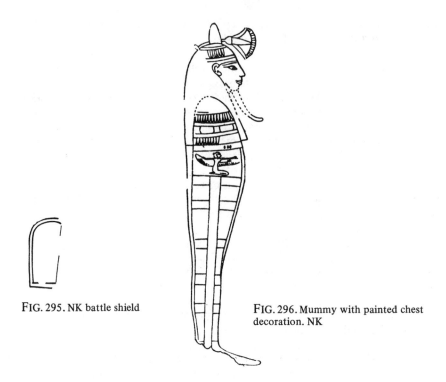

FIG. 295. NK battle shield

FIG. 296. Mummy with painted chest decoration. NK

In discussing these questions one's attention should not be confined to male figures, as female figures often provide a clearer indication. If the chest area of the human form were to be considered a front view, one would expect to find the second breast in women, and we have seen that there were plenty of ways of depicting this. It should be pointed out that, as with the Ḥesireʻ figures, Old Kingdom female figures normally have relatively narrow chests.

In studying the female form we come to a very important observation. The clothing and jewellery covering human bodies has been used[19] to find a point of reference for determining the views in which its parts are represented. If we find a piece of decoration which we know from statues to have been placed in the middle of the chest also in the middle of a drawing we may be tempted to deduce from this that the chest itself is represented in a front view. But cases where a human being is in fact given in a side view show that this assumption can lead us astray. If anything is certain, it is that the mummy in fig. 296 is consciously seen from the side. So the kneeling divine figure appears to be on the side, a little above elbow level. Yet we know from real mummy wrappings (Propyl. 400.3) that protective figures[20] of this sort were always painted exclusively on the front of the chest (cf. p. 142). Similarly the strips of leather in fig. 203 and pl. 60 in fact intersect in front of the chest,

[19] As did von Bissing (1911–14, text to no. 34, last column but one).
[20] On the significance of wings in Egyptian artistic symbolism see Schäfer 1928.115, and for some instances already Meyer 1884.192.

though in reliefs and paintings they appear to cross on the upper arm. Countless examples of other decoration could be cited in addition to these. The drawing of female breasts with their clothing is an exactly reverse case. We know from vast numbers of statues[21] that the broad bands of the older form of female dress, which were sewn to its top border at the front and at the back, ran symmetrically over both breasts, and they were certainly not only dress straps, but also supported the bust.[22] But who would manage to deduce this state of affairs from pictures like pl. 26, which show a bare breast? So it can be seen that the positioning of articles of clothing and decoration does not tell us anything about the view of the parts of the body they cover. The artist was quite happy if, for example, the clothing did not lie over one breast. It was scarcely necessary to render precisely what was there, as everyone who saw the picture without hesitation interpreted the data it provided correctly on the basis of his own experience. Thus we have again observed with clothing and decoration that, as soon as a body is fixed on the picture surface, its meaning, as far as the determination of middle, front and back is concerned, changes as the work progresses, so that in our case the middle of the area enclosed by lines representing a side view can be treated more or less as the middle of the chest.

This can also be observed where the determination of the *back* line is in question. We know from a whole series of statues that the traditional writing equipment (pl. 1), which consists of reed-pen container, colour mixing board, and a small bag of colour, was most readily carried so that the board with the small depressions was on the front of the chest and the container and the bag on the shoulder blade. For a two-dimensional artist (as in pl. 15) the back line of the drawing replaces the back of the body, front and behind of course being determined by the general direction in which the body moves. And this is why the bag and the container seem to us to be lying on the outline of the shoulder. In the same way Egyptian artists represent a standing statue against its back pillar as in fig. 297. For them it was enough to have rendered the idea 'the statue has a pillar behind it'. This of course looks much more familiar to us in a strictly lateral view (fig. 297b). The broad, soft lengths of cloth,

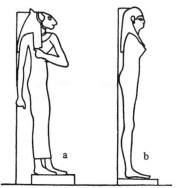

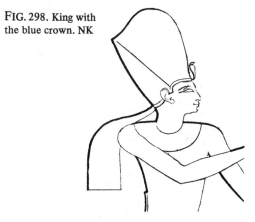

FIG. 298. King with the blue crown. NK

FIG. 297a–b. Drawings of statues with back pillars. Late

[21] Propyl. 234 [M fig. 222, many parallels, e.g. L-H pl. 21, Sm pl. 29B (J.R.B.)], 236.
[22] [The garments would have had to be gathered very tightly below the bust for this to be the case. The form of the straps may be partly conditioned by modesty (J.R.B.).]

which from the eighteenth dynasty on hang down the back of the neck below some
royal crowns, start by running in a direction as if they were on top of the shoulder
(fig. 298); under Amenhotpe II they are slightly raised (*Atlas* 1.298); at Amarna
(where all forms are to be seen) they flutter realistically (pl. 28). In statues the older,
longer form of woman's head-dress is divided up, with a broad, compact mass behind
on the shoulder blades, and the rest lying in two thick strands on the breasts.[23] In
two dimensions one of these two front strands falls vertically down from the ear,
fitting in with the side view of the head (pl. 21, 26), although the back mass is drawn
as if the way it fell were determined by the outline of the shoulders; yet we know from
countless statues that the outside edges of the shoulders were not even touched by
the hair. Again, the backmost outline has imposed itself on the artist's mind instead
of the back of the body.

It will be helpful to add here a few details about the history of this hair-style.[24]
The main point to be observed is that artists begin also to place the second of the
front strands in front of the shoulders; this attempt seems to have been begun not in
representations of human females, but in an area normally very resistant to innovation,
the representation of divinities;[25] many Egyptian gods' hair is identical to that of
women. From a very early period the desire made itself felt ever more strongly that
gods should have human form, even the ones who were in fact worshipped as animals.
But this idea, which probably spread from a particular group of divinities, never
became the rule for all representations. Animal form had very great power, and only
a few gods attained a completely human form; mostly what was accomplished was
a mixed form, in which an animal's head was added to a human body (pl. 64). In
part there is no doubt an aesthetic reason for all of these animal-headed mixed figures
wearing 'women's coiffure'; it will have been adopted all the more readily because it
united the animal head which was often recalcitrant—one only has to think of Thoth,
the god of writing's, thin-necked ibis head—in an effective way with the human chest.
It is also very comprehensible that a special innovation seems to have been made for
this linking of animal and human being: while purely anthropomorphically represen-
ted divinities have to be content with the old style and have only one strand of hair
on their chests, with animal-headed ones the second strand is almost always brought
in front of the shoulder, behind the face, from about the fifth dynasty on. By making
this strand terminate on the chest a much stronger impression was achieved that the
animal head and human chest were viably joined.[26] The innovation was not uni-
versally welcomed for representations of human women, and was adopted compara-
tively seldom. The relative frequency of the two is worth noting, because it prevents
one thinking in terms of conscious observation. Rather the phenomenon should be
explained in the same way as were the different ways in which birds' wings are
attached to their bodies (fig. 275) and the horns to a crown (fig. 79), that is, in this
case, that the artist wishes to show that the starting-point of the strand which emerges
from behind the neck corresponds to that of the completely visible one. It may be

[23] Propyl. 236 [parallels L-H pl. 21, Sm pl. 29B], 291.1 [W fig. 295 (J.R.B.)].
[24] [Cf. now Müller-Kriesel 1960 (J.R.B.).]
[25] Cf. also the statue of King Djoser, Propyl. 228–9 [L-H pl. 16–17, Sm pl. 15A (J.R.B.)].
[26] This impression is still stronger in two wooden reliefs of the goddess Tewere in the British
Museum, nos. 1318 and 35813, where she is shown as a hippopotamus standing upright.
Two elongated female breasts hang down close to each other on the edge of the figure,
under the two front strands of hair.

noted here as a curiosity that in Late Period bronzes the goddess Bastet's round cat-head is normally attached to the human body without any intermediary.[27]

The basic form of the back line can in fact only be seen in the head and neck, and then from the armpit down. Therefore, in the picture the hair and cloth covering the neck would have to disappear behind the shoulder, only to reappear below the armpit. Some draughtsmen are more or less aware of this, and act accordingly: for example, attempts are sometimes made to adapt the cloth lengths to the real line of the back (fig. 299), so that they cut behind the shoulder, though they still have to fall in a slight curve, out of habit and in order to correspond with the basic form, even if they no longer lie upon the shoulder at all.[28] If a man hunting in papyrus thickets has hung some long-stemmed lotus flowers over his shoulder with the blossoms in front and the bases of the stalks behind, the drawing (fig. 300) shows the bases next to the line of the back. Occasionally long male wigs like female ones are found, and these run down the back more or less in a straight line (fig. 301). It can be deduced from the quite abnormal treatment of the front strand here that this artist conceived the chest area, despite the breadth of the shoulders, as bounded behind by the back line, and in front by the chest line, in a side view. Fundamentally both parts of the hair are drawn in the same way here, in the broad-shouldered form, as they are for the left and middle figures in the top register in pl. 64, in the pure lateral image.

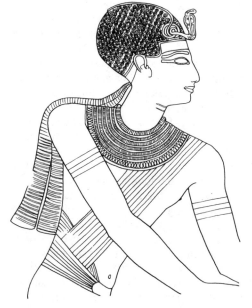

FIG. 299. King with the blue cap. NK
[This cap is in fact yellow (J.R.B.).]

[27] [This treatment is the exception rather than the rule (J.R.B.).]

[28] See above p. 288. The fluttering persists well into the nineteenth dynasty (pl. 56). Every method of treating these bands is in fact found at Amarna. In the relief Davies 1903–8.6 pl. 29, 42 they appear to divide so that one of them lies on the forward shoulder and the other on the back, in a manner superficially similar to that of fig. 301.

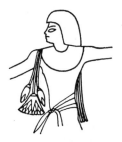

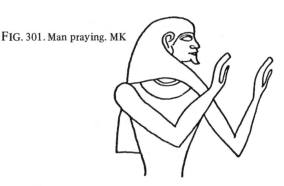

FIG. 301. Man praying. MK

FIG. 300. Man with lotus
stems. NK

Head and neck. Just as the image of the human form is the most important element
in art, the head is in turn the most important part of the human figure. As the example
of the girl with the beads on p. 160 shows, children may render the head in place of
the whole body, or they may, as primitives do, make it larger than the torso and limbs,
just as more mature art persists for a long time in emphasizing the importance of
certain figures by making them larger. In Egypt value judgement is also expressed in
other ways: in a good Old Kingdom relief [Hassan 1932 pl. 28] the head is in finely
worked sunk relief, while the body is just in incised lines; and it has been observed
with reliefs in the tomb of Sety I that only the king's face is modelled, while his
body is an unmodelled surface. Erman's description contains everything essential
about the head in Egyptian art. The head determines the direction of the action, and
is almost always in a side view. On heads turned 90° and 180° see p. 214.

The *eye* with its black eyebrows and lids has various forms between almond and
lancet shape. Sometimes the point on the outside where the lids meet is drawn out
into a broad so-called cosmetic line, which then runs parallel to the line of the eye-
brows. The small lump of flesh in the wider inner corner (the caruncle or nictitating
membrane) is disregarded. The iris is mostly brown—blue with blond Libyans—and
the pupil black, unless both are quite simply black. Without exception the human
eye is seen from in front, and the fundamental image of the human face includes a
full view of one eye. This rendering was probably adhered to so tenaciously because
it is the only one in which the eye is felt to be alive and looking, with its clearly
visible white and complete circle of the iris and pupil; this impression was further
heightened for example in reliefs of kings in Old Kingdom pyramid temples by the
use of rock crystal and coloured stone inlays with copper eyelids and eyebrows.[29]
I want to avoid introducing into my discussion of the rendering of the eye any idea
that this was a difficult task: in their treatment of human finger- and toe-nails
(pl. 71, 74, cf. pp. 296, 298) Egyptian draughtsmen very early achieved a complete
mastery of a very similar problem to the one set by a lateral view of the eye, and a
clear side view of this type would not in itself be alien to the basic character of
depiction based on frontal images, any more than a comparable drawing of a nail is.
Ancient Babylonian reliefs frequently give the impression at first sight that the eyes

[29] As these inlays have always fallen or been torn out the holes are the only evidence for the
earlier condition of the pieces (pl. 20). Almost all the cases I know of inlaid eyes in relief
are from Old Kingdom royal tombs.

FIG. 302. Fragmentary drawing of a baboon eating. NK

have indeed been depicted in a lateral view. But this is an illusion. In such cases the artist has been able to place a front view of the eye on the edge because the relief is very thick and rounded. Fig. 302, from an ostracon, shows a very remarkable Egyptian eye in a baboon's head [cf. Schäfer 1938.27 ff, fig. 1–2]. It is not a front view but a squeezed lateral one with the line of the iris made into an upright ellipse and the pupil a vertical stroke. Siegfried Schott drew my attention to the fact that there are many parallels to this form in New Kingdom funerary papyri: mammals' eyes, and of course those of animal-headed demons, seem generally to be shown in this way.[30] So it must be a special form for the eyes of monkeys, mice, hippopotami, etc., just as birds have circular ones, and hawks and cows have special forms of their own. A fifth or sixth dynasty relief artist once thought of representing the eyelashes (fig. 303). He could have arranged them along the lids of the normal eye, which he retained. But he was more concerned that they should point forwards, so that here we again find an instance of sharp shifts of meaning between the different parts of a picture. What was previously only the furthest extreme in the drawing now becomes the frontmost part, and both upper and lower lids send out pairs of parallel delicately curved lines towards the root of the nose: these indicate the eyelashes [cf. Schäfer 1938.27–8, fig. 3–4]. Greek art also retained eyes seen from in front for a long time, even after artists had begun to express transitory emotions by facial expression (Hartwig 1893.163). In Egyptian art the eyes themselves never show emotion. A weeping eye has three water-lines running down the cheek which start from the whole lower lid, and not just from the corner �™ (e.g. Davies 1925a pl. 20, 22); there is only one case where a single tear is falling from the corner. The sleepily blinking eyes of the tired guard in fig. 136 (= pl. 41) may serve as a transition to the expression of lasting states, which Egyptians are very well able to convey to us by varying the depiction of the eye. The mastery with which the intense listening of blind people is shown in the New Kingdom is noteworthy.[31] Ramesses III's relief artists were able, as Amarna artists already had been, to give the faces of fallen enemies clear signs of death (Nelson 1929.32, 1931.15). I know of no cases where the eye is shown turned to the side. The procedure for representing the eye in two and three dimensions in different periods needs to be studied more closely: in statuary the large, clear Old Kingdom eyes are quite different from the tired ones, overshadowed by a heavy upper lid, in Middle Kingdom portraits.[32] In the Amarna Period this method of using a large upper lid was sometimes intensified in a subtly calculated way, by making the lower lid almost disappear in comparison with it, in

[30] [W. van Os remarks in a letter commenting on Brunner-Traut 1956.113 that a baboon's eye looks quite different when seen from the side. He says that the eye is squashed laterally, so that the iris and pupil have the form of a standing ellipse. He refers to van Os 1943.778 fig. 88 and 780 fig. 89B. The latter shows the eye in a front view. The artist made the necessary room for this by elongating the skull so that the animal appears to have two foreheads. In this way Schäfer's interpretation is confirmed.]

[31] Propyl. 388.2 [cf. L-H pl. 210 (J.R.B.)].

[32] Propyl. 281.2 [W fig. 259 (J.R.B.)].

order to achieve something close to the king's dreamy, abstracted gaze. Elsewhere this is only found in Greek art around 300 B.C. In the Late Period in Egypt almost paper-thin lids are again preferred.[33] The changing treatment of the surface of the eyeball should also be studied. At the end of the Late Period the corners of the eyes are cut back much deeper, making the eyes almost spherical. Here a form which is also occasionally found in the Old Kingdom has been readopted.

In relief the *nose* of a face seen from in front is normally flanked by two depressions, and in painting by two lines. But occasionally in New Kingdom paintings, as in many modern children's drawings, there is a lateral image in the form of a corner with one long and one short enclosing line, placed in a perspective-like way in the face (fig. 304). In carefully executed reliefs the philtrum between the nose and the upper lip is placed next to the outline like the navel and other such parts. A quite

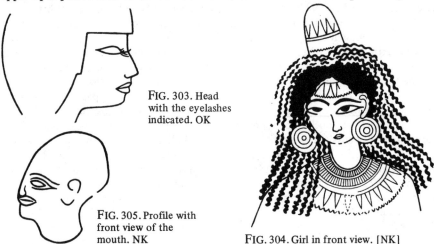

FIG. 303. Head with the eyelashes indicated. OK

FIG. 305. Profile with front view of the mouth. NK

FIG. 304. Girl in front view. [NK]

unique treatment of the nose and the mouth occurs in a New Kingdom relief published by Hermann (1939; fig. 305 here), where a front view of the mouth is pushed up against the outline of the cheek, despite the fact that it would be quite clear in a normal side view. The nose, which looks as if it has been pressed out of shape, defies explanation. Or should nose and mouth together be regarded as a malformation? In reliefs and statues the edges of the lips are often surrounded by a ridge almost like an applied thread; this is also found, though not frequently, on modern people. The rendering of the slit of the mouth and the hole of the nose with a black line is discussed on p. 73. Transitory movements around the mouth are again first visible in the New Kingdom, and the mouth itself is sometimes open, a quite new feature.[34] Enduring qualities like seriousness and strength appear, often in a very striking form, from the Middle Kingdom on. A kind expression becomes more frequent in the New Kingdom, and it is widespread in the Late Period, almost in the form of a smile. The Greeks took this over and used it as a fixed, and for a long time frozen, form for a variety of

[33] Propyl. 433 [cf. L-H pl. 258, 260, Sm pl. 183A, 185, W fig. 631, 665–6 with parallels (J.R.B.)], pl. XXII.
[34] e.g. Propyl. 388.2 [cf. some figures in L-H pl. 208 (J.R.B.)]; Nina Davies–Gardiner 1915 pl. 15 top L. Compare the remarks about lions on p. 15.

emotions. The essential character of Amarna art is expressed by the mouth as well
as by the eyes. The ears are often placed strikingly high on the head, as has frequently
been observed is the case with statues, though no explanation has been produced in
either case. From the Old Kingdom on, the channels and protruberances of the ear
are caught fairly well.

Good-quality Old Kingdom reliefs (pl. 70) show in the *neck* one sternocleido-
mastoid muscle running down from the ear to the meeting-point of the collar-bones.[35]
Attempts have been made to deduce from this that the neck is in a three-quarter view,
and these have relied for support on the opinions of specialists like anatomists and
modern artists. But this only proves yet again that the isolated use of an expert's
opinion seldom helps, and can indeed, as in this case, lead us into error, because the
expert seldom has the necessary historical knowledge, and often even has no histori-
cal sense. The only thing that helps the archaeologist is to acquire the knowledge
for himself, so far as it may be necessary and possible, and then to judge the matter
on his own.

Legs, including lap and buttocks. In mature Egyptian art standing men almost
always have their legs a pace apart, even when they are surrounded by seated or
kneeling people (pl. 21), and are therefore certainly not walking. So standing cannot
be distinguished from measured walking. The parts below the navel are mostly covered
to a little above the knee by clothing, so that the body structure cannot be seen.
Naked figures (pl. 21, L) exhibit a rule, first observed by Erman,[36] which is scarcely
ever broken, that the further leg steps forward. This is true not only for classical
Egyptian, but also for all pre-Greek art. It is a strange aberration when two serious
scholars think it correct to say, one of rows of Assyrian warriors, the other of a row
of hunters on a late predynastic slate palette, that the figures are keeping step in a
military sense.

Animals also obey this rule, quadrupeds by pairs of legs, so that none of them
walk with an alternate gait as in nature; instead they amble (fig. 271). Birds are
depicted in the same way, not only their legs,[37] but also, as for example in
figs. 56 and 138, their wings, which hover over the king like a protective roof.
Egyptian art worked these motifs into very beautiful symbolic images; we can sense
this especially when the wings are spread above and behind the king's head, one
stretched horizontally forwards, the other hanging at an obtuse angle. The rule which
applies to animals' legs must have been adopted secondarily for poses of this sort.
With human beings there are only a few exceptions where the leg nearer to the viewer
steps forward, and the intention in these cases seems to be to place a greater emphasis
on movement.[38] This interpretation is probably close to the ancient artists' intention,
as creative people of all periods and cultural levels experience the stimulating effect
of the out of the ordinary. In the regular arrangement, and already on the slate
palettes (pl. 4), the line of the stomach, against which the penis is placed, is con-
tinued down into the nearer (back) thigh. The front outline of the back thigh con-
tinues as a channel running up into the region of the groin and occasionally further

[35] Von Bissing (1911–14, text to no. 34, last column).
[36] Erman n.d. [1885] 532, 534. On the effects of this habit on sculpture see p. 323.
[37] Propyl. 417 [cf. Sm pl. 129 (J.R.B.)]; pl. IX.1 [*Beni Hasan* 4 pl. 6 (J.R.B.)].
[38] Gaebler (1930.199) makes the interesting observation that on the mature archaic Greek
 coins of Stagira images of ambling wild boars are earlier than images with an alternate gait.

to the iliac crest; careful artists make its end visible above the loin-cloth. The penis lies on the surface of the further (forward) thigh (cf. p. 302).

Where the male body becomes visible again below the loin-cloth the muscles around the knee (pl. 77) are visible from the time of the slate palettes on, and are often excellently observed, especially in the Old Kingdom. To explain how the calf is rendered I shall start by treating the battlefield palette (pl. 4). The powerful legs of the prisoner at the top on the right show the calf muscles, as do the remaining human legs in the relief, but they do not distinguish inside and outside. From the Na'rmer palette (pl. 8–9) on, long, sinuous muscles begin to predominate. The ankle-joints are sometimes rendered in painting by a U-shaped outline. In the Old Kingdom an attempt can be seen to distinguish inside and outside, with rather curious results, but the big calf muscle is not indicated at all. In reliefs of the fourth to sixth dynasties, which almost always distinguish inside and outside views, even if this only means that the further leg is formally neutral[39] —as is often the case—the back depression curves at least a little and comes near in form to the outline of the calf (pl. 23). But in general it is the longitudinal aspect of the furrows which is emphasized, and in the Middle Kingdom especially, the long tense strands of muscle stand out with their sharp edges (pl. 76), while in the New Kingdom the form of men's legs often reminds one of women's. This is in conformity with the feminine quality of the second part of this period, which is so great that quite frequently only the trimmings reveal whether a man or a woman is shown; sometimes even an expert is unable to decide about damaged pieces. It is only in the twenty-fifth dynasty that we find Old and Middle Kingdom forms taken up again and developed (LD 5.13b, d). Now for the first time individual groups of muscles are often correctly defined. This appears to continue to the end of the twenty-sixth dynasty (pl. 67). After this a new treatment, closer to that of the New Kingdom, emerges. It has been observed several times that a large proportion of modern Egyptians' calves are not very highly developed; this should be borne in mind when considering the ancient treatment of calves. In all such matters Assyrian art is the exact opposite of Egyptian (cf. p. 32). One sometimes looks in vain for firmness of the knee-joints in standing figures, even in masterpieces like the Ḥesire' panel (pl. 1): contrast this with the beautiful Berlin relief of Sekhemka, which dates from the later Old Kingdom [Propyl. 258].

In pictures of men normal standing cannot be distinguished from measured walking, as the soles of the feet are flat on the ground in both cases.[40] Whether the figure is standing or walking, in emphatically forward-moving action the back heel is raised (pl. 42), while the front foot is quite flat. This does not occur in running poses. A popular special form for standing men is based on what is called in Greek and more modern art 'Stand- und Spielbein' ['supporting leg and free leg'] ; the late Amarna period picture of a young king in Berlin (pl. 47) is an especially beautiful example of this. But the form is quite common from the middle of the Old Kingdom on. In particular, it can be seen in the many varying attitudes tomb-owners or overseers adopt, leaning on their staffs as they watch their people at work. The figure of a sleeping guard propped against a doorpost in fig. 216 is a very striking variant. The Amarna relief has two aesthetic shortcomings in the leg which takes no weight: there

[39] [Formenstumm, cf. above, p. 101, and Epilogue, pp. 420–21 (J.R.B.).]
[40] Fig. 285a is quite unreliable on the point, cf. p. 265 [but see also Chapter 5 n. 11 (J.R.B.)].

is a false overlapping of the toe (cf. p. 264), and the transition from the rather weak ankle to the calf is not very successful. But while we may find points like these (which are of the type mentioned on p. 33) momentarily disconcerting, they are forgotten in the charm of the whole.

In contrast with this uniform depiction of men, standing and walking women are distinguished by a closed or open pose of the legs.[41] As stated on p. 33 the arches of standing women's feet are treated as if they were transparent. As women are covered from the Old Kingdom on by a long garment (p. 121), which appears to be so tight as to adhere perfectly to the body, figures of clothed women are just as useful for a study of the rendering of the parts of the body as are those of naked girls. Thus the parallel legs of standing women are seen to overlap; we should prob-ably take them, together with the abdomen, to be a perspective-like oblique image.

According to Schmarsow (cf. p. 172) Egyptian reliefs and paintings acquire 'an active energetic quality' especially from the forward stepping pose of the many men depicted; 'it gives an impression of genuine motion from place to place, or at least displays freedom of movement, which is the privilege of all living things.'[42] In Egyp-tian statues too, even if the figure is clothed in an ankle-length garment, the forward-stepping pose is visible beneath it,[43] while Mesopotamians prefer in such a case to show the legs in a closed position. The same tendency can be observed from the fact that the 'pure lateral image', in which only one leg would be visible, is not used for living human beings (p. 109).

Children and primitive people often use a method of drawing human beings and animals in which the legs are completely separate, next to one another, rather like those of the human-legged snakes in pl. 64 bottom, which do not have any genitals either. This separation does not occur in the fox-headed human being next to them, so that it is possible to distinguish by means of overlapping (cf. pp. 177, 280) which leg is meant to be nearer to the viewer, and which further from him.

Many ancient American and Hittite pictures show the toes on both feet as if in a view from above.[44] In Egyptian art this is found with figures of erect walking monkeys, as if the artist felt he needed to make it clear that monkeys do not have feet, but hands, on their rear legs as well as on their front ones.[45] When human feet are rendered in this way, as in fig. 306, the works in question are on a level common to the whole world, below the point at which any art has individuality. The attraction of the base line, discussed on pp. 198–202, did most to remove such feet from Egyptian art. But a disconcerting trait remains even in classical Egyptian art, that even the foot whose outside should face the viewer does not have the little toes (pl. 21), as if both feet were viewed from the inside. In addition, the arch of the foot is rendered, although it can in reality only be seen from the inside (p. 33), and both arches cannot be seen at once. If the artist bothers to render them at all, he places hollows under both feet, as earlier Greek vase painters do (Reichhold 1919 pl. 1), so that the figures

[41] An instructive example is Propyl. 252 [Borchardt *et al.* 1913 pl. 29 (J.R.B.)] with female offering-bearers in the bottom register and a standing female figure in the top one.
[42] Schmarsow 1905.284 [extensively modified. The phrase 'etwas Tätig-Wirksames' does not occur in the passage cited (J.R.B.).]
[43] Propyl. 345 [cf. L-H pl. 204 (J.R.B.)].
[44] Even when a base line runs beneath the foot (von Sydow 1923.405). Cf. p. 163.
[45] This is clear e.g. in Worringer 1927 fig. 6, Spiegelberg 1930c pl., and not infrequently elsewhere.

seem to our eyes to be standing rather unsteadily. I have mentioned on pp. 33 and 295 that the arch is often treated as if it were transparent. Sometimes one has the impression that it is intentionally quite low on one foot, and rather higher on the other. Feet seen from the outside and firmly pressed to the ground are first found in relief in Amarna art (pl. 73); the feet of statues are always like this.[46] Occasionally at the end of the reign of Thutmose IV or the beginning of that of Amenhotpe III, and more frequently from the Amarna period on, all the toes of one foot are shown in two dimensions in a pure side view, in advancing layers, each overlapping with the next (pl. 73, cf. Davies 1927.17 n.4). When the little toes are missing and the arch is shown on both feet the pictorial form originates in an image based on the inside of the foot. The two points are therefore related and must be treated together. Wilhelm Stapel[47] suggested to me in a letter that this curious fact can best be understood by assuming that a man originally observed his own foot and not someone else's. Because of the way in which human legs can be moved one will much more often tend to observe and touch the inside than the outside of the foot sole; and it may be as a result of this that the inside view was established as an image for both feet. So this striking rendering of the foot would be a survival from the beginnings of drawing. The important place that observation of one's own body has in the representation of human beings can often be noted among children and primitive people. The big toe-nail is almost always in a pure lateral image from the Old Kingdom on (pl. 74); in careful work the cuticles are indicated on both feet and hands. In figures of goddesses like fig. 212 the feet are given in a view from above down to the instep, as shown on p. 224. In front views of some gods the feet are also seen from in front.

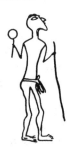

FIG. 306. Figure scratched on a slate palette. ED

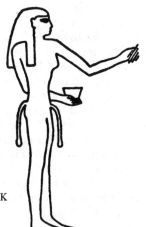

FIG. 307. Priestess. OK

Arms. At rest the arms hang down free on either side of the body. In this way one of the changes of meaning I have discussed arises, when one considers the original meaning of the outside lines of the torso. For while in the drawing the arms hang

[46] Human heels in Lutz 1927 pl. 1.2 (OK); Berlin 1188, 1200 (MK); Davies 1923 pl. 2 (NK). Dog's paws in Anthes 1930b.109.
[47] [Cf. Chapter 1 n. 3 (J.R.B.).]

down in front of the chest and behind the back, they should of course be imagined as being to right and left of the chest, so that the outlines of the torso have to do duty as right and left as well as front and back, just as with the breast of a person wearing a piece of jewellery. Although the jutting breast in pictures of women is very troublesome in this respect it is only occasionally allowed to overlap with the arm; artists prefer to avoid this by raising the arm slightly.[48] The bridge of skin in front of the armpit from the chest to the arm is normally rendered by a small hook between the two (pl. 14).

In the Old Kingdom especially a swelling of the biceps of the bent arm is indicated on figures leaning against a long staff (pl. 21).[49] This does not of course mean that an organic process as such is being observed here; it is one of those lines which sometimes strike the artist as being noteworthy and whose apparently organic character I discuss on p. 338. In statues there are two slight parallel indentations in the side of the deltoid muscle. In two dimensions they can be seen best in good fifth dynasty reliefs, and are apparently in the surface of the shoulder at the front; even with the right arm in pl. 23 one should not be led to imagine that what is depicted is the side. In a New Kingdom painted tomb the bottom half of the muscle is drawn rather like a heart on a playing card. Other arm muscles can first be seen on the Na'rmer Palette (pl. 8–9). There the forearm is governed by two stiff longitudinal strands, while on the upper arms a furrow can be seen, which must more or less correspond to the muscle on the inside behind the biceps. If it were assumed that this was a conscious reproduction of a real view one would have to believe that the artist wanted to indicate that the arm raised to strike a blow was seen from the inside. This assumption is improbable when one considers what was said on p. 210; it is much more likely that the image of the forward arm was taken over for the other one (cf. pp. 263–4). This situation is different from the one in the figure of the same king in pl. 7, where the surface of the raised forearm is covered with veins, while the hanging one has longitudinal furrows, or in one of the wooden reliefs of Ḥesire' (pl. 15), where we can see the furrow of the biceps quite clearly on the arm to the right on the picture surface, while the other one has a smooth surface. So the view of one is quite deliberately distinguished from that of the other here, as with the legs, by taking the limb that is in front in the picture as the one further from the viewer. And the second part of Erman's rule is that, with the arms too, if one is to be stretched further forward than the other, this is almost always the one in front in the figure's direction of movement, so that no overlapping is necessary (Erman–Ranke 1923.479). In this way figures like the priestess in fig. 307, which seem left-handed to us, are often produced. Yet the artist of this picture emphasized, in a strange enough way to be sure, that the left arm is holding the bowl, and that the one stretched out with the brush is the right one. In the Old Kingdom exceptions with the arms are still rare, but in the New Kingdom the desire to avoid overlapping is not so strong. At that period it was probably even found agreeable to break the harmony of motion of the arms and legs—which had previously given pleasure—quite frequently.

Hands. If the hand which is in front in the basic form of picture hangs down empty its thumb is always turned towards the body. But the hand hanging open behind the

[48] On this see Scharff 1928.42. The illustration Erman–Ranke 1923.249 differs from its source, LD 2.21.Weigall 1924.159 is a photograph of an unusual case where, in a picture of a living person, the breast overlaps the arm, which is pressed close to the body right down to the fingers (NK).

[49] On comparable details in Greek vase painting see Reichhold 1919.14, 47, 57.

back in the picture is mostly so placed that the thumb is turned away from the body
(fig. 166). This strange positioning of the hand poses great problems as long as the
human figure is taken to be the rendering of a single real view. But it does the artist
an injustice to consider his work in this way. Certainly his sole intention was to
produce the impression that 'both hands are in the same posture', and after his own
fashion he succeeded in this. But if the ideas that 'the hands are in complementary
positions' or 'the thumbs (or palms) of both hands are on the side towards the body'
had predominated for him there was no law stopping him from expressing that either,
as is shown by a whole series of pictures (fig. 308).

 Open hanging hands are almost always slightly bent. All five fingers of bent hands,
whether they are hanging or outstretched (pl. 71), are given in a side view in which
the four small ones lie close one on top of the next without overlapping. The grad-
ations in their length are not normally followed. And the bridge between the bones
of the main part of the hand and the thumb is usually lacking, so that the hollow at
that point is almost always deeper than in reality.

 Pl. 69, a part of a relief from the end of the Amarna period showing a standing
statue, in a side view as was the practice at that time, has a remarkable hand. In the
earlier periods it was customary in statues to turn the palms of hands hanging idle
next to the body towards it; but in the eighteenth dynasty, and perhaps already
occasionally in Middle Kingdom figurines, the hands are turned backwards. In the
delightful limestone figure from Amarna the artist secured the hand with the normal
attachment to the body and also with a cushion-like filling (Schäfer 1931a pl.21).
The relief under discussion contains an attempt, in drawing a statue in this pose, to
extend the side view of it to a hand, that is to start drawing the hand from the little
finger. More successful hands of living people in motion seen from the narrow side,
from the time of Tut'ankhamun, can be found on pl. 48–50.

 As regards the *nails*, the thumb-nail is always, and the remaining finger-nails
mostly, drawn from the side; only on a hand seen from the top with the fingers
stretched out straight next to each other ⟨⇒⟩ –their length is normally distinguished
in the process–and on a fist seen from inside with the fingers clenched (pl. 68) do
these four nails appear in a full view from above.

 From the time of the slate palettes on (pl. 4) hands seen from the inside are found
sporadically at all periods; these show the lines on the palm.

 If either the left or the right hand is touching an object the thumb always lies on
top of it: in this way the poses of the hand in pl. 23 and 71, and fig. 124 and 180,
come into being. A hand carrying something flat is hardly ever pressed against it
(pl. 71); pl. 23 is a rather extreme instance in this respect. If a hand is holding a
cylindrical vessel or something of the sort (fig. 309), the thumb is on the opposite
side to the four fingers.

 Already in the Old Kingdom the fingertips are bent back slightly. In the New
Kingdom this is exaggerated for ornamental effect (pl. 49). Fingers bent at the
joints are really a discovery of the second half of the eighteenth dynasty (pl. 50, 72).
In the early periods the fingers are not at all mobile, while a lively play of them is
appreciated in the New Kingdom (pl. 48). I reproduce an attractive example here
(fig. 310), Akhanyati (Akhenaten) and his queen's fingers intertwined, but this type
of drawing is very rare even at Amarna. Most examples of this kind, even from
Amarna, show the hands grasping each other lying limp, almost stretched out in one
another, as is still the custom now among refined Egyptians. The artist of pl. 23 was

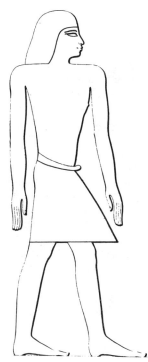

FIG. 309. Arm with hand hold-
ing spherical pot. Hieroglyph.
OK.

FIG. 310. Hands of
the royal couple. NK

FIG. 308. Standing man. OK

attracted by the idea of showing how the pen lay between the scribe's fingers. He
succeeded admirably in his not entirely simple task, but only because he unintention-
ally gave the left arm a right hand, and was thus able to show the hand from the side
of the thumb (cf. p. 247). It is very often impossible to trace Egyptian drawings of
fingers back to a real view of the hand.

The representation of hands as closed or open does not seem arbitrary, but appears
to be determined by a custom that varied with the spirit of the age. The pose will also
have artistic significance, as in sculpture, since the fact that in sculpture men clench
empty hands much more often than women, and that on mummiform coffins open
or clenched hands almost serve to distinguish male from female,[50] should not just be
interpreted on a superficial level. Clenched fists must rather be a visible expression
of determined male strength. But there were no unbreakable rules in matters of this
sort.

I have now considered the essentials of the basic form for rendering the human
figure in two dimensions. *In conclusion* I must again emphasize that these figures
should never be judged as human forms comprehended in one glance. Such a view
does not do justice to the artist's intention, and jeopardizes unprejudiced aesthetic
appreciation. The pictures are exemplifications of the 'vision' based on frontal

[50] As Siegfried Schott showed me, this rule does not always work. On open and closed hands in
relief see *Giza* 1.30. On the change in the poses of arms and hands in the transition from the
third to the fourth dynasty see *Giza* 1.154—5.

images, and to our eyes they often exhibit shifts of meaning without transition, turns of 90°, and other similar oddities, as do all pre-Greek representations of human beings. For us the sharpest break in archaic Greek art is between thighs and torso, in Mexico between abdomen and chest (fig. 289), and in Egypt between chest and shoulders. One of these procedures may be more acceptable to our eyes than another, but they are all fundamentally the same. We are adjusted to unified pictures based on visual images, so that we feel thrown this way and that when we observe these pictures of human beings closely; but an Egyptian will have found a special degree of attraction in the truth and life of the large number of images, which were for him clearly ordered and brought together.

Apart from the restriction just repeated above, that we have only fixed our attention on the pose at rest, that is, we have not on the whole used any figure represented in motion, I must now reveal another reservation, that we have only considered the state of affairs with *figures facing right*. Again it was Erman[51] who saw that, when an Egyptian artist was free to choose which way a figure should face, he made it face right. This may be related to the fact that the Egyptian script starts from the right. When we, who write from left to right, start to draw a human being, a figure facing left probably occurs to us first. There are several proofs of the correctness of this second statement of Erman's, but none more satisfying than the one I shall describe. A New Kingdom painter sketched an ostracon with the window at which the king receives ['window of appearances'] and all the pictures surrounding it (fig. 311). In Egypt main figures in the decoration of real walls always face and complement

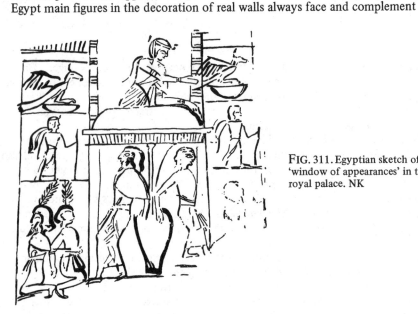

FIG. 311. Egyptian sketch of the 'window of appearances' in the royal palace. NK

[51] Erman–Ranke 1923.480. The behaviour of illiterate individuals and peoples in this respect should be studied.

one another;[52] and this was no doubt so on the window the artist had in mind. But in his drawing the birds and kings on both sides of the window-frame face right, and this must be because the impulse to make figures look to the right was so strong that in this case it overcame the one that always triumphs elsewhere, the impulse to symmetrical opposition. This statement of Erman's, like the other one about the treatment of the limbs (p. 293), has done a lot to enable us to understand the Egyptian method of representing human beings. Erman recognized that there is a considerable difference between figures according to whether they face right or left, and he made us aware of it.[53] We have seen that figures facing right do not give a unified view at all, but that a generally accepted standard form was developed, in which the form and position of the individual parts is fixed. It is clear that the situation was not entirely the same for *figures turned to the left*, so that when comparing several such figures one finds wide variety of views of the same parts. One example is the representation, which I have already discussed above, of a standing man with the long staff which, as we know from statues, was always held in the left hand, with the short sceptres in the right hand. In two-dimensional pictures of men facing right the forward arm in the picture, which holds the staff, counts as the left arm, and the backward one with the sceptre is the right one. Accordingly the left hand with its clenched fingers is seen from the inside (fig. 166), just as we should expect, and the right one is seen from the outside, while the horizontal sceptre passes in front of the body. If we were now to produce a complementary figure to this one which would face left without reversing the distribution of the sceptres among the hands, we could only draw it in a view from the back. In such a drawing the left hand on the body, which holds the staff, would show its back, and the hanging right one would show its clenched fingers. The sceptre would have to disappear behind the body, and the back of the loin-cloth, and not the front and the overlaid panel, would be shown. In reality there are no back views at all in Egyptian art before the New Kingdom (cf. p. 210), although they do not in themselves necessarily contradict the principle of depiction based on frontal images. Staff-carrying men who face left sometimes show the inside of the hand holding the staff, and sometimes the outside, and the same alternation occurs with the short sceptre. The sceptre itself is sometimes drawn over the thighs and sometimes disappears behind them. So every part is shown both in the same way as it would be in a figure facing right, and in exactly the opposite way; only the back view of the loin-cloth is never seen. Therefore the reversal of views of parts, as against pictures of figures facing right, relates only to these parts, and where it occurs its only function is to characterize them as belonging to the right or the left hand—if the artist accorded any value at all to the distinction. One should practise a similar restraint in treating the exceptional cases of apparently perspective parts of a figure that is represented according to frontal images (pp. 265–7). The importance of symmetry in these questions has quite correctly been emphasized; an example is the figures of dead men which face one another towards the door on the outside wall of a tomb, rather as in fig. 166–7. It is fair to say that the building up of a 'vision' out of individual images, which are not

[52] Propyl. 219 [there are enormous numbers of examples of this (J.R.B.)] 327 [Calverley *et al.* 1933–58.4 pl. 22 (J.R.B.)].

[53] Von Recklinghausen (1928) studies figures facing left (cf. Schäfer 1930.385 n. 247b); see also Bonnet 1924.

brought together to form a unified visual image, emerges on the whole much more obviously in figures facing left than in those facing right. Anybody who is afraid of succumbing to the inclination to view Egyptian pictures of human beings through modern eyes will find protection against this error in the observation of figures facing left.

Contradictions between an Egyptian picture and our modern requirements might arise if, when we used the notions of right and left, we put ourselves in the position of the figure represented. An Egyptian would more probably have distributed right and left according to their position on the picture surface. In a sacred book instructions are given for drawing the picture of the cow of heaven which forms part of the same book. One of the notes (Roeder 1915.146 1.9) says that the udder should be placed against the surface of the left shank (cf. p. 294). The picture itself[54] shows a cow facing left with its legs in a walking posture, and the udder is correctly placed in the surface of the forward leg, but that is the right one, and not the left one as the text prescribes. Unless one reckons with the possibility that the picture of the cow originally drawn for the text looked to the right, in which case the udder would have been against the surface of the left leg, one can only assume that the Egyptians called the leg that was on the left in the drawing the left leg. Another inscription[55] describes precisely how a defeated prince came to pay submission, leading a horse with his right hand and holding a sistrum in his left hand. In the picture which is meant to show the scene, and which is placed above the great inscription, every one of us would think that we saw the horse's reins in the left hand of the prince, who is facing left, and the sistrum in his right hand.[56]

Before we turn to describing further developments of the basic form, we should study another one, in which the equal, broad shoulders disappear, so that the whole figure appears to be reducible to a *side view* of a human being. But although we have added two further parts, the chest and the abdomen, to the others which were previously always interpreted as lateral images, we must take care not to say that the fundamental form renders a side view. The broad shoulders alone would refute that. We can only say that most parts of the figure are imagined from the side.

But a few fairly pure side outlines of human beings are found, even at the beginning of the historical period; these are where people are using both arms raised on one side (p. 4, 9 mid.) or when they are so tightly wrapped in a garment covering the torso that their arms are not free, as for example in fig. 248.

Thus in the Early Dynastic Period certain types of picture of the human body were combined to make a more or less unified view, although this had not been the aim.[57]

From the moment that the broad-shouldered basic form was completely developed, peculiar new attempts at side views can be seen. They are an example of how tenacious a form is once it has been created, for the new image only manages to separate itself from the basic form with the utmost difficulty, and it always retains important or minor elements of it mixed in with what is new.

[54] Erman−Ranke 1923.306. Reproduced again in Schäfer 1928.104 fig. 28. [Blackman−Fairman 1942 pl. 4 (J.R.B.).]

[55] Victory stela of King Piye (Pi'ankhi) 1. 58. The picture in Mariette-Bey 1872 pl. 1.

[56] Another similar representation with an accompanying text (LD 4.40c) was cited in the context of determining the Egyptian words for right and left (Chabas 1865.11).

[57] Klebs (1915a) produces a considerable amount of data on the history of side views [profile].

I know of no case where the width of the shoulder at the front in the picture has disappeared, while the back part is retained.

Mostly the reverse happens, and the line of the back is well caught by the artist. On the other hand one notices already on the Na'rmer palette (pl. 9 mid.) that the front outline of the chest could scarcely have as smooth a transition to the neck as the back does. Only by trying to draw the action oneself does one realize what is obscured by the supple flow of the movement of the arm, namely that the shoulder juts forward a little. This peculiarity becomes more marked from the beginning of the Old Kingdom on, under the influence of the geometric structure of the basic form. The shoulder that is turned away from the viewer, which is the forward one in the picture, protrudes more and more until it is quite as wide as in the basic form, and its arm is attached in just the same way as in the basic form (pl. 23—4). In this case the treatment of the shoulder turned towards the viewer splits into two sub-types.[58] *Either* the arm is attached to the chest at the same point as the other one, so that the figure looks as if the torso in the basic form has been folded longitudinally (pl. 16)—although this would of course be a false explanation of the processes involved (cf. p. 85), even though there is a Middle Kingdom painting (fig. 312) where two chest outlines are visible next to each other. Fig. 313 R renders the pose of the statue in fig. 313 L and centre in two dimensions: the artist wanted to show that both arms were in front of the body. *Or* at least it is appreciated that the shoulder turned to the viewer is foreshortened (pl. 23—4), and the beginning of the arm on that side is transferred to the outline of the back, in which process the armpit is almost never overlooked, though the shoulder is often exaggeratedly contracted.

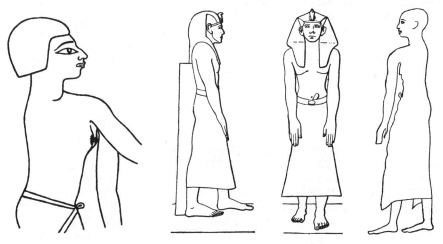

FIG. 312. Man picking figs. MK

FIG. 313. The same attitude of prayer in an Egyptian statue (L and centre) and in relief. MK

These two forms, which are still often executed in the crudest manner in the New Kingdom, especially in religious representations,[59] were originally linked to a

[58] Madsen treated these forms (1905.65), but the representation he started from is certainly of a hump-backed cripple.

[59] e.g. in Naville n.d. pl. 21; LD 3.67.

forward movement of both arms, and this remains true of the first one (pl. 16). But the second (pl. 24) is found from the end of the fifth dynasty even in calm, dignified standing figures of tomb-owners if they are shown as stout and middle-aged (not if they are shown as weak and old). These figures were particularly popular in the sixth dynasty and continued to occur into the Middle Kingdom. In them one arm really does hang down within the area of the torso. The line of the shoulders and shoulder-blades is normally brought a greater or lesser distance into the body, though the inside of the arm sometimes keeps close to the line of the back. These curious forms were abandoned for persons of dignity after the Middle Kingdom, and they were only adopted again in the archaizing Late Period.

It would be hard to credit that a parallel for this type of figure exists anywhere in the world. Yet they do exist. I refer briefly to the relatively frequent occurrences of forward placed shoulders in Cretan-Mycenaean and in Assyrian art. What is most striking is that the temple reliefs of Angkor Wat in Cambodia contain figures (pl. 97) which are not only surprisingly similar, but which also serve to confirm that this method of drawing the shoulder is a preliminary stage in the evolution of views from the side. For it must be noted that in this picture the figures that are drawn in this way are the ones which are turned with their heads in a pure side view towards the chief figure, the middle one, which should probably be imagined to be facing the viewer. In order to evaluate these lateral faces one should pass in review the endless series of reliefs where thousands of figures in three-quarter views are lined up, while there are only these few side views. And it is noteworthy that these heirs to Greek-influenced art maintained the use of the three-quarter view of the human face, once they had adopted it, with particular enthusiasm.

The Indo-Chinese pictures are representatives of a later stage in an art that was originally fertilized by Greek influence. In the peculiar drawing of the shoulder we have another confirmation of the fact that pre-Greek methods of rendering nature will in the end re-emerge on the surface, however long they have been suppressed by Greek ones. It would be wrong to think of Egyptian influence in this case.

These rather crude Egyptian forms satisfy the condition formulated on pp. 285–6, at least in part, by incorporating the shoulder that is nearest the viewer within the area of the torso. The further one also moves gradually back, and the harsh effect is softened by rounding the lines. Almost entirely lateral shoulders are applied to the human form and used more or less independently of the pose of the arm only from the sixth dynasty on, but even then they are extremely rare. The situation is the same in the Middle Kingdom, though some artists seem then to use the form a little more[60] than others. Even at the beginning of the eighteenth dynasty the preliminary stage I have described, of a lateral image of the shoulders, is still quite predominant. Towards the end of the dynasty the side view is probably preferred, although the choice often still depends on what the figure is doing and a completely pure lateral view of the shoulders is never produced, even where one might be most ready to see one, that is, when the line of the back is taken over the shoulder into the upper arm, as in pl. 54. In such cases anyone who knows Egyptian pictures in the originals will succumb to the flattery of the line which frequently encompasses complete parts of the body in one sure, bold stroke of the brush (cf. p. 77).

[60] See e.g. LD 2.126ff, that is, if the publication is accurate in this respect; this can no longer be checked; cf. p. 265.

The development of a side view satisfies an inclination which seemed already to be present in many elements of the basic form. So one might expect that the basic form would simply disappear. But this is in no way the case. We find next to each other a varied assembly of the narrow side view and, in a large majority of the figures, the broad-shouldered basic form. It is not only that the broad-shouldered form always remains the normal one for nobles (p. 62), it is also normal for the rest of the people. We should not dismiss the problem with a reference to the tenacity with which the Egyptians kept to their old habits in all fields. The solution is not arrived at by the application of a handy phrase; there seem to be other contributory causes.

The reader will not have missed the observation that the purer side view first occurs in pictures of living human beings in the sixth dynasty. I emphasize the word living, since this view is already present in the fifth dynasty, but it is only used—except as I have said for particular movements—for motionless human beings, in the rendering of *statues*. On whole tomb walls among the many pictures of human beings only the statues with upper arms hanging motionless (fig. 205, 314) show the more correct side view.[61]

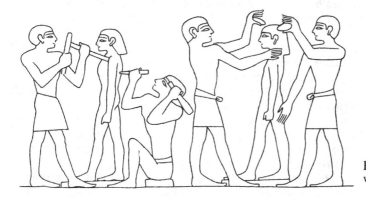

FIG. 314. Sculptors working on statues. OK

This fact has been related to a technique sculptors used (cf. p. 331, Edgar 1905. 147) of indicating the statue to be produced on the squared surfaces of the initial block. In that context the 'basic form' could not of course be used, and instead a 'pure lateral image' was as necessary for the sides (p. 105) as was a 'pure front image' for the front (p. 207), although neither of them constitutes an advance on the principle of representation based on frontal images.

But even if the procedure with the block as I have described it was really developed by the fifth dynasty, when side views of statues first occur, this would still not explain why what had been learnt for statues was restricted in drawing and relief to the representation of the shoulders of statues and was not taken over for living beings. The reason is probably a deeper one; that a picture executed consistently from the side was often felt to be somewhat lifeless, whereas the many-faceted basic form with its multiple references (pp. 299–300), whose contradictions were not felt, seemed to be the only representation appropriate to a living person. And for this reason the side view is always used—as it already was in the Early Dynastic Period

[61] Noted by Pietschmann in his translation of Perrot–Chipiez 1882–1903 *Ägypten* 866 n. 2.

(p. 302)—as an appropriate form for pictures of men restricted by being bound or by wearing tight garments which cover the arms.

From the eighteenth dynasty on there are occasional[62] figures of women with two breasts[63] and not one. In a painting discovered by Prisse d'Avennes in the eighteenth dynasty tomb of Qenamun (fig. 315)[64] the forward breast is seen as usual from the side, while of the other one only the nipple and its areola are visible, in the position they would have to occupy if an artist were told to draw them in a three-quarter view. The fact that the nipple is not encircled by a line marking the swelling of the breast fits very well with the softness of the swelling (cf. p. 16). Norman Davies convinced me at the time—and this has since been confirmed by the publication[65]—that Prisse's drawing is reliable, as was to be expected, even though, characteristically, it is too smooth. The original of fig. 316 = pl. 107 was found in the ruins of the Yati (Aten) temple at el Ashmunein.[66] As described on p. 288 and as is also the case with the hair in fig. 315, Amenhotpe IV's daughter's long curls covering her temples are drawn as if they lay on her shoulder. The pose of head, shoulder, and breast in these two oblique front views is identical. They correspond to the back view in fig. 284, and both are certainly not drawings from nature, although they use images derived from three-quarter views. I shall add to these examples another observation relating to the position of the navel. While it is placed close up to the front wall of the stomach in the Old and Middle Kingdoms, unless the figure has a paunch, like the ones in pl. 37 (cf. p. 285), this extreme treatment is softened in later periods. There is a smooth transition from the navel to the surface, and in the Amarna period the navel is often almost in the middle (pl. 47). The lines of women's thighs also move away from one another (p. 295).

It is instructive to compare the different ways of representing the official clothing which the vizier, the highest state official, wears from the Middle Kingdom on. The garment is a long cloak which starts below the chest, and is supported in front by two straps which start from a clasp at the nape of the neck. The oldest form, fig. 317c, which however returns in pl. 48 extreme R, renders the cords vertically in a front view. Fig. 317b, where the cords and their lower limits are brought close to the out-line of the torso, and fig. 317a, where they are led along it, can be understood on the basis of what has been said about the nipples and the navel. In pl. 48 R (the chief figure) the visual impression of how the strap runs over the curve of the chest eventually dominates, and this picture therefore corresponds to the three-quarter views of the breasts in fig. 315–16 (fig. 316 = pl. 107). The breast of the ptolemaic Harpokrates in fig. 218 is one of those Egyptian drawings which will probably never be satisfactorily explained. An explanation of the superficially similar girl musician's breasts in fig. 217b could probably be made if one were to assume that the girl was turned in such a way that the lute made it impossible to show the second breast.

Features like the ones I have been discussing suffice to make many contemporary scholars consider that a particular figure is intended as a whole to be an oblique view.

[62] Matz's remark (1923–4 [1925] 5), that three-quarter profile views were very common in the New Kingdom, is over-hasty.

[63] I was told long ago by Bénédite that the drawing of the spoon in Prisse 1847 pl. 48.2 was wrong. [Photograph and bibliography Wallert 1967. 144 no P 28, pl. 24. See below, p. 308 (J.R.B.).]

[64] [1879 *Atlas* 2 pl. 60 (J.R.B.).]

[65] [Davies's publication is reproduced as fig. 315 (J.R.B.).]

[66] [Not a temple but blocks from el Amarna reused as foundations (Cooney 1965, Roeder 1969). It would seem most natural to interpret the rendering of the breasts as a front view (J.R.B.).]

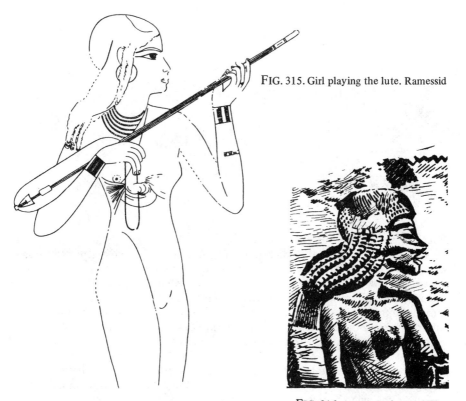

FIG. 315. Girl playing the lute. Ramessid

FIG. 316. Amarna princess. NK

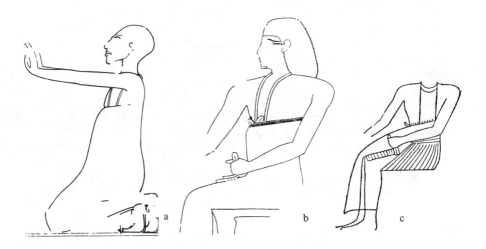

FIG. 317. a–c Viziers' dress. MK, NK

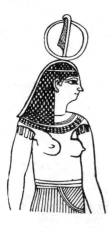

FIG. 318. Sun god. Graeco-Roman

Such is certainly inadmissible, as there is no ground at all for extending deductions about a detail beyond that detail (cf. p. 267). And this is of course especially true of a further idea: as these figures appear not to deviate much from the basic form except in these characteristic places, and as they are among figures in the basic form, one might wonder whether the Egyptians themselves understood figures which are entirely in the old image-based form as an assemblage of oblique views. But mis-interpretations of this sort, which I myself have at times not been resolute enough in avoiding, are produced again and again by people trapped in our modern way of looking.

Prisse himself showed how easily we read an oblique view into the basic form—though one must bear in mind his excitement at discovering the figure in the tomb of Qenamun—when he published in another book a wooden ointment spoon with a relief of a girl and gave the girl a second breast, which Bénédite confirmed does not in fact exist at all. Similarly draughtsmen of the beginning of the last century occasionally[67] introduced imaginary layers of muscle into Old Kingdom tomb reliefs, although they are worlds apart from the actual content of the originals they copied. This mistake is a pointer to the reason why we learn to adapt to the basic Egyptian form so relatively quickly and painlessly: we unconsciously interpret it as a three-quarter view.

This was already done by artists in Roman Period Egypt (fig. 318), and, as Wiede-mann noticed, this was also what the half-savage people of distant Meroe, who assimilated Graeco-Roman and Egyptian elements into their art, did when they drew their fat queens—but not their goddesses—in exactly the same way.[68] Of course, these late pictures cannot be used to provide hints for interpreting purely Egyptian representations.

That should conclude the study of the representation of human beings in Egyptian two-dimensional art, within the limits set for this chapter. But I should not like to finish without extending the present topic—the application of the results of Chapter 4

[67] e.g. Rosellini 1834 pl. 5. Compare also the wrong drawing of a spoon in Prisse (n. 63 above).

[68] In LD 5.48 a drawing of a breast like fig. 318 is next to one like fig. 207 middle. Wiedemann observed that goddesses still retain the age-old rendering of the breast at Meroe (1906.778, 804). Cf. LD 5.55.

to the special case of the human form—into a formulation which has already been implied.

It would be unjust to Egyptian artists not to mention what probably played an essential part in maintaining the broad-shouldered form as well as the side view. It is certainly no coincidence that among two-dimensional works of ancient and modern art at least four-fifths of the pictures of human beings are not even attempts to produce lateral images. So it seems in fact that for relief and painting a broad view of the human form is needed more than a narrower side view. This is quite independent of whether the approach is based on frontal images or on perspective. As we have seen, the narrower side view is very often useful for particular actions. And it can also become the true expression of the artist's cast of mind or of that of his period. But no great two-dimensional art will exist for a long time with pure lateral images alone. And this must have contributed to the retention in Egypt of a representation of the human form which makes the width of the shoulders unmistakable next to a narrow side view, despite the tendency discussed above to direct the figures' action only along the picture surface.

The many hundreds of square metres of reliefs at Angkor Wat, with their constant, identical three-quarter-view faces and torsos, show how another art was able to make do with scarcely more than one method of representation. It is worth recommending a walk among the plaster casts of these reliefs in the Berlin Museum für Völkerkunde,[69] and immediately after that a return to the Egyptian reliefs; one will acknowledge even more gratefully how correct was the sensibility of the Egyptian artists in developing representations based on broad-shouldered and side views, and retaining both so that they alternate beautifully, instead of limiting themselves to just one of them.

[69] [Now in West Berlin (Dahlem) J.R.B.).]

7 THE BASIC PRINCIPLES OF THE RENDERING OF NATURE IN THREE DIMENSIONS, AND HOW THEY RELATE TO THE PRINCIPLES FOR TWO DIMENSIONS

The first two chapters of this book treated of Egyptian art as a whole; the following ones on two-dimensional representation only glanced now and then at three-dimensional work. Now that we have learnt about two-dimensional representation the question arises, whether it is possible that depiction based on frontal images, while it is the dominant mode in two dimensions, is not in three. A rendering of objects based, as depiction after frontal images is, on a distinct mode not of expression but of the apprehension of nature, would have to govern representation in both two and three dimensions, although the forms produced would of course be different. It should be noted that the 'would have to' in my argument is not an initial hypothesis but the surprising conclusion reached at the end of a chain of thought. Everyone has probably accepted instinctively that the two areas of Egyptian art belong together, but the tendency has been to juxtapose them in a very superficial way. The realization that one cannot understand either correctly without having grasped how they are related intellectually in their rendering of nature is mostly lacking.

My task in this chapter then is to isolate the principle of depiction based on frontal images as the unifying element between 'pre-Greek' two- and three-dimensional works of art, and to transform the instinctive feeling referred to above into a well-founded conviction. So I shall primarily treat sculpture, returning to the whole in the process.

Diodorus (about 50 B.C.) relates (1.98) how the famous pair of sculptors Telecles and Theodorus, who lived in the fifth century, had produced a cult image of the Pythian Apollo for the people of Samos, by agreeing between themselves on the total size of the statue and then by one brother's completing the right-hand side and the other the left simultaneously, one of them on Samos, the other in Ephesus. Diodorus describes the technique employed and the finished composite statue, which resembled an Egyptian one 'in almost every respect'. The Greeks themselves were not concerned to have a method of work which would make it possible to fit separately produced halves together with such astonishing precision that the work could pass as that of one man. The Egyptians probably carried such a technique to the greatest degree of perfection ever achieved.

The passage, reproduced in its entirety in Appendix 2, probably goes back to Hecataeus of Abdera (about 300 B.C.), and was the stimulus for a book by Julius Lange, published in 1892 (Lange 1899), which was described by Furtwängler, quite correctly, as an 'art-historical discovery of the first importance, comparable to the discovery of a natural law'. In the following paragraphs I shall single out a few of Lange's observations.

Statues and statuettes of human beings and animals produced by all peoples not affected by fifth-century Greek art are divided into two symmetrically equivalent parts, if one imagines a plane running, in human beings, from front to back through the skull, nose, spine, chest-bone, and navel down to the split in the body, and

correspondingly in animals. This plane is unalterable, and is not bent or turned, in whatever other way the pose of the figure may change. So though a figure may bend forwards or backwards, it may not bend sideways at the neck or at the hips, and above all it may not turn. The legs are not always placed symmetrically, but their positioning is in accordance with the direction set by the torso and the head. The posture of the arms is freer still, but it remains strictly limited by that of the rest of the figure.

The opposed, 'Greek' type of sculpture can be represented by the Lysippus statue reproduced in every history of art, of a wrestler scraping off oil, sweat, and dust after a match. No such plane can be discovered in it.

Lange's law applies to groups of figures as well as to single figures. There is a fourteenth-century Egyptian group that might have been made to illustrate the method of 'pre-Greek' sculpture (pl. 88–9):[1] a king is holding his wife or daughter on his knee. He is seated with his head and torso straight, not turned, and his thigh and feet are at right angles to the torso. Both upper arms are in a parallel plane to these parts. The woman is sitting on the man's lap, exactly at right angles to him, in herself again completely obeying the law. Her head is turned at right angles, and her mouth appears to be touching his, in the piece as it stands unfinished, but, as Rudolf Anthes has observed to me, would later be separated from it. It is a sign of the strength with which the law rules Egyptian sculpture that this rigidly constructed group represents Amenḥotpe IV, and so belongs to the Amarna Period, the freest in all Egyptian art.

The discoverer of the 'law' linked it closely to symmetry, indeed he considered it to be based on symmetry. That is wrong and does not fit the facts. It must have seemed to Lange that a torso that leant to one side but was not turned in any other way broke the law which operated elsewhere. But he glossed over the fact that figures can turn their heads, even if only at right angles, just as they can in two-dimensional representations. And above all he failed to incorporate poses of the arms and legs, of which only a minority are symmetrical. Here he pointed out something different, that the legs are not always placed symmetrically, but that they follow the direction established by the torso; or that the positioning of the arms is even freer, but that it is still closely limited by that of the rest of the figure. But this is too easy a solution to the problem. For, first, the limbs are rather freer than the torso, but the fundamental aim expressed by this method of representing them must be analyzed: however big or small the piece may be, and in whatever material it may be made, the aim is to make at least one surface of the arms and legs which are in motion, or at any rate the upper arms and thighs, lie in planes parallel with or at right angles to that of the torso. Secondly, the positioning of the limbs is not conditioned by that of the torso alone. Why should they not jut out obliquely from a torso that is in itself symmetrical?

Lange's discovery is called the 'law of *frontality*'[2] and the works which obey it are said to be '*frontal*'. These words are unusable for my purposes; I should prefer to

[1] In Schäfer 1923a.23–4 I mistakenly took the wooden figure Fechheimer 1921.132–3 as an example of directional straightness; in fact it contains sharp turns, and it is now included below, n. 15.

[2] [Schäfer uses two words in the German: *frontal* for Lange's term and *richtungsgerade* for his own. In order to distinguish '*frontal*' as a rendering of the Lange term from Schäfer's *geradvorstellig* (based on frontal images) I place the former in italics. See further Translator's Introduction (J.R.B.).]

speak of a 'rule of straight directions'[3] or of 'fixed axes'. In this way the terms 'freedom of direction' or 'axially free' form themselves more or less automatically for the sculptural method of which Lysippus' wrestler scraping himself is an example.

This is not a simple renaming of Lange's law; a new rule has been put in its place. It cannot be based on symmetry, as that is visibly disturbed by various fundamental characteristics of pre-Greek sculpture.

In rejecting Lange's law I do not wish to deny him credit. Lange opened the door to a new understanding, for he sensed a fundamental property of earlier sculpture and discovered how widespread it was. In addition, he proved that two-dimensional works also changed when sculpture liberated itself. But he was unable to arrive at his final objective, an understanding of the reasons behind these parallel developments, from the starting-point of '*frontality*'; and in fact the more comprehensible situation in Egyptian art was a necessary aid to this.

Lange himself felt that a whole series of peculiarities in his '*frontal*' statues did not obey the rule of symmetry. *Frontality* and symmetry, he said, are not the same, although they are extremely close to one another. But symmetry will have to disappear entirely from the new rule: it has nothing to do with directional straightness. Only in statues of objects that are symmetrical in nature do the two normally coincide, and even then it is by chance, and only completely the case in very primitive figures. If the objects that served as models were not symmetrical, and the halves of their main mass were unequal, more or less like a leaf from a lime-tree, no three-dimensional representation of them would ever be symmetrical, although it would still be directionally straight. In order to illustrate this it is not even necessary to imagine new types of object, we can content ourselves with already existing objects whose movements break the rule of symmetry. Anyone who upholds the 'law of *frontality*' will, as I said before, have to designate as exceptions all statues inclining their heads sideways without turning them,[4] turning their heads sideways at right angles, or having asymmetrically placed limbs. But nothing in any of them goes against the rule of 'directional straightness'. For if a figure inclines without turning or turns only at right angles, as with the limbs in the statue group discussed above, one of the frontal views of each part will always remain within the criss-cross of planes parallel with each other or intersecting at right angles.

Primitive people and also the less sophisticated among our own contemporaries tend to position themselves '*frontally*' the moment they are going to be drawn or photographed, and if they are standing, they keep themselves 'at attention' [*Front machen*] in an almost military fashion. The use of 'at attention' may remind the reader that a drill officer also gives out his orders when the troops are '*frontally*' assembled. It may be useful to continue for the moment to use the word *frontality* in order to characterize contexts like this separately. This 'true *frontality*' may express either one of two things: an unconditional self-willed readiness to obey a higher power, or its opposite, a superior dignity that demands respect. The poses of Egyptian statues are doubtless meant to express these feelings in many cases. But that probability is not enough to explain the rule even for statues, let alone reliefs and paintings. There must be many peoples for whom the representation of human

[3] I already used the word *richtungsgerade* [directionally straight] in the 2nd ed. of this book (p. 35), but only as a German-language equivalent for '*frontal*'.

[4] [W fig. 415–16, cf. also n. 15 below.]

beings in a front view is the most natural mode, as it is in three dimensions. But we have seen that that is not true of Egypt. There, even where there is a cultic (p. 217) connection between the viewer and the figure represented, and where one would expect that the image would look at the worshipper '*frontally*' even in two-dimensional work, the image looks sideways without paying attention to him. So it is very unlikely that *frontality* could have conditioned the whole rendering of nature in sculpture as well. True *frontality* and the effects of representation based on frontal images may sometimes coincide, but they do not necessarily do so. Where it happens we have another case of the coming together of superficially similar phenomena which are however of quite different orders. But it can be seen that the two must be fundamentally separate[5] merely from the fact that a pure directionally straight statue admits of turning of the head, while a truly *frontal* one only allows the viewer to be 'face to face', or, etymologically, 'forehead to forehead'.

Shortly before Lange published his discovery Emanuel Löwy (1891.17) had identified the main elements of a law similar to Lange's law though not formulated in such an impressive and all-embracing manner, from the archaic Greek *kouroi* which had earlier all been called Apollo on the basis of the Diodorus passage referred to above—the most famous of them is probably the Apollo of Tenea in Munich.[6] Then in a later study (Löwy 1900.33, 1913[1915]) he made a statement whose implications go beyond Lange. Others had already observed before him that archaic Greek sculpture is fundamentally composed of four fairly sharply defined views at right angles to one another: the front one, two of the sides, and the back one. Anybody who knows Egyptian statues will say that they are still more clearly quadrilateral than Greek *kouroi*. Löwy states that these four views are those among the original artist's remembered images which make the first and the strongest and most lasting impression on him.

It is however not especially significant that the word 'image' [*Vorstellung*] crops up here again with sculpture after becoming so familiar to us in our discussion of two-dimensional representation, for I had a purpose in insisting on adding 'frontally viewed' [*geradansichtig*] to it on p. 91. But it is still tempting to follow up this clue to an inner relationship.[7]

More weight should be attached to the fact observed by Lange, that two- and three-dimensional representation both changed fundamentally at the same time. In Greece directionally straight sculpture began to give way gradually to directionally free work around 500 B.C. So this transition occurred at the same time as drawing based on frontal images began to give ground to obliquely viewed drawing. And the diffusion of the changes in two- and three-dimensional art throughout the world is the same. Just as it is only peoples and individuals who have been warmed by the rays of Greek art of the fifth century B.C. who draw using oblique views, these same people alone produce directionally free sculpture. All others make directionally straight works.

By drawing attention to the identical spatial and temporal diffusion, on the one hand of drawing based on frontal images and directionally straight sculpture, on the

[5] On directional straightness and dignity see p. 317.

[6] [In e.g. Gombrich 1968.100, fig. 85 (J.R.B.).]

[7] As happens frequently in this book, I give an exposition of the issue as it will appear to anyone who reads academic publications. Löwy's ideas were not the starting-point for my own.

other, of oblique drawing and directionally free sculpture, we have made a great step towards a solution of our problem: we can discuss with more confidence whether directional straightness in three dimensions is not closely related to the basis of two-dimensional work in frontal images.

Let us recall *very briefly the process involved in two-dimensional depiction.* When a 'pre-Greek' artist draws objects with one surface only (fig. 34) from nature, as we have seen[8] he does not feel his way over the drawing surface in accordance with his foreshortened visual images, but he follows his images of the unforeshortened objective reality. Therefore the surfaces of the originals are always treated as though the viewer were looking straight at them, although they are placed obliquely to him.

If objects are clearly understood as being three-dimensional and have distinct viewing surfaces the picture of the main surface is produced in the same way as that of an original with a single surface: it is set down in a straight unforeshortened view [gerade Sicht]. The artist adds the subsidiary surfaces to the main one, again from images of straight views (fig. 50). So it is even possible for pictures of dice to be made—and this does in fact occur in children's drawings—when the subsidiary surfaces are attached in squares above and to the sides of the main one. An Egyptian two-dimensional artist constructs his 'vision' of an object, that is a three-dimensional original, by reproducing the individual frontal images that seem important to him and composing them into a picture. In the process he changes his mental standpoint with almost every part—but it is a *mental* standpoint: in his role of two-dimensional artist he is fixed to the spot in front of his work surface. He cannot physically walk round his picture and work at it from different sides. Nor does he break through the picture surface, which is impenetrable to him, or at least is treated as if it were; so he has to spread out the surfaces whose dispositions his hand is imitating, and which are available to him in frontal images only, in *one* plane of the picture.

At the present juncture it is particularly important to recall these processes. For this purpose I shall refer again to the drawing in fig. 286a, where in particular the rectangular base dish which, as the companion picture (b) shows, was at a sharp angle to the artist's line of vision, should be noted. Again we see how vigorously the habit of drawing on the basis of frontal images lives on, even in people who have been influenced by the method of using oblique views—and it is clear from the mouth of the candlestick, which is not drawn like the base of the flower-pot in fig. 49, that our artist was.

Turning to *three-dimensional works* it is necessary to exclude from consideration the pieces that have been called *Brettchenfiguren.*[9] These (fig. 319) render the human form in a front view, and as they are 'pre-Greek' they naturally do this on the basis of frontal images, without foreshortening. Although they are cut from fairly thick slabs of material they have only one basic surface. So they and a few similar works, like the ancient Greek representation of the goddess of victory (fig. 320) in which it is especially clear how all the surfaces, even including the head, are deployed in an almost draughtsmanlike way[10] in a single plane, occupy a place between two- and three-dimensional representation, only much nearer the former.

[8] [Ch. 4.2.1 (J.R.B.).]

[9] [Flat figurines or 'Brettidolen' (Renfrew 1969.3) (J.R.B.).]

[10] Compare e.g. the kneeling figure on the cylinder seal Propyl. 470.6, or the early Greek one in Weber (1920.269).

FIG. 319. 'Flat figurine' of a goddess. From Troy

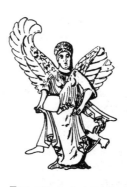

FIG. 320. Archaizing Greek figure of the goddess of victory.

But the real difficulties in interpreting the three-dimensional rendering of objects only emerge fully if the parts of the originals are not rendered in one plane, as in two-dimensional art, but their three dimensions are all present in the reproduction too. Here again some pieces must be left out of consideration, in this case those where there is scarcely any trace of a detailed treatment of the human form and, as for example in children's productions, the mass is simply rendered as a cylinder with a sphere on top of it. If the artist is no longer satisfied with an image of this sort the four sides are in most cases very clearly articulated, though transitions are of course made by means of a slight or considerable rounding of the surface. In Egyptian statues where the lower part of the body down to the feet is covered, the pose with one foot forward is retained: this is not so in the Near East (p. 295).

The creator of a piece of true sculpture based on frontal images can attack his work from all sides, as he also exploits the dimension of depth, and so is able, unlike a two-dimensional artist, physically to feel his way along the directions of the surfaces and lines of the original by removing and adding material.

With spherical originals the representation produces itself automatically. But if the original has one surface that makes a good starting-point a 'pre-Greek' artist will place himself in front of it in order to view it straight on [in gerader Sicht] . His treatment of the other surfaces depends on the nature of the original. If it is essentially and inalterably characteristic of it that its surfaces are *not* at right angles to one another they will also meet at acute and obtuse angles in the reproduction— imagine for example a three- or four-sided pyramid. This is not so with human beings and animals. The dichotomy between directionally straight and directionally free techniques only becomes apparent when we consider subjects like these, as their parts change direction extraordinarily frequently, but always return from any movement to a position of rest, and this position has two axes at right angles to each other: the width of chest and shoulders, and the direction of the head and of walking. This enduring characteristic holds a pre-Greek artist's attention so strongly that it is used as the basis for all figures of human beings and animals, even if they are executing a movement. They are fixed by these two axial planes which intersect at right angles. And at least one of the main surfaces of each limb adapts to these planes, so that they are in planes that run more or less parallel to the fundamental interior ones and look from the outside rather like a box. In sculpture a limb only rarely falls outside

the directions of both intersecting planes, although the artist's hand that is feeling its way as a result adapts itself to planes that are not shifted from the true, that is to unreal ones.

In this way the head, upper arms, and thighs in particular are brought together with the torso in an axially fixed directional unity. Therefore a pre-Greek three-dimensional work is mostly made up of four, or if one includes the worked under-side as in pl. 83, six views at right angles to one another, running in more or less parallel pairs.

Now if it is demonstrated that the same mental processes take place in the pro-duction of three-dimensional works as in that of two-dimensional ones, it is possible to understand what has hitherto only been established as a fact, that at the same time as two-dimensional works based on frontal images are replaced by works based on oblique images, three-dimensional works based on frontal images also give way to works based on oblique images. So the phrase 'based on frontal images' should apply to two- and three-dimensional art. I only persist in using 'directionally straight' and 'in fixed axes' here because they are more vivid in this context.

This newly discovered rule of directional straightness, which applies to statues of both men and animals, must appear different from the 'law of *frontality*' in the following respect. *Three-dimensional representations of human beings, animals, and other objects that are symmetrical round an axis, which are produced by all peoples and individuals who have not been influenced directly or indirectly by Greek fifth-century art, conform to the 'rule of directional straightness'. This rule results from the opposition between the method of representation based on frontal images and the structure of the objects serving as originals: a plane is imagined as a starting-point, and the other principal planes of the torso and limbs adapt to it to form an intersection of planes at right angles.*

Thus it is clear that Lange's 'law of *frontality*' only covers a small part of the ground. Indeed it is fair to say that it stood in the way of an insight into the nature of the relationships between two- and three-dimensional representation, though of course it was not possible to link them correctly at a time when the basic principles of two-dimensional representation had not been understood. But many discoveries that were important in themselves have later hindered the progress of knowledge by their very authority.

The sole though significant implication of Lange's rule is that statues and figurines are enclosed within invisible walls whether the limbs are freed or whether they re-main imprisoned in the mass of the material, as we saw on pp. 48–53.

Pre-Greek sculpture is not more based on a defined, unified view of the original than are reliefs and paintings (Blunck 1924.377); its basis is a 'vision'[11] which is then elaborated to form the work after the artist has received his inspiration. While in the vision breadth and depth are still intermingled, the two separate when they are attached to the framework of the two planes at the core and are reconstituted, with the help of individual additional or ordering images, to make a unity that can look very different from the visual image of the original object.

Very primitive figures really only render an abstract idea of a motionless human being or animal: a human being's arms hang down on both sides, and are not detached from the body at any point, nor are the legs of a standing figure separated at all. An

[11] [*Schau*, the image of a natural form conceived as a whole (J.R.B.).]

important decision was taken when the arms and legs were freed. The sort of impression this must have made can be gathered from Diodorus' legendary story about Daedalus of Athens (4.763), who was the first artist in Greece to free the limbs from the body in order to represent walking and other actions—though the story of course only applies to full-scale statues: small figurines with separate arms and legs are already found in early predynastic Egypt (Propyl. 175). In the art of the historical period the original method of representing with the forms still trapped in the stone continues to apply, even in the Late Period, to images of a few gods like Khonsu, Min, Ptaḥ, and perhaps Osiris;[12] in these cases the form that had been consecrated by age was retained in the later periods.[13] Some of these divine figures were later reinterpreted so that they appear to be figures clothed in close-fitting garments or held rigid by wrappings (fig. 60). It is instructive to note that statues of Min, like the predynastic figures from Koptos (p. 51) divide the legs by means of a furrow and indicate the scrotum and the kneecaps—the latter by means of triangles[14]—while later pictures seldom show these details.

The framework determined by frontal images is then, just as in relief and painting (p. 336), completed and given a new appearance which depends on the images, observations, and powers of expression which the artist has at his disposal. Already in the Early Dynastic Period the working of the forms of the body sometimes goes quite a long way, especially in ivory figurines of women. It is a lucky accident that the group in pl. 88–9 is preserved as an almost pure framework. It is possible to imagine on the basis of other complete works of Amarna art how much expressiveness, fidelity to nature, and charm the artist could have put into it.

It might be thought that the constraint of a rule would produce a deadening and intolerable uniformity, and many readers may have acquired a fixed belief of this sort from what they have read about Egyptian sculpture. In particular they will have in mind statues of tomb-owners and statues consecrated in temples. But just as we have found true *frontality* next to directional straightness on pp. 312–13, *the repose and the use of a small repertory of forms in these statues exists alongside the use of fixed axes and has a quite different foundation, which is the restraint in expression and self-controlled character demanded by the man's dignity, and by the placing and context of the statue.* And the demand for respect or the offering of it can equally well be expressed by poses of this type. At all events, it is not the rule of directional straightness which causes this uniformity. In fact a good sense of motion can be manifested within the limits set by the rule. There are for example many stone and wooden *servant figures* (statuettes placed in tombs as grave goods) in which one hardly notices that there is this invisible net cast over the representation: 'it is so alive it might be in motion, yet deep down it is fixed' (Hebbel, *Michelangelo*, 1855). Just as in two-dimensional representation, when artists later went over to directionally free perspective methods, they unleashed a variety of forms of expression so rich that the range produced by the axially fixed method and based on frontal images seems relatively poor.

Just as the regular form of representation in two dimensions, based on frontal images, appears in three dimensions in the guise of directional straightness or fixed

[12] As far as I know Erman was the first to state this (*Ausf. Verz.* 122, 249, 296).
[13] Cf. pp. 48–52 and Schäfer–Andrae 1942.75.
[14] Cf. Propyl. 179 [W fig. 27 (J.R.B.)].

axes, one would expect to find that two-dimensional exceptions (pp. 262–5), which I termed perspective-like or apparently perspective, have their counterparts in three dimensions, in *exceptions* that turn at angles other than right angles and bend at an oblique angle to the axes crossing at the shoulder. And cases of this sort do occur, very seldom in the Old Kingdom and still rarely in the Middle Kingdom, but more frequently in the New Kingdom. Even then, however, exceptions of this sort are found mainly in small pieces, more rarely in stone than in other materials, and more rarely still in hard stones than for example in limestone; altogether the number of cases is infinitesimal compared to the thousands of works with fixed axes.[15] The same is true here as it is with exceptions in two dimensions (pp. 265–9): our understanding is distorted if they are used to characterize Egyptian art to the same extent as works based on frontal images. Might it be that exceptions are commoner in three dimensions than in two? And if so is this because the hand is freer to feel its way over the block in accordance with the sculptor's image of the lines and surfaces of the original?

A large proportion of Egyptian statuary consists of groups in which a man and wife or god and man, standing or seated, clasp one another so that the weaker one places himself under the protection of the stronger, or the stronger one takes on the protection of the weaker. We have seen that in similar groups in relief or painting (p. 176) the two bodies scarcely ever nestle against one another; they mostly stand stiffly one beside the other with the arm grasping the partner frequently lengthened; alternatively the bodies may be close to one another so that one shoulder and part of the adjoining chest is obscured. In three dimensions figures that nestle against one another are not quite as rare.[16] The lengthening of the arm is also found, while other possibilities peculiar to sculpture are exploited in the rendering of overlappings: either the entire embracing figure is moved backwards so that its arm can overlay the other's body and remain parallel to it, or the obscured side of the body is moved back on its own or more than the other, so that the figure is turned slightly. This fact relates to my next point.

[15] The exceptions should be collected systematically. Below is a list of some material I have at hand: Fechheimer 1921.36 (Berlin 16202, Schäfer 1908.25). Burlington pl. 13 bottom [now in Møgensen 1930 pl. 15, A 64]. A bronze in the Athens Polytechnic (Lange 1899 p. XXVII). Von Bissing 1911–14.29, also text to 4, conclusion, and to 50, n. 3. Arundale–Bonomi n.d. pl. 24 fig. 87. The figures of goddesses which have their arms round Tut'ankhamun's canopic shrine in protection [two visible in L-H pl. 197 (J.R.B.)]. Weigall 1924 pl. 139 (H.R. Hall and Sidney Smith kindly inform me that the shoulders are at an angle of about 25° to the direction of the legs, while the head is vertically above the shoulders). Capart 1927–31.1 pl. 40–4. Hall 1923 pl. 20.2; but he is not 'drawn to one side by the rheumatisms of age', he was certainly carrying something. The piece is probably New Kingdom in date. A Late Period bronze Harpokrates in the Louvre [E. 7735] has its head turned half right [perhaps because it formed part of a group with Isis (J.R.B.)]. A limestone figure in the Louvre of a seated dog [E. 11657 (J.R.B.)] has its head turned slightly to the right. (References to the last two pieces supplied by Alexander Scharff.) Cf. also n. 1 above. [Late eighteenth dynasty servant figures or cosmetic jars which show axial freedom are not uncommon, cf. W fig. 412–18, 409, with n. 12 to p. 447. An additional statue is Copenhagen, Ny Carlsberg Glyptotek AE.I.N. 1597, Møgensen 1930 pl. 15, M fig. 646 (J.R.B.).]

[16] I only know two husband and wife groups in which the wife could be meant to be leaning against the husband, one in stone in the Pelizaeus Museum in Hildesheim [probably 2972, Hermann 1959 pl. 1a (J.R.B.)], the other in wood in the Louvre [probably the same as Aldred 1952, Old Kingdom no. 41, W fig. 140 (J.R.B.)] (both OK); cf. von Bissing's remarks (1911–14, text to pl. 4). On embraces see also Ch. 4 n. 134.

Some poses do not adhere to the rule but none the less should not be considered exceptions, because the only aim of the divergence is to place one hand or one foot at a particular point in the work, just as we saw was the case in two-dimensional works (p. 264). Suppose a man is carrying a tub in front of him with outstretched arms and the tub is much wider, or on the other hand much narrower, than his shoulders. The situation is similar though much more extreme, for example, in Middle Kingdom limestone figures of wrestlers, as in Propyl. 291.2.[17] Here the men's limbs and torsos are forced out of the directionally straight intersecting axes by sheer necessity, and this is probably the extreme of turning, interlocking, and intertwining found in Egyptian sculpture, to be compared with the lion licking itself discussed on p. 217.

FIG. 321. Children play-
ing a guessing game[?]. OK

FIG. 322. Cripple beating a boy. OK

Another instructive group figure of human beings is fig. 321 from the end of the Old Kingdom, which represents children playing. However, the nature of the game, in which one of the boys is riding on the back of the other's neck, facing in the opposite direction, is not clear.[18] The artist constructed the main part of his group with complete fixed axes, only twisting the head of the kneeling boy sideways and upwards. By a lucky chance there is also preserved a similar two-dimensional group (fig. 322). This latter must, it is true, be taken to represent a cruelly deformed cripple ill-treating a boy, so that its content is quite different; but, as Roeder was the first to recognize, it is formally almost identical.[19] So we again have an oppor-tunity to see how a problem is solved in two and in three dimensions. The most

[17] [Von Bissing 1911–14 pl. 29 (J.R.B.).]
[18] [See also Schäfer 1942.173 n. 2 with fig. 7.] [The piece has been illustrated several times, e.g. W fig. 134, Aldred 1952, Old Kingdom no. 56; he suggests the game may be leap-frog (J.R.B.).]
[19] [1939 (J.R.B.).]

striking fact, made somewhat less clear by the deformity of the cripple, is that in the relief the arm that is striking appears to be moved forward, while the shoulders in the statue group are at right angles to the direction in which the figure is looking. So the two pieces have the same relationship to one another as pl. 11 and fig. 134 (p. 146). The difference in the treatment of the heads of the underneath figures in the groups is also worth noting. If an artist of this period had wanted to represent a head turned at an angle he would only have had two possibilities at his disposal: either a turn of 180°, which would be impossible in this position, or one of 90° to a front view, which does not however occur in the Old Kingdom on live human beings performing an action (p. 209). The face in the statue group, which should according to the rule be turned completely to one side, has only been deflected into an oblique position by the exigencies of the pose. We now find an aesthetic charm in the contrast between the head and the body, but this probably did not exist for an Egyptian. It is likely that all he would have gathered from the work would have been factual information about a particular pose of the head. And anyone who reads a cunning, anxious, waiting glance in the face is certainly ascribing to the artist an intention which is quite foreign to Egyptian art as a whole.

This group teaches us how sculptors who used the procedure described in this chapter to produce their works coped with oblique turns when these were necessary. Roeder took it as obvious that they would still have used preliminary drawings, so that the position of the boy's twisted head on the block prepared for this group would have been occupied by a drawing based on an oblique view. It would then follow that not only sculptors but also other artists were familiar with representations of this sort, and if this does not seem to be the case in the monuments we possess the reason must be that the evidence has disappeared. But we do not know at all whether complete views of the figures to be produced were already drawn on the block surface in the Old Kingdom. And the conclusion that all artists must have been familiar with oblique views is completely untenable. Anyone who gives due weight to the fact that there are hundreds of thousands of faces based on frontal images in Egyptian art prior to the advent of Greek influence, and not a single one based on an oblique image, will have to agree that the conclusion is a hasty one. Even if it were assumed that one group was constructed with the help of preliminary line drawings, one would have to deduce that the head was freely worked from a projection that was left after the rest was finished.

Among *animals* the best-known true *exceptions* to the rule, figures of cats and other animals lying half on their side, are most strikingly represented by the great lions and rams from Amenhotpe III's temple at Soleb in Nubia. But in the lions[20] the rule is operative for the front paws, which are crossed at right angles, and for the direction of the head;[21] in the rams it is only the view from behind that shows us how directional straightness and the rendering of the oblique pose interact in the representation.[22] For the lion we can see in fig. 184 how a New Kingdom relief

[20] Propyl. 343 [W fig. 403 (J.R.B.)].

[21] Compare the hippopotami discussed on pp. 215–16.

[22] It would not surprise me if these figures of animals lying on their sides were influenced by Cretan art. The pose can be found in Egyptian statuettes from the MK on (Berlin 13892, Burlington pl. 50). The panthers in von Luschan 1919 pl. 44.5 (from Benin), and for example the recumbent dog in Engelbach 1923 pl. 14.8, show the appearance of a figure of this sort in an obsolutely directionally straight form, and they also show the importance of the image of the view from above.

artist solved the same problem [cf. also Sm pl. 150 A], only giving the raised jaw with its bared teeth a different expression. If one of the strict images of sphinxes (pl. 90) is placed next to the recumbent lions we have before us two achievements of equal inner greatness, and with the spirit of two high points in Egyptian culture. European art took both these forms over into its repertory.

Just as directional straightness applies to individual figures it also applies to two or more if they constitute an artistically unified group. The figures then stand next to each other, facing in the same direction, or in front of or behind one another, or at right angles to one another. The funerary models of herds of oxen, of boats with their crews, and of workshops with their artisans, that were placed with the dead in tombs and which I discussed on p. 38, are not always real artistic groups but rather, as Krahmer said, 'excerpts from reality', and indeed among the funerary models preserved there are many of little value, whose only attraction is their subject-matter.

Only the concept of representation based on frontal images can solve the problem of the nature of the relationship between the two areas of Egyptian art. No other approach will prove ultimately satisfactory.

Attempts have been made to approach the question using space as a starting-point, 'static' space as Krahmer [1931] calls it, or in von Kaschnitz-Weinberg's phrase, 'pure existential space' [reiner Seinsraum, n.d. (1933)]. The essential characteristic of both of these, in two (cf. p. 310) and in three dimensions, is said to be that they distinguish the three dimensions clearly so that they are placed in opposition, per-pendicular to one another. This is clearly the case in sculpture. But an attempt to include two-dimensional work in one of these spatial categories runs into difficulties. It has to be assumed that it has abandoned the clear-cut opposition of its three axes and placed one in the same plane as the other two, in other words made depth and breadth equivalent. Von Kaschnitz-Weinberg (n.d. [1933] 7 ff.) accepts this without hesitation, while Krahmer (1931.65) at least admits that all we could do is to recon-cile ourselves to this peculiar, and to us somewhat incomprehensible, fact, simply noting that static space results in Egypt in two especially sharply divided types of representation: a spatial one and another, in which all indication of depth is excluded and objects are rendered in a two-dimensional[23] form. It is astonishing that, at this point, where hypothetical space ceases in fact to be space, it should not have occurred to Krahmer or von Kaschnitz-Weinberg that it must be wrong to use space as the starting-point for an approach to the subject, and that another must be found to re-place it.

Since directional straightness encloses Egyptian statues as it were in invisible rectangular boxes we would seem to be dealing with something that could be called 'cubism'. And one could not object to the adoption of the word for Egyptian works, provided it was used to refer to the perception and formation of a work as an ex-ternal process.[24] But modern artistic theorists have declared for example that 'cubism in sculpture is the way in which the work of art fills the mass which contains it',[25]

[23] [Zwei-dimensional and not Schäfer's normal word flach; this is because the passage para-phrases Krahmer (J.R.B.).]

[24] On creation 'from the outside inwards' [von aussen heran] and 'from the inside outwards' [von innen heraus] cf. also Hamann 1908.37–42.

[25] Blunck 1924.377 [modified (J.R.B.)]. She also makes a number of useful observations on the points dealt with in the next few paragraphs.

and this formulation also includes the idea that 'the figure to some extent presses out of its own accord to make a form that fills the cube'.[26] But 'pre-Greek' sculptors knew nothing of cubism in this sense, so that it is better to avoid the term. If it is necessary to characterize a series of forms that tend to use right angles the words dice-shaped[27] or geometrical(ly rectilinear) are adequate.

As Löwy and others have observed, it follows from the dominance of the four main views that Egyptian statues do not in fact give an effect of depth. The spatial aspect of the work of art which is present in our minds did not at that time enter the artist's consciousness, and Greek art too only began in the course of the fourth century to come to grips with the problem of space in relation to sculpture.

The word 'cubism' (from cubus, a cube or die) is meaningless when applied to the tendency for Egyptian two-dimensional representations to use right angles. It could only be used for an art which possesses and uses in two dimensions the means to indicate corporeality.

In contemporary specialist usage the word has acquired nuances which render it completely unsuitable for a discussion of Egyptian art.

It is in addition always necessary when talking of Egyptian art to 'allow the angle eighty to a hundred degrees' from time to time, as the architect Theodor Fischer[28] wittily recommended for the drawing up of plans for ideal cities.

There is one curious link between two- and three-dimensional representation, which is not related to the basis of both in frontal images: the Greek *kouroi* discussed above (p. 313) have *their left foot forward,* and this peculiarity has been traced back to Egyptian models. And indeed Egyptian statues which represent human beings or animals in a walking pose, with very few exceptions, have their left feet forward. Whether or not the influence that has been assumed in fact exists, it is necessary to ask why Egyptian statues have their legs in this position. It has been said[29] that the Egyptians believed it brought luck to start out on the left foot. That may well be so, though there is no evidence for their having such a belief. But it is probably only necessary to state the correct explanation[30] for all others to be superseded.

First of all I shall draw attention again to the Egyptian artists' preference, originally noted by Erman, for making their figures of human beings or animals face right when they were able to produce them without being constrained by a relationship of symmetrical opposition or by any other factor which might make them face in the opposite direction.

Then let us bear in mind that we are dealing with the production of a figure in a 'walking pose'. When working the block the artist would naturally start from an image that showed the forward position of the stretched leg clearly, so that he could make sure of the proportions necessary in the material; in this case, as Erman observed, he would be represented walking to the right.

Associated with this was another rule of Erman's, that the legs of human beings and animals which are further from the viewer in two-dimensional representations are almost without exception the ones which are in front in the direction in which the

[26] Löwy 1913 [1915] 11, 33. [This precise phrase does not occur in Löwy (J.R.B.).]
[27] [*Würflig* in German can mean 'cuboid' (J.R.B.).]
[28] [1864–1938, architect and planner, influenced the Bauhaus school (J.R.B.).]
[29] Pietschmann in his translation of Perrot–Chipiez 1882–1903, *Ägypten* 685.
[30] Bénédite (1922.25 n. 1) was on the right track.

figure is moving. This detail will also hold good for statues in progress, and that brings us back to the point where we started. The relationship becomes much clearer in the period when the technique of drawing the outline of the figure on the prepared sides of the squared block is introduced.

If the sculptor had preferred the left side of the block this would be evident, as the right leg would be placed in front. But if one compares the left and right sides of a statue whose left leg is placed in front (pl. 86–7), one may be led to suspect that the left side of a statue is of lesser importance for the sculptor as well as for the viewer: if one views from the left the back pillar and the filling obscure the backward leg. This unfortunate view with one leg only, the one that does not carry the weight, is certainly the subordinate one.

Thus we have seen how the practices of Egyptian two-dimensional representation also come to apply in three dimensions. The same transfer can be shown to occur in a work of Hittite art, also based on frontal images: in a gate at Boğazköy-Hattusas two huge lion sphinxes on its framing blocks face anyone who approaches;[31] they are worked both in front and behind. The hind leg, which is stretched back to take a step, is represented in the same way that we found used in an early German book illustration (fig. 53a), except that the Hittite artist has exploited his liberty to reduce the figure at this corner of the block, and has run the back and side surfaces together by bending the leg slightly.

In modern books Egyptian statues are often shown in *oblique views* only. Yet we know that this does not conform to Egyptian sensibilities. Egyptians did not of course close their eyes when they happened to see a statue from such an angle; but when an object struck an Egyptian's eye in this way the oblique view as such did not give him pleasure as it does us. If he were presented with a mixture of oblique and straight images [*schräg- und geradsichtige Bilder*] he might put the oblique ones aside because they were restless and disturbed him, and select the straight ones. But this latter idea has been carried to the length of stating that we should, if we are to proceed in a properly scientific manner, only publish statues in straight views. That would distort the facts in two ways. As regards Egyptian artists' methods of work, we should be reminded of what we discovered about oblique views in the context of two dimensional representation (pp. 89–90), that they do not appear in the works themselves, but that they help at a subconscious level in their formation. They are latently present in the same way in three-dimensional works. It is inconceivable that even a directionally straight statue be completed without their assistance.

We come now to the question of how we should present Egyptian statues to fellow scholars. It is not enough just to achieve a general similarity, the range of forms of which we have instances must be reproduced as comprehensively as possible, and with a minimum of preconceptions. The primary method will certainly be to use full-front and side views. But although these give the basic information they often fail to register sculptural detail objectively.

For this reason, when I was preparing a publication of all the statues in Berlin, I had photographs made of at least one of the two oblique front views of every head which had any artistic merit. It would of course have been desirable to have many more pictures, but even if the number is limited to three a coverage of this order is probably only possible for large reference volumes or specialized monographs.

[31] [Akurgal–Hirmer 1962 pl. 66 (J.R.B.).]

Normally not more than one reproduction will be permitted, and then one may, depending on the purpose of the illustration and the nature of the object to be reproduced, use an oblique view without hesitation, although this is only because it will include the largest proportion of the detailed forms—which recalls Goethe's dictum quoted on p. 89, that we can only really comprehend an object from an angle of 45°. In this context the notion of a mental image is quite irrelevant, as is the restraint I have advocated several times in this book in the use of the word 'view' [*Ansicht,* p. 91]: here we are concerned to place every element of a piece in front of the viewer as firmly, surely, and unmistakably as a good cast would, regardless of how an Egyptian might have felt.

Apart from this, nobody who is concerned to grasp the essential character of Egyptian art will be able to disregard its basic requirement of frontal views. This is another point where an effort after genuine understanding parts company with the self-indulgence which, from another point of view justifiably, accepts stimuli from the work of art without asking whether these are not foreign to its nature (p. 5). It goes without saying that this applies to architecture just as much as to sculpture. Publications of buildings must also consist essentially of frontal views, although oblique ones need not be entirely avoided.

Egyptian statues of human beings and animals should almost always be exhibited in such a way as to show their front to the spectator. But as I have already mentioned it is by no means always the front which is aesthetically most effective. Interesting studies could be made as to which side should be accorded this pre-eminence in the various basic forms of statue, for example in standing figures, seated ones, block statues, the half scribes' pose with one leg placed vertically, or the full one in which the figure is squatting cross-legged, various kneeling postures, figures leaning forwards or backwards, and so on. A view could be singled out for the greater number and clarity of its distinguishing marks or for its beauty, or for both; the other sides will exhibit these qualities to a lesser extent.

Thus for example the lion head in pl. 79 only really reveals its attractiveness in a side view, and the front view provides a notable contrast in this respect. There are not many otherwise good works where one view is so much superior to another. But even the portrait bust of Nafteta (Nefertiti)—and probably the beautiful queen herself—will be found to be most effective in a side view, and will have been found to be so in the past.[32] The artist certainly started from the side view when he conceived the work, though it was equally certainly set up to be viewed from the front when completed. But the two views do not depart as significantly from one another in a work of this excellence as in the lion's head. It was an essential aspect of the artist's ability, how well he was able to reconcile the separate images of the breadth and depth of an object. The Amenhotpe III recumbent lion from Soleb[33] cannot be faulted from this angle. There are of course also figures whose front view must be taken as the starting-point. It depends on the structure of the figure represented.

Anybody who looks at a number of Egyptian statues in succession will inevitably find that the front and side views are not equally important for all the parts of a figure. It is necessary to remember what was said about two-dimensional work, where the artist pursues his 'vision' of a human figure in frontal images, changing his stand-

[32] This is obvious in the case of figures kneeling stretched forward. One example Fechheimer 1921.96; another with the preliminary drawings Schäfer 1931a pl. 50 (Berlin 21238).
[33] [W fig. 403 (J.R.B.).]

point for almost every element in the process. Similarly a sculptor placed himself differently in relation to the chest and the legs of a figure, and so on. This opposition is clear enough in standing figures, but still sharper in seated ones (Löwy 1913 [1915] 25 n.1). Artists only registered turns in their originals in right angles, changing their physical and mental standpoint at the same time, almost always excluding inter-mediate postures: we can now see the reason for this. The artists' expression of their 'vision' adhered to fixed axes, and this fact must be related to the Late Period practice in which Egyptian sculptors' apprentices were taught at first to make individual parts of the body, so that we have large numbers of separate heads, torsos, hands, legs, and feet (pl. 75) etc., among the apprentice pieces preserved from workshops. In direction-ally straight sculpture the knowledge gained in this way could immediately be applied in any context,[34] provided that the correct relative proportions of the parts were observed when combining them. The results of an application of this technique in directionally free work can be seen in the curious Hellenistic-style bronzes from Galyub in the Hildesheim museum (Ippel 1922.20 para. 4), where an Egyptian who produced the casting patterns perversely used a piecemeal technique which was practical for his native directionally straight works but impossible for directionally free 'Greek' ones.

As was already observed on p. 26, one should not fall into the error of thinking that the geometrical nature of the new art was determined by building with squared blocks.[35] That technique evolved when the geometrical tendency was already strong enough to suggest it. 'The cube of stone to be worked guided the Egyptians just as little as it did the archaic Greeks; it was there to obey, to adapt itself to the artists' formal inclinations.'[36]

It must of course be admitted that many Egyptian sculptors will have inserted a figure in a block in their minds' eye, and it might be imagined that the inventor of the block statue was one such.[37] But it was certainly not a regular, rectangular block for building that provided the stimulus, but at most a rough-hewn one which corres-ponded approximately to that form. One might remember the man who conjured the Great Sphinx at Giza out of a ridge of rock about twenty metres high and seventy-five metres long.

The presence of a figure hunched into a 'cube' among Michelangelo's work can probably be explained along the same lines: the piece in question is the Leningrad figure of a crouching boy[38] who is stretching both his hands out towards the toes

[34] Diodorus' assertion (see Appendix 2) that Egyptians made their statues out of previously completed parts may originate in this characteristic.

[35] Borchardt (1928) discusses a teaching relief which probably dates to the third dynasty. Cf. Capart 1927–31.1 pl. 2 – unless the piece is a Late Period archaizing work. [There is a comparable piece in the Metropolitan Museum in New York which is generally taken to be early (Hayes 1953.56–60, fig. 37, W fig. 164).]

[36] What follows is based partly on Löwy (1913 [1915] 10, 19).

[37] p. 51. Cases where there are still block surfaces around the squatting figure are important for the history of the form (Firth–Gunn 1926.2 pl. 41). A very remarkable standing statue from the time of Ramesses II may be compared with these block statues (Wennofer, in the Louvre [A66], Alinari photo 23886; Wreszinski drew my attention to this, producing photographs from several angles). In this statue the human figure is contained in a rectangular pillar of stone whose surfaces and corners are retained, partly (next to the head and between the loin-cloth and the feet) by using 'bridges'. [On block statues of this type see now Müller 1966, Eggebrecht 1966 (J.R.B.).]

[38] [Cf. Ch. 2 n. 123 (J.R.B.).]

of his right foot and bending his head in the same direction. And if one can assume that in this case Michelangelo saw a block which he envisaged as a human form, this could also be imagined to be so with the David in Florence. The history of the making of the David is different in so far as the block in question had been intended decades earlier for another statue of a human being but had been damaged while being worked.[39]

The beautiful description of a sculptor's work in Michelangelo's madrigal to Vittoria Colonna has nothing to do with 'envisaging' a figure in a block, but will rather apply to any figure that is produced by removing material: 'Lady, as when stone is chipped from a hard alpine block a living figure takes up its place within, and grows there more the more the block shrinks, so . . .'–(the following lines relate the poem to its dedicatee).[40]

[Schäfer did not complete the rest of Chapter 7. He wanted to include a critical discussion of Anthes's 'Werkverfahren Ägyptischer Bildhauer' (1941), but came to a halt in the middle of composing it. I have therefore used Schäfer's own corrected copy of the third edition as the basis for the missing section.][41]

The result of this dominance of the four main views in 'pre-Greek' three-dimensional work is that when we view Egyptian statues frontally they *give us no artistic sensation of depth* (Löwy 1913 [1915] 11). But just as Egyptians deduced images of depth to which we are not sensitive from their two-dimensional works (p. 101), when they contemplated a three-dimensional 'pre-Greek' work the front and side views coalesced in their minds to produce an image of depth. We no longer create on the basis of frontal images, and we prefer to place ourselves at an oblique angle when photographing Egyptian works of art, so that we can document the two views at once. The same opposition applies here which I expressed on p. 89 in the form of an imaginary conversation between an Egyptian and a Greek, using also Goethe's statement of the importance of oblique views, which was produced by a 'Greek' mind.

It is extremely important, after all these observations and all this theorizing, to study more closely the *technical procedures* of Egyptian art and to see how they relate to what I have said. Nowhere are we as fortunate as in Egypt in being able to watch artists at work in their studios.

It is reasonable to suppose that in the course of the centuries major Egyptian artists laid down how a craftsman should go about producing the main poses of human beings and animals that occur in art, in order to achieve an absolute balance and a perfect assurance and beauty (pp. 332–4). This store of experience, knowledge, and wisdom would then have been passed on in studios from generation to generation, and would have increased. The amount of preserved evidence for the existence of this studio tradition grows from year to year, and new information on detailed points is constantly being unearthed.

In the Old Kingdom frameworks of lines and dots (fig. 323) are used for the composition of two-dimensional works, and these are replaced in the Middle Kingdom by squared grids (fig. 324) which, like the frameworks, fix the proportions of the figure.

[39] [This does not seem to be so: Michelangelo appears to have completed a statue begun by Agostino di Duccio, perhaps under the supervision of Donatello, some thirty years earlier (Cf. Seymour 1967.27–41) (J.R.B.).]

[40] [Michelagniolo Buonarotti, *Rime*. Bari: Laterza 1960, 82 no. 152. Schäfer uses a translation by Rilke. The translation here is my own (J.R.B.).]

[41] [The terminology in this section has been modified to make it consistent with the rest of the book. Translations of *geradvorstellig* and *Regel* have been substituted for ones of *geradansichtig-vorstellig* and *Gesetz* (J.R.B.).]

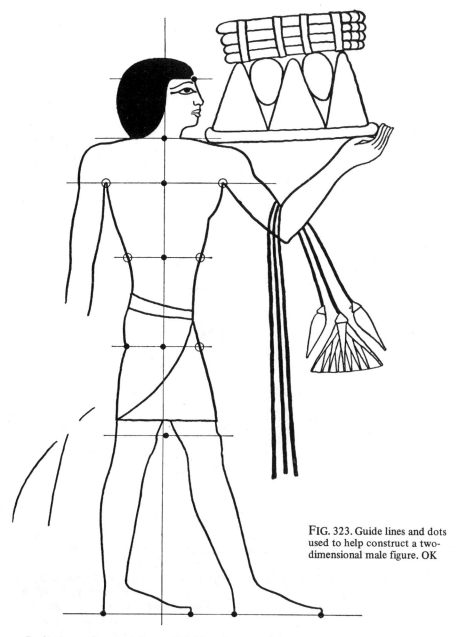

FIG. 323. Guide lines and dots used to help construct a two-dimensional male figure. OK

Preliminary drawings for works of sculpture—chiefly in stone—are preserved from about 1400 B.C. on, the earliest from the sculptors' studios at Amarna. An example is a monkey's head (Fechheimer 1921.89) which is completely worked in front, but flat at the back from the top down. The front view of the head has been roughly daubed in black on this surface. The piece was evidently meant to serve as a guide

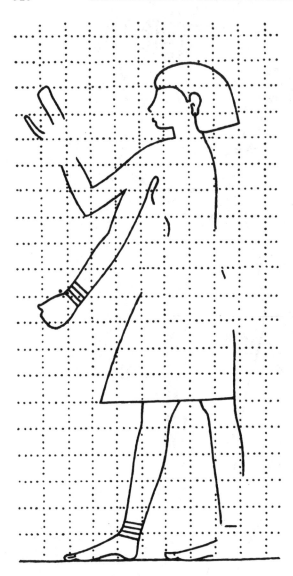

FIG. 324. Grid for sketching. MK

to a pupil, showing on the back the first stage of work for the front view, and on the other side the front view itself. And on a half-finished statuette of a king kneeling stretched forward[42] the side views—which are of course by far the most important— and a few strokes of the front view, have been drawn with a fine brush. Several other unfinished pieces of sculpture with outlines and frameworks painted on them have been found elsewhere at Amarna. Fundamentally the same procedure, schematized in the precise geometrical form of a squared grid, is found also in the Late Period. Here we can see how an artist who wished to produce a figure of a human being or

[42] Berlin 21238 (Schäfer 1931a pl. 50).

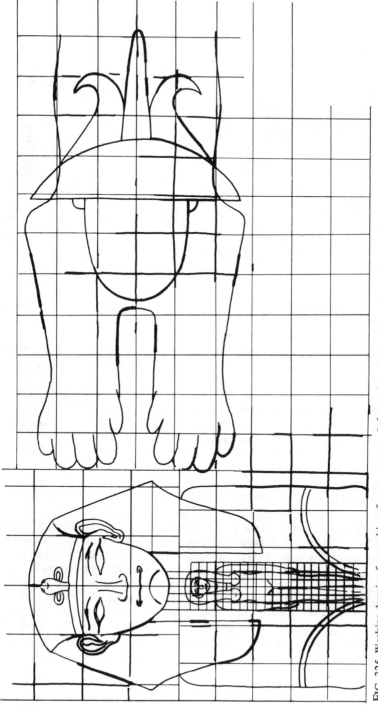

FIG. 325. Working drawing for a sphinx, from a papyrus. L front view, R view from above. [A piece from the left side view, showing the forepaw, is also preserved, but is not reproduced here.] Graeco-Roman. [Only small fragments of the papyrus are preserved. These are shown with thick lines; thin lines indicate restoration (J.R.B.).]

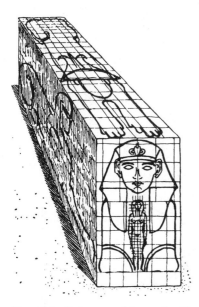

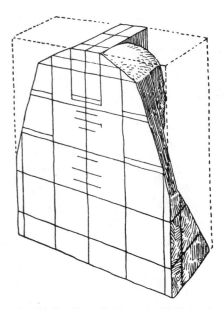

FIG. 326. Block prepared for work with
preliminary drawings of a sphinx.
Sketched on the basis of fig. 325

FIG. 327. Teaching piece, king's head, back
view. Late

an animal just as he had been taught to do it—which was by no means always the
case—cut his block at right angles and covered the surfaces with the linear grid. On
this basis he sketched the figure completely on every side, more or less as he saw it
hidden in the block behind the sketch (pp. 85, 332). There is a papyrus preserved
which shows the front, side, and top views of a sphinx drawn in this way (fig. 325).
Fig. 326 and pl. 91 show sketches of this sort transferred in an appropriate manner
to a block. The process was somewhat simpler if the artist only noted the position
of the various parts of his figure by means of lines on the grid, rather as in the frame-
work for the two-dimensional representation in fig. 323. Fig. 327 shows a head of
a king that has only been begun; I have drawn it from the back, restoring the shape
of the original block with dotted lines. Thus the original piece which, like the monkey
head discussed above, only shows the front half of the head, has at the back the
initial stage of work, and in front a more advanced one, again as in the monkey head.
As I said, the first certain examples of these two methods, often punctiliously worked
out down to the last detail, date from shortly after 500 B.C., and we do not know
exactly how far back the techniques go; but they are certainly several centuries older.
It is clear at all events that the basic idea of the procedure is the same as existed a
thousand years earlier. Many half-finished Late Period statues (e.g. Propyl. 447.2)
still bear traces of the original surfaces of the block with their lines marking the
parts of the body. Of course, one part after another of the grid and the preliminary
drawing became victims of the work as it progressed (pl. 91); the drawing was then
repeated at various removes. This too is shown by the finds from the studios at

Amarna,[43] among them the figure of a kneeling king discussed above. In addition, the whole figure is mostly worked at the same rate; one part is not finished before the others. So the whole has a unity at every point. As soon as the first rough stages, still completely geometrical, were passed, the succeeding layers were removed by wearing down the surface with blows, chiselling, drilling, and polishing (cf. pl. 75). It can be seen from granite and sandstone heads from the studio of Thutmose, where the lips of unfinished works have been painted red, how much Amarna artists at least tried actively to achieve the final effect of their works even before the last stages.

In the passage referred to at the beginning of this chapter Diodorus (p. 310, see Appendix 2) relates the joke practised by two famous archaic Greek sculptors. Telecles and Theodorus, the sons of Rhoecus, agreed on the dimensions of the cult statue of Apollo they were going to make, and then each produced one half of the statue, one of them in Samos and the other in Ephesus. When the right and left halves were placed together they fitted each other like the unified work of one man. There is no need to ask whether the story is in fact true. In principle an archaic Greek, i.e. 'pre-Greek' and therefore directionally straight statue which used Egyptian methods of work, to which Diodorus refers specifically, could probably be produced in this manner. We possess a very satisfying demonstration of the precision with which the Egyptians themselves were able to maintain identical proportions in companion pieces: two reliefs with the same subject-matter were found in pieces in an excavation at Thebes (Winlock 1923.35), neither of them complete. But the discoverers were able to compose pieces taken from both reliefs into a single picture, and nobody would suspect that the result was not a unity from the start.

If Egyptian sculptors had a training of this order one can scarcely assume that they would have set any store by a full-scale clay model for a whole statue.[44] A trained artist could dare to set to work at once on the block itself, without any risk of ruining it in the carving.

The frameworks of lines lay the foundations for the figure's proportions. This applies to work in three dimensions as much as in two: the proportions are not arbitrarily altered within a single figure. Just as the reduction of more distant figures is unknown in two-dimensional work, it never occurred to the Egyptians, even in the largest colossal statues, to make the upper parts larger, for example, as a concession to the perspective reductions which we find disconcerting. As we know from Plato (p. 87) Greek sculptors did something of the sort from the end of the fifth century on. In groups of several figures the Egyptians often use several different scales as they do in two dimensions, for example when the head of a family is singled out from his dependants.[45] On the other hand the rule that in groups the tops of figures of equal status are on the same level, whether the figures are standing or seated, applies here as it does in two dimensions.[46]

Anyone who knows the carefully elaborated technical processes of Egyptian art[47]

[43] Unfinished works from the workshop of Thutmose at Amarna (Berlin); also an apprentice piece for a torso, Late Period, Berlin 23218.

[44] The situation is different with models of parts which are executed separately, as with the casts of faces discussed on p. 58.

[45] Propyl. 242 [W fig. 130, remote parallel M fig. 221, W fig. 116], 333 [W fig. 392 (J.R.B.)].

[46] p. 234. Propyl. 231.2 [near parallel M fig. 221 (J.R.B.)].

[47] Gardner (1890) assumed without knowing it that archaic Greek sculpture was produced in a way very similar to that used in Egyptian sculpture. On the development in Greece see

will be able to see how superbly they fulfil the requirements of representation based
on frontal images. They produce the directional planes, in which the frontal images
of the parts of the body would in any case come to repose without the method of
using squared blocks (p. 315), before the beginning of the actual work, and in the
concrete form of the block itself. None the less one must not misunderstand the
nature of the situation and fall into the error of reversing the relationship between
the factors by assuming the rule of directional straightness to be derived from the
method of work. That is not its source; it comes from the human mind. 'It is not
outside, only a fool seeks it there/it is in you, you bring it eternally forth.' Just as it
should never be forgotten that not only sculptors in stone and wood, who remove
material as they work, but also artists in clay and metal, who add it, create direction-
ally straight figures, it should also be borne constantly in mind that the rule also
applies to ancient and modern peoples among whom no trace of the fixed block
procedure, nor indeed the simplest preliminary drawing for a three-dimensional work,
is found, i.e. it applies even to the earliest prehistoric art. One has only to refer to
two-dimensional work. There it is quite obvious that the frameworks and grids of
lines were not the origin of depiction based on frontal images. It is impossible to con-
sider the process of work to be the reason for three-dimensional animal and human
figures fitting into planes that intersect at right angles, and for all the objects and
parts of objects in two-dimensional representations being spread out on the surface
on the basis of frontal images. On the contrary, the form of Egyptian works is the
most appropriate garment for the essential features of representation based on
frontal images. On the one hand it exhibits these features in the most emphatic way,
in the form of a strictly geometrical section. On the other hand it reminds us (p. 19)
that the geometrical stamp which it was given is one of the chief elements which
originally went to produce a truly 'Egyptian' art.[48]

Of course, the preliminary drawings on the surface of the block of a statue do not
have the same appearance in every respect as a two-dimensional work (pp. 85, 305).
One has only to consider how different a human shoulder will have to be on the
side of a block from what it is in a normal relief or painting. A 'pure lateral image' is
necessary here, while in other reliefs or paintings the shoulders are shown spread out
as on the front surface of a statue block. The pictures have an identical basis in frontal
images, but they appear different because of their different functions. The fundamental
opposition is at work here, between two-dimensional representations and three-dimen-
sional ones produced by removing material. In two-dimensional work the hand which
feels its way over the picture surface in accordance with the artist's image of the lines
surfaces of the original intentionally lets itself be deflected on to that surface by
the latter's own resistance, and spreads out in a single place lines and surfaces corre-
sponding to those of the original, a process which results in the 'directional neutrality'[49]
mentioned several times in other chapters of this book. The sculptor, on the other
hand, already when he is making his preliminary drawing directs his attention to
breaking through the stone, to grasping at his image of the position of the parts of
the original in space. In this context 'directionally neutral' forms of the type found

Blümel 1927.10 ff., and in Italy Goethe's translation of Benvenuto Cellini's autobiography
(1803), Appendix 9.2, *Skulptur, Marmorarbeit.*

[48] [The editor has omitted pp.323 middle–325 top of the 3rd ed. (Schäfer 1930) at this point,
as the passage repeats material discussed earlier in this same chapter.]

[49] p. 152, 217–18, and *passim.*

in two-dimensional works or even in the goddess of victory in fig. 320—who is indeed flying towards the viewer with her body turned completely in his direction—cannot occur.

Thus the Egyptian two- and three-dimensional works of art are visibly and invisibly related in the closest degree. The to us surprising composition of a sculptor's 'vision' out of individual images of a two-dimensional character is not an intellectualizing Egyptian aberration[50] but, as can be shown in ancient American and Slav (Von Sydow 1923.381, 395, 489) and other similar works, a fundamental element, present from the beginning (pp. 313–14). The further development which led to Egyptian technical procedures is no doubt a product of the intellect; none the less it is not an aberration, but the attainment of the goal set for 'pre-Greek' art. *From the time when their art acquired its own language the Egyptians, in both two- and three-dimensional work, brought to a state of classical purity something which, except where it was influenced by the Greek fifth century, underlay the representational art of the whole world almost like a dream, displaying in the process a unity and precision of purpose scarcely to be found elsewhere, so that the resultant product almost seems to belong exclusively to them.*

The procedures invented by the Egyptians for the preparing of a two- or three-dimensional work of art are, as can be seen from my description, indissolubly linked to fixed proportions in figures, to a 'canon of proportions'. For not only are the dots and lines of the helping framework in fig. 323 always of course in the same positions, the lines of the squared grid (fig. 325) always intersect with the body at the same points. So they really do establish the proportions of the work of art, and are thus different from the similar grids which we also use, but which only serve to transfer a design from one place to another at the same scale or at a different one. In this grid it is a matter of complete indifference where the lines intersect with the figures.

If we consider that every figure in a 'pre-Greek' two-dimensional work of art can be repeated at a different point in the same picture with only its scale changed,[51] and that the limbs of the bodies are always spread out uniformly without foreshortening on the picture surface, we can see that the method of representation based on frontal images, when used by a people with the Egyptians' feeling for geometry, is the most favourable breeding-ground for a system for fixing proportions and for its further development. Only in such a context could lines and dots indicating proportions be used to the extent to which they were in Egypt, where they are found wherever one looks.[52] It would make very little difference indeed whether the proportions were deduced from measurements of large numbers of human bodies, whether they were read off works of art which were considered exemplary and in closest harmony with the formal sense of a period, or even whether they were established by a single artist on the basis of his own sensibilities. There is no means of deciding the issue, though we can probably reject *a priori* the idea that the average was taken from measurements of large numbers of bodies; it is quite implausible for the period in question.

[50] As Worringer maintains (1927.83).

[51] Cf. p. 152, and for corresponding phenomena in three dimensions p. 315.

[52] Since Lepsius's fundamental essay in LD Text 1.233–6 the best treatment has been Edgar's (1905). Since then the material has grown considerably, cf. in particular Mackay 1917. It would probably be worth collecting it afresh. [Cf. now Iversen 1955, 1957, 1960, 1968, 1971, Hanke 1959, Munro 1969, Wolf 1957 Chapter 60.]

More detailed study might well reveal a significant division within Egyptian art in the use of the canon of proportions.[53] For while the rules governing proportions in figures of living beings were evidently generally adhered to, at least for long periods of time, this does not seem to have been the case outside the area of animal and human forms. In these cases too the artist took into account certain of the proportions of the parts when he prepared his working drawing, but it seems to have been left to his own judgement how he should order the sizes of objects. For example, the Egyptians never seem to have arrived at establishing a generally valid ratio between the height and thickness of columns.

It is clear that the significance of the search for a canon, and the course of that search, in Egypt, Greece, and the Renaissance, are different in each case.[54] An Egyptian's search should not for example be interpreted on the lines of Dürer's saying: 'Truly, the rule of art is concealed in nature; he who can pull it out has it. If you can seize it, it will save you from many faults in your work. And through geometry you may give your work much certainty.'[55] Each of the three has a completely different intellectual background. But it is without doubt true that the Egyptian solution continued to exercise an influence on Greek, Renaissance, and later efforts in the same direction, sometimes giving life and sometimes no doubt stifling it.

For the effect which aids of this sort have on art always has positive and negative aspects. In Egypt they were on the one hand a strong support, and raised the average level of art, keeping it strikingly high. We can now understand why Egyptian pieces, even of moderate quality, still almost always possess a certain degree of sureness and dignity. On the other hand they encouraged the tendency to work with formulae, to which Egyptians were naturally easy prey. And it cannot be denied that the sensitively worked-out rules of proportion in the end became oppressive (cf. p. 302) and must have crushed a fair amount of talent, especially at the time when they determined everything down to the smallest detail, and when the sources of inspiration of Egyptian art had themselves become stale (pp. 67–8).

[53] [*Verhältnisschlüssel.* On the previous page Schäfer uses *Proportionskanon.* The meaning is in practice the same (J.R.B.).]

[54] [Cf. Panofsky 1955a Chapter 2 (J.R.B.).]

[55] [Albrecht Dürer, *Vier Bücher von Menschlicher Proportion* (1528), Appendix to Book 3, 'The aesthetic excursus'. Schäfer has modernized the German. Part of the German text and translation, Panofsky 1955b.279 (J.R.B. I am indebted to Prof. E. Wind for this translation and references).]

8 CONCLUSION

> If one is not to sacrifice the ability to produce
> a general survey one must have some knowledge
> of as many areas as possible, apart from being a
> master in one's own restricted field; not to do so
> is to remain ignorant of everything except one's
> own speciality, and in some circumstances to be
> generally uncouth.
> Jacob Burckhardt, *Weltgeschichtliche
> Betrachtungen.*

By bringing together two- and three-dimensional representation I have brought full
circle the task I undertook in this book.

I have shown that the fundamental principle of the rendering of nature in both
areas, representation on the basis of frontal images, applies to anything from child-
ren's, Stone Age, and modern primitive art to the highest achievements not only of
Egyptian, but also for example of Babylonian, Cretan-Mycenaean, early Greek,
ancient Chinese, and ancient American art, whether it be two- or three-dimensional,
made of stone, metal, wood, or any other material. This method of depiction based
on frontal images occurs without any outside stimulus in all human beings (p. 275),
although all of us now are alienated from it by the influence of the Greek fifth
century B.C. The images we all retain are now, as a result of conscious or unconscious
education, thoroughly intermingled with oblique views from our earliest years on.
Anybody who studies many different children will be able to observe how they
gradually lose their powers of resistance and abandon the positions of depiction
based on frontal images one after another, in a fairly regular sequence, to the en-
croachments of the method based on visual impressions. Given the strength of the
attack what is surprising is not that everybody finally capitulates, but the length of
time people hold out.

The Greeks produced, among other differences, a division in the representational
art of the world. Wherever their intellectual heritage has not taken effect, therefore
in Egypt as well as elsewhere, the basic principles for rendering nature in two and in
three dimensions are essentially the same for the simplest adult, even for a child, as
for the greatest artist. But wherever Greek influence has an effect, and still more
where the logically constructed form, which was worked out in the Italian Renais-
sance from the Greek heritage in two-dimensional art, exerts its influence, everyone
must at some juncture struggle to make the transition from drawing based on frontal
images to the use of oblique views. None of us is spared this struggle, and up till
recently anybody who had made it felt a little pride at having made a great step to-
wards what he believed to be true art.

It must be kept clear that both depiction based on frontal images and perspective
representation, closely though they are tied to art and despite the fact that, as we
shall see, they may in certain circumstances have an aesthetic effect, have funda-
mentally very little to do with the artistic side of a work. To be sure, one of these

two methods is present—the product of a state of the human mind—as a form of expression in every representational art, but in so far as it is an important part of its 'structure', it is only the foundation for artistic activity (cf. p. 85). I should like to make this relationship comprehensible by speaking of two 'layers' or 'levels'—or whatever else one may wish to call them—in a work of art, though the terms are of course only to be taken as analogies. One of them, which will in different cases be based on frontal images or use oblique views, I shall call the *'framework'*,[1] and the other the *'level of expression'*. Only someone who is quite clear as to what, in Egyptian works of all periods, derives from the 'framework', that is, the method they have in common of using frontal images, will be able to assess what there is in addition to this in the 'level of expression' which is the result of the master's own formal inclinations, that is, what can be attributed to the other force at work in artistic creation, which manifests itself most clearly in purely ornamental works, but which also has an effect in every other work of art, including representational works.

Julius Lange constructed his 'law of *frontality*' (cf. Ch. 7) on the basis of symmetry, in other words on my upper 'level', that of expression, where other basic aesthetic feelings like pleasure in certain proportions, in parallel lines and surfaces, and in true *'frontality'*[2] also belong. But in order to arrive at my 'rule of directional straightness' it was necessary to work down through the 'level of expression' to the 'framework'. Modern people like ourselves can best clarify the relationship between the two levels by means of an example from fully developed perspective. Nobody would claim that a drawing which had been constructed purely mathematically was a work of art; it could be a product, or even a trick, of a technician who knew nothing at all of art. It may still have an effect, for example by giving pleasure in the overcoming of difficulties. But it can also have a genuinely aesthetic effect by using startling new foreshortenings or by giving an illusion of great space, or in yet other ways. Only then the effect is not basically due to the creator, who is not an artist, but to his original in nature. The situation with similarly produced two-dimensional pictures based on frontal images is identical to that with constructed[3] perspective; it is also the same for three-dimensional works of both types. Individual artists and peoples superimpose on these foundations, which are common to the whole world and which only serve the purpose of objective representation, an endless variety of well-formed expressions which 'animate [them], infuse [them] with spiritual qualities, and raise [them] to the level of art'; and of course, as in all the products of culture, the intellectual element always remains a minor one in comparison with the emotional. The most enduring events of this sort in Egyptian art were those described on pp. 12–13, in the period of transition from the Early Dynastic Period to the Old Kingdom; the most striking were probably at Amarna (p. 153).

The two 'levels' will almost always appear simultaneously in the physical form of the work, so they can only really be distinguished theoretically. But there are circumstances in which they can separate, as for example when a mathematical construction is used as a helping basis for a genuine work of art in perspective. The cage of lines

[1] I have abandoned the term 'level of the study of nature' [*naturerforschende Schicht*], which I used in the 3rd ed. under the influence of a saying of Hildebrand (1913), because it could evoke misleading associations with naturalism.
[2] pp. 312–13 [and Ch. 7 n. 2 (J.R.B.).]
[3] [i.e. perspective using a vanishing point (J.R.B.).]

and dots (fig. 323) or the squared grid (fig. 324) play the same part in Egyptian art, where the artist lets himself be guided by aids of this sort in sketching his figures.

Although the framework, whether mathematically fixed or not, contains none of the actual artistic achievement, it is still important both in two and in three dimensions for the other level. It plays a vital part in determining the structure of a figure, and in the process it fixes not the type of artistically expressive forms, but their positioning in space. Its role is more or less that of the skeleton in the living body, and it already has an effect at the stage of 'inspiration' for the planned work of art. One might apply to the framework what Goethe said to Zelter,[4] that it is the 'vessel into which anyone may pour what he can'. And, on the other hand, the dictum of W. Schäfer,[5] the poet and painter, would be appropriate for the level of expression: form is 'not a mould into which one may pour whatever one likes; it proceeds from the content and is a manifestation of it.' This latter is the form Goethe had in mind in the statement quoted on p. 41.

The idea of the two levels cannot be used at all for expressionist works of art (pp. 153, 275), as the striving to perceive and render an objective reality (pp. 46, 89) is very far indeed from being the foundation of their expression.

The appearance expression gives to the framework can range, with many intermediate types, from the strictest naturalism or realism to an almost complete dissolution of natural forms into flowing ornamental forms, strictly geometrical or broken ones; the various types reflect the varying strength of the relationship between the forms in nature and man's inner formal inclinations. *But it should at all events be made clear that the expressive imprint which a work of art bears is not based on the use of frontal images or of perspective.*[3a]

Naturalism and geometrization, static forms like those mentioned on p. 000, and dynamic forms, all are found on both types of foundations. But this is not true of the *method of organic representation.* This latter, which first occurs at the same time as true perspective and is bound up with it, does not perceive any part of a living body as being independent, but subordinates one to another, so that none of them can move without others also being involved, and ultimately, as in Gottfried Keller's marvellous literary rendering of the fencer of Ravenna (*Der gruene Heinrich* [1854–5] IV.1), all the organs in a body are presented as animated by a single will. But this sort of conception of an organism is unattainable in pre-Greek art, which is based on frontal images, and so should not, as Krahmer already realized (1931.64, quoted on p. 268), be applied in its context, as such art does not subordinate the parts to each other in helping roles, but sets them out independently next to one another. Mostly it will be possible to establish from a figure in motion whether the representation contains any organic subordination, by seeing if the muscles are modified as against a figure at rest, but not in the case of a motionless one. In the latter an artist will be able, by using very frequent and closely contiguous observations of detail, to produce an organic illusion quite unintentionally, even in a directionally straight work. The two portraits Propyl. pl. 4 and 12[6] should be studied with this in mind. The first, in the Cairo Museum, dates from the fourth dynasty,

[3a] [Cf. Appendix 6 for a passage of the 3rd ed. omitted at this point (J.R.B.).]

[4] [Karl Friedrich Zelter (1758–1832). Architect and musician, who corresponded with Goethe 1796–1892, and knew him personally from 1802 (J.R.B.).]

[5] [Wilhelm Schäfer (1868–1952), also a prose writer, interested in German folklore (J.R.B.).]

[6] [Propyl. pl. 4 = L-H pl. 24, Sm pl. 44B, Propyl. pl. 12 = W fig. 488, cf. L-H pl. 184 (J.R.B.).]

about 2550, while the second, in the Berlin Museum, belongs to the end of the twenty-sixth dynasty, around 500 B.C. Just as in two-dimensional work it was necessary (p. 269) to distinguish between perspective and perspective-like, the word we use to describe the phenomenon is not a matter of indifference. I shall speak of 'organic' and 'apparently organic'.

From all this it can be seen that the proof that the rendering of nature on the basis of frontal images is a fundamental characteristic of all pre-Greek art in no way does violence to its historical realization in innumerable different forms of expression, which tend in different directions, and each of which includes an endless series of sub-groups; no more violence is done than would be to European painting from the sixteenth century on, by observing that during these four centuries all its branches used pure perspective as a foundation.

It is clear how important it is for the aesthetic evaluation of any art or work of art to bear in mind the difference between the two 'levels'. Even if they are physically indissociable in a work a scholar must scrupulously keep them apart in his mind. If he does not do this he betrays what Plato laid down for all time as the highest task of scholarship (*Phaedrus* 265 d-e): it must be capable of considering a great deal of scattered material together in a unified picture, but it must also know how to take things apart and, as he rather caustically says, this must be done neatly at natural joints and not as a bad cook does it, crudely cutting through the bones. But this separation does not only satisfy the desire to think and feel in tidy units; our whole conception of Egyptian art would be false if we were to attribute its use of frontal images to the working of the aesthetic instinct, explaining in this way the directional straightness of statues and, in two-dimensional works, the lack of foreshortening and the spreading out of the viewed surfaces of an object on the picture surface. In particular, very natural-seeming works seem to prevent scholars from recognizing their underlying basis in frontal images. Thus I was able to establish its presence in Cretan art about twenty years ago, yet in 1934 G.A. Snijder[7] was still associating Cretan art with eidetic imagery although such imagery incorporates all the foreshortenings of normal vision (p. 93). A large proportion of the wrong judgements of Egyptian art have similar origins.

I shall illustrate this with one further example, which is however the one which comes nearest to the truth. Alessandro della Seta says (1906.29):[8] '. . . the eye attempts to place itself successively in front of the object in such a way that the outline of each view rests in a parallel plane, in other works in a plane at right angles to the central axis of the visual cone.' And this should apply to two- and three-dimensional work. Just as I spoke in the earlier editions of this book (see also p. 315) of parallel surfaces but failed to draw the necessary conclusions, della Seta also felt that the connecting link between the two genres was their basis in frontal images, but allowed himself to be sidetracked by a purely external characteristic, the 'view . . . in a parallel plane', although it is clearly secondary, a phenomenon consequent upon the basic formal construction, not the root of it. For in the construction of a figure on the basis of frontal images in two-dimensional work the parallelism of the planes is produced only when the picture surface is encountered; and in three

[7] [Snijder 1936 (J.R.B.).]
[8] [Della Seta's text has been translated from the Italian—Schäfer's rendering is not quite accurate. The subsequent quotations have been modified for the same reason (J.R.B.).]

dimensions, only in figures where the frontal view encounters figures with two axes at right angles to each other like human beings and animals. These are the only sub- jects which appear to be enclosed in a rectilinear prism, with pairs of parallel views. The fundamental cause and its specific outcome should not be equated. Della Seta's 'parallel plane' only describes, it does not explain. We have seen how in pre-Greek sculpture the parallelism of the planes arises for epistemological reasons at the fundamental level, not for aesthetic ones at the level of expression. But anybody who, like della Seta, does not see the difference between the two types of parallelism and so confuses the two levels, inevitably slips on to the aesthetic level, the level of expression, and so away from the truth.

But even though the mere products of the 'framework' are not the expression of the aesthetic instinct, they can, as I indicated above, come to have an aesthetic im- portance. Thus, for example, forms based on frontal images have an aesthetically productive effect on people brought up in that type of intellectual climate, because they are for them just what normally supports the actual layer of expression. On the other hand they will of course be an aesthetic hindrance to anybody who has grown up surrounded by perspective and directionally free art, and so has learnt to con- sider the latter to be the framework for his expressive forms. For such people, as was indeed the case for us a few decades ago, even the degree of precision in perspec- tive will be important.

Corresponding factors are of course also present within Egyptian art. As soon as it had taken the step of using some apparently perspective adaptations to visual images these became capable of having an aesthetic effect. One is reminded of how, in the New Kingdom, pleasure was taken in intensified overlapping and layering (pp. 177–89). In addition, Egyptian close layer depictions are from the start a mixed phenomenon (p. 179), as the precise parallelism of the lines is the expression of an aesthetic impulse. And when, on the other hand, these overlappings and layerings are dropped in Egyptian religious art or in the archaizing Late Period and the early, simpler renderings of nature are retained or readopted, they are also taken up in their character of elements in a formal language that is enveloped by the aura of venerable age. But when a genuine transition occurs to drawing which contains perspective elements, the meaning of the forms which originally derived from representation based on frontal images is completely distorted. This effect can be studied very well as Greek art invades Egypt, when old forms are not simply cast aside, but are retained for centuries in addition to the new ones. A magnificent tomb dating from about 300 B.C.[9] has been discovered in Middle Egypt. Its reliefs were designed and executed by Egyptians who must have worked for some time in Greek studios in Lower Egypt. Their work includes religious pictures based purely on frontal images, next to them secular ones where an image-based foundation has been overlaid in a Greek manner,[10] and lastly groups which appear to go back to a sketch book from a Greek workshop.[11] So these artists must have studied the foreign method of representing with oblique views fairly seriously. Of course artists and viewers lost the ability simply to take as objective the old instinctive rendering of nature on the basis of frontal images. Of

[9] Lefebvre (1923–4), sample pictures in Schäfer 1928 [and in many modern books (J.R.B.).] Cf. also Ch. 2. n. 61.

[10] Propyl. pl. XXIII [Sm pl. 87, W fig. 691 (J.R.B.)].

[11] On the fact that the Greek-style reliefs are also distinguished by their colour (e.g. by a peculiar bluish red) see Schäfer-Andrae 1942.121.

necessity, in this light people came to view it as false. And if it was still retained despite this, it could only have been because its forms were no longer taken to be objectively faithful, but were taken as expressive forms. In this way the forms deriving from frontal images moved from the framework on to the level of expression. A 'graecizing' Egyptian artist like the master of the tomb mentioned above found his counterpart on the other side in a Greek master who had to produce a statue of Isis and wished to adapt himself to the Egyptian spirit for it. He did not simply 'egyptianize' the figure, but also he did not simply clothe his work in the directionally free Hellenistic form of his period (Propyl. 446.4); instead he chose an apparently archaizing Greek one.[12] He certainly did not suspect that there was a fundamental justification of this choice—that Greek sculpture before the fifth century was still, like Egyptian, based on frontal images and directionally straight. But, of course, like his whole generation, with its tendency to assimilate alien styles, he was in fact only able to arrive at an aesthetic grasp of an archaic directionally straight work, even as regards the framework. The same is true of everybody who is seriously influenced, however indirectly, by the Greek fifth century.

This intellectual shift also determined to a large extent later peoples' evaluation of Egyptian works of art.[13] Because it produces forms, determined by frontal images, which are unfamiliar to those accustomed to the use of oblique views the framework becomes unduly prominent in the eyes of such viewers. In this way it muffles the level of genuine expressive forms and forces itself misleadingly into its place. This process is most clearly visible in statues, with their directional straightness, which belongs to the level of the framework but it is almost always taken to be an expressive form. And this happens all the more readily since, for reasons given above (p. 4), the effect of the use of a fundamentally alien rendering of nature, based on frontal images, does not strike everyone as much in three dimensions as it does in two, where it is easier to separate the two levels. The genuine forms of expression, in which the formal inclinations of different people and periods were distilled into a style, do not attract the attention so easily. They only become apparent in the transformations of the lines and surfaces enveloping the image-based forms. It is fair to say that by far the largest proportion of what seem to the layman to be Egyptian forms of expression are not in fact forms of that type.

In this way we can also gain an insight into the true relationship between ancient Egyptian works of art and modern ones which resemble them, and may indeed sometimes be inspired by them.[14] It is quite unthinkable that a contemporary artist should again create works naturally on the basis of frontal images. Our artists will never again be able to drink from the spring from which these issued. Imagine what would be necessary before it became possible again: an artistically gifted person would have to be brought up in such a way that he never encountered two- or three-dimensional works which took foreshortening into account, or had them described

[12] Propyl. 446.1. As is shown by other pieces of this type, the left arm hung straight down, while the right arm, which held a snake or a sistrum, was stretched out horizontally. The positioning of the right foot is not quite directionally straight.

[13] On this see Schäfer 1927a, 1928.

[14] Treated in detail in Schäfer 1927a, 1928.

to him. Quite apart from whether it would be desirable, a programme of this sort is completely fanciful. We cannot live in our own culture and at the same time be, as many of our artists wish to be, 'pre-Greek' creative people, whether Greeks, Egyptians negroes, or children.

When modern artists produce statues that appear to be identical to Egyptian ones in their strictly geometrical, cuboid structure (pl. 104), or when painters spread the surfaces of objects in geometrical shapes across the picture surface (pl. 106), they are only able to meet Egyptian works at the level of expression. Anyone who compares the forms of representation of so-called expressionism with Egyptian ones will always attribute a slightly false meaning to the latter. The Italian painter who gave the doctor in pl. 102 R a very curious shoulder would certainly admit calmly that his picture was in the normal sense contrary to nature, but he would say that he wished to or had to paint it in this way because of an inner compulsion, or he would say that he needed that particular form at that point in his picture. For him the relationship between external reality and his painting is a relatively insignificant matter. But an Egyptian who drew men as in pl. 23 was convinced that he was rendering reality. The basis of his forms in frontal images was part of the framework, it became part of it because of his devotion to nature, and was maintained by his belief in an objectively accurate rendering of reality.

It does not detract from this formulation to concede that even an Egyptian often chose the 'view' of an object for a particular part of his work because it filled an area appropriately or contributed to a satisfying distribution of masses. This use alters nothing in the rendering of the object, which belongs in itself to the lower level. This latter is in this case dealt with at the first encounter with the object, even though the aesthetic demands of the level of expression, such as integration with the composition as a whole and similar factors, may also have played a part. Perspective painters also often determine the choice of views in a work in the light of considerations of this sort.

On the other hand, in an expressionist picture the choice of a frontally viewed form for an object or part of one, like the doctor's shoulders in pl. 102, may in fact be influenced by thoughts about objective reality. But in that case the first consideration was the aesthetic element, and depiction of objective reality only secondary.

At the beginning of this book, when discussing the difference between an amateur's and a scholar's viewing of works of art, I indicated that anyone, in particular a creative artist, is free to derive a stimulus even from a misunderstanding of a work. But such a person must bear firmly in mind that before he can help a scholar to interpret pre-Greek works he must first learn from him the significance of the two levels.

Self-restraint of this order has by no means always been exercised in recent decades, and as a result a genuine threat to the serious study of Egyptian art has arisen, as writers on art have introduced the freedom appropriate to a purely pleasure-seeking viewer into academic work too. It is true that older Egyptological ideas on the subject were unsatisfactory. But, at least in writing on two-dimensional work, they did incorporate a correct insight; at all events they lumped non-epistemological elements in the framework together with aesthetic values without suspecting what was the difference between them—but the way to the truth was not completely blocked. And there had also been quite deep insights into the nature of three-dimensional representation, although the fundamental points had not yet been reached. Then a new approach, under the influence of modern movements in art, pushed these

beginnings aside and its proponents became more and more fixed in the belief that they could comprehend ancient works just as they did modern ones, by way of a purely aesthetic approach. Hedwig Fechheimer was the most effective champion of this attitude, especially in her *Die Plastik der Ägypter* (1923). It was certainly a matter for rejoicing that the love of modern artists for Egyptian works grew and spread to wider circles. But one's delight was impaired considerably by the observation that this movement was linked to the travesty of scientific study which I have mentioned. As a result people have been prevented from seeing what divides modern from ancient Egyptian art. Certainly modern art has been able to make people look at wider varieties of art, and has made people aesthetically more receptive to strange forms and less easily put off by infringements of the rules of perspective, but its use to enrich our perceptions has in all cases led away from the understanding of the true character of the rendering of nature in 'pre-Greek', and therefore also in Egyptian art. This character can be grasped only by the intellect.

In the simple sense of increased artistic quality there is no place for the concept of progress from representation based on frontal images to representation according to visual impressions. In the first two lectures in his *Ueber die Epochen der neueren Geschichte* (1888) von Ranke touches several times on the concept of 'progress' in history. He considers that unqualified progress, an absolutely decisive advance, can in the realm of external values be assumed, as far back as we can follow history, for everything relating to our perception of and mastery over nature. But he thinks that the concept of progress cannot be applied to the creations of genius in representational art and in literature, as these are all directly related to the divine, and although they may be dependent on their period, their truly creative aspects are independent of what goes before or comes after them.

This perception of the limits of the concept of progress is entirely consistent with the separation which I have discovered to be necessary between the two levels in a work of art that imitates nature.

We can see that the transition in Greece from a rendering of nature based on frontal images to one similar to or indeed faithful to visual impressions is also a turn away from a recording of nature in individual elements towards a unified approach; and this process occurs at the lower level, in the framework. This latter, to which one could apply Hildebrand's phrase, a 'sort of natural science', corresponds to what von Ranke called the 'perception of and mastery over nature'. And in this context the concept of progress can be used, if the degree of closeness to the visual or tactile forms of the world of objects, the rendering of the natural phenomena of light, or the development of perspective, etc., is taken to be the dominant factor, and if we then study how these problems are progressively brought nearer to a 'solution'.

But this still has nothing to do with the actual *artistic value* of the works. This value exists at the level of expressive forms, and there are some works which are valuable and other which are valueless in this respect, but there is no continuous progress through different periods: every creation of a genius is in direct relation with the divine, and what Goethe said about literature when discussing *Des Knaben Wunderhorn*[15] often applies in such cases: 'true poetic genius, when it occurs, is

[15] [*The boy's magic horn* – collection of folk lyrics, published 1805–7 by Achim von Arnim and Clemens Brentano. The work influenced the German romantic lyric, and poems from it were frequently set by nineteenth-century composers (J.R.B.).]

complete in itself; even if imperfections in language, in superficial technique, or in any other such area stand in its way, it still possesses the higher inner form which in the last analysis has everything at its command; and its effect is often more magnificent in a dark, opaque context than it is later, in the light.'

Although it will now be clear that the Greek transformation no more embodies a truly artistic progress than the weakening of perspective by movements in recent art denotes a falling off, it is even now still necessary to give frequent reminders that the dignity and value of Egyptian art are not dependent on its having reached successive stages towards the solution of the problem of rendering objects and space so that they are like visual images, and that even complete adherence to perspective and directional freedom would never have been able to enhance its artistic quality.

The concept of progress is for many people very similar to that of *development,* which I already discussed once (p. 270), but which it would be useful to mention again briefly here. While a study of the notion of progress was of assistance in throwing light on the situation in every individual work or art, whether image-based or using oblique views, a further consideration of the notion of development will help to illuminate the relationship between the two fundamental methods of rendering nature. The word development is used in peculiarly conflicting ways. But it is not at all for me to decide which meaning it should rightly have. It is enough for my purpose to observe the distribution of its two meanings, for which it would be better if we had two words,[16] in art-historical writing. The two usages can be characterized separately as follows.

First, it is used in the narrower sense previously exemplified in plants: that a rigid chain of manifestations is passed through with a sure purpose, leading to a situation stated by us to be the goal in the endless succession of growth and decay.

Secondly, the word is given a broader sense: that an organism realizes itself without an inner goal in a chain of manifestations until it is extinguished; and the form of the individual elements cannot be predicted.

This double meaning of the word is the reason why its use in art-historical writing is often so hard to comprehend. Our study of the concept of progress has already provided a preparation for an understanding of the levels in a work of art.

In the light of this it is likely that the first, purposeful sense of the word development will not have any meaning on the level of 'expression', although the second one, of a series of manifestations without an inner goal, will have an application. And it is in fact impossible to say, for example, that the expressive forms of the art of King Nebuchadnezzar of Babylon, of the New Kingdom in Egypt, or of the European Baroque were a goal at which what went before, ancient Babylonian, Old Kingdom, or romanesque art, was aiming.

But although one cannot speak of purposeful development at the level of expression it is quite justifiable to do so for the framework. At this level there are substantial differences between the two types of art based on frontal images and on oblique views.

The tendency in art towards impressionism, described above, was a basic element in the transformation in fifth-century Greece. At that time an impulse was channelled

[16] The two meanings could be distributed between the words 'unfolding' and 'development' [*Entfaltung* and *Entwicklung*], but this would not be entirely satisfactory, as the images implicit in the two words are too similar to each other.

on to the level of the framework which, although it was not always equally active
and pressing, and may sometimes even have halted for a long time, tended towards
a definite goal, towards as exact a rendering of visual impressions as possible. No
amount of theorizing will remove this development in the rendering of nature from
the study of art from the fifth century B.C. to the end of impressionism in our own
time. It may well be said that it culminated and was fulfilled in impressionism.
Every history of the art of this time-span will have to include a presentation of this
purposeful development as an essential part. But it should by this time be clear that
in the description of expressive forms we can use the word development only in the
second of the two senses defined above.

What happened in the period following impressionism is in a way similar to what
might occur in a prehistoric art. In prehistoric art individual steps towards adapting
to oblique sight are not outstandingly important. If one were to attempt to apply
the concept of purposeful development to a pre-Greek art the observation would of
necessity follow that it had no development. And one often reads such statements
about Egyptian art. Presumably their authors are not aware that their judgement
only exemplifies the lack of clarity in their concepts. For the most part it is the
second concept of development which can be applied correctly to Egyptian art, as
the vast proportion of its history takes place at the level of expressive forms, so that
any treatment of it has almost exclusively to depict changes in these forms.

Let us return once again to a point discussed earlier, and ask whether the word
style[17] can be used for art based on frontal images or obliquely viewed works as
such, apart from their expressive forms. In accordance with its derivation from Latin
stilus (scribe's slate-pencil) the word was originally used for written expression alone,
only becoming a technical term for representational art in the eighteenth century.
Anyone who assumes with me that the word style is to be used where something
particular, independent of nature, takes on a form in human creations, and that the
application of the word need not today be confined to art—anyone who accepts
this will see that we must use it not only for the upper level, the level of expression
in a work of art, but also for the lower level, the framework. So he will answer the
question in the affirmative, for in both cases, in works based on frontal images or in
works that conform to visual impressions, we have to do with a magisterial forcing
of natural forms into the form of the images which the human mind constructs of
them. In representation according to visual impressions this is especially evident in
perspective drawings, and in image-based representation in the directional straight-
ness of statues. An example from two-dimensional art will serve to show how more
restricted patterns can overlay broader ones. It is part of the style of all pre-Greek
representation based on frontal images that the thumb and four fingers of a hand
are shown in two-dimensional works in a full view next to one another. But if the
four fingers are laid close next to one another and the nails are seen from the side,
that is Egyptian style. And if the fingertips are bent elegantly backwards, that is
the style of a particular period within the New Kingdom.

My task was to show the essential character of the rendering of nature in Egyp-
tian art. For this purpose it was necessary to place it—having described its full extent
and illustrated this with examples—where it belongs, among the arts of other peoples
who depict on the basis of frontal images, and as an antithesis at least to sketch the

[17] [Cf. also pp. 57, 59 (J.R.B.).]

method of depicting according to visual impressions. It might seem attractive to recombine these two groups into a unity and to search for genuinely fundamental laws in art, which would be common to all of humanity from the earliest times up till the present. But it is to be expected that an attempt to derive a concept with a general validity from the two methods of rendering nature, if it were at all practicable, would leave only an uninteresting residue which would satisfy nobody. At all events it is far from being my intention in this book; and attempts of this sort could only be made for the level of expression.

Anybody who wishes to understand Egyptian art must attempt to gain a clear comprehension of the method of rendering nature on the basis of frontal images. But the book's aim will only be achieved in full if the reader no longer has to force the content to the front of his mind, in other words if he both understands and enjoys an Egyptian work of art as a unity, without first having to set to work at it with all his mental equipment.

It will now be seen more clearly in what aspects of their works the Egyptians' artistic achievement should really be sought, and where it is not to be found. Certainly not in the way in which frontal views of the surfaces of objects are spread over the picture surface, nor in the directional straightness of the three-dimensional works, but of course in the particular character which these fundamental elements, which are not unique to that country and are in no way aesthetically inspired receive in Egypt. One should hope to gain an insight into this particular character; this is the area where the intellect (p. 6), which alone should have a say in the study of the framework, ought to hold back and yield precedence to sensibility. A modern artist may derive stimuli for himself in this area without risking any misunderstanding.

Prepared as we are by the transformations in European art in the last half-century we no longer find so many obstacles to an encounter with Egyptian art as our elders did. But the tenacity which it exhibited in retaining the full vitality and purity of the method of representing on the basis of frontal images may easily make this method seem to obtrude. Anybody who does not overcome this effect by making the method as much as possible part of himself will find it hard to avoid receiving the impression that Egyptian art has no real history.

Many people will be able to grasp something of the specifically Egyptian form, which separates it from the other forms of the general pre-Greek method of rendering nature on the basis of frontal images, by looking at a single work, provided it is a genuine work of art. But 'none of our ideas of what is valuable, sacred, good, or beautiful produce a definite repertory of forms from themselves in strict logical succession', and the same is true of the idea of what is Egyptian. 'Even when the work reflects the content [of the ideas] clearly the form and colouring with which this is done is still one of many possible ones, and it is conditioned by existing facts beside which other facts, which would have given the same content different forms and colourings, are none the less conceivable' (after Lotze 1884). And for that reason the appearance in which the Egyptian spirit is clothed is not always the same.

Every period searches anew for the form of expression appropriate to it, and a single period exhibits first one and then another side to us, as, in such a rich and ancient culture, a number of secondary streams may exist parallel to the dominant one. So in the last analysis it is only the totality of the forms making their appearance in the living process of history which reveals the whole nature of Egyptian

art. And we should not just lament the fact that its course was completed long ago and is at such a distance from us; we should be glad of the advantage this distancing gives us in enabling us to view it as a whole.

It might now be possible to order the innumerable forms of expression, which have been produced in the world's art to date, into large, more or less sharply defined groups, but, so far at least, nobody has succeeded in setting up 'laws' governing the order in which they make their appearance, which would be valid not only for a particular cultural area, but for every people, everywhere in the world. Probably such an attempt would get no further than the noting of a few parallels,[18] which would not be enough to justify any talk of laws of development.

The art historian's task is to resurrect for us and to enable us to experience the changing unity of a given field. It was not my intention in this book to do this, although it may offer a number of contributions in that area. My aim was rather to point to what anyone intending to write a history of Egyptian art would have to clarify in his mind before he could reasonably set to work.

There have been many attempts to write histories of Egyptian art; some have advantages of one sort, others of another. But it seems to me that many important problems still need to be solved. The contributions which have appeared hitherto are no more than drops in the ocean. Only when what is absolutely necessary has been done will it be possible to write histories of Egyptian art which can offer to scholars and laymen what they have a right to expect. In my *Die Kunst Ägyptens* in the *Propyläenkunstgeschichte*, vol. 2 (Schäfer–Andrae, 1925, 1930, 1942) the reader can find an attempt, based on the work of four previous generations and using the points of view elaborated in this book, *Principles of Egyptian art,* to outline the course of that art's life so far as this is possible at the present time. I thought I owed it to the readers of my book to dare to do this.

[18] [Cf. the basic approach of Wolf (1957).]

APPENDICES

I ETANA'S FLIGHT TO HEAVEN

[Translation by E. A. Speiser, 'Akkadian myths and epics', in Pritchard (ed.) 1955 and 1969.118, copyright © Princeton University Press, reprinted by permission, with the summary modified after the discoveries of J. V. Kinneir Wilson (1969), to whom I am indebted for advice. Restored passages are in square brackets, uncertain renderings in italics (J.R.B.).]

[The eagle says it will carry Etana up to the heaven of Anu. It picks him up.]
When he had borne [him] aloft one league,
The eagle says to [him], to Etana:
'See, my friend, how the land appears!
Peer at the sea at the sides of E[kur]![1]
'The land has indeed *become* a hill;
 The sea has turned into the water [*of a stream*]!'
When he had borne [him] aloft a second league,
The eagle says to [him], to Etana:
'See, my friend, how the land appears!'
 'The land [...]!'
When he had borne him aloft a third league,
 The Eagle [says] to him, to Etana:
'See, my friend, how the land appe[ars]!'
'The land has turned into a gardener's ditch!'
After they had ascended to the heaven of A[nu],
 Had come to the gate of Anu, Enlil, and Ea,
The eagle (and) E[tana to]gether did o[beisance].
 [...] the eagle (and) Etana.
[They do not receive the plant of birth. The eagle says it will take him to the heaven of Ištar. It picks him up.]
[When he had borne him aloft] one league:
'My friend, take a glance at how the land [appears]!'
'Of the land ... [...],
And the wide sea is just like a tub.'
[When he had borne him aloft] a second league:
'My friend, cast a glance at how the land appears!'
'The land has turned into a furrow [...],
And the wide sea is just like a bread basket.'
[When he had borne him aloft] a third league:
'My friend, cast a glance at how the land appears.'

[1] Mountain House in the sense of World Mountain.

'As I glanced round, the land [*had disappeared*] ,
And upon the wide sea [mine eyes] could not feast!
My friend, I will not ascend to heaven!
Halt in (thy) tracks that [. . .] !'
[They fall down. A new tablet shows that a second attempt is successful, and they finally receive the plant.]

APPENDIX 2

PRODUCTION AND APPEARANCE OF THE CULT IMAGE OF APOLLO OF SAMOS, AFTER DIODORUS 1.98.5–9

TRANSLATION AND NOTES BY ANNE BURTON. (For commentary see Burton 1972.)

They say that the most distinguished of the ancient sculptors, Telecles and Theodorus the sons of Rhoecus, spent some time with them [the Egyptians] . They constructed the statue of the Pythian Apollo for the Samians. For it is said that half the statue was worked in Samos by Telecles while the other half was completed at Ephesus by his brother Theodorus.[1] And that when the parts were placed together they fitted so closely that the entire work seemed to have been completed by one man. This method of construction is nowhere practised among the Greeks, but among the Egyptians it is of common occurrence. For among them the proportions of statues are not assessed according to their visual appearance, as is the case among the Greeks, but as soon as they set out the stones and have apportioned and prepared them, at that stage they estimate the proportions from the smallest parts to the largest. For dividing the structure of the entire body into 21 parts plus ¼ cubit in addition,[2] they thus present symmetrically the proportions of the figure. Thus whenever the artisans reach an agreement as to its size, they separate and prepare the various sizes of their work in such close proportion and so accurately that the individuality of their method arouses astonishment. And the statue in Samos, in accordance with the craftsmanship of the Egyptians, was cut into two from the head downwards and the figure was divided in the centre as far as the genitals,[3] each half exactly matching the other at every point. And they say that it is for the most part rather like the Egyptian statues, having its arms stretched down, and its legs in a stride.

Notes
Diodorus' use of language in this passage is not very explicit, and one is forced to conclude that he was not really certain himself of the process he was describing, At all events, certain elements appear to be exaggerated.
1. Theodorus was the son, not the brother of Telecles, and lived probably *c.* 550 B.C. (see *RE* 5a2.1917–20).
2. The 'twenty-one parts and one-fourth in addition' (Oldfather, Loeb edition) so long unexplained, has been elucidated by Iversen (1968, 1971). Clearly the 'twenty-one parts' refers to the twenty-one units into which the Saite canon divided the standing male form from feet to eyes. The τέταρτον must refer to the supra-canonical

distance from the root of the nose to the crown of the head, which on the Saite grid occupies 1½ squares. Iversen demonstrates that τέταρτον must refer to a quarter of a standard measure, which in this case is clearly the royal cubit of six squares, one quarter of which is one and a half squares.

3. It seems more than likely that what we have here is a garbled reference to the division of the figure by the frontal axis line, which in the case of sculpture in the round ran between the eyes, along the nose, and through the navel to a point between the feet. It has further been suggested that this may be a confused account of sand-casting in bronze, but as Ridgway (1966.68) notes, it is generally believed that the two Samian sculptors cast by the lost-wax process. (Some Egyptian bronzes, presumably cast by the lost-wax process, are made in two parts with the join down the vertical axis.) It may have been possible for the two sculptors, by using the Saite canon, to execute the statue in two halves, but it seems far more likely that this is pure embroidery. What Diodorus seems to be emphasizing is not the making of the statue in two halves, but the adoption of strict proportions (which could make the other possible). This is clear from 98.7. In other words, he appears to be attributing to the Samian sculptors the fabrication of a *kouros*, as opposed to the completely naturalistic statues of the Hellenistic age.

APPENDIX 3

PLATO, *LAWS* 656. TRANSLATION BY JOHN TAIT

It appears that among them [the Egyptians] this principle that we have just been discussing was recognized long ago, that the young people in the cities ought regularly to study fine figures (σχήματα) and fine music (μέλη). These they prescribed, and they displayed them and exhibited their nature in their cults (ἐντοῖς ἱεροῖς). Painters and others who produce figures (ζώγραφος) and such like were not at that period permitted to make innovations or to create forms other than the traditional ones, nor is it permitted now, either in art or in any kind of music. If you look you will find that things that were painted or carved there ten thousand years ago—I do not just mean 'ages ago', but actually ten thousand years—are in no respect finer or worse than modern products, but were executed with the same skill.

APPENDIX 4

PLATO, *SOPHIST* 235 c – 236 c. TRANSLATION BY JOHN TAIT

Stranger: Well, in accordance with our previous method of drawing distinctions, I think I can see two kinds of imitation right away; but at the moment I seem unable to make out to which of them the type of imitation we aré seeking belongs.

Theaetetus: Would you please tell me first, which are the two kinds that you mean?

Stranger:	The first imitative art I can see is that of producing a likeness. A good example is when you make a copy of something, following the proportions of the model in its length, breadth, and depth, and then you go on to add the proper colour to each part.
Theaetetus:	What? Do not all those who imitate something attempt to do just that?
Stranger:	Certainly not those who create any kind of large scale piece in sculpture, or in painting. For if they rendered the true proportions of beautiful objects, you know, the upper parts would look smaller than they should, and the lower parts bigger, because we look at the former from further away and the latter from nearer to.
Theaetetus:	Certainly.
Stranger:	So do you not see that the artists nowadays care nothing for truth and that they incorporate into their images not proportions that really are beautiful, but those that appear to be so?
Theaetetus:	Indeed they do.
Stranger:	Is it not reasonable to call something that is a different object and yet is like, a likeness?
Theaetetus:	Yes.
Stranger:	And should we not call the division of imitation that is concerned with this the art of producing a likeness, just as we did a moment ago?
Theaetetus:	We should call it that.
Stranger:	Well, what shall we call a thing that appears to be a likeness of something beautiful because of a poor viewpoint but which, if someone could acquire the power to get an adequate view of this type of thing, would not even be like the object of which it purports to be a likeness? Surely, if it has the look of a thing, but is not a likeness, we should call it an appearance.
Theaetetus:	Certainly.
Stranger:	Now is there not a great deal of this type of imitation in painting and in all other kinds of imitation?
Theaetetus:	Of course.
Stranger:	And the art that creates appearances and not likenesses, may we not name it the art of producing an appearance?
Theaetetus:	Quite so.
Stranger:	So these are the two forms of image-making I meant, the art of

producing a likeness and the art of producing an appearance.

Theaetetus: You were quite right!

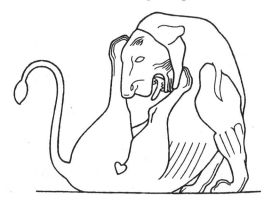

FIG. 328. Lion licking itself. Late [Discussed p. 217. Cf. pl. 109.]

Note [by Schäfer] :

From the examples which Plato cites it is possible to gain a more or less adequate notion of how the 'art of appearances', which he rejected, looked: it was the perspective rendering of nature whose influence was at that time becoming increasingly powerful.

The same is not true of the art he wanted. He named no model of it and left behind him no clear positive statements about its forms. We can, to be sure, deduce from his placing it in opposition to the art of deception that Plato was thinking of an unforeshortened rendering of nature, that is, something we know to be a peculiarity of all 'pre-Greek' art.

But it never occurred to Plato that an art that already existed on earth could satisfy his requirements for an 'ideal' art. So we cannot gain any idea of the form of what he required in addition to the avoidance of 'visual errors'. He came right at the beginning of the study of art, before the creation of a strict terminology for the material forms of representational art.

Plato probably did not even think of Egypt, and at all events he does not mention it by name; and in the passage in *Laws* 656 (above, Appendix 3) he praises something quite different from the forms of Egyptian art.

Winckelmann's inspiration for the passage quoted on p. ix of this book certainly came from Plato, and he formulated the insight which he acquired in this manner in the most concise possible form. But he acted entirely independently in relating Plato's ideas to an art that existed at the time, pre-perspective Greek art.

As can be seen from what was said above, Winckelmann misinterpreted Plato on this point, but the misinterpretation was of that fruitful sort I discussed on p. 5, and it is only because of this that the sentence can be used as the motto for a book on Egyptian art.

Winckelmann places 'what man is' and 'how he appears' in opposition. Goethe does no more than repeat this at greater length (above p. ix, B), but he speaks of 'essence' or 'essential character' [*Wesen*] and 'appearance' or 'outward form' [*Erscheinung*] . In the light of the connection between his writing and that of Winckelmann it is of course clear that 'essence' is to be taken simply in the sense of

'what man is'. One must not be led astray by modern writing on Egyptian art, which uses the word *Wesen* frequently, in a deeper sense, just as it is inclined in general to approach everything from a metaphysical angle, although in the process it only too easily turns into a mania for profundity for profundity's sake.

APPENDIX 5

ORNAMENTAL INSCRIPTION FROM A TEMPLE (pl. 36, cf. pp. 65, 151)

The inscription reproduced on pl. 36, Berlin 16953, covers a huge fine limestone plaque, 2·16m long and 1·04m high.

At a first glance a specialist will see that this beautiful piece was produced in the twelfth dynasty, under King Amenemhat III, and that it comes from a temple of the crocodile-form water god Sobk. The inscription also tells us that the temple was in the province which is now called the Faiyum, one of the most fertile areas of Egypt; and it was Amenemhat III's predecessors who first reclaimed the area from swamp land, although the name of the god of its capital city occurs in earlier inscriptions. At that time the town and its rich farming land were on a large peninsula, almost surrounded by water. We are now used to calling it by its Greek name Krokodilopolis, 'town of crocodiles'. Our inscriptions probably come from the great temple which this king built here for Sobk.

We now know that the Egyptians were the first people to learn that words are composed of separate sounds; but they none the less retained throughout their history all sorts of features left over from the earlier pictographic script (p. 150). Of course, the view that hieroglyphs as a whole are some sort of pictorial riddle is not permissible, for they are clearer and more comprehensible for someone who knows the language than many simpler scripts. But for their large ornamental inscriptions the Egyptians did consciously retain and cultivate what we might call the 'esoteric' side of their script, as they knew what effects could be achieved by exploiting it. Our plaque is a superb example of the way in which the Egyptians knew how to and loved to create meaningful action between the signs in ornamental inscriptions.

It will be observed that the piece consists of a vertical central line of text and two completely symmetrical halves, in their turn each composed of four lines. The signs in the two innermost lines face the central line, while the outside pairs each constitute a unity, as their signs face each other.

In the Egyptian script the signs normally point towards the beginning of the text on the right. Exceptions are always determined by symmetry or other intrinsic factors.

The central line of our tablet contains the king's title and the name he adopted on his assumption of the throne. The name is enclosed in the well-known so-called 'cartouche', whose origin and true significance I will not discuss any further here. To our eyes, and probably to those of most Egyptians, it simply separates the king's name from its surroundings, and so emphasizes it. The cartouche stands on a sign like a necklace, and this brings us straight into the realms of symbolism. Neither

here nor elsewhere in the inscription should the reader render what it expresses into words; it is present for a thoughtful reader like beautiful flourishes between the lines.

The necklace ⌐☰⌐ wrote the name of the town Ombos, near the modern Tukh in Upper Egypt, and in abbreviated writing it also stood for the derived epithet 'the Ombite', a word for the god of the town, Seth, who was incorporated in the Osiris myth as the latter's murderer. Just as Horus, Osiris' son, stood in vengeance for his father's death on the back of Seth, whom he had felled, the Horus falcon is placed on the necklace sign in one of the Egyptian royal titles ⌐☰⌐ , and in our inscription the king's name is placed on Seth's ☐ . This is because every living Egyptian king counts as the god Horus become man, and every dead king counts as Osiris. So we can see already here that a simple knowledge of the signs is not enough to evoke the images intended by the scribe.

This central line, which means 'king of Upper and Lower Egypt, lord of the two lands, Amenemhat III [who] over[comes] Seth', faces right. However, the artist would probably have preferred not to have turned it to one side but, which was not possible with these particular signs, to have left it undefined, as the sun sign ⊙ in the cartouche is; for this line relates to the ones on both sides of it.

They both relate closely to the central line, and both read 'beloved of Sobk of Krokodilopolis'. The highly stylized image of a crocodile, which goes back to an ancient cult figure (p. 106), dominates the line with its headdress of horns, feathers, and a sun disk ⌐☐ . It is lying on a carrying pole ⌐☰ (cf. fig. 48) of the type on which images and symbols of gods were carried. The name Sobk is written phonetically in signs of modest size above the back of the crocodile. The long carrying pole of the support grows out of a curious structure. It consists of two connected buildings ☐ with screen walls between them (cf. fig. 77); antelope heads on stakes are placed in the middle of their roofs. One of these buildings wrote the name Krokodilopolis, as can be seen in the second line from the edge. But as in Egyptian the dual was phonetically similar to the adjectival form the two here in conjunction with the image of the god mean 'Sobk the Krokodilopolitan'. The word 'beloved of' is written underneath in conventional phonetic signs.

Now it should be borne in mind that the two lines, and in particular the images of crocodiles, are facing the central line with the king's name, as if the god were stating his love to the king. And in addition the carrying pole of the image of the god has two arms attached to it which hold out a ⚥ and a ⌐ to the king's name; the first is the hieroglyph for 'life' and the second the one for 'good fortune'. So Sobk gives the ruler his blessing and good fortune as well as love. And this is in fact what the plainly written lines behind the ones with the crocodiles say: 'speech: I give you all life and good fortune as the sun-god (has them).'

The two pairs of lines at the edges give the king's 'common' name, the one he already possessed·before he ascended the throne, and call him the 'son of the sun god, beloved of him' and 'beloved of Horus the lord of the lake country who is

worshipped here in Krokodilopolis',[1] that is, the god who was worshipped next to
Sobk in Krokodilopolis. Here too the fact that the two lines face one another[2]
indicates that the god is speaking to the king. The king's name again stands in victory
over that of Seth.

Finally, when we have observed that the whole area of the inscription is framed
at the top by the sky ⌐⌐ , at the bottom by the line of the ground, and on the
the sides by the sky's supports, so that the whole universe is encompassed on the
stone, we shall have exhausted the meaning the inscription offered, in and between
the lines, to an informed observer.

We can still derive pleasure from pursuing the artist-scribe's involved allusions.
But their presence does not obscure the most important elements. Despite, or even
perhaps because of, the play of meaning, the inscription reveals at a glance what it
was primarily meant to state, the king's and the gods' names and their relationships
with each other.

It was not intended to do any more. It was meant first of all as a decorative
piece, which would 'give pleasure while being meaningful at the same time'. And
indeed the task has been acquitted in a masterly fashion.

But to take purely superficial pleasure in the work we need to know nothing of
this meaning. The expansive treatment of the noble, stylistically pure, yet accurate
pictorial signs, and the balance between flat and rounded relief with the differing
effect of its shadows, both of course have a much greater impact in the huge original
than on a much reduced photograph. There are no disturbing empty spaces, no over-
crowded areas. Unity is not destroyed, yet the whole is beautifully articulated in
accordance with its content, and the cartouches and the heavy, very concrete croco-
dile bodies, which are rather larger than the rest of the signs, discreetly but notice-
ably emphasize the principal subject-matter.

This piece demonstrates particularly well what a treasure the Egyptians' pictorial
script was for them. But it was not one which fell out of heaven into the laps; they
had first to create it and then to lavish all their care on it. A comparison with other
pictorial scripts shows that it must have been in the artistic nature of a people like
the Egyptians to control the varied superabundance of signs of the most diverse
types and sizes, as has been done in good inscriptions, without doing violence to
their basic character. For only when it has been considered that the objects always
remained clearly recognizable, and that the sequence and ordering of the signs
were fixed in all but a few cases, will it be possible to appreciate how much artistic
effort many generations must have expended even on such apparently artisan pro-
ducts, until they succeeded in creating something in which the proportions of the
individual signs, their relative proportions and the weighing of empty and filled space
were as perfect as they were in Egyptian inscriptions of the best periods. So we
should not be surprised that even important artists did not consider it beneath their
dignity to work on mere inscriptions.

[1] [Another translation would be 'beloved of Horus who dwells in Krokodilopolis, lord of the
lake country' (= the Faiyum, cf. Wb. 5.226.6–227.2) (J.R.B.).]
[2] The two signs at the bottom of the second line from the right have been made to face the
wrong way under the influence of the ends of the other lines.

It is interesting to note on the original that two different hands worked on this relief. On the right almost all the signs are worked in greater detail, but the artist of the left side, who left all that to the painter, was evidently the more brilliant. One only has to compare the crocodile heads, the owls 𓅓 , and the lion heads ⟨ to see that the difference is one of artistry and not just of technique.

It goes without saying, if we are to imagine an Egyptian work in limestone as the artist intended it we must think of its as painted down to the last detail: with the sky at the top blue, perhaps with yellow stars, the background white or pale blue-grey, and lastly the hieroglyphs themselves with all their lively yet harmonious colours, rendering all the birds' plumage and other such details.

Originally the inscription was probably above a small door, not on its own but surrounded by other inscriptions and pictures. For we must not forget that what we admire in a single piece was achieved by Egyptian artists hundred- and thousandfold in every well-built temple.

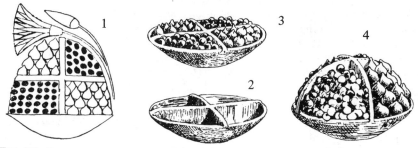

FIG. 329. Compartmented bowls. 1 Filled, after an Egyptian drawing. NK 2 Empty, as found. NK 3 The same bowl, filled. 4 Reconstruction on the assumption that there were bowls with high divisions between the compartments. [Discussed p. 101 n. 40.]

APPENDIX 6

THE RELATIONSHIP BETWEEN EXPRESSIVE CHARACTER AND THE RENDERING OF NATURE, AND TERMINOLOGICAL PROBLEMS IN DISCUSSING IT

(Schäfer removed a large part of the last chapter of the third edition of this book from the fourth edition. Certain parts of the text none the less retain their value, and a part, corresponding to p. 330–1 of the third edition, is given below. The text has been modified to conform with the terminology of the fourth edition, and cross-references are to the present edition. Full references are given for works not cited elsewhere in the book. It should be noted that Schäfer later modified his view of the 'organic', cf. p. 337 above. The passage comes before the paragraph beginning 'naturalism and geometrization' on p. 337 above. (J.R.B.))

The expressive character of a work of art may be manifested in many different degrees of realism, from the most meticulous to an almost total dissolution of natural forms in ornamental or geometric shapes, and these degrees tend all too often to be

considered to be degrees of value. But in themselves they have little to do with the value of a work:[1] they are a reflection of the differing relationships, in terms of strength and efficacy, between natural forms and the artist's innate formal inclinations (cf. p. 39 ff. above). At all events it should be observed that the realistic or non-realistic character of a work of art is unrelated to whether its basis is in frontal images or in oblique views. Thorough-going realism and, for example, sharply geometrical forms are found in works built on both these broad bases, as are the different forms of expression mentioned above pp. 18–20, the static, the dynamic. and the organic. Inexperienced observers who do not pay attention to this point can be seriously misled. The realism of, for example, palaeolithic, Cretan-Mycenaean or bushman art[2] may easily lead them to believe that these works are not based on frontal images, whereas in reality they are, just as much as Egyptian art is. The danger of this happening is of course much greater in a more supple art, like those named, than in one that is geometric in character, like Egyptian art. And within Egyptian art itself the correct understanding of the basis of the rendering of nature is more at risk in Amarna art than elsewhere.

Nor are 'painterly' modes of representation and ones which delineate surfaces sharply dependent in themselves on a rendering of nature based on frontal images or on oblique views. Rather, both methods are found on the basis of both types of rendering. Examples of the two in obliquely viewed modern works are available to everybody. Among art based on frontal images one needs only to compare palae-olothic cave paintings (von Sydow 1923.426–8, pl. 24) with sharply outlined Egyptian works.

(After a paragraph stating the same as p. 337, last para. Schäfer goes on to discuss other terminological pairs which have been used in similar contexts to his *geradvorstellig/schrägansichtig* and to his distinction of two 'levels'. He holds that the alternative terms proposed confuse these two pairs of distinctions, the first of which describes the two different types of 'framework'. Among these rival terms Verworn's *'ideoplastisch/physioplastisch'*, although championed by Frankfort (1932), are no longer current, nor are Worringer's theories in *Abstraktion und Einfühlung* (1907). Schäfer also rejected Kühn's *'sensorisch/imaginär'* and Franz Boas's 'symbolic/ perspective'.[3]

However, although these terms and the views they express are undoubtedly unsatisfactory as they stand, they do refer to a problem on which Schäfer barely touches here or elsewhere in the book. This is the question of how we are to explain the very varying degrees of 'realism' in image-based representational art, for Schäfer's appeal to 'formal inclinations' serves only to rephrase the question: why should many 'primitive' artists have such overriding formal inclinations, and why, in Egypt and elsewhere (e.g. China), a development towards greater 'realism' can be seen—

[1] p. 42 above; emphasized in particular by Worringer (1907; 1920, introduction).
[2] The strikingly realistic drawings of an eskimo child discussed by Bühler (1924.303, after Levinstein 1905 pl. 68–9, fig. 161–3) are fundamentally based entirely on frontal images, despite a few intrusive oblique views. One would need to know what pictures etc. the child had seen, although it is of course very difficult to establish this, especially among primitive peoples. Among our own children it is not easy. As far as I know Wulff is the only author to have done this, with his own son (1927), but much must have escaped him (cf. for example his fig. 304, which represents kangaroos, after an album of war pictures).
[3] *Primitive art* (Oslo: Aschenhoug 1927, Cambridge Mass.: Harvard University Press 1928, New York: Dover 1955) 68–80.

a 'realism' which seduces the viewer into reading it as perspective? In addition, works which depart very radically from realism can be said to show things 'as they are' only in a symbolic sense which requires its own explication. A further factor of interest is that developments towards greater realism seem to correlate to some extent with social changes. None the less, our lack of detailed knowledge of the social background from which the works issued is likely to impede progress along these lines. Perhaps more evidence could be found in child art or, more plausibly, in studies like Gombrich's (1968). Clearly the question is not susceptible of such clear-cut formulation—and solution—as the distinction between image-based and other art—although Schäfer intentionally worked with a somewhat idealized conception, thus simplifying the distinction. (J.R.B.))

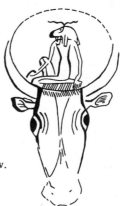

FIG. 330. Head of the goddess Hathor in the form of a cow. Between her horns the sun disk with the sun god. NK [Discussed p. 214 n. 178.]

ADDENDA

In an attempt to minimize delays in publication I decided to restrict the amount of supplementary material in this edition, attempting no systematic survey of later publications for new evidence. Most of the additions to Schäfer's material date perforce to before 1971. The following pages contain a selection of further data not incorporated in the main text of the book, both parallels from standard works— deliberately few in number—and stray observations made in the intervening years. I also note some differences of opinion with Schäfer; neither these nor the Introduction constitute a critique of the work. For reasons of space citations of works not in the bibliography are given in a more condensed style than is used there.(J.R.B.)

p. xiii, n. 5
For a complete bibliography of Schäfer's writings up to 1939 cf. *ZÄS* 75 (1939) 1–16. The volume is a Schäfer Festschrift, and contains a number of articles of relevance to the book.

p. 41, n. 87
A better example of the phenomenon Schäfer is discussing would be the motif of the 'uniting of the two lands', cf. pp. 155–6 Schäfer 1943.84, n. 5, with references; p. 86, n. 5 *ibid.* remarks on the connection.

pp. 48–9
The explanation of these staff poses given here is open to question in view of the increasing number of two-dimensional examples where the staff is apparently clasped to the chest, cf. n. 109, and add H. W. Müller, *Ägyptische Kunstwerke . . . Sammlung E. und M. Kofler-Truniger, Luzern* (Münch. Äg. Stud. 5, Berlin 1964), no. A 85 (third dynasty ?); H. Goedicke, *Re-used blocks from the pyramid of Amenemhet I at Lisht* (Metropolitan Museum of Art, New York 1971) no. 17, pp. 38–41 with 40, no. 108. The staff in this pose would in theory need to be slightly shorter than that held out at arm's length, and the combination with the unusual dress (*bȝt*-emblem) worn at the centre of the chest in the last example suggests that what is shown may be a specific ritual or courtly attitude. It cannot, however, be excluded that the pose was chosen in this case simply because it harmonised with the dress. (In Staehlin 1966 pl. 39, fig. 59 the staff is fused with the *bȝt*. This may be a secondary misinterpretation.) Confirmation of the view that the pose is a distinct one may additionally be found in the series of wooden reliefs of Ḥesireʿ (e.g. pl. 1 here), one of which has the pose with hand across the chest (L. Borchardt, *Denkmäler des Alten Reiches* 1 [CGMC, Berlin 1937], no. 1430, pl. 27). Since this is part of a carefully executed and no doubt planned series showing a variety of attitudes, it is likely that the distinction between the normal pose (pl. 1) and this one is meaningful.

p. 50, n. 114
The colour of Egyptian bronzes seems to have varied considerably, and it is possible to find among well preserved and cleaned pieces colours ranging from a pale, brassy yellow, which might imitate gold, to a deep reddish colour which is set off with gold

inlays of a paler yellower colour. Much of this variation must have been intentional, as is shown by its exploitation for inlay. There was also a rare variety of bronze, called 'black bronze' in Egyptian texts, which was mostly inlaid. cf. J. D. Cooney, *ZÄS* 93 (1966) 43–7.

p. 56 with n. 130
The *rḫjt* bird, which writes the word 'subject' has raised wings (in fact crooked to prevent flying) and is frequently shown with added human arms in a gesture of adoration.

p. 59, top
A number of clear cases have now been identified where Middle and New Kingdom artists borrowed from their predecessors—as indeed they would inevitably do, sometimes archaistically. Such phenomena may already be present in the Old Kingdom, cf. for example the problems of dating discussed by Scharff, *MDAIAK* 8 (1939) 29–32. For an early Middle Kingdom example of such borrowing see H. G. Fischer, *Artibus Asiae* 22 (1959) 240–52.

p. 71 with n. 6
The identification of the object shown as a cap removes the evidence for the princesses' Libyan origins (first pointed out by Ransom Williams 1932.42 n. 29; see also *Cambridge Ancient History* 1 (2)³ (1971) 171, with references).

p. 75 Depth of relief
The maximum depth of cutting of hieroglyphic signs at Medinet Habu (twentieth dynasty) is about 8 cm. Some monumental sunk reliefs on the east face of the inner enclosure wall of the Graeco-Roman Period temple at Kom Ombo are so deeply cut that the hands of the figures are modelled almost completely in the round (the figures themselves are not, of course). The effect is however, less 'plastic' than that of much Amarna period relief, which has great depth only in relation to its generally modest scale. Although the rendering of nature is not changed by such 'plasticity' it may plausibly be linked with other developments at the same time. For examples see Cooney (1965), and pl. 107 here. See also below to p. 306.

p. 75 Choice of raised or sunk relief
Ramesses II recut in sunk relief a number of his father Sety I's raised reliefs in the eastern (outer) parts of his temple at Abydos (PM 6.5). This might be attributed to a change in taste, but many other motives are conceivable. In general the inner parts of temples have raised relief and the outer ones sunk relief, a distinction maintained down to the Graeco-Roman Period. Schäfer's contention that sunk relief was chosen for areas in semi-darkness is questionable: the inner areas of temples were darker, and, in present-day conditions with the colour largely missing, raised relief seems to be more easily visible in the dark and with the strongly directed light from small openings. The detail in sunk relief is of course lost in such conditions.

p. 83, n. 6
The quotation is probably from *Mencius,* VII. A. 25: 'Mencius said, 'When he ascended the Eastern Mount, Confucius felt that Lu was small, and when he ascended mount T'ai he felt that the Empire was small. Likewise it is difficult for water to come up to the expectation of someone who has seen the Sea . . .'.

(Tr. D. C. Lau, *Mencius* [Harmondsworth 1970] 187). The date of writing down of the comment is therefore late fourth century B.C., although extant copies will of course be much later.

p. 98, fig. 45
An Egyptian parallel to this is a predynastic bowl in the Museum de Lyon, which has a painting of two crocodiles (or possibly lizards) on the interior. The bodies and legs are imagined from above, and jaws and perhaps heads from the side. Cf. *L'Égypte avant les pyramides* (Le Grand Palais, Paris 1973) 31 fig. 29.

p. 115, pl. 105
A. Hermann, *Jahrbuch für Antike und Christentum* 5 (1962) 60–69 with pl. 1, suggests that the iconography of the sarcophagus with the resurrection of Lazarus is directly influenced by Egyptian art.

pp. 119–20, fig. 83
The block is republished by H. G. Fischer, *Dendera in the third millennium B.C.* (New York 1968) fig. 27. The drawing is slightly more accurate. The object is BM 1260.

p. 120
In a special context an example of a part of the body shown outside it is Borchardt *et al.* 1913 pl. 9, where a trampled enemy surrenders hand and heart in one gesture. The hand is against the profile of the chest at about the level of the heart; the heart is next to it, fully visible and possibly held between index finger and thumb. Cf. H. G. Fischer, *JEA* 59 (1973) 224–6.

p. 124
The holes in the ground occupied by hedgehogs etc. could of course never be placed in the ground in a normal Egyptian picture, as this would involve their protruding below the base line, i.e. into the register below, unless the base of the register were very thick. Where it is thick the resultant picture looks rather like a map. Schäfer mentions an example p. 126, n. 77.

pp. 146–7, fig. 135a
The arrangement of the boy's game which puzzles Schäfer is capable of a variety of explanations. As it stands it shows that the running boy is coming towards the two others. Any other scheme would have involved placing the running boy between them. Apart from the unduly spaced composition which would be produced by such an arrangement the scene would be ambiguous in that the second seated boy would appear to be *behind* the running boy. Alternatively, if one of the two boys in their present positions were reversed he would appear to be facing away from the running boy. A more compact and to us more comprehensible representation of the motif would involve, as is demonstrated in Schäfer's own drawing, showing the third boy jumping and not running. The apparent creation of a space between the two seated boys is of course illusory.

p. 148, fig. 136
A very good reproduction of a parallel to this figure from the tomb of Menna (PM 1².1.134–5(2)) is J. Pirenne, *Histoire de la civilisation de l'Égypte ancienne* 2 (Neuchâtel–Paris 1962) pl. 6, facing p. 260. This and Nina Davies-Gardiner 1936

pl. 51 suggest that Schäfer's figure may be a misinterpretation of an earlier model.

p. 151
L-H pl. 70 shows an interesting example of a bird with detached head. The bird is on a table with other slaughtered birds which are part of the dead man's provisions, and so is not part of the script; but the idea of showing head and body separately is the same.

pp. 151–2
For discussions of the absence of gods and kings in Old Kingdom tomb reliefs see Wolf 1957.260 with p. 685, n. 2 to Chap. 70 (references).

p. 166, n. 123
Add: [Cf. D. Dunham, *Bulletin of the Museum of Fine Arts* 35 (Boston 1937) 52–4.]

pp. 173–7
A most unusual instance of the groupings Schäfer is discussing here is Munich G1. 298, *Staatliche Sammlung ägyptischer Kunst* (München 1972) pl. 39 (late eighteenth dynasty). In this right-facing group the wife seems to be envisaged as being on her husband's right, and has been placed on a lower seat (partly, no doubt, in order to fit into the composition) further back in the picture than her husband (i.e. to the left), with her left hand round his back. The wife is proportionately smaller than she normally is in relation to her husband and her subordination is clearly expressed, although the detail of her using her left arm makes her, in normal terms, in front of him (but not further forward in the direction in which the figures face on the picture surface). For the wife to sit on the right, as the arrangement here implies, is contrary to the normal situation in private sculpture, but paralleled in royal groups of the period.

Durham N 1932 (twelfth dynasty: S. Birch, *Catalogue of the Egyptian antiquities at Alnwick Castle* [London 1880] pl. I) may also be cited in this context. Here the wife is seated in front of the husband on a separate chair of identical form to his. But here again subordination is clearly shown: the husband's figure is the height of two registers of offering-bearers and offerings facing him and his wife, while the wife herself fits into the composition of the lower register. It is most unlikely that this is the Middle Kingdom case Schäfer cites without reference, as Birch's work, privately printed, has very little circulation.

Schäfer's case could be *Meir* 2 pl. 2. Here the woman is in front of the man. She is the same height as the man and wears the cosmetic lines of eye and eyebrow which are normally the mark of the exalted or dead (the man has them too). It is not possible to explain the group as some sort of mistake on the part of the artist, as the woman has her hand round her husband in the normal manner. The effect is, however, decidedly unfeminine, as are a number of the figures of women in the same tomb, e.g. *Meir* 2 pl. 6. In many cases in the tomb the normal slight difference in height and build between men and women is not observed.

p. 179, fig. 174
The layering of Amenhotpe IV and Nafteta probably reflects their identical status, and is thus in some sense 'programmatic'. Compare also the layering of Amenhotpe I and 'Ahmose-Naftera in I. E. S. Edwards, British Museum, *Hieroglyphic texts from Egyptian stelae etc.* 8 (London 1939) pl. 46 no. 989. It seems that close layering is

almost always used for items of identical genre and status—as indeed it should be in conformity with normal Egyptian conventions of representation. Cf. J. R. Harris, *Acta Orientalia* 35 (1973) 5—13, nn. 40—45; *idem, Acta Orientalia* 36 (forthcoming).

p. 193
The most striking example of a hunting scene enclosed within a net, on a monumental scale, is that from the pyramid temple of Saḥureʿ, where a wealth of detail, human and animal, is contained in the net and bracketed by the hunting king (Borchardt *et al.* 1913 pl. 17).

p. 209
It has been suggested that a large proportion of the full-face figures in the Theban necropolis may have been destroyed because of the fear of the evil eye. This would, however, modify the picture of their rarity only very slightly. Cf. for the destruction of faces generally Nina Davies—Gardiner 1936.3.xl viii. On mutilation of monuments as a whole cf. A. R. Schulman, *JARCE* 8 (1969-70) 29—48, esp. 36—7.

p. 210
Hathor almost always has a human head when her body is anthropomorphic. On exceptions cf. Hornung 1971.102—4, P. Derchain, *Hathor Quadrifrons* (Uitgaven Ned. Hist. Arch. Inst., Istanbul 1972).

An example of a back view of a head is the figure of the goddess, E. Otto, *Osiris und Amun* (München 1966)/*Egyptian art and the cults of Osiris and Amon* (London 1968) pl. 9, R. This shows the wig only, with one strand coming down the middle of the body, presumably one of the side strands. The body is otherwise normal. (Ptolemaic Period, Book of the Dead papyrus). Back view heads are also found among pictures of dead enemies in the New Kingdom, see next entry.

p. 214, n. 178
Full-face figures are relatively common in mythological and astronomical pictures, and in the underworld books. This might suggest that they were felt to be out of character with the ordered world—part of which, no doubt, was the standard mode of representing the human figure—and so belonged in liminal and 'uncreated' areas.

It is also significant in this context that front and back view heads in New Kingdom reliefs are much commoner in pictures of dead figures, or ones about to be executed, than in ones that are alive. Cf. e.g. Tutʿankhamun's painted box (lions and human beings: L-H pl. XXXIV, Nina Davies—Gardiner 1962); Medinet Habu battle reliefs (*MH* 1.33—4, 37, 39; front and back views in the last two). All the examples cited are also enemies, therefore belonging to the disordered world.

pp. 218—19
The interpretation of pl. 20 given is not the only one possible. A statue group in the Metropolitan Museum of Art, New York (in e.g. Hayes 1953.70 fig. 46, W fig. 116) gives an alternative realization within the limits of sculpture. It shows a nome deity standing beside King Saḥureʿ and holding out the sign of life sideways towards him. However, it is much more likely that this is a sculptural convention to express an action which would, if literally shown, give a group of two figures facing one another, than that it gives us the way in which it was in fact performed.

p. 219
A parallel to the Theodosius composition from a culture comparable to the Egyptian

is to be found in a statue of Urningirsu of Lagaš, which has offering-bearers lined round the base, facing towards the middle beneath the ruler's feet (23rd. century B.C., H–S pl. 138–9).

p. 222
On the equipment of the sun boat cf. G. Jéquier, *Considérations sur les religions égyptiennes* (Neuchatel 1946) 27–38.

p. 225, n. 195
The 'abstract' case of the king smiting enemies is republished by Labib Habachi, *MDAIAK* 19 (1963) 22 fig. 6, pl. 5.

p. 234 with fig. 250
The scene shown in fig. 250 is republished by Säve-Söderbergh (1957 pl. 22, p. 25 with n. 1), who concurs with Schäfer's interpretation. From the much damaged parallel groups below it would appear that it was the height of the sacks above the head, i.e. the total height of the figure, rather than the height of the heads themselves, which determined the arrangement.

p. 236 Vaults and domes
On vaults and domes see p. 54. As both were present in brick architecture, and vaults were rare and domes absent in stone architecture, Schäfer's argument here is not very strong. However, the vaulted shapes of the lids of sarcophagi and the ceilings of New Kingdom royal tombs support his position. On vaulted rooms in temples see W. Barta, *MDAIAK* 22 (1967) 48–52.

p. 238, n. 214
Smith (1946 pl. 47c) illustrates an Egyptian example of this phenomenon (fourth dynasty).

p. 240
An excellent illustration of water painted only, with preparatory grid-lines, is the colour reproduction in *Mereruka* 1 pl. 11.

p. 250
For a discussion of unusual overlaps between a man, a pond, and a dom palm cf. G. Fecht, *Literarische Zeugnisse zur "persönlichen Frömmigkeit" in Ägypten* (Abh. Heidelberger Ak. d. Wiss., Phil.-hist. Kl. 1965.1) 87–8 with n. 48. One example is *Atlas* 1.111. Fecht argues that these pictures convey an identification of the dead man with the dom palm.

p. 251, n. 228
The figure Fechheimer 1921 pl. 54–5 shows a squatting girl whose left foot is tucked under her right leg with its sole visible on the right-hand side next to the right foot. Whether this is more comfortable than the position with the instep flat on the ground may be doubted. The pose may be a simple transposition into three dimensions of a form like fig. 268 k, l, or r. The treatment of the right foot is highly conceptual and an interesting example of axial fixity.
 Smith (1946.14) remarks on the fact that squatting figures are much rarer in three dimensions than in two. Although this can to some extent.be explained by the function of the figures (working poses are less common in three dimensions than in

two) it may add weight to the assumption that the two-dimensional pose is in part a representational convention.

Chapter 5

5.1

Two further cases of possible foreshortenings may be noted here. Smith (1946.281 with fig. 124–5 [OK]) suggests that a foreshortening is to be observed in the way in which a goddess's hand curves round the breast she is holding to suckle a king. This is a detail mostly not retained in later representations of the same motif, cf. e.g. Naville n.d. 2 pl. 53 (indistinct); Brunner 1964 pl. 12. It is doubtful, however, whether an Egyptian would have felt this to be a foreshortening. The form as shown depicts how the hand disappears behind the chest, and the rounding expresses the rounding of breast and chest. The only alternative way of showing this would have been to finish the hand with a sharp line. So it is likely that rendering the mode of disappearance rather than the foreshortening was the aim of the artist.

The second case is a form which occurs in representations of enemies being smitten; cf. Labib Habachi, *MDAIAK* 19 (1963) 39 fig. 17, pl. 11b; Cooney 1965.82 (drawing), 83 (photograph). The enemy's head cowers down on his body, and the pose as a whole could be taken as a shrinking backwards—away from the picture surface. It should be noted, however, that no perspective reduction is involved. The neck is unusually short, but this is probably meant to show downward movement rather than reduction. It does, none the less, constitute a departure from the normal canon of proportion.

5.1.3

A close parallel to fig. 277a is *Gîza* 5.85 fig. 20. This differs in that the line of the bottom of the fringe is oblique, possibly to show that it fluttered sideways in the breeze. Parallels for a curved fringe are Davies 1902.1 pl. 8 (one of two shades), 1902.2 pl. 8 = *Atlas* 3.10 (photograph); Davies 1902.2 pl. 18 (= fig. 288b). In the second example there are four shades, three with oblique fringes. Two of these have oblique, nearly horizontal bottom lines, the third being lost at this point. The fourth fringe is too damaged for its form to be certain. All the examples with curved fringes therefore come from the late Old Kingdom tombs at Deir el-Gebrawi. The two shades Davies 1902.1 pl. 8 have asymmetrical cross-struts, the intersection displaced towards the top on one and towards the bottom on the other. If the asymmetry indicated that the shades were domed the rendering would constitute an oblique image, but any interpretation will be uncertain. Certain details in these compositions are evidently meant to indicate the spatial relationships of the litter, the shade-bearers and the shades, and the asymmetry of these shades may have reinforced the details. For further examples of shades see *Meir* 5 pl. 31 = 59 (fringes absent); *Beni Hasan* 2 pl. 16; in *Atlas* 3.9, *Gîza* 11.251 fig. 100 the shades are lost.

All the cases cited, except fig. 277b, show the tomb-owner being carried in a litter, and are thus the forerunners of fig. 285. Shades were also shown sometimes when he was simply standing, cf. e.g. LD 2.9 (the form of the fringe may be suspect), *Mereruka* 2 pl. 167–8 (shade lost).

For a study of sunshades with complete references see now H. G. Fischer, *Metropolitan Museum Journal* 6 (1972 [1973]) 151–6.

5.1.7

The drawing of the detail of the wheel-axle in fig. 110b and 283 is inaccurate.
Measurement of the two ends of the axle on the original illustration shows that
they have the same diameter. The axle swells at each end to prevent the wheels
from slipping off. It follows that the wheels are probably on the outside, between
the verticals of the ladder and the axle swellings. The overlappings do not of course
convey any foreshortening.

The 'perspective' character of this detail was already doubted by Smith (1946.
327), and discussed again and dismissed by Senk (*ASAE* 54 [1957] 207–11).
Neither observes the inaccuracy of Schäfer's drawing, but Senk's analysis of the
'perspective' character is in other respects correct.

5.1.8

Schäfer's discussion does not do full justice to the problems posed by this figure.
Cf. my remarks in a review of the reprint of Groenewegen-Frankfort (1951) in
JEA 60 (forthcoming).

5.1.9, with n. 11

The Griffith Institute, Ashmolean Museum, Oxford, has a copy of *Beni Hasan* which
gives the results of a collation by N. de G. Davies, made in preparation for a new
edition. His sketch of the shield (fig. 331) appears to settle the issue in favour of
Rosellini. Davies shows no vertical strut, but it is possible that this was lost when he
studied the scene (about 1930). Despite this reversal of Schäfer's view there seems
to be no warrant for taking this as an example of foreshortening: the hand could be
shown in no other way.

FIG. 331. Tracing of
N. de G. Davies's collation
of the shade in fig. 285.

pp. 272–3

For examples of foreshortenings in another culture than the Egyptian cf. the Maya
instance in e.g. R. Huyghe (ed.), *Larousse encyclopedia of prehistoric and ancient
art* (London etc. 1962) 99 fig. 135, 107 fig. 157. The foreshortening is more striking
in the former (the well-known Bonampak wall painting, discussed e.g. Gombrich
1968.122 with note), but in both cases it should be noted that the figures are
composed of a set of isolated images and not seen from a unified point of view. In
other words, they still resemble Egyptian modes of representation more than
western ones. The significance of such phenomena needs to be examined by
specialists in the material in question.

pp. 274–5

A major work which supplements and corrects these remarks is M. H. Pirenne,
Optics, painting and photography (Cambridge 1970). Pirenne demonstrates the
irrelevance of considering the shape of the retina in discussing perspective. A per-
spective construction, as with Dürer's woodcuts, intends to produce the same
impression on the retina as the scene which it renders, not a reproduction of the
retinal impression. Nor should the latter be confused with 'what we see'.

p. 278, fig. 288b
Photographs in *MDAIAK* 11 (1943) pl. 20; 12 (1944) pl. 12; Sm pl. 171. A later
parallel is Stockholm MM 11422, a bronze situla of the Saite-Persian period.

p. 290, n. 29
A possible Ptolemaic example of inlaid eyes in relief is in the first hypostyle hall of
the temple of Kom Ombo (PM 6.184 (45); photograph Weigall 1924.347). The three
animal-headed divinities on the right-hand side of the relief have holes in places of
eyes (checked on original).

p. 292 Ridge round the lips
Cf. discussion of this phenomenon by B. V. Bothmer, *Brooklyn Museum Annual* 8
(1966–7) 81 with n. 42.

p. 293
Examples of reversed leg postures (nearer leg in front of further leg) are: Davies
1923 pl. 23 (PM 1^2.1.183 (2)); Nina Davies–Gardiner 1936.1 pl. 37 (PM 1^2.1.189
(17): wrongly placed in tomb 80); naos of Amasis, Louvre D 29, figure of *ḥ'pj*,
bottom left front, inaccurately published without the relevant detail by Piankoff,
RdÉ 1 (1933) 163 fig. 2 (the detail is just visible on his pl. 8). In the first cases the
movement of a dancer is shown. I have no explanation for the last, which is probably
a copy of an earlier relief in the pyramid temple of Saḥure' (cf. Baines, *Göttinger
Miszellen* 4 [1973] 9–14). Since the figure faces right it cannot be dismissed as an
incorrect reversal of a right-facing model. The detail is not in the Saḥure' archetype.

Another problematic figure is on the funerary stela BM 638, P. Munro, *Die
spätägyptischen Totenstelen* (Ägyptol. Forschungen 25, Glückstadt 1973) pl. 43,
fig. 154. The object is of a very low technical competence. It is dated by Munro
(pp. 113–14) between the twenty-sixth and the thirtieth dynasty, i.e. before the
period of Greek influence. The figure faces left, and so is reversed as against the
'basic form'; but left facing is standard for this class of object, and the reversal not
otherwise normally found.

p. 294
Schäfer does not discuss the treatment of the kneecap, partly no doubt because it
is almost invisible in the normal basic form. It does, however, provide a striking
example of variation in an image-based mode of representation, comparable in
some respects with variations in the representation of nipples. Graeco-Roman
temple reliefs, in particular, show a wide range of forms of kneecaps, and in general
emphasize them more than earlier art. The most extreme form, not found at early
periods, shows the kneecaps in a complete front view, next to a knee-profile which
takes no account of the kneecap. For intermediate forms cf. e.g. *E* 13 pl. 530, for
intermediate and extreme forms *E* 12 pl. 384. The forms vary with the thickness
of the relief, as does the general 'plasticity', of which they can be part. I see no
reason for assuming Greek influence in order to explain these representational
details.

p. 295
Schäfer's suggestion that women's overlapped legs and the treatment of their
abdomens are a 'perspective-like oblique image' is surely unnecessary and already
improved on by his discussion of other overlapped legs and similar elements on

pp. 104–07. Of the two complementary interpretations given there the more plausible is the suggestion that legs were layered simply to show that two were present. Schäfer uses the explanation of 'liveliness' again on p. 305 in discussing the rarity of pure side views of the human figure. Again it can be suggested that this is because of the smaller amount of information contained in a side view. The female abdomen clearly poses more of a problem than the legs, but there is no reason for regarding the image of the two as a consistent one. The inconsistency between this passage and pp. 106–07 is possibly due to a less complete revision of the later section.

p. 296 Outside toes

The well-known early case is Nina Davies, *Scenes from some Theban tombs* (Oxford 1963) pl. 5 (Theban tomb 38, reign of Thutmose IV). A further example is published by A. Mekhitarian, *MDAIAK* 15 (1957) pl. 42.3 (PM 1^2.1.153 (6)). This invalidates Mrs Davies' statement that the phenomenon is unique at that date. The first of these two cases is curious also in that each of the pair of figures with outside toes shown has only one foot rendered and the foot is disproportionately large. This gives the impression that the composition may be modified from a rather different archetype. For example, two big toes from different feet could have been made the first two toes of the five on a single foot.

See also next entry.

p. 297

The plate just referred to (Theban tomb 38) shows the same scene as the photograph Weigall 1924.159; the drawing gives less overlap than the photograph would suggest, and it may be that the artist used flesh colour as a fill-in between breast and arm. In addition to the breast detail the lower part of the arm appears to be overlapped by the hips, and the fingers are shown without the thumb, which is presumably to be imagined hidden by the thigh. From these various details it can be seen that these two figures are highly unusual in a number of respects. As Mrs Davies remarks, the quality of the work is not so fine that one would immediately attribute the departures from the norm to an artist of unusual calibre.

p. 298 with pl. 69

The Amarna and later gesture referred to probably has a symbolic character, cf. for example the figure of Osiris, *Les merveilles du Louvre* 1 ([Paris] 1958) 108.

For a good example of the palm of the hand cf. Riefstahl 1951 pl. 1, since frequently reproduced, e.g. Sm pl. 145 B.

p. 302

Other explanations of the instructions for drawing a cow are possible. It seems likely that the Egyptians automatically reversed normal right-and-left relationships in left-facing figures. Cases where this does not occur—which are of course many—are probably adaptations to the visual image.

p. 304 'Profile' shoulders

A thirtieth dynasty example (W. M. F. Petrie, *The palace of Apries (Memphis II)* [London 1909] pl. 17, 25) shows that the form was tending at that time to be considered a true profile. In this right-facing figure the treatment of the right shoulder is softened considerably and the staff is, abnormally, in the right hand. Comparison with an Old Kingdom example with the staff in the right hand is

revealing; there the pose is very different and much less 'illusionistic' (cf. G. Goyon, *Kêmi* 15 [1959] pl. 9, no. 5 lower). In the Late case the left hand is shown next to the profile of the long cloak, as it were wrapped round the front of the figure. The left (further) shoulder is indicated only by a very slight convex curve next to the neck, the rest of the front line apparently depicting the line of the paunch and the cloak covering it.

p. 306 Front-view breasts

There are examples of front-view breasts where the bottom line of the breast is rendered rather than the nipple. Cf. fig. 207; Smith 1946.323 fig. 198 (sketch only, unfinished), and, more remotely, fig. 212 (with many parallels). These should not necessarily be taken to show that the breasts are pendulous, as there is no other way for an Egyptian artist to indicate the underside of the breast.

Fig. 315–16, pl. 107

An example of a comparable rendering of a woman's breasts is on an inlaid box of Tut'ankhamun, best illustrated in [C. Desroches Noblecourt] , *Toutankhamon et son temps* (Le Petit Palais, Paris, 1967) 115; see also TP 125, C. Desroches Noble-court, *Tutankhamen* (London 1963) 271 fig. 176. Here the woman is turning; although the breasts appear to be in a front image their outline, without the nipples, is expressed on both sides of the body (rather like fig. 288b here without the nipple). Fig. 316 is none the less exceptional, therefore, in the small extent to which the breasts influence the profile. It should be noted that all the examples of related phenomena date approximately to the fourteenth century B.C. (cf. also the remarks of Cooney 1965.29). For parallels in the Near East cf. H. Frankfort, *Cylinder seals* (London 1939) pl. 36 a, b, h (all male figures); B. Buchanan, *Catalogue of ancient Near Eastern seals in the Ashmolean Museum* 1 (Oxford 1966) pl. 29 no. 375 (four female figures). The main scene on the Tut'ankhamun box may have a frontally viewed single breast (as in fig. 217b here), partially obscured by the overlapping arm (cf. Sm pl. 151, L-H pl. XXXVI), but it is hard to judge the detail from photographs.

There is an extremely common tendency for the position that could be occupied by a woman's second breast in two-dimensional rendering to be obscured either by an arm or by an object placed in front of it. The existence of a number of exceptions where the position is empty and the second breast consequently indicated suggests that this was, at any rate in the mid-eighteenth dynasty, felt to be a weakness in the standard rendering of nature, and with turning figures or others whose pose implied a front view an alternative closer to the visual image was being sought. A contribu-tory factor would no doubt be male artists' interest in female breasts—rather as in the incident of the moustache recounted on p. 88. In the case of fig. 316 the search was probably aided by the tendency, visible fairly often in sunk relief, to-wards greater 'plasticity', possibly a reflection of the rounded forms favoured in sculpture at the time.

Cf. also to p. 75.

p. 318, n. 15

The figure Weigall 1924 pl. 139 is BM 50703. It represents a ram-headed demon, and the object is a wooden statuette from the Valley of the Kings. The demon is likely to be a figure from the underworld books, and, as remarked above to p. 214, full-face figures are relatively common in the illustrations to these. So the demon's

pose could well be an 'imitation' in three dimensions of an abnormal one found in two.

A partial exception to the rule of directional straightness is the surprisingly large number of statues which have their heads raised from the horizontal, a pose which B. V. Bothmer suggests denotes looking at the sun. Cf. *Kêmi* 20 (1970) 37–48. Some cases may be more apparent than real, as the axis of the eye in a face which appears to be tilted backwards is sometimes horizontal. It is also possible that aesthetic considerations play a part, cf. J. D. Cooney, *Brooklyn Museum Bulletin* 15.1 (1953) 1–25.

p. 382

Blümel 1927. There is an English translation: C. Bluemel, *Greek sculptors at work*[2]. London: Phaidon 1969 ([1]1955).

CHRONOLOGICAL TABLE

[This table is adapted from Hornung (1967.168—9). I am grateful to Prof. Hornung and to the publishers, Wissenschaftliche Buchgesellschaft, for permission to use it. Schäfer's terminology has been modified to conform with modern usage (J.R.B.).]

The Egyptians did not count the years of their history from a single given year. They dated by regnal years of kings, so that they needed lists in which lengths of reigns were registered precisely. There are preserved important fragments of such lists, in which the rulers' names were arranged by families (dynasties); scholarship's task is to reconstruct the correct order of kings from these and from what can be deduced from other monuments. It has become customary to group the dynasties further, with divisions as follows: Predynastic, Early Dynastic (ED), Old Kingdom (OK) [First Intermediate Period (First Intermediate)], Middle Kingdom (MK), [Second Intermediate Period (Second Intermediate)], New Kingdom (NK), [Third Intermediate Period], Late Period (late), Graeco-Roman Period (Graeco-Roman).

[Margins of error in absolute dating are roughly as follows: Early Dynastic, 50—100 years; Old Kingdom, up to 50 years; First Intermediate Period, doubtful, 2134 is probable for the beginning of the eleventh dynasty; twelfth dynasty, dates astronomically fixed; Second Intermediate Period—New Kingdom, about 20 years, margin probably much narrower for dynasties 18—19; Third Intermediate Period, about 20 years; Late Period, fixed to within one year (J.R.B.).]

Predynastic Period	before 2900
Early Dynastic Period	about 2900—2628
First dynasty	about 2900—2763
Na'rmer, 'Aḥa, Djer, Wadj, Dewn, 'Anedjib, Semerkhet, Qa'a	
Second dynasty	about 2763—2628
Ḥetepsekhemui, Re'neb, Ninetjer, Peribsen, Sened, Kha'sekhem-Kha'sekhemui	
Old Kingdom	about 2628—2134
Third dynasty	about 2628—2575
Djoser, [Sekhemkhet], Ḥuni	
Fourth dynasty	about 2575—2465
Snofru, Khufu (Kheops), Re'djedef, Re'kha'ef (Khephren), Menkaure' (Mykerinos), Šepseskaf	
Fifth dynasty	about 2465—2325
Userkaf, Saḥure', Neferirkare', Niuserre', Djedkare' Izezi, Wenis	

Sixth dynasty	about 2325–2150
Teti, Pepi I, Merenreʻ, Pepi II	
Seventh–eighth dynasty	about 2150–2134
First Intermediate Period	about 2134–2040
Ninth–tenth dynasty (Herakleopolis)	about 2134–2040
Eleventh dynasty (Thebes)	about 2134–2040
Middle Kingdom	about 2040–1650
Eleventh dynasty (all Egypt)	about 2040–1991
Mentuḥotpe II	
Twelfth dynasty	1991–1785
Amenemḥat I, Senwosret I, Amenemḥat II, Senwosret II	
Senwosret III, Amenemḥat III, Amenemḥat IV	
Thirteenth dynasty	about 1785–1650
About sixty kings, the most prominent	
called Neferḥotep, Sobkḥotpe, Sobkemsaf	
Fourteenth dynasty (Delta)	about 1720–1650
[existence doubtful]	
Second Intermediate Period	about 1650–1551
Fifteenth–sixteenth dynasty (Hyksos)	about 1650–1540
Seventeenth dynasty (Thebes)	about 1650–1551
Seqenenreʻ, Kamose	
New Kingdom	1551–1070
Eighteenth dynasty	1551–1306
ʻAḥmose, Amenḥotpe I, Thutmose I, Thutmose II,	
Hatšepsut, Thutmose III, Amenḥotpe II, Thutmose IV,	
Amenḥotpe III, Amenḥotpe IV–Akhanyati (Akhenaten),	
Semenkhkareʻ, Tutʻankhamun, Aya, Haremḥab (1333–1306)	
Nineteenth dynasty (early Ramessid)	1306–1186
Ramesses I, Sety I, Ramesses II (1290–1224),	
Merneptaḥ, Siptaḥ, Sety II, Tewosre	
Twentieth dynasty (late Ramessid)	about 1186–1070
Sethnakht, Ramesses III–XI	
Third Intermediate Period	about 1070–715
Twenty-first dynasty	about 1070–945
Smendes, Psusennes I, Amenemope,	
Siamun, Psusennes II	
Twenty-second dynasty	about 945–715
Kings calles Šešonq, Osorkon, Takelot	
Twenty-third dynasty (parallel)	about 808–715
Twenty-fourth dynasty (Delta)	about 730–715
Tefnakhte, Bocchoris	

Late Period	715–332
Twenty-fifth dynasty ('Ethiopian')	715–664 [?]
Forerunners: Kašta, Piye (Piankhi), before 715; Šabaka, Šebitku, Taharqa, Tanutamun (Assyrian occupation 671–664 or 656)	
Twenty-sixth dynasty	664–525
Psammetichus I, Neko II, Psammetichus, Apries, Amasis, Psammetichus III	
Twenty-seventh dynasty (first Persian domination)	
	525–404
Twenty-eighth dynasty	404–399
Amyrtaios of Sais	
Twenty-ninth dynasty	399–380
Nepherites, Achoris	
Thirtieth Dynasty	380–343
Nectanebo I, Teos, Nectanebo II	
Thirty-first dynasty (second Persian domination)	
	343–332
Graeco-Roman Period	332 B.C.– A.D. 395
Ptolemaic dynasty	304–30 B.C.
Roman occupation	30 B.C.– A.D. 395

LIST OF BERLIN MUSEUM NUMBERS, WITH
PRESENT LOCATIONS OF OBJECTS

[The Berlin Egyptian Museum collections were divided for storage during the Second World War, and the building itself was destroyed. By far the largest proportion of the objects is now in East Berlin, in the Staatliche Museen zu Berlin, Ägyptisches Museum. Objects which were stored in West Germany during the War are now in a new museum, the Ägyptisches Museum Berlin, Staatliche Museen Preussischer Kulturbesitz (Charlottenburg), in West Berlin (catalogue W. Kaiser *et al.*, title as name of museum [1967]). A number of further objects cannot at the moment be traced. In view of this situation I have compiled the following list of the numbers Schäfer cites, in order to ease any search for the objects themselves. Most of the objects in the West are published in the catalogue cited above, but there has been no systematic publication of material in East Berlin since the war. Data for this list have been collected from the files of the Griffith Institute, Ashmolean Museum, Oxford, and from information very kindly supplied by Dr. Steffen Wenig of the East Berlin Museum. E = East Berlin, W = West Berlin, unkn = present location unknown (J.R.B.).]

Number	Location	Number	Location	Number	Location
29	E	7781	unkn	15081	E
813	unkn	7954	unkn	15084	E (another fragment with the same number is in West Berlin)
1105	E	7955	W		
1107	E	8816	unkn		
1108	E	8957	W	15129	E
1119	E	9610	W	15158	unkn
1121	E	10834	E	15316	W
1131	E	11978	unkn	15321	E
1186	E	12411	E	15335	E
1188	E	12489	renumbered 12514, E	15337	W
1191	E	12694	E	15420	E
1197	E	13028	W	15454	E
1200	E	13187	W	15466	W
1882	unkn	13297	E	15693	E
1883	E	13824	E	15756	E
2089	E	13826	E	16100	E
2112	E	13892	W	16162	E
2296	E	14113	E	16202	W
3316	W	14200	E	16326	E
4358	E	14314	E	16700	W
6709	E	14362	E	16953	E
7265	E	14593	E	17021	W
7278	E	15000	W	17540	E
7290	E	15004	E	17800	E
7325	unkn	15071	E	18529	E

Number	Location	Number	Location	Number	Location
18539	E	20488	W	22440	E
19079	E	20672	W	22445	W
19120	unkn	20788	W	22588	W
19400	unkn	21238	E	22820	E
19747	W	21263	E	22881	W
19782	E	21364	E	23007	W
20036	E	21762	E	23217	unkn
20037	E	21782	E	23218	W
20039	E	21783	E	23798	unkn
20078	E	21784	E	p3152	E
20132	unkn	21822	unkn	p11775	E
20304	E	21839	W		
20363	E	22117	unkn		

CONCORDANCE OF PLATE NUMBERS IN GERMAN
AND ENGLISH EDITIONS

German (Schäfer 1963)	English	German	English
1 (frontispiece)	1	24.1	40
2.1	2	24.2	41
2.2	4 (top)	25.1	42
2.3	3	25.2	43
3	4 (main)	26	44
4	5	27.1	45
5	8–9	27.2	46
6.1	6	28	47
6.2	7	29	48
7	10	30.1	49
8.1	11	30.2	50
8.2	12	31	51
8.3	13	32	52
9.1	14	33.1	53
9.2	15	33.2	54
10.1	16	34	55
10.2	17	35.1	56
10.3	18	35.2	57
11	19	36	58
12.1	20	37.1	59
12.2	21	37.2	60
13	22	38.1	61
14.1	23	38.2	62
14.2	24	39.1	63
15.1	25	39.2	64
15.2	26	40.1	65
16.1	27	40.2	66
16.2	28	41	67
17	29	42.1	68
18.1	30	42.2	69
18.2	31	42.3	70
19.1	32	42.4	71
19.2	33	42.5	72
20.1	34	43.1	73
20.2	35	43.2	74
21	36	43.3	75
22	37	44.1	76
23.1	38	44.2	77
23.2	39	44.3	78

German	English		German	English
45	83		51	93
46.1	79		52.1	94
46.2	80		52.2	95
46.3	81		53.1	96
47.1	86		53.2	97
47.2	87		54.1	98
48.1	88		54.2	99
48.2	89		54.3	100–101
49.1	84		55.1	102
49.2	85		55.2	103
50.1	90		56.1	104
50.2	91		56.2	105
50.3	92		56.3	106

107–9 are not illustrated in photographs in the German edition. Where a new original has replaced that used in the German edition the plate correspondence has been noted as if the objects illustrated were the same. Details as to which originals have been changed can be found in the list of sources for plates (pp. 376–379).

SOURCES FOR TEXT FIGURES

(The first figure in brackets after an entry gives the page of occurrence, any subsequent ones other pages on which the figure is mentioned.)

About half the figures in the text are redrawn from the same sources, or new sources or originals have been found for them. Such cases are indicated by an asterisk *.

For a number of the Berlin objects it has not been possible to verify the quality or the fidelity of the line drawings, or the method by which they were produced. This stricture affects in particular fig. 1, 2, 72, 150, 203, 216, 237, 288, 290, 294, 309, 313. Judging by Schäfer's frequent disregard for quality in this respect one must conclude that the drawings should be treated with caution, despite the fact that the objects were in the collection of which he was the curator. This will seldom be of relevance to the particular points which he is discussing. Many of the figures not replaced in this edition are also unsatisfactory, but it was not practicable to change them. Acknowledgements are due to all the institutions from whose publications the text figures have been drawn; mention should be made in particular of the Metropolitan Museum of Art, New York and the Egypt Exploration Society, London, both holders of the copyright in a large number of Davies's publications, and of the Oriental Institute of the University of Chacago (J.R.B.).

1 Berlin 11978. (xxv, 21)
2 Berlin 11978. (xxv, 21)
3 Prisse (1879 Atlas 1 pl. 35) [original unreliable (J.R.B.)] . (1, 47, 224)
4 Schäfer (1926a. 1881). (10, 26)
5 a Detail from pl. 9 top R. (11)
 b Propyl. 190, L-H pl. 6.* (11)
 c Ranke (1936 pl. 323, below L) [drawing from photograph] . (11)
6 Petrie (1901 pl. 20).* (13, 258)
7 Petrie (1901 pl. 23).* (13, 258)
8 Murray (1905 pl. 1 R). (19)
9 a Prisse (1879 Atlas 1 pl. 14).* (20)
 b Borchardt (1911−36.1.16 no. 15).* (20)
10 Prisse (1879 Atlas 1 pl. 14).* (20, 40)
11 Davies (1900−1.2 pl. 27).* (20, 21, 56)
12 Berlin 14200 [tracing from photograph] .* (21)
13 Prisse (1879 Atlas 2 pl. 68). (21, 22)
14 Lauer (1936 pl. 38).* (25)
15 Berlin 22820, Anthes (1930b pl. 7). (33, 184, 282)
16 Holwerda−Boeser−Holwerda (1908 pl. 23).* (33, 184)
17 Balcz (1930a pl. 17). (40)
18 a−c Schäfer (1944.113 fig. 4) [redrawn, cf. Ch. 2 n. 87 (J.R.B.)] . (41)
19 Statue of Sepa, Louvre A36/37, in e.g. M fig. 202.* (49, 48, 51)
20 Hildesheim, Pelizaeus Museum, tomb of $Whm-k_3$ [cf. Kayser 1964 p. [32] (J.R.B.).] (49, 48)

21 Chassinat–Palanque (1911 pl. 36) [Cairo JdE 36284 (J.R.B.)] .* (49, 48)
22 Leclant (1956.135 fig. 13).* *Atlas* 2.167. (56, 55)
23 Davies (1941 pl. 31 L).* [Not identical to the illustration in the German
 edition: Schäfer appears to have fused elements from two figures (J.R.B.).]
 (63, 62)
24 Davies (1941 pl. 36 R).* (63, 62)
25 Davies (1903–8.3 pl. 18). (64)
26 Hernandez-Pacheco (1918.12 fig. 7a).* (69, 160)
27 Möller (1909 nos. 13, 193, 241). (70, 151, 257)
28 Lange–Schäfer (1902 pl. 80). (72)
29 Berlin 18529. [The original is much blackened (J.R.B.).] (73)
30 a Propyl. 408. (76)
 b Relief fragment in private possession.* (76)
 c *Atlas* 1.153. (76)
31 Schematic drawings. (77, 76)
32 From the original. (90, 100, 104, 112, 202)
33 From the original. (93)
34 Rosellini (1832 pl. 49).* (93, 124, 243, 314)
35 From the originals. (95, 101, 102, 109)
36 From the originals. (95)
37 Relief in Hamburg, Museum für Kunst und Gewerbe. The pattern on the edge
 of the basket has been added on the basis of *Ani* pl. 34. (96, 95, 168)
38 Erman–Ranke 1923.223. (96)
39 Lacau (1904 pl. 50).* (96)
40 Jéquier (1921.28 fig. 77).* (96)
41 Rosellini (1834 pl. 89). (97, 96, 104, 170)
42 Rosellini (1834 pl. 89) [Schäfer's reference to Denon is wrong (J.R.B.)] . (97)
43 a Prisse (1879 Atlas 2 pl. 73.4) [PM 2^2.98 (282), drawing unreliable (J.R.B.)] .
 (98)
 b Prisse (1879 Atlas 2 pl. 82.4) [original is much damaged, cf. *Atlas* 1.296
 second register, extreme R (J.R.B.)] . (98)
 c Nina Davies (1936 pl. 14).* (98, 225, 261)
 d Prisse (1879 Atlas 2 pl. 79.5) [simplified, location of object unknown (J.R.B.)] .
 (98, 95, 97)
 e Nina Davies–Gardiner (1926 pl. 20).* (98, 144, 285 with n. 17)
44 Freehand drawing. (98, 97, 100)
45 *Beaux arts, chronique des arts et de la curiosité, le journal des arts 73ᵉ année,
 nouvelle série nᵒ. 115, 15 mars 1935.* Paris: Gazette des Beaux Arts, p. 2 'La
 vie des Musées, au conseil des Musées nationaux' [Tracing from photograph,
 enlarged; definition is poor. The object is in the Louvre (J.R.B.)] .* (99, 98,
 120, 149)
46 Schäfer (1934.11 fig. 12). (99, 98)
47 Nina Davies–Gardiner (1926 pl. 18).* (100, 99)
48 Von Bissing–Kees (1923 pl. 16).* (100, 99, 106 n. 45, 353)
49 From the original. (100, 95, 99, 314)
50 Steindorff (1913 pl. 133) [now in Wild 1966 pl. 174 (J.R.B.)] . (100, 314)
51 After the original. (100)
52 Wild (1953 pl. 111) (= *Atlas* 3.39, Steindorff 1913 pl. 110).* (102, 101)

53 a Swarzenski (1927.63) [simplified] . (103, 102, 323)
 b Swindler (1929 fig. 269 L).* (103, 102)
54 After the original. (103)
55 Davies (1903–8.4 pl. 6).* (104, 139)
56 Mace-head of Na'rmer, Oxford, Ashmolean Museum E3631. New drawing from original.* (105, 104, 166, 177, 230, 293)
57 After various originals in Theban tombs (*Atlas* photographs). (105, 225)
58 Leth (1959 no. 24). København, Kunstindustrimuseet 21/1956. Tracing from photograph [new original, Schäfer's reference in the German edition is wrong (J.R.B.)] .* (106, 105)
59 Murray (1905 pl. 38 no. 25). (106, 105)
60 Lacau (1904 pl. 35 no 97).* (106, 317)
61 Murray (1905 pl. 37 no. 5).* (106, 209)
62 Lacau (1904 pl. 40 no. 193).* (107)
63 Lacau (1904 pl. 40 no. 191). (107)
64 After the original. (109, 121)
65 After the originals. (110, 107)
66 Brunner (1964 pl. 12) [the picture is reversed in the German edition (J.R.B.)] .* (111, 56, 99, 110 with n. 55, 139, 140, 235)
67 Quibell (1913 pl. 18).* (111, 140)
68 Tracing from Farina (1929 pl. 21) [Schäfer refers also to Heidelberg 318, now in Otto (1964 fig. 22–3), but the figure there is very indistinct (J.R.B.).] .* (112)
69 Quibell (1908 pl. 39). (113, 112)
70 L Author's drawing from the original in Cairo. (113, 112)
 R Wilkinson–Birch (1878.413) [modified] . (113, 112)
71 [Schäfer's reference is to Berlin 13028, but this is wrong; for the type see for example Davies (1941 pl. 9 top L) (J.R.B.).] (113, 112)
72 Berlin 20363. (113)
73 Davies (1930 pl. 17).* (113, 56)
74 Calverley *et al.* (1933–58.3 pl. 14) (tracing from photograph).* (114, 124)
75 Naville (n.d. pl. 45).* (114, 120)
76 Borchardt (1964.209 no. 1790 pl. 112) [simplified drawing adapted from photograph] .* (115, 145)
77 Murray (1905 pl. 38). (116, 115, 145, 353)
78 Berlin 4358 [tracing from photograph] .* (116, 115, 145)
79 LD 3.215, 299 no. 69 [reversed] . (116, 261, 282, 288)
80 a Davies (1930.1 pl. 11, 2 pl. 11a) [simplified] . (117, 116, 282)
 b Davies (1926b.7 fig. 3) [drawing from photograph] .* (117, 116, 282)
 [The references to these two were switched in the German edition (J.R.B.)] .
81 Von Bissing (1956 pl. 19). (117)
82 *Beni Hasan* 2 pl. 4.* (118, 182)
83 Petrie (1900b pl. 8) [from photograph] . (119, 120, 149)
84 Koch-Grünberg (n.d. pl. 30). (119, 120)
85 Koch-Grünberg (n.d. pl. 9).* (121, 119, 120, 124, 142)
86 Davies (1934 pl. 19) [PM 1^2.172 (17)] .* (122, 121)
87 Mariette (1873 pl. 31). (122, 121)
88 Naville (1886.1 pl. 174). (122, 202)

89 Berlin 20488. (123, 122, 209, 251)
90 Daressy (1901 pl. 15 no. 25074) [drawing from photograph] . (123, 16 n. 17, 122)
91 Davies (1923 pl. 4) [schematic] . (123)
92 a–b Quibell (1913 pl. 21 no. 70, 22 no. 78).* (123, 167)
93 a Borchardt (1899.83). (123, 125, 167)
 b Berlin 1108. (123, 167, 169)
 c Lacau (1904 pl. 32 no. 47). (123, 169)
 d Capart (1906 pl. 4). (123, 169)
94 Tracing from pencil and watercolour MS. of Sir J. Gardner Wilkinson, in Griffith Institute, Ashmolean Museum, Oxford, 2.17 (1828 ?).* (124)
95 Rosellini (1834 pl. 37) [some figures omitted–also in *Beni Hasan* 2 pl. 17 (J.R.B.)] . (124, 166, 199 n. 172)
96 Rosellini (1832 pl. 50, restored). (124, 163, 239)
97 a Von Bissing–Kees (1923 pl. 2).* (125, 106, 163, 229, 251)
 b *Codex Magliabecchiano XIII. 3. Manuscrit mexicain post-Colombien reproduit en photochromographie aux frais du Duc de Loubat* pl. 67. Rome: Danesi 1904 [drawing from coloured reproduction] . (125, 163, 239)
98 LD 2.98d. (125, 144, 167, 169)
99 Gardiner (1913 pl. 46) [drawing from photograph] . (126, 125)
100 Devéria (1872 pl. 3). (126, 125, 230)
101 Davies (1900–1.1 pl. 22).* (126, 127)
102 Leemans (1867 T 2 pl. 8) [tracing] .* (127, 134, 230)
103 Davies (1903–8.3 pl. 11). (127, 128 n. 78, 215)
104 Piankoff (1953 pl. 173) [tracing from photograph. The photograph's definition is poor for the bottom L corner of the picture (J.R.B.)] .* (128)
105 Schäfer (1939.150 fig. 5) [after Prisse (1847 pl. 35.4)] . (129, 128)
106 Prisse (1879 Atlas 1 pl. 52 lower) [PM 5.185 (9)–(10) (J.R.B.)] . (129)
107 Davies (1903–8.1 pl. 26).* (130, 128, 131, 132, 134)
108 Davies (1903–8.1 pl. 18).* (130, 104, 128, 131–4, 199)
109 Schematic drawing after a drawing by Ludwig Borchardt. (131, 128)
110 a Petrie (1898 pl. 4) [schematic, omitting figures] .* (132, 131)
 b Quibell–Hayter (1927 frontispiece) [schematic, omitting figures] . (132, 131, 263 with n. 8)
111 a Nina Davies–Davies (1933 pl. 8) [missing detail in front of middle entrance] . (132)
 b Free drawing. (132)
112 Borchardt (1907b.59 fig. 1, 61 fig. 2) [no more recent publication (J.R.B.)] . (133, 129, 199)
113 Junker–Schäfer (1921.107). (135, 134)
114 Petrie (1901 pl. 4 no. 11) [drawing from photograph] . (135, 134)
115 Wilkinson–Birch (1878.1.371), cf. *Atlas* 1.279 [in Wilkinson MSS. 2.12 (Griffith Institute, Ashmolean Museum, Oxford); Wilkinson's original water-colour gives a rather indistinct outline to the holes in the bins; the scene was more damaged than the published drawing shows (J.R.B.)] .* (136, 134, 230, 260, n. 4)
116 a Tracing from Schott photograph 7019, in Griffith Institute, Ashmolean Museum, Oxford.* (136, 134, 137)
 b Davies (1903–8.6 pl. 18). (136, 137, 215)

117 Berlin 12694 [= Ranke 1936 pl. 226, Schulman 1968 pl. 1 fig. 3; drawing from photograph] .* (137, 134)
118 Davies (1902.1 pl. 9). (138)
119 Rosellini (1834 pl. 125) [photograph in Piankoff–Maystre (1939 pl. 5) (J.R.B.)] . (139, 56)
120 Von Bissing–Kees (1923 pl. 23). (139, 15, 111 n. 55 from 110)
121 Lefebvre (1923–4.3 pl. 10).* (139, 140)
122 Quibell (1913 pl. 18). (140, 99, 110 with n. 54)
123 Quibell (1913 pl. 19) [objects on L are not shown in full] . (140)
124 LD 2.61a.* (141, 140, 176, 298)
125 LD 2.42a [Lieder Squeeze XII, in the Griffith Institute, Ashmolean Museum, Oxford, shows that the wife's hand on the husband's shoulder was omitted by the ancient draughtsman (J.R.B.)] .* (142, 141, 176)
126 Épron–Daumas (1939 pl. 17).* (143, 101, 140–1, 183, 184 n. 228, 253)
127 a Davies (1925b pl. 5).* (143, 142)
 b Quibell–Hayter (1927 pl. 9) [drawing from photograph, enlarged] . (143, 144)
128 Davies (1943.2 pl. 62).* (143, 144)
129 Davies (1922.2 pl. 55) [tracing from photograph] .* (144)
130 Reisner (1907 pl. 25 no. 12501). (144, 146)
131 Hildesheim, Pelizaeus Museum, tomb of $Whm-k_3$.* (145)
132 Davies (1922.1 pl. 23).* (146, 145)
133 New York, Metropolitan Museum M.M.A. 11.150.46 (Winlock 1921.21 fig. 4) [drawing from photograph] . (146, 145)
134 Berlin 1883, Propyl. 341.1. (146, 320).
135 a Eaton (1937.55, fig.).* (147)
 b Adaptation of 135a.* (147)
136 Berlin 18539 = pl. 41 here [tracing from photograph; parallel Sm pl. 109 J.R.B.)] .* (148, 106, 291)
137 Quibell–Green (1902 pl. 76).* (149, 150)
138 [Schäfer cites for this drawing Möller (1924 pl. 2, fig. 2), but the drawing is different; original publication is Quibell (1900 pl. 15 no. 7): Schäfer's version is considerably restored in comparison with it (J.R.B.).] (150)
139 Schäfer (1908.105). (152, 151)
140 Petrie (1905 pl. 63, no. 65, 65 no. 18, 64 no. 70) [drawings from photographs] . (154, 153)
141 Randall-MacIver–Mace (1902 pl. 14 no. D46). (154, 70, 259 n. 1, 278)
142 Quibell–Green (1902 pl. 76). (155, 233)
143 MH 2 pl. 85.* (157, 156)
144 Quibell–Green (1902 pl. 75) [photograph of copy Case–Payne 1962 (J.R.B.)] .* (158–9, 26, 70, 149, 160, 163, 189, 196, 247, 248)
145 Lauth (1870, plate).* (158, 160, 239)
146 From the original. (160)
147 Piankoff (1954 pl. 149) [tracing from enlargement. The water lines on the original have been omitted from the illustration (J.R.B.)] .* (161)
148 Davies (1943.2 pl. 53).* (162)
149 a After the original, in a collection outside Germany. (163, 162)
 b Prisse (1847 pl. 33) [emended. The plate is reproduced in Leclant (1965 pl. 47, cf. pp. 68–9) (J.R.B.)] . (163, 162)

150 Berlin 14593. (163, 150, 166)
151 Davies (1900–1.1 pl. 21 L).* (164, 147, 166, 193, 205, 239)
152 Bouriant–Legrain–Jéquier (1903 pl. 1).* (165, 203)
153 Davies (1900–1.2 pl. 15).* (167, 166)
154 Jéquier (1929 pl. 7, 6). (167, 170)
155 *Atlas* 1.49 (drawing from photograph) [PM 1^2.321(8)]. (168, 161, 167, 199, 239)
156 Davies (1900–1.1 pl. 14 no. 303). (168, 127, 145, 167, 199, 211)
157 Lange–Schäfer (1902 pl. 91 no. 558) [= Cairo 20732, photograph on pl. 55]. (168)
158 Davies (1900–1.1 pl. 15 no. 351). (168, 169)
159 LD 2.98a. (169, 188)
160 Borchardt (1893.1). (169)
161 a Lacau (1904 pl. 33 no. 70).* (170)
 b [probably adapted from (a) J.R.B.)]. (170)
162 Davies (1925 pl. 11). (170)
163 Davies (1903–8.3 pl. 25 G).* (172, 176 n. 136, 178)
164 LD 2.36c. (173, 27)
165 Schematic drawing. (174, 173)
166 LD 2.21 (Berlin 1107). (174, 48, 51, 301)
167 LD 2.20. (174, 33, 48, 51, 301)
168 a LD 2.10a.* (175, 106, 140, 176, 177)
 b Nina Davies–Gardiner (1915 pl. 18).* (as last)
169 Quibell (1900 pl. 19 no. 6) [part only]. (178, 181, 202)
170 Westendorf (1968.21) [tracing from photograph].*(178)
171 As 170.* (178)
172 Davies (1903–8.4 pl. 22). (179, 16)
173 Newberry (n.d. pl. 15).* (180, 179)
174 Davies (1903–8.2 pl. 37). (180, 179, 181)
175 *Atlas* 1.205 [drawing from photograph, PM 1^2.116 (15)]. (180)
176 *Atlas* 1.233 [drawing from photograph, PM 1^2. 134–5]. (181, 180, 185)
177 Davies (1925 pl. 5). (181, 53)
178 a Verworn (1909 fig. 22c) [and Kühn 1929.276 fig. 67, after Cartailhac, no
 source given; Verworn gives no source (J.R.B.)]. (182, 185)
 b Kühn (1929.278 fig. 68, after Breuil, no source given). (182, 185)
179 Davies (1902.1 pl. 5). (182, 161, 230)
180 LD 2.129 [PM 4.147 (15)–(16)].* (183, 184 n. 228, 298)
181 Murray (1905 pl. 37 S).* (184)
182 LD 3.164. (184, 186, 189)
183 a *Mereruka* pl. 30.* (185)
 b *Atlas* 1.136 [PM 1^2.65 (8)]. (185)
184 Prisse (1879 Atlas 2 pl. 39) = *Atlas* 2.92. (187, 186, 189, 199, 320)
185 LD 3.161. (187, 186)
186 Rosellini (1834 pl. 7) [= *Beni Hasan* 1 pl. 30]. (187, 186, 188)
187 Child's drawing. (188, 186)
188 Davies (1903–8.3 pl. 21).* (189, 187–8, 198, 226)
189 Schematic drawings. (189, 187)
190 LD 3.95 [in Davies 1903–8.1 pl. 32, much destroyed but almost identical
 except for the detail of a *šadūf* in the pond, and shading around it (J.R.B.) (191)

191 Davies (1903–8.5 pl. 5).* (192, 193)
192 Davies (1920 pl. 6–7). (194, 193)
193 Wilkinson–Birch (1878.2.92 fig. 357) [PM 1^2.353 (11)]. (195, 15, 215)
194 Davies (1943.2 pl. 18).* (197, 168, 198)
195 Davies (1902.2 pl. 9). (199 with n. 172)
196 Davies (1902.1 pl. 11).* (199, 237)
197 Newberry (n.d. pl. 21). (200, 190, 240)
198 Lange–Schäfer (1902 pl. 1 no. 20007) [drawing from photograph, simplified].* (200)
199 LD 2.111a [slightly simplified]. (201, 166, 200, 231)
200 LD 2.13. (201, 166, 202, 231)
201 LD 2.49b [Giza, tomb G 6020]. (201, 166, 202, 231, 255)
202 After the original [precise source not given]. (202)
203 Berlin 19400. (203, 202, 286)
204 B. Meissner, *Grundzüge der babylonisch-assyrischen Plastik* (Der Alte Orient 15), Leipzig: Hinrichs 1915, 130 fig. 221. (203)
205 Newberry (n.d. pl. 15).* (204, 203, 245, 305)
206 *Atlas* 3.21 [Boston, Museum of Fine Arts, 21.961, drawing from photograph]. (205, 217)
207 *Atlas* 1.404 [drawing from photograph. Another example of the same scene Møgensen (1921 pl. 9, p. 28 fig. 24) (J.R.B.)]. (205, 308 n. 68)
208 Blackman (1920 pl. 20) [drawing from photograph]. (206, 205)
209 Boston Museum of Fine Arts 04.1761. Redrawn from Smith 1946.324 fig. 199.* (206)
210 Lacau (1904 pl. 25) [drawing from photograph]. (206, 49, 285)
211 Boeser (1909 pl. 9) [drawing from photograph]. (206)
212 Leemans (1867 M 15–18 pl. 4).* (207, 224, 296)
213 Leemans (1867 M 5 pl. 9).* (208, 207)
214 Nina Davies–Gardiner (1926 pl. 31) [simplified].* (209, 207)
215 Rosellini (1832 pl. 131 top register R), corrected from a photograph. (209, 207)
216 Berlin 13297. (209, 294)
217 a Quibell–Hayter (1927 pl. 15) [corrected from a photograph]. (210, 209)
b Davies (1917 pl. 15 [with frontispiece and pl. 16]) [simplified]. (210, 209, 267, 306)
218 Philae, Temple of Isis, hypostyle hall, E part of back wall: drawing from photograph. (210, 209)
219 Davies (1943.2 pl. 60).* (210, 202)
220 a *Atlas* 3.16 [drawing from photograph; also in Davies (1900–1. 1 pl. 21 L]. (211, 210)
b *Mereruka* 2 pl. 164, 165.* (211, 210)
221 Davies (1929.234–5 fig. 1A, 1B).* (212–3, 128 with n. 79, 140)
222 Davies (1927 pl. 30; in colour pl. 34). (214, 217)
223 *Atlas* 1.112 [drawing from photograph, PM 1^2.28 (4)]. (214, 217)
224 *MH* 4 pl. 205 [Schäfer's source should read LD 3.213 (J.R.B.)].* (215, 214)
225 *Relazione* 1.149 fig. 149 [drawing from photograph]. (216, 214)
226 LD 2.22 (Berlin 1107). (216, 215)
227 a–b Davies (1927 pl. 42) [b is reversed]. (216)
c Säve-Söderbergh (1957 pl. 16).* (216, 217)

228 Budge (1912 pl. 84).* (218)
229 Naville (1886.1 pl. 28). (218)
230 Schematic drawings. (219)
231 Davies (1926b pl. 14).* (220, 137, 219)
232 Wild (1966 pl. 172).* (220, 17 with n. 26, 219)
233 Davies (1903–8.2 pl. 37). (221, 186, 191, 203, 219, 222)
234 a–b Piankoff (1954 pl. 173) [tracing from photograph].* (223, 222, 225)
235 Winlock (1955 fig. 52 lower) [drawing from photograph]. (223)
236 Author's drawing after the original in the Great Pylon at Philae. (224)
237 Berlin 29. (224)
238 Davies (1930.1 pl. 11).* (225, 226)
239 Lange (1939 pl. 60) [drawing from photograph]. (226, 225)
240 *MH* 4 pl. 203.* (227, 226)
241 Calverley *et al.* (1933–58.2 pl. 18) [only the left-hand figure is in the source
 cited (J.R.B.)]. (228)
242 LD 2.52 [Giza tomb G 6020]. (228)
243 *Beni Hasan* 1 pl. 13. (228)
244 *Beni Hasan* 2 pl. 4, also using figures from Rosellini (1834 pl. 100, 101). (228)
245 Davies (1903–8.1 pl. 8) [modified]. (229)
246 Schäfer–Andrae (1943.679) [from photographs in Boeser 1911 pl. 23–4
 (J.R.B.)]. (229, 231)
247 Davies (1922.1 pl. 12).* (231)
248 Von Bissing–Kees (1923 pl. 16).* (232, 29, 233, 302)
249 LD 2.83b. (233, 172, 174)
250 Säve-Söderbergh (1957 pl. 22).* (235, 234)
251 Lanzone (1881–6 pl. 304, p. 802). (239, 238)
252 De Morgan (1903 pl. 22) [drawing from photograph]. (239)
253 Berlin 20078, von Bissing (1956 pl. 12). (240, 106, 237–9)
254 *Meir* 1 pl. 2.* (241, 239, 243)
255 Davies (1902.1 pl. 3).* (242, 161, 243)
256 Berlin 15466, Scharff (1929.171 fig. 93).* (244, 243)
257 Strzygowski (1885 pl. 5.4) [drawing of a mosaic in the Baptistery in Florence].
 (244, 243)
258 L Scharff (1926b pl. 2) [drawing from photograph].* (245, 56)
 Centre Schematic section.
 R Petrie (1920 pl. 15.49).
259 Gayet (1894 pl. 36).* (246, 190, 245)
260 Conwentz (1894 pl. 4). (246, 163)
261 Quibell–Green (1902 pl. 75, enlarged). (246, 160, 247)
262 Davies (1943.2 pl. 58).* (247, 93, 191, 198–9 with n. 172, 240, 248, 250)
263 Davies (1943.2 pl. 110).* (248, 191, 198, 240, 248, 250)
264 After the original. (249, 248)
265 a *Atlas* 1.3 [drawing from photograph]. (249, 250 n. 226)
 b Davies (1943.2 pl. 79).* (249, 250)
266 Davies (1902.2 pl. 5). (250)
267 Davies (1917 pl. 22) = *Atlas* 1.178. (250)
268 a *Atlas* 1.243. (a–u: 252, 251, 253)
 b *Atlas* 1.423.

c *Atlas* 1.2.

d occasional wrong drawing of *a*.

e Wilkinson–Birch (1878.2.448).

f *Atlas* 1.376.

g Boeser (1911 pl. 7)

h Erman (1905.130).

i *Atlas* 1.245.

k LD 2.127.

l *Atlas* 1.339.

m *Atlas* 1.175.

n *Atlas* 1.254.

o *Atlas* 1.91c.

p *Atlas* 1.339.

q *Atlas* 1.144.

r *Atlas* 1.91a.

s *Atlas* 1.268.

t Lange–Schäfer (1902 pl. 55 no. 456).

u Müller (1940 fig. 27).

All these drawings are only schematic renderings of their originals.

269 LD 2.111b. (253, 255)

270 LD 2.108. (253, 255)

271 Holwerda–Boeser–Holwerda (1908 pl. 12) [drawing from photograph]. (254, 196 n. 166, 253, 255)

272 *Atlas* 3.62 [drawing from photograph]. (255, 254)

273 *Kosmos,* July 1946.7 (Stuttgart) [drawing from photograph]. (256, 255)

274 Schematic drawings. (260)

275 Schematic drawings. (260 with n. 4, 261)

276 Berlin 18539 = pl. 24.2 here [schematic]. (261)

277 a Propyl. 266 [drawing from photograph].* (261 with n. 5, 260 n. 4)

b Fischer (1958.30 fig. a).* (261, 262)

278 Boeckler (1933 pl. 1, 38) [drawing from photograph and coloured reproduction]. (262)

279 Hildesheim, Pelizaeus Museum, chamber of Hemiunu (photograph *Giza* 1 pl. 17– shows sign damaged). (262)

280 Jéquier (1921.102 fig. 278) [reversed and much simplified]. (262 with n. 6)

281 Wild (1953 pl. 111) (= *Atlas* 3.39, Steindorff 1913 pl. 110).* (263, 268)

282 *Atlas* 3.111 [drawing from photograph]. (263, 268)

283 Quibell–Hayter (1927 frontispiece) [from watercolour; reversed and inaccurate]. (263, 239 n. 216, 268)

284 a Davies (1943.2 pl. 64).* (264, 59, 265, 306)

b LD 3.42. (264, 59, 306)

[The painting has been reproduced many times, e.g. Propyl. 365.1, Sm pl. 104B, Mekhitarian 1954.51 (J.R.B.).]

285 a Rosellini (1834 pl. 93). (266, 186, 265, 294 n. 40)

b LD 2.126. (266, 186, 265)

286 After the originals. (267, 314)

287 *Meir* 1 pl. 8. (268)

288 a Berlin 13826, 20304. (278)
 b Berlin 20132 (Schäfer 1930.260 fig. 239).* (278)
289 Seler (1906 pl. 48).* (279, 278, 285, 300)
290 Berlin 13824, 13826, 14314, 14362, 15129, 19120. (279, 71 n. 5, 278)
291 *MH* 2 pl. 111 (PM 2^2.493 (67)–(69).* (281, 280)
292 Winter (n.d. pl. 88.5) [drawing from photograph]. (281)
293 After the original. (282, 281)
294 Berlin 22588 [= pl. 108]. (282)
295 Davies (1923 pl. 27).* (286, 265, 285)
296 Nina Davies (1938.30 fig. 9).* (286)
297 Roeder (1914 pl. 80 g–h). (287)
298 LD 3.198c [PM 4.126–7]. * (287, 288)
299 Calverley *et al.* (1933–58.3 pl. 34) [tracing from photograph].* (289, 282)
300 *Atlas* 1.423 [simplified drawing from photograph]. (290, 289)
301 Berlin 1191 [drawing from photograph].* (290, 289 with n. 28)
302 Berlin 22881. (291)
303 Schäfer (1938.27 fig. 3) [Berlin 23798, simplified drawing from photograph].
 (292, 291)
304 *Wall decorations of Egyptian tombs, illustrated from examples in the British
 Museum* pl. 4. London: British Museum 1914 [drawing from coloured
 reproduction]. (292)
305 Hermann (1939 pl. 8b) [drawing from photograph]. (292)
306 Petrie (1914 pl. 6) [drawing from photograph].* (296, 163, 295)
307 Borchardt *et. al.* (1913 pl. 47).* (296, 297)
308 LD 2.72a.* (299, 298)
309 Above: Berlin 21784. (299, 298)
 Below: Berlin 1186. (299, 298)
310 Davies (1903–8.6 pl. 7).* (299, 179, 298)
311 Berlin 3316 [the drawing is not entirely accurate, cf. the excellent photograph
 in Brunner-Traut 1956 pl. 11 no. 26 (J.R.B.)]. (300, 171)
312 Nina Davies (1936 pl. 7) [drawing from watercolour reproduction]. (303)
313 L and mid. Berlin 1121. (303, 285)
 R Berlin 21822. (303)
314 *Atlas* 1.402, photograph also in Møgensen (1921 pl. 9). (305)
315 Davies (1930 pl. 10a) [drawing from painted reproduction, simplified]. (307,
 285 n. 17, 306)
316 Roeder (1969 pl. 8 no. 218 VII) [drawing from photograph, see now pl. 107].
 [The source Schäfer cites has the same photograph.] (307, 306)
317 a Davies (1941 pl. 34)–photograph in Baud (1935.104 fig. 43).* (307, 306)
 b Davies (1943.2 pl. 75).* (307, 306)
 c Lange–Schäfer (1902 pl. 71 no. 221). (307, 306)
318 Berlin 813. (308 with n. 68)
319 Dörpfeld *et al.* (1902 pl. 44 facing p. 360) [drawing from photograph]. (315,
 314)
320 Studniczka (1898 pl. 2) [modified]. (315, 218, 314, 333)
321 After Schäfer (1942.173 fig. 4) [original in Chicago, Oriental Institute
 no. 10639, cf. Breasted Jr. (1948.90 with pl. 86)]. (319)

322 Roeder (1939 fig. 15).* (319)
323 After the original in the door of Berlin 1108, using Lepsius *Notebook* fol. 1.242.
 (327, 16, 277, 326, 333, 337)
324 After *Meir* 6 pl. 30.2 (photograph). (328, 326, 333, 337)
325 Berlin P. 11775 [tracing from photograph].* (329, 210, 330, 333)
326 Reconstructed drawing after fig. 325. (330, 210)
327 Drawing after Berlin 8957 [photograph of front in Propyl. 448.1]. (330)
328 Berlin 23007 [= pl. 108]. (351, 217)
329 1 *Atlas* 1.91. (1–4: 355, 101 n. 40).
 2 Berlin 22117.
 3–4 Free drawings.
330 Daressy (1901 pl. 5 no. 25019) [drawing from photograph]. (357, 214 n. 178).

SOURCES FOR PLATES

(The figures in brackets after each entry give the pages on which the plate is mentioned.)

[It has not been possible in all cases to secure photographs of the objects reproduced in the plates; in a few cases a different original has been substituted, and in others photographs from books have been reproduced (J.R.B.).

Plates designated⁺ are from different prints from those in the German edition; those designated⁺⁺ are from different originals.]

1 Cairo Museum CG 1427; courtesy Hirmer Fotoarchiv München.⁺ (12, 16, 142, 217, 277, 287, 294)
2 Pairs, Louvre E. 11255; photo Marburg. (14, 47, 138, 177, 281 with n. 6)
3 Staatliche Museen Berlin 15084; courtesy of museum.⁺ (146, 280 with n. 5, 281–2)
4 British Museum 20791 (large fragment)–Ashmolean Museum Oxford 1171–1892; photo of cast courtesy Ashmolean Museum.⁺ (14, 34, 47, 118, 138, 177, 260, 262, 280, 294, 302)
5 Paris, Louvre E. 11052; courtesy of museum. (75, 106 n. 46, 226)
6 Ashmolean Museum Oxford E 3632. courtesy of museum.⁺ (178, 233, 239, 282)
7 Cairo Museum CG 14716 (detail of 8); courtesy Hirmer Fotoarchiv München.⁺ (12, 47, 297)
8–9 Cairo Museum CG 14716; courtesy Hirmer Fotoarchiv Müchen.⁺ (8: 10, 16 n. 14, 40, 115, 156, 163, 225, 233, 282, 294, 297. 9: 10, 118, 163, 177, 190, 233, 282, 294, 297, 302–3)
10 Pairs, Louvre E. 11007; courtesy of museum.⁺ (98)
11 British Museum 55586; courtesy of museum.⁺ (283, 320)
12 Boston, Museum of Fine Arts; courtesy of museum.⁺ (280, 282)
13 Wadi Maghara, Sinai, Petrie (1906 pl. 47); rephotographed from book. (283)
14 Cairo Museum CG 1429; photo Marburg. (74, 98, 283, 285, 297)
15 Detail from 1; courtesy Hirmer Fotoarchiv München.⁺ (283, 287, 297)
16 Staatliche Museen Berlin 15756; photo Marburg. (47, 75, 166, 184 n. 147, 240, 303–4)
17 Boston, Museum of Fine Arts 09.202; courtesy of museum.⁺⁺ (155)
18 Staatliche Museen Berlin 16162; courtesy of museum.⁺ (225)
19 Paris, Louvre E 15591; courtesy of museum. (44, 169)
20 Staatliche Museen Berlin 16100; rephotographed from retouched print in Borchardt (1907 pl. 16).⁺ (155, 218, 290 n. 29)
21 Saqqara, tomb of Ti; rephotographed from Steindorff (1913 pl. 130).⁺ (22, 119, 144, 233, 288, 293, 295, 297)
22 Saqqara, tomb of Ti; courtesy Hirmer Fotoarchiv München.⁺ (118, 144, 233, 238–9)
23 Staatliche Museen Berlin 1108; courtesy of museum. (75, 144, 168, 294, 297–8, 303, 341)
24 Staatliche Museen Berlin 15321; courtesy of museum.⁺ (76, 144, 303–4)

25 Staatliche Museen Berlin 21782; courtesy of museum.⁺ (156, 245)
26 Saqqara, tomb of Ti; courtesy Henri Wild and Institut Français d'Archéologie Orientale, le Caire.⁺ (16, 121, 278, 287–8)
27 Leiden, Rijksmuseum van Oudheden F. 1904/3/1; courtesy of museum.⁺ (17, 114, 215, 218, 222)
28 Saqqara, tomb of Ti; courtesy Henri Wild and Institut Français d'Archéologie Orientale, le Caire.⁺ (107)
29 Staatliche Museen Berlin 20036; courtesy of museum.⁺ (15, 126, 237)
30 Staatliche Museen Berlin 1131; photo Marburg. (16, 179, 182)
31 Cairo Museum, from the tomb of Nefersešemptah; photo Marburg. (26, 74, 217)
32 Staatliche Museen Berlin 15004; photo Marburg. (17, 121)
33 Saqqara, tomb of 'Ankma'hor; rephotographed from *Atlas* 3.74. (120)
34 Staatliche Museen Berlin 15420; photo Marburg. (199, 240)
35 Staatliche Museen Berlin 1108; courtesy of museum. (21, 44)
36 Staatliche Museen Berlin 16953; photo Marburg. (65, 151, 352–6)
37 Staatliche Museen Berlin 7265; courtesy of museum. (16 n. 17, 78, 285, 306)
38 Staatliche Museen Berlin 1119; courtesy of museum.⁺ (147, 240, 243)
39 *Meir* 2 pl. 25.2; rephotographed from book.⁺ (117)
40 El-Kab, tomb of Sebeknakht; photographed from reproduction in Tylor (1896 pl. 2).⁺ (239 n. 216, 260 n. 4)
41 Staatliche Museen Berlin 18539; courtesy of museum.⁺ (148, 180, 261, 291)
42 Sheikh 'Abd el-Gurna, tomb 69 (Menna); courtesy Hirmer Fotoarchiv München.⁺ (22, 121, 161, 233, 238–9, 243, 251, 285, 294)
43 Sheikh 'Abd el-Gurna, tomb 52 (Nakht); courtesy Metropolitan Museum of Art, New York.⁺ (44)
44 Sheikh 'Abd el-Gurna, tomb 55 (Ra'mose); courtesy Hirmer Fotoarchiv München.⁺ (72, 188)
45 Staatliche Museen Berlin 7290; courtesy of museum.⁺ (78, 285)
46 Leiden, Rijksmuseum van Oudheden K 14–5; courtesy of museum.⁺ (183)
47 Ägyptisches Museum Berlin-Charlottenburg 15000; courtesy of museum.⁺ (121, 294, 306)
48 Staatliche Museen Berlin 12411; photo Marburg. (78, 298, 306)
49 Staatliche Museen Berlin 12411; courtesy of museum.⁺ (298)
50 Staatliche Museen Berlin 12411; photo Marburg. (101, 298)
51 Berlin 8816 (location unknown); courtesy Staatliche Museen Berlin.⁺ (72, 112)
52 Staatliche Museen Berlin 7278; photo Marburg. (78, 156, 234)
53 Staatliche Museen Berlin, cast G 185; courtesy of museum. (209)
54 El-'Amarna, tomb of Mahu; rephotographed from Davies (1903-8.4 pl. 12 A).⁺ (285, 304)
55 Karnak, location No. H. 24; courtesy the Epigraphic Survey, the Oriental Institute, University of Chicago, Luxor.⁺⁺ (15, 28, 78, 184, 193, 197, 233)
56 Karnak, location No. H. 2/3-3a; courtesy the Epigraphic Survey, the Oriental Institute, University of Chicago, Luxor.⁺ (15, 28, 184, 233, 289, n. 28)
57 Medinet Habu, funerary temple of Ramesses III; courtesy the Oriental Institute, University of Chicago (reinforced photograph).⁺⁺ (15, 184)
58 Beit el-Wali, temple of Ramesses II; courtesy the Oriental Institute, University of Chicago.⁺ (28, 207, 233, 234–5)



59 Thebes, Valley of the Kings, tomb of Ramesses X; photograph of watercolour in Rosellini (1844 pl. 65). (73, 120, 155, 230, 235)
60 Berlin 7325 (location unknown); courtesy Staatliche Museen Berlin. (71, 106, 233, 286)
61 Funerary papyrus of Yuya, Cairo Museum; rephotographed from Naville (1908 pl. 18).[+] (156, 233)
62 Leiden, Rijksmuseum van Oudheden T 2; courtesy of museum.[++] (155, 165, 219, 237)
63 Funerary papyrus of Yuya, Cairo Museum; rephotographed from Naville (1908 pl. 21). (26, 36, 151)
64 Staatliche Museen Berlin P 3152; courtesy of museum. (34, 288–9, 295)
65 Cairo Museum 25/12 24/20; rephotographed from *Atlas* 1.417. (115)
66 Staatliche Museen Berlin 29; courtesy of museum. (78, 155, 222–3)
67 Staatliche Museen Berlin 2112; courtesy of museum. (294)
68 Staatliche Museen Berlin 21784; courtesy of museum.[+] (298)
69 Staatliche Museen Berlin 2089; courtesy of museum.[+] (298)
70 Staatliche Museen Berlin 21783; courtesy of museum.[+] (293)
71 Staatliche Museen Berlin 21784; courtesy of museum. (290, 298)
72 Staatliche Museen Berlin 7278; photo Marburg. (285, 298)
73 Ägyptisches Museum. Berlin-Charlottenburg 20672; courtesy of Museum.[+] (296)
74 Staatliche Museen Berlin 1108; courtesy of museum. (290, 296)
75 Ägyptisches Museum. Berlin-Charlottenburg 15316, 19747, 20788; courtesy of museum.[+] (325, 331)
76 Staatliche Museen Berlin 12489 (renumbered 12514); courtesy of museum. (294)
77 Staatliche Museen Berlin 21783; courtesy of museum. (294)
78 Berlin 15158 (location unknown); courtesy Staatliche Museen Berlin. (76)
79 Staatliche Museen Berlin 21762; courtesy of museum.[+] (11, 15, 58, 324)
80 Staatliche Museen Berlin 10834; courtesy of museum.[+] (107)
81–2 Agyptisches Museum Berlin-Charlottenburg 16700; courtesy of museum.[+] [++] (15, 58)
83 Staatliche Museen Berlin 22440; courtesy of museum.[+] (11, 15, 34, 316)
84 Staatliche Museen Berlin 14113; courtesy of museum. (58)
85 Staatliche Museen Berlin 21364; courtesy of museum.[+] (59)
86–7 Ägyptisches Museum Berlin-Charlottenburg 17021; courtesy of museum.[+] [+] (24, 323)
88–9 Cairo Museum JE 44866; photo Marburg. (311, 317)
90 Cairo Museum CG 42069; rephotographed from von Bissing (1911–14 pl. 38 A).[+] (33–4, 321)
91 Ägyptisches Museum Berlin-Charlottenburg 22445; courtesy of museum.[+] (330)
92 Berlin Staatliche Museen VAN 2385; courtesy of museum. (33)
93 British Museum; courtesy of museum. (15)
94 Rome; photo Alinari. (188 n. 154)
95 Istanbul; photo Marburg. (219)
96 Rome; photo Tübingen. (196)
97 Photograph of a cast in the Museum für Völkerkunde, Berlin-Dahlem. (253, 304)

98 Beni Ḥasan, tomb 3; from a painting by Nina M. Davies; courtesy Metropolitan Museum of Art, New York.[++] (260)

99 Staatliche Museen Berlin 15335; courtesy of museum. (260)

100–01 Collection Dr. and Mrs. O. R. Impey, Oxford; by kind permission of the owner.[++] (260)

102 The original of this is cut out of an exhibition catalogue. Magri held one-man exhibitions in Florence and Milan. The text surrounding the photograph mentions his polyptych in the Villa Matter at Mestre (cf. Comanducci 3.1056). Precise source not traced. The painting is earlier than 1922, as it appears in the second edition of this book (Schäfer 1922 pl. 51.1). (341)

103 Kunstmuseum Basel 2213; courtesy of museum.[+] (123 n. 73, 214 n. 180)

104 Galerie Louise Leiris, Paris; courtesy of gallery.[+] (341)

105 Ravenna, Museo Nazionale; courtesy of museum.[+] (115)

106 Rephotographed from *Grosse Berliner Kunstausstellung, Katalog,* 1926 fig. 56. Berlin: Verein Berliner Künstler. (341)

107 Collection Norbert Schimmel, New York; by kind permission of the owner and Dr. J. D. Cooney.[++] (306–7)

108 Ägyptisches Museum Berlin-Charlottenburg 22588; courtesy of museum.[++] (282)

109 Ägyptisches Museum Berlin-Charlottenburg 23007; courtesy of museum.[++] (217, 351)

ABBREVIATIONS AND BIBLIOGRAPHY

[The references listed here are limited to the works cited in the book and to works used as sources for illustrations: no attempt has been made to provide a bibliography of writing on Egyptian art. References enclosed in square brackets have been added by Dr Brunner-Traut or by myself. Abbreviations are included in the alphabetical order of the references; n.p. = no place of publication given n.d. = no date of publication given. Where a date stands without a following letter in the citation and there is more than one work listed under that year the work cited is *a* of the year. Capitalization has been restricted, except in German, to proper names and their derivatives. Arabic numerals have been preferred to Roman, except in citations of works using a dual system. One or two non-Egyptological titles of great length have been listed only at their place of occurrence in the text. (J.R.B.)]

(For abbreviations used in captions to figures and plates see Chronological Table.)

AAA University of Liverpool, Annals of Archaeology and Anthropology, issued by the Institute of Archaeology. Liverpool 1908—48.

[Abu-Bakr, A.M. 1953, *Excavations at Giza 1949—50.* The University of Alexandria: Faculty of Arts. Cairo: Government Press.]

AJSL The American Journal of Semitic Languages and Literature. Chicago: University of Chicago Press 1895—1941.

[Akurgal, E. — Hirmer, M. 1962, *The Art of the Hittites.* London: Thames and Hudson.]

[Aldred, C. 1952, *The development of ancient Egyptian art from 3200 to 1315 B.C.* London: Tiranti.]

Amtl. Ber. Amtliche Berichte aus den königlichen Kunstsammlungen, later *Berliner Museen, Berichte aus den preussischen Kunstsammlungen, Beiblatt zum Jahrbuch der preussischen Kunstsammlungen,* Berlin: Grote.

Andrae, W. 1930, *Das Gotteshaus und die Urformen des Bauens.* Berlin: Schoetz.

Ani The Book of the Dead, facsimile of the papyrus of Ani in the British Museum; London: various publishers 1890.

Anonymous 1925, 'Recent discoveries at the Giza pyramids'. *Museum of Fine Arts Bulletin* 23.12—4. Boston.

Anthes, R. 1930a, 'Die Vorführung der gefangenen Feinde vor dem König'. *ZÄS* 65.26—35.

Anthes, R. 1930b, 'Eine Polizeistreife des Mittleren Reiches in die westliche Oase'. *ZÄS* 65.108—14.

[Anthes, R. 1941, 'Werkverfahren ägyptischer Bildhauer'. *MDAIAK* 10.79—121.]

Arundale, F.—Bonomi, J. n.d., *Gallery of antiquities selected from the British Museum.* London: various publishers.

A. S. 1922, 'Recent acquisitions from Egypt'. *Museum of Fine Arts Bulletin* 20.25—7. Boston.

ASAE Annales du Service des Antiquités de l'Égypte. Le Caire: Imprimerie de l'Institut Français d'Archéologie Orientale (later Cairo: Central Organisation for Government Printing Offices) 1900—.

ASE Archaeological Survey of Egypt, under the auspices of the Egypt Exploration Fund (later Society). London: various publishers 1893—.

Atlas W. Wreszinski, *Atlas zur altägyptischen Kulturgeschichte*. 3 parts, Part 3 'unter Mitwirkung von Hermann Grapow bearbeitet von Heinrich Schäfer'. Leipzig: Hinrichs 1923—.

Ausf. Verz. Königliche Museen zu Berlin: Ausführliches Verzeichnis der aegyptischen Altertümer und Gipsabgüsse[2]. Berlin: Spelmann 1899.

[Badawy, A. M. 1966, book review. *Journal of the American Research Center in Egypt* 5.128–9.]

[Baker, H.S. 1966, *Furniture in the ancient world*. London: The Connoisseur.]

Balcz. H. 1930a, 'Die ägyptische Wandgliederung'. *MDAIAK* 1.39–92.

Balcz, 1930b, 'Symmetrie und Asymmetrie in Gruppenbildungen der Reliefs des Alten Reiches'. *MDAIAK* 1.137–52.

[Barta, W. 1970, *Das Selbstzeugnis eines altägyptischen Künstlers* (*Stele Louvre C14*). Münchener Ägyptologische Studien 22. Berlin: Hessling.]

[Barta, W. 1971, 'Bemerkungen zur Darstellung der Jahreszeiten im Grabe des *Mrr-wj-k₃.j*'. *ZÄS* 97.1–7.]

[Barthel, T. 1958, *Grundlagen zur Entzifferung der Osterinselschrift*. Universität Hamburg, Abhandlungen aus dem Gebiet der Auslandskunde 64, Reihe B. Völkerkunde, Kulturgeschichte und Sprachen 36. Hamburg: Cram, de Gruyter.]

Baud, M. 1935, *Les dessins ébauchés de la nécropole thébaine* (*au temps du Nouvel Empire*). MIFAO 63.

[Baumgartel, E. J. 1948, 'The three colossi from Koptos and their Mesopotamian counterparts'. *ASAE* 48.533–53.]

[Baumgartel, E. J. 1968, 'About some ivory statuettes from the "main deposit" at Hierakonpolis'. *Journal of the American Research Center in Egypt* 7.7–17. Princeton: American Research Center in Egypt — Locust Valley, N.Y.: Augustin.]

Bénédite, G. 1896, 'Une statue de reine de la dynastie bubastite au Musée du Louvre'. *Gazette des Beaux Arts* 1896.1.477–85. Paris.

Bénédite, G. 1922, 'Signa verba. Les jeux d'écriture dans l'image'. *Recueil d'études égyptologiques dédiées à la mémoire de Jean François Champollion* 23–42. Bibliothèque d'Étude de l'École des Hautes Études, Sciences Historiques et Philologiques, fasc. 234. Paris: Champion.

Beni Hasan P. E. Newberry *et. al., Beni Hasan*. 4 vols. ASE 1, 2, 5, 7. 1893–1900.

Benndorf, O. 1899, 'Über den Ursprung der Giebelakroterien'. *Jahreshefte des Österreichischen Archäologischen Institutes in Wien* 2.1–51. Wien: Hölder.

Bergmann, E. von, 1879, *Hieroglyphische Inschriften gesammelt während einer im Winter 1877–78 unternommenen Reise in Ägypten*. Wien: Faesy & Frick.

BIFAO Bulletin de l'Institut Français d'Archéologie Orientale du Caire. Le Caire: Institut Français d'Archéologie Orientale 1901—.

Bissing, F. W. von 1898, 'Zur Polychromie der altaegyptischen Skulptur'. *RT* 20.120—4.

Bissing, F. W. von 1908, *Einführung in die Geschichte der ägyptischen Kunst.* Berlin: Glaue.

Bissing F. W. von 1911—14, *Denmäler ägyptischer Skulptur.* 2 vols plates, 1 vol. text. München: Bruckmann.

Bissing, F. W. von 1912, *Der Anteil der ägyptischen Kunst am Kunstleben der Völker.* München: Verlag der K. B. Akademie der Wissenschaften.

Bissing, F. W. von 1925, *De oostersche grondslag der kunstgeschiedenis (het oude Egypte en Voorazië).* 's-Gravenhage: Nijhoff.

Bissing, F. W. von 1929, 'Der Meister des Grabes des Merreruka-Meri in Saqqara'. *ZÄS* 64.137—8.

Bissing, F. W. von 1930, 'Ein indirekter Beweis für das Alter der Hyksossphingen'. *ZÄS* 65.116—19.

[Bissing, F. W. von 1941, *Der Fussboden aus dem Palaste des Königs Amenophis IV zu el Hawata im Museum zu Kairo.* München: Bruckmann.]

[Bissing, F. W. von 1955, *Altägyptische Lebensweisheit.* Die Bibliothek der Alten Welt, Reihe der Alte Orient. Zürich: Artemis.]

[Bissing, F. W. von 1956, 'La chambre des trois saisons du sanctuaire du roi Rathoures [V^e dynastie]'. *ASAE* 53.319—38.]

Bissing, F. W. von — Kees, H. 1923, *Das Re-Heiligtum des Königs Ne-Woser-Re (Rathures)* 2. Leipzig: Hinrichs.

Blackman, A. M. 1918, 'The funerary papyrus of Nespeher'an'. *JEA* 5.24—35.

Blackman, A. M. 1920, 'A painted pottery model of a granary'. *JEA* 6.206—8.

[Blackman, A. M. — Fairman, H. W. 1942, 'The myth of Horus at Edfu — II'. *JEA* 28.32—8.]

Blümel, C. 1927, *Griechische Bildhauerarbeit. JDAI* Ergänzungsheft 11. Berlin: de Gruyter.

Blunck, E. 1924, 'Psychologische Beiträge zur Frage der Behandlung des Raumes in der ägyptischen Flachkunst und Plastik'. *Archiv für die gesamte Psychologie* 47. 301—92. Leipzig: Akademische Verlagsanstalt.

[Boardman, J. 1967, *Pre-classical: from Crete to archaic Greece.* Harmondsworth: Penguin.]

Boeckler, A. 1933, *Das goldene Evangelienbuch Heinrichs III.* Jahresgabe des Deutschen Vereins für Kunstwissenschaft. Berlin: Deutscher Verein für Kunstwissenschaft.

Boeser, P. A. A. 1909, *Beschreibung der aegyptischen Sammlung des niederländischen Reichsmuseums der Altertümer in Leiden* 2 *Die Denkmäler der Zeit zwischen dem Alten und Mitteren Reich und des Mittleren Reiches* 1 *Stelen.* Haag: Nijhoff.

Boeser, P. A. A. 1911, *Beschreibung der ägyptischen Sammlung des niederländischen Reichsmuseums der Altertümer in Leiden. Die Denkmäler des Neuen Riches* 1 *Gräber.* Haag: Nijoff.

Bonnet, H. 1924, 'Die Rechts- und die Linksansicht im ägyptischen Reliefstil'. *OLZ* 27.554—8.

Borchardt, L. 1893, 'Die Darstellung innen verzierter Schalen auf ägyptischen Denkmälern'. *ZÄS* 31.1–9.

Borchardt, L. 1896, 'Altägyptische Werkzeichnungen'–'Zur Geschichte des Luqsortempels'. *ZÄS* 34.69–76, 122–38.

Borchardt, L. 1897a, *Die ägyptische Pflanzensäule*. Berlin: Wasmuth.

Borchardt, L. 1897b, 'Die Dienerstatuen aus den Gräbern des Alten Reiches'. *ZÄS* 35.119–34.

Borchardt, L. 1898, 'Das Grab des Menes'. *ZÄS* 36. 87–105.

Borchardt, L. 1899, 'Hieroglyphen für "Brauer". *ZÄS* 37.82–3.

Borchardt, L. 1902–3, 'Die Cyperussäule'. *ZÄS* 40.36–49.

Borchardt, L. 1907a, *Das Grabdenkmal des Königs Ne-User-Re'*. Ausgrabungen der Deutschen Orient-Gesellschaft in Abusir 1902–4 1. Leipzig: Hinrichs.

Borchardt, L. 1907b, 'Das Dienstgebäude des Auswärtigen Amtes unter den Ramessiden'. *ZÄS* 44.59–61.

Borchardt, L. 1910, *Das Grabdenkmal des Königs Śa₃hu-Re' 1 Der Bau*. Ausgrabungen der Deutschen Orient-Gesellschaft in Abusir 6. Leipzig: Hinrichs.

Borchardt, L. 1911–36, *Statuen und Statuetten*. 5 vols. CGMC. Berlin: Reichsdruckerei.

Borchardt, L. 1917, *Die Annalen und die zeitliche Festlegung des Alten Reiches der ägyptischen Geschichte*. Quellen und Forschungen zur Zeitbestimmung der ägyptischen Geschichte 1. Berlin: Behrend.

Borchardt, L. 1917–18, 'Sphinxezeichnung eines ägyptischen Bildhauers'. *Amtl. Ber.* 39.105–10.

Borchardt, L. 1923, *Porträts der Königin Nofret-ete aus den Grabungen 1912/13*. Ausgrabungen der Deutschen Orient-Gesellschaft in Tell-el-Amarna 3. Leipzig: Hinrichs.

Borchardt, L. 1926, 'Jubiläumsbilder'. *ZÄS* 61.30–51.

Borchardt, L. 1928, 'Ein Bildhauermodell aus dem frühen Alten Reich'. *ASAE* 28.43–50.

Borchardt, L. 1931, 'Ein verzierter Stabteil aus vorgeschichtlicher Zeit'. *ZÄS* 66.12–4.

[Borchardt, L. 1964, Denkmäler des *Alten Reiches (ausser den Statuen)* 2. CGMC.]

Borchardt, L. *et al.* 1913, *Das Grabdenkmal des Königs Śa₃hu-Re' 2 Die Wandbilder*. Ausgrabungen der Deutschen Orient-Gesellschaft in Abusir 7. Leipzig: Hinrichs.

[Bossert, H. T. 1937, *The art of ancient Crete from the earliest times to the iron age*. The Earliest Cultures of the Mediterranean Countries 1. London: Zwemmer (tr. of 3rd German ed.).]

[Bothmer, B. V. 1960, *Egyptian sculpture of the Late Period 700* B.C. *to* A.D. *100*. The Brooklyn Museum. ²1969 New York: Arno.]

Bouriant, U.–Legrain, G.–Jéquier, G. 1903, *Monuments pour servir à l'étude du culte d'Atonou en Égypte 1 Les tombes de Khouitatonou*. MIFAO 8.

Breasted, J. H. 1908, 'Oriental Exploration Fund of the University of Chicago, second preliminary report of the Egyptian expedition'. *AJSL* 25.1–110.

[Breasted Jr., J. H. 1948, *Egyptian servant statues*. Bollingen Series 13. n.p.: Pantheon Books.]

Britsch, G. 1926, *Theorie der bildenden Kunst*. Ed. Egon Kornmann. München: Bruckmann.

Brugsch, H. 1871, 'Bau und Maasse des Tempels von Edfu'. *ZÄS* 9.32–45.

[Brunner, H. 1964, *Die Geburt des Gottkönigs*. Ägyptologische Abhandlungen 10. Wiesbaden: Harrassowitz.]

[Brunner, H. 1965, *Hieroglyphische Chrestomathie*. Wiesbaden: Harrassowitz.]

Brunner-Traut, E. 1938, *Der Tanz im alten Ägypten*. Ägyptologische Forschungen 6. Glückstadt–Hamburg–New York: Augustin.

[Brunner-Traut, E. 1956, *Die altägyptischen Scherbenbilder (Bildostraka) der deutschen Museen und Sammlungen*. Wiesbaden: Steiner.]

[Brunner-Traut, E. 1957a, 'Die Krankheit der Fürstin von Punt'. *Die Welt des Orients* 2.307–11. Göttingen: Vandenhoeck & Ruprecht.]

[Brunner-Traut, E. 1963, *Altägyptische Märchen*. Die Märchen der Weltliteratur. Düsseldorf – Köln: Diederichs.]

Buck, A. de l 929, *Het typische en het individueele bij de Egyptenaren*. Leiden: Ijdo.

Budge, E. A. W. 1912, *The Greenfield Papyrus in the British Museum*. London: various publishers.

Bühler, K. 1924, *Die geistige Entwicklung des Kindes*[4]. Jena: Fischer.
[Abridged tr. of [5] by O. Oeser, *The mental development of the child*. London: Routledge & Kegan Paul 1930.]

Bulle, H. 1912, *Der schoene Mensch im Altertum* [2]. Der Stil in den bildenden Kuensten und Gewerben aller Zeiten 1. München – Leipzig: Hirth.

Burger, F. 1913, *Die deutsche Malerei vom ausgehenden Mittelalter bis zum Ende der Renaissance* 1. Handbuch der Kunstwissenschaft. Berlin-Neubabelsberg: Athenaion.

Burlington Burlington Fine Arts Club, *Catalogue of an exhibition of ancient Egyptian art*. London: private 1922.

[Burton, A. 1972, *Diodorus Siculus Book I: a commentary*. Etudes Préliminaires aux Religions Orientales dans l'Empire Romain 29. Leiden: Brill.]

[Calverley, A. M. *et al.* 1933–58, *The temple of King Sethos I at Abydos*. 4 vols. London: Egypt Exploration Society–Chicago: University of Chicago Press.]

[Cameron, M. – Hood, S. 1967, *Catalogue of plates in Sir Arthur Evans'* Knossos fresco atlas. Farnborough: Gregg.]

Capart, J. 1905, *Primitive art in Egypt*. Tr. A. S. Griffith. London: Grevel.

Capart, J. 1906, *Chambre funéraire de la sixième dynastie aux Musées Royaux du Cinquantenaire*. Bruxelles: Vromant.

Capart, J. 1907, *Une rue de tombeaux à Saqqarah*. 2 vols. Bruxelles: Vromant.

Capart, J. 1921, 'The memphite tomb of King Haremhab'. *JEA* 7.31–5.

Capart, J. 1927–31, *Documents pour servir à l'étude de l'art égyptien*. 2 vols. Paris: Pégase.

Capart, J. 1928, *Lectures on Egyptian art*. Chapel Hill: University of North Carolina Press.

Capart, J. 1932, 'Ein vorgeschichtliches Elfenbeinstab?'. *ZÄS* 68.69–70.

Carter, H.– Newberry, P. E. 1904, *The tomb of Thoutmôsis IV*. Mr. Theodore M. Davis' Excavations: Bibân el Molûk. Westminster: Archibald.

[Case, H. – Payne, J. C. 1962, 'Tomb 100: the decorated tomb at Hierakonpolis'. *JEA* 48.5–18.]

CdÉ *Chronique d'Égypte.* Bruxelles: Musée du Cinquantenaire 1925–.

CGMC Catalogue Général des Antiquités Égyptiennes du Musée du Caire. 1896–. Le Caire, unless otherwise stated.

Chabas, F. 1865, 'Lettre à M. le Docteur R. Lepsius sur les mots égyptiens désignant la droite et la gauche'. *ZÄS* 3.9.–11.

[Chadwick, J. 1958, *The decipherment of Linear B.* Cambridge: University Press.]

Champollion-le-Jeune, J. F. 1845, *Monuments de l'Égypte et de la Nubie* 2. Paris: Firmin-Didot.

Chassinat, E. – Palanque, C. 1911, *Une campagne de fouilles dans la nécropole d'Assiout.* MIFAO 24.

Choisy, A. 1904, *L'art de bâtir chez les Égyptiens.* Paris: Rouveyre.

[Clarke, S. – Engelbach, R. 1930, *Ancient Egyptian masonry–the building craft.* London: Oxford University Press.]

[Clère, J. J. 1958, 'Fragments d'une nouvelle représentation égyptienne du monde'. *MDAIK* 16.30–46.]

Cohen, S. 1925, 'Wert und Richtung'. *Germanisch-romanische Monatsschrift* 13.1–13. Heidelberg: Winter.

[Commanducci A. M. Comanducci, revised by L. Pelandi and L. Servolini, *Dizionario illustrato dei pittori, disegnatori e incisori italiana moderni e contemporanei*[3]. 4 vols. Milano: Patuzzi 1962.]

Conwentz 1894, 'Bildliche Darstellungen von Thieren, Menschen, Bäumen und Wagen an westpreussischen Gräberurnen'. *Schriften der Naturforschenden Gesellschaft in Danzig* NF 8.3–4. 191–219. Danzig: Engelmann-Verlag, Leipzig.

[Cooney, J. D. 1953, 'Egyptian art in the collection of Albert Gallatin'. *JNES* 12.1–19.]

[Cooney, J. D. 1965, *Amarna reliefs from Hermopolis in American collections.* The Brooklyn Museum.]

Cornelius, H. 1908, *Elementargesetze der bildenden Kunst.* Leipzig–Berlin: Teubner.

CRAI *Comptes Rendus des séances de l'Académie des Inscriptions et Belles-lettres.* Paris: Picard.

Curtius, L. 1923, *Die antike Kunst* 1 *Ägypten und Vorderasien.* Berlin-Neubabelsberg: Athenaion.

Daressy, G. 1901, *Ostraca.* CGMC.

Daressy, G. 1917a, 'Chapelle de Mentouhotep III à Dendérah'. *ASAE* 17.226–36.

Daressy, G. 1917b, 'L'art tanite'. *ASAE* 17.164–76.

[Davies, Nina 1936, *Ancient Egyptian paintings.* 2 vols. Chicago: University of Chicago Press.

[Davies, Nina 1938, 'Some representations of tombs from the Theban necropolis'. *JEA* 24.25–40.]

Davies, Nina – Gardiner, A. H. 1915, *The tomb of Amenemḥēt (no. 82).* Theban Tombs Series 1. London: various publishers.

Davies, Nina – Gardiner, A. H. 1926, *The tomb of Huy, viceroy of Nubia in the reign of Tut'ankhamūn (no. 40).* Theban Tombs Series 4. London: various publishers.

Davies, Nina – Davies, N. de G. 1933, *The tombs of Menkheperrasonb, Amenmosĕ, and another.* Theban Tombs Series 5. London: various publishers.

[Davies, Nina M. – Gardiner, A. H. 1962, *Tut'ankhamūn's painted box*. Oxford: Griffith Institute/University Press.]

Davies, N. de G. 1900–1, *The mastaba of Ptahhetep and Akhethetep at Saqqareh*. 2 vols. ASE 8–9.

Davies, N. de G. 1902, *The rock tombs of Deir el Gebrâwi*. 2 vols. ASE 11–12.

Davies, N. de G. 1903–8, *The rock tombs of el Amarna*. 6 vols. ASE 13–18.

Davies, N. de G. 1917, *The tomb of Nakht at Thebes*. Publications of the Metropolitan Museum of Art Egyptian Expedition, Robb de Peyster Tytus Memorial Series 1. [New York].

Davies, N. de G. 1920, *The tomb of Antefoker, vizier of Sesostris I, and of his wife Senet (no. 60)*. Theban Tombs Series 2. London: various publishers.

Davies, N. de G. 1921, Review of Schäfer 1919. *JEA* 7.222–8.

Davies, N. de G. 1922, *The tomb of Puyemrê at Thebes*. 2 vols. The Metropolitan Museum of Art, Robb de Peyster Tytus Memorial Series 2–3. [New York].

Davies, N. de G. 1923, *The tombs of two officials of Tuthmosis the Fourth (nos. 75 and 90)*. Theban Tombs Series 3. London: various publishers.

Davies, N. de G. 1925a, *The tomb of two sculptors at Thebes*. The Metropolitan Museum of Art, Robb de Peyster Tytus Memorial Series 4. [New York].

[Davies, N. de G. 1925b, 'The tomb of Tetaky at Thebes (no.15)'. *JEA* 11.10–18.]

Davies, N. de G. 1926a, 'An apparent instance of perspectival drawing'. *JEA* 12.110–12.

Davies, N. de G. 1926b, 'The work of the graphic section'. *Bulletin of the Metropolitan Museum of Art*, Dec. 1926, Part 2.3–16. New York.

Davies, N. de G. 1927, *Two Ramesside tombs at Thebes*. Publications of the Metropolitan Museum of Art Egyptian Expedition, Robb de Peyster Tytus Memorial Series 5. [New York.]

Davies, N. de G., 1928, 'The graphic work of the expedition'. *Bulletin of the Metropolitan Museum of Art*, Feb. 1928, Part 2.59–72. New York.

Davies, N. de G. 1929, 'The town house in ancient Egypt'. *Metropolitan Museum Studies* 1.233–55. New York: Metropolitan Museum of Art.

Davies, N. de G. 1930, *The tomb of Ken-Amūn at Thebes*. 2 vols. The Metropolitan Museum of Art Egyptian Expedition. New York.

[Davies, N. de G. 1933, *The tomb of Nefer-hotep at Thebes*. The Metropolitan Museum of Art Egyptian Expedition.[New York].

[Davies, N. de G. 1934, 'Foreigners in the tomb of Amenemhab (no. 85)'. *JEA* 20.189–92.]

[Davies, N. de G. 1941, *The tomb of the vizier Ramose*. Mond Excavations at Thebes 1. London: Egypt Exploration Society.]

[Davies, N. de G. 1943, *The tomb of Rekh-mi-Rē' at Thebes*. 2 vols. Publications of the Metropolitan Museum of Art, Egyptian Expedition 11. New York.]

Dehio, G. 1926, *Geschichte der deutschen Kunst* 3. Berlin–Leipzig: de Gruyter.

Delattre, Père 1899, 'Fouilles exécutées à Carthage, pendant le premier trimestre de 1899, dans la nécropole située entre Bordj-Djedid et la colline de Saint-Monique, par le R. P. Delattre, Correspondant de l'Académie'. *CRAI* 4eme Série 27.308–22.

Delbrück, R. 1899, *Beiträge zur Kenntnis der Linearperspektive in der griechischen Kunst*. Bonn: Georgi.

Demel, H. 1929, *Die Reliefs der Kultkammer des Kaninisut und ihre Stellung in der Kunst des Alten Reiches. Jahrbuch der Kunsthistorischen Sammlungen in Wien, Neue Folge*, Sonderheft 25. Wien: Schroll.

Devéria, T. 1872, *Le papyrus de Neb-qed*. Paris: Franck (Vieweg).

Dilthey, W. 1924, *Die geistige Welt, Einleitung in die Philosophie des Lebens* 2. Gesammelte Schriften 6. Leipzig–Berlin: Teubner.

[Donadoni, S. 1942, 'Heinrich Schäfer e l'arte egiziana'. *La Critica d'Arte* 7 (N.S.2).59–75. Firenze: Sansoni.]

[Donadoni, S. 1967, *La letteratura egizia*. Nuova edizione aggiornata. Le Letterature del Mondo. Firenze: Sansoni–Milano: Accademia.]

Dörpfeld, W. *et. al.* [1902], *Troja und Ilion*. Athen: Beck & Barth.

[Drioton, E. 1938, 'Deux cryptogrammes de Senenmout'. *ASAE* 38.231–46.]

[*E* de Rochemonteix, M.–Chassinat, E. *Le temple d'Edfou*. 14 vols. 1892–. MIFAO.]

[Eaton, E. S. 1937, 'Two parallels to ancient Egyptian scenes: an Egyptian high jump'. *Bulletin of the Museum of Fine Arts* 35.54–5. Boston.]

Edgar, C. C. 1905, 'Remarks on Egyptian 'sculptors'models' '.*RT* 27.137–50.

[Eggebrecht, A. 1966 'Zur Bedeutung des Würfelhockers', in *Festgabe für Dr. Walter Will* 143–63. Köln–Berlin–Bonn–München: Heymann.]

Engelbach, R. 1923, *Harageh*. British School of Archaeology in Egypt and Egyptian Research Account, twentieth year 1914. London: British School of Archaeology –Quaritch.

[Engelmann, H. 1963, *Der griechische Alexanderroman, Rezension* Γ *Buch II*. Beiträge zur klassischen Philologie 12. Meisenheim am Glan: Hain.]

[Épron, L. – Daumas, F. 1939, *Le tombeau de Ti* 1. MIFAO 65.]

Erman, A. n.d. [1885], *Aegypten und aegyptisches Leben im Altertum*. 2 vols. Tübingen: Laupp. [Tr. H. M. Tirard, *Life in ancient Egypt*. London – New York: Macmillan 1894.]

Erman, A. 1905, 'Ein Maler des Neuen Reiches'. *ZÄS* 41.128–31.

Erman, A. 1909, *Die ägyptische Religion*[2]. Handbücher der königlichen Museen zu Berlin. Berlin: Reimer. [Tr. of 1st ed. by A. S. Griffith, *A handbook of Egyptian religion*. London: Constable 1907.]

Erman, A. 1923, *Die Literatur der Aegypter*. [English ed. tr. A. M. Blackman, *The literature of the ancient Egyptians* (London: Methuen 1927); new edition with an introduction by W. K. Simpson, *The ancient Egyptians, a sourcebook of their writings* (New York: Harper and Row 1966).]

[Erman, A. 1934, *Die Religion der Ägypter*. Berlin–Leipzig: de Gruyter.]

Erman, A.–Ranke, H. 1923, *Aegypten und aegyptisches Leben im Altertum*[2]. Tübingen: Mohr. ᐟ

Evans, A. 1921, *The palace of Minos* 1. London: Macmillan.

[Evans, A. n.d., *Knossos fresco atlas.* Farnborough: Gregg.]

[Evans-Pritchard, E. E. 1965, *Theories of primitive religion.* Oxford: Clarendon Press.]

[Evans-Wentz, K. Y. 1927, *The Tibetan Book of the Dead.* London: Oxford University Press. (German ed. tr. Louise Göpfert-March, *Das tibetanische Totenbuch.* Zürich – Leipzig: Rascher [2] 1942.)]

Evers, H. G. 1929, *Staat aus dem Stein.* 2 vols. München: Bruckmann.

Farina, G. 1929, *La pittura egizia.* Milano: Treves.

Fechheimer, H. 1921, *Kleinplastik der Agypter.* Die Kunst des Orients 3. Berlin: Cassirer. (some copies dated 1922.)

Fechheimer, H. 1923, *Die Plastik der Agypter*[4]. Berlin: Cassirer.

Firth, C. M. 1926, 'Preliminary report on the excavations at Saqqara (1925–1926)' *ASAE* 26.97–101.

Firth, C. M. 1927, 'Excavations of the Service des Antiquités at Saqqara (November 1926–April 1927)'. *ASAE* 27.105–11.

Firth, C. M. – Gunn, B. 1926, *Teti pyramid cemeteries.* 2 vols. Service des Antiquités de l'Égypte, Excavations at Saqqara. Le Caire: Imprimerie de l'Institut Français d'Archéologie Orientale.

[Firth, C. M. – Quibell, J.E. – Lauer, J.-P. 1935, *The Step Pyramid* 2. Service des Antiquités de l'Égypte. Le Caire: Imprimerie de l'Institut Français d'Archéologie Orientale.]

[Fischer, H. G. 1958, 'Eleventh dynasty relief fragments from Deir el Bahri'. *Yale University Art Gallery Bulletin* 24.2.29–38. [New Haven].]

[Fr Frankfort, H. *The art and architecture of the ancient Orient.* The Pelican History of Art. Harmondsworth: Penguin 1956.]

[Frankfort, H. 1932, 'On Egyptian art'. *JEA* 18.33–48.]

Frankfort, H. (ed.) 1929, *The mural painting of el-'Amarneh.* London: Egypt Exploration Society.

[Fukai, S. – Horiuchi, K. 1969, *Taq-i-Bustan* 1. The Tokyo University Iraq-Iran Archaeological Expedition Report 10. University of Tokyo: Institute of Oriental Culture.]

Gaebler, H. 1930, 'Die Münzen von Stagira'. *SPAW* 1930.293–304. Berlin: Akademie der Wissenschaften (de Gruyter).

[Galling, K. 1950, *Textbuch zur Geschichte Israels.* Tübingen: Mohr (Siebeck).]

Gardiner, A. H. 1913, 'An unusual sketch of a Theban funeral'. *PSBA* 35.229.

Gardiner, A. H. 1917, 'An archaic funerary stela'. *JEA* 4.256–60.

[Gardiner, A. H. 1960, *The Kadesh inscriptions of Ramesses II.* Oxford: Griffith Institute/University Press.]

[Gardiner, A. H. 1961, *Egypt of the Pharaohs.* Oxford: Clarendon Press.]

[Gardiner, A. H. – Peet, T. E. – Černý, J. 1952–5, *The inscriptions of Sinai.* 2 vols, vol. 1[2]. Egypt Exploration Society. London: Egypt Exploration Society –Oxford University Press.]

Gardner, E. A. 1890, 'The processes of Greek sculpture as shown by some unfinished statues at Athens'. *Journal of Hellenic Studies* 11.129–42. London.

Gayet, A. 1894, *Le temple de Louxor*. Mémoires publiés par les membres de la Mission Archéologique Française au Caire 15. Paris: Leroux.

Giza Junker, H., *Giza*. 12 vols. Akademie der Wissenschaften in Wien [later: Österreichische Akademie der Wissenschaften], Philosophisch-historische Klasse, Denkschriften, 69–75. Wien–Leipzig: Hölder–Pichler–Tempsky, later Wien: Rohrer 1929–55.

Glück, H.–Diez, E. 1925, *Die Kunst des Islam*. Propyläen-Kunstgeschichte 5. Berlin: Propyläen.

[Gombrich, E. H. 1968, *Art and illusion*[3]. London: Phaidon.]

[Goneim, M. Z. 1957, *Horus Sekhem-khet, the unfinished step pyramid at Saqqara* 1. Service des Antiquités de l'Egypte. Le Caire: Imprimerie de l'Institut Français d'Archéologie Orientale.]

[Goyon, G. 1949, 'Le papyrus de Turin dit 'des mines d'or' et le Wadi Hammamat'. *ASAE* 49.337–92.

Grapow, H. 1924, *Die bildlichen Ausdrücke des Aegyptischen*. Leipzig: Hinrichs.

Grapow, H.–Schäfer, H. 1937, 'Eine ungewöhnliche ägyptische Darstellung der Sonnenbarke'. *ZÄS* 73.97–102.

[Grapow, H. 1956 'Zu dem Deckenbild Ramses des Sechsten mit den Aufriss-zeichnungen der Sonnenschiffe'. *ZÄS* 81.24–8.]

Griffith, F. Ll. 1922, 'Oxford excavations in Nubia'. *AAA* 9.67–124.

Griffith, F. Ll. 1926a, 'Stela in honour of Amenophis III and Taya, from Tell el-'Amarnah'. *JEA* 12.1–2.

[Griffith, F. Ll. 1926b, 'The teaching of Amenophis the son of Kanakht. Papyrus B. M. 10.474'. *JEA* 12.191–231.]

[Griffiths, J. G. 1959, 'Remarks on the Horian elements in the royal titulary'. *ASAE* 56.63–86.]

[Groenewegen-Frankfort, H. A. 1951, *Arrest and movement*. London: Faber and Faber. Reprinted, New York: Hacker 1972.]

[Groenewegen-Frankfort, H. A. 1972, Review of Schäfer 1963. *JNES* 31.123–4.]

Gunn, B. 1926, 'Inscriptions from the step pyramid site'. *ASAE* 26.177–96.

Hall, H. R. 1923, 'A wooden figure of an old man'. *JEA* 9.80.

Hamann, R. 1908, 'Das Wesen des Plastischen.' *Zeitschrift für Ästhetik und allgemeine Kunstwissenschaft* 3.1–46. Stuttgart: Einke.

Hamann, R. 1944, *Ägyptische Kunst, Wesen und Geschichte*. Berlin; Knaur.

[Hanke, R. 1959, 'Beiträge zum Kanonproblem'. *ZÄS* 84.113–19.]

Hartwig, P. 1893, *Die griechischen Meisterschalen der Blüthezeit des Strengen rothfiguren Stiles*. Stuttgart–Berlin: Spemann.

[Hassan, S. 1932, *Excavations at Giza* 1929–1930. The Egyptian University. Oxford: Oxford University Press.]

Hauttmann, M. 1929, *Die Kunst des frühen Mittelalters*. Propyläen-Kunstgeschichte 6. Berlin: Propyläen.

[Hayes, W. C. 1953, *The Scepter of Egypt* 1. New York: Harper and Metropolitan Museum of Art.]

Hebbel, F. 1855, *Michel Angelo, ein Drama in zwei Akten.* [Various editions.]

[Helck, W. 1954, 'Bemerkungen zum Ritual des Dramatischen Ramesseumpapyrus'. *Or* 23.383–411.]

Helmholtz, H. von 1903a, 'Optisches in der Malerei', in *Vorträge und Reden*[5] 2.93–135. Braunschweig: Vieweg. [Tr. in Warren–Warren 1968.139–68.]

Helmholtz, H. von 1903b [first published 1878], 'Die Thatsachen in der Wahrnehmung' in *Vorträge und Reden*[5] 2.213–47. Braunschweig: Vieweg. [Tr. in Warren–Warren 1968.207–35.]

Helmholtz, H. von 1903c, 'Uber das Sehen des Menschen', in *Vorträge und Reden*[5] 1.85–117. Braunschweig: Vieweg.

Hermann, A. 1929, 'Zur Frage einer ägyptischen Literaturgeschichte'. *ZDMG* 83.44–66.

[Hermann, A. 1932, 'Das Motiv der Ente mit zurückgewendetem Kopfe im ägyptischen Kunstgewerbe'. *ZÄS* 68.86–105.]

Hermann, A. 1939, 'Eine ungewöhnliche Gesichtsdarstellung des Neuen Reiches'. *ZÄS* 75.60–3.

[Hermann, A. 1959, *Altägyptische Liebesdichtung.* Wiesbaden: Harrassowitz.]

[Hermann, A. 1961, book review. *Zeitschrift für Volksunde* NF 57.149–53. Stuttgart: Kohlhammer.]

Hernandez-Pacheco y Esteban, E. 1918, *Estudios de arte prehistorica.* Comisión de Investigaciones Paleontológicas y Prehistóricas, Junta para Amplicación de Estudios y Investigaciones Científicas, Nota 16. Madrid.

Hildebrand, A. 1913 ([1]1893), *Das Problem der Form in der bildenden Kunst.* Strassburg: Heitz. [Tr. of [3] by M. Meyer and R. M. Ogden, *The problem of form in painting and sculpture.* New York–Leipzig–London–Paris: Stechert 1907] .

Hölscher, U. 1910, *Das hohe Tor von Medinet Habu.* Leipzig: Hinrichs.

[Hölscher, U. 1954, *The excavations of Medinet Habu 5 Post-Ramessid remains.* OIP 66.]

Holwerda, A. E. J. – Boeser, P. A. A. – Holwerda, J. A. 1908 (some copies 1905), *Beschreibung der aegyptischen Sammlung des Niederländischen Reichsmuseums der Altertümer in Leiden, die Denkmäler des Alten Reiches, Atlas.* Haag: Nijhoff (1905 copies Leiden: Brill).

[Hornung, E. 1964, Review of Schäfer 1963. *Bibliotheca Orientalis* 21.169–71. Nederlands Instituut voor het Nabije Oosten te Leiden.]

[Hornung, E. 1967, *Einführung in die Ägyptologie: Stand, Methoden, Aufgaben.* Die Altertumswissenschaft. Darmstadt: Wissenschaftliche Buchgesellschaft.]

[Hornung, E. 1971, *Der Eine und die vielen.* Darmstadt: Wissenschaftliche Buchgesellschaft.]

Hoskins, G. A. 1835, *Travels in Ethiopia, above the second Cataract of the Nile: exhibiting the state of that country, and its various inhabitants, under the dominion of Mohammed Ali: and illustrating the antiquities, arts and history of the ancient Kingdom of Meroe.* London: Longman, Rees, Orme, Brown, Green & Longman.

[H-S Hirmer, M. – Strommenger, E., *The art of Mesopotamia*. London: Thames and Hudson 1964.]

Immermann, K. 1836, 'Mondscheinmärchen'. Book 6, Chapter 12 of *Die Epigonen*, a novel. Various editions.

Ippel, A. 1922, *Der Bronzefund von Galjûb* (*Modelle eines hellenistischen Goldschmieds*). Pelizaeus-Museum zu Hildesheim, Wissenschaftliche Veröffentlichung 2. Berlin: Curtius.

[Iversen, E. 1955, *Canon and proportions in Egyptian art*. London: Sidgwick and Jackson.]

[Iversen, E. 1957, 'The Egyptian origin of the archaic Greek canon'. *MDAIAK* 15.134–47.]

[Iversen, E. 1960, 'A canonical master-drawing in the British Museum. *JEA* 46.71–9.]

[Iversen, E. 1968, 'Diodorus' account of the Egyptian canon'. *JEA* 54.215–18.]

[Iversen, E. 1971, 'The canonical tradition', in *The legacy of Egypt*[2], ed. J. R. Harris, 55–82. Oxford: Clarendon Press.]

Jaensch, E. R. 1925 ([2] 1929), *Die Eidetik und die typologische Forschungsmethode*. Leipzig: Quelle & Meyer. [Tr. O. Oeser, *Eidetic imagery and typological methods of investigation*. London: Kegan Paul, Trench, Trubner–New York: Harcourt Brace 1930.]

Jaensch, E. R. 1930, 'Über den Aufbau des Bewusstseins (unter besonderer Berücksichtigung der Kohärenzverhältnisse)'. *Zeitschrift für Psychologie und Physiologie der Sinnesorgane I. Abteilung, Zeitschrift für Psychologie. Ergänzungsband* 16.1–39. Leipzig: Barth.

JDAI Jahrbuch des kaiserlich Deutschen Archäologischen Institutes, later *Jahrbuch des Deutschen Archäologischen Institutes.* Berlin: Reimer, later de Gruyter 1886– .

JEA Journal of Egyptian Archaeology. London: Egypt Exploration Society 1914– .

Jéquier, G. 1908, 'Les temples primitifs et la persistance des types archaiques dans l'architecture religieuse'. *BIFAO* 6.25–41.

Jéquier, G. 1921, *Les frises d'objets des sarcophages du Moyen Empire*. MIFAO 47.

Jéquier, G. 1929, *Tombeaux de particuliers contemporains de Pepi II*. Service des Antiquités de l'Egypte, Fouilles à Saqqarah. Le Caire: Imprimerie de l'Institut Français d'Archéologie Orientale.

JNES Journal of Near Eastern Studies. Chicago: University of Chicago Press– London: Cambridge University Press.

Jolles, A. 1908, 'Die ägyptisch-mykenischen Prunkgefässe'. *JDAI* 23.209–50.

Junker, H. 1926 'Vorläufiger Bericht über die vierte Grabung bei den Pyramiden von Gizeh'. *Anzeiger der Akademie der Wissenschaften in Wien, philosophisch-historische Klasse* 1926.12.63–120. Wien.

Junker, H. 1928, 'Von der ägyptischen Baukunst des Alten Reiches'. *ZÄS* 63.1–14.

Junker, H. 1929, 'Vorläufiger Bericht über die siebente Grabung der Akademie der Pyramiden von Gîza'. *Anzeiger der Akademie der Wissenschaften in Wien, philos.-hist. Klasse* 1929.11–14.72–150. Wien.

[Junker, H. 1959, *Die gesellschaftliche Stellung der ägyptischen Künstler im Alten Reich*. Österreiche Akademie der Wissenschaften, philosophisch-historische Klasse, Sitzungsberichte 233.1. Wien: Rohrer.]

Junker, H. – Schäfer, H. 1921, *Nubische Texte im Kenzi-Dialekt*. Akademie der Wissenschaften in Wien, Sprachkommission 8. Wien: Hölder.

[Kantor, H. J. 1947, 'The Aegean and the Orient in the second millennium B.C.' *American Journal of Archaeology* 51.1–103. n.p.: Archaeological Institute of America.]

[Kantor, H. J. 1952, 'Further evidence for early Mesopotamian relations with Egypt'. *JNES* 11.239–50.]

Kaschnitz–Weinberg, G. von n.d. [1933], 'Bemerkungen zur Struktur der ägyptischen Plastik'. *Kunstwissenschaftliche Forschungen* 2.7–24. Berlin: Frankfurter Verlags-Anstalt.

[Kayser, H. 1964, *Die Mastaba des Uhemka*. Hannover: Fackelträger–Schmidt-Küster.]

[Kayser, H. 1969, *Agyptisches Kunsthandwerk*. Braunschweig: Klinkhardt & Biermann.]

Kees, H. 1921, *Studien zur ägyptischen Provinzialkunst*. Leipzig: Hinrichs.

[Kees, H. 1943, 'Farbensymbolik in ägyptischen religiösen Texten'. *Nachrichten von der Akademie der Wissenschaften in Göttingen, philologisch-historische Klasse* 1943.11.413–79. Göttingen: Vandenhoeck & Ruprecht.]

[Kees, H. 1944, 'Tanis'. *Nachrichten von der Akademie der Wissenschaften in Göttingen, philologisch-historische Klasse* 1944.7.145–82. Göttingen: Vandenhoeck & Ruprecht.]

[Keimer, L. 1940, *Études d'égyptologie* 2. Le Caire: Imprimerie de l'Institut Français d'Archéologie Orientale.]

Keller, Gottfried 1854–5, *Der gruene Heinrich* [many editions]. [Tr. A M. Holt, *Green Henry*. London: Calder 1960.]

[Kinneir Wilson, J. V. 1969, 'Some contributions to the legend of Etana'. *Iraq* 31.8–17. London: British School of Arachaeology in Iraq.]

Klebs, L. 1915a, 'Die Tiefendimension in der Zeichnung des Alten Reiches'. *ZÄS* 52.19–34.

Klebs, L. 1915b, *Die Reliefs des Alten Reiches (2980–2475 v. Chr.)*. Abhandlungen der Heidelberger Akademie der Wissenschaften Stiftung Heinrich Lanz, philosophisch-historische Klasse 3. Heidelberg: Winter.

Klinger, M. n.d. [1919], *Malerei und Zeichnung*. 11–20 Tausend. Leipzig: Insel, *or* 5 1907, Leipzig: Thieme.

Klöden, K. F. von 1911, *Karl Friedrich von Klödens Jugenderinnerungen*. Ed. Max Jähns, Karl Koetschau. Leipzig: Insel (1 1874). [Tr. (anon.) *The self-made man, autobiography of Karl Friedrich von Klöden*. 2 vols. London: Strahan.]

Koch-Grünberg, T. n.d., *Anfänge der Kunst im Urwald*. No publisher, n.p. n.d. [Berlin 1905].

[Kolbenheyer, E. G. 1935, *Neuland*. München: Kangen–Müller.]

Koldewey, R. 1903, 'Das Istartor in Babylon'. *Mitteilungen der Deutschen Orient-Gesellschaft zu Berlin* 19.7–28.

Krahmer, G. 1931, *Figure und Raum in der ägyptischen und griechisch-archaischen Kunst.* Achtundzwanzigstes Hallisches Winckelmannsprogramm. Halle (Saale): Niemeyer.

Kreitmaier, J., S.J. 1923, *Beuroner Kunst*[4] [5]. Freiburg im Breisgau: Herder.

Kügelgen, W. von 1870, *Jugenderinnerungen eines alten Mannes.* Ed. P. von Nathusius. [16]Berlin: Hertz 1894. [Tr. anon., *Bygone days, or an old man's reminiscences of his youth.* 3 vols. London: Chapman & Hall 1871.]

Kühn, H. 1929, *Kunst und Kultur der Vorzeit Europas, das Paläolithikum.* Berlin– Leipzig: de Gruyter.

[Kühn, H. 1952, *Die Felsbilder Europas*[2]. Stuttgart: Kohlhammer. Tr. A. H. Brodrick, *The rock pictures of Europe.* London: Sidgwick and Jackson 1956.]

Lacau, P. 1903a, 'Sur quelques représentations de vases égyptiens'. *RT* 25.177–80.

Lacau, P. 1903b, 'Métathèses apparentes en égyptien'. *RT* 25.139–61.

Lacau, P. 1904, *Sarcophages antérieurs au Nouvel Empire* 1. CGMC.

Lange, H. O. 1925, *Das Weischeitsbuch des Amenemope.* Det Kgl. Danske Videns-kabernes Selskab, historisk-filologiske Meddedelser 11.2. København: Høst.

Lange, H. O. – Schäfer, H. 1902, *Grab- und Denksteine des Mittleren Reiches* 4. CGMC. Berlin: Reichsdruckerei.

Lange, J. 1899, *Darstellung des Menschen in der älteren griechischen Kunst.* Strassburg: Heitz.

Lange, K. 1939, *Ägyptische Kunst.* Zürich – Berlin: Atlantis.

[Lange, K.–Hirmer, M. 1967, *Ägypten*[4]. München: Hirmer. = *Egypt*[4]. London: Phaidon (1968) (plate numbering identical in the two editions).]

Lanzone, R. V. 1881–6, *Dizionario di mitologia egizia.* 3 vols. Torino: Doyen.

[Larsen, H. 1950, 'True vaults and domes in Egyptian architecture of the Early Kingdom'. *Acta Archaeologica* 21.211–34. København: Munksgaard.]

[Lauer, J. P. 1936, *La pyramide à degrés, l'architecture* 2. Service des Antiquités de l'Egypte, Fouilles à Saqqara. Le Caire: Imprimerie de l'Institut Français d'Archéologie Orientale.]

[Lauth, F. J. 1870, 'Die älteste Landkarte nubischer Goldminen'. *Sitzungsberichte der königl. bayer. Akademie der Wissenschaften* 1870.2.4. München: Straub.]

[Layard, A. H. 1853, *A second series of the monuments of Niniveh.* London: John Murray.]

LD *Denkmaeler aus Aegypten und Aethiopien, nach den Zeichnungen der von Seiner Majestaet dem Koenige von Preussen Friedrich Wilhelm IV nach diesen Laendern gesendeten und in den Jahren 1842–1845 ausgefuehrten wissenschaft-lichen Expedition, auf Befehl Seiner Majestaet herausgegeben und erlaeutert von* C. R. Lepsius. Berlin: Nicolai n.d. 6 Abtheilungen [cited by *Abtheilung*, not by volume number].

LDErg. *Denkmäler aus Aegypten und Aethiopien, herausgegeben und erläutert von Richard Lepsius, Ergänzungsband, herausgegeben von Eduard Naville, unter Mitwirkung von Ludwig Borchardt bearbeitet von Kurt Sethe.* Leipzig: Hinrichs 1913.

LD Text *Denkmäler aus Ägypten und Äthiopien, Text.* 5 vols. *Herausgegeben von Édouard Naville.* 1st 3 vols.: *unter Mitwirkung von Ludwig Borchardt bearbeitet von Kurt Sethe,* vol. 4: *bearbeitet von Walter Wreszinski.* Leipzig: Hinrichs 1897–1913.

[Leclant, J. 1956, 'La "mascarade" des boeufs gras et le triomphe de l'Égypte'. *MDAIAK* 14.128–45.]

[Leclant, J. 1965, *Recherches sur les monuments thébains de la XXVe dynastie dite éthiopienne.* 2 vols. Institut Français d'Archéologie Orientale, Bibliothèque d'Étude 36. Le Caire: Imprimerie de l'Institut Français d'Archéologie Orientale.]

Leemans, C. 1867, *Aegyptische monumenten van het Nederlandsch Museum van Oudheden te Leyden* 3. Leyden: Brill.

Lefebvre, G. 1923–4, *Le tombeau de Petosiris.* 3 vols. Service des Antiquités de l'Égypte. Le Caire: Imprimerie de l'Institut Français d'Archéologie Orientale.

[Lefebvre, G. 1949, *Romans et contes égyptiens de l'époque pharaonique.* Paris: Maisonneuve.]

Legrain, G. 1929, *Les Temples de Karnak.* Fondation Égyptologique Reine Élisabeth. Bruxelles: Vromant.

Lepsius, C. R. 1871, *Über einige aegyptische Kunstformen und ihre Entwicklung.* Abhandlungen der königl. Akademie der Wissenschaften zu Berlin 1871.1. Berlin : Reichsdruckerei der königl. Akademie der Wissenschaften (G. Vogt).

[Leth. A. 1959, *Kinesisk kunst i Kunstindustri Museet/Catalogue of Selected objects of Chinese art in the Museum of Decorative Art Copenhagen.* Kφbenhavn: Det Danske Kunstindustri-museum.]

Levinstein, S. 1905, *Kinderzeichnungen bis zum 14. Lebensjahr.* Leipzig: Voigtländer.

[L-H Lange–Hirmer 1967.]

Lidzbarski, M. 1892, 'Wer ist Chadir?' *Zeitschrift für Assyriologie und verwandte Gebiete* 7.104–16. Berlin: Felber.

Lidzbarski, M. 1893, 'Zu den arabischen Alexandergeschichten'. *Zeitschrift für Assyriologie und verwandte Gebiete* 8.263–312. Berlin: Felber.

[Liebeschütz, H. 1930, *Das allegorische Weltbild der heiligen Hildegard von Bingen.* Studien der Bibliothek Warburg 16. Leipzig–Berlin: Teubner.]

Loret, V. 1902, 'Le mot '. *Revue Égyptologique* 10.87–94. Paris: Leroux.

Lotze, H. 1884, *Mikrokosmos, Ideen zur Naturgeschichte und Geschichte der Menschheit*[4]. 3 vols. Leipzig: Hirzel.

Löwy, E. 1891, *Lysipp und seine Stellung in der griechischen Plastik.* Hamburg: Verlagsanstalt und Druckerei A. G. (Richter).

Löwy, E. 1900, *Die Naturwiedergabe in der älteren griechischen Kunst.* Rom: Loescher. [Tr. J. Fothergill, *The rendering of nature in early Greek art.* London: Duckworth 1907.]

Löwy, E. 1911, 'Typenwanderung II'. *Jahreshefte des Österreichischen Archäologischen Institutes in Wien* 14.1–34. Wien: Hölder.

Löwy, E. 1913 [1915], *Stein und Erz in der statuarischen Kunst.* Reprinted from *Kunstgeschichtliche Anzeigen* 1913. Innsbruck: Wagner'sche k. k. Universitäts-Buchhandlung.

Ludwig, H. 1882, *Lionardo da Vinci, Das Buch von der Malerei.* 4 vols. Quellen-schriften für Kunstgeschichte und Kunstechnik des Mittelalters und der Renaissance 15–18. Wien: Braumüller.

[Luquet, G.-H. 1913, *Les dessins d'un enfant.* Thèse . . . Lille. Paris: Alcan.]

[Luquet, G.-H. 1927, *Le dessin enfantin.* Paris: Alcan.]

Luschan, F. von 1913–14, 'Naturspiele und Anfänge der Kunst'. *Aus der Natur, Zeitschrift für den naturwissenschaftlichen und erdkundlichen Unterricht* 10.6–15. Leipzig: Quelle & Meyer.

Luschan, F. von 1919, *Die Altertümer von Benin.* Staatliche Museen zu Berlin, Veröffentlichumgen aus dem Museum für Völkerkunde 8. Berlin-Leipzig: de Gruyter.

Lutz, H. F. 1927, *Egyptian tomb steles and offering stones of the Museum of Anthropology and Ethnology of the University of California.* University of California Publications, Egyptian Archaeology 4. Leipzig: Hinrichs.

[M Michałowski 1969.]

Mackay, E. 1917, 'Proportion squares on tomb walls in the Theban necropolis'. *JEA* 4.74–85.

[McMahon, A. P. 1956, *Treatise on painting [Codex Urbinas Latinus 1270] by Leonardo da Vinci.* 2 vols., translation and facsimile. Princeton: Princeton University Press.]

Madsen, H. 1905, 'Ein künstlerisches Experiment im Alten Reich'. *ZÄS* 42.65–9.

Mariette-Bey, A. 1872, *Monuments divers recuellis en Égypte et en Nubie.* Paris: Franck (Vieweg).

Mariette-Bey, A. 1873, *Dendérah, description générale du grand temple de cette ville.* Paris: Franck (Vieweg).

Maspero, G. 1897, *Histoire ancienne des peuples de l'Orient classique—les premières mêlées des peuples.* Paris: Hachette.

Maspero, G.–Steindorff, G. 1889, *Ägyptische Kunstgeschichte.* Leipzig: Engelmann.

Matz, F. 1922 [1924], 'Zur Komposition ägyptischer Wandbilder'. *JDAI* 37.39–53.

Matz, F. 1923–4 [1925], 'Das Motiv des Gefallenen'. *JDAI* 38–9.1–27.

MDAIAK Mitteilungen des Deutschen Institutes für Ägyptische Altertumskunde in Kairo, later *Mitteilungen des Deutschen Archäologischen Institutes, Abteilung Kairo.* Augsburg, later Berlin, later Wiesbaden, later Mainz 1930–.

MEEF/S Memoir(s) of the Egypt Exploration Fund (from 1920: Egypt Exploration Society). London: various publishers 1888– .

Meir Blackman, A. M., *The rock tombs of Meir.* 6 vols. (5–6 with M.R. Apted). ASE 22–9. 1914–53.

[Mekhitarian, A. 1954, *The great centuries of Egyptian painting.* Geneva–Paris–New York: Skira.]

Mereruka The mastaba of Mereruka. 2 vols. OIP 31, 39. 1938.

Metz, P. 1929, *Die eidetische Anlage der jugendlichen in ihrer Beziehung zur künst-lerischen Gestaltung.* Friedrich Mann's pädagogisches Magazin Heft 1252, Studien zur psychologischen Ästhetik und Kunstpsychologie mit pädagogischen Anwen-dungen 2. Langensalza: Beyer.

Meyer, E. 1884, *Geschichte des Altertums* 1. Stuttgart: Cotta.

MH Medinet Habu. 8 vols. OIP. 1930–70.

[Michałowski, K. 1969, *The art of ancient Egypt.* London: Thames & Hudson.]

MIFAO Mémoires publiés par les Membres de l'Institut Français d'Archéologie Orientale. Le Caire: Imprimerie de l'Institut Français d'Archéologie Orientale 1902– .

Møgensen, M. 1921, *Le mastaba égyptien de la Glyptothèque Ny Carlsberg.* Copenhague–Christiania–Berlin–Londres–Paris: Gyldendal–Nordisk.

[Møgensen, M. 1930, *La Glyptothèque Ny Carlsberg, la collection égyptienne.* Copenhague: Levin & Munksgaard.]

Möller, G. 1909, *Hieratische Paläographie* 2. Leipzig: Hinrichs.

Möller, G. 1910, 'Die Zeichen für die Bruchteile des Hohlmasses und das Uzatauge'. *ZÄS* 48.99–106.

Möller, G. 1924, 'Die Ägypter und ihre libyschen Nachbarn'. *ZDMG* 78 (N.F.3) 36–60.

Moortgat, A. 1930, 'Der Kampf zu Wagen in der Kunst des alten Orients'. *OLZ* 33.841–54.

[Morenz, S. 1960, *Ägyptische Religion.* Die Religionen der Menschheit 8. Stuttgart: Kohlhammer.]

[Morenz, S. 1968, *Die Begegnung Europas mit Agypten.* Sitzungsberichte der Sächsischen Akademie der Wissenschaften zu Leipzig, Philologisch-historische Klasse 113.5. Berlin: Akademie-Verlag.]

[Morenz, S.–Schubert, J. 1954, *Der Gott auf der Blume. Artibus Asiae*, Supplementum 12. Ascona: Verlag Artibus Asiae.]

Morgan, J. de 1903, *Fouilles à Dahchour en 1894–1895.* Vienne: Holzhausen.

Moritz, K. P. 1785–90, *Anton Reiser, ein psychologischer Roman.* Berlin.
 [Tr. P. E. Matheson, *Anton Reiser. A psychological novel.* The World's Classics. London: Oxford University Press 1926.]

[Morris, E. H.–Charlot, J.–Morris, A. A. 1931, *The Temple of the Warriors at Chichen Itzá, Yucatan.* 2 vols. Carnegie Institution of Washington Publication no. 406. Washington D.C.]

Müller, H. W. 1940, *Die Felsengräber der Fürsten von Elephantine.* Ägyptologische Forschungen 9. Glückstadt–Hamburg–New York: Augustin.

[Müller, H. W. 1966, 'Ein Kopf von einem frühen Würfelhocker in der ägyptischen Staatssammlung München', in *Festgabe für Dr. Walter Will* 121–41. Köln–Berlin–Bonn–München: Heymann.]

Müller, W. M. 1898, 'Die ältesten Anfänge der ägyptischen Geschichte'. *OLZ* 1.101–3.

Müller, W. M. 1904, 'Neue Darstellungen 'mykenischer' Gesandter und phönicischer Schiffe in altägyptischen Wandgemälden'. *Mitteilungen der Vorderasiatischen Gesellschaft* 9.113–80. Berlin: Peiser.

[Müller-Kriesel, C. 1960, 'Die Frauenfrisur im alten Ägypten'. Unpublished dissertation, Leipzig.]

[Munro, P. 1969, 'Zum Kanon des ägyptischen Flachbildes'. *ZDMG Supplementa* 1. 1.82–4. Wiesbaden: Steiner.]

Murray, M. A. 1905, *Saqqara mastabas* 1. Egyptian Research Account, tenth year 1904. London: Quaritch.

Naville, E. 1886, *Das ägyptische Todtenbuch der XVIII. bis XX. Dynastie. Einleitung* 1 vol., *Text* 2 vols. Berlin: Asher.

[Naville, E.] 1908, *The funeral papyrus of Iouya*. Theodore M. Davis's excavations: Bibân el Molûk. London: Constable.

Naville, E. 1910, *The XIth Dynasty temple at Deir el-Bahari* 2. MEEF 30.

Naville, E. 1911, 'La population primitive de l'Égypte'. *RT* 33.193–212.

Naville, E. 1916–18, 'Les dessins des vases préhistoriques égyptiens'. *Archives Suisses d'Anthropologie Générale* 2.77–82. Genève: Kundig.

Naville, E. 1920–2, 'Les dessins des vases préhistoriques égyptiens II'. *Archives Suisses d'Anthropologie Générale* 4.197–206. Genève: Kundig.

Naville, E. n.d., *The temple of Deir el Bahari* 1–2. Egypt Exploration Fund. London: various publishers.

Nelson H. H. 1929, *Medinet Habu 1924–28* 1 *The epigraphic survey of the great temple of Medinet Habu*. Oriental Institute Communications 5. Chicago: University of Chicago Press.

Nelson, H. H. 1931, *Medinet Habu reports* 1 *The epigraphic survey*. Oriental Institute Communications 10. Chicago: University of Chicago Press.

Newberry, P. E. n.d., *El Bersheh*. 2 vols. ASE.

[Neuss, W. 1922, *Die katalanischen Bibelillustrationen um die Wende des ersten Jahrtausends und die altspanische Buchmalerei*. Veröffentlichungen des Auslandsinstituts der rheinischen Friedrich Wilhelms-Universität Bonn. Bonn–Leipzig: Schroeder.]

[Nims, C. F. 1965, *Thebes of the pharaohs*. London: Elek.]

[Nims, C. F. 1968, 'Second tenses in Wenamun'. *JEA* 54.161–4.]

Northampton *et al.* 1908, *Report on some excavations in the Theban necropolis during the winter of 1898–9*. London: Constable.

OIP Oriental Institute Publications. Chicago: University of Chicago Press 1923– .

OLZ Orientalistische Literaturzeitung. Berlin 1898– .

[*Or Orientalia, commentarii periodici pontificii instituti biblici* nova series. Roma: Pontificium Insititum Biblicum 1932– .

Opitz, D. 1930, [Schäfer's reference reads 'Die Saalburg Bd. 2 Dez. 1930 S.108'. The book could not be located (J.R.B.).]

Orsi, P. 1892, 'X. Siracusa—di un nuovo ipogeo greco scoperto nel predio Gallitto presso Siracusa'. *Notizie degli Scavi di Antichità comunicate alla R. Accademia dei Lincei* 1892.354–65. Roma: R. Accademia dei Lincei.

[Os, W. van 1943, 'Die ägyptische Zeichenkunst'. *Jaarbericht van het Vooraziatisch-Egyptisch Gezelschap Ex Oriente Lux* Deel 2 no. 8, add. to p. 602, pp. 767–84. Leiden: Brill.]

[Otto, E. 1951, *Der Vorwurf an Gott*. Hildesheim: Gerstenberg.]

[Otto, E. 1964, *Aus der Sammlung des Ägyptologischen Institutes der Universität Heidelberg*. Werke der Kunst in Heidelberg 1. Berlin–Göttingen–Heidelberg–New York: Springer.]

[Panofsky, E. 1955a, *Meaning in the visual arts*. New York: Doubleday.]

[Panofsky, E. 1955b, *The life and art of Albrecht Dürer*[4]. Princeton University Press.]

[Pedretti, C. 1964, *Leonardo da Vinci, On painting, a lost book (Libro A)*. Berkeley–
Los Angeles: University of California Press.]

Perrot, G.–Chipiez, C. 1882–1903, *Histoire de l'art dans l'antiquité*. 8 vols. Paris:
Hachette. Tr. R. Pietschmann, *Geschichte der Kunst im Altertum*, 1. *Ägypten*.
Leipzig: Brockhaus 1884.

Petrie, W. M. F. 1892, *Medum*. London: Nutt.

Petrie, W. M. F. 1895, *Egyptian decorative art*. London: Methuen.

Petrie, W. M. F. 1898, *Deshasheh 1897*. MEEF 15.

Petrie, W. M. F. 1900a, *The royal tombs of the first dynasty* 1. MEEF 18.

Petrie, W. M. F. 1900b, *Dendereh 1898*. MEEF 17.

Petrie, W. M. F. 1901, *The royal tombs of the earliest dynasties* 2. MEEF 21.

Petrie, W. M. F. 1903, *Abydos* 2 *1903*. MEEF 24.

Petrie, W. M. F. 1905, *Roman Ehnasya (Herakleopolis Magna)*. Special extra publi-
cation of the Egypt Exploration Fund. London: various publishers.

Petrie, W. M. F. 1906, *Researches in Sinai*. London: John Murray.

Petrie, W. M. F. 1914a, *Tarkhan* 2. British School of Archaeology in Egypt and
Egyptian Research Account, nineteenth year 1913. London: School of
Archaeology–Quaritch.

Petrie, W. M. F. 1914b, 'Paintings of prehistoric towns'. *Ancient Egypt* 1914.1.32-4.
London–New York: Macmillan, London: British School of Archaeology in
Egypt.

Petrie, W. M. F. 1917, *Scarabs and cylinders with names*. British School of Archae-
ology in Egypt and Egyptian Research Account, twenty-first year 1915.
London: various publishers.

Petrie, W. M. F. 1920, *Prehistoric Egypt*. British School of Archaeology in Egypt 31.
London; various publishers.

Phylakopi *Excavations at Phylakopi in Melos*. Society for the Promotion of
Hellenic Studies, Supplementary Paper 4. London 1904.

[Piankoff, A. 1954, *The tomb of Ramesses VI*. 2 vols. Egyptian Religious Texts
and Representations 1. Bollingen Series XL. New York: Pantheon Books.]

[Piankoff, A. 1957, *Mythological Papyri*. 2 vols. Egyptian Religious texts and
Representations 3. Bollingen Series XL. New York: Pantheon Books.]

[Piankoff, A.–Maystre, C. 1939, 'Deux plafonds dans les tombes royales'. *BIFAO*
38.65–70.

[Picard, C. 1935, *Manuel d'archéologie grècque, la sculpture* 1, *période archaique*.
Paris: Picard.]

Pieper, M. 1927, *Die ägyptische Literatur*. Handbuch der Literaturwissenschaft.
Wildpark–Potsdam: Athenaion.

[Pietschmann 1884, see Perrot–Chipiez.]

[PM B. Porter–R.L.B. Moss (later with E. W. Burney), *Topographical bibliography
of ancient Egyptian texts, reliefs, and paintings*. 7 vols. Oxford: Clarendon Press
1927–51, [2]1960– .]

Poulsen, F. 1912, *Der Orient und die frühgriechische Kunst.* Leipzig–Berlin: Teubner.

Prisse d'Avennes, E. 1847, *Monuments égyptiens* etc. Paris: Firmin-Didot.

Prisse d'Avennes, E. 1879, *Histoire de l'art égyptien.* Text 1 vol., Atlas 2 vols. (unnumbered plates). Paris: Bertrand.

[Pritchard, J. B. 1955, *Ancient Near Eastern texts relating to the Old Testament*[2]. ([3] 1969). Princeton: Princeton University Press.]

Propyl. Schäfer–Andrae 1942.

PSBA Proceedings of the Society of Biblical Archaeology. London: Society of Biblical Archaeology 1878–1918.

Quibell, J. E. 1900, *Hierakonpolis* 1. Egyptian Research Account 4. London: Quaritch.

Quibell, J. E. 1907, *Excavations at Saqqara* (1905–1906). Service des Antiquités de l'Égypte. Le Caire: Imprimerie de l'Institut Français d'Archéologie Orientale.

Quibell, J. E. 1908, *Tomb of Yuaa and Thuiu.* CGMC.

Quibell, J. E. 1913, *The tomb of Hesy.* Service des Antiquités de l'Égypte, excavations at Saqqara (1911–1912). Le Caire: Imprimerie de l'Institut Français d'Archéologie Orientale.

Quibell, J. E. 1923, *Archaic mastabas.* Service des Antiquités de l'Égypte, excavations at Saqqara (1912–1914). Le Caire: Imprimerie de l'Institut Français d'Archéologie Orientale.

Quibell, J. E.–Green, F. W. 1902, *Hierakonpolis* 2. Egyptian Research Account 5. London: Quaritch.

Quibell, J. E.–Hayter, A. G. K. 1927, *Teti pyramid, north side.* Service des Antiquités de l'Égypte, excavations at Saqqara. Le Caire: Imprimerie de l'Institut Français d'Archéologie Orientale.

Randall-MacIver, D. – Mace, A. C. 1902, *El Amrah and Abydos 1899–1901.* Special extra publication of the Egypt Exploration Fund. London: various publishers.

Ranke, H. 1907–8, 'Statue eines hohen Beamten unter Psammetich I'. *ZÄS* 44.42–54.

[Ranke, H. [1936], *The art of ancient Egypt.* Vienna: Phaidon–London: Allen & Unwin.]

[Ranke, H. 1948, *Meisterwerke der ägyptischen Kunst.* Basel: Holbein.]

Ranke, L. von 1888, *Ueber die Epochen der neueren Geschichte. Vorträge dem Könige Maximilian II von Bayern im Herbst 1854 zu Berchtesgaden gehalten von Leopold von Ranke.* Ed. A. Dove. Leipzig: Duncker & Humblot.

Ranke, L. von, 1916, *Die grossen Mächte.* Neu herausgegeben von Friedrich Meinecke. Leipzig: Insel.

[Ransom Williams, C. 1932, *The decoration of the tomb of Per-nēb: the technique and the color conventions.* Department of Egyptian Art vol. 3. New York: Metropolitan Museum of Art.]

RE G. Wissowa *et al., Paulys Real-Encyclopädie der Classischen Altertumswissenschaft, Neue Bearbeitung.* 24 + 9 vols. with supplements. Stuttgart: Metzler, later Drückenmüller 1894– .]

Recklinghausen, H. von 1928, 'Rechtsprofil und Linksprofil in der Zeichenkunst der alten Ägypter'. *ZÄS* 63.14–36.

Reichhold, K. 1919, *Skizzenbuch griechischer Meister.* München: Bruckmann.

Reinach, S. 1912, *Répertoire des reliefs grecs et romains* 3. Paris: Leroux.

Reisner, G. A. 1907, *Amulets* 1. CGMC.

Reisner, G. A. 1913, *Models of ships and boats.* CGMC.

Relazione Relazione sui lavori della missione archeologica italiana in Egitto *(1903–1920).* 2 vols. Torino: Chiantore [1927].

[Renfrew, C. 1969, 'The development and chronology of early Cycladic figurines'. *American Journal of Archaeology* 73.1–32. n.p.: Archaeological Institute of America.]

[Reuterswärd, P. 1958, *Studien zur Polychromie der Plastik* 1 *Ägypten.* Acta Universitatis Stockholmiensis, Stockholm Studies in History of Art 3.1. Stockholm: Almqvist & Wiksell.]

[Richter, G. M. A. 1950 (new ed. 1971), *The sculpture and sculptors of the Greeks.* The Metropolitan Museum of Art. New Haven: Yale University Press–London: Oxford University Press.]

[Richter, L. 1909, *Lebenserinnerungen eines deutschen Malers.* Ed. Heinrich Richter, introd. Ferdinand Avenarius. Leipzig: Hesse & Becker]

Ricci, C. 1887, *L'arte dei bambini.* Bologna: Zanichelli.

[Ricke, H. 1944, *Bemerkungen zur ägyptischen Baukunst des Alten Reichs* 1. Beiträge zur Ägyptischen Bauforschung und Altertumskunde 4. Zürich: Borchardt-Institut.]

Rodenwaldt, G. 1927, *Die Kunst der Antike, Hellas und Rom.* 2 eds. Propyläen-Kunstgeschichte 3. Berlin: Propyläen.

Roeder, G. 1914, *Naos.* CGMC. Leipzig: Breitkopf & Härtel.

[Ridgway, B.S. 1966, 'Greek kouroi and Egyptian methods'. *American Journal of Archaeology* 70.68–70. n.p.: Archaeological Institute of America.]

Roeder, G. 1915, *Urkunden zur Religion des alten Ägypten.* Religiöse Stimmen der Völker. Jena: Diederichs.

Roeder, G. 1927, *Altägyptische Erzählungen und Märchen.* Die Märchen der Weltliteratur. Jena: Diederichs.

Roeder, G. 1939, 'Freie Plastik aus Ägypten in dem Rijksmuseum van Oudheden'. *Oudheidkundige Mededelingen uit het Rijksmuseum van Oudheden* NR 20.1–23. Leiden: Rijksmuseum van Oudheden.

[Roeder, G. 1969, *Amarna-Reliefs aus Hermopolis.* Pelizaeus-Museum zu Hildesheim, Wissenschaftliche Veröffentlichung 6. Hildesheim: Gerstenberg.]

Rosellini, I, 1832, *I monumenti dell'Egitto e della Nubia* 1 *monumenti storici.* Pisa: Niccolò Capurro.

Rosellini, I 1834. *I monumenti dell'Egitto e della Nubia* 2 *monumenti civili.* Pisa: Niccolò Capurro.

Rosellini, I. 1844, *I monumenti dell'Egitto e della Nubia* 3 *Monumenti del culto.* Pisa: Niccolò Capurro.

Roth, H. Ling 1921, 'Models of Egyptian looms'. *Ancient Egypt* 1921.4.98–9. London–New York: Macmillan–Chicago: Egyptian Research Account.

RT Recueil de Travaux Relatifs à la Philologie et à l'Archéologie Égyptiennes et Assyriennes. Paris 1880–1923.

[Saad, Z. Y. 1947, *Royal excavations at Saqqara and Helwan (1941–1945).* Supplément aux Annales du Service des Antiquités de l'Égypte, Cahier 3. Le Caire: Imprimerie de l'Institut Français d'Archéologie Orientale.]

Sachs, C. 1921, *Die Musikinstrumente des alten Ägyptens.* Staatliche Museen zu Berlin, Mitteilungen aus der ägyptischen Sammlung 3. Berlin: Curtius.

[Säve-Söderbergh, T. 1957, *Four eighteenth dynasty tombs at Thebes.* Private Tombs at Thebes 1. Oxford: University Press for Griffith Institute.]

Schäfer, H. 1892, *Commentationes de papyro medicinali Lipsiensi (Papyrus Ebers).* Dissertation, Berlin, Friedrich-Wilhelm-Universität. Berlin: Schade (Francke).

Schäfer, H. 1903, *Die altägyptischen Prunkgefässe mit aufgesetzten Randverzierungen.* UGÄA 4 (1905).

Schäfer, H. 1904, 'Die Spitze der Pyramide König Amenemhets III'. *ZÄS* 41.84–5.

Schäfer, H. 1908, *Priestergräber und andere Grabfunde vom Ende des Alten Reiches bis zur griechischen Zeit vom Totentempel des Ne-user-rê.* Ausgrabungen der Deutschen Orient-Gesellschaft in Abusir 1902–1904 2. Leipzig: Hinrichs.

Schäfer, H. 1911 'Scheinbild oder Wirklichkeitsbild?, eine Grundfrage für die Geschichte der ägyptischen Zeichenkunst'. *ZÄS* 48.134–42.

Schäfer, H. 1913, *Kunstgeschichte in Bildern, neue Bearbeitung* 1, *Das Altertum, erstes Heft, ägyptische Kunst.* Leipzig: E. A. Seeman.

Schäfer, H. 1915a, 'Einiges über Entstehung und Art der ägyptischen Kunst'. *ZÄS* 52.1–18.

Schäfer, H. 1915b 'Kunstwerke aus der Zeit Amenophis' IV'. *ZÄS* 52.73–87.

Schäfer, H. 1915c, 'Die Vokallosigkeit des "phönizischen" Alphabets. Gedanken zur Geschichte des Alphabets'. *ZÄS* 52.95–8.

Schäfer, H. 1918–19, 'Ägyptischer Vogelfang'. *Amtl. Ber.* 40.163–84.

Schäfer, H. 1919, *Von ägyptischer Kunst, besonders der Zeichenkunst.* 2 vols. Leipzig: Hinrichs.

Schäfer, H. 1920, *Sinn und Aufgabe des Berliner ägyptischen Museums.* Der Alte Orient 22.1–2. Leipzig: Hinrichs.

Schäfer, H. 1921, *Das Bildnis im alten Ägypten.* Bibliothek der Kunstgeschichte 2. Leipzig: E. A. Seeman.

Schäfer, H. 1922, *Von ägyptischer Kunst, besonders der Zeichenkunst.* Zweite stark vermehrte Auflage. Leipzig: Hinrichs.

Schäfer, H. 1923a, *Grundlagen ägyptischer Rundbildnerei und ihre Verwandschaft mit denen der Flachbildnerei.* Der Alte Orient 23.4 Leipzig: Hinrichs.

Schäfer, H. 1923b, *Die Religion und Kunst von el-Amarna.* Meisterwerke in Berlin. Berlin: Bard.

Schäfer, H. 1923c, 'Flachbild und Rundbild in der ägyptischen Kunst'. *ZÄS* 58.138–49.

Schäfer, H. [1923] d, *Kunstwerke aus el-Amarna.* 2 vols. Berlin: Bard.

Schäfer, H. 1926a, 'Die angebliche Entstehung der ägyptischen Wandbilder aus Wandbehang'. *Deutsche Literaturzeitung* 47.1879–84. Berlin: de Gruyter.

Schäfer, H. 1927a, 'Ägyptische und heutige Kunst. Zur Stellung der ägyptischen in der Weltkunst'. *Die Antike* 3.187–267. Berlin–Leipzig: de Gruyter.

Schäfer, H. 1927b, 'Weltgebäude der alten Ägypter'. *Die Antike* 3.91–127. Berlin–Leipzig: de Gruyter.

Schäfer, H. 1928, *Ägyptische und heutige Kunst und Weltgebäude der alten Ägypter.* Zwei Aufsätze. Berlin–Leipzig: de Gruyter.

Schäfer, H. 1929a, *Die Leistung der ägyptischen Kunst.* Der Alte Orient 28.1–2. Leipzig: Hinrichs.

Schäfer, H. 1929b, review of Worringer 1927. *Deutsche Literaturzeitung* 1929.15.707–28. Berlin: de Gruyter.

Schäfer, H. 1929c, 'Bildhorizont in einem ägyptischen Literaturwerke um 1100 v. Chr.'. *OLZ* 32.812–19.

Schäfer, H. 1929d, 'König Amenophis II als Meisterschutz'. *OLZ* 32.233–44.

Schäfer, H. 1929e, 'Die Sonne auf den Obelisken'. *OLZ* 32.721–5.

Schäfer, H. 1930, *Von ägyptischer Kunst: eine Grundlage.* Dritte, neugestaltete und stark vermehrte Auflage. Leipzig: Hinrichs.

Schäfer, H. 1931a, *Amarna in Religion und Kunst.* 7te Sendschrift der Deutschen Orient-Gesellschaft. Leipzig: Hinrichs. (Reworking of Schäfer 1923b, 1923d.)

Schäfer, H. 1931b, 'Zum Wandel der Ausdrucksform in der ägyptischen Kunst'. *ZÄS* 66.8–11.

Schäfer, H. 1931c, 'Weiteres zum Bogenschiessen im alten Ägypten'. *OLZ* 34.89–96. [The German edition quotes wrong title and page reference for this article.]

Schäfer, H. 1931d, 'Bildhorizont in einem ägyptischen Literaturwerke um 1100 v. Chr.'. *OLZ* 34.921–2.

Schäfer, H. 1932a, 'Die "Doppelkrone" der Pharaonen, ihr Bild und ihr Sinn'. *OLZ* 35.697–704.

Schäfer, H. 1932b, 'Die Ausdeutung der Spiegelplatte als Sonnenscheibe'. *ZÄS* 68.1–7.

Schäfer, H. 1933, 'Der Reliefschmuck der Berliner Tür aus der Stufenpyramide und der Königstitel *Ḥr-nb* 🦅 '. *MDAIAK* 4.1–17.

Schäfer, H. 1934, 'Die Simonsche Holzfigur eines Königs der Amarnazeit'. *ZÄS* 70.1–25.

Schäfer, H. 1935a, 'Koptische und altägyptische Zeichnung eines Armsessels'. *OLZ* 38.73–84.

Schäfer, H. 1935b, 'Altägyptische Bilder der auf- und untergehenden Sonne'. *ZÄS* 71.15–38.

Schäfer, H. 1936, *Das altägyptische Bildnis.* Leipziger Ägyptologische Studien 5. Glückstadt–Hamburg–New York: Augustin.

Schäfer, H. 1938, 'Ungewöhnliche ägyptische Augenbilder und die sonstige Naturwiedergabe'. *ZÄS* 74.27–41.

Schäfer, H. 1939, 'Wieder neue ungewöhnliche Darstellungen von Sonnenschiffen und das Viergespann des Brandenburger Tores'. *MDAIAK* 8.147–55.

Schäfer, H. 1942, 'Hilfen zur Erforschung ägyptischer und anderer 'vorgriechischer' Kunst'. *JDAI* 57.158–82.

Schäfer, H. 1943, 'Die "Vereinigung der beiden Ländern"'. *MDAIAK* 12.73–95.

Schäfer, H. 1944, 'Leben, Ewigkeit und ägyptische Kunst'. *Nachrichten von der Akademie der Wissenschaften in Göttingen, philologisch-historische Klasse* 1944.5.93–120. Göttingen: Vandenhoeck und Ruprecht.

Schäfer, H. 1957, 'Das Niederschlagen der Feinde'. *Wiener Zeitschrift für die Kunde des Morgenlandes* 54.168–76. Wien: Orientalistisches Institut.

[Schäfer, H. 1963, *Von ägyptischer Kunst: eine Grundlage.* 4. verbesserte Auflage herausgegeben und mit einem Nachwort versehen von Emma Brunner-Traut. Wiesbaden: Harrassowitz (the edition translated here).]

Schäfer, H.–Andrae, W. 1925, *Die Kunst des alten Orients.* Propyläen-Kunstgeschichte 2. Berlin: Propyläen.

Schäfer, H.–Andrae, W. 1930, *Die Kunst des alten Orients*². Propyläen-Kunstgeschichte 2. Berlin: Propyläen.

Schäfer, H.–Andrae, W. 1942, *Die Kunst des alten Orients*³. Propyläen-Kunstgeschichte 2. Berlin: Propyläen.

Schäfer, H.–Möller, G.–Schubart, W.,1910, *Ägyptische Goldschmiedearbeiten.* Königliche Museen zu Berlin, Mitteilungen aus der Ägyptischen Sammlung 1. Berlin: Curtius.

Schäfer, H.–Schubart, W. 1926, 'Entwicklung der staatlichen Museen in den Jahren 1905–1920 – Ägyptische Abteilung', in *Hauptwerke aus den staatlichen Museen zu Berlin, Wilhelm von Bode zu Ehren herausgegeben von den Abteilungsleitern* 11–17, with descriptions of plates 1–6. Berlin: Grote.

Scharff, A. 1926a, *Die archaeologischen Ergebnisse des vorgeschichtlichen Gräberfeldes von Abusir el-Meleq.* Ausgrabungen der Deutschen Orient-Gesellschaft auf dem vorgeschichtlichen Gräberfeld von Abusir el-Meleq. Leipzig: Hinrichs.

Scharff, A. 1926b, 'Vorgeschichtliches zur Libyerfrage'. *ZÄS* 61.16–30.

Scharff, A. 1928, 'Ein Frauenrelief der Pyramidenzeit'. *Amtl. Ber.* 49.40–3.

Scharff, A. 1929, *Die Altertümer der Vor- und Frühzeit Ägyptens.* Staatliche Museen zu Berlin, Mitteilungen aus der ägyptischen Sammlung 5. Berlin: Curtius.

[Schenkel, W. 1962, 'Die Farben in ägyptischer Kunst und Sprache'. *ZÄS* 88.131–47.]

[Schindewolf, O. 1960, 'Darwins Abstammungslehre in der Sicht eines Paläontologen'. *Universitas* 15.649–61. Stuttgart: Wissenschaftliche Verlagsgesellschaft.]

Schmarsow, A. 1905, *Grundbegriffe der Kunstwissenschaft am Übergang vom Altertum zum Mittelalter* etc. Leipzig–Berlin: Teubner.

Schneider, H. 1907, *Kultur und Denken der alten Ägypter.* Leipzig: Voigtländer.

[Schott, S. 1950, *Hieroglyphen, Untersuchungen zum Ursprung der Schrift.* Akademie der Wissenschaften und der Literatur, Abhandlungen der geistes- und sozialwissenschaftlichen Klasse 1950.24. Wiesbaden: Akademie der Wissenschaften und der Literatur in Mainz–Steiner.]

[Schott, S. 1959, 3 chapters in H. Kees (ed.), *Ägyptische Schrift und Sprache.* Handbuch der Orientalistik 1.1.1.18–36. Leiden: Brill.]

Schuchhardt, C. 1926, *Alteuropa*². Berlin–Leipzig: de Gruyter. [⁵ 1944, Berlin: de Gruyter.]

[Schulman, A. R. 1968,'A private triumphal relief in Brooklyn and Hildesheim'. *Journal of the American Research Center in Egypt* 7.27–35. Princeton.]

Seler, E. 1906, *Codex Borgia, eine altmexikanische Bilderschrift der Bibliothek der Congregatio de Propaganda Fide* 2. Berlin.

Seler, E. 1915a, *Beobachtungen und Studien in den Ruinen von Palenque.* Abhandlungen der Königlichen Preussischen Akademie der Wissenschaften 1915.5. Berlin: Akademie der Wissenschaften (Reimer).

[Seler, E. 1915b, 'Die Ruinen von Chich'en Itza in Yucatan', in *Gesammelte Abhandlungen zur amerikanischen Sprach- und Altertumskunde* 5.197–388. Berlin: Behrend. [reissued Graz: Akademische Druck- u. Verlagsanstalt 1961.]]

[Senk, H. 1967, 'Vier Bemerkungen zu H. Schäfer, Von ägyptischer Kunst. 4. Aufl. 1963'. *ZÄS* 94.150.]

Seta, A della 1906, 'La genesi dello scorcio nell'arte greca'. *Atti della Reale Accademia dei Lincei* anno 102 serie 5.12.121–242. Roma.

Sethe, K. 1902, *Imhotep, der Asklepios der Ägypter, ein vergötterter Mensch aus der Zeit des Königs Doser.* UGÄA 2.4.

Sethe, K. 1917, 'Zwei bisher übersehene Nachrichten über Kunstwerke aus Kupfer aus den ältesten Zeiten der ägyptischen Geschichte'. *ZAS* 53.50–4. [=*JEA* 1 (1914) 233-6.]

Sethe, K. 1922, *Die altägyptischen Pyramidentexte* 4. Leipzig: Hinrichs.

Sethe, K. 1928, 'Altägyptische Vorstellungen vom Laufe der Sonne'. *SPAW* 1928.22.

Sethe, K. 1929, 'Das Papyrusszepter der ägyptischen Göttinnen und seine Entstehung' *ZÄS* 64.6–9.

Sethe, K. 1930, *Urgeschichte und älteste Religion der Agypter.* Abhandlungen für die Kunde des Morgenlandes 18.4. Leipzig: Deutsche Morgenländische Gesellschaft.

[Seymour, C. Jr. 1967, *Michelangelo's David.* A. W. Mellon Studies in the Humanities. n.p.: University of Pittsburgh Press.]

Shorter, A. W. 1930, 'The tomb of Aaḥmose, supervisor of the mysteries in the house of the morning'. *JEA* 16.54–62.

[Slow, D. 1964, review of Schäfer 1963. *JEA* 50.191–2.]

[Sm Smith 1958.]

[Smith, W. S. 1946, [2] 1949, *A history of Egyptian sculpture and painting in the Old Kingdom.* London: Oxford University Press, for Museum of Fine Arts Boston. [[1] on spine: Harvard University Press, [2] on spine: Museum of Fine Arts Boston] .]

[Smith, W. S. 1958, *The art and architecture of ancient Egypt.* The Pelican History of Art. [Harmondsworth] : Penguin.]

[Smith, W. S. 1965, *Interconnections in the ancient Near East.* New Haven–London: Yale University Press.]

[Snijder, G. A. 1936, *Kretische Kunst, Versuch einer Deutung.* Berlin: Mann.]

SPAW Sitzungsberichte der (königlich) Preussischen Akademie der Wissenschaften. Berlin: Akademie der Wissenschaften (Reimer) later (de Gruyter.)

Spiegelberg, W. 1903, *Geschichte der ägyptischen Kunst bis zum Hellenismus.* Leipzig: Hinrichs.

Spiegelberg, W. 1906, 'Varia'. *RT* 28.161–87.

Spiegelberg, W. 1929, 'Note on the feminine character of the New Empire'. *JEA* 15.199.

Spiegelberg, W. 1930a, *'nṯrw* "Götter" = Bilder'. *ZÄS* 65.119–21.

Spiegelberg, W. 1930b, 'Befestigte Brunnenanlagen in Palästina'. *ZÄS* 65.57–8.

Spiegelberg, W. 1930c, 'Ein Skarabäus mit religiöser Darstellung'. *OLZ* 33.249–52.

Spiegelberg. W.–Dyroff, K.–Pörtner, B. 1904, *Aegyptische Grabsteine und Denksteine aus süddeutschen Sammlungen* 2. Strassburg: Schlesier & Schweikhardt.

Spiegelberg, W.–Sethe, K. 1918, 'Das Grundwort zum Lautzeichen ꜣ *ḏ*. *ZÄS* 55.89–92.

Sponsheimer, H. 1925, 'Zwei Kapitel zur Frage der Parallelerscheinung'. *Jahresbericht des Vereins ehemaliger Adolfiner E. V. in Moers*. Moers. Pannen.

Sponsheimer, H. 1928, 'Überschneidungen und Deckungen im vorgriechischen Flachbilde'. *Festschrift dem Gymnasium Adolfinum gewidmet vom Verein ehemaliger Adolfiner zum Einzug in das neue Heim Moers 1928* 51–64. Moers: Pannen.

Springer, A. 1923, *Die Kunst des Altertums*[12] . Nach Adolf Michaelis bearbeitet von Paul Wolters. Handbuch der Kunstwissenschaft 1. Leipzig: Kröner.

[Staehelin, E. 1966, *Untersuchungen zur ägyptischen Tracht im Alten Reich*. Münchener Ägyptologische Studien 8. Berlin: Hessling.]

Stapel, W. 1928, *Volksbürgerliche Erziehung. Versuch einer volkskonservativen Erziehungslehre*[3] . Hamburg: Hanseatische Verlagsanstalt.

Steindorff, G. 1913, *Das Grab des Ti*. Veröffentlichungen der Ernst von Sieglin Expedition in Ägypten 2. Leipzig: Hinrichs.

Steindorff, G. 1920, 'Eine Statue der Frühzeit'. *ZÄS* 56.96–8.

Steindorff, G. 1923, Rektorwechsel an der Universität Leipzig am 31 Oktober 1923, 2 'Das Wesen des ägyptischen Volkes'. Leipzig: Naturwissenschaftliche Werkgemeinschaft an der Universität.

Steindorff, G. 1928, *Die Kunst der Ägypter*. Leipzig: Insel.

Strzygowski, J. 1885, *Iconographie der Taufe Christi*. Muenchen: Riedel.

Studniczka, F. 1898, *Die Siegesgöttin, Entwurf der Geschichte einer antiken Idealgestalt*. Akademische Antrittsrede. Leipzig: Teubner.

Stumpf, C. 1918, *Empfindung und Vorstellung*. Abhandlungen der Königlich Preussischen Akademie der Wissenschaften 1918.1. Berlin: Verlag der königl. Akademie der Wissenschaften (Reimer).

Swarzenski, H. 1927, *Vorgotische Miniaturen, die ersten Jahrhunderte deutscher Malerei*. Königstein im Taunus–Leipzig: Karl Robert Langewies.

Swindler, M. H. 1929, *Ancient painting from the earliest times to the period of Christian art*. New Haven: Yale University Press–London: Oxford University Press.

Sydow, E. von 1923, *Die Kunst der Naturvölker und der Vorzeit*. Propyläen-Kunstgeschichte 1. Berlin: Propyläen.

[Thomas, E. 1959, 'Terrestrial marsh and solar mat'. *JEA* 45.38–51.]

[TP Yoyotte 1968.]

Tylor, J. J. 1896, *Wall drawings and monuments of el Kab: the tomb of Sebeknekht.* London: Quaritch.

Uexküll, J. von 1928, 'Welt und Umwelt'. *Deutsches Volkstum, Monatsschrift für das Deutsche Geistesleben* 10.21–36. Hamburg: Hanseatische Verlagsanstalt.

UGÄA Untersuchungen zur Geschichte und Altertumskunde Ägyptens. Leipzig: Hinrichs 1896– .

Unger, E. 1917, *Die Reliefs Tiglatpilesars III aus Nimrud.* Publikationen der kaiserlich Osmanischen Museen 5. Konstantinopel: Ahmed Ihsan.

[Vandier, J. 1965, review of Schäfer 1963. *Revue d'Égyptologie* 17.225–7. Paris: Klincksieck.]

[Ventris, M.–Chadwick, J. 1956, *Documents in Mycenean Greek.* Cambridge: Cambridge University Press.]

Verworn, M. 1909, *Die Anfänge der Kunst.* Jena: Fischer.

[W Wolf 1957.]

[Wallert, I. 1967, *Der verzierte Löffel.* Ägyptologische Abhandlungen 16. Wiesbaden: Harrassowitz.]

[Warren, R. M.–Warren, P. 1968, *Helmholtz on perception: its physiology and development.* New York–London–Sydney: Wiley.

[Watzinger, C. 1931, review of Schäfer 1930. *Deutsche Literaturzeitung.* 52.833–6. Leipzig: Quelle & Meyer.]

[*Wb.* A. Erman–H. Grapow, *Wörterbuch der ägyptischen Sprache.* 7 vols in 12. Leipzig: Hinrichs (later also Berlin: Akademie) 1926–63.]

Weber, O. 1920, *Altorientalische Siegelbilder.* 2 vols. Der Alte Orient 17–18. Leipzig: Hinrichs.

Weigall, A. 1924, *Ancient Egyptian works of art.* London: Fisher Unwin, Adelphi Terrace.

[Weinberger, M. 1967, *Michelangelo the sculptor.* 2 vols. London: Routledge & Kegan Paul–New York: Columbia University Press.]

[Westendorf, W. 1968, *Das alte Ägypten.* Kunst im Bild. Baden-Baden: Holle. Tr. L Mins, New York–London: Abrams.]

Wiedemann, A. 1906, 'Die Zeichenkunst im alten Ägypten'. *Die Umschau* 10 Nr. 40–1. Frankfurt a. M.: Bechhold.

Wiedemann, A. 1920, *Das alte Ägypten.* Kulturgeschichtliche Bibliothek, 1. Reihe: Ethnologische Bibliothek. Heidelberg: Winter.

Wiedemann, A. 1921, 'Die ägyptische Geschichte in der Sage des Altertums', in *Festgabe Friedrich von Bezold dargebracht zum 70. Geburtstag von seinen Schülern, Kollegen und Freunden* 22–58. Bonn–Leipzig: Schroeder.

Wiegand, T. n.d. [1904] , *Die archaische Poros-Architektur der Akropolis zu Athen.* 2 vols. Berlin: Schoetz & Parrhysius.

[Wild, H. 1953, *Le tombeau de Ti* 2. MIFAO 65.]

[Wild, H. 1966, *Le tombeau de Ti* 3. MIFAO 65.]

Wilkinson, J. G.–Birch, S. 1878, *The manners and customs of the ancient Egyptians.* 3 vols [vol. 1 cited without number] . London: Murray.

Williams Ware, E. 1927, 'Egyptian artists' signatures'. *AJSL* 43.185–207.

[Wilson, J. A. 1951, *The burden of Egypt*. [Chicago] : University of Chicago Press. (Paperback ed., same publisher, title *The culture of ancient Egypt* 1956 ff.)]

Windelband, W. 1919, *Präludien*[6]. 2 vols. Tübingen: Mohr.

Winlock, H. E. 1921, *Bas-reliefs from the temple of Ramesses I at Abydos*. The Metropolitan Museum of Art Papers 1.1. New York.

Winlock, H. E. 1923, 'The museum's excavations at Thebes'. *Bulletin of the Metropolitan Museum of Art* Dec. 1923.2.11–37. New York.

[Winlock, H.E. 1942, *Excavations at Deir el Baḥri 1911–1931*. New York: Macmillan.]

[Winlock, H. E. 1955, *Models of daily life in ancient Egypt from the tomb of Meket-Rēʻ at Thebes*. Publications of the Metropolitan Museum of Art Egyptian Expedition 18. Cambridge Mass.:Harvard University Press.]

Winter, F. n.d., 'Kretisch-Mykenische Kunst'. *Kunstgeschichte in Bildern, neue Bearbeitung*. Leipzig: Kröner.

[Wit, C. de, 1963 review of Schäfer 1963. *CdÉ* 38.238–40.]

Woermann, K. 1915, *Geschichte der Kunst aller Zeiten und Völker*[2]. 6 vols., vol. 1 *Die alte Kunst Ägyptens . . . und der Mittelmeerländer*. Leipzig: Bibliographisches Institut.

[Wolf, W. 1935, *Individuum und Gemeinschaft in der ägyptischen Kultur*. Leipziger Ägyptologische Studien 1. Glückstadt: Augustin.

[Wolf, W. 1951, *Die Stellung der ägyptischen Kunst zur antiken und abendländischen und Das Problem des Künstlers in der ägyptischen Kunst*. Hildesheim: Gerstenberg.]

[Wolf, W. 1957, *Die Kunst Ägyptens, Gestalt und Geschichte*. Stuttgart: Kohlhammer.]

[Wolff, M. 1938, 'Ein Bildhauerlehrstück für eine ungewöhnliche Löwendarstellung'. *ZÄS* 74.113–24.]

Wölfflin, H. 1915, *Kunstgeschichtliche Grundbegriffe*. München: Bruckmann. [Tr. by M. D. Hottinger, *Principles of art history*. London: Bell 1932.]

Wölfflin, H. 1941, *Gedanken zur Kunstgeschichte*[3]. Basel: Schwabe.

[Wollheim, R. 1970, *Art and its objects*. Harmondsworth: Penguin.]

Wolters, F. 1924, *Der Wandrer*. Berlin: Bondi.

Worringer, W. 1907, *Abstraktion und Einfühlung*. Neuwied: Heuser. New ed. 1948, München: Piper. [Tr. Michael Bullock, *Abstraction and empathy*. London: Routledge & Kegan Paul 1953.]

Worringer, W. 1920, *Formprobleme der Gotik*[8–12]. München: Piper. [Tr. and ed. H. Read, *Form in gothic*. London: Putnam 1927, [2]London: Tiranti 1957.]

Worringer, W. 1927, *Ägyptische Kunst–Probleme ihrer Wertung*. München: Piper. [Tr. and ed. B. Rackham, *Egyptian art*. London: Putnam 1928.]

Wreszinski, W. 1927, *Bericht über die photographische Expedition von Kairo bis Wadi Halfa zwecks Abschluss der Materialsammlung für meinen Atlas zur altägyptischen Kulturgeschichte*. Schriften der Königsberger Gelehrten Gesellschaft 4.2. Halle a. S.: Niemeyer.

Wulff, O. 1907, 'Die umgekehrte Perspektive und die Niederschrift', in *Kunstwissen-schaftliche Beiträge August Schmarsow gewidmet zum 50. Semester seiner akademischen Lehrtätigkeit.* Kunstgeschichtliche Monographien, 1. Reihe, Beiheft 1. Leipzig: Hiersemann.

Wulff, O. 1913–4, *Altchristliche und byzantinische Kunst.* 2 vols. Handbuch der Kunstwissenschaft. Berlin-Neubabelsberg: Athenaion.

Wulff, O. 1927, *Die Kunst des Kindes.* Stuttgart: Enke.

[Yoyotte, J. 1968, *Treasures of the pharaohs.* [Geneva] : Skira.]

ZÄS Zeitschrift für Ägyptische Sprache und Altert(h)umskunde. Leipzig: Hinrichs 1863–1944, Leipzig–Berlin: Hinrichs–Akademie 1954– .

ZDMG Zeitschrift der Deutschen Morgenländischen Gesellschaft. Leipzig 1846– 1944, Wiesbaden 1950–.

EPILOGUE

ASPECTIVE

by Emma Brunner-Traut

Schäfer wrote at the end of his 1956 Preface: 'Indeed . . . nobody can study any art really seriously [more precisely: representational art—sculpture, relief, and painting] if he has not reflected on these problems. At the very least the distinction between the "pre-Greek" and "Greek" renderings of nature should be outlined wherever art is taught.' Anyone who has seriously come to grips with this book will agree unhesitatingly.[1] It is not a work of art history, nor is it a structural analysis or an appreciation of Egyptian style, and least of all a paraphrase for aesthetes. In principle the expressive and beautiful qualities of Egyptian art are not even touched upon. The author found sentimentality and pathos equally repellent, and he was contemptuous of 'sensitivity', considering it self-indulgence. He thought philosophical interpretation was necessary, but that its time had not yet come; therefore it was not permissible. But he was aiming at none of these things. What he wrote could be described as a *grammar of Egyptian art*. He isolated the rules of formal construction, their transformations and syntactic employment, with the cool objectivity and scientific skill of a linguist. His dictionary of the language of ancient Egyptian art and his compositional syntax allow one to read the pictures correctly, in fact they decipher them; they are the basis of any understanding of the subject, and any of the other approaches mentioned above must start from them. So this 'elementary instruction book' does not compete with any of the modern art books, in fact their subjects do not coincide at all; on the other hand, any study of art must be made with a knowledge of Schäfer's rules if it is not to miss the point entirely, as the properly artistic formation of the works overlays, in structural terms, the level Schäfer termed the framework, that is, the comprehension and representation of reality (cf. p. 423—4). I can only judge how something[2] is expressed in such a strange world if I have understood what is intended.

'Any study of art', not just any study of ancient Egyptian art, should be made in awareness of Schäfer's discoveries. The claim is a large one, but it is justified. This requirement is illuminated sharply by the problems that surround modern art. Present-day critics and interpreters attempt to come to grips with the phenomenon of

[1] Among the many scholars who are in agreement with this I shall quote Frankfort (1932.36–7): '. . . Schäfer is not out merely to formulate an ingenious theory, he wants to demonstrate how a particular attitude towards visual impressions, a particular view as to their reality, underlies the whole multifarious structure of Egyptian art. It is of the utmost value for Egyptology that his book should be as complete and comprehensive as it is; there is no type of representation and very few, if any, isolated instances, which cannot be found in it, brought into relation with the dominating idea of all pre-Greek art.

... . And it remains his great achievement to have shown convincingly that Egyptian art, granted a certain attitude towards visual impressions which differs from ours, is consistent in itself and can be fully understood.'

[2] This is not to deny in any way that 'something' may not be only sensed, or indeed fundamentally hidden.

art in many ways, without ever arriving at its basic level. The book's unfortunately over-modest title meant that many people could only discover it by chance, while foreigners were put off by the gothic type in which it was printed. How many false trails and detours could otherwise have been avoided![3]

This Epilogue has a twofold purpose in its attempt to replace the term Schäfer coined for Egyptian representational methods, *'geradvorstellig'* [based on frontal images],[4] with the expression 'aspective'. I feel justified in making the suggestion, since Schäfer himself was never satisfied with his clumsy and ineffective word.

In the first place I hope to have found in 'aspective' a term that can be extended in its uses to include the other manifestations of Egyptian culture as well as art. This seems possible because 'aspective' characterizes the mentality isolated by Schäfer more coherently and comprehensively, thus including by implication all the cultural phenomena which have the same ultimate origin.

The second reason why I am tempted to tinker with Schäfer's 'framework' is that I intend to reply to people who maintain that they have carried their results further than Schäfer and dismiss his work as old-fashioned, or, disregarding his results, attempt to interpret Egyptian art solely on the basis of its structure.

Schäfer did state his critical position with regard to various philosophers of art in his last articles, but less attention was paid to his replies than one would desire, because he obstinately limited himself to using his own method of analysis and the language appropriate to his mode of study. In this way his central conclusion, that the method of observation used for Western art cannot be adopted at all for the study of Egyptian art, was not understood; at a cognitive level, not at a formal one, there has been such an earth-shaking change that we cannot understand Egyptian art from the outside, and must instead approach it through its own laws of thought.

I think discussion can only be profitable if Schäfer's advocate takes into consideration the conceptual world and the terminology of the other interpreters.[5] I am

[3] This is true also of Wilson, who is still saying that'the flat planes of statuary appeared . . . skilfully twisted in relief' (1951.53).

[4] Cf. Translator's Introduction.

[5] As Schäfer himself took issue with his critics I am relieved of pursuing this task in detail (cf. especially section IX of the text to *Atlas* 3 pl. 114–15A, and section IV of the text to *Atlas* 3 pl. 113; both these studies were reissued separately; Schäfer 1938, especially pp. 36 ff.; Schäfer 1942; cf. also Preface n. 5 and Index to this book). However important the achievements of these authors may be in their own fields—they are all specialists in related disciplines – they have not found the key to an understanding of Egyptian art. Their 'new' formulations can all be found in a careful reading of Schäfer, for example: the relationship of Egyptian art to haptic processes, the separation of Egyptian art from that of primitive people and of children, the culturally determined differences between Egyptian and e.g. Babylonian art, static values, the peculiar properties of space, etc. – all discussed in several places (cf. Index). Structural analysis as an exclusive approach— however fruitful it may be within its own limits – has failed in the case of Egyptian art, as indeed its best practitioner has admitted (Krahmer 1931.65). This is because it assumes that the formal language of an art is correctly understood through an attempt to reveal 'the form in which the power, which in art represents symbolically cosmic or divine energy, is manifest' (von Kaschnitz-Weinberg n.d. [1933]). But we have learnt to understand the language of art in the context of our perspective mode of representation, which is appropriate to our image of the world, and the Egyptian image of the world, which is foreign to us, has a totally different formal language. We must proceed slowly and cautiously if we are to understand this language.

attempting this in the hope of demonstrating the superiority of Schäfer's arguments.[6]

I shall compare briefly the aspective and perspective modes of representation, and then elucidate the concept 'aspective' and apply it to art and to other phenomena of culture. In the process particular attention will be paid to the fundamental categories of time and space, without which perception is impossible.

Whatever position scholars take up[7] they are agreed on one point, that Egyptian art—and with it all art termed 'pre-Greek' by Schäfer, children's drawings, and drawings by primitive people—is characterized by an intellectual attitude, which Schäfer calls a 'basis in frontal images' [Geradvorstellung], which differs from perspective, and which I intend, I believe with good reason, to call 'aspective'.[8] If one considers the millennia of the history of art it becomes clear that the division in methods of representation between perspective and aspective occurs at a level whose significance is not equalled by that of any distinction of any other order between works of art. Schäfer too was aware that this distinction is not based on a division

[6] It goes without saying that as much Egyptological knowledge as possible must be assumed before an approach of this sort which 'starts from the inside' (I do not wish to confuse this with a psychologistic approach) is attempted; in particular, what the Egyptians say about themselves in texts must be included in the discussion. I am well aware that we 'may know much', even if what we know is nothing in comparison with what we do not know, but should know before we ask such a difficult question. And I must also concede that my exposition here should be substantiated in greater detail than is possible in the context of an epilogue. But what encourages me to undertake it despite these reservations—let me repeat—is my feeling of duty towards the author, that his case should be stated before it is distorted by interpretations which do not, in my opinion, do him justice. But, apart from people who take me to task for an over-hasty attack on the subject, there may be others who will feel that my exposition of aspective and characterization of Egyptian art as aspective is truistic. Perhaps such people can resign themselves to an effort to introduce the concept in a slightly more scrupulous way and to evaluate it against other tangential or overlapping definitions. In general I can expect to do no more than to give a pointer in the direction in which the solution should be found.

[7] It is disconcerting to survey the confusion of supposedly distinctive characterizations; this confusion has its origin partly in the fact that the distinguishing marks are not conceived at a fundamental enough level, and for this reason are not adequate in all cases, and partly in an insufficiently precise definition of their polarity. Thus, for example, the overworked 'psychologism' or 'psychology' can mean something quite different when used by different scholars; and the same is true of subject/object oppositions: both these conceptual pairs will be discussed briefly in the text. The persistent hostility of recent research to the 'psychological' approach, continued in the belief that works of art are being 'misused to test psychological hypotheses about their periods', can be objected to on the following grounds: 'the intellect encounters the mystery of its own origin in the order of nature' (C.F. von Weizsäcker) and vice versa—'the key to the hieroglyphs of nature lies in the depths of the soul' (Eduard Spranger), not only as the intellectual mediator between subject and object, according to the 'great analogy of man and world' (Schopenhauer) or Herder's 'great analogy of nature', but in that the intellect also encounters the mystery of the human soul in the structure of art, just as much as the riddle of art lies in the depths of the soul. Therefore a scholar is equally justified in starting from either end—quite apart from the fact that I am not primarily asking a question about artistic *form* here, but about the logical basis of that form, so that, strictly speaking, I am treating an area of epistemology [Erkenntnistheorie] and not one of artistic theory.

[8] While this book was in the press a thorough treatment of this subject appeared, dedicated to the memory of Jean Capart and Heinrich Schäfer: Henri Asselberghs, *Chaos en Beheersing* (1961).

that could be separated from the rest of culture, but that it reflects a basically different attitude to the world.

Man can only ever represent the objective world from the standpoint of an attitude to the world which he already holds—and which we must express on a philosophical plane. It scarcely needs to be mentioned that the Egyptians did not themselves formulate their method of representation at a philosophical level: their method of representation was the only one appropriate to their general intellectual orientation. Their artistic will was not the product of epistemological reflection of the type we shall and must now attempt if we are consciously to follow the achievements brought about purely by instinct. Before we begin our task it should once more be stated explicitly that aspective or perspective are expressions of perceptual attitudes, therefore that we are not studying psychological inclinations or strictly artistic modes of expression, still less individual psychic intuitions or mood, or the changeable expressions of style. We are far more interested in the Egyptians' perceptual attitude that lies behind all this; this is not without relevance for the representation of forms, indeed its importance is absolutely fundamental (cf. Schäfer p. 336–7 above).

If we pose the question, *what was the Egyptian artist's perceptual attitude to the object he was depicting*, we receive a convincing if only partial answer: an Egyptian renders what he is depicting part for part as it really and ideally *is*, always, everywhere, and for everybody. A square surface is shown as an equal, right-angled quadrilateral. Greek or Western perspective renders the same original as it *appears* to the viewer, an arbitrary individual at a random point in time in a particular spot chosen by him and in whatever lighting there chances to be. Depending on where the viewer places himself the sides are foreshortened, the angles are distorted, and the line becomes finer as distance increases; in painting the colours and the shadows change, while an aspective artist will normally only render local colours without shadows.

If the original is a physical object with several facets, for example a box, all the sides cannot be represented equally. An Egyptian artist sees his task as one of selection, that is of evaluation. He always renders at least the side of the object which is chiefly viewed, and in addition he normally shows as many adjacent sides as are necessary to define what the object is. As with a flat object, all the sides are unforeshortened in the picture: they are artistically combined. An object of this sort is composed from the individual views which characterize it; these are based on the single mental images essential for us to identify it.[9] They are enumerated in the process of drawing and related artistically according to the image of the whole—which is not figurative but conceptual—without sacrificing the truth they contain. Of course, the number and selection of individual images varies with different artists, but the range of variation is soon brought under control by convention. A canon of accepted patterns emerges and comes to serve as a repository of standard forms.

[9] It would be wrong to imagine that the picture was composed like a mosaic, for the artist selects on the one hand, while on the other hand he keeps before him the idea of the whole. The idea that the art which I call aspective, and which Schäfer compared with the products of children and primitive people, is similarly 'childish' is equally mistaken; only the cognitive aspect is the same; the artistic form, in so far as children and primitive people desire to or are capable of producing it, will present itself differently in each context.

Now while this rendering of nature, which I call aspective, aims at a true represent-
ation of the object, perspective representation simulates a space extending behind
the picture surface, i.e. it *apparently points into the distance*. The well-known world
of perception becomes a world of appearance, which Plato and Aristotle equally
stigmatized as 'deceitful' and 'cheating'. Leonardo da Vinci, for our purposes the
best representative of the Renaissance, speaks of illusion and emphasizes that the
achieving of an illusion of corporeality and pictorial depth is the painter's most
important task. He says in his *Trattato della Pittura*: 'the primary purpose of the
painter is to make a plane surface display a body in relief, detached from that plane,
and he who in that art most surpasses others deserves most praise'[10] Only 'the
ignorant public . . . want nothing in painting but beauty of colour, altogether for-
getting the beauty and marvel of depicting a relief on what in reality is a plane
surface.'[11] Thus perspective reveals itself to be the art of appearances.

Egyptian artists, on the other hand, as we have heard, select from the infinite
spectrum only those possibilities which are free from the illusion of perspective, and
still more from the *trompe l'oeil* which was in favour in the Hellenistic and Baroque
periods; the characteristic individual parts of an object are set unforeshortened
paratactically side by side, rather as a continuous action can be rendered simul-
taneously in a picture as several fixed phases placed next to one another.

One point should be strongly stressed here: the *individual* parts are rendered with-
out foreshortening, the action is analyzed into *single* acts occupying single points in
time. The object as a whole is 'foreshortened' in that not all its parts are represented,
so that it too suffers a loss of truth. An object rendered in perspective is of course
subject to an arbitrary point of view, but once this point of view is laid down the
rendering of the object to be depicted is much more unambiguously fixed than is the
case with aspective, indeed in perceptual terms only one representation is permissible.
So the opposition of truth and deception is not so simple after all, the distinction is
of a different order.[12] The Egyptian's truth is restricted since it applies only to the
individual parts.

We find ourselves similarly checked if we follow to a conclusion the often repeated
assertion that Egyptian art has an 'objectivizing' orientation and Greek art a 'sub-
jectivizing' one[13]—here we substitute aspective and perspective for Egyptian and
Greek. It is true that an Egyptian may be said to place his object for depiction in the
centre and to encircle it with thoughts, while a Greek places *himself* at the mid-point
and assembles all the optical lines that start from the object in *his* eye, and so is
acting anthropocentrically. Yet there is a subjective moment in the act of selection,
evaluation, and ordering in Egyptian art, while a Greek is perceptually, purely, ob-
jectively bound to his subject, once he has taken up his position in relation to it. So
it seems to me that the objectivizing/subjectivizing opposition[14] also needs restricting,

[10] In Renaissance music the return to monody represents the striving to give an illusion of
space; compare the Venetian and Florentine schools, especially the spatial distribution of
instrumental groups and choirs.

[11] Ludwig 1882.1.404–5 no. 412; McMahon 1956.161 no. 434, fol. 133. [Translation reproduced
from McMahon by permission of the Princeton University Press (J.R.B.).]

[12] The best treatment of all these definitions is in Wolf (1957).

[13] Cf. below p. 426 and Schäfer p. 272 above.

[14] Schäfer rejected the pair of terms of '*Daseins-*' and '*Wirkungsform*' [form of existence and form
of effect (on the viewer)] coined by Hildebrand on the grounds that it externalized the
phenomena and rendered them superficial. It scarcely needs saying that the opposition

even though this should not affect the fact that an Egyptian artist *gives himself to the object*, while a perspective artist *takes his distance* from it.

I intend this image of *taking one's distance* quite literally, that an Egyptian keeps his mind's eye close up to the object—I hope to show that he only ever fixes his gaze on one part of it—while a perspective artist raises his head—in the broadest sense— and, because he is distanced in this way, gains a more comprehensive sight of the object.[15] An aspective artist knows neither the image of perspective, which can be taken in at a glance, nor the single[16] 'fruitful moment' of comprehension which is just as characteristic of perspective art. An Egyptian places physically and temporally delimited *individual parts* next to one another. Although he places the isolated parts next to one another he always retains a *mental image* of the *whole* and his representation makes reference to what he *knows*. I have already indicated that he does not let the individual parts stand isolated in the picture, but brings them together to form an artistic unity.

As I said, *perspective* reflects the observation of the world from a 'higher' human standpoint, and the object is seen in the context of mankind's separation from the inanimate world. The object thus set at a remove is incorporated as a whole into a single field of vision, and is seen in relation with its environment. The size and the mutual relationships of objects depend on their distance from the viewer so that, instead of their having their own value and obeying their own laws, as they do in the aspective view, their value and conditions of existence are relative. The individual parts of an object are subordinated to the whole, and these elements are represented in their functional interdependence. The point at which a man stands determines the pictorial area selected and its ordering. Here I mean to emphasize not the 'man' but the 'standpoint', bearing distancing[17] in mind. Of course the man stands at the mid-point only in so far as he feels superior to the object and so makes himself the aim and outcome; thus he renders himself self-conscious at the same time.

Greek perspective remains a perspective of succession, successive when it moves from consideration of single objects to that of a whole picture area, with the result that there is always a certain tension between the object, which exists on its own, and the 'subject' who perceives it. But this type of perspective, which was discovered by the Greeks—it was first found in their art, and then became scientific knowledge— and discovered by them alone, found a logical continuation in the Renaissance in scientific perspective, that is, constructive perspective based on the assumption that man is the *sole* source of knowledge, for reality is no longer experienced by observation alone, but also by calculation. The uncompromising adoption of the Greek discovery by the Renaissance makes the latter the most extreme and radical opponent of ancient Egypt.

'naturalistic-idealistic' is out of place here. I shall not discuss the usefulness of all the criteria which have been predicated to aspective and perspective to set them off against one another, but one group deserves special mention: paratactic/hypotatic. This pair involves an ordering system with which I shall later be concerned. The connection between hypotaxis and perspective should become clear in the next section.

[15] It should become clear from what follows that a price has to be paid for this raising of the head.

[16] To anticipate a further objection I should make it clear that when I say 'unifying' or 'united' I do not mean 'homogeneous' but centred (seen together); Egyptian art was more unified in the sense of homogeneous than any other.

[17] [*Ab-stand*, lit. 'standing away', word-play (J.R.B.).]

But although a Greek takes up a different position in the cosmos, and Greek thought and imagination had man as their concern to a quite different degree, in his aspirations he shows himself to be a man of moderation. From the point of view of the discovery of perspective Greek art may be considered specifically human: human and moderate as compared with the Renaissance, but anthropocentric as compared with the Egyptians' aspective attitude. The sudden leap to perspective is part of the general transformation of man's relationship with the world, which first made possible the existence of a *Weltanschauung*, as the term is generally understood—instead of myth. Perspective presupposes a different ranking of man in the cosmos, that he take up a different position.

This changed viewpoint—the 'higher standpoint'—can be seen clearly when we consider the new problem, most striking in the Renaissance, of reconciling visual order and the order of importance. If God in heaven is to be subject to perspective size ratios he can no longer be represented at all without losing his might. So God must be removed from perspective logic if he is to maintain his pre-eminence (cf. in detail Jantzen 1960.20f).

Egyptians do not struggle to achieve a 'personal viewpoint', they conceive that their task is to integrate themselves into the absolute and universal order which was laid down once and for all by God; they do not arrive at knowledge through critical perception but through believing acceptance, in the role of the 'truly silent man', one who is silent before Ma'at, the divine order (cf. Brunner 1957a.116–26, esp. 119, 123). A view like this is not a basis from which a man can raise himself 'above' the world.

Before concluding this section on the search for knowledge I should like to raise one more point, which Schäfer did not emphasize. It should not be claimed that all the rules worked out by Schäfer are necessary constituent parts of aspective art. If one looks at the rest of the world one finds, for example, that neither equal height of seated or standing figures in a group (isocephaly), nor the equivalence of size and importance [*Bedeutungsmassstab*] is universal. A whole series of rules of construction are not of the essence, but are accident, more precisely the ones that make up the 'canon' of proportion are specifically Egyptian. So they should not be considered necessary to the epistemological basis.[18]

In the preceding section I considered the Egyptians' relationship with the world; this next one will be devoted to a search for a more appropriate *terminology*. To the end Schäfer was uneasy, as were other people, because he could not characterize the essence of Egyptian art and all other typologically related arts better than by saying

[18] But, as far as inclinations in ornament are concerned, e.g. the preference for filling out a corner or for cubes as against circles (Crete) or cylinders (Babylonia), these elements are part of the artist's formal expression, and therefore belong to Schäfer's 'level of expression'. The same is ture of the tendency to abstraction. But, despite the striving to illuminate the hidden essence in the infinite variety of nature, Egyptian works of art retain their concreteness, just as all Egyptian conceptual thought remains rooted in reality, so that even symbols can reassume bodily form and perform actions.

In its forms and methods the Egyptian script is an excellent example of how the Egyptians remained to observation. No other script has remained so close to the pictorial: all have tended towards the use of pure signs. On the lack of an alphabet cf. pp. 441–2. Another example is Egyptian science, which only departs from observation as far as paradigmatic rules, never reaching the cold heights of abstract theorems. Cf. p. 441.

they were 'pre-Greek' and 'based on frontal images' [*geradvorstellig*].[19] 'Pre-Greek'
has the disadvantage that it is taken chronologically by everyone who is not fore-
warned, so that only the great early civilizations are included, and not the logical
basis of representation by modern primitive peoples, by children, and uneducated
adults, not the 'retrogressive' phases of Western art, nor yet some contemporary
movements. But '*geradvorstellig*', which Schäfer arrived at after hesitant progress
from '*geradaufsichtig und vorstellig*' through '*geradansichtig-vorstellig*' suffers from
the disadvantage that it is entirely unknown in other linguistic usage and for this
reason evokes no immediate imaginative response; as a result the term has not suc-
ceeded in gaining acceptance, and it has no chance at all of becoming established
in the way 'perspective' is.

On the other hand, the term '*geradvorstellig*' is meant to summarize all of Schäfer's
detailed results, and not only is it extremely thoroughly thought out, with all its
deeper implications examined, it is also the metal forged from sixty years' work, and
sounds so worthy of respect that doubts cast on it must be fully justified. The con-
siderations that encourage me to suggest a new word for the concept are that
'*geradvorstellig*' can only with difficulty be applied to other cultural values, that it
has not been introduced into art-historical writing, and that to the day of his death
Schäfer was never satisfied with it. The Master tried repeatedly to subsume 'pre-
Greek' and '*geradvorstellig*' in a single non-composite, positive term which would
evoke an immediate understanding. But in this search there was one restriction he
could not overcome: his distaste for words of foreign origin. On that ground the
term I propose would have been rejected by him out of hand, although I do not see
any greater misdeed in adopting it than Schäfer's own when he substituted words of
German origin for foreign ones, even in quotations from other people's works.[20]

I think a different reservation attaches itself more immediately to my suggestion:
the term has become fashionable in a fair number of non-artistic contexts,[21] and is
used imprecisely in various senses by many people who have a confused apprehension
of its meaning. But precisely this weak impression it gives, together with its corres-
ponding popularity, make one hopeful for its adoption. The term in question is
'aspective'.

What is meant in the normal usage of the word? *Aspective* describes a restricted
viewing, a gaze directed at one individual part. When the individual part is separated
off from its context it loses its relational values, i.e. it simultaneously loses both its
relationship with its surroundings and modifications this relationship may produce.
In other words, one may say that the individual part regains its own proper form in
an 'aspective' view, and all the distortions, displacements, and foreshortenings which
it would have undergone through its subordination to a whole disappear. It is as if
we placed ourselves in front of the individual part forehead to forehead instead of
demanding that it 'submit'. Aspect viewing, or 'aspective' as I would like to call it,
therefore means precisely what Schäfer isolated in Egyptian art and termed '*gerad-
ansichtig*' ['based on frontal views'], and, as the viewing can only ever be mental,
'*geradvorstellig*' ['based on frontal images'].

[19] For the terms and English translations see Translator's Introduction and Schäfer pp. 91–2
above.
[20] It seems to me that words of foreign origin, if they are not arbitrarily used, are necessary in
scientific writing to make one's meaning unambiguous, and are in fact desirable, in consider-
ation of the international character of science, where it is possible to coin a term which will
cross linguistic boundaries.
[21] This is not accidental, as I shall attempt to show at the end of this Epilogue, cf. pp. 444–5.

In other consistently thought-out works 'aspective' is not taken to be a derivative of aspect, i.e. individual view, but a-spective in the sense of non-(per)spective. This usage of aspective is not at all detrimental to the one I intend for it, in so far as a-spective with an alpha privative means 'perspective-free', and is thus only a negative way of expressing what I wish in my use of the term to characterize positively. So a reader with this overtone of aspective in the back of his mind will not be led astray. And if we take a-spective literally as 'non-viewing',[22] this meaning fits excellently the implication inherent in aspective, that is the implication of (mental) image ['*Vorstellung*'] as the polar opposite of 'view' ['*ansehen*'] . This seems to me to emphasize the second element in Schäfer's *geradvorstellig*. And when he changed '*geradansichtig-vorstellig*' to '*geradvorstellig*', apart from tautening the term he wished to remove the implication of 'seeing', since Egyptian pictures are, as he showed, to an extraordinary degree independent of the sense of sight. One might object that, although their rendering is not dependent on immediate visual impression, the image was originally received by the organs of sight[23] 'after thorough consideration' as Schäfer put it. But in any case seeing always comes first with any artist, even if he sketches his picture in a dark room with his gaze turned inwards. And 'aspect' as against the '*Ansicht*' employed by Schäfer, lays primary stress on mental vision and is scarcely used at all today for optical seeing,[24] so that it approaches quite closely what Schäfer calles 'image' [*Vorstellung*] . Therefore 'aspective' avoids the false implication Schäfer feared, while the indirectness of the connection with seeing is expressed.

And the reservation that 'view' refers too emphatically to an observer, while the life of Egyptian art was led *sub specie aeternitatis*, is avoided in the same way since, as I have said, 'aspect' is meant to describe an inner process. So it seems reasonable to hope that the terms aspect-individual view [*Aspekt-Einzelsicht*] /aspective-delimiting method of seeing [*Aspektive-ausgrenzende Schweise*] , and the adjective aspective, which I have proposed in order to characterize the basic logical approach of Egyptian and other artists of the same type, are relatively unlikely to be misunderstood, while still describing precisely the set of facts Schäfer isolated.

'Perspective'—which has been common property for centuries, and is precisely and unambiguously defined as a concept—is now just as freely wrenched away from its original meaning as 'aspective' is. All *perspicere* means is to 'view precisely, to examine, to observe'—if we wish to reduce it to a single expression: concentrated or unified seeing. *Aspicere* has more or less the same basic meaning as *perspicere*: 'consider, look at, observe precisely'; however, I should like to use it in the sense of delimited or individual seeing.[25] Both words characterize a mode of seeing which is fundamentally very much the same, and although I am now forming a polarity out of them, the root of *specere*, which is common to both, is still preserved intact, and this expresses the fact that in both cases a man is in some sort of relationship of

[22] [Word-play in the German (J.R.B.).]

[23] The sense of touch can be disregarded in this context.

[24] It might be objected here that perspective also chooses views or selects parts for every picture, but this would be to misunderstand the differentiation between aspective and perspective made above. If pressed hard enough the most divergent concepts can be reconciled, yet the pair of 'words' myth/*logos*, which have almost identical basic meanings, has been developed to mark the difference between opposing ages of mankind, between aspective and perspective. Myth has a particular meaning, while the meaning of *logos* tends towards the general and absolute, and its mode of expression can always be linked with something else.

[25] This insight also occurs once in Schäfer, p. 272 above.

'seeing' with the object. The asymmetrical consonance of aspective/perspective is thus not coincidental, but the product of inner necessity.

To sum up, there seem to me to be several reasons for using the term 'aspective': it is advantageous for the two branches of an explanation to be traceable to a common root; we now have a single term in place of two, and it is one which probably has more associations for the hearer than 'geradvorstellig', which is unknown in other contexts. Finally, in aspective a doublet in sound and etymology has been found for perspective, and the sound opposition is perhaps itself suggestive of the inimical relationship.

This new term I have proposed to characterize the mode of representation specific to the Egyptians is not intended to be just one more to add to the collection. I hope rather to have grasped the approach Schäfer identified in a word that is not yet worn out by usage, and is unambiguous, generally comprehensible, and can be taken over to describe other cultural values. In order to test its practicality for the study of Egyptian art and culture I shall now examine more of its properties and develop its implications further on a conceptual plane.

According to my definition aspective is exclusively a mode of seeing opposite and in the presence of the object, not forwards or backwards in time, and not moving outside its *boundaries*. In particular, it does not relate the object, which it has separated in this way in space and time, to the totality of elements that constitute its real existence, and it does not link it functionally to another object, even in a causal relationship. This delimiting mode of seeing is completely orientated towards its object, so that it does not place it in a framework of causality that extends beyond it. The percept seems to remain flat in the plane in which it exists, without reference to what is in front or behind, to past or future.[26] The boundary is the first and last criterion of aspective.

By observing each part on its own, separating it from its environment and closing it off, aspective accords it independence. So any change is a leap from one individual, independent form to another, and not, as in perspective, a transition with functional connections which are subject to a more general law. While perspective excludes individual parts from an explanation as soon as they have been subjected to this general law, aspective explains each individual phenomenon by means of an individual act of the will (cf., in greater detail, Cassirer 1925.63-5). In this context it is significant that aspective, as it has no general law that encompasses everything and is raised to the level of abstraction, remains bound to the concrete object and directs its entire attention to it. The delimited part acquires independent values and is declared to be the agent of these values in so far as it has been selected and separated off; for the individual parts are in no way adopted in the work in such a way as to add up precisely and entirely to the whole (cf. n. 9 above).

How far is the *delimiting mode of seeing reflected in Egyptian art?*

Specifically Egyptian art, which appears before us at the same time as an intellectual step forward of general importance in the history of mankind, around 3000–2800 B.C., is distinguished from its neolithic forerunners by a new intellectual order. Clear boundary lines and firmly established values are the characteristic signs of a

[26] It is worth noting in passing that there is hardly a 'true' existence next to an 'apparent' one, indeed different degrees of reality can hardly be said to exist, nor can foreground or background presence. Far from a dividing wall between image and reality being set up, even images and objects come together to a large extent. The ideal and the real, being and meaning, also coalesce.

new mental attitude.[27] The outlines of the individual figures are sharply drawn and figures stand on a base line, the picture surface is articulated into different areas and is sharply delimited at the top and the sides; there is moulding around stelae, as round the edge of a pylon and a false door; tomb walls meet one another firmly, each one covered with its own pictures and divided from the next by a band of colour. Registers are placed one above the other, and the ceiling is also clearly separated off. The four sides of an obelisk are treated as separate areas: the dividing line or boundary is a fundamental element in the form of Egyptian two-dimensional art.[28]

In aspective every part is viewed separately.[29] Art tends to have a closed character. All the characteristic traits are in principle the same in any representation, whether a scene in a tomb or temple, or a floor painting in a palace, or wall-decoration in a dwelling house. They are also independent of the subject, pictures of the underworld or burial processions, children's games or workshops. And although, despite the early development of a canon of lasting standard forms, the process of creating produces scarcely two figures that are truly identical, these variations with their lively, changing qualities are always equally confined within the same limits.

It could not be the task of an epilogue to test the term 'aspective' which is suggested here, exhaustively against what Schäfer developed as a fundamental doctrine, and this is not in fact necessary, provided that it can be shown that the key notions are the same. If I rely, as Schäfer did, following Lessing, on 'the reader's gradually accustoming himself to attaching the concept to the word [geradvorstellig], although he may not do so at first, so that he may perhaps come to use it himself in the end', it is because I do not think that testing the *single rules* against the term aspective will necessitate much effort on the part of the reader: the emphasizing of figures through size (equivalence of size and importance [Bedeutungsmassstab]), missing parts, false transparency, 'sections', equal height of seated or standing figures in a group (isocephaly), association of ideas—all these phenomena in Egyptian and other arts of the same type are equally included in the term 'aspective', just as they are in 'geradvorstellig' or in 'pre-Greek', which latter invites one to pursue false trails, as it seems to be meant historically (on accidents cf. p. 427).

I shall now turn to the use of the notion of aspective, especially in the context of the basic articulations in which all phenomena present themselves as forms or occurrences, *space* and *time*.

Let us be permitted to pause briefly at space and time. Since they are quite simply *the* forms in which sense data are ordered, and are (according to Kant) *a priori* the forms of our sense perceptions 'already present in the spirit' which make experience possible at all, it is essential to consider the particular relationship of Egyptian art

[27] This emphasis on boundaries was already recognized by Alois Riegl.

[28] Schäfer, pp. 193–4 above, stresses the importance of defined boundaries and the connection between ordering into registers and lack of pictorial depth.

[29] I should concede again at this point that I am assuming, in the context of this general survey, a knowledge of Schäfer's material, and that I must restrict myself to the essential facts in this Epilogue. I shall discuss significant exceptions briefly (p. 443); other departures from the norm do not affect the basic character of the whole or the fundamental problem. I must beg the reader's goodwill in keeping this in mind.

to space and time.[30] First, I shall deal in theoretical terms with the effect of aspective on the comprehension of space and time, and then I shall attempt to clarify my arguments by the use of examples.

As aspective sees individual phenomena in a relatively close-up view, delimited one from another, and does not see them from a certain distance in functional relation to the whole, or measure them against a foreground or a background, the illusory space in perspective representation is *a priori* impossible. Correspondingly, the idea of time as endless succession is equally foreign to it. And it may quite generally be said at the start that aspective art is able to exclude space and time as inessential. In this way they are removed from the subject-matter of the art. A work which represents pure existence corresponds to the nominal sentence in language. We shall see some examples of this; but pure existence is no more the unique and obvious mode of expression in art than the nominal sentence is in language. A general space- and time-lessness in art should not be deduced from the occasional non-representation of space and time. And occasional space- and time-lessness will only concern us as far as it is appropriate in the context of art.

In accordance with the definition of aspective the essential characteristic of the space belonging to it is that it is sharply delimited and detached from its surroundings by clear marks; it is self-contained and thus a separate, independent structure. But because, in this case of space, the aspective mode does not grasp the elements of reality as a unity, it comprehends them, in a positive sense, in a paratactic succession of individual parts, of surfaces. In this delimiting mode of seeing space, as a material object, is apparently dematerialized and raised to a symbolic higher reality [*Überwirklichkeit*], despite the spatial qualities it possesses. For us, who think from the point of view of centred[31] space, this space remains 'dumb', as it is only the space within the object when represented in aspective.

Retaining the image of raising one's head, one may say that when it is close in front of the eye space is never more than a surface, and it can only be experienced by touch, or for an observer by knowledge, for the eye can only perceive depth from a distance. But the surfaces placed next to each other do not represent flatness, but space.

Nor is geographical space a stranger to aspective thought, it dominates in the every-day world; unique, precisely fixed locality is its preserve. Mythical space (see below pp. 434, 439–40), on the other hand, is only seen as form, close up and on its own, unrelated to its position in its environment; therefore it is primarily a concept defining essential character, so that this space can be repeated and can be placed anywhere, in other words its geographical fixity can be abandoned. This short sketch will have to suffice as a treatment of space, as we cannot spare more time for it; let us instead give more space to time.

What does a delimiting mode of seeing mean in relation to *time*? First of all and quite simply, it is removed from the endlessness of its progress. The section removed may be as little as a moment, or—at a slightly greater remove—a stretch of time. When the section is made independent and enclosed between bar-lines, in other words the beginning and the end are linked, cyclical form emerges. This cyclical form of time

[30] By speaking of 'continuum, phase, stage' or 'abrupt, without transition' and 'next to one another', and on the other hand of 'lapse of time, endlessness', I have already alluded to the conceptual pair of space and time, in the context of which reality is viewed.

[31] This should not be understood as the opposite of 'endless'; on 'dumbness' cf. p. 435).

loses the essential character of (endless) running away; one ring is placed by the next, and their relationship with the complete course of the event is no longer seen. Time circles in itself, it flies, but it raises itself up as a continuation, so that aspective time, although it has a temporal character, has the form of non-time, of apparent fixity, when viewed from the standpoint of historical time, which presupposes a distancing on the part of the observer. Aspective time has no absolute fixed point. It is differentiated from empirical time as another sort of time, which has the appearance of a perpetual present, and yet can be transposed into any form of temporality. Aspective time seems to a historically orientated person to be a juxtaposition of all other forms of time. As a self-contained, cyclical time it has the appearance, though not the reality, of a duration which includes neither transformation nor change, neither genesis nor dissolution—in the sense of complete occurrence—among its properties. This time circles inside itself alone, just as hunting animals circle round a cup, and it is especially well suited to expressing eternal recurrence. Phenomena under this heading are above all seasonal events in nature, or habitual actions, or the rhythmic repetition of historical events, if they are viewed in the same light as the renewal of the foliage on a tree, and not as individual and unique actions. Compared to historical and astronomical time aspective time seems time-'less' and raised to the status of a symbol of constancy, although it still has temporal qualities. It is not time as such, but rather its relationship both with the before and after, which is outside the ring of its own circle, and with a fixed point, which goes unregarded. So this time is, for us, dumb in the sense I explained above (p. 432), as we start from the historical, irreversible character of time. Neglect of its relational aspects seems like an eternal fixity; but time is in no way truly defeated when it is represented cyclically or expressed in terms of characteristic fundamental phases or (atomic) moments. And time is seen so close up that its flow has apparently ceased and its movement can only be read step by step.

Let us now see whether and how we can find in Egyptian art the form of *space* and *time* sketched above.

The basic thesis of Schäfer's work is that perspective *space* does not occur in Egyptian *two-dimensional art*. But the idea that there is in consequence no representation of space is based on the false idea that space can only be 'dynamic' (see p. 436), only the perspective representation of depth. After what has been said we should not expect to find space in two-dimensional art in the form of [an illusion of] depth, but as a simultaneous presence of all its dimensions.

As Egyptians only grasp space in paratactic succession and can only render it by means of 'sides' which in reality run in depth, they have a basic preference for two-dimensional representation, just as the Greeks aim at depth. If they do not need the side running in depth to express something essential they do not represent it. They are fundamentally uninterested in depth (cf. Schäfer p. 101 above). But when it is necessary to show the essential character of something, Egyptian art has its solution—sometimes a very precise one—ready (see Schäfer p. 89 above). One only needs to consider the image of a standing man to see at once that delimited parts of the man which run into depth are part of his essential nature; these are the shoulders and eyes, if the rest is seen in profile. So here a depth element is included in the picture of a man, which is for the rest shown entirely in profile; this is not done in order to represent depth, but to catch the essential in the image of a man. Thus

we have shown already that a man is not represented in a spaceless or unmaterial way, he is not intentionally deprived of his body in order to be immortalized. The human body is meant to be a physical object (see Schäfer pp. 87, 326 above), even if the delimiting mode of seeing does not encompass it in a glance, but takes its viewing planes one by one. Thus space is seen successively in terms of planes—and this space is only the space inside an object—and not as an illusion of depth. In front and behind, and indeed all distance, is characterized by means of overlapping and of layer depictions, or even without using overlappings (see Schäfer pp. 189–98 above).

Surrounding space can equally be rendered in the appropriate essential characteristics: trees, fields, ponds, sky, water, the space inside structures. The Meidum geese are already provided with clumps of grass to indicate locality. Thickets in the underworld are at the least characterized by the names of the zones, underworld books by the gates, and the sun's path too is determined. These places are characterized in accordance with their general, repeatable nature, in a general and repeatable way. But we can mostly fix them conceptually, apart from a few scenes in houses, courtyards, or streets, or the king's 'intercourse with the gods', where the accompanying texts [*Beischriften*], which, as is well known, should not be considered a decorative subsidiary element or random addition, but an essential part of the picture, (cf. e.g. Schäfer p. 18 n. 27 above), do not help. Where a picture is not determined the artist is relying on the viewer's automatically knowing. And spaces that are not characterized are mostly lacking in specific individual elements, and may even—as with house, courtyard, and street—substitute for one another.

The geographical location is also stated wherever this seems necessary, above all with historical events. I am thinking, for example, of the representation of a Syrian fort at Deshasha, and in later periods of the journey to Punt or military campaigns (cf. p. 443). But exact locality occurs also in the private sphere: a particular person's tomb. Any tomb or a typical tomb is not meant, but a given tomb, a geographically fixed place. The dwelling house (of Ineni) is just as unambiguously intended as, for example, the pylon of the Luxor temple represented in that same temple. And, of course, Ti's fields are Ti's fields and not just any fields; it is the accompanying text which determines unspecific motifs of this sort.[32]

From the above it is clear that the Egyptians certainly possessed a method of expressing space,[33] but their own particularizing, aspective mode of representation, which expresses itself in surfaces alone when referring to depth, expresses itself qualitatively and thus repeatably when referring to locality, and may even speak geographically. To be sure, there is no expression of space for eyes that demand perspective: the space remains dumb for us. Dumbness in regard to direction is part of this spatial dumbness.[34]

The Egyptians did not deny space entirely even though they tended towards flat planes and inclined in favour of views of planes; and they did not at all suppress space 'in order to' give their pictures an everlasting character in the process. Their use of paratactic succession was not meant to remove the pictures from life (cf. Schäfer p. 305 above), but, as a review of themes and aims will show, they had no alternative

[32] In their tendency to typical forms as against illustration similar to nature the Egyptians did not in any way renounce the attribution of individual identities to works: the use of names aims at making attribution entirely precise.

[33] Although of course they are always indifferent to space, see p. 433.

[34] See p. 443 for exceptions and for the development of the impression of depth.

method. Apart from this, their spatial language is not a formal one; it is the one that fits their perceptions, and derives from their fundamental attitudes. Their space unfolds itself on flat planes, just as a short-sighted person picks it up piece by piece.

The aspective method of representation makes it possible to bring places that are far removed from one another together in the same picture, and it can on the other hand place two pictures side by side to make two statements about the same place. Thus officials stand next to shepherds in the fields (tomb of Ti, north wall) and the same workshop can be shown as often as the work going on in it requires. 'Next to', 'above', or 'below' one another is a false way of expressing this in so far as the different (simultaneous) localities have no functional relation to one another—although they do of course have a mental one—nor a causal one: they are represented isolated from one another, alone, independent, and complete in themselves. As they do not take their surroundings into account they may be moved around, since they are each of them seen as a separate section.

Space in *sculpture* is aspective, as in two-dimensional art. The many types of space which have been attributed from our modern point of view to Egyptian statuary, non-space, objective space [*Raum an sich*], its spatial perfection as against the spacelessness of two-dimensional art, all come down to space from the Egyptian point of view, which, as is the case in two-dimensional art, fails to fulfil the requirements of spatial rendering only if we think of it from a perspective viewpoint. The figure which is fixed axially in nature appears in statuary as if in a box, that is, space which could not be more clearly formulated for an image. This stereometric space naturally possesses depth—no method on earth could interpret it away—it is firm and closed, defined by clear boundaries. The space stands, then, as an absolute, it is an independent structure, but it is not a space that corresponds to perspective, centred space, where all the lines of force converge on a secret centre point or proceed from it, and where the dynamic system contains all the directions that can be imagined, and thus an infinite range of views (cf. Krahmer 1931). The figure is not proposed as a functional structure in which any alteration would necessarily bring with it the alteration of every part, it is not a related composition but—according to the aspective way of thinking—paratactically assembled from the aspective views of its planes. For this reason sculpture—judged from a unifying point of view—is space-'less', but only from this inadequate position. In the Egyptians' own aspective view it is a perfect body (cf. Schäfer p. 326 above) and we can only say that it is spatially or physically 'dumb'. The figure is indeed not an organism in our use of the word, but it still has bodily life.[35]

Although Schäfer scarcely mentioned *temples* one may remark in passing that these buildings too do not constitute organisms of functionally variable size (ever more pylons could be added in the front, without the width of the temple being increased correspondingly), but that they separate spaces of almost mathematical precision from the world by means of their sharply defined boundaries and surfaces placed at right angles to one another. They surround the sacred precinct in a uniquely closed, sharply articulated manner. It is clear how the individual parts do not stand in a 'perspective' relation to the whole from the case of columns, which do not

[35] Cf. in addition Schäfer, text to *Atlas* 3 pl. 114–15A, section IX; Schäfer 1944; in this book p. 46 and *passim*.

'function' as supporting elements, but lead their own separate existence. The situation is comparable in tombs and dwelling houses.

Let us now consider the monuments' relationship with *time*. We cannot but expect them to be phased or to have a cyclical form appropriate to the aspective world-view, that is, without the quality we consider all-important of limitless growth and decay; they are indeed fixed in stages sharply set off against one another. The clearest representation of this sort of time is found in paintings which are split up almost cinematically into phases (see Schäfer pp. 227–30 above), as with children's games or the wrestler groups in Beni Ḥasan. While human beings are mostly shown in the prime of life, children and young people are also found, characterized by fingers in their mouths and the lock of youth, or by size; and, far more often than has hitherto been recognized, signs of age are shown (cf. also Riefstahl 1951). These stages, which correspond more or less to generations, indicate the main divisions of a man's life; there are also images of pure identity.[36]

And there is no lack of movement and action in Egyptian pictures; in other words, there is no lack of the process aspect that is typical of life. But, I repeat, movement is not expressed—as in perspective—by means of muscular tension and variation and by functional interplay, but by gestures. Consider, for example, pictures of running messengers and soldiers or trains of offering-bearers (cf. Schäfer pp. 294–5 above). Constantly repeated activity or the cyclically returning work in a workshop and in the fields are shown by means of standardized gestures, which should none the less not be judged to be 'detemporalized' and therefore 'removed from life': they are aspectively delimited and 'run their course', that is, the gestures express transitory elements with clarity. The flowing of water is an instance, and there are many others.

How else than by gestures could the Egyptians in their aspective mode of representation express movement? In this light the gestures do not represent an ideal concept of an action, that is, they are not images entirely removed from life; they are the actions themselves, although they are expressed in aspective time and are thus 'dumb' for us in respect of time.

But actions that occur only once at a definite point and historical events are also represented, if they are ever considered worth representing, and the resulting pictures are not fundamentally different from pictures of recurrence. Apart from the scenes already mentioned, which can be fixed geographically (cf. p. 434), and which simultaneously have the temporal qualities of a date, there are cases like the transport of the el Bersha colossus (fig. 205), and especially burial scenes in tombs. Are they to be understood as detemporalized in order to satisfy the needs of eternity? There can of course be no question here of recurrence. A comparison of unambiguously historical pictures with all other types provides definite confirmation, and shows more clearly than any theory, that Egyptian artists had no alternative; in aspective terms they were able to express themselves thus and in no other way.

Sculpture has exactly the same temporal form as the one I have just outlined. Alongside men in the prime of life there are figures of old men; the function statues perform means that children are seldom represented. Movement is no more alien to statues than to two-dimensional art, but the movement is not that of an organism, it is not organic and functional interplay (see Schäfer pp. 337–8 above), but a gesture that has been elaborated into a form. Movement is known from servant figures and

[36] See below (for sculpture) and p. 443 (for nominal sentences).

also from statues of nobles, although the latter, as in relief and painting, tend in their basic attitude simply to be there, as befits their dignity. A noble normally only needs to be present: state and not action accords with his position (cf. Schäfer p. 317 above)—his image is the counterpart of the nominal sentences (see p. 443). Figures of nobles are shown in action almost solely when in contact with gods, for example as offering-bearers, praying, or 'pushing' a cult vessel forward; officials also write. These figures 'do not move', not because (except when pure identity is represented) they are detemporalized, in other words because their death 'must' be overcome, but rather because the people rendered only in this fundamental attitude deserve this repose because of their status, while the others who are moving can only express this movement in aspective by means of gestures. What meaning would the presence of servant figures in the next world have if they could not mill flour or brew beer? But both categories, those in repose and those performing an action, are represented in the same way, not organically. They only produce the effect of abstracted symbols for people who think from the context of linear time, only to us do they seem like 'eternalized' hieroglyphs, since we are used to reading movement (cf. also p. 16, n. 17) off the dynamic play of muscles.[37] They are indeed 'dumb' with regard to time, but not timeless.

The purpose of a statue, whether it is intended for a tomb or a temple, or as a toy, makes no difference to its formation in relation to time. Or could a specialist really imagine that an ancient Egyptian artist could have fashioned an object of daily use like a decorated spoon in the form of a swimming girl's body 'organically' in this case with a play of muscles expressing movement,[38] because it was not destined for 'eternity'? The Egyptians' only temporal language was the one I have outlined. Cyclical and historical time are not differentiated in their treatment. They must be deduced from the motif and not the form.

To summarize: Egyptian art, two- or three-dimensional, is not spaceless or timeless; I should like to term it 'dumb' as regards space and time. I am not saying this for the satisfaction of introducing a term of my own, but in order to establish clearly that space and time can unquestionably be contained in a representation and yet not speak to us. It is only ourselves, studying the constructions from the logical standpoint of perspective, who find neither space nor time, since we take them in from a distance as unities with all their relationships with what is in front and behind, with derivation and future. But as soon as we use the mode of seeing appropriate to aspective we discover space and time even if they are factors without any relevance, and we discover them to be individual (cyclical) forms, independent and enclosed, fixed into phases or sharply delimited. They have no dynamism, only form.

Let us now consider the *space-time system* within which the Egyptians thought in their *everyday world.*

They articulated *space* clearly at the beginning of their history and defined its boundaries; directions in the sky were fixed into two intersecting axes based on the east-west path of the sun and the south-north flow of the Nile, and the space that

[37] 'Dynamic' is not meant here in Schäfer's sense of p. 319 (the 'exceptions'), but in the sense of organic-dynamic; I am intentionally adopting art-historical terminology here.

[38] Von Kaschnitz-Weinberg's assertion (n.d. [1933] 19) that the Egyptians stylized a normal animal in a different way from a deified one is based on a false comparison of pieces from two different periods. But I am not concerned with style here.

was ordered in this way was pinpointed by a $\underline{d}r$-boundary. Not only were the boundaries of the entire country precisely calculated,[39] individual spaces within the total area were separated off; the surface area of every nome was calculated. The discovery of geometry and its development to a high level sprang from this new spatial thinking. Thus space is mentally subdivided just as the cube of a statue is by its imaginary inner surfaces. The boundaries between the individual spatial areas, that is the geographical junctures, were called $t_3\check{s}$; these can be crossed, they are dividing lines. The $\underline{d}r$-boundary, on the other hand, which is fundamentally uncrossable because it is the absolute limit, is of a mythical character and remains the $\underline{d}r$ even after experience has shown that it is not the real end.[40] Geographical space corresponds to experience, mythical space stands beside it as something apprehended spiritually. It can be seen how dominant this mode of thought was from the fact that the caves which are the sources of the Nile were still localized in Elephantine (and Old Cairo), three thousand years at least after the Egyptians had become acquainted with the further course of the Nile to the south of Elephantine (cf. also below n. 47).

The Egyptians of course knew of linear *time* in their everyday world, even though mythical time is inherent in their chronology. Regnal years are indeed added up, that is, counted successively, but the reckoning of time begins afresh with each new (Horus) king. Closed periods stand next to one another, but each one counts its era from the beginning again. Every king stands at the beginning of time, he overcomes chaos for the first time, ties the two lands together, smites his enemies, and by these actions ritually causes Egypt to come into being.[41] It should at least provide food for thought, that the periodicity of Egyptian chronology, which has no fixed point, contrasts with the linear Olympic era or the Roman time reckoning *ab urbe condita*, in analogy with the opposition of aspective-cyclical and perspective modes of thought; the tension in the Greek mode of thought noticed in Greek (successive) perspective found its expression in dating by Olympiads. The large-scale subjection of time by calendars, clocks, and more sophisticated measuring equipment[42] scarcely needs discussion here.[43] As with space different terms correspond to the two different conceptions of time ($_3t$ and tr).[44]

From a historical point of view the Egyptians achieved this, as a result of God's actions at the 'beginning of time', in the construction of their state at the turning-point of prehistory and history, more precisely in the two centuries after 3000 B.C. . It was then that the Egyptians separated their world off from foreigners, became settled, and, in founding new settlements, defined the boundaries between them and those of their neighbours, developed the art of surveying for the necessary redefinition of field boundaries after the yearly inundation of the Nile, and measured

[39] Senwosret I's white chapel in Karnak (Lacau–Chevrier 1956).

[40] It should be mentioned briefly that the two words soon become confused.

[41] On history see also pp. 439–40.

[42] The discovery of writing, whose aim is to fix fleeting words beyond the realms of time and space, is also part of this complex of ideas.

[43] In astronomy mythical thought stands in the way of scientific, just as magic stands in the way of medicine.

[44] Cf. Otto's study (1954). The existence of two words for eternity, $\underline{d}t$ and $n\underline{h}\underline{h}$, probably reflects the duality of the Egyptian mythical and historical notions of time. I cannot discuss the problem here because of its extreme difficulty, and because I should have to adduce a large amount of evidence.

time for the same purpose. Through this the Egyptians released themselves from their attachment to the 'object', from their imprisonment within time and space, and confronted those two phenomena. They confronted them close to, so that they only perceived them aspectively, in sections, but they were nonetheless definitely distanced from them. It is probably something more than just a provocative formulation to place this struggle for form, this creative delimiting, in opposition to an earlier chaotic *Märchen*-like world in which the value-concept of order as just described did not exist. We can imagine that the space and time concepts of this earlier world were of the same type as those of early peoples—although this cannot be strictly proved, only suggested by analogy. Scientific study has indicated very clearly that they did not orientate themselves towards linear time, in other words to 'history', by using the term 'pre-history' to describe that period.[45]

On the other hand, Egyptian history is not, in comparison with our conception of history—in the terminology I am using at the moment a 'perspective' one—primarily a chain of events, but the acting-out of a ritual. Royal actions were repetition, the reaccomplishment on earth of mythical examples; new events produced new ritual scenes. The eighteenth dynasty is the first period that is clearly open to unique events, and also open to the past, that is to chronology.

At this time a whole series of king-lists was produced, and their articulation into three 'kingdoms'[46] proves that history is understood as linear succession. We do not know what previous material these 'historiographers' had at their disposal, but it seems that we should take the Palermo stone as a monumental record of registered dates. The chronological procedure underlying the lists presupposes a considerable distancing from events, and its tendencies are counter-'mythical' (see next section).

After this excursus into the treatment of the concepts of space and time in the Egyptians' everyday world, which is familiar with geographical space and historical and chronological time, I shall now turn to the *mythical idea of space and time,* starting with a consideration of this conceptual pair in the context of the Egyptian doctrines of creation.[47]

The essential characteristic of the world *before* creation is boundlessness. This boundlessness, which we might call temporal and spatial infinity, is represented by a single creator god (*Ḥḥ*). Boundlessness is part of the original existence before creation, and the aim of creation is to overcome it. The creator's act is to separate and delimit ordered regions from the chaotic material of creation [the amorphous *materia prima*]. The account of creation in Genesis is similar to this mythical version; in Genesis too a chaotic existence that is already present is ordered by dividing off and by elimination from the endless wealth of possibility: the forms of the earth, of its creatures and manifestations, are created. Naming is an essential part of this creative process. Just as differentiation is even now the basis of intellectual creation,

[45] We find a similar view of this conceptual pair among modern peasants and among children; events that occur outside the individual's mental horizon are 'far away' or even 'abroad'; Charlemagne was the husband of the Empress Maria Theresa, or Frederick the Great was the husband of Queen Louise.

[46] OK, MK, NK in the Turin Papyrus and in the row of statues in the Ramesseum (Ranke 1931).

[47] For on understanding of the mythical notions of time and space cf. two articles by H. Brunner (1955, 1957b).

so was the undivided divided. The primeval hill is the archetype of a sacred de-
limited area; it is the first piece of solid matter in the primeval waters, the Nun. The
primeval hill is present in every temple and in every throne.

The creator gave form to amorphous space; but he also gave form to time by
creating the path of the sun with its rhythm of years and days. The division of the
underworld, by the sun god's journeying stages, by gates, and by horoscopes and
hourly prayers reflects the struggle for an order fixed into divisions. Thus creation
should be understood as giving form to a pre-existent chaos.

The account of creation is not a philosophical teaching, it is a mythical statement
about the genesis of the world. Myth is the expression of the aspective mode of see-
ing both in itself as an object and as a mode of representation. Aspective is present
in the juxtaposition of self-contained groups of images and events which do not
relate to one another, just as the individual divinities, each of whom contains one
aspect of the *numen*, do not coalesce to make a single figure which summarizes
THE God. It can also be seen in the particular 'mythical' notion of space and time.

The cyclical conception of time is quite at home in myth and is also filled with
linear elements because of the past character of the narrative forms within the myths
(genealogies of gods, Geb's assumption of the throne, etc.). The events of history
take place (lit. 'run') within the circle. Mythical time is like the snake biting its own
tail, it stands for zero and for endlessness but is itself neither of them; rather it is
the ever-present form of time which, because it has no fixed point in the present
and is therefore not linked to the world of today, knows no yesterday or tomorrow—
except within its own circular form. So the figures of myth are situated in time, but
in their own individual, delimited, cyclical time. Just as its fluid figures never come
down to earth and, although they are close enough to be seized, resist any firm grip,
so the history of these figures is eternally completing itself without ever *being* com-
plete in our eyes; and the place where this history happens is both localized (Buto)
and can be transposed geographically, and is therefore a non-place. Mythical places
can be made actual anywhere—consider for example the primeval hill in temples and
the tombs of Osiris—and can also exist simultaneously in several places. The mythical
world is a space enclosed in itself, it 'lacks depth' in so far as it does not include
human beings. Myth's natural habitat is a non-present omnipresence in space and time,
and this is the purest instance of how the delimiting mode of seeing sees. Space and
time do indeed possess quality in the full sense of the word, but, as we are used to
viewing from a distance, to our eyes they do not possess perspective or any of the
features enumerated above, which are consequent on it.

Thus the cyclical mythical conception of time lifts the stories of the gods up out
of linear time, and presents them as a circular form of existence revolving on itself
in such a way that they always happen yet appear never to, just as they appear to
happen nowhere yet happen everywhere. This dumbness deceives the modern historian
or geographer into believing that space and time are non-existent, although they ex-
isted for a person who lived mythically—not one who inquired mythologically.
Myth's character is one of repetition when it represents the cycle of growth and decay
of nature and human beings (the Osiris myth); repetition, in the sense of the succes-
sion of human beings, belongs to it as long as it holds sway over humanity as a pattern.
Apart from this, even mythical time may be unique, as are for example the act of
creation and the end of the world (cf. Brunner 1954–6).

If we want to set off myth against our own (scientific) mode of comprehending the world, we can do no better than quote Ernst Cassirer, who writes:[48]

Myth lacks any means of extending the moment beyond itself, of looking ahead of it or behind it, of relating it as a particular to the elements of reality as a whole. Instead of the dialectical movement of [our epistemological] thought, in which every given particular is linked with other particulars in a series and thus ultimately subordinated to a general *law* and process, we have here a mere subjection to the impression itself and its momentary 'presence'. Consciousness is bound by its mere facticity; it possesses neither the impulsion nor the means to correct or criticize what is given here and now, to limit its objectivity by *measuring* it against something not given, something past or future. And if this mediate criterion is absent, . . . all phenomena are situated on a single plane. . . . The resultant picture of reality lacks the dimension of depth— the differentiation of foreground and background so characteristically effected in the scientific concept with its distinction between 'the ground' and that which is founded on it.

The characteristic elements of mythical thought could not be formulated more aptly; they are analagous to what I believe I have discovered about the aspective mode of representation in the realm of art.

In the genesis of the ancient atomic theory one can see clearly how it is the new concept of 'the ground' of causality that demanded and called forth a new concept of 'element' and a new relation between the whole and its parts. . . . Thus we see that the divisions and subdivisions of reality which scientific cognition undertakes are merely an expression and as it were a conceptual cloak for the necessary relations by which science seeks to comprehend and unambiguously determine the world of change. Here the whole is not so much the sum of its parts as a construct of their mutual relation; it signifies the unity of the dynamic connection in which each one participates and which it helps to accomplish.[49]

In contrast, all Egyptian *scientific knowledge* is a clear product of the aspective mode of seeing. This can be seen in philology and history (see pp. 438–9), in medicine and astronomy, in mathematics, and more so in law or in other more pragmatic disciplines. This science works out nomenclature and the forms which diseases assume. It is a sort of science of lists, and shows single results made absolute, and the effect they have on one another or their interdependence are not among the problems considered. It is revealing to study the order in which medicine treats the parts of the body [cf. below, n. 59, end]. Innumerable examples of the same approach could be found not only in the various branches of scientific knowledge, but also in the rules of wisdom in *ethics*. Rules of conduct are not formulated in terms of basic ethical principles, they always relate only to concrete instances. In terms of content they are directed at the man who integrates himself uncritically into the order of the world as it pleases God.

The multiplicity of scientific experience, concepts, and judgements is just formulated paradigmatically, not in an abstract doctrine which fundamentally encompasses the endless material. Although we know of a few general doctrines, the primary achievement of Egyptian scientific thought is in the ordering and evaluating of manifold phenomena and in grouping them in categories. A rule derived from experience becomes a norm, and a solution, once arrived at, is retained even when a simpler method is found in another area (e.g. within mathematics). The Egyptians always confront phenomena close to and do not place themselves at the lofty height of all-embracing ideas. In their *script* too they abstracted a phonetic form from a pictographic one, but they never developed an alphabet, although it was contained in their

[48] 1925.47–8 = pp. 35–6 of translation.
[49] Cassirer 1925.67 = pp. 50–1 of translation.

phonetic script. Interesting conclusions can also be drawn from the highest product
of the mind, language, which I intend to discuss in more detail in a moment. A
certain amount of grouping according to rules, but also a facet-like juxtaposition of
statements, are the results which are produced by the Egyptian way of observing
phenomena individually and separately. Every rule is stated absolutely and stands
firm without modification or relation next to the others. The continuous range of
possibilities is mastered by maintaining firmly the stages considered to be important.
As long as an abstraction remains synonymous with an image it can never be carried
a stage further, and can never become the sort of general statement towards which
'perspective' scientific thought strives. 'Atoms were regarded as the ultimate, irredu-
cible parts of matter only as long as the analysis of *change* seemed to find an ultimate
foundation in them.'[50]

I shall now indicate how the relationships with an object of concern or with time
and space that can be deduced from the aspective world view manifest themselves in
other human areas of expression, taking *language*, the phenomenon which most deeply
characterizes mankind, as my example. Here a true timelessness can be perceived in
the fluid images and in grammatical forms, while parataxis and the 'tense system'
reveal the aspective mode of expression to us most clearly.

In general it is necessary to remember that Near Eastern languages are relatively
rich in fluid, timeless expressions and forms. In Hebrew *nāgaʻ* and *qārēb* and in
Aramaic *ᵃtāh* mean both 'to come' and 'to be coming' and 'to be present'; they can
express the tension between the eschatological 'here and now' and the hope of 'not
yet' with regard to the coming of the God of judgement.

In third-millennium Egyptian there are just a few cardinal instances of syntactic
subordination: clauses of circumstance, temporal clauses, and conditional clauses.
And even for these the formal means of expression are not well developed and in
some cases completely lacking, so that we have to do with virtual subsidiary clauses.
We can follow the constant increase in the number of logical differentiations in the
relationships of subordination to principal clauses as the language develops, with a
specially large change in late Egyptian; it is fascinating to observe how these new
subordinations at first have no external markers, and how the language then appro-
priates certain words, which previously had different meanings, to characterize them
(e.g. *m-ḫt, ḥr-sȝ*). It can be shown from features of this sort that the Egyptian langu-
age was predominantly paratactic at the time it was fixed in writing, and hypotactic
forms first develop to a significant extent after the Middle Kingdom. This develop-
ment presupposes an increasing distancing of the speaker from the object spoken
about. Only with this greater distancing are the relationships between sentences
recognized, the barriers dividing the situations referred to overlooked.

When we compare the Oriental tense system with the Western one a distinction
characteristic of the opposition between aspective and perspective emerges. Our
present-day European languages express the temporal relationship with the speaker
of the action or state described by means of their verbal forms and sentence con-
structions, and are thus constructed out of a distancing between the speaker and
what is happening, which is necessary if events are to be viewed as a whole and placed
in relation with one another. The speaker is at the mid-point of this system, just as a
perspective artist is in the middle of his artistic systems. This system is most consis-

[50] Cassirer 1925.67 = pp. 50–1 of translation; cf. also the quotation above, p. 441.

tently realized in Latin with its clear and 'complete' inventory of tenses. Egyptian is different. Here the individual 'tenses', that is the individual conjugations, express primarily a type of action (or state): one that is beginning, or complete, or lasting, or repeated, or habitual, or energetic, etc. They leave the action's relationship with the speaker entirely open, and do not state whether what is described is situated in the past, whether it is desired, whether it is certain to happen in the future, or anything of the sort. Such a disregard of the temporal and modal relation with the speaker brings considerable difficulties with it, not only for our way of thought; the Egyptians too afterwards worked out means of expressing the stage in time where it seemed indispensable. On the other hand, this method has its advantages. The action or state can be described incomparably better, it can justify itself without reference to time, and it is not subordinated to the observer. This dumbness with regard to time must, after what I said above, be taken as an outcome of aspective thought, and as a mode of expression it corresponds to similar mythical and artistic forms. It should also be emphasized that the types of 'action' do indeed lack a relationship with the speaker, but that they have a temporal content in so far as they characterize actions just as much as if the action were seen from the speaker's distance; and the type of event may be formulated especially intensely. It is by no means timeless or detemporalized, but only appears so if we evaluate the action as a succession in front of our eyes. Similarly one may say of (spatial) depth, that it indeed exists as the space inside an object, just as much as a story is represented as a set of events in time.

In addition there exists in Egyptian—this is a significant point—a construction that occurs in other Semitic languages, which describes pure existence without any relation to the temporal process: the nominal sentence (see p. 436). The absolute use of the infinitive is timeless in a similar way to the nominal sentence. These timeless constructions correspond to the 'images for eternity' of pure identity (see pp. 432–3).

The change in direction I have noted in Egyptian scientific thought *towards our 'perspective' style of observation* does not occur without a corresponding change in the other areas. From the eighteenth dynasty on[51] there is a significant change in the Egyptian world picture. This is the time when Egypt extends her frontiers, and her intellectual horizon comes to include the experience of other countries' influence in Egypt, and finally when she recognizes herself to be dependent on foreign powers (Wenamun). We learn of Thutmose III's drive for knowledge; his scientific records (the hippopotamus relief and 'botanical garden') and historical interests (annals) go beyond what we are accustomed to call 'scientific knowledge' in the earlier periods. Already in Hatšepsut's time extraordinary gifts for scientific observation are shown in the reliefs of the Punt journey. The feeling for unique events grows and the battle of Qadeš too departs from the schema of (positive) order. Innovations in language (the optative) and in the study of history have already been mentioned (pp. 439, 442–31).

In the art of the same period we can see a mass of details which give expression to the new mentality. In tombs and temples representations turn corners in the rooms and move onto the ceiling too; in Medinet Habu the intentional reduction of the

[51] Egyptian culture reached this pitch of achievement after three periods of *crescendo*; the *crescendo* can be observed in the OK, and MK, and the NK, as has been impressively shown by Wolf (1957).

temple gates aims at a perspective effect, and 'perspective exceptions' increase in number. Vertical layer depictions gain an exceptional degree of importance, and the surface is also treated—significantly, in historical reliefs—as ground or space (see Schäfer pp. 191–4 above). Everywhere we find compositions indicative of a greater distancing from the object.[52] This development sadly comes to an end in Egypt; this was probably inevitable, as the consequent development of the changed intellectual outlook would have led to the break-through into perspective[53] which was only accomplished successfully by the Greeks.

The Egyptian's decisive perception is the boundary, and this boundary is the boundary of their knowledge.

Mankind's intellectual history is one of raising the head. Consciousness is the result of a simple perception of things or of the feeling of oneness with them, and then, in confrontation with them, it produces its own image of their reality. Man apprehends their form through a perception of their limited character. But he is so near to the object that he can only comprehend depth as succession. He only masters the whole by comprehending its parts one by one.[54] For the close eye the object is so intimately bound to the position in which it stands and to its presence that the dynamics of space and time are not experienced. Only in the next stage of the raising of the head can man perceive the object at once as a dynamic unity standing free in its environment, encompassed by space and shot through with time, as a whole whose parts stand in relation to one another and tend in the same direction. This mode of seeing, called 'perspective', and the preceding one, 'aspective', are milestones in man's journey towards self-consciousness and towards a consciousness of objects as separate entities, characteristic signs of man's relationship with the world, with God, and with himself.

It seems to me that all the rules which Schäfer formulated for Egyptian art derive from this one idea. On the basis of these rules it is easy to see how the siting of Egyptian statues, essentially bound to the walls behind them,[55] arises, as against the Greeks' sculpture placed in free space, or how the character of the colours in painting changes from 'polychrome' to 'colouristic'. This exposition could be greatly enlarged and developed, but that can be left to the reader, whose path has been prepared by Schäfer.[56]

I hope too that my formulation may result in a reconciliation of 'psychologism' and 'structural analysis'. It should no longer be difficult to uncover the origin of the contradictions alleged by structural analysis and to see where the mistake crept in.

[52] Countless details could be listed here, e.g. the movement of the mouth (Schäfer p. 292 above), quite apart from large-scale transformations of colouring in painting; I leave it to the reader's ingenuity to search them out. The index, especially under NK, will be of assistance.

[53] Against this cf. Schäfer p. 267 above.

[54] Otto was the first to see that the Egyptians expressed totality by adding two parts together (1938). Several writers have since studied the question.

Excellent examples of the independence of individual parts can be found in the fable of the dispute of the head and the body, and in everything to do with the absolute status of different limbs. Cf. Ranke 1924; Dawson 1930–1; Firchow 1953, or Hermann 1955.127, and Hermann 1956.95, and Hermann 1961b.101 with references cited.

[55] Cf. Schäfer p. 24 above.

[56] Excellent collection of distinguishing features in Wolf (1957.262–95 and *passim*).

I have tried to show that the conceptual pair of space and time presents the same appearance not only in art and myth—where the same tendency could be attributed to the Egyptians, as the events of myth must take place, even in a time-'less' context— but also in the Egyptian language, in ethics, science, and to a large extent even in the discipline that is furthest removed from and most antagonistic to this way of observing nature, the study of history. And this dumbness as to space and time is not purposeful, it is the *genus dicendi* itself.

From what I have said it will be quite clear that von Kaschnitz-Weinberg's fine dictum, which crops up in all subsequent histories of Egyptian art and in other Egyptological works, that Egyptian art was the most grandiose attempt to overcome death, cannot be maintained.[57] This false interpretation is based on values appropriate to an alien system, those of perspective art, which have been taken over and applied to Egyptian art, instead of the latter being judged according to its own standards. So Schäfer was right to insist to the last on separating his two levels, even if the 'framework' has the effect of determining form. If we view Egyptian art as an aspective representational form it appears free of the optative tendency which von Kaschnitz-Weinberg attributed to it. Space and time, the necessary prerequisites for life, express themselves in different ways, as form, as 'static' gestures, but the subject represented is not in any way removed from existence, it is intended to have full life. Egyptian works can only become eternal through the material they are made of and the magic inherent in them. One should bear in mind at the same time that there is also a successful form of representation for true space- and timelessness.

In this final section I should like briefly to discuss the *relationship of modern art with ancient Egyptian art*. This is in accordance with Schäfer's intentions.

Schäfer demonstrated cogently that what I have called aspective in opposition to perspective is only the logical substructure, on the basis of which the formal superstructure of artistic expression is raised. He used various terms for these two creative levels but normally called them the framework and the level of expression [*Gerüstschicht und Ausdrucksschicht*]. He gave a good summary on p. 34 of *Ägyptische und heutige Kunst* (Schäfer 1928):

Each of the two types [aspective and perspective] corresponds to a particular condition of the human mind, but distinctions of this sort belong more in the realm of epistomology than of aesthetics. To use a phrase of Adolf Hildebrand, they are the result of the 'study of nature' which is of course present in all representational art, but is only the foundation of artistic activity. Only when one is clear about this point . . . can one perceive what the Egyptian masters use as artistic means of expression over and above the simple aim of representing the object The artistic achievement of an individual artist or of an individual people consists in the character which they impart to this fundamental level. Thus Egyptian, Babylonian, Assyrian, Hittite, Cretan-Mycenaean, early Greek, and ancient American forms of expression, each of them varying with their periods, . . . all overlay the frontally viewed, image-based [aspective] substructure. On the other hand Italian, German, Dutch, French, Spanish, and English art overlay the pure perspective substructure, each of them with its own numerous sub-groups. I characterize here the level of the 'study of nature' as the lower and the 'level of expression' as the higher only in order to achieve a graphic presentation of their relationship in representational art. This does not affect the fact that ... the basic stimulus to any art is 'expression'.

[57] My earlier work in this area also misses the point and is in need of correction; I am disowning it explicitly. I refer to the relevant parts of the articles Brunner-Traut 1953; Brunner-Traut 1957b; Brunner-Traut 1959.

I agree with Schäfer's opinion that most modern wrong judgements of Egyptian art stem from an attribution of the aspective qualities to the level of aesthetic expression. And whenever a modern structural analysis is undertaken the fact is overlooked that, as I have said, there is such a gulf between the aspective and perspective worlds that we no longer have any direct access to the formal laws of Egyptian art.

Schäfer's judgement of 'contemporary art'—in other words expressionism of the 1920s—begins by emphasizing that both Egyptian and contemporary modes of creation are free to a large extent from the (perspective) visual impression, so that they are both 'image-based' (aspective). Both treat the material content of their originals with great freedom: in both solid objects become transparent; both unite several visually irreconcilable views of the same object in one image; both mingle views and sections, both bring temporally or spatially distant objects together, or associate different phases of an action in one picture, both use association of ideas. Yet Schäfer states in his analysis—into which he incorporates further common traits both in painting and sculpture—that the correspondence is largely deceptive. It is external in so far as modern art displaces onto the aesthetic level (form) elements that make up the framework (perception-cognition) in Egyptian art. But even then, in 1928, he made some reservations.

But I myself believe that the closeness of modern art to Egyptian art is based on a similarity in their fundamental approaches,[58] and that Egyptian art does not merely serve to provide the sort of stimulus Richard Strauss experienced in front of the Giza pyramids in 1892, when he wrote to Cosima Wagner: 'As a spectator one marvels at how the ancients in the *naïveté* always hit unconsciously on the right forms. It is as if one approached the fundamental condition of artistic feeling and was refreshed by this monumental *naïveté*, as Antaeus was by touching the earth.'[59]

[58] [Three paragraphs, and the last sentence of the whole Epilogue, have been omitted at this point in accordance with Dr. Brunner-Traut's wishes. This has been done because the original version was too brief, and the author has carried her research much further in the meantime. She means to publish it separately (J.R.B.).]

[59] This parallel could also be demonstrated for all the manifestations of life. Instead of the extended exposition which would be necessary I shall take an example at random: a perceptive discussion of Max Frisch's *Andorra* contains the following passage: 'Frisch has evolved a special style in *Andorra*: the juxtaposition of fore-, middle-, and background, and the presence at once of past, present, and future, break all the normal limits of space and time.' Compare also the similar mingling of categories in Gerd Gaiser's *Schlussball*, the openness of Hemingway's short stories, of the alternation of the main figures in Heinrich Böll's *Billard um Halbzehn*, which has the same function as the rule of the equivalence of size and importance [*Bedeutungsmassstab*]. One might also refer to 'white sound' in electronic music. Lastly, it is worth pondering on the youth of today's rejection of history. [Footnote modified by the author (J.R.B.). One work which applies the notion of aspective to another area of Egyptian culture is H. Blersch, 'Die "Aspekte" des Leibes in der altägyptischen Medizin', Institut für Geschichte der Medizin der Universität Freiburg im Breisgau, Dissertation 1970.] Cf. now also *Lexikon der Ägyptologie*, art. 'Aspektive', by E. Brunner-Traut (Wiesbaden: Harrassowitz 1973).

REFERENCES

References which are not in this list are in the main list of abbreviations and references for the book.

Asselberghs, H. 1961, *Chaos en beheersing*. Documenta et Monumenta Orientis Antiqui 8. Leiden: Brill.

Brunner, H. 1954–6, 'Die Grenzen von Zeit und Raum bei den Ägyptern'. *Archiv für Orientforschung* 17.141–5. Graz: Selbstverlag Weidner.

Brunner, H. 1955, 'Zum Zeitbegriff der Ägypter'. *Studium Generale* 8.584–90. Berlin–Göttingen–Heidelberg: Springer.

Brunner, H. 1957a, *Altägyptische Erziehung*. Wiesbaden: Harrassowitz.

Brunner, H. 1957b, 'Zum Raumbegriff der Ägypter'. *Studium Generale* 10.612–20. Berlin–Göttingen–Heidelberg: Springer.

Brunner-Traut, E. 1953, 'Die Darstellweise in der ägyptischen Kunst: ein Wahrheitsproblem'. *Universitas* 8.481–92. Stuttgart: Wissenschaftliche Verlagsgesellschaft.

Brunner-Traut, E. 1957b, 'Die Geburtsstunde des Zeitbewussten Menschen in Altägypten'. *Universitas* 12.497–508. Stuttgart: Wissenschaftliche Verlagsgesellschaft.

Brunner-Traut, E. 1959, 'The rise of consciousness in ancient Egypt'. *Universitas, Quarterly English-language Edition* 3.71–8. Stuttgart: Wissenschaftliche Verlagsgesellschaft.

Cassirer, E. 1925, *Philosophie der symbolischen Formen, zweiter Teil: das mythische Denken*. Berlin: Cassirer. [tr. Ralph Manheim, *The Philosophy of Symbolic Forms,* Vol. 2: *Mythical Thought.* New Haven, Conn.: Yale University Press–London: Oxford University Press 1955.]

Dawson, W. R. 1930–1, 'Notes on Egyptian magic'. *Aegyptus* 11.23–8. Milano: Università Cattolica.

Firchow, O. 1953, 'Die Mischgestalt des Toten'. *Mitteilungen des Institutes für Orientforschung* 1.313–25. Berlin: Akademie-Verlag.

Hermann, A. 1955, 'Beiträge zur Erklärung der ägyptischen Liebesdichtung', in O. Firchow (ed.), *Ägyptologische Studien,* Deutsche Akademie der Wissenschaften zu Berlin, Institut für Orientforschung, Veröffentlichung 29.118–39. Berlin: Akademie-Verlag.

Hermann, A. 1956, 'Zergliedern und Zusammenfügen: religionsgeschichtliches zur Mumifizierung'. *Numen* 3.81–96. Leiden: Brill.

Hermann, A. 1961b, 'Das steinharte Herz'. *Jahrbuch für Antike und Christentum* 4.77–107. Münster: Aschendorff.

Jantzen, H. 1960, *Das Abendland in der Geschichte seiner Kunst.* Festvortrag anlässlich der Verleihung des Reuchlin-Preises der Stadt Pforzheim 1959. Pforzheim: Selbstverlag der Stadt Pforzheim.

Lacau, P.–Chevrier, H. 1956, *Une chapelle de Sésostris Ier à Karnak.* Service des
Antiquités de l'Égypte. Le Caire: Imprimerie de l'Institut Français d'Archéologie
Orientale. [Plate volume appeared 1969.]

Otto, E. 1938, 'Die Lehre von den beiden Ländern Agyptens in der ägyptischen
Religionsgeschichte'. *Studia Aegyptiaca* 1.10–35. Analecta Orientalia 17.
Roma: Pontificium Institutum Biblicum.

Otto, E. 1954, 'Altägyptische Zeitvorstellungen und Zeitbegriffe'. *Die Welt als
Geschichte* 14.135–48. Stuttgart: Kohlhammer.

Ranke, H. 1924, 'Die Vergottung der Glieder des menschlichen Körpers bei den
Ägyptern'. *OLZ* 27.558–64.

Ranke, H. 1931, 'Vom Geschichtsbilde der alten Ägypter'. *CdÉ* 6.277–86.

Riefstahl, E. 1951, 'An Egyptian portrait of an old man'. *JNES* 10.65–73.

INDEXES

These indices cover the Mottoes, p. xi, the Author's Preface, pp. xxvii—xxx, and the main text of the book, pp. 1—357. Figure captions are not indexed. For the figures and plates the page references in the lists of sources, pp. 365—79, should be consulted. Discussions of particular subjects and motifs may also be located by way of the list of contents, pp. v—vii. New material incorporated in this edition has been indexed. Footnotes are not distinguished from text in index entries.

The indices are modelled to some extent on the index in the German edition, the main change being the separate listing of personal names.

Abbreviations

ch. children's drawings
Chap. Chapter
E. Egypt, Egyptian etc.
2-d two-dimensional art
3-d three-dimensional art

Abbreviations for historical periods are those used in the Chronological Table.

GENERAL INDEX

This list includes geographical names.
N before a number = cross-reference to index of Personal Names.

PERSONAL NAMES

All personal names occurring in the book are listed here, whether ancient or modern, real or fictional. G before a number = cross-reference to General Index.

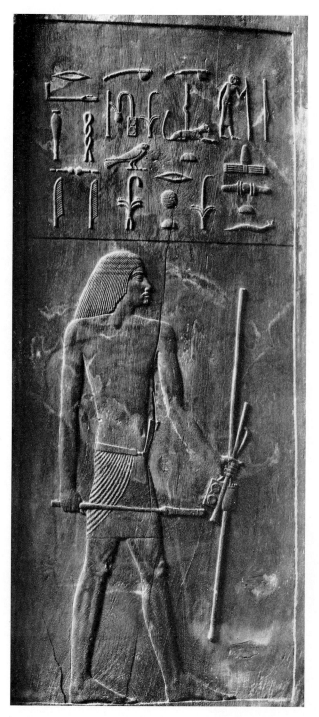

1. Wooden relief of Ḥesireꜥ. OK

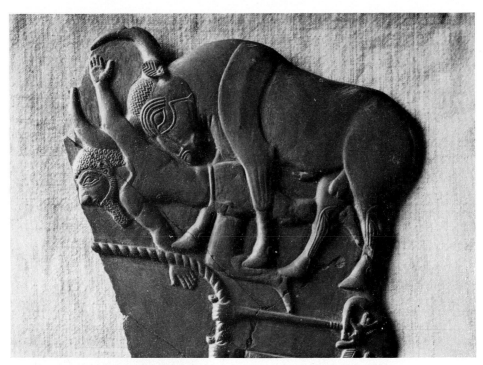

2. Slate palette with the king in the form
of a bull (detail). Predynastic

3. Warrior with a prisoner. Predynastic

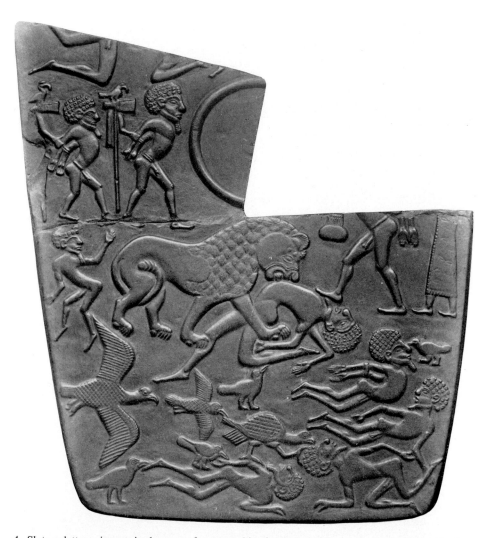

4. Slate palette: prisoners in the upper fragment; king in the form of a lion on the battlefield in the lower fragment. Predynastic (cast)

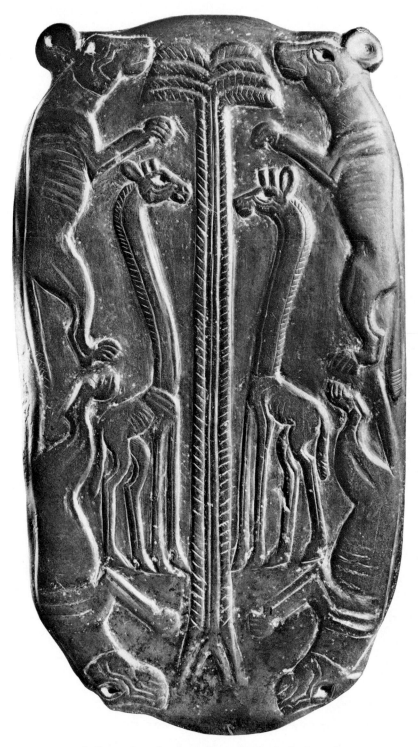

5. Slate palette showing palms and animals. Predynastic

7. King Naꜥrmer (detail from 9). ED

6. Mace Head: a late predynastic king inaugurates state irrigation work. Predynastic/ED

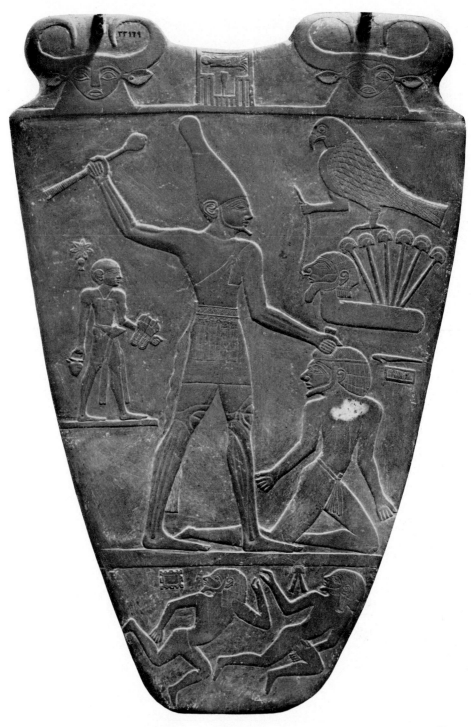

8 and 9. Slate palette of King Naʿrmer. ED

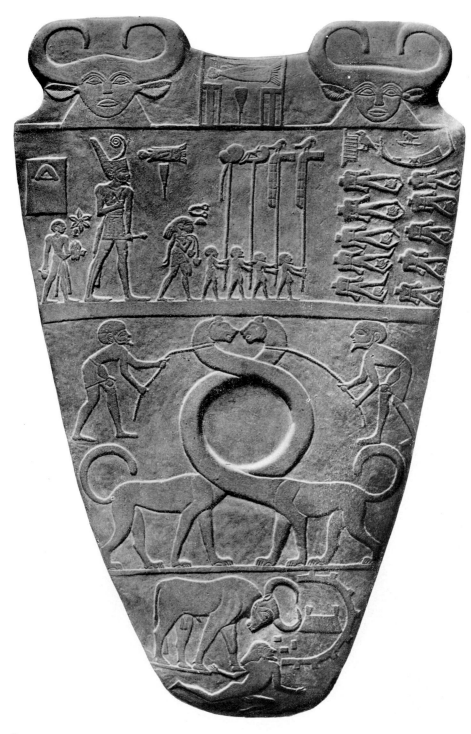

Recto

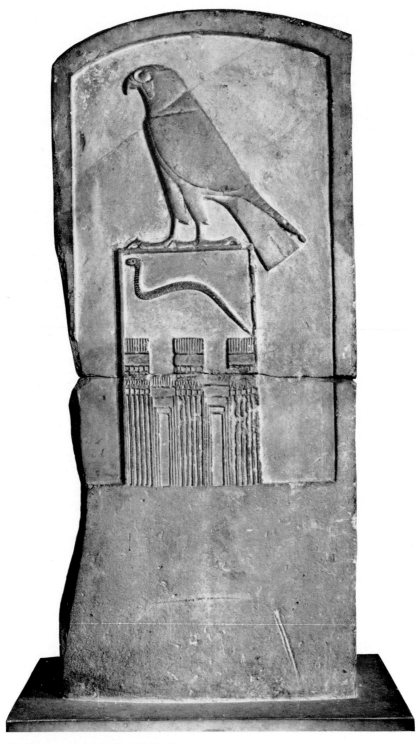

10. Funerary stela of King Wadj. ED

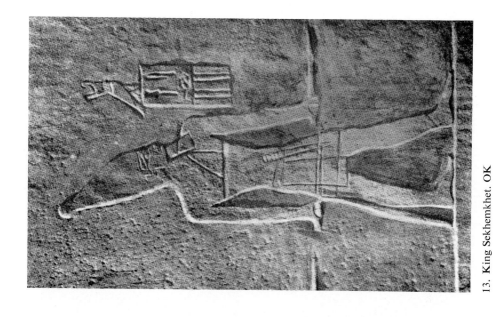

13. King Sekhemkhet. OK

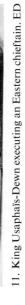

11. King Usaphaïs-Dewn executing an Eastern chieftain. ED

12. Dwarf. ED

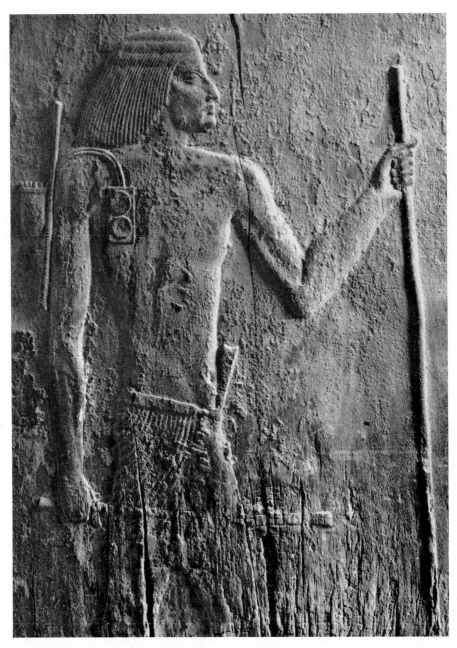

14. Relief of Ḥesireꞌ with a scribe's palette over his shoulder. OK

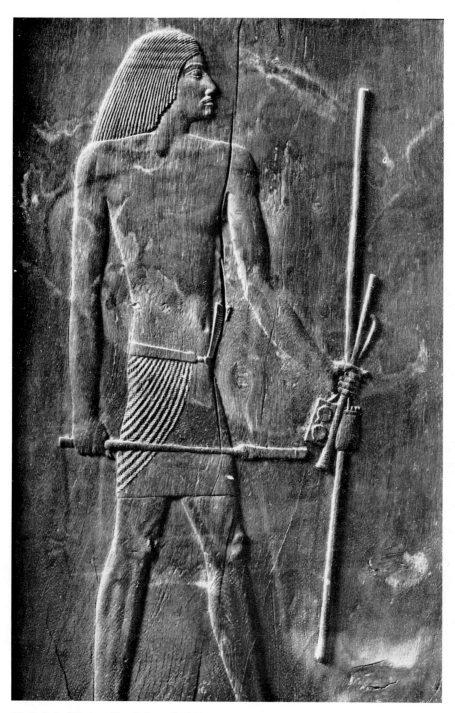

15. Relief of Ḥesireᶜ (detail from 1). OK

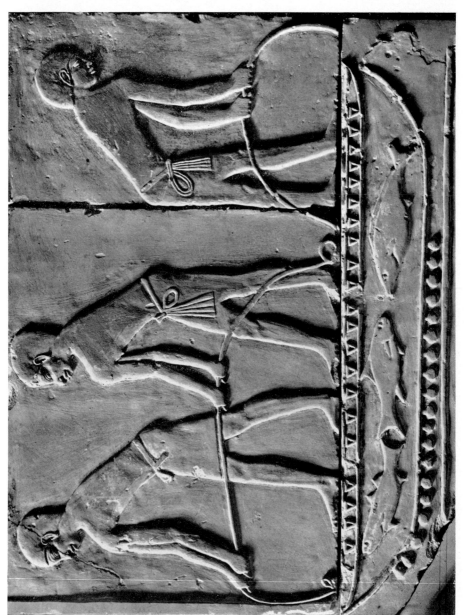

16. Netting fish. OK

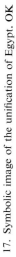

17. Symbolic image of the unification of Egypt. OK

18. Chest (?) on a sled, decorated with feathers at the top. OK

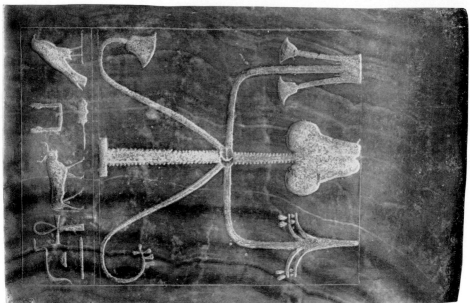

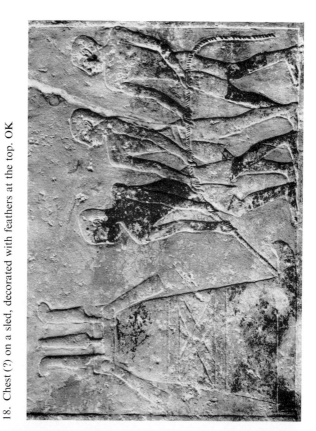

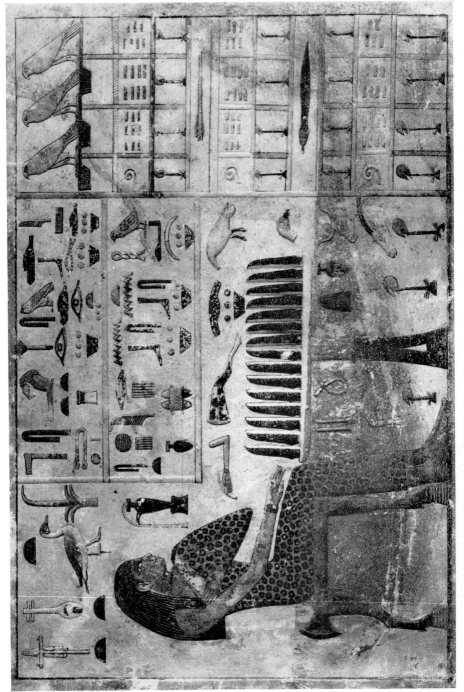

19. The deceased seated by a table piled with food. OK

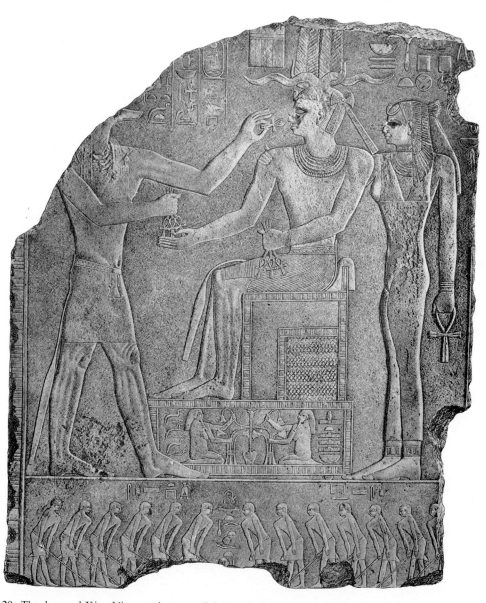

20. The deceased King Niuserreᶜ between divinities. Below: bodyguard around the throne. OK

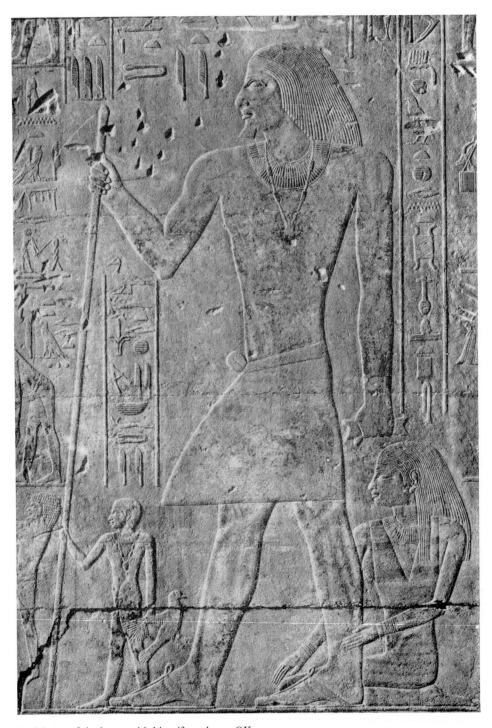

21. Master of the house with his wife and son. OK

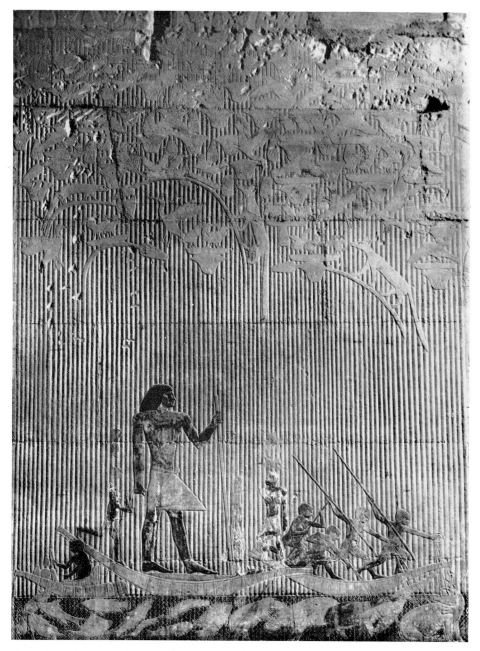

22. Hunting hippopotami in a papyrus thicket. OK

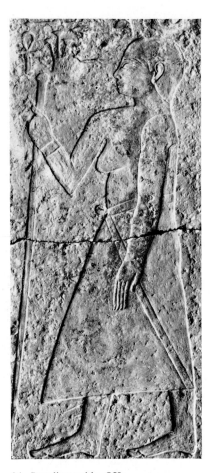

23. Scribe. OK

24. Standing noble. OK

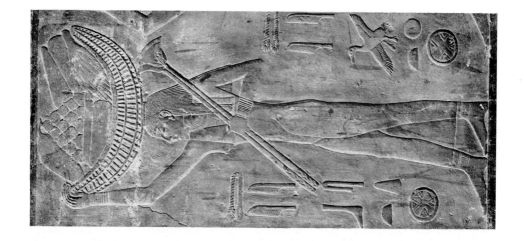

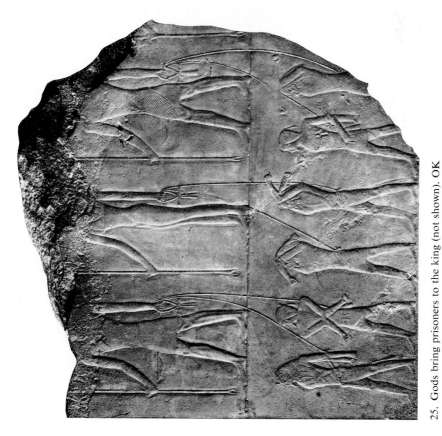

25. Gods bring prisoners to the king (not shown). OK

26 (*right*). Peasant girl with gifts. OK

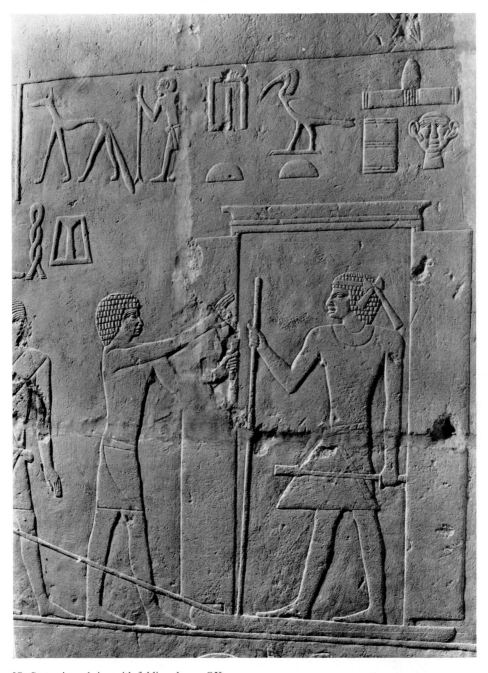

27. Statue in a shrine with folding doors. OK

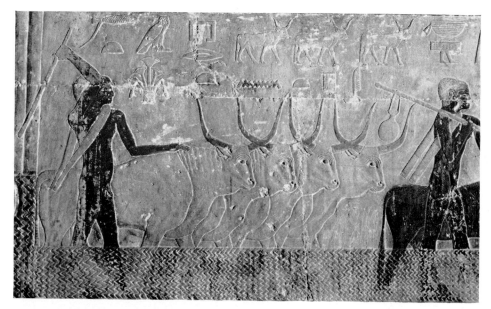

28. Herd of oxen in the water. OK

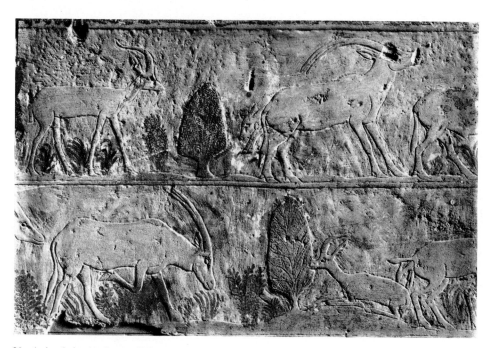

29. Animals in the desert. OK

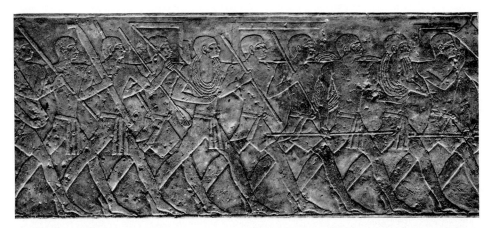

30. Sailors returning home. OK

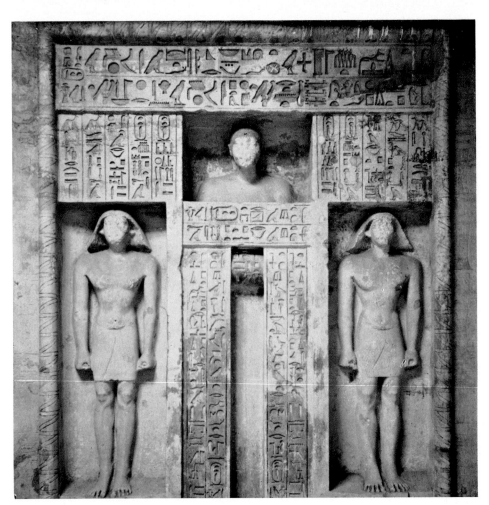

31. False door with semi-statues. OK

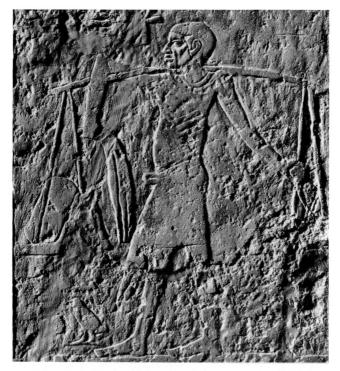

32. Thin old man with offerings. OK

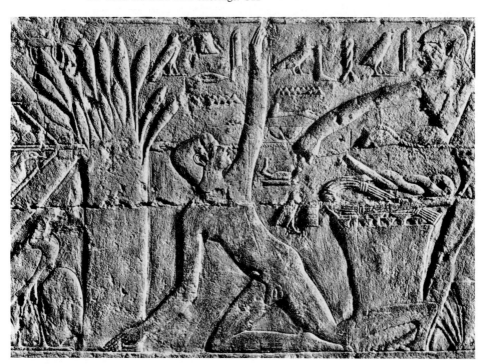

33. Catching birds. OK

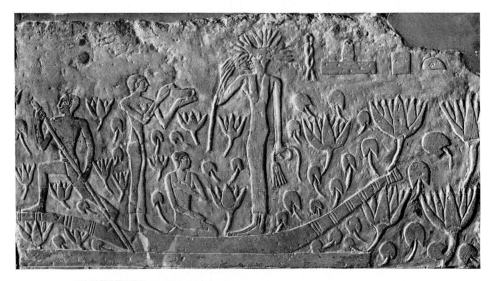

34. Pleasure trip on a lake covered with lotuses. OK

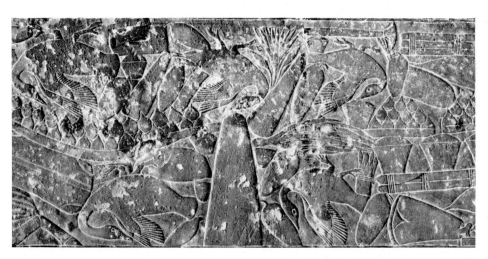

35. Still life: food. OK

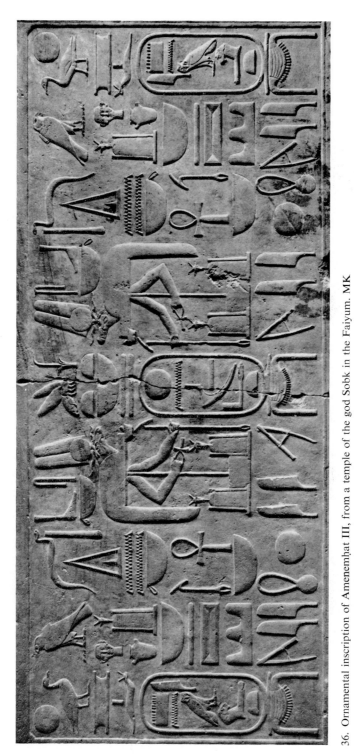

36. Ornamental inscription of Amenemhat III, from a temple of the god Sobk in the Faiyum. MK

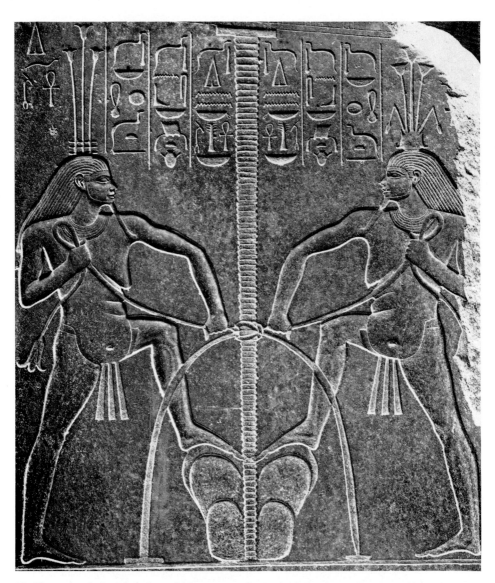

37. The gods of the two halves of the country tie the heraldic plants of Upper and Lower Egypt round the hieroglyph for 'to unite' (cf. 17). MK

38 (*left*). Spearing fish in a papyrus thicket. MK

39. Harvesting papyrus. MK

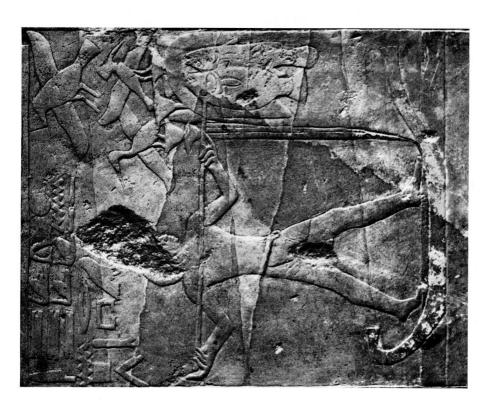

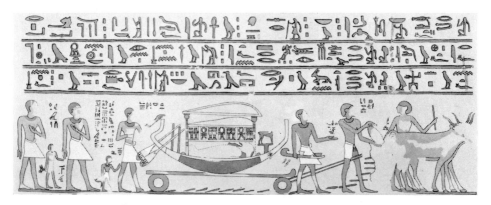

40. Wagon carrying a coffin, with water being poured in front of it. Second Intermediate

41. Reapers with sleeping overseer. NK

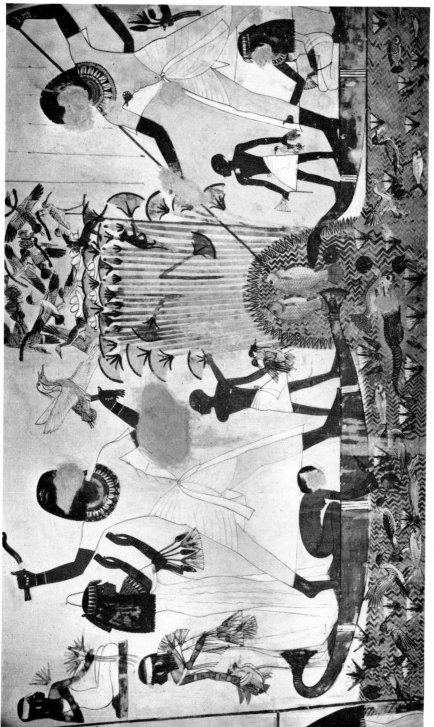

42. Spearing fish and hunting birds in a papyrus thicket. NK

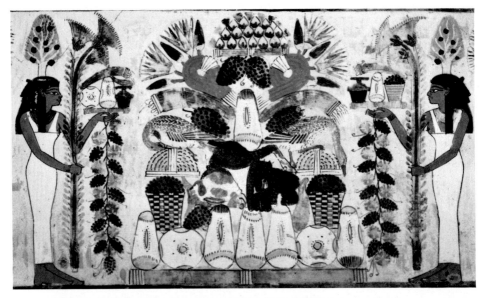

43. Tree goddesses bringing food to the deceased (not shown). NK

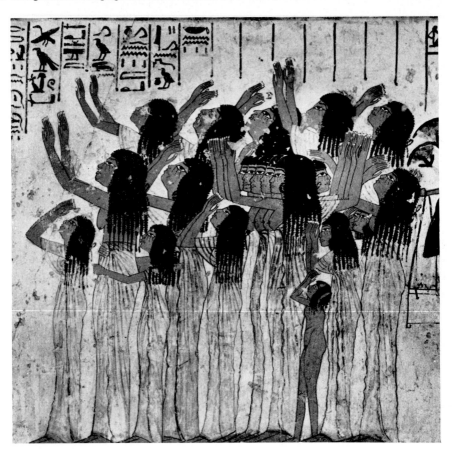

44. Women mourning. NK

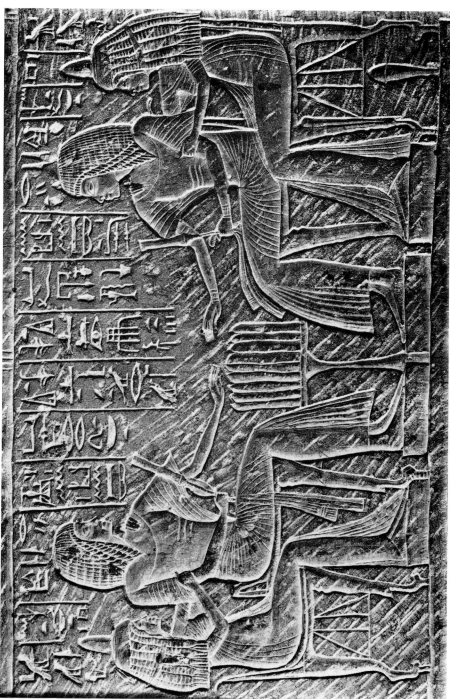

45. The deceased and his wife by the dining table. NK

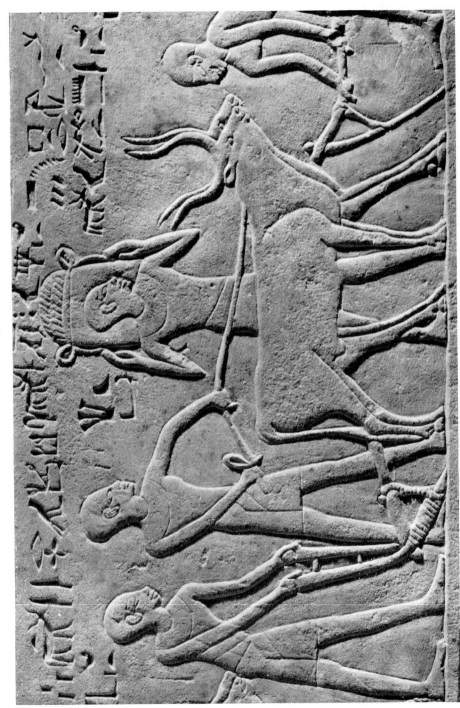

46. Ploughing. NK

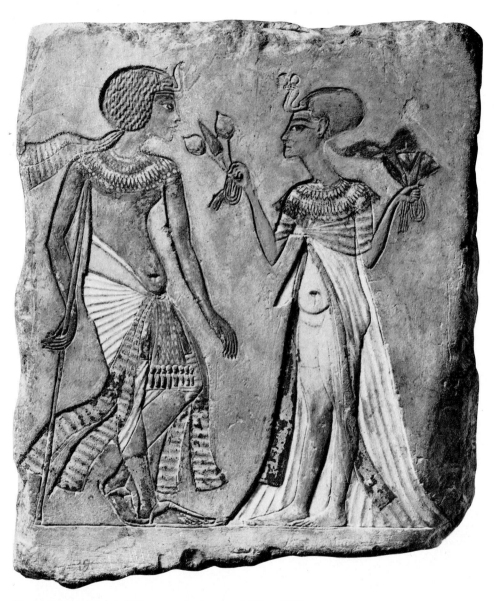

47. An Amarna king and his queen. Sculptor's trial piece. NK

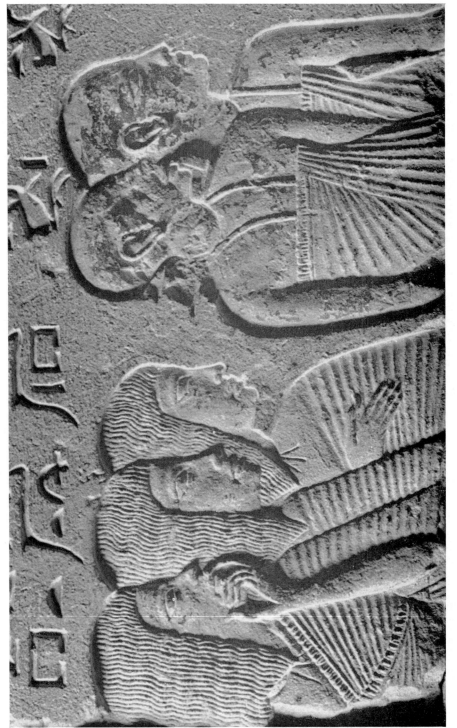

48. Mourning figures from the funeral procession of a high priest of Memphis. NK

49 and 50. Details from the same picture as 48. NK

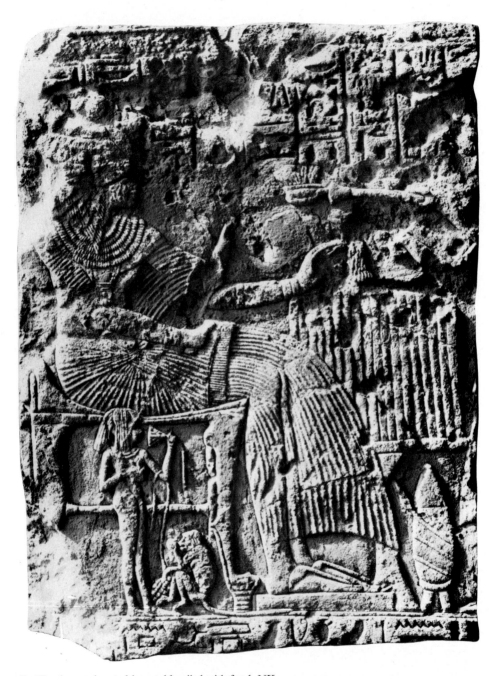

51. The deceased seated by a table piled with food. NK

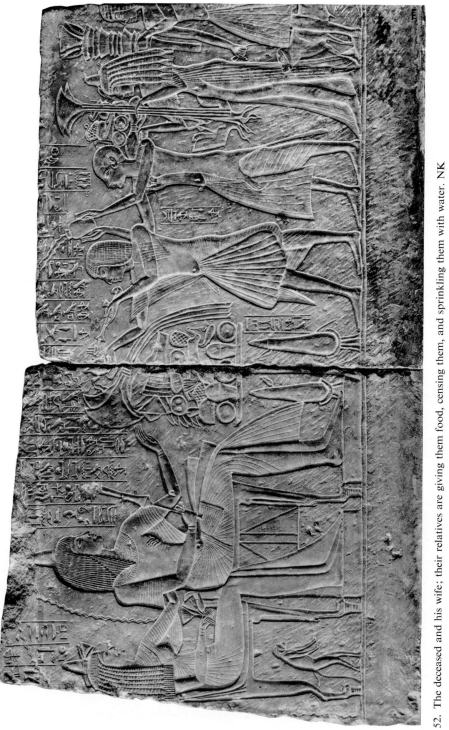

52. The deceased and his wife; their relatives are giving them food, censing them, and sprinkling them with water. NK

54. Servant greeting his master. NK

53. Asiatic soldier shot by an arrow (cast; detail from the same scene as 55). NK

55. Sety I storming a Cannanite hill fortress (below *a* is the man who is climbing from the field on to the hill). NK

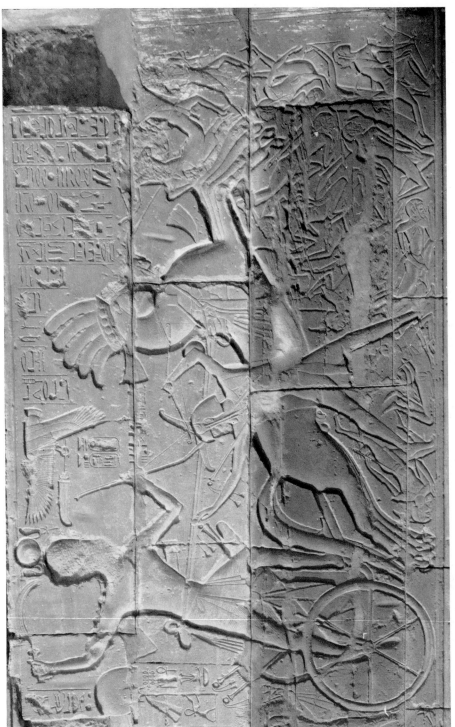

56. Sety I fighting the Libyans. NK

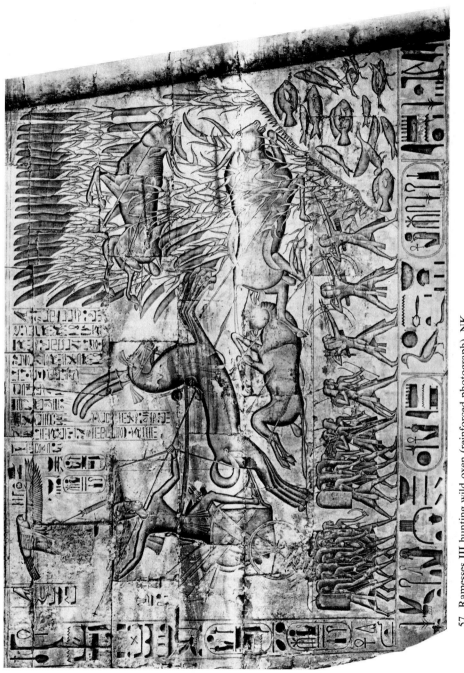

57. Ramesses III hunting wild oxen (reinforced photograph). NK

58. Ramesses II capturing a fortress. NK

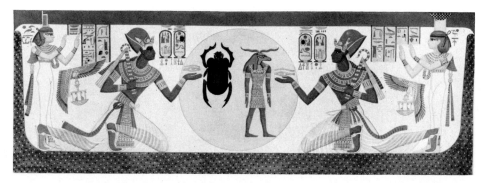

59. Sun, sky, and earth. NK

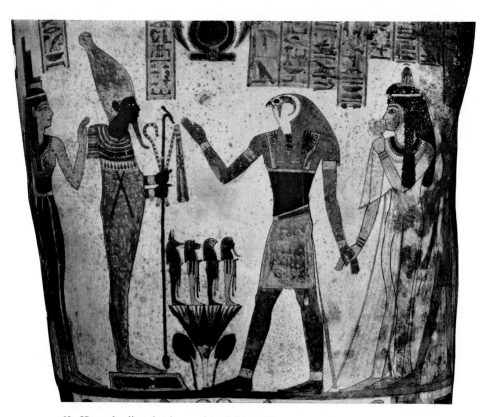

60. Horus leading the deceased to Osiris. NK

62. The sun in an image of the world. NK

61. Water being sprinkled over the deceased. NK

63. Part of the *Book of the Dead*. Spells relating to the gates of the underworld, with vignettes of their guardians. NK

64. Part of a mythological papyrus with pictures of genii of the underworld. NK

65. Detail from a picture of the necropolis. Late

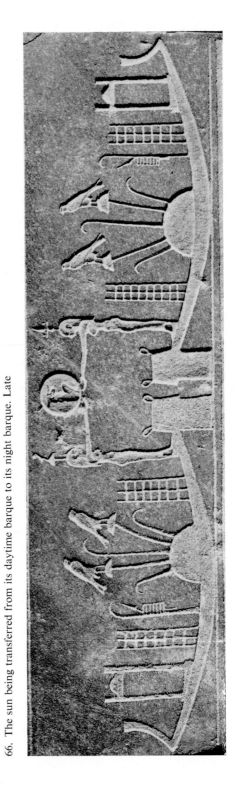

66. The sun being transferred from its daytime barque to its night barque. Late

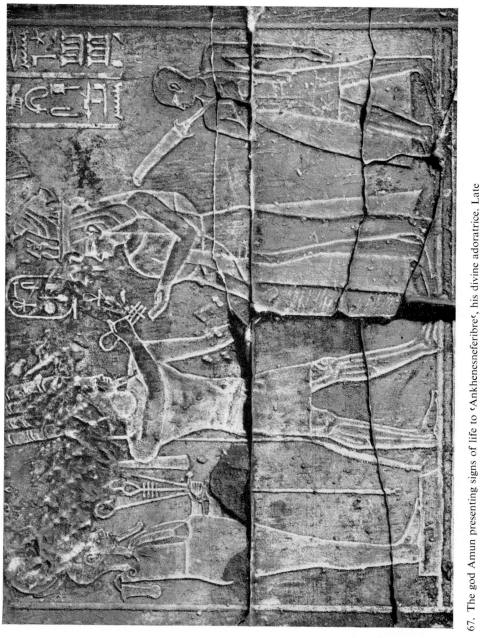

67. The god Amun presenting signs of life to ʿAnkhenesneferibreʿ, his divine adoratrice. Late

70

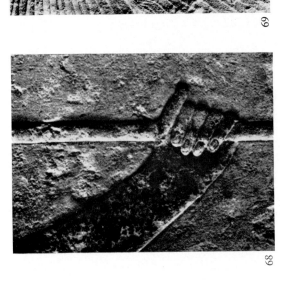

69

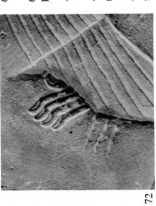

72

68

71

68. Hand holding a sceptre. OK

69. Hand hanging loose; from a picture of a statue. NK

70. Neck muscles. OK

71. Hand carrying an offering table. OK

72. Finger joints; folds of flesh on the chest (detail from 52). NK

73. Foot of Amenḥotpe IV. Sculptor's trial piece. NK

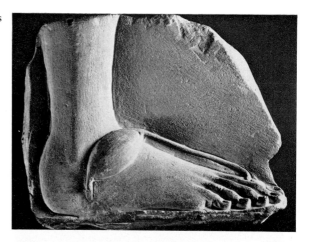

74. Foot. OK

75 (*below*). Stages in the production of a foot in sculpture. Apprentice pieces. Late

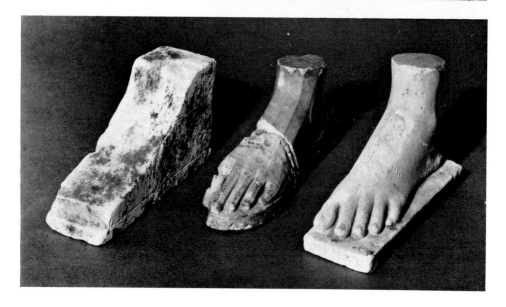

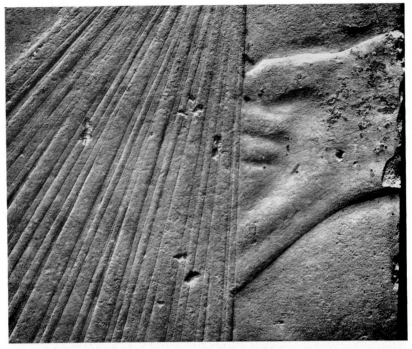

77. Knee muscles. OK

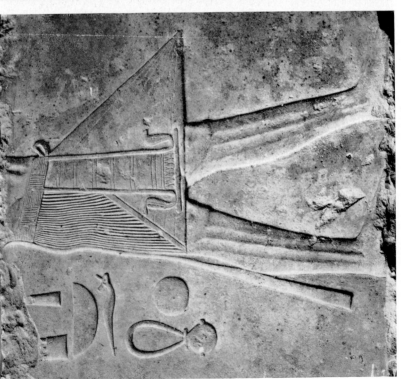

76. Detail from a picture of a king. MK

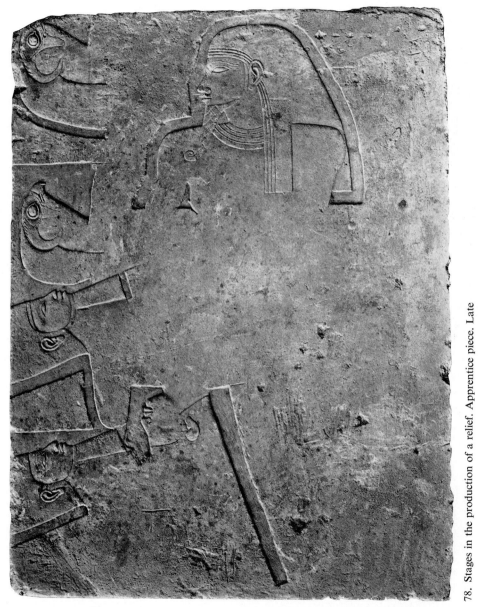

78. Stages in the production of a relief. Apprentice piece. Late

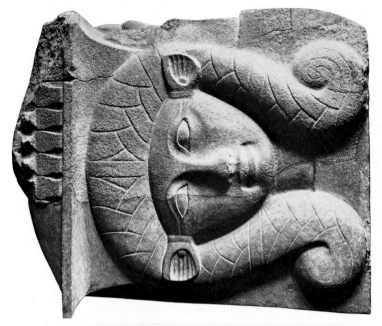

80. Hathor head from a column. MK (?)

79. Head of a lion. OK

81 and 82. Head of a lion; right profile and front view. OK

83. Lion. Predynastic/ED

84. Head of an official; from Amarna. NK [This is mostly considered to be a female head, and was so published by Schäfer himself (1931a pl. 26) (J.R.B.).]

85. Head of a princess; from Amarna. NK

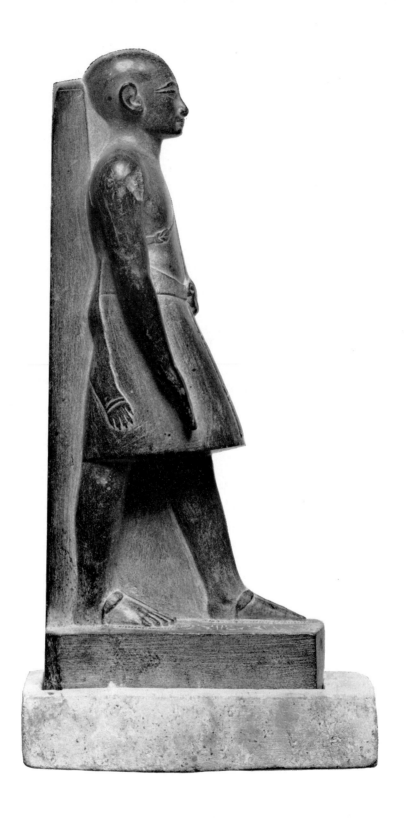

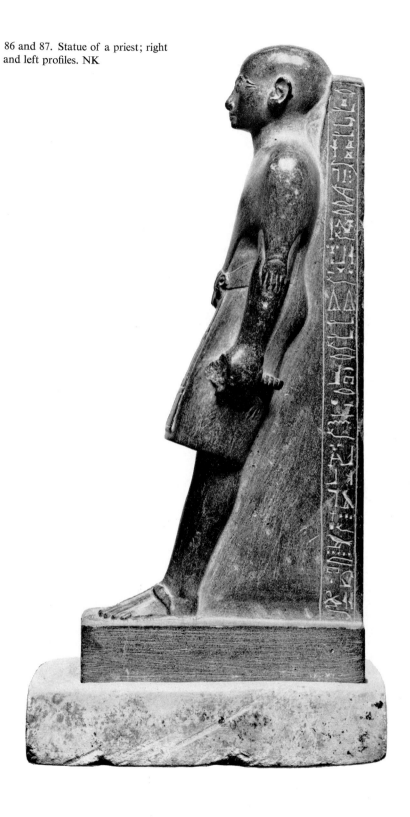

86 and 87. Statue of a priest; right and left profiles. NK

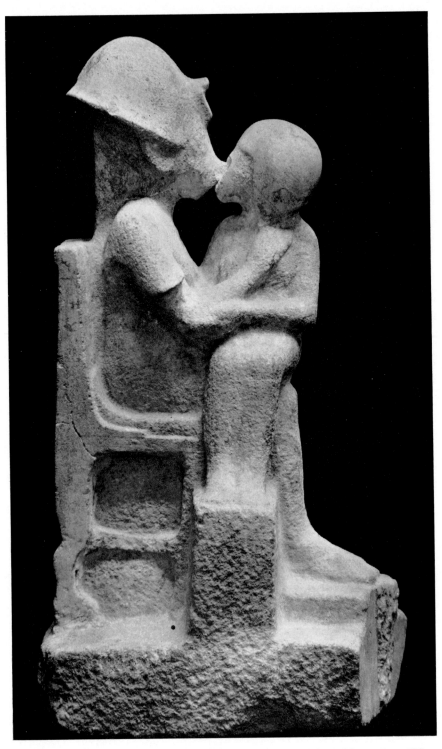

88 and 89. Unfinished group: Amenḥotpe IV and a daughter; right and front views. NK

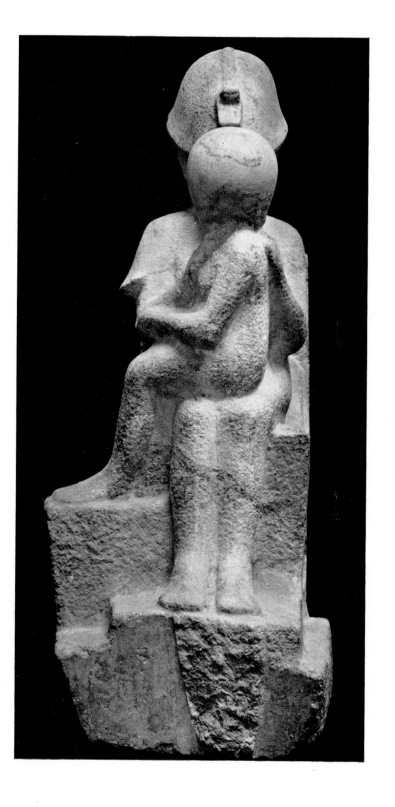

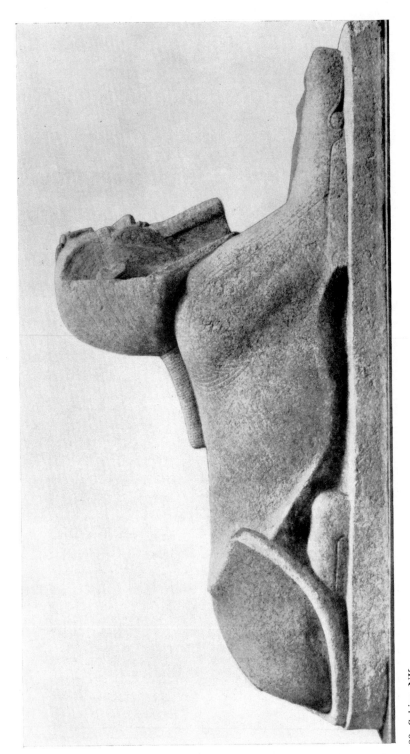

90. Sphinx. NK

91. One stage in the production of a sphinx. Apprentice piece. Late

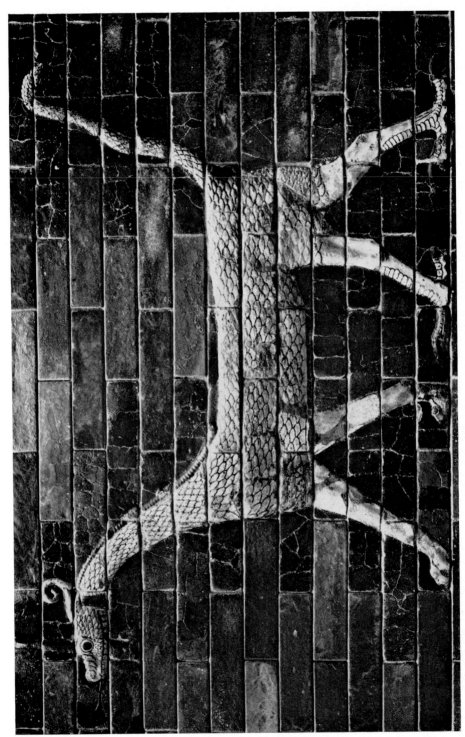

92. Composite monster (mušḫuš); from the Ištar Gate in Babylon. Neo-Babylonian Period

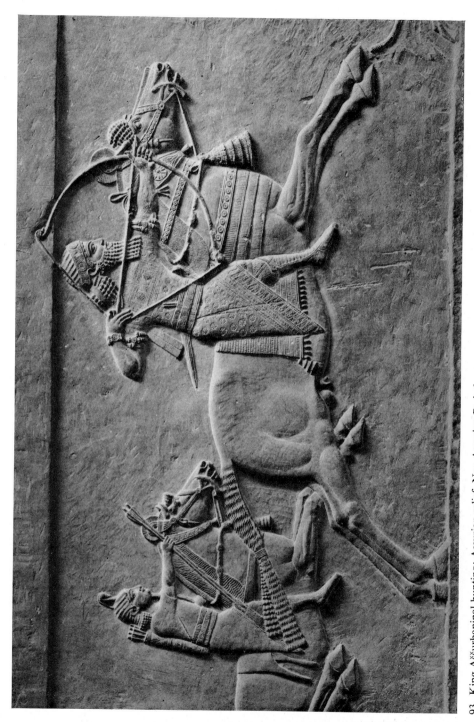

93. King Aššurbanipal hunting; Assyrian relief. Neo-Assyrian Period

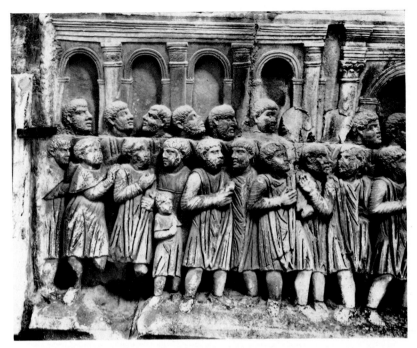

94. Relief from the Arch of Constantine in Rome

95. The Eastern Emperor Theodosius in the gallery of the Circus; below: envoys paying homage. A.D. 390

96. Detail from the Antoninus Column in Rome

97. Relief from the temple of Angkor Wat in Cambodia (cast)

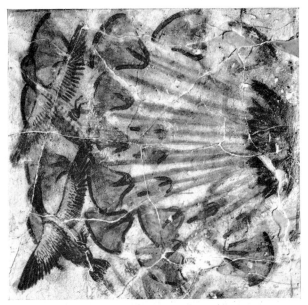

99. Ducks in a papyrus thicket. NK

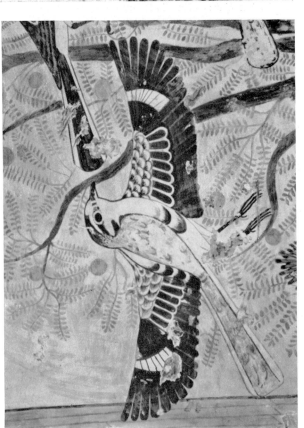

98. Masked shrike in a tree. MK

100 and 101. Japanese painting of sparrows in flight, viewed from above and below (details). By Gantoku (1805–59)

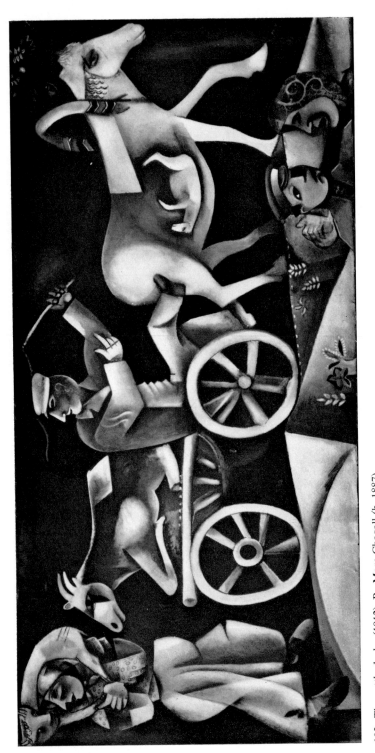

102. The cattle dealer (1912). By Marc Chagall (b. 1887)

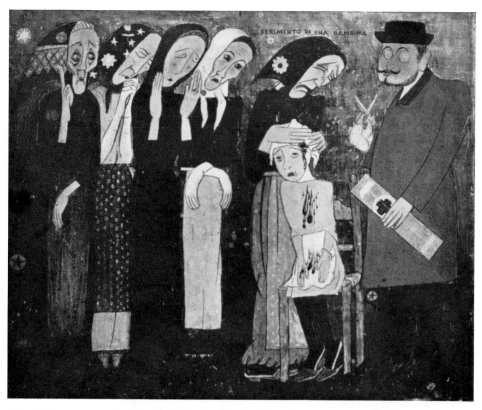

103. *Ferimento di una bambina* (a child's wound). By Alberto Magri (1880–1939)

104. *L'étreinte* (the embrace) (1918). By André Derain (1880–1954)

106. *Sommertag* (summer day). By Oskar Nerlinger (b. 1893)

105. Resurrection of Lazarus (detail), from a sarcophagus. Early Christian

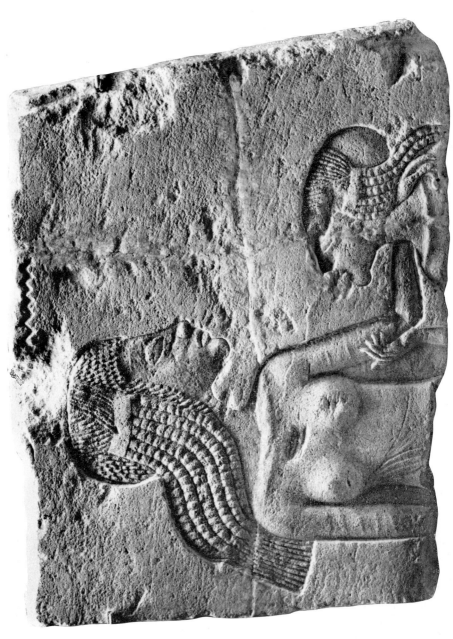

107. Two Amarna princesses. NK

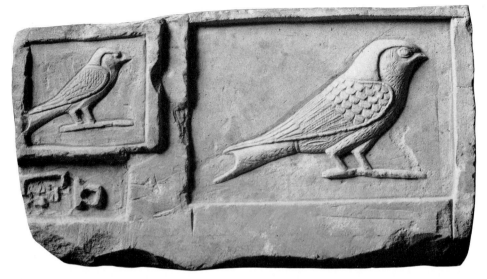

108. Apprentice relief of a hieroglyph (martin, one of the *hirundinidae*). Late

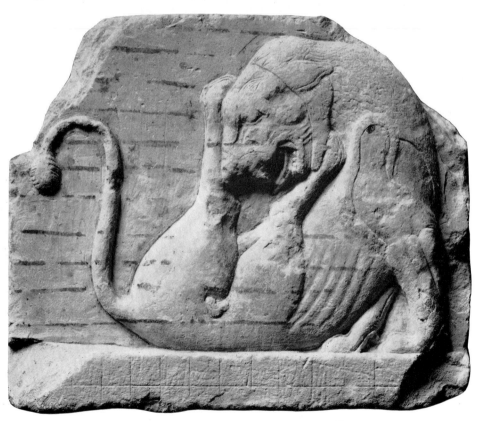

109. Apprentice relief with traces of proportional grid: lion licking itself. Late